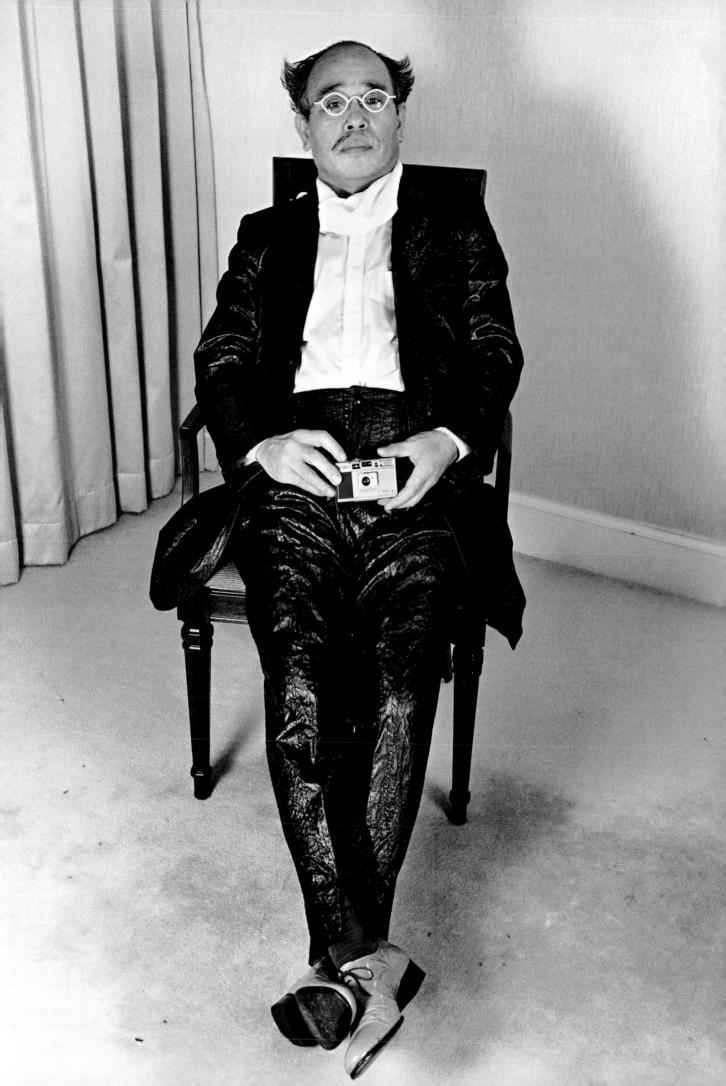

A
R
A
K
I

NOBUYOSHI ARAKI

SELF · LIFE · DEATH

Edited by Akiko Miki, Yoshiko Isshiki and Tomoko Sato

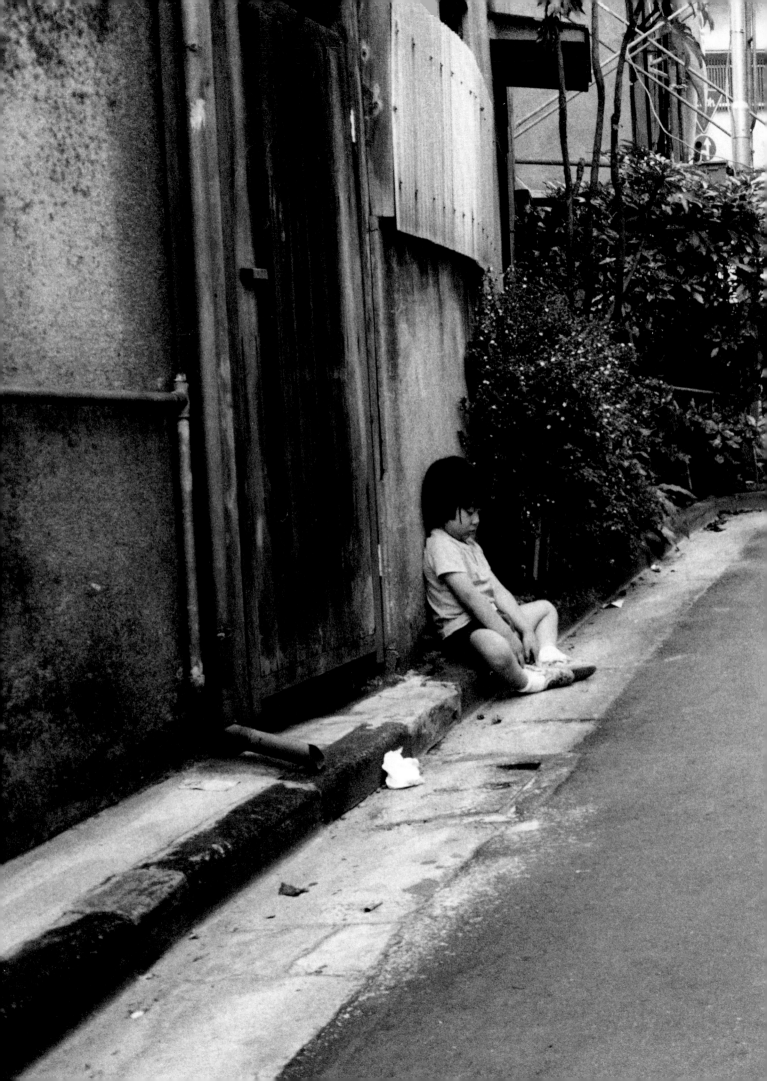

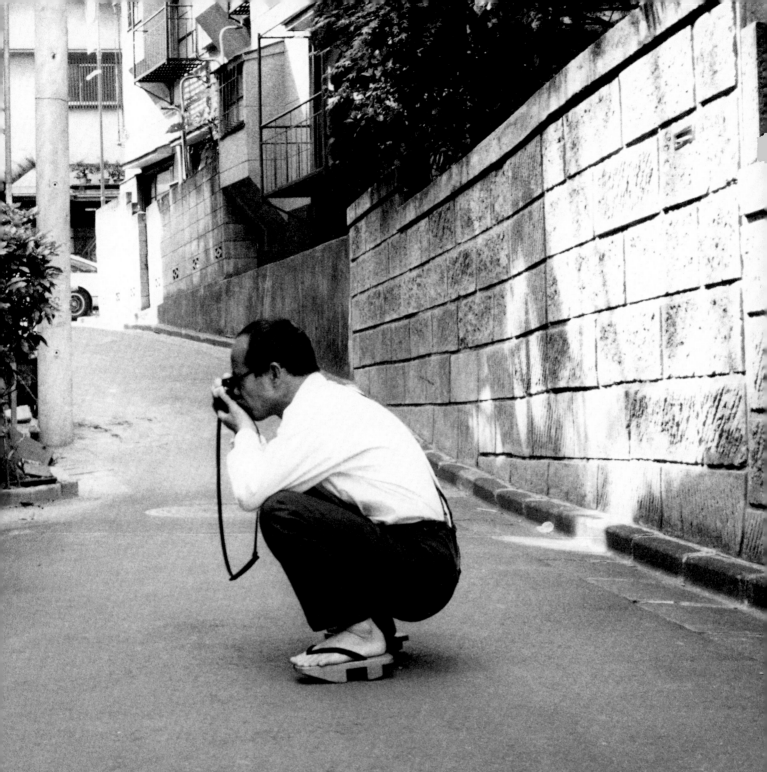
85 5 27

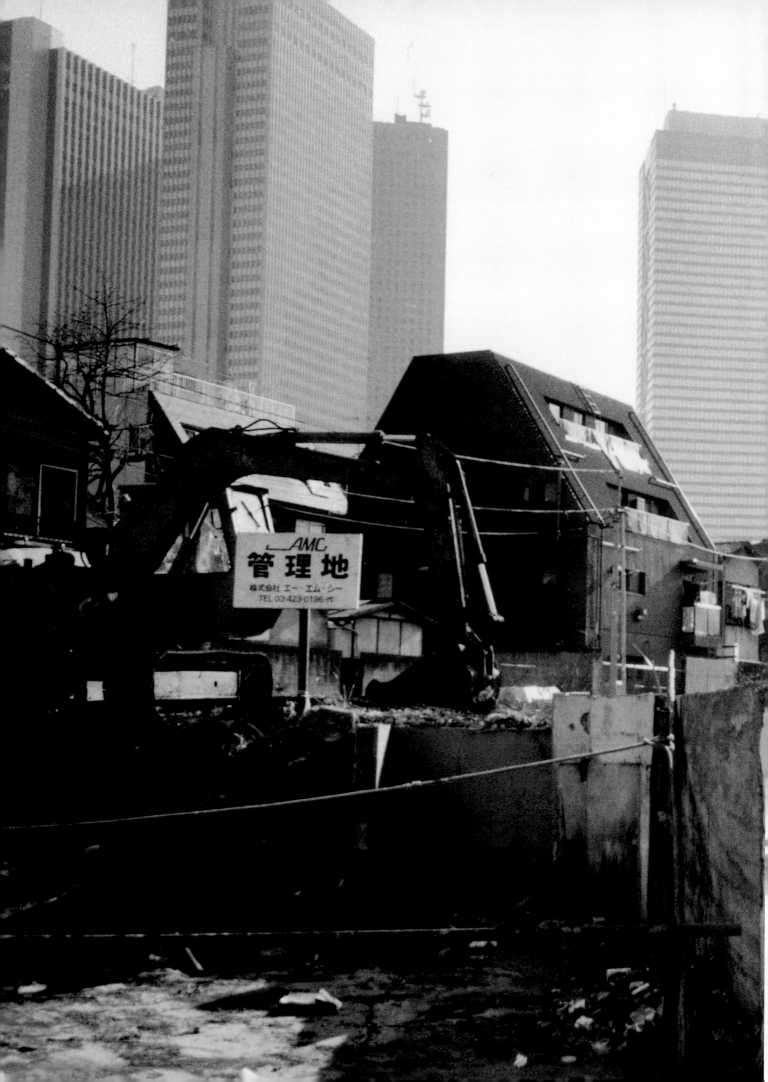

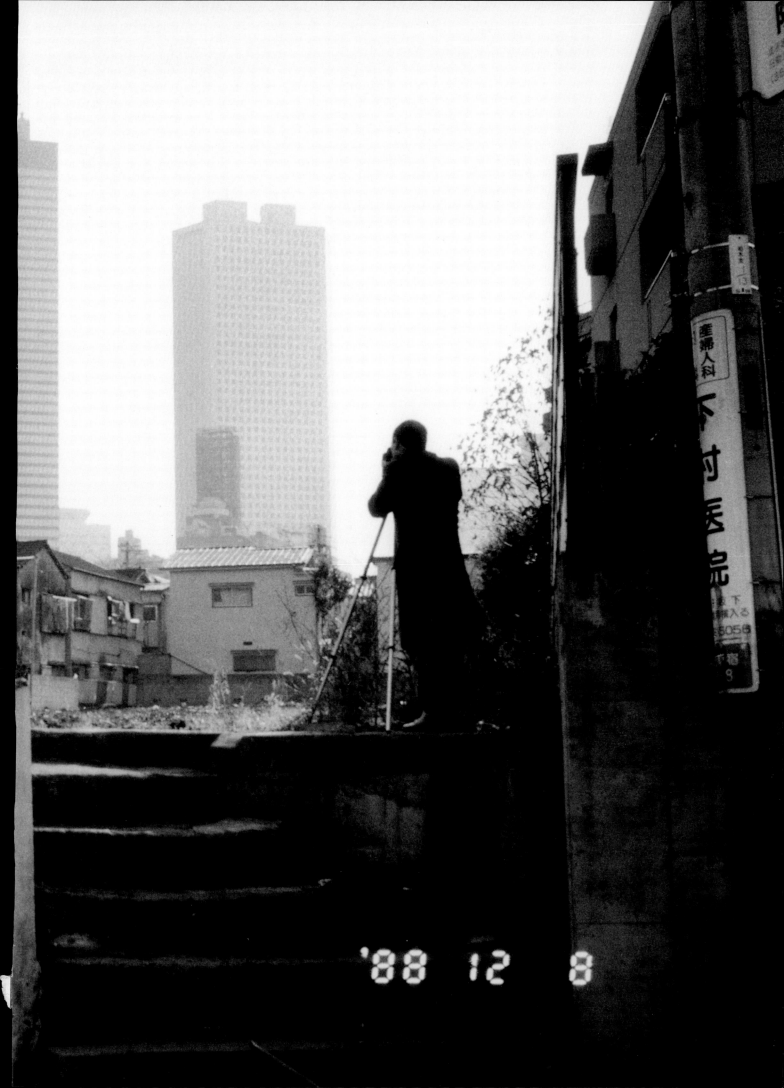

'88 12 8

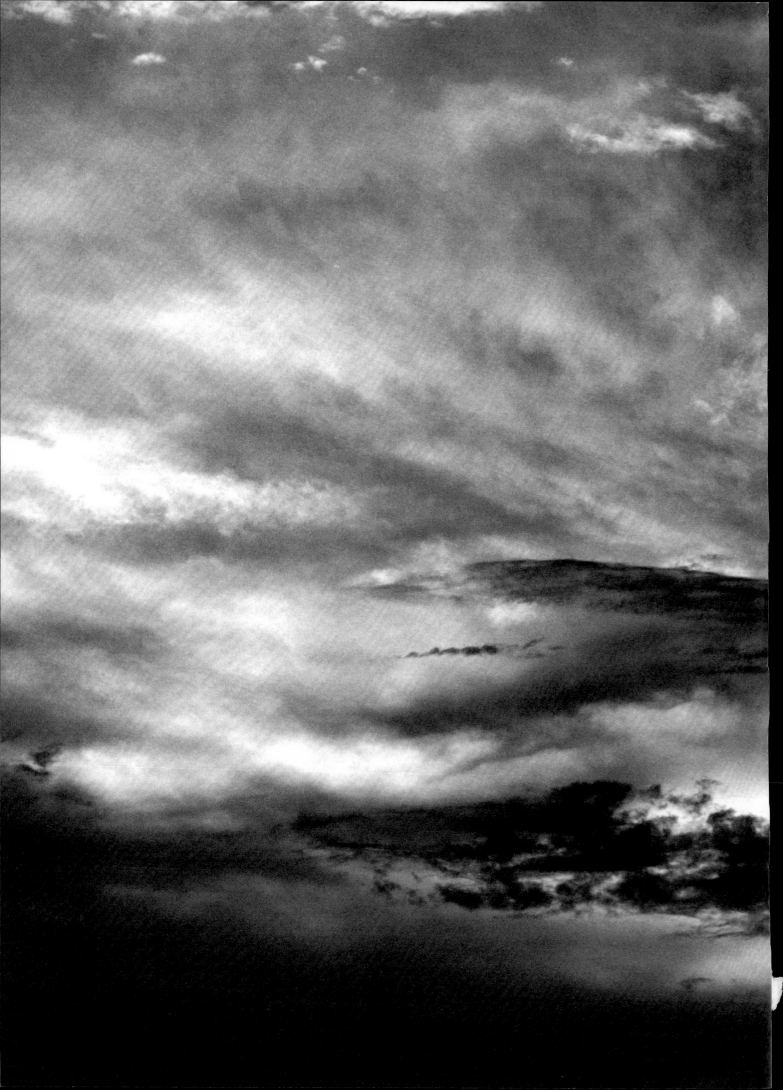

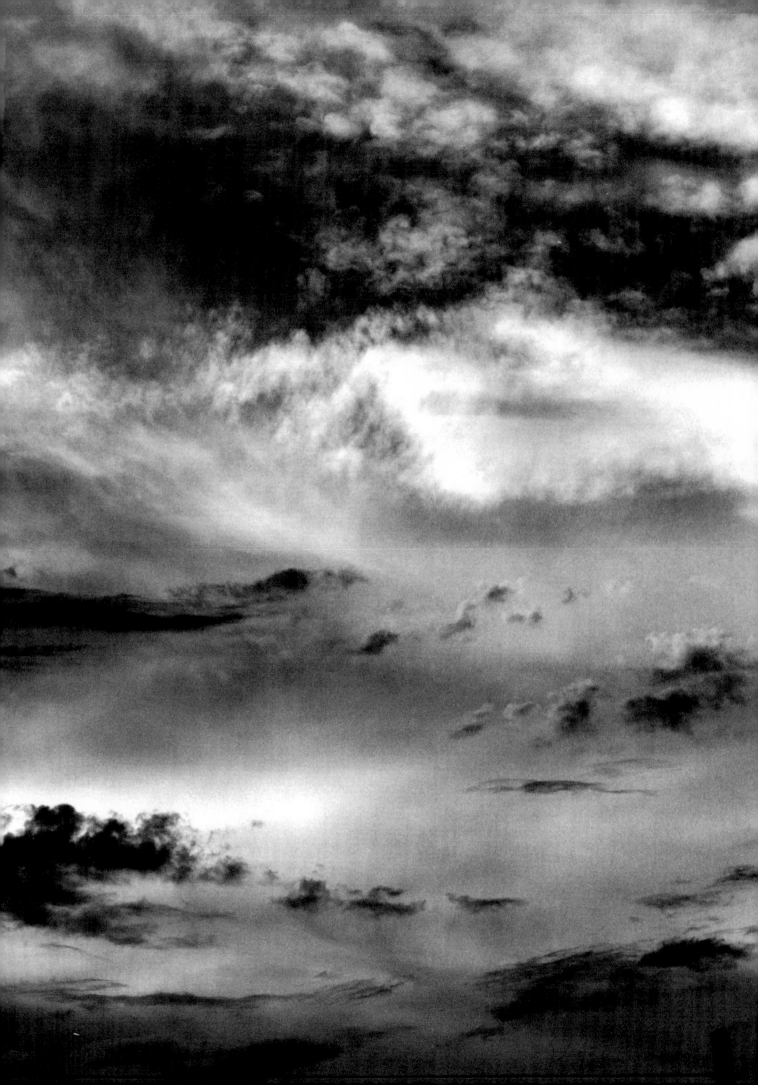

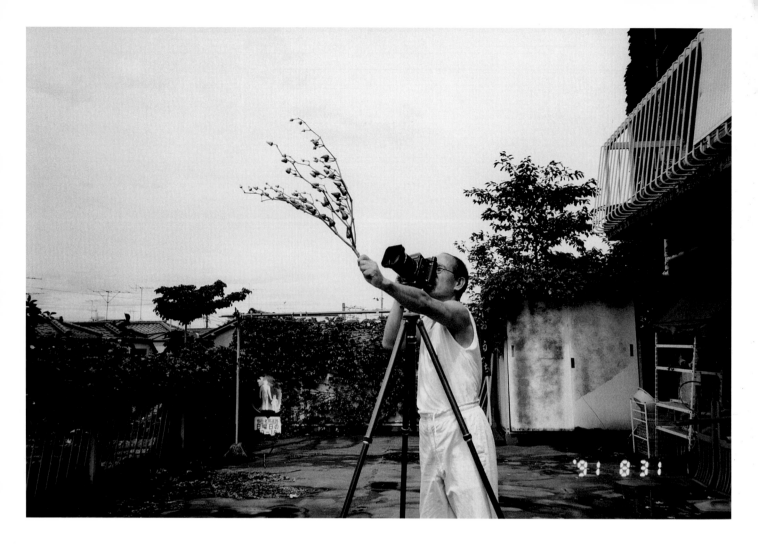

'91 8 31

THE PHOTOGRAPHIC LIFE OF

NOBUYOSHI ARAKI

Akiko Miki

Nobuyoshi Araki is one of Japan's most celebrated photographers both at home and abroad. His photographs are highly controversial and often regarded as enigmatic.

Araki's photographs incorporate a wide range of images: scenes from his own honeymoon, including sexual acts; enlarged photographs of genitalia and flowers; bondage scenes of trussed-up women hanging from the ceiling; Tokyo street scenes, taking in the bustling commercial and entertainment quarters as well as back streets and alleyways. These images mirror Araki's own private world and vision. Using Polaroids, compact cameras and Leicas, Araki turns himself into an excess production machine that explores everything within its immediate reach and creates a vast store of images out of everyday life. Apart from its quantity, Araki's work is noted for its innovation, particularly the colouring of his prints; his incorporation of words and the blurring of fact and fiction to create photographs that require 'reading'; the colour-copied enlarged images; the installations that incorporate objects; the *Arakinema*, a method of display where slide projectors superimpose images with a music accompaniment. A distinctive Araki motif is the appearance of the photographer himself, in surreal guise with dark glasses and moustache, in many of his images.

The name and face of this middle-aged man are a familiar presence in the Japanese mass media. There are more than three hundred books published by or about Araki. His photographs are widely known in Japan and he himself appears frequently on TV and in magazines and other print media. His already abnormal fame within Japan grew further during the 1990s, coinciding with increasing interest in his work outside Japan. Until then Araki had been virtually unknown overseas but from this time onwards galleries around the world began to handle his work, he was invited to take part in large international exhibitions and several leading European art museums presented solo exhibitions.

This interest, however, tends especially in Europe to concentrate on aspects of Araki's work that are not altogether representative of his four decades as a photographer. The sensationalism attached to his 1980s treatment of sexual mores, bondage, nudes and enlarged genitalia has attracted attention to this one strand of his work. Equally the novelty of his display methods and his outspoken remarks about people and form have had more than their share of critical focus. In orthodox feminist criticism there has been much condemnation of the supposed objectification and fetishization of women in his photographs. Such approaches to his work are meaningful in themselves and present clues to the appreciation of his work, but fail to capture the essence of Araki's activities over the last four decades.[1]

Araki's photographs do not easily fit into the standard categories of art, journalism and advertising; they distance themselves from the ordinary codes that enable us to interpret photographs, and their extreme variety of form and meaning when presented en masse creates a barrier to understanding. The non-Japanese viewer unfamiliar with the idioms of Japanese culture may be perplexed by many of Araki's images. As well as all this, the unbalanced expansion of Araki's fame has produced a stereotyped image of a pornographic photographer who shoots women with their legs wide open and his own remarks about his 'genius' have taken on a life of their own. Criticism against this background ends up in a cul-de-sac, getting no further than discussion of Araki as controversial and enigmatic.

But who exactly is Araki, and what features of his life and career have led him to form his current ideas about photography? How should we interpret his photographic activities stretching back almost half a century. As a highly varied 'body in motion', Araki is not someone who can be grasped simply. My aim in this brief article is to examine these questions by following the development of his career.

TOKYO'S *SHITAMACHI*:
THE PROTOTYPE OF ARAKI'S UNIVERSE

Araki was born in 1940, on the outskirts of *Shitamachi*, the old traditional quarter of Tokyo. A year later, Japan entered the Second World War. Araki encountered photography at a very early age, learning through imitation as he assisted his father – a craftsman making *geta* clogs and an amateur photographer. He began taking his own photographs while still at primary school. Throughout his years at high school and university, he regularly submitted work to competitions in photography magazines, earning a fair amount of prize money in the process and revealing his talent at an early stage. Most of the photographs he submitted were either portraits of women or snapshots of traditional quarters of the city, the two subjects that have dominated Araki's work throughout his career.

Araki was a highly able pupil at school and studied at one of Tokyo's elite senior high schools. Although tempted by a literary career, in 1959 he enrolled in the department of photography and printing in the engineering faculty at Chiba University. His time at Chiba and subsequently at the Tokyo advertising agency, Dentsu, was highly significant in determining his orientation as a photographer. In general in Japan, passing from a national university to employment in a major advertising agency is considered to be a successful path. But Araki himself seems to have felt dissatisfied with this route and to have followed it only in order to reassure his parents about his future. The course at Chiba University centred on technology and chemistry, which held no interest for him, while the work in the photography division of Dentsu was conservative in the extreme, allowing him little scope to exercise his creativity.

Disillusioned with lectures that amounted to little more than chemistry experiments, he found himself veering towards cinema. He rarely turned up for lectures and instead spent his time watching vast numbers of Japanese and foreign films. Influenced by Italian neo-realist films as well as the 1950s realistic photography movement led by Ken Domon and others, he began to feel that drama exists in most ordinary

scenes of life.[2] A product of his involvement with film at this time was the 16 mm film *Children in Apartment Blocks*, from 1963, featuring children in the *Shitamachi* neighbourhood. This film, which was Araki's graduation project, also allowed him to produce his photographic collection *Satchin*. His determination and exceptional negotiating skills were evident as he not only inveigled his professor to allow him to submit a film – not officially an option on his course – but even persuaded the university to set up a new department of photography and advertising. Araki's technique in this film was not up to the level of his ideas, and it was by no means a success, but the *Satchin* collection was awarded the first Taiyo prize in 1964, the first major recognition of his photographs. Araki reflects himself in the images of the boy Satchin, and the sense of oneness with the children who appear in the photographs and the vital energy present amidst the poverty of Japan (which was still recovering from the impact of the War) create a powerful impression.

Araki was drawn to *Shitamachi* as his subject matter because this was the area he knew best and because it remained uniquely unscathed while Tokyo as a whole underwent rapid transformation. As the 1964 Tokyo Olympics drew closer, expressways were built through the city, the *Shinkansen* bullet train came into service and many of the city's old streets were brushed aside. Against the background of this urban renovation and the Americanization of society during the 1960s and 1970s, the Japanese sense of identity began to crack. People started to question what it meant to be Japanese. In photography too, there was a move away from the idea of everything being centred on Tokyo, and photographers began to look towards the regions. Araki's photographs of traditional Tokyo at this time generally focus on lost images of the city, an undercurrent in the work of many photographers of the era. During the 1990s when Araki began to photograph other Asian cities, his attention was drawn to places with the same atmosphere as the Tokyo he once knew and which had ceased to exist.

THE FIRST ROUND

The year before being awarded the Taiyo prize, Araki had begun working as a photographer at Dentsu. Encouraged by the warm reception that *Satchin* received in the photographic world and as a reaction against the conservative work he was expected to do at Dentsu, he became involved in subversive tactics that aimed to undermine the very idea of photographic advertising. But there were benefits too. Dentsu was a big company with all the facilities he needed, enabling him to engage in all kinds of experimental activities. It had a major social presence and it was at Dentsu that Araki met his future wife Yoko, which marked the beginning of the 'first round' of his career.[3]

A round in a boxing match could scarcely be bettered as a metaphor for Araki's work at this time. At the moment the gong sounded, he was in the centre of the ring. During this period he began to explore the possibilities for a new type of realism in photography, different from that of *Satchin*: he mechanically stuck the faces of large numbers of middle-aged women into scrapbooks; he photographed scenes inside an underground train in a wholly detached manner as objects and experimented with techniques of collage and montage, a series of experiments that reached a peak in 1970. This was the year of the Osaka EXPO, when Japan finally seemed to have extracted itself from the chaos of the post-war era and come to the end of a decade of rapid growth. The EXPO served to advertise at home and abroad Japan's now completed process of modernization. On the personal level, this followed immediately on the death of Araki's father, and these important social and personal events clearly evoked strong responses in him.

In the solo exhibition *Sur-Sentimentalism Manifesto No.2: The Truth about Carmen Marie* he presented in 1970, Araki exhibited enlarged photographs of female genitalia on large panels. In line with his pet theory that 'photography is all about reproduction (*fukusha*),' he formed the group Geribara Fukusha Shudan 5 and made a catalogue of three hundred women clad in swimming costumes with their telephone numbers. He also exhibited a series of nude photographs at ramen noodle restaurants in Ginza in an attempt to insert photographs into the everyday urban environment. Another venture, this time in the genre of mail art, involved sending copies of his private photographic anthology *Xerox Photo Album* (a limited edition of seventy produced illicitly on a Dentsu copying machine) both to famous people and to ordinary people randomly selected from the Tokyo telephone directory.

The most controversial aspect of Araki's work, the depiction of genitalia, was already present at the very outset of his career. Generally interpreted as an attempt to bring to light everything that society chooses to conceal, as an act of liberation from repression, his focus on genitalia invites further analysis. There is no doubt that he deliberately sought to be provocative in the midst of the fraught, tinderbox atmosphere that pervaded the politics of the time, characterized by the vociferous protest movement against the US-Japan Security Treaty and the ensuing struggles in the universities.[4] Perhaps he was also keen to pit his work against the equally provocative work of other young photographers, those who presented their work in the magazine *Provoke*.[5] However, it seems he wanted to express his determination to establish himself as a professional photographer on the basis of the idea that 'society won't reveal itself as it really is unless one begins with the female genitalia.' His continuing use of this motif ever since suggests not so much a manifestation of revolt against the repressive nature of Japan's regimented society as an indication of his own personal obsession with female genitalia. For Araki, the genitalia are synonymous with his ontological beginnings and an entrance to a mysterious other world. One also senses a kind of impatience to discover the truth of photography in this motif.

Araki often refers to his period at Dentsu as one of learning and apprenticeship. Indeed, during this time he determined the future orientation of his work. He developed the idea of

'photography as reproduction' and began to experiment with the face and street scenes as subject matter, with the effects of rich narrative and repetition, and with the incorporation of quotation and collage. Dentsu also gave him experience of editing, presentation, advertising, methods of distribution and the use of himself as an adjunct to his photographs, lessons that he made good use of in his subsequent work.

In 1971 Araki published *Sentimental Journey*, a record of his honeymoon with his wife Yoko and the starting point for his photography in every sense, from the preface manifesto discussion of the genre of the 'I' photograph to the handling of double-page spreads, the intimations of death, the sense of the inevitable passage of time, the appearance of motifs such as travel, women, scenery, sex and death, and many of the other elements that were to inform his future photographic activity. Having determined his orientation as a professional photographer, his apprenticeship ended. Araki decided to leave Dentsu in 1972 to pursue a new career as a freelance photographer.

Araki started traipsing through the streets of Tokyo to take photographs, as if to return to or perhaps cling to the basics of photography. The photographs he took at that time were gathered in the collection *Tokyo, in Autumn*, which was finally published in 1984 and is characterized by Araki's distinctive pose, concern for detail and sense of decay. He seems to have superimposed the form of Tokyo as it underwent drastic change onto a new turn in his own life; the photographs as a whole are pervaded by a mood of nostalgia and a sense of loneliness. The period when Araki was at Dentsu and engaged on extreme experimentation coincided with the period of student protest and the rise of underground youth culture; subtle premonitions of a contrasting age of apathy are present in this work.

The Japanese economy, previously developing smoothly, was severely shaken in 1974, the year of the oil shock. At the invitation of Shomei Tomatsu, Araki co-founded the Workshop Photography school together with photographer Daido Moriyama and others, gaining new experience as a teacher.[6] He was also having to face up to the death of his mother; he photographed her face soon after death, something he had been unable to do when his father had died. In the inaugural issue of the college's quarterly magazine, Araki tried to convey his feelings as he wavered between his positions as son and photographer, and one even senses his determination to confront head on any future deaths of those close to him:

Looking at my mother, reduced to such a small pile of bones after emerging with a blast of hot air, I regretted again that I hadn't brought my camera along. This was something that I really should have caught on my camera. Together with my wife, we selected the larger bones and put them inside the urn, and I felt a strong urge to photograph her ribs, to photograph my mother in close-up ... This was a manifestation of my self-interest as a photographer. Perhaps it was a failing on my part as a human being. But that's neither here nor there ... I wanted to take some photographs. Out of self-interest, I wanted to take some photographs. My mother's death was both a criticism and an encouragement of me as a photographer.[7]

Having reached a turning point in his photographic life, Araki began to publish work from the mid-1970s in general magazines rather than just photography journals and tried his hand at producing films and videos. He published selections of essays in which he describes his approach to photography, including *Between a Man and a Woman is a Camera* (1978), *Essays on Photography* (1981), *Nobuyoshi Araki's Pseudo-Reportage* (1980), which portrays the construction of a world in which we move backwards and forwards between truth and fiction by means of words and images, and *Nobuyoshi Araki's Pseudo-Diary* (1980), a diary made up of photographs bearing the date taken with a compact camera. These publications are linked by the idea that photographs are lies rather than representations of reality or fact. However objective one might strive to be, one cannot remove personal feelings entirely from a photograph, and the best response is to occupy oneself entirely with the personal realm, to incorporate lies into reality for dramatic effect. The basis for Araki's work therefore are the places and people that Araki himself – 'I' – feels intimately, that is subjects such as his wife Yoko, the female genitalia where we have our beginning, and the traditional and entertainment districts of Tokyo that Araki refers to as a 'womb'. The world can only be seen from such starting points. Through communication between the photographer and his subject, Araki captures the expressive potential of the subject. The idea of capturing the time spent together by photographer and subject and the relationship between the two of them is thus made more explicit. At the same time, Araki's method involves the use of quotations from classical literature in the creation of the settings, the distancing effect created by the sudden insertion of wholly unconnected things into the flow, the manipulation of dates, the strengthening of the fictive quality through the appearance of this weird character, the photographer Ararchy, in the guise of the photographer himself, and the enticement into a photographic world where images and words intermingle. His method of photography is further consolidated and theorized by his own writings.

Araki's collaboration with the editor Akira Suei now played an important role in the development of his work. As a professional in the field of erotic material, Suei gave Araki the opportunity to present work in his magazines such as *Weekend Super* and *The Age of Photography*. Using the work he made for these magazines, Araki came up with collections such as *Dramatic Shooting!: Actresses*, which was based on the idea that 'all women are actresses', and *Nobuyoshi Araki's Pseudo-Reportage*. In 1979 he also began work on a bondage series for the magazine *SM Sniper*. Araki's image as a dynamic, but somewhat disreputable, character began to be established.

Celebrated Araki works from the 1980s include *Tokyo Nude* (1989), an impressive collaboration with Suei, and collections of photographs of Tokyo taken from many different angles, among them *Oh, Shinjuku!* (1984), *Tokyo Story* (1989) and *Tokyo Diary* (1989). In *Tokyo Lucky Hole*, photographs taken

between 1983 and 1985 when the bubble economy was beginning to expand, but not published until 1990, Araki shows the sexual customs of the Kabuki-cho entertainment quarter of Shinjuku, which was still bright and lively prior to enforcement of the new law regulating adult entertainment businesses of 1985. While in *Tokyo Lucky Hole* Araki appears to have immersed himself in the 'womb' of this metropolis, in most of his Tokyo photographs from this period Araki seems to distance himself from the scenes more than he would have done previously. In *Tokyo Nude*, made at the height of the bubble economy era, Araki shows the city as a metaphor for the female body. Tokyo appears before us enveloped in an over-ripe erotic fragrance accompanied by scenes of death. Extensive urban redevelopment was occurring throughout Tokyo, with cold, uniform buildings covering the city. Araki's subtle response was perceptively picked up by one critic in a discussion of *Tokyo Lucky Hole*, who wrote that Araki looks 'under a stone, the proper but false surface of the town, to find a real world of swarming life forms underneath'.[8]

THE SECOND ROUND

In 1990 Araki lost his beloved wife Yoko. She had also been his principal model and his closest ally. He photographed every stage of his wife's death, something he had not been able to do when his parents died. A year later he published *Sentimental Journey / Winter Journey* (1991), which includes some photographs from Araki's professional debut, *Sentimental Journey*, and the intimations of death contained in that earlier work are here present in the form of a real death.

The significance of these events for Araki is reflected in a conversation he had with fellow-photographer Kishin Shinoyama at around this time, a conversation that developed into a heated exchange and resulted in them breaking off relations for some time. Shinoyama was troubled by the direct presentation of a real death; it seemed to him antithetical to Araki's style of realism, which he characterized as based on banter between falsity and truth.[9] Araki's approach appears to destroy everything that he had built up until then, and in this sense Shinoyama's reservations were quite natural. But the experience of his parents' deaths and of photographing the dead had enabled Araki to leap forward artistically and to express himself with much greater profundity; this was the point he had reached with the death of Yoko.

The best photographs are those that generate a sense of surprise when we're confronted by things created by nature. It's all down to whether the photographer is able to press the shutter without flinching.[10]

Being able to press the shutter when confronted by the death of the person dearest to him and to express his feelings naturally in *Sentimental Journey / Winter Journey*, allowed Araki to release himself from the various obsessions that had held him back until then and to open up new vistas for himself as a photographer.

In *Sentimental Journey / Winter Journey*, which takes the form of a photographic diary, the incorporation of the written word allows the viewer to become absorbed in the narrative and share Araki's emotions through a sense of pathos and despondency. Relief from this heavy atmosphere is provided by the final photograph in the collection, an image of their cat Chiro, which can be seen as Yoko's alter ego, frolicking in the snow and offering a clear portent of return and rebirth. The intertwining and fusion of life, death and sex are the ingredients of a world in which life leads to death and then back again to life, and it is this world that stands at the foundation of Araki's photographs. Araki's vision responds sensitively to decay, destruction, impermanence and distress; his photographs are dominated by the pallor of death. But at the same time there are hints of sex and the presence of life. The pallor of death stimulates the reverberations of life, while decay foreshadows a new era to come. By the side of high-rise buildings, which can be seen as metaphors for cemeteries, light and shade intermingle, noises and smells rise up, and Tokyo is brought into relief as a living entity. One can see here the Buddhist notion of life and death enshrined in the concept of metempsychosis,[11] but Araki is constantly aware of the fact that photography is a medium of death in that it stops a moment in time dead in its tracks, and his concern has always been to breathe life into this moment. He has stated over and over again that the photographs bearing dates and the *Arakinema* events are acts of resuscitating the dead. In recent years Araki has frequently photographed large colour copies of flowers that he has let loose in various rivers, a manifestation of the Japanese custom of *shoryo-nagashi* in which the spirits of the dead are sent back to the other world.[12] The seriousness with which Araki tackles the themes of life and death are evident in this ritualistic approach. Photographs dominated by urban detritus are sucked up in the flow of the river, perhaps meaning that photographs present no more than one of the many images subject to mass consumption in the modern age.

Immediately after Yoko's death and probably in response to this traumatic event, Araki embarked on a vast range of new projects. Several of the methods with which he experimented during this rallying period have enriched Araki's artistic world from the 'second round' onwards, a stage in Araki's career often likened to a major explosion. *Laments: Skyscapes / Intimate Views* (1991) contains black-and-white prints of views of the sky touched up with acrylic colours. Backgrounds are simplified to bring the foreground into clear relief in depictions of the balcony of their apartment, with its many memories of Yoko and her various belongings. The photography critic Kotaro Iizawa has discussed the 'intimate views' in terms of the sand play therapy used in Jungian psychotherapy and he states that 'Araki was able to recover tactility from the reified world that resulted from Yoko's death by directing an intense gaze onto material objects.'[13]

This interest in 'material objects' was evident in Araki's work from early on, for example in his photographs of the faces of middle-aged women and the enlarged photographs of genitalia,

but by once again setting himself up in opposition to 'material objects' he created highly accomplished works such as *Erotos* (1993). The series of photographs gathered together under this Araki portmanteau word, which combines *eros* and *thanatos*, presents parts of the human body and a variety of material objects as images that resemble the female genitalia. Although the idea of death is strongly invoked by the merciless exposure of the fine details of things, the damp and humid quality of the images gives them the sensuousness of living things.

Araki's work began to be shown more frequently in major exhibitions outside Japan from the early 1990s. His first overseas solo exhibition, *Akt-Tokyo*, was held in the Austrian city of Graz in 1992. This exhibition subsequently travelled to Germany, Italy and the Netherlands and helped trigger Araki's popularity outside Japan. Moving away from his home ground of Tokyo, he began to photograph other Asian cities such as Hong Kong, Bangkok, Shanghai and Taipei. Features of Araki's activities during this 'second round' of his career include the diversity of the methods he uses to present his work, the reconstitution and recreation of his previous work, collaborations with practitioners of other art forms and more frequent involvement in performance activities. He also published comprehensive collections of his photographs and writings.[14]

The change in Araki's frame of mind from around the mid-1990s, his new desire to convey the joy of life in the raw, is evident in the *Hitomachi* series of photographs taken with a Leica set in the *Shitamachi* area of Tokyo, which delves into the nature of daily happiness and returns to the starting point of Araki's career. In his 'Japanese Faces' project begun in 2002, Araki continues his lifelong interest in the human face, which he once described as a person's 'private parts', aiming to present a comprehensive picture of Japanese people in the twenty-first century by photographing tens of thousands of Japanese faces. The 'Faces' project is likely to occupy him for a long time and may constitute the major endeavour of his career. Araki still blazes with enthusiasm, as if trying to encourage people in the current era of economic malaise that has followed the bursting of the Japanese economic bubble.[15]

THE ABSOLUTE PHOTOGRAPHER

Araki is constantly moving between pairs of opposites: fiction and fact, sacred and secular, presence and absence, art and obscenity, past and future, internal and external, light and dark, positive and negative, tradition and innovation, dynamism and stasis, beauty and ugliness, professionalism and amateurism, photography and film, photography and literature, photography and art, country and city, subject and object, life and death. There is no hierarchical distinction in Araki's work between commercial photographs, private photographs, photographs got up to look like private photographs or any other of the enormous variety of photographs that he creates. People of all descriptions – the famous and the unknown, the beautiful and the plain – all appear mixed up in Araki's photographic world. But from within this chaotic panoply of images, the atmosphere of the age and feelings are constantly invoked. This well of plentiful images that changes from one moment to the next in the manner of a kaleidoscope. The moment one seems to have grasped an image, it gives way to the next. By constantly betraying our expectations, Araki goes about changing our ingrained manner of viewing things.

Why does Araki continue to call himself a genius? His aim in using terms such as 'genius' and 'Ararchy' (another Araki portmanteau word, which combines 'Araki' and 'anarchy') is not merely to goad himself.[16] In contrast to painters and sculptors, photographers do no more than 'reproduce' reality, and his use of the word 'genius' is an example of Arakian irony. 'Genius Ararchy' is a kind of medium created by Araki as he plays out his life as a photographer and continues to encapsulate it with his camera.[17] Discussion of whether or not Araki is a genius as a photographer is pretty much a fruitless enterprise, but everyone who knows Araki is agreed that he is indeed a genius when it comes to putting effort into his work.

Throughout his career, Araki has demonstrated boundless energy and an unflagging interest in exploration. His freewheeling spirit has been unfettered by existing frameworks and preconceptions, and he has expanded his range of expression by opening himself up to everything that comes his way with a flexibility that enables him to take in his stride the caprice of nature, the whims of chance and the opinions of others. He has always been concerned with how best to display and advertise his expressive faculty. The expansion of scale that has characterized his work during the 'second round' of his career has been possible because of his ability to respond to changing times, for example, in the frequent use of photographs in the language of contemporary art, the appearance of mixed media and installation works, and the breakdown of barriers between moving and still pictures.

The fanatical degree of popularity that Araki has enjoyed in Japan since the 1990s is closely connected with the various changes that have occurred in our world: values have been shaken to their foundations, everything has come to be regarded as possessing equal value, and, in an age when the sense of reality has grown flimsy, people have begun to search for their own selves, to reconfirm exactly where they stand, and thus reassert the notion of the personal. But at the same time, it is precisely because Araki has continued to adhere rigorously to the ideals of self and photography through every stage in his career that his work has proved to be so persuasive and popular.[18]

Over many years Araki has tried to answer the questions 'Who am I when I take photographs?' and 'What is photography?' As if he has himself turned into a camera, Araki has continued his quest by taking photographs day in and day out and spewing forth a vast quantity of images. For Araki, writing, drawing pictures, engaging in a riotous nightlife, eating and perhaps living itself are all essentially manifestations of photography.[19]

Today anyone is able to take photographs with a simple camera; the barrier between professional and amateur is increasingly blurred and the very meaning of the word 'photographer' is being called into question. It has been pointed out that Araki, under such conditions, has deliberately established a fictive image for himself as an 'absolute photographer' by being concerned not so much with what to photograph as with how to give expression to oneself through the medium of photography and by play-acting the role of photographer.[20] This is probably correct. But regardless of whether his is a fictive image or not and of the fact that no one believes in the idea of the 'absolute photographer', there seems no more appropriate term to describe Araki.

Araki's act of photography itself is a manifestation of his unique style of expression that accurately reflects society as it exists during the second half of the twentieth century and in the early years of the twenty-first century, a visual age with an abundance of images, with mass media, mass production and high-level consumption. His photographic world mirrors reality in all its complexity and with all its contradictions. As his emotionally charged images thrust themselves upon us they strike a responsive chord in our hearts.

To keep this thing going for a long time, you just have to carry on taking photographs. By taking photographs you make discoveries about yourself and come to realize various things. If you are constantly being made aware of things, this gives you the impulse to carry on. You learn things through taking photographs; photography is your teacher. The main thing is to keep on taking photographs for ever and ever.[21]

1 This is not to say that there have been no attempts to grasp the essence of Araki's work or to interpret it from other perspectives; rather that the focus of attention has tended to be somewhat biased. There have in particular been a number of attempts to focus on Araki's work featuring the urban environment of Tokyo, and there have been several comprehensive solo exhibitions in recent years in Europe.

2 Influence from the films of Vittorio de Sica and Roberto Rossellini is evident, for example, in Araki's use of amateur actors and close-ups. *Gemi: La Passion de Jeanne d'Arc*, which he created from a scrapbook several years later, was strongly influenced by Carl Theodor Dreyer's *The Passion of Joan of Arc* (1928) in its attempt to reveal the essence of characters through the use of close-up photography and fixation. Several years later, Araki tried directing but found himself unable to cope physiologically with the rhythm of film-making and came to realize that his own goals were essentially different from those of the cinema. If there is still something that interests Araki in the cinema as a medium, it is primarily the presence of time flow and the potential of film as a more sensual medium than photography, which is essentially cold and objective. He reveals his interest in *Arakinema*. Araki has pointed out on several occasions that *Arakinema* is all about intercourse between images and between life and death, whereby a 'dead' photograph is brought back to life.

3 In a conversation with the photographer Kishin Shinoyama, Araki talks about the end of the first round and the start of the second round of his career. 'That's why it's all about me. Because I'm the first reader of my work. I feel that this marks the end of the first round of my life as a photographer. It started with Yoko and it ended with Yoko.' From 'Lies and truth, skilled and unskilled: Nobuyoshi Araki in conversation with Kishin Shinoyama' in *Nami*, February 1991. Reprinted in Toshiharu Ito (ed.), *Araki Nobuyoshi: Ararchism* (Tokyo: 1994).

4 The series of protests against revision of the US-Japan Security Treaty peaked in 1960. Tens of thousands of protesters marched daily on the National Diet, but in the long run to no avail. The anger of students at the conservatism of their universities boiled over later in the decade, with sustained protest activities between 1966 and the early 1970s.

5 *Provoke* was founded in 1968 by the photographers Takuma Nakahira, Koji Tagi, Yutaka Takanashi and Takahiko Okada. Daido Moriyama joined them from the second issue of the magazine. The group disbanded in 1970.

6 The Workshop Photography school was founded in 1974 and ran until 1976. In addition to Araki and Daido Moriyama, photographers who took part included Masahisa Fukase, Eikoh Hosoe and Noriaki Yokosuka. Each man delivered a unique course of lectures, with Araki introducing dance into his.

7 Inaugural issue of the magazine *Workshop*, 1 September 1974.

8 Takahashi Naohiro, *Love You Tokyo*, exh. cat., (Setagaya Museum of Art, 1993).

9 Shinoyama, 'Lies and truth', op. cit., and Ito, *Ararchism*, op. cit.

10 Nobuyoshi Araki, Akihito Yasumi (ed.), *Nobuyoshi Araki x Nick Waplington: Sentimental Comedy, Nobuyoshi Araki's Photographic Art* (Tokyo: 1998), p.152

11 It's worth mentioning in this context that Araki's personal name, Nobuyoshi, has a Buddhist significance and was given to him by the abbot of the temple situated across the road from the house where Araki was born.

12 A traditional Japanese ceremony held annually as part of the Festival of the Dead, in which spirits of deceased ancestors are symbolically mounted on a boat or float and sent downstream back to their abode in Pure Land of Amida Buddha.

13 Kotaro Iizawa, *Araki!* (Tokyo: 1994), p.199

14 See Bibliography.

15 In tracing Araki's activities over the years in this article I have referred especially to the biography contained in the exhibition catalogue *Sentimental Photography, Sentimental Life* presented at the Museum of Contemporary Art, Tokyo, Ito, *Ararchism*, op. cit. and Iizawa, *Araki!* op. cit.

16 Araki expounds on this matter in detail in the following interview contained in this anthology: Nobuyoshi Araki in discussion with Kotaro Iizawa, *Becoming a Genius!* (Tokyo: 1997), pp.203–5.

17 Many critics have discussed Araki as a 'medium' in his own right, e.g. Hideki Kiriyama, 'Araki as Medium', Chapter 8 of *Tales of Nobuyoshi Araki* (Tokyo: 1998).

18 I should say also that, today, when it has become possible for anyone to manipulate photographic images using Photoshop, the idea of the 'photographic lie' sounds more plausible than ever before. Now that digital photography is becoming the norm, the feelings and humid sensations that lurk within Araki's photographs are coming to the fore. It is also possible to discuss the links between photography, performance art and conceptual art, the sense of speed in Araki's photographs, concordance with the sensibility of the age and other such factors that have underpinned Araki's popularity during the 1990s in terms of viewpoints other than sensationalism and intermingling of genres, bodily expression, the mundane and the supra-mundane, urban space theory, etc.

19 Part of a discussion with Araki held at a meeting attended by this writer in November 2004. Araki stated that writing articles and drawing illustrations were for him all aspects of photography.

20 Kiriyama, op. cit.

21 Nobuyoshi Araki, Akihito Yasumi (ed.), *Nobuyoshi Araki x Takashi Honma, Nobuyoshi Araki's Photographic Art* (Tokyo: 1998), p.114

ICE THAT DOESN'T MELT

Jonathan Watkins

This is a night on the town, Tokyo with Araki. First, dinner at a restaurant where clearly he knows the menu inside out, and the waiters are like family. The food is wonderful. At some point he stops me from pouring a drink for myself, explaining that someone else should do it; otherwise, according to a local tradition, my sex life will be doomed to a seven-year drought.

Next, to a karaoke bar. We walk briskly through the brightly lit streets, and almost everyone we pass seems to recognize the artist. 'Hey, Araki! Hey, Araki!' and he responds with amazing energy, always laughing, always taking photographs. Up a flight of stairs, the bar is decorated with posters and other memorabilia that suggest the artist is a regular here. As for the sing-along, Araki's preference is for slow sentimental numbers.

It is about midnight and we have one more destination: a bar that is famous for its range of cocktails. In my memory we are downstairs and the room is quite dark. The table around which we sit is softly spot-lit. Laughter and more laughter. We order obscure drinks, carefully measured with beautiful colours. The waiter asks if we would like some ice, and wistfully Araki replies, 'Give us ice that doesn't melt'.

———

Araki doesn't frame his photographs for exhibitions. Usually they are pinned, stapled or glued to the wall, with nothing to isolate them from the environment in which they are being seen. Black-and-white or colour, in a variety of formats, Araki's photographs exist in series, to explore a theme, sometimes revealing a narrative, but above all to disclose a remarkable openness. This artist is best known for his erotic images, but equally he conveys intense passion for the most uncontroversial things: a shop display of fruit and vegetables, a suburban house, a bicycle covered in plastic, children playing, an old woman in a subway carriage, tree, skies, a configuration of gas meters, people on a pedestrian crossing, middle-aged businessmen and so on. For him, everything is interesting.

Araki's catholic curiosity signifies a particular scepticism. He doesn't believe in art as something transcendental, necessarily beyond the ordinary. Instead he asserts the continuity between his photography and whatever else there is in the world, producing work that suits his milieu, as poignant as it is unforced and unpretentious. Certainly there is a hyperactivity that characterizes his practice – he is one of the most prolific artists that ever lived – but when it comes to definitions of art, Araki is easygoing. In this respect he has much in common with other contemporary artists, such as Rirkrit Tiravanija, Georges Adeagbo, Fischli and Weiss and Ayse Erkmen. More often though Araki is considered alongside Nan Goldin, Boris Mikhailov, Larry Clark and so on, but this reflects a view of contemporary art limited to checking styles and media. Certainly there has been a refreshing rise of 'straight photography' since the 1980s, but this in turn is symptomatic of a shift across all art forms away from the self-conscious cleverness of early post-modernism, towards an

understanding of the value of the everyday. When asked recently about the artists with whom he identified, Araki above all nominated On Kawara.[1]

Araki's voice is as relevant as that of any other artist in the global conversation that is our art world. Superseding his reputation as the *bête noire* of feminism, increasingly there is an acknowledgement of his all-too-human complexity, his sensitivity to currents of cultural energy through the development of an extraordinary self-awareness. Araki is engaged in the here and now, is absolutely of his time, and his indifference to art could not be more progressive. On the other hand, such indifference harks back to a time when art as a concept didn't exist in Japanese culture. Art came along with so much else imported from the West from the mid-nineteenth century, following two hundred years of isolationism, and there was then a frenetic cultural exchange, clearly reflected in 'artistic' practice on both sides. In the West, Japanese motifs and pictorial structures quickly became very fashionable; in Japan, for the first time, artists became acquainted with single-point perspective, oil paint and canvas. And picture frames.

Araki's work is in tune with a contemporary preference for artlessness – an art paradoxically against its own institution – and, at the same time, it is reminiscent of much that older Japanese traditions have to offer. It has the wit and candour, for example, found in Sei Shonagon's *Pillow Book*. Written in the tenth century, this extraordinary diary interweaves observations on the variety of people Shonagon meets, aspects of the natural world, the nature of her domesticity and courtly life to evoke a wealth of experience with the lightest touch. Her references to sexual encounters are funny and matter of fact, devoid of the kind of conscience that comes later with Christianity. More obvious traditional precedents for Araki's work exist in *ukiyo-e-shunga*, the booklets of woodblock prints from the eighteenth and early nineteenth centuries depicting sexual activity in graphic detail. They were ostensibly erotic, for women as well as men, incidentally instructive and now, as well, fascinating for the social mores they convey, especially through the details of costume and furniture and other objects that make up the settings, and written narratives.

The 'floating world', famously depicted by *ukiyo-e*, was translated 'world of pleasure' to repudiate the 'world of life in Japan during the as intended primarily as ly this that Araki claims that "photography is a u are using photography get beyond death. I react appiness. I'm not Roland

IT'S NO GOOD GETTING THEORETICAL OR PHILOSOPHIZING.[3]

I DON'T LIKE ANYTHING THAT SMACKS OF PHILOSOPHY.[4]

About philosophy, Araki protests too much. His insistence on happiness is like Warhol's bland utterances, a foil for a profundity that lies at the heart of his work. His position is philosophical, in a Nietzschean sense, suspicious of conventional morality, preferring an apprehension of 'present experience' to introspection, and essentially realistic. Elsewhere Araki explains that 'if there is no unhappiness, no death or sadness, I think there is something weak about happiness'[5] and this is a vital key to an understanding of his work, and what makes it so compelling.

Sentimental Journey is the series of 108 photographs that Araki took in 1971, documenting his honeymoon with Yoko, a young woman he'd met seven years earlier at the advertising agency where he worked. First presented in the form of a book, it might easily be an allusion to *ukiyo-e-shunga*. The first image is of Yoko literally on a journey, on a train, looking not out of the window at the landscape flashing by, nor at the camera, but lost in her own thoughts. Her hairstyle, make-up, dress and handbag, and the style of the carriage interior design amount to an archetypal (Westernized) picture of the 1960s, a hopeful image from a hopeful decade.

Next, we see Yoko wearing the same dress, just arrived, sitting on a bed in the couple's twin hotel room. Then we see her on the same bed, naked after sex, not indulging in any kind of exhibitionism, but simply being there; later, close-up and also reflected in a mirror. The following long sequence of photographs depicts their experiences out and about – on the street, in parks, cafés and restaurants – interspersed with images of their intimacy. Towards the end of the book there is a picture of Yoko in the throes of an orgasm, taken by Araki presumably in a similar state, and the effect is electric. Then there is an image of two empty beds, sheets and pillows creased to bear the traces of their recent occupancy, a head and shoulders portrait of Yoko, and some landscapes as we are pulled away from the heart of the narrative, going back to where the journey started.

Without captions to accompany the images of *Sentimental Journey*, sometimes it is difficult for us to know exactly what we are looking at – this roof-line, this rock on the pavement? – in the same way there are obscure snapshots in every photo album. Not intended as secrets, they speak of something once special and shared, even more affecting, in a way, because their original point is lost on us.

Recently Araki provided a commentary on a survey of his work, including two images from *Sentimental Journey*. Concerning the photograph of Yoko asleep in a boat – one of the most tender images ever made – he remembered,

Yoko and I had been having really heavy sex – that's why she's asleep in the boat like that. We were staying in an old Japanese inn in Yanagawa called O-hana. I took the picture without really thinking about it much, but look at it and you can see it's the journey to death, to the other world. Look at her curled up in the foetus position. She just got into that position naturally. Funny, isn't it? [6]

Yoko died in 1990.

Sentimental Journey continued, in a sense, after 1971. Araki took many photographs subsequently of his life together with Yoko, usually indoors, often with their cat Chiro. A picture of Yoko watching TV, with Araki and Chiro on a sofa, sums up his idea of happiness: 'Things don't get any better than that.'[7] Towards the end there are photographs taken inside the hospital where Yoko was being treated, others taken on the way there, a photograph of Araki holding hands with Yoko for the last time, and then finally, the last portrait of Yoko, in her coffin, her beautiful face surrounded by flowers and the cropped gestures of some of those paying their last respects. At the bottom right-hand corner, the camera's digital calendar records the date: 90.1.29.

Araki took other photographs during this time, at home. Also dated digitally, they depict, for example, Chiro looking through windows (90.1.26), Chiro on top of the microwave oven (90.1.29), Chiro playing on the balcony, now covered with snow (90.2.1), Chiro walking past the shrine that Araki had made next to the TV, complete with burning candle, [...] and a favourite picture of Yoko (90.2.1). This [...] raph was taken in a hotel in Kobe

[...] always like to have a pre-dinner [...] bath – that's why her hair is wet [...], and we were about to go out for [...] to set and the light is very soft and [...]ing for a woman. Me, I have sex so

[...] (Yoko) has taught me to understand what a portrait is ... if I hadn't documented her death, both the description of my state of mind and my declaration of love would have been incomplete. I found consolation in unmasking lust and loss, by staging a bitter confrontation between symbols. After Yoko's death I didn't want to photograph anything but life honestly. Yet every time I pressed the button, I ended up close to death, because to photograph is to stop time ... [9]

Araki could not be more aware of the fundamental message of his medium, the axiom usually associated with Roland Barthes, that mortality inevitably is embodied in photographic images. Araki's inclusion of the dates in his photographs around Yoko's funeral could not be more eloquent in this respect, again bringing the work of On Kawara to mind. The ongoing *Today* series by Kawara, accumulating date paintings for days that are past, likewise springs from a preoccupation with the inexorable passage of time, but Araki's alternative to Kawara's minimalism is an unashamedly excessive sentimentality, or nostalgia. It goes against the grain of good taste, of fine art, but then that probably won't matter to Araki.

Tokyo Nostalgia is a very large work, consisting of thousands of 6 x 4 black-and-white photographs taken by Araki from 1985

[handwritten marginal note: Explain sequence of events for intimate photos.]

23

to 1992. Exhibited in its entirety, it requires a wall approximately 25 metres (82 feet) in length. From a distance its rigorous grid structure is impressive in its immensity, animated overall by the compositional gist of each rectangular shape, impossible to read in any detail. Close up, the assortment of subject matter is relentless, overwhelming, sometimes sexually very explicit, sometimes extremely banal. Sequences of images, often quick successive shots, run vertically down the wall to suggest action through the frames of cinematic film. Here, for example, is a walk down the street, meeting people as we did on our night out together. Here are people getting food out of a van for their restaurant, and here are others drunk in a karaoke bar. Here is the *shunga-like* story of the young woman getting undressed before she embarks on a medley of love-making, including oral sex and bondage, eventually smiling to show off a fistful of yen to the camera.

And here, and here, and here, are images of Yoko punctuating the whole lot. She constitutes both a *memento mori* for Araki, a reminder that this infinite variety is bound ultimately for the same nothingness, and the trigger for the cathartic activity made manifest in *Tokyo Nostalgia*. A look at any biography of Araki, listing his exhibitions and publications, makes obvious the dramatic jump in his productivity since 1990, symptomatic as he explains, of his need for consolation. *Tokyo Nostalgia* is particularly interesting, not just for its size, but also because of its retrospective nature, its suggestion of a desperate, futile attempt to recapture things the way they used to be.

Some argue that Araki's work is best seen in book form – thus strengthening the connection with *shunga* – and of course this is an available option, but it significantly limits the scale of the imagery and also the possibility for actual juxtapositions, without the turning of pages necessarily obscuring other pictures. Consistent with what is signified by the framelessness of the work, is also the fact that it becomes more physically engaging, more part of our immediate world as it requires us to walk around it. *Tokyo Nostalgia*, for example, is enveloping. In the case of *Sentimental Journey*, augmented often by the later photographs about Yoko's death, a 'single hang' forms a time-line on gallery walls so that viewers literally have to make a journey in their encounter with it.

A recent series of still lifes, entitled *Vaginal Flowers*, is usually installed with the images abutting each other on all sides. Consisting of large format digital prints in colour, the overall effect is like that of wallpaper, morbidly excessive in its brightness and all-over close-up detail, too much of too much. Again, in an exhibition rather than a book, it impinges, pushing itself into the real spaces we occupy. On one occasion Araki exhibited this work outdoors, like a series of posters, in the streets of the old city of Shanghai.

Flowers frequently occur in Araki's work. The first time, he remembers, was in 1973:

(There was) this Jokanji temple near my parents' house. It had been used for throwing out the unwanted dead in the old days.

I used to play there when I was a kid so I knew the place pretty well. Anyway I saw this withered amaryllis there and I thought 'Great', took along a white background and just snapped away until sundown. That was the start of me and flowers.[10]

He adds, 'flowers have the smell of death', knowing certainly that he is not the first person to have made this observation. The same applies to his insistence on the resemblance between the vagina and flowers and the poetic analogy between flowers and the beauty of youth. Such sentiments, for example, are not unknown in *shunga*. The fact that something is a cliché doesn't make it any less true, in the same way that Araki's familiarity with cheap karaoke songs doesn't make them any less potent. The repetition of a truism, arguably, makes it a mantra, conducive to meditation.

The constant reappearance of Yoko in Araki's work is inextricably linked with the leitmotif of flowers. We see flowers in *Sentimental Journey* – most memorably with a butterfly – and, in one of his earliest photographs of Yoko, Araki poses her naked except for an eye patch, holding a flower (an orchid?) in front of her genitals. There are flowers in Yoko's hospital ward, flowers in her coffin, and eventually flowers accompanying the memorial portrait of her. Her image, like the flowers in the photographs, is fixed in time, a likeness suggesting the possibility of immortality. All photographic subjects are still life, not to be confused with life still going on. In photographs Araki can have ice that doesn't melt.

1 On Kawara (b. 1933) is a Japanese artist based in New York. Concerned primarily with the nature of time and human consciousness, he is best known for his 'Today' series, an ongoing series of 'Date Paintings', which simply bear the date on which they were made.

2 Tetsuro Ishida, 'Interview with Araki Nobuyoshi' in *Araki Nobuyoshi: Sentimental Photography, Sentimental Life*, exhibition catalogue (Tokyo: Museum of Contemporary Art, 1999), p.75

3 Ibid., p.75

4 Ibid., p.74

5 Ibid., p.75

6 'Notes of a Photomaniac', *Araki by Araki: The Photographer's Personal Selection* (Tokyo: Kodansha International, 2003), p.407

7 Ibid., p.407

8 Ibid., p.407

9 Roland Hagenberg and Walter Vogel, 'Interview with Nobuyoshi Araki', *cuerpos, memorias. Nobuyoshi Araki – Larry Clark, Fotografías*, Colección Imagen Doble Vision No. 31, Editions Alfons el Magnànim, Istitució Valenciana d'Estudis I Investigació, Valencia, 1994.

10 'Notes of a Photomaniac', op. cit., p.406

S
E
L
F

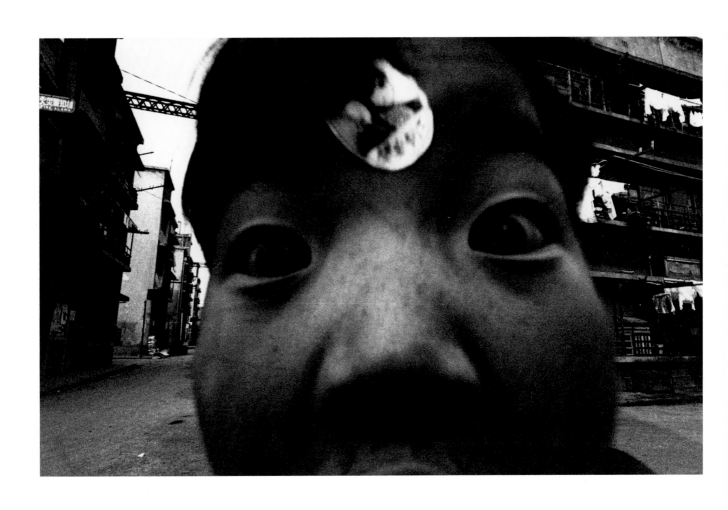

27

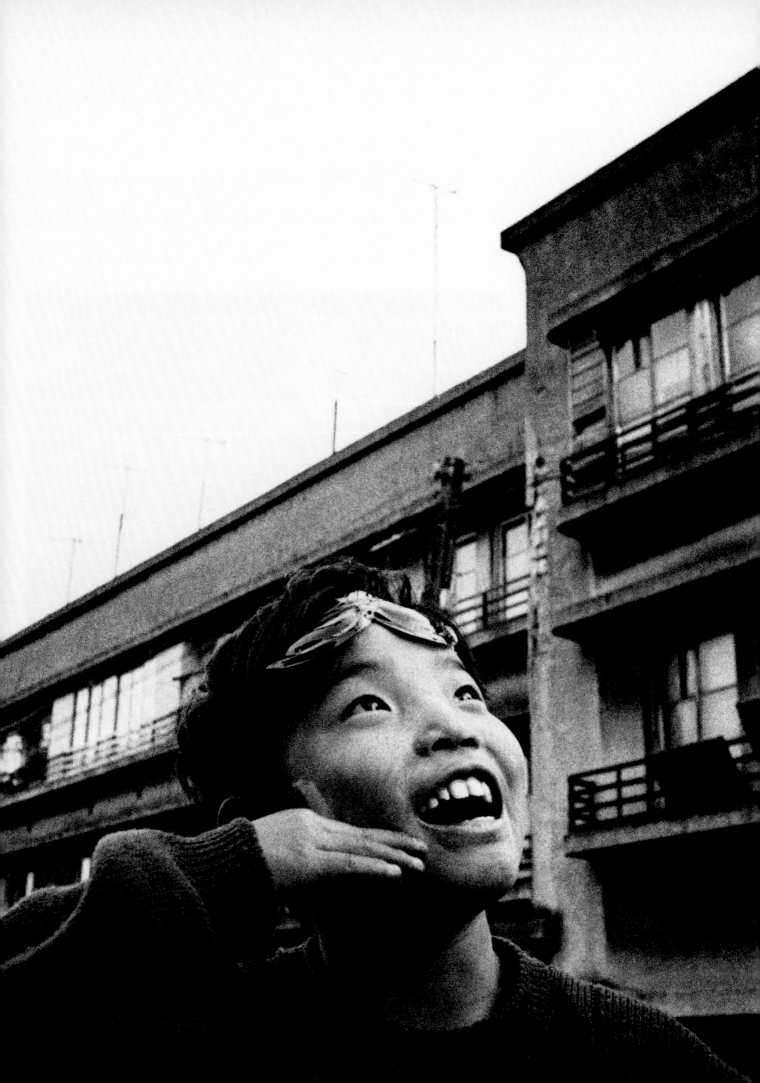

SATCHIN

SATCHIN
—

THOUGHTS
ON RECEIPT OF THE
1st TAIYO PRIZE
—

SATCHIN IS WONDERFULLY LIVELY.

It was on a summer day a couple of years ago. I'd gone into an apartment block in Tokyo's Mikawajima district that I'd come across quite by chance. There were several darkly suntanned kids rushing around energetically. They were wonderfully animated. One of the boys aimed a catapult at me and burst out in laughter when he saw me duck out of the way in surprise. There was nothing loaded in the catapult. I immediately took a liking to this boy. His name was Sachio Hoshino and he was a fourth-grader at primary school. He had the nickname '*Satchin*'; he looked after his younger brother, Mabo, and he got on well with the girls. He'd jump and leap around, get into fights, get angry and generally live life to the full. This album is a document of one year in his life.

Being vain and a bit of an innocent, I started boasting to my friends that I was going to be awarded the 1st Taiyo Prize[1]. They didn't take me seriously and just thought that I'd started blowing my own trumpet again, but I felt pretty confident of my prospects. From seeing Carl Theodor Dreyer's *The Passion of Jeanne d'Arc* and Robert Bresson's *A Man Escaped* in the film library at the Museum of Modern Art, I'd learnt that a documentary record reveals the essence of a character by constant, intensive focus on the character. I had a go at making documentary films but it ended up as a failure precisely because I wasn't focusing intently enough. This experience set me into action and I took on the challenge with a camera. Now I found that my past experience in film production came in handy. I wouldn't like to say whether the resulting images are any good or not, but I was able to reveal the personality of this person called Satchin.

Prizes are great; you get money and they encourage people like me who work by themselves. It makes me very happy.

[1] An award for photographers presented by the influential art magazine, *Taiyo*, which was founded in 1963. Araki was the winner of the first year's prize.

SATCHIN IS ALL ABOUT
SELF-TIMER PHOTOS
—

1.

I visited the photographer Taikichi Irie[1] in Nara in May and asked him what the city meant to him. He replied that it represented 'nostalgia for ancient cities'.

As he spoke, Irie was stroking with his potter's hand his white long-haired approximation of a dog, named Chin, who was sitting on his lap. I had to suppress the urge to suggest he start photographing Bodhisattvas wearing Shiseido lipstick. Maybe I sensed his age and the length of his career. Or maybe I flinched from the shallowness of my own youth.

Old people shouldn't have complexes. But maybe that's not it. There's nothing wrong with people being sentimental. He admitted he somehow felt unconvinced when he photographs a completed work of art, but I can't see anything wrong with feeling sure of yourself in this respect. After all, it's not as if he was in the business of taking photographs of works of art created today. The Buddhist statues he photographs were created ages ago and have since suffered the ravages of time. He's photographing them in the form in which they continue to exist today. There's no reason not to feel sure of yourself when you do this.

I have a great affection for Taikichi Irie, who still worries about these matters. When he ushered me into his room, he nonchalantly opened the window and let in the rustling sound of the early summer trees, fragrant and clad in fresh greenery. This action made me hold him in even greater affection than before.

2.

I was infected at the time by neo-realism. All I knew about then was theory and still photography. Partly because of my own inadequate study, I'd never seen such incontrovertible neo-realist film masterpieces as Roberto Rossellini's *Open City* (1945) and *Paisan* (1946) or Vittorio de Sica's *Shoeshine* (1946) and *Bicycle Thieves* (1948). It was then that I encountered the old apartment block in Mikawajima that had stood there since before the war and, with it, Satchin. I was utterly captivated by the sight of this building, constantly being violated by everyday life, and by this sweaty and energetic little boy. I was really excited by the exquisite neo-realist setting and kept on pressing the shutter. After a year of playing energetically together, I noticed there was something wonderfully dramatic about such nondescript everyday situations. Then I saw myself reflected in Satchin.

3.

I'm working at the moment for the advertising agency Dentsu. I've learnt all about 'naming' since I've been at Dentsu, and I think the name 'Satchin' was a great idea. I used to be known at the time as 'Nobuchin'. In the same vein I used

to call Sachio Hoshino 'Satchin'. Satchin is Nobuchin. Satchin is quite simply a self-introduction by Nobuchin. Giving it a special name, I suppose you might describe these as 'self-timer photos'. I tried to set out quite naturally from the idea of the self-timer photo.

As a photographer I adopted a particular pose just like the extravagant poses assumed by *Kabuki* actors.

Ihei Kimura[2] said of this pose that 'my worry is that if you keep on in this vein, you'll end up with work that looks as stereotyped as picture-card storytelling'[3]. But I'm not at all averse to ending up like a picture-card storyteller. I really like picture-card storytelling. Indeed, unaware, I may well actually be aiming to become a kind of picture-card storyteller. I say this because, in terms of my experience of visual images, it was the famous *Ogon batto* (Golden Bat) picture-card story and cartoon that influenced me enormously. The style assumed by Golden Bat, when he makes his bold appearance as the friend of justice, was Satchin's customary pose. What's more, I was born in Minowa in the Shitaya district (now Taito ward) of Tokyo, which is one of the main centres for picture-card storytelling. Koji Kato writes as follows in his book *Machi no geijutsuron* (Study of Local Community Art): 'There were more than a thousand picture-card storytellers in Tokyo from around 1931. The number of establishments producing the pictures steadily increased, and there were as many as fifteen in and around Minowa. Most of them were producing pictures for Golden Bat.' I'd like to see more and more of Golden Bat!

4.

It was a bit presumptuous of me, but I felt quite confident that I'd get the prize. I discover drama in inconsequential everyday situations, and that was how I discovered Satchin. More than a half of Satchin is really performance and presentation. Attempting to uncover the potential of this

perfectly ordinary person as an actor in the manner of Vittorio de Sica seems to have revealed my own potential for sentimentality. Perhaps I should have stuck rigorously by the principles of shitty realism, but I seem to have ended up with pissing realism instead.

It's really embarrassing to see how much of me is revealed in *Satchin*. But at the same time it gives me a kind of pleasure. This applies to the captions as well:

'I'M STRONG! I'M FAST! I'M THE BEST!'

'HOW ABOUT THAT? PRETTY COOL, EH?'

'KUNI SAYS THAT SHE REALLY LIKES ME.'

'I WON'T PLAY UNLESS I'M THE PITCHER!'

It all brims with self-confidence. It's all about putting on a show. It took me aback seeing the portrait of Satchin picking his nose. It reminded me of myself picking my nose as I once watched a low-class bargirl with her legs wide open waiting to catch the last train home.

[1] Taikichi Irie (1905–92), photographer famous for landscapes and pictures of Buddhist statues.

[2] Ihei Kimura (1901–74), influential photographer who established documentary photography in Japan.

[3] Picture-card storytelling or *Kamishibai* (paper theatre) was a form of children's popular entertainment, particularly flourishing in the 1920s and 30s. The storyteller was also a candy seller, riding a bicycle equipped with a small wooden frame. Children were entertained on the street by his stories, which were accompanied by vividly coloured pictures seen through his wooden frame.

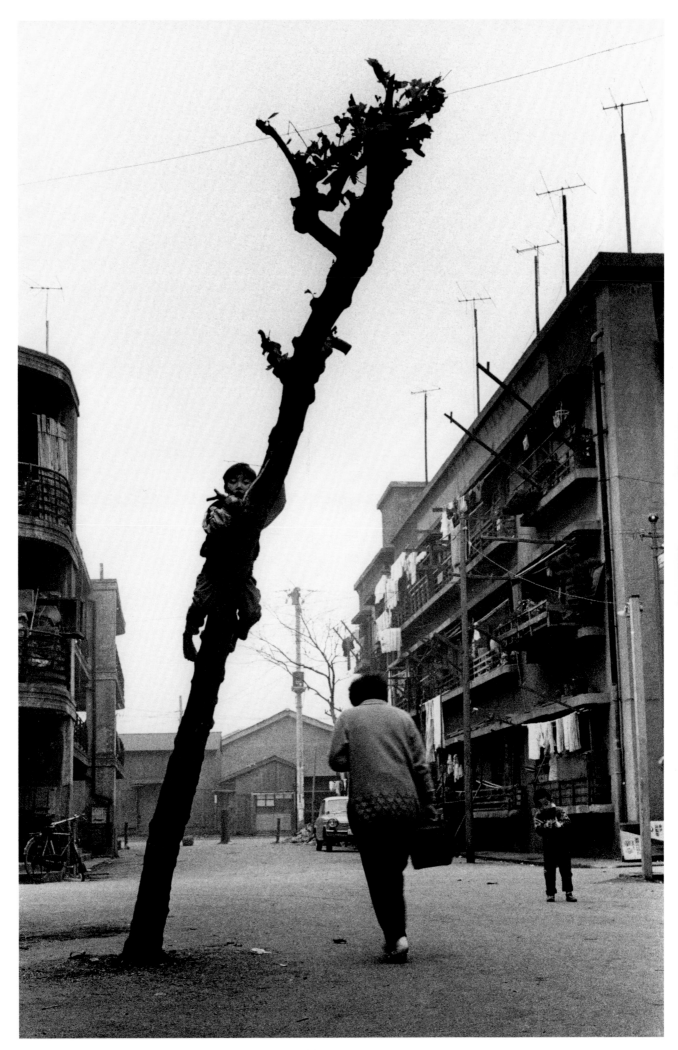

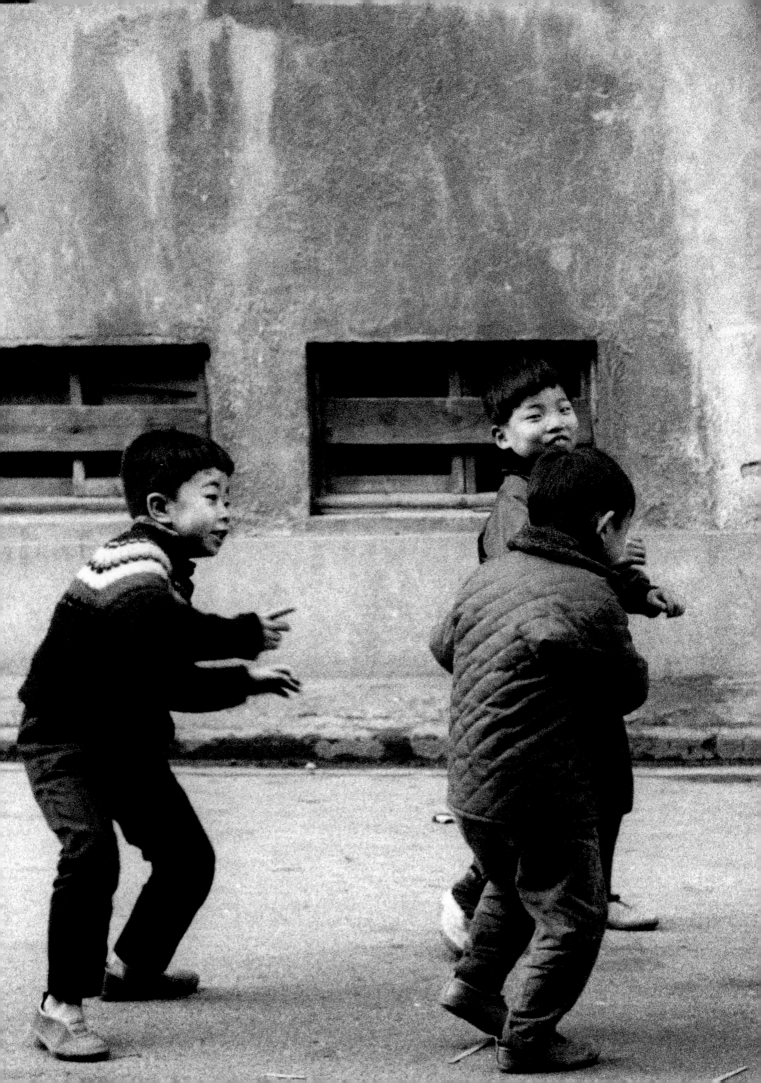

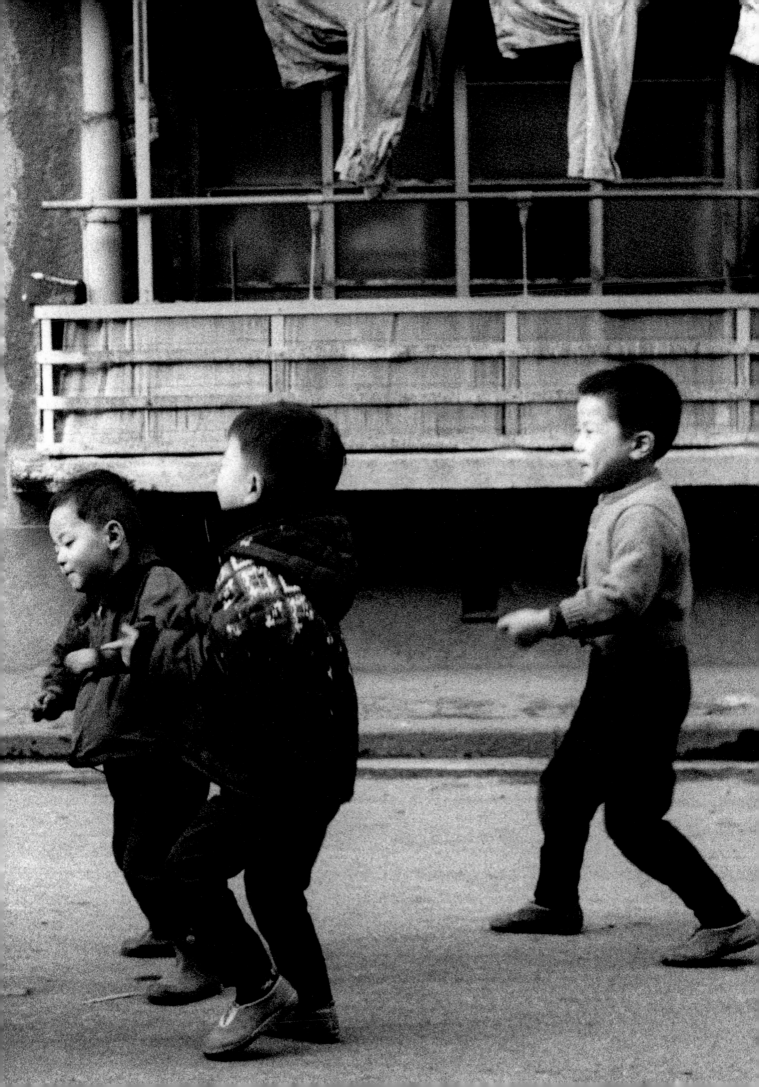

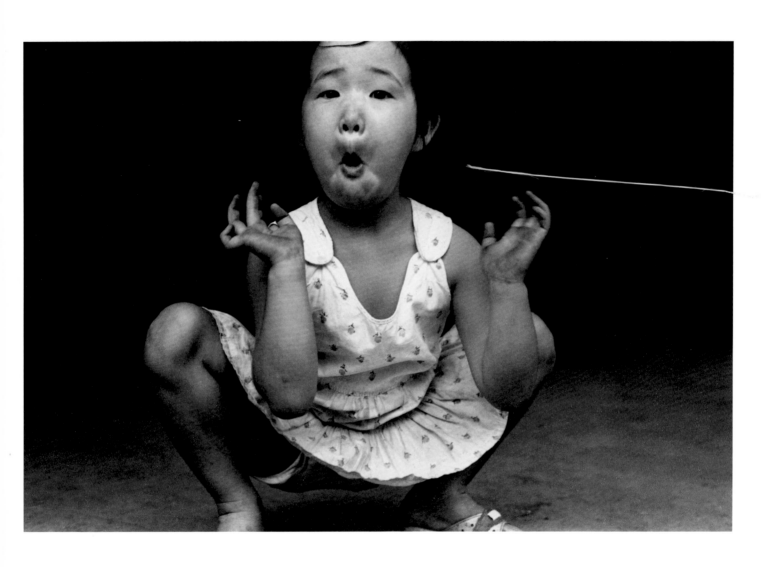

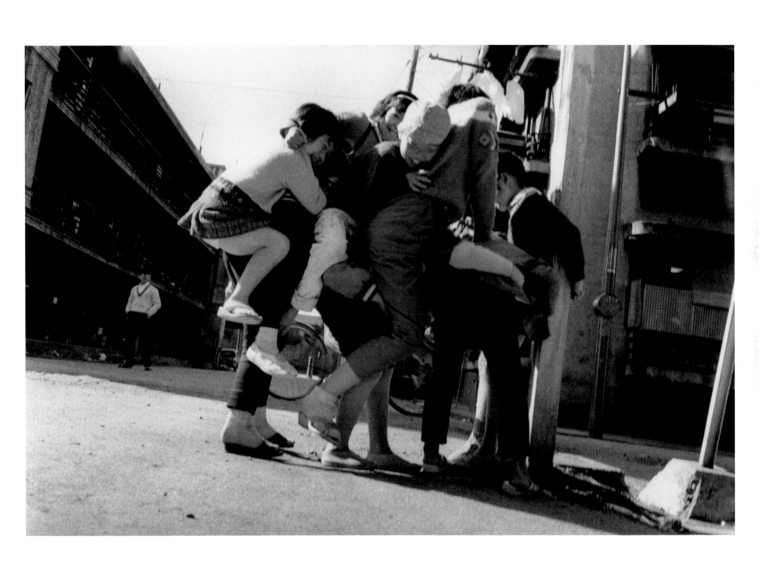

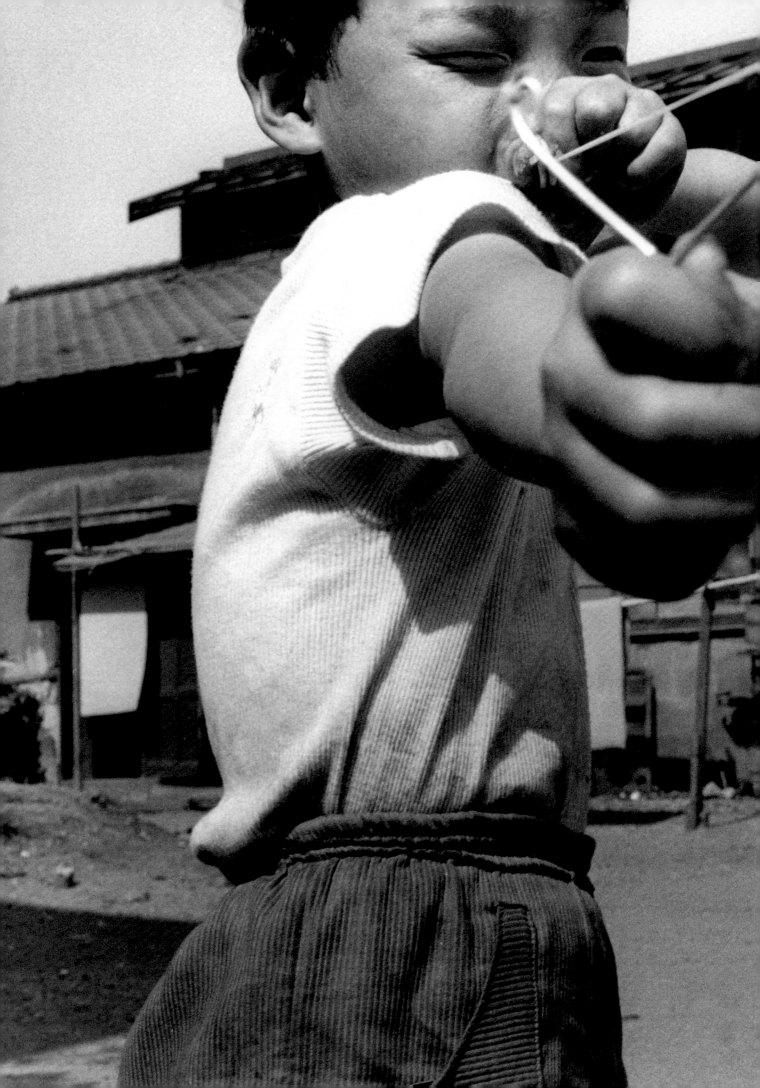

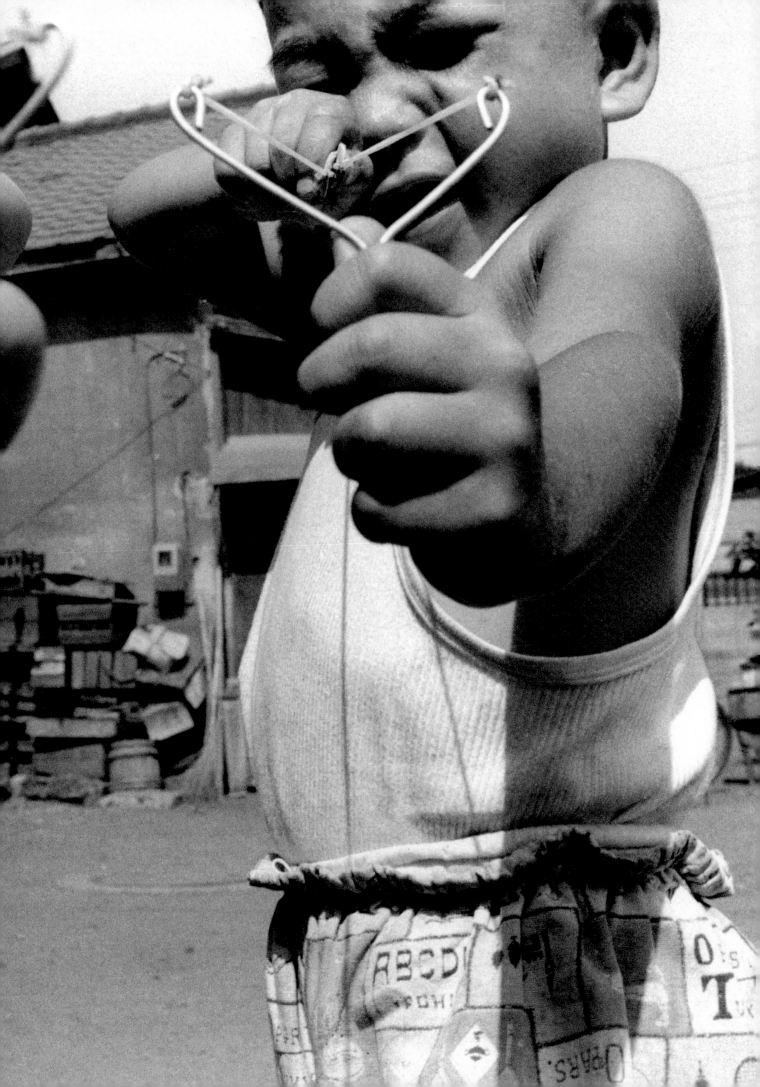

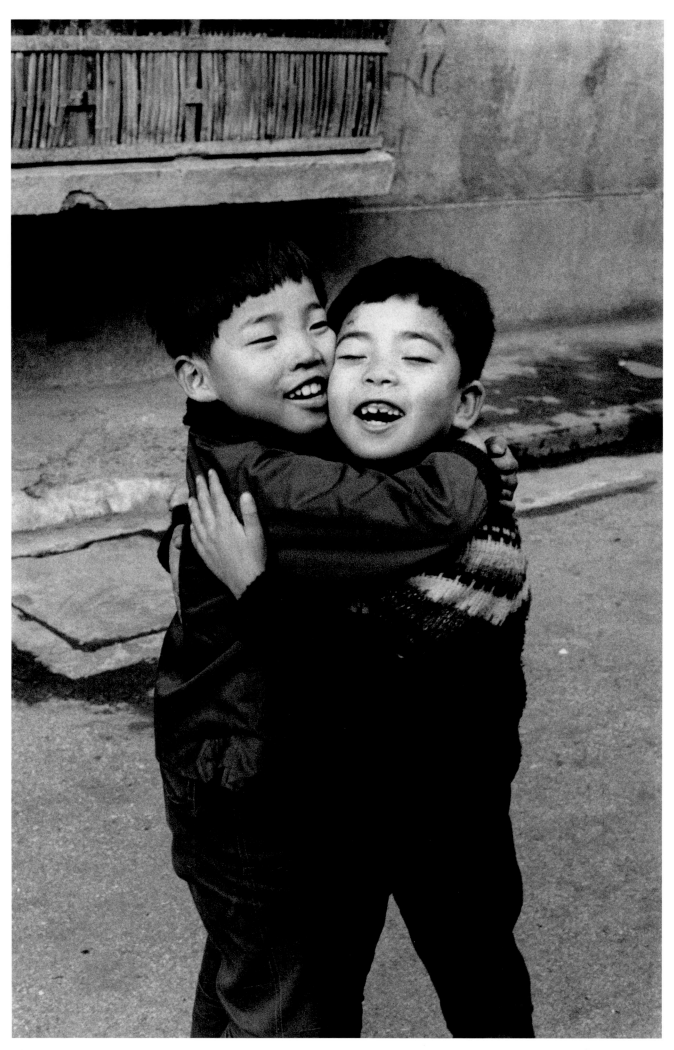

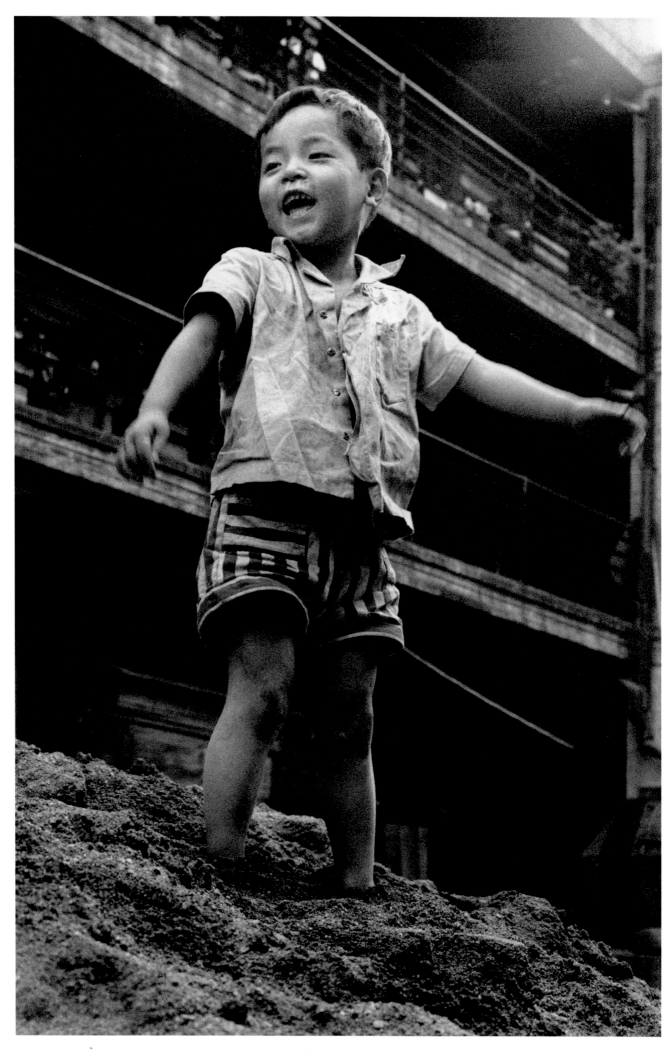

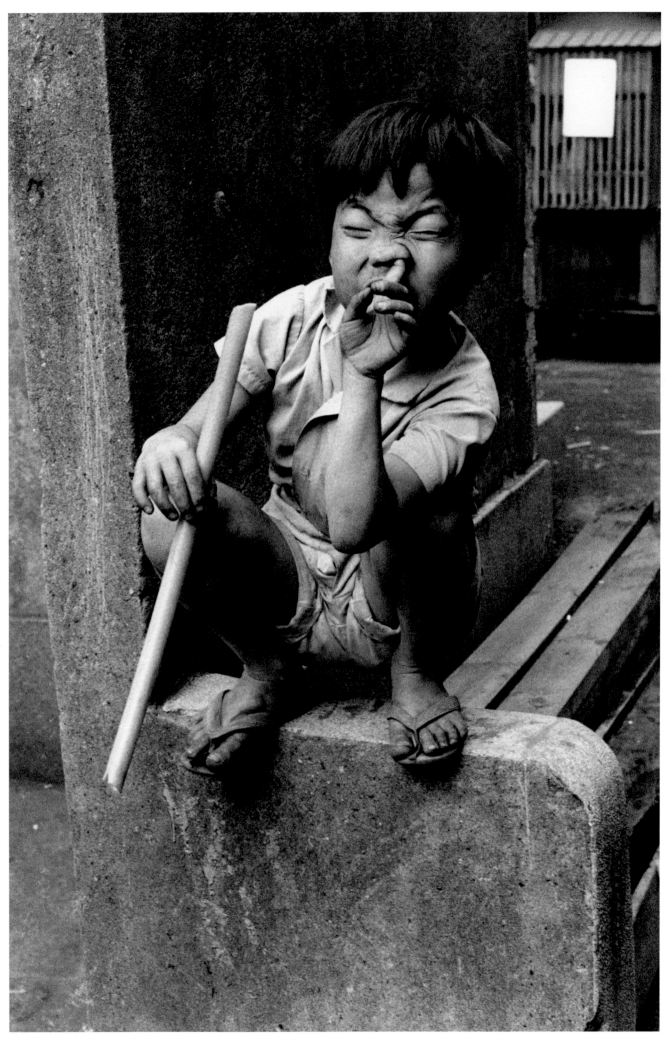

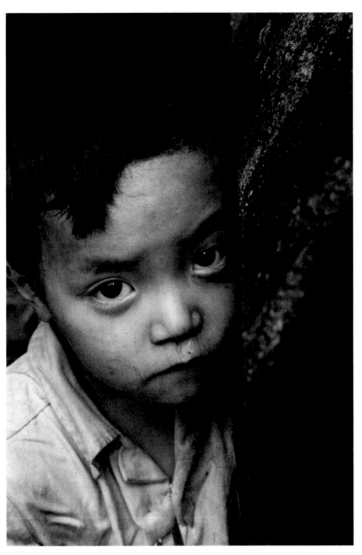

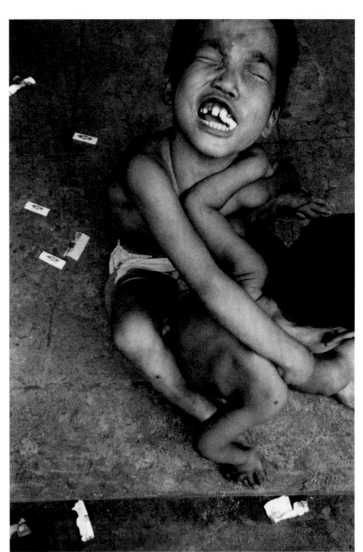

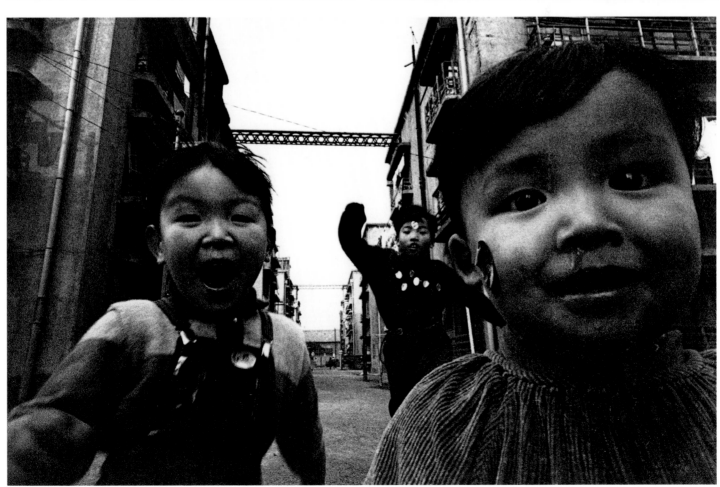

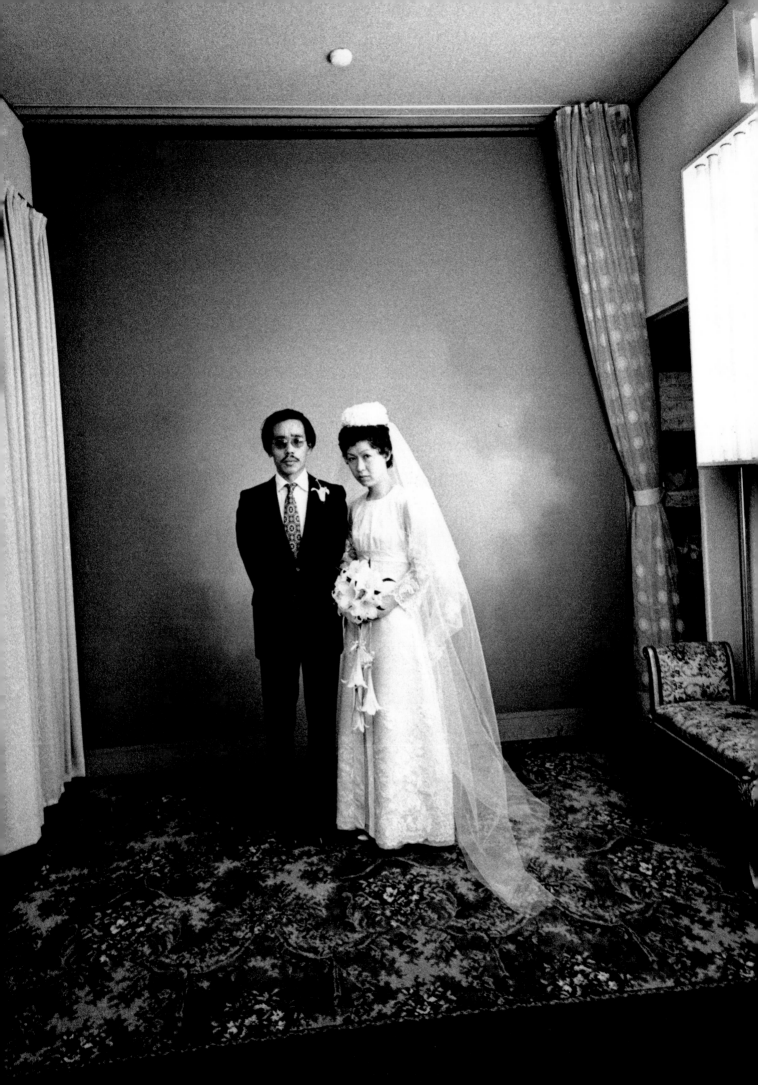

SENTIMENTAL JOURNEY

PREFACE TO
SENTIMENTAL JOURNEY
—

Dear Reader

I can't bear it any longer., and it's not because I'm suffering from chronic diarrhoea and tympanitis. It's just because there are so many fashion photographs around, and I simply can't put up with the fact that all the faces, the naked bodies, the private lives, the scenery all look so fake. This book is different from all these fake photographs. This 'Sentimental Journey' is a symbol of my love, the resolve of a photographer. I'm not saying that these are truthful photographs just because I photographed my own honeymoon. My point of departure as a photographer was love, and I just happened to have started from the idea of the 'I' novel. My whole career has been along the lines of an 'I' novel. I feel that it's the 'I' novel that comes closest to photographs. All I've done is to arrange the photographs in accordance with the passage of my honeymoon, but I'd like you to flick through the pages. The old-fashioned greyish tone was created by offset printing. It's become an even more sentimental journey for me. It's a success and I'm sure you'll like it. I feel something in the slow progression of daily routine.

Yours sincerely
Nobuyoshi Araki

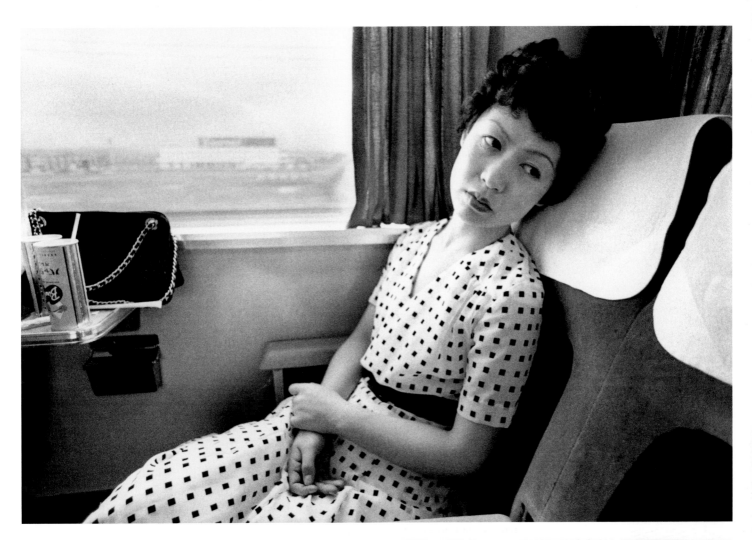

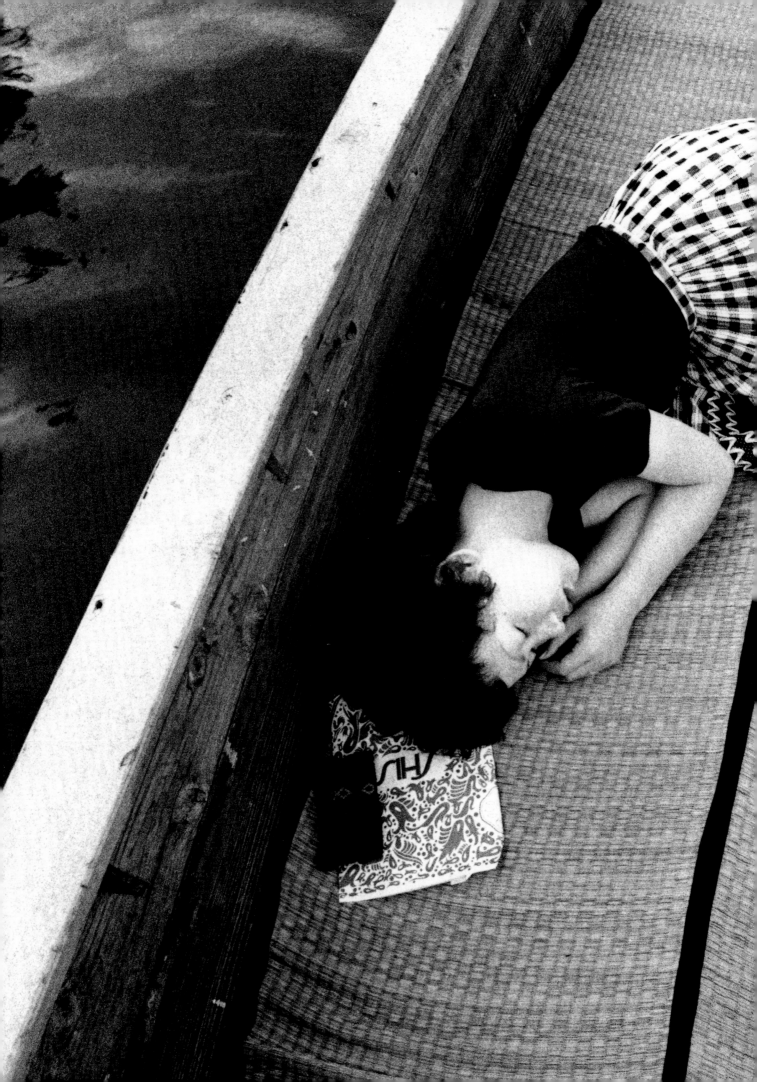

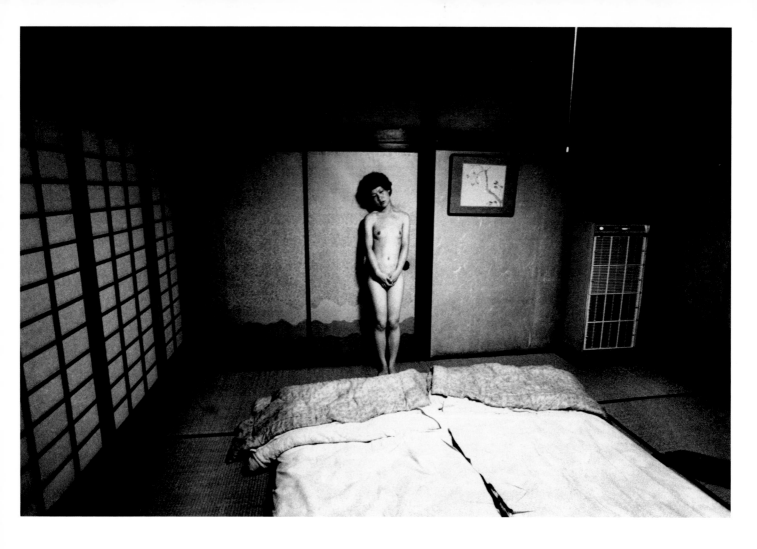

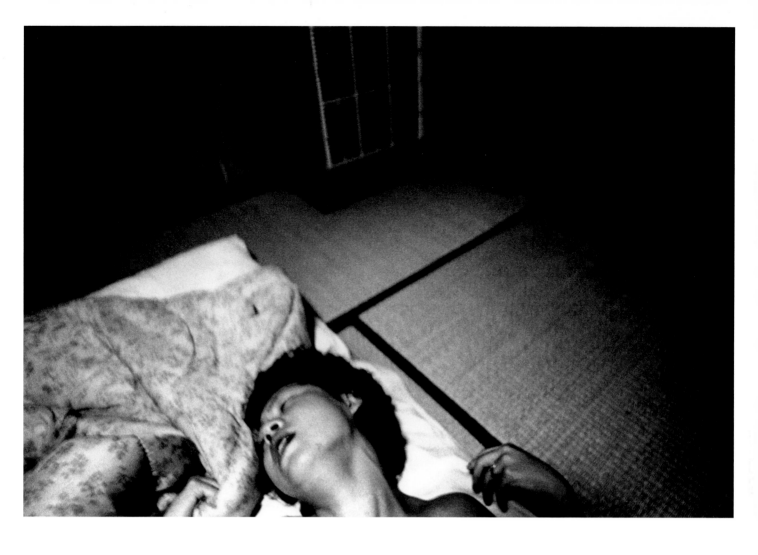

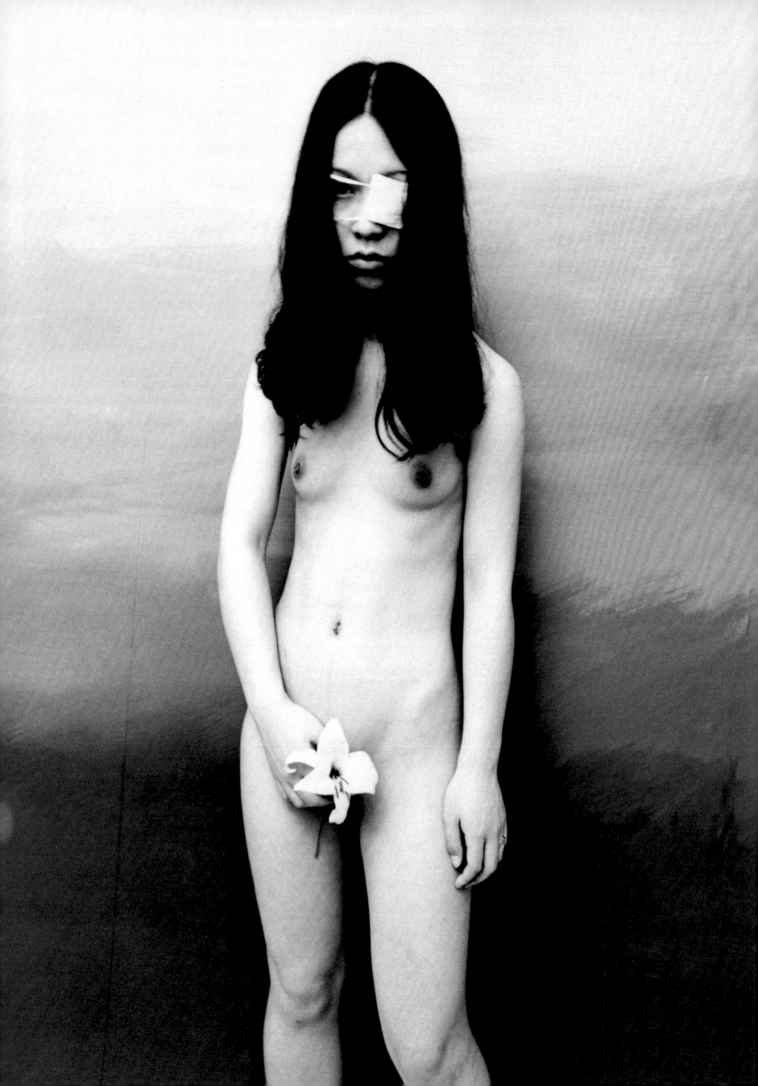

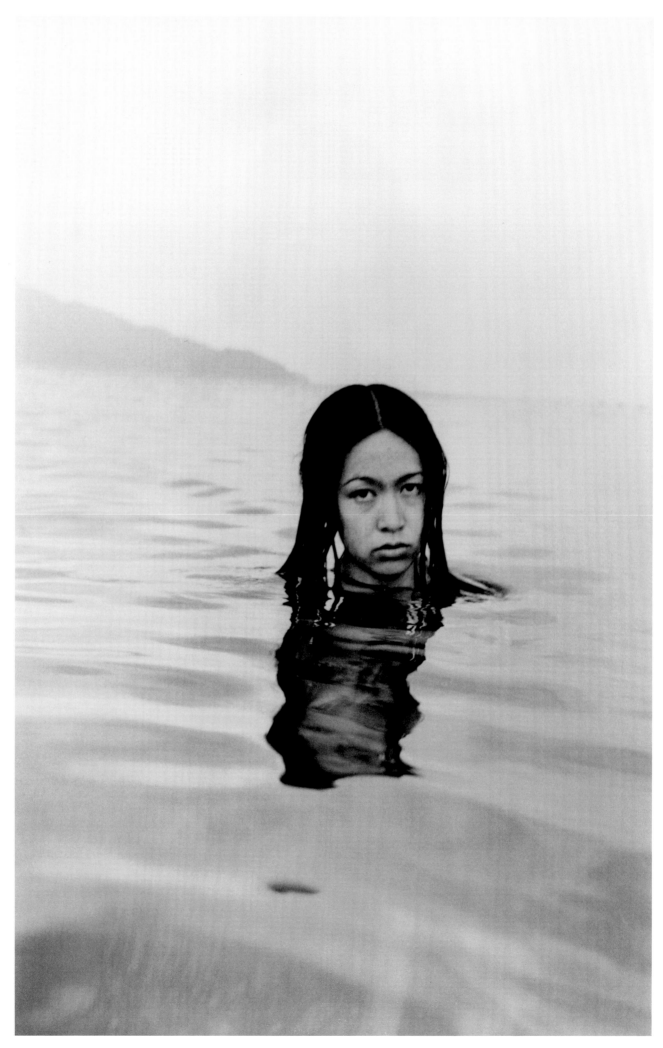

'I BELIEVE
AN I-NOVEL IS THE
CLOSEST FORM OF
EXPRESSION
TO PHOTOGRAPHY.'

QUESTIONNAIRE:
MY TEN FAVOURITE PHOTOGRAPHERS
—

1. JACQUES-HENRI LARTIGUE
He's aware that photography is all about relishing the prospect of pressing the shutter after experiencing the joy of living.

2. DIANE ARBUS
Her photographs are so sad.

3. EUGÈNE ATGET
Whatever the situation, there's no heartlessness in his photos.

4. FÉLIX NADAR
His curiosity and craving for honour are amazing, from hot-air balloons to underground passageways. He's similar to Kishin Shinoyama.

5. MAN RAY
He photographs women of the type I like in ways I like.

6. BRASSAÏ
His style is very similar to mine.

7. ARAKI C. BRESSON *ah… a slip of the pen; I mean* HENRI C. BRESSON.
He's closer to me stylistically than Brassaï.

8. IHEI KIMURA
He used to imitate me.

9. KISHIN SHINOYAMA
His collection *Hareta hi (A Fine Day)* is on course for Hawaii.

10. NOBUYOSHI ARAKI
Well, I can't leave him out!

Being asked to give my favourite ten photographers is about as difficult as asking a photographer to get his dick up. Photographs only show the surface and don't show what goes on inside. Photographers cover up their innards, I mean their genitals, and don't put them on display. I've never been in a public bath with any them, so I wouldn't know which of them is the biggest. I suppose the biggest is Wegee Sausage. Well, leaving pricks aside, I guess my favourite is Nobuyoshi Araki. That's because there's never been a photographer before in the world who's been so ready to disclose his private parts. Pretty unique in the universe, I'd say. A bit of an extraterrestrial. And it's all deliberate, perhaps formalised. Not so much form as duty. There's this sense of duty to photography. Duty and affection for the object of the photograph. Well, maybe Benny Volence or Obbly Gayshern[1] is my favourite photographer. Perhaps I ought to be a little more modest. I suppose I've just listed all these names pretty much at random.

[1] The names Benny Volence and Obbly Gayshern are Araki's joke; they are made-up names derived from the words benevolence and obligation. Araki seems to be indicating his respect for photographers who understand and represent the ethical virtues of benevolence and obligation.

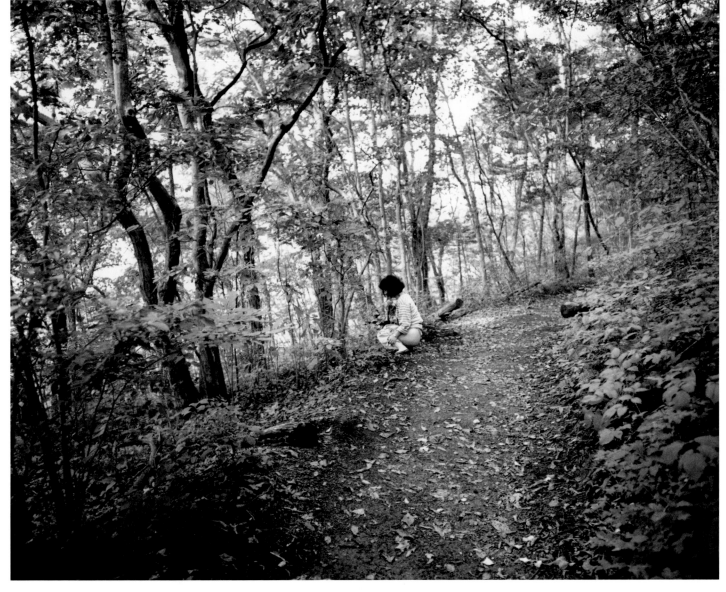

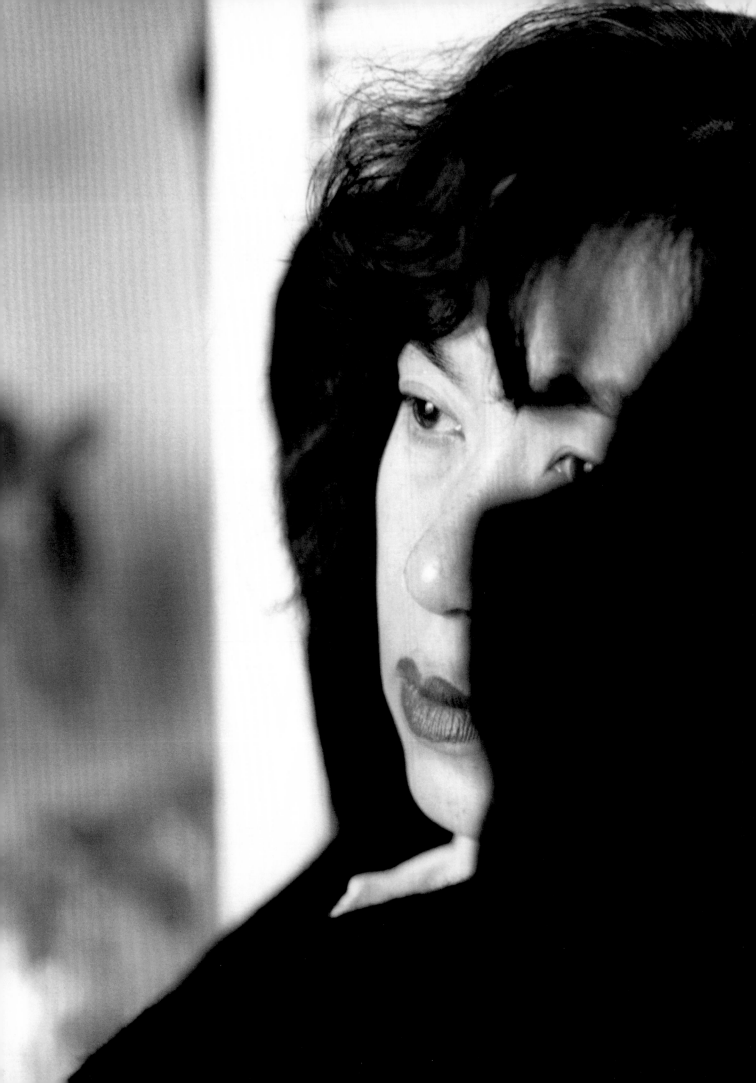

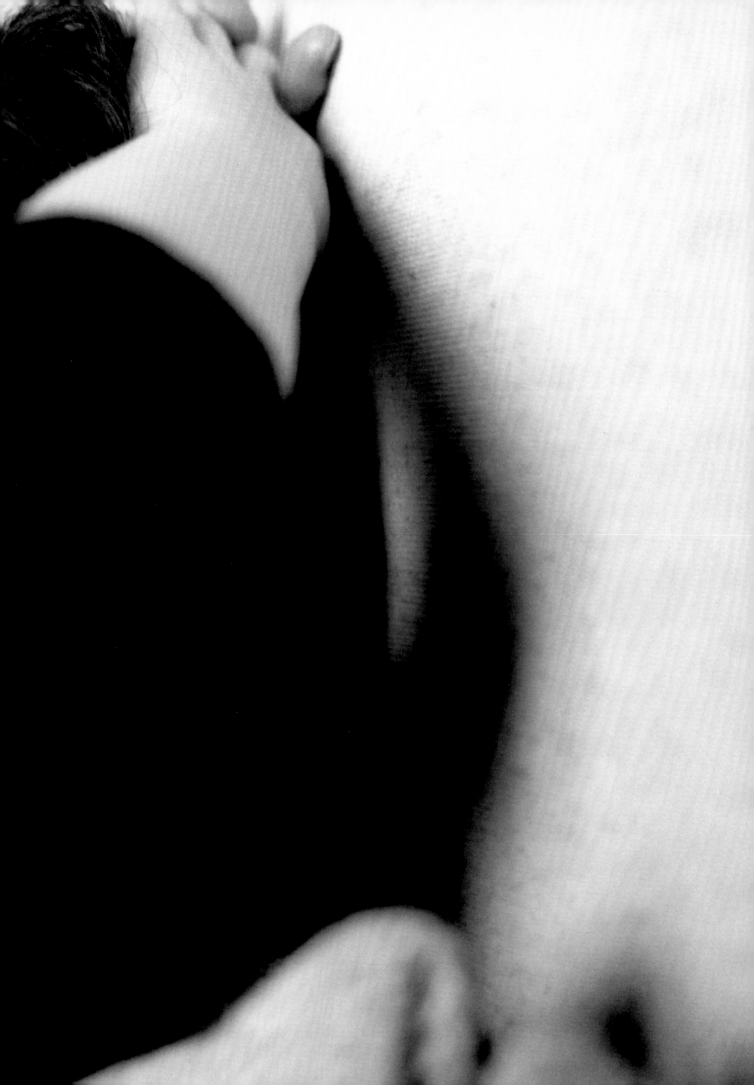

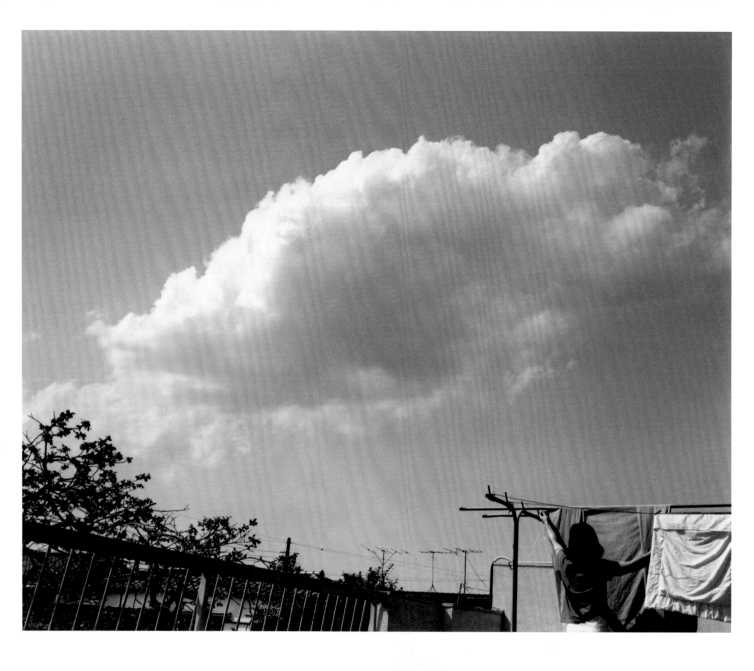

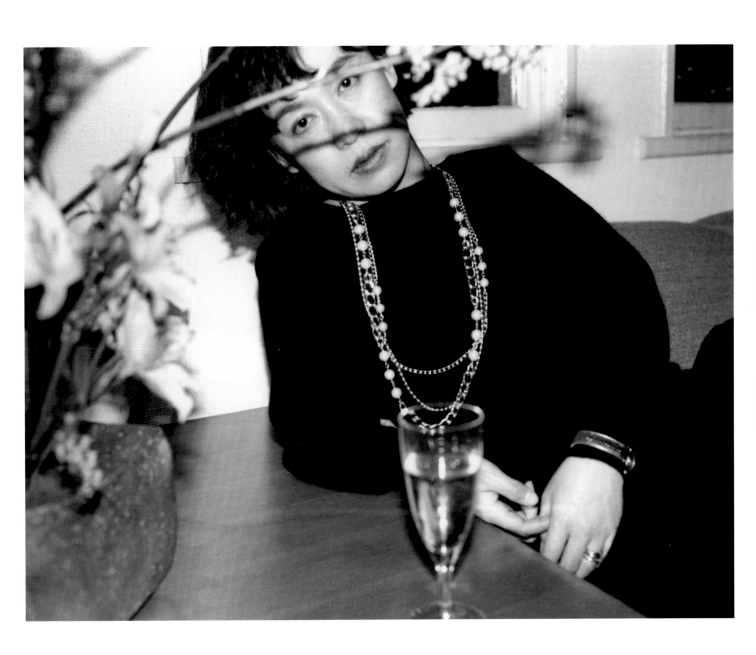

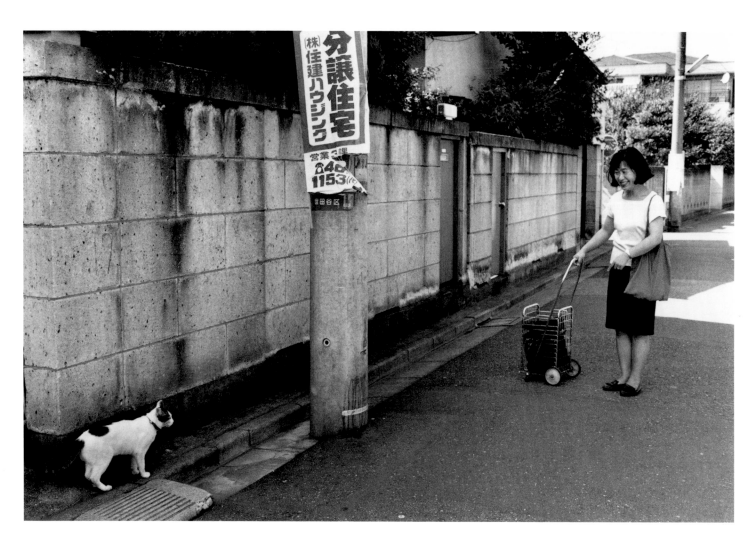

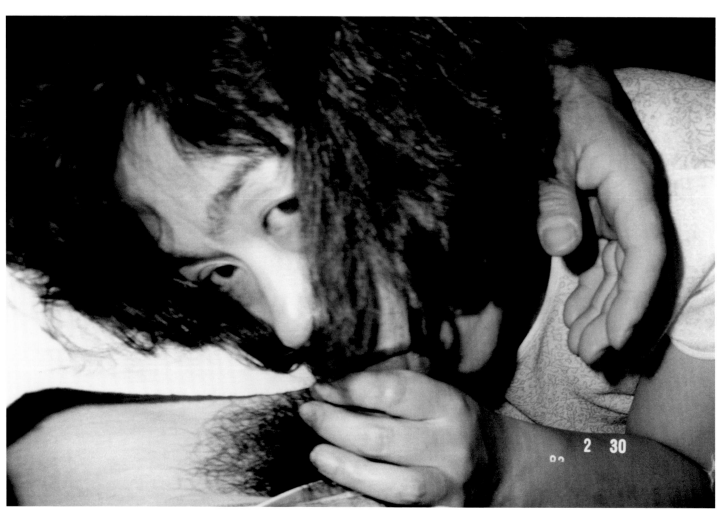

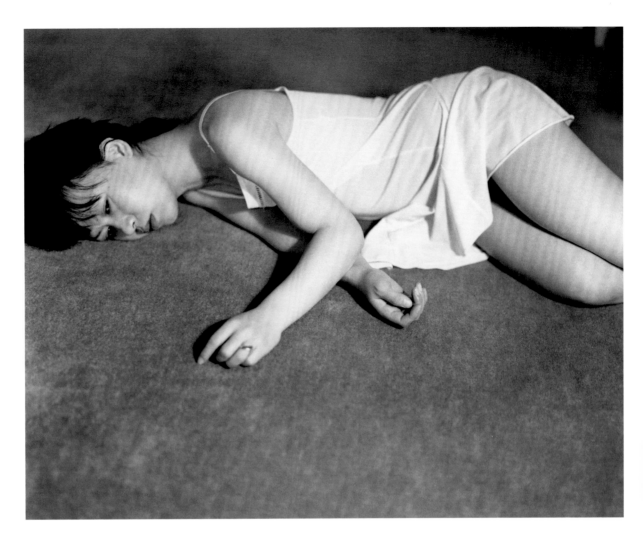

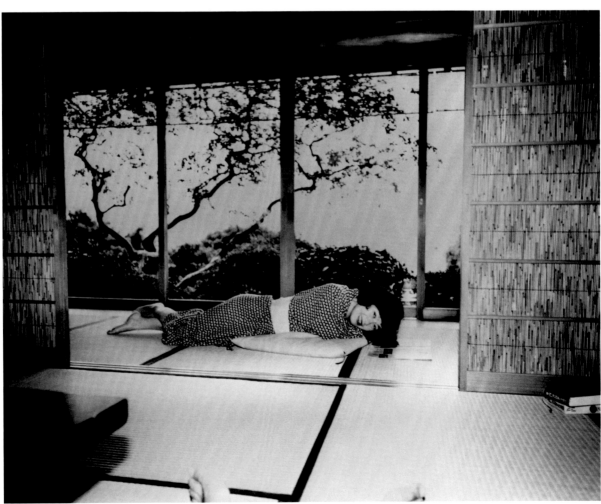

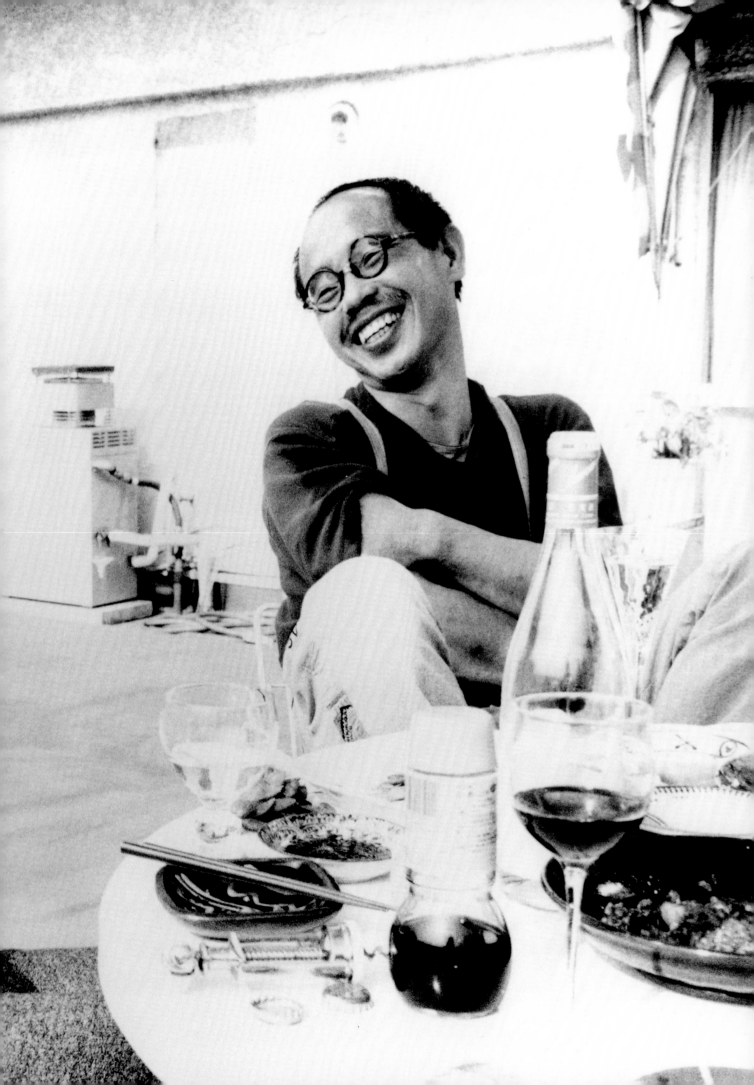

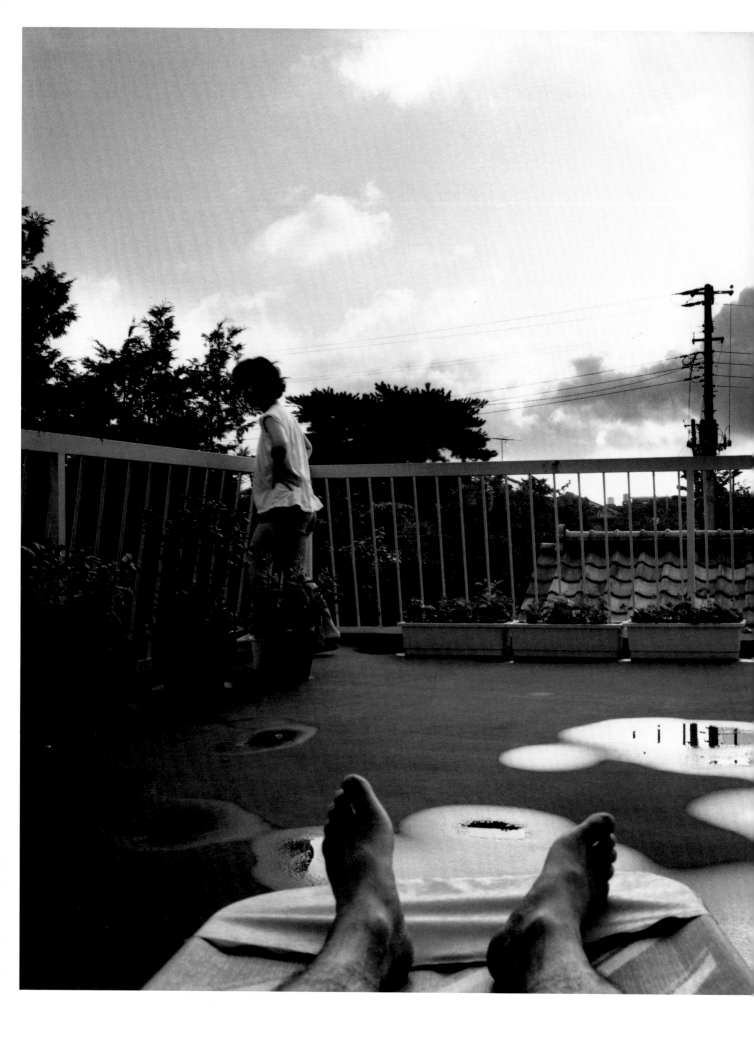

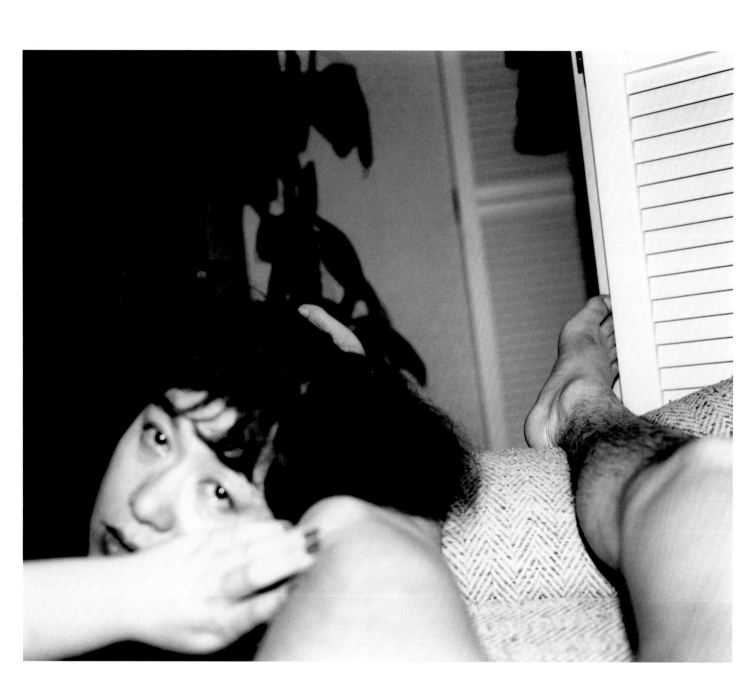

'GENIUS ARARCHY'

—

Q
You started describing yourself as 'Genius Ararchy'. How long have you been calling yourself this?

A
It must have been from around the time I was working for Dentsu, although I'd been called a genius before then too. I think it probably came from the fact that I used to say that, since I'm a genius, they shouldn't be asking me to do certain types of work like the photographs for posters. I guess that was probably it, although I don't remember exactly. It was from around just after forming the group *Fukusha shudan geribara 5*.

I reckon it's because I'm so conservative. Because I'm conservative and methodical, I reckoned that anarchy was just up my street, and so I decided to spur myself on by calling myself 'Ararchy'. Ararchy thus comes from 'anarchy'. I wanted to be, had to be an anarchist.

I decided on it myself, calling myself a genius and using the name Ararchy.

Q
It's usual to wait to get yourself called a genius, but you decided to do it yourself.

A
Well, you can't sit around waiting for someone else to call you a genius. Nobody calls you a genius if you die when you're past fifty. You're only a genius in retrospect if you die in your twenties. When you reach a certain age, people may start calling you 'maestro' or 'master' or whatever. Nobody's going to call you a genius unless you do something astonishing when you're still young.

But it would have been a disaster if I'd been a genius from the outset. I wouldn't be doing what I'm doing today.

Q
But 'Genius Ararchy' has become a kind of sobriquet for you these days. It must be heartening to continue to be called this.

A
Yes, that's right. I hope I'll go on being called this. Normally you'd feel embarrassed about being continually referred to like this. But the word 'genius' gradually comes to take on a different meaning from usual. It becomes a kind of nickname. This is one aspect of it. Maybe that's why people copy the idea these days and create TV programmes with titles like *'Genius Takeshi'*. Well, maybe Beat Takeshi[1] is a genius, but it gets a bit much when every Tom, Dick and Harry starts referring to himself as a genius. It's other people who should call you a genius if you merit it.

Q
But to continue calling yourself a genius might seem easy enough, but in reality it's quite difficult. It was around the time of the big explosion when you were at Dentsu that this happened.

A

I guess it must have been. I didn't say I was when I won the Taiyo Prize for *Satchin*. That's not what it's all about. I felt very self-confident, but it was when I was at Dentsu that this became a catch-phrase that I used to mouth myself.

There's this custom at Dentsu of getting lots of different people together and making them come up with ideas at random. It's known as brain-storming. I used to be summoned frequently to the copywriters' office, and I'd come up with barmy ideas such as for a commercial in which a man dressed like Charlie Chaplin would get embroiled in a traffic jam and then walk along the roofs of cars all the way to Hokkaido. Some of these ideas were actually used for TV commercials. That was why they used to think highly of me.

In that sense Dentsu was a great experience. You're regarded as an intellectual if you come up with lines like 'the medium is the message' when you're chatting up a girl or suchlike. I didn't really set out to study this and that at Dentsu, but I picked up things all the same. This irresponsible guy from the heart of Tokyo with his endless stream of barmy ideas: this was where I came into bloom.

Sending a Xerox photo album to someone you've never met before is something that anyone who has any experience of direct mail in a company might do. But there needs to be something else, like sending the Cola bottles I photographed in 'Petchankora'[2] covered in urine. From around that time it seemed to me that you had to do something naughty or mischievous to be interesting. There's no sense of scale. There's no sense of being some-one really significant. It all seems too close at hand. There's no dignity.

During the 1960s when I was at Dentsu, the pho-tographers belonging to the generation above me were doing really attractive work. This was an age when violence and excess were all the rage. It's easy to get involved in photographs, and you'll be done for if you simply follow the camera. I observed these muddy waters from a distance while I was at Dentsu. When people in the generation before me were blowing themselves up, I was watching from the safety of the castle keep. A bit like Hideyoshi![3] Not like Oda Nobunaga[4]. Kishin Shinoyama[5] ended up as Tokugawa Ieyasu![6]

I mentioned Hideyoshi, but it was a bit like being a cowardly general. I can't get into that world and I'm not interested in doing so either. I wasn't really interested in fraternizing with the times.

[1] Beat' Takeshi Kitano (b.1947), influential film director, actor and popular figure on Japanese television.

[2] A series of photographs of squashed cans of Coca Cola ('Petchancola'). Araki photographed these found objects, which had been run over by cars and scattered in Tokyo streets, in 1972–3.

[3] Hideyoshi Toyotomi (1536–98), the second of three military dictators responsible for the unification of Japan; died of old age.

[4] Nobunaga Oda (1534–82), the first of the three feudal warlords who unified Japan; murdered at the age of thirty-eight.

[5] Kishin Shinoyama (b.1940), leading figure in post-war Japanese photography, along with Araki.

[6] Tokugawa Ieyasu (1542–1616), succeeded Hideyoshi and completed unification of Japan. He became the founder of Tougawa Shogunate, which lasted over 250 years.

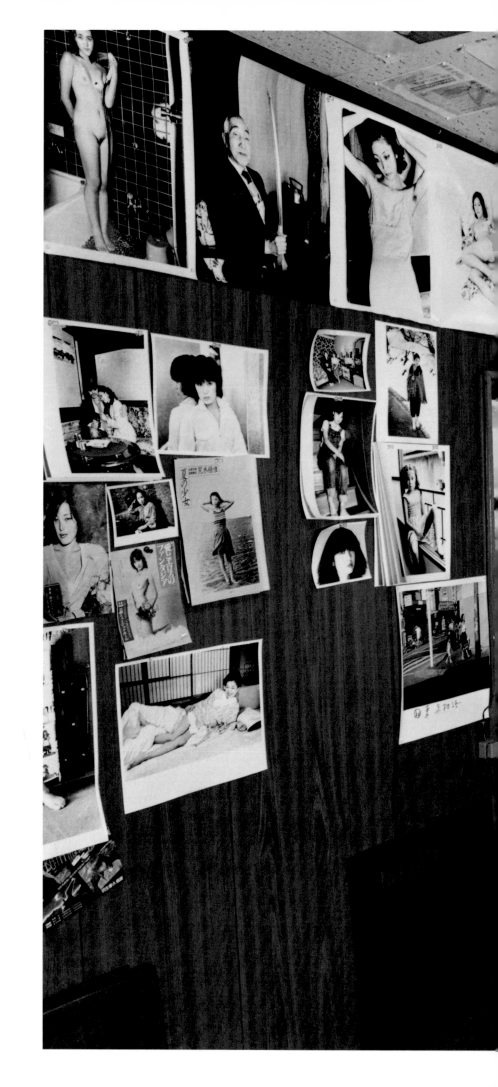

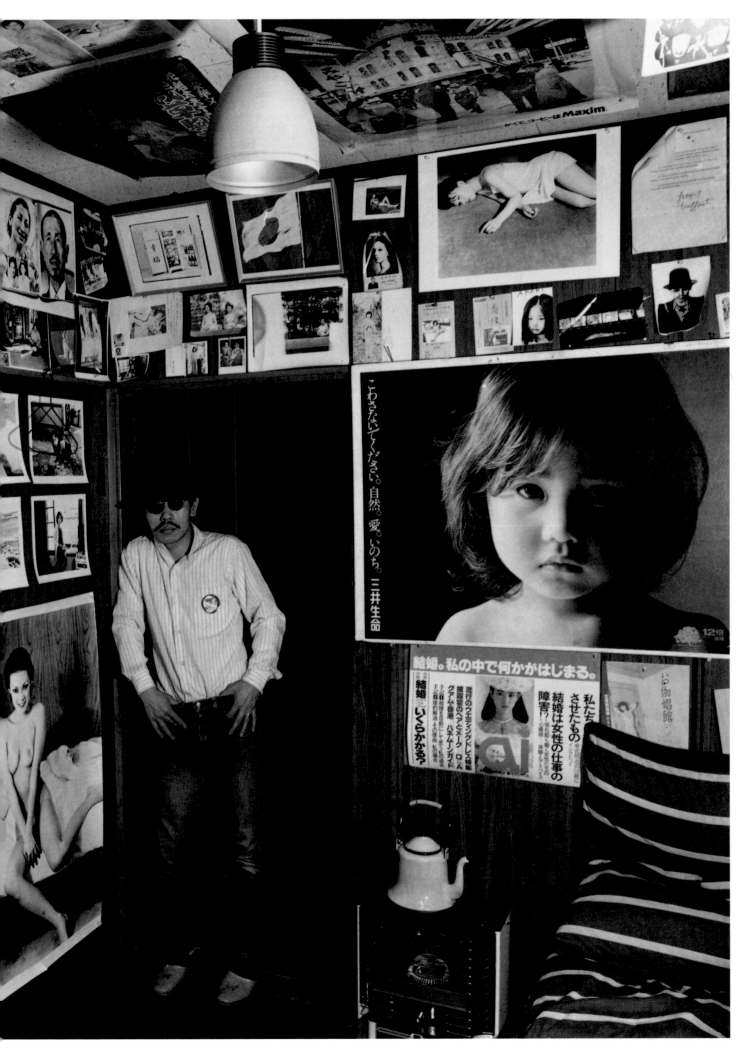

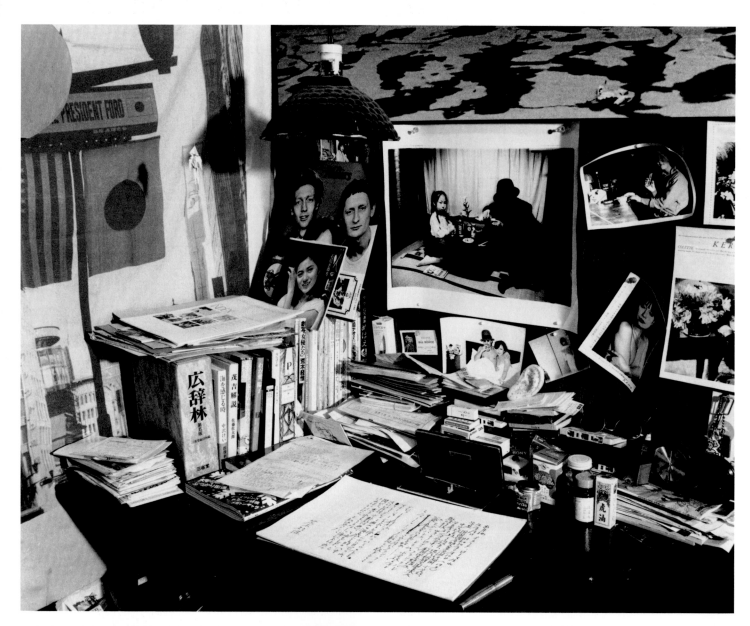

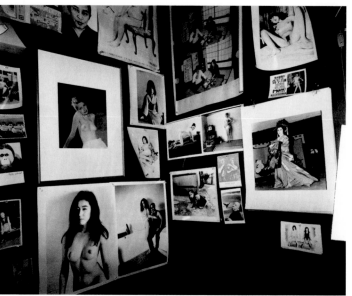

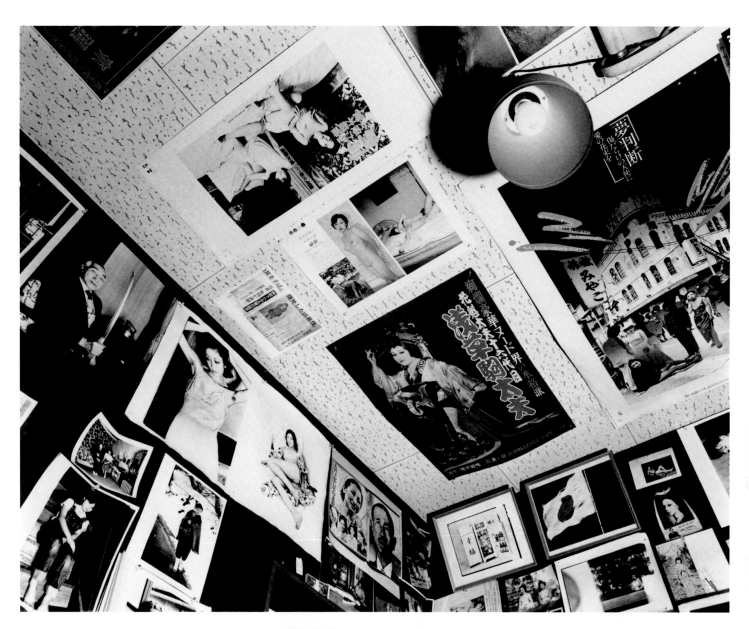

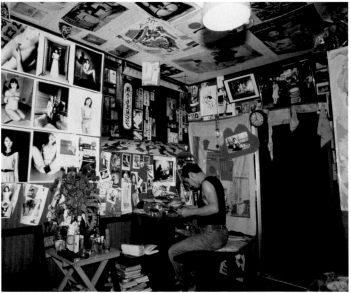

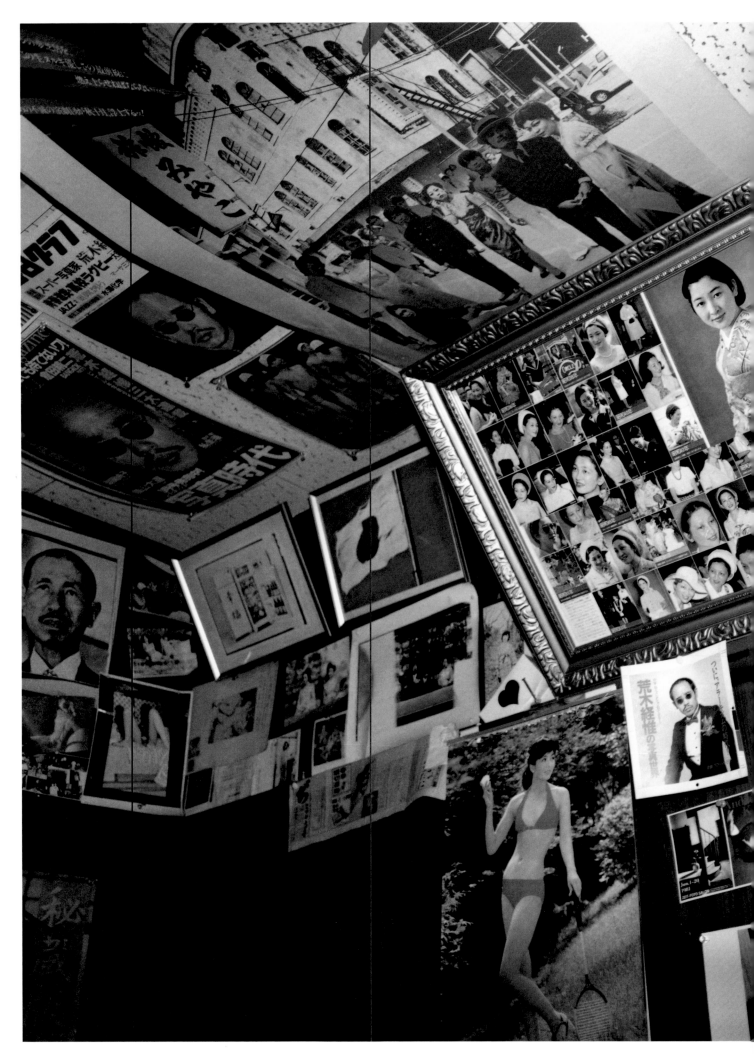

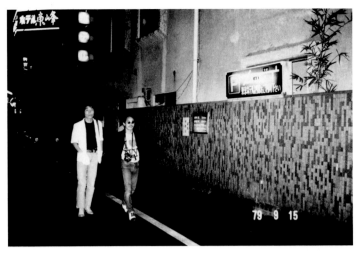

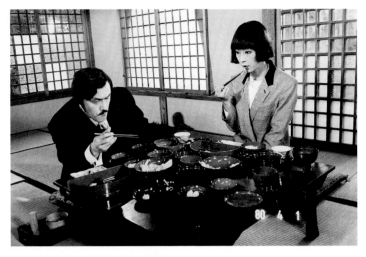

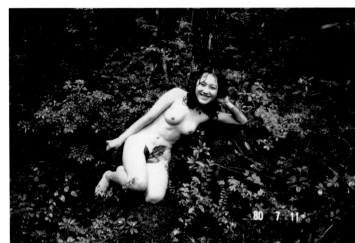

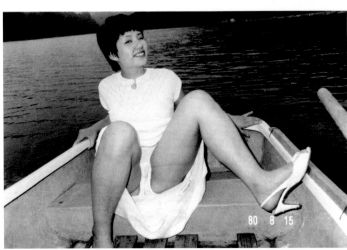

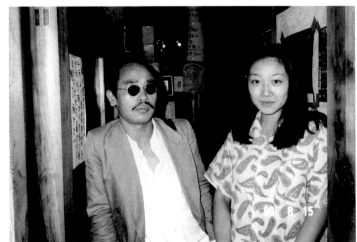

PRIVATE
DIARY

WHEN YOU'RE DEAD
WHAT'S LEFT IS WORKS OF ART
—

Taking photos of Ginza, I recalled the idea of the 'dated city'. It's great to shoot cities – especially Tokyo – with the date inserted. This is at last being understood even by hard-line European intellectuals.

They think that what you produce has to be permanent and that, when you're dead, what's left is the work of art. In other words, art has to be permanent, eternal. That's why you shouldn't put the date into your work. If you do, it stops being a work of art. With the date there it becomes the product of a single specific day and can no longer be art. That's the way they used to think anyway. But they've come to realise recently why it's a good idea to add the date. They've made some progress!

I was interviewed by a French broadcasting channel when I did an exhibition at Prato in Italy, and they asked me insistently why I put the date in my photographs.[1] I seem to remember replying that 'Rome wasn't built in a day'. The date is neither here nor there as far as I'm concerned. It's just there as a sign, as if it were my signature.

But it's effective if a photograph does carry the date. It seems somehow lacking if there's no date. In Europe they expect you to explain the precise logic behind all this. You say it's a good idea simply because it's a good idea, but they try and get an explanation out of you. I don't like Paris; they're not prepared to take things as they come!

I can explain it if I have to, but all the interest vanishes if you have to explain this kind of thing. It's just not interesting because it means that all the mystery, or perhaps I might better say the enigmatic quality, disappears. Without a bit of perfunctoriness, no matter how insignificant, all the interest evaporates. It's precisely this perfunctory sense, this sense that you don't know entirely what's going on, that makes an artist! It's not necessarily a good thing to be understood, and it's this that makes the artist!

I don't know but it seems to me that there's something distinctive about Japan in the context of world art. There's this sense that some kind of flaw is required. Maybe it's not so much a flaw, but there's this innate distaste for perfection, as if things had to be broken or soiled in some way.

The date was pretty chaotic at first. I'd change it every time I took a photograph. I'd end up taking photos covering several years on a single day, going back way into the past. I took photographs supposedly dating from 1995 in 1980 or thereabouts. Some people get fooled by the date! I'd take colour photographs bearing a date around 1920 featuring people who were completely unknown to me, and I'd add a caption to the effects that these were my parents.[2]

[1] This interview took place on the occasion of Araki's solo exhibition at Prato in Italy. Araki was interviewed by French national radio as part of a two-day feature on him in advance of his exhibition in Paris starting in November 2000. While occasionally showing his irritation at the disputatious questions he was being asked, Araki ended up overwhelming the interviewer with his witty ripostes. A recording of this interview was broadcast in the exhibition hall while the Paris solo exhibition was being held.

[2] Araki has written as follows: 'I suppose I can admit now that Geishun (Greeting spring), the photograph that appeared under my name in *Modern Photography 75: The End of Modern Photography*, the feature that appeared in the April edition of the magazine *Asahi Camera* wasn't my work at all. It was taken by one of my staff members, Koshiro Yaehata … A photograph taken by someone else becomes a photograph taken by Nobuyoshi Araki once the name Nobuyoshi Araki appears on it. The title *Geishun* is intended to ridicule the nature of fame in photography and to give some idea of the awe-inspiring quality of the written word.' (From *Otoko to onna no aida ni wa shashinki ga aru* (Between Men and Women is a Camera). Araki has written in a similar vein about the photograph *Chichi to aijin* (Father and his Lover).

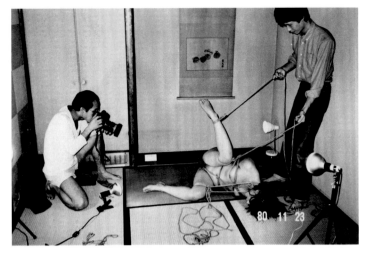

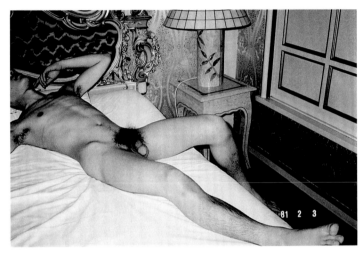

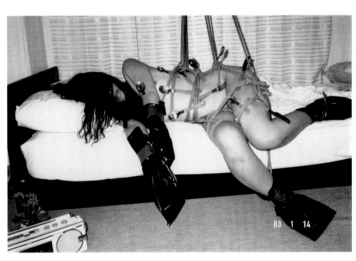

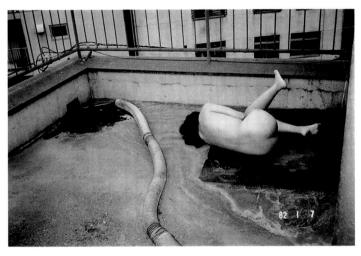

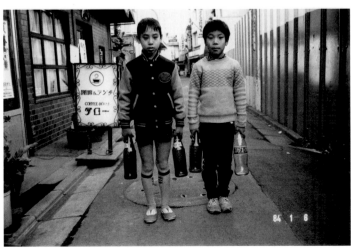

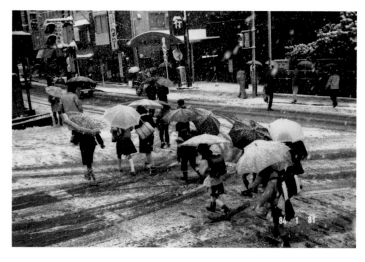 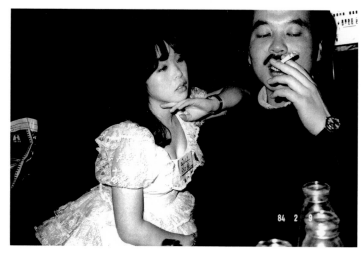

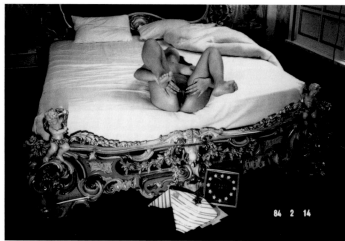 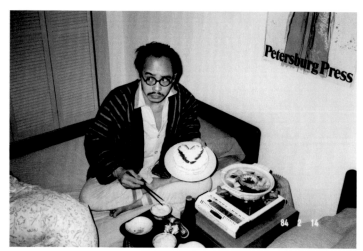

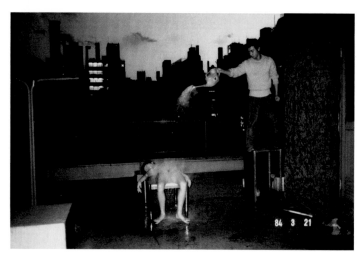

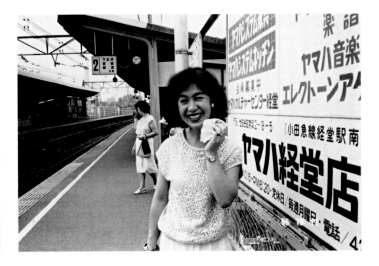

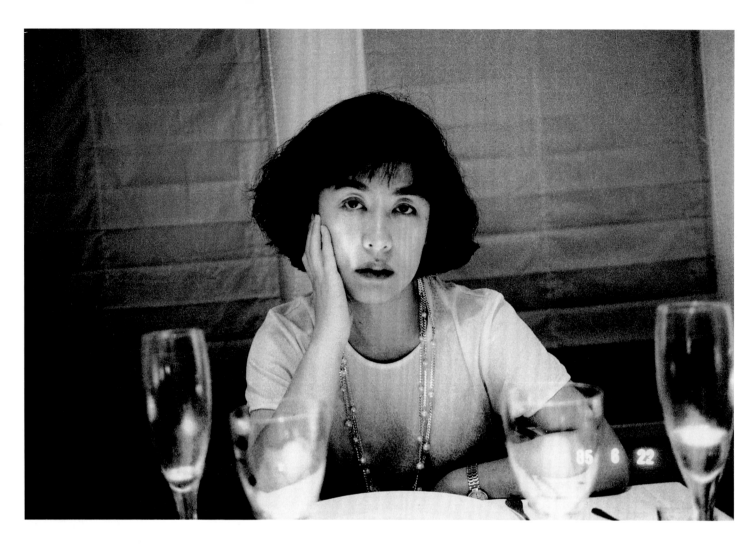

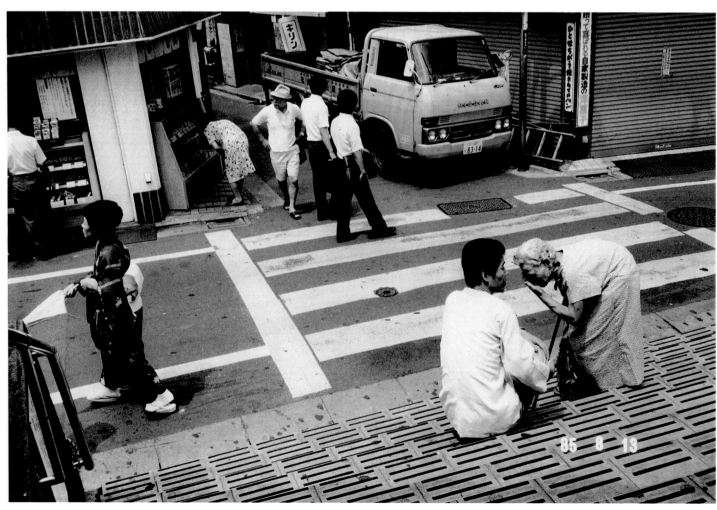

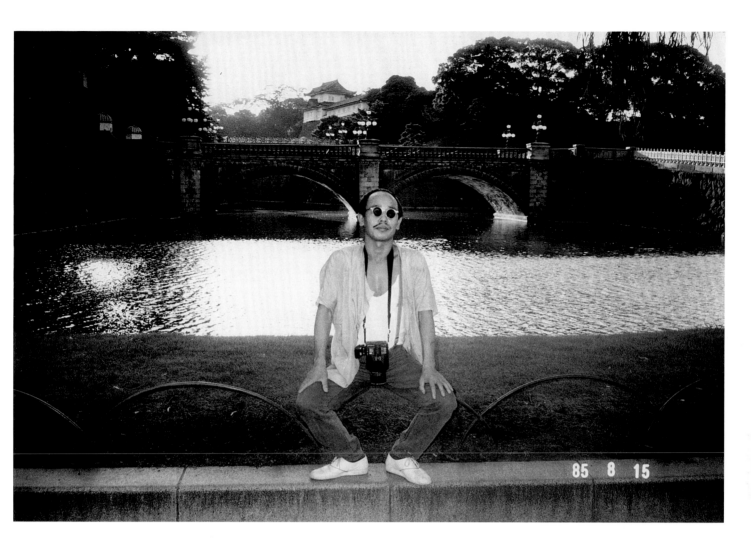

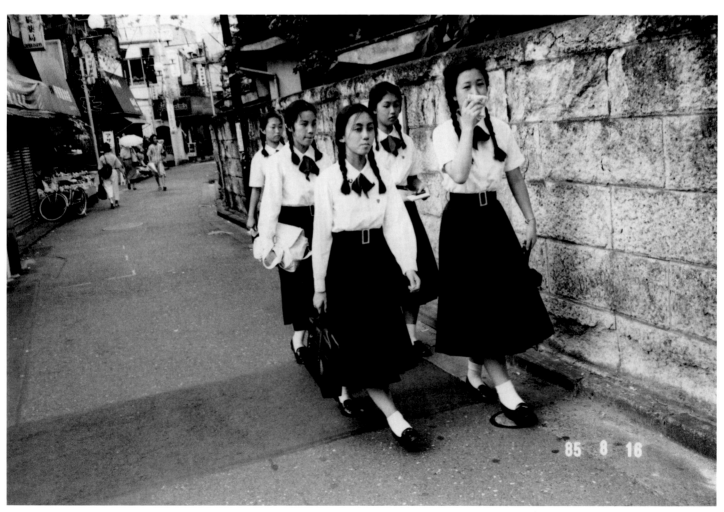

85 A 30

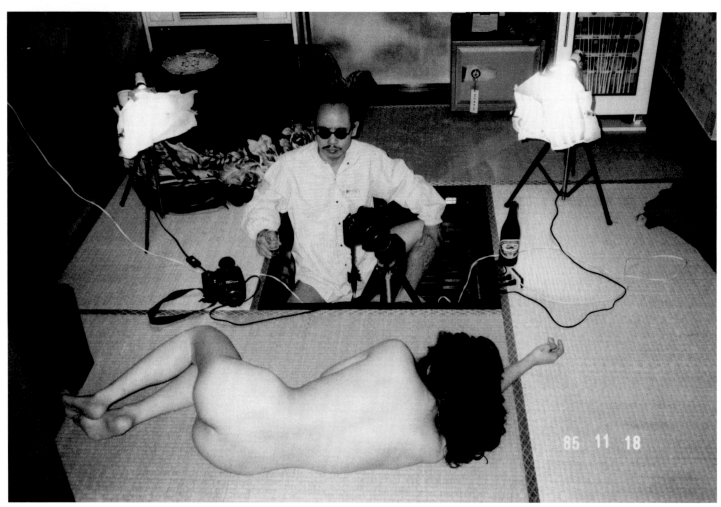

85 11 18

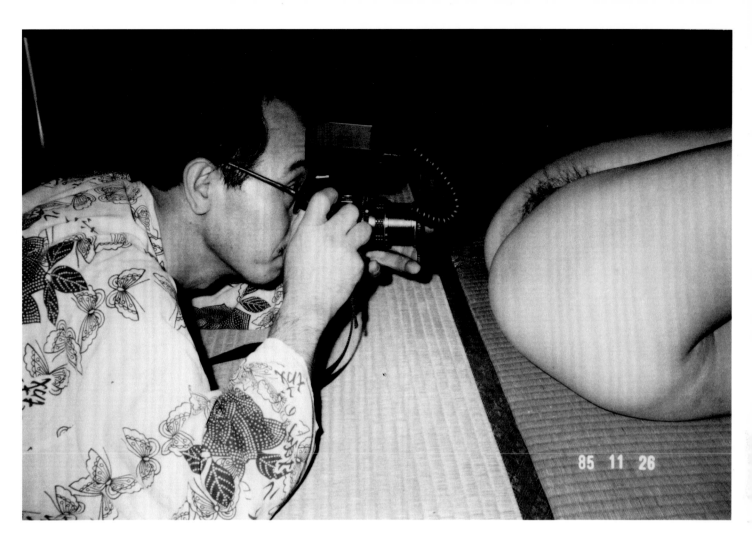

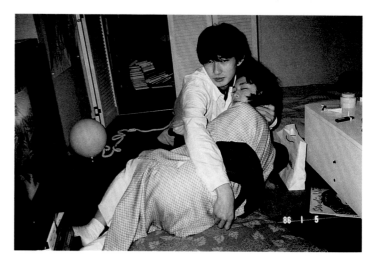

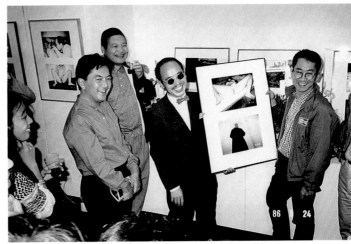

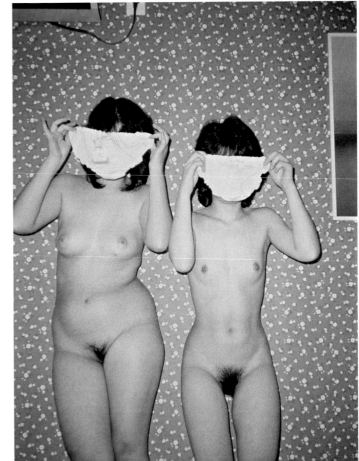

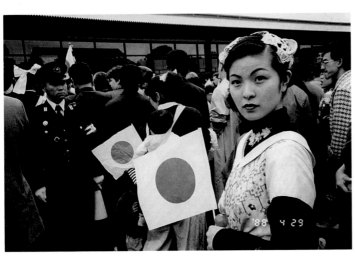

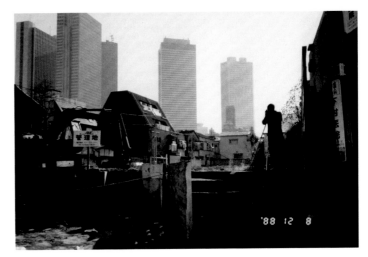

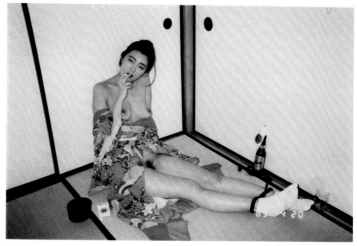

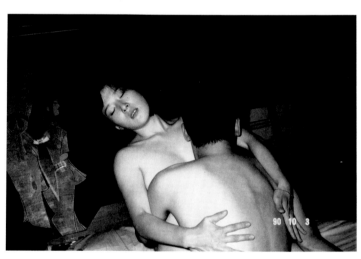

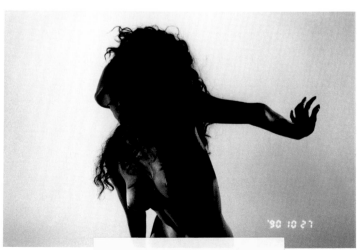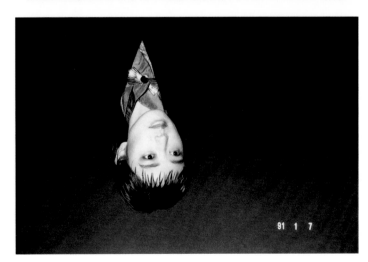

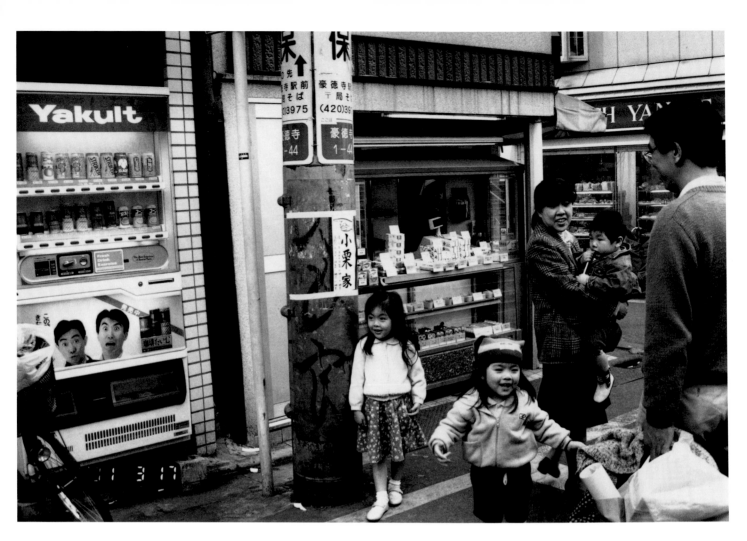

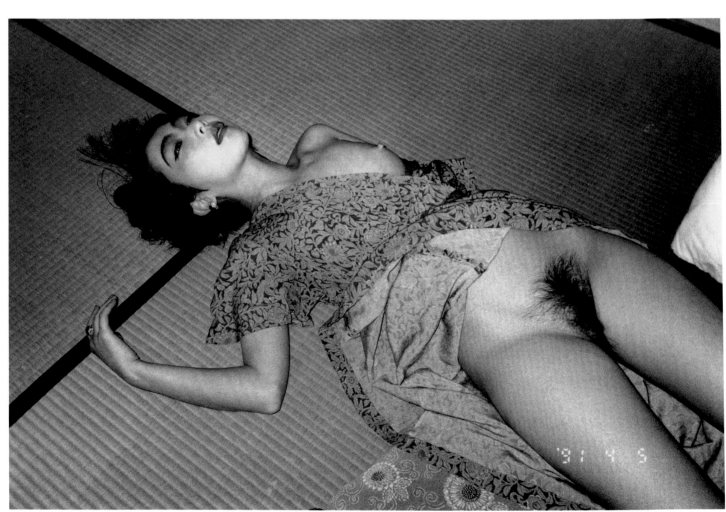

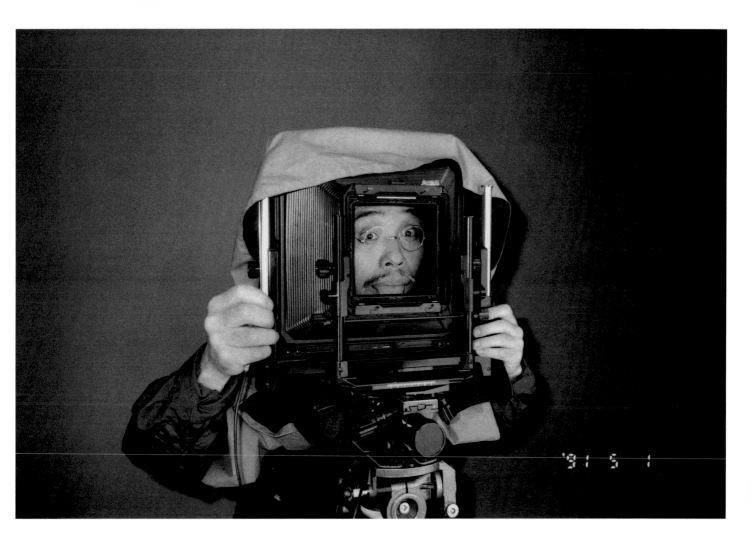

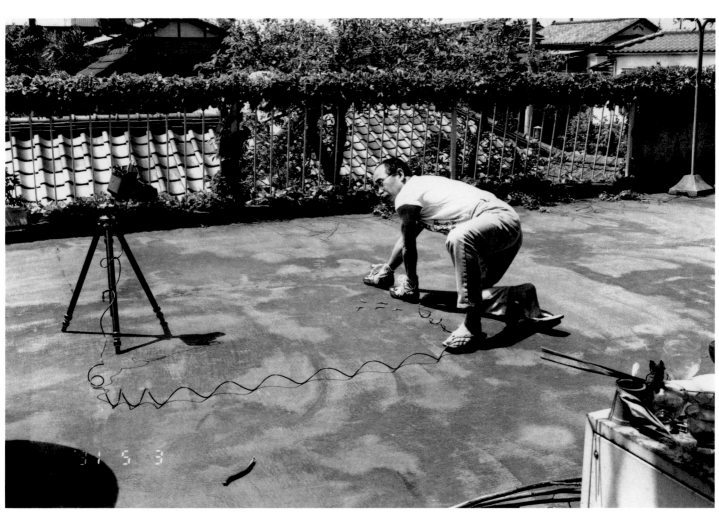

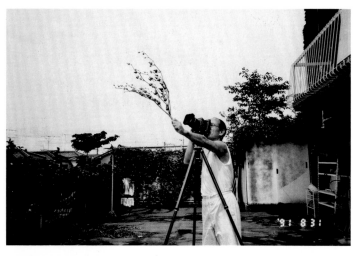

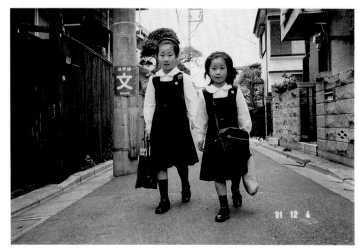

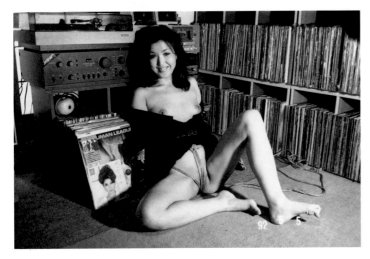

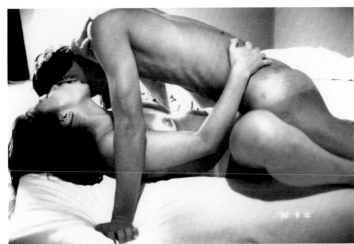 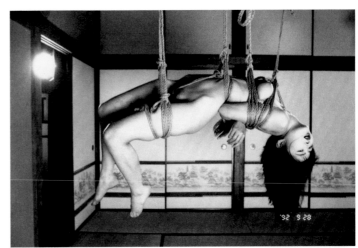

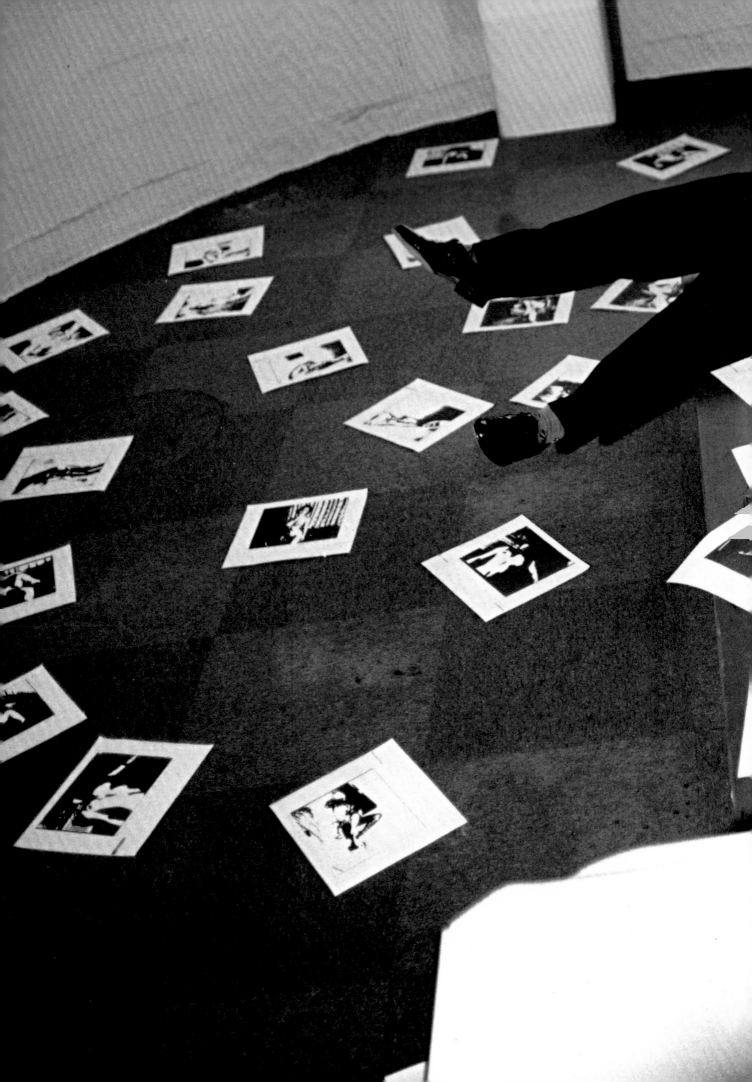

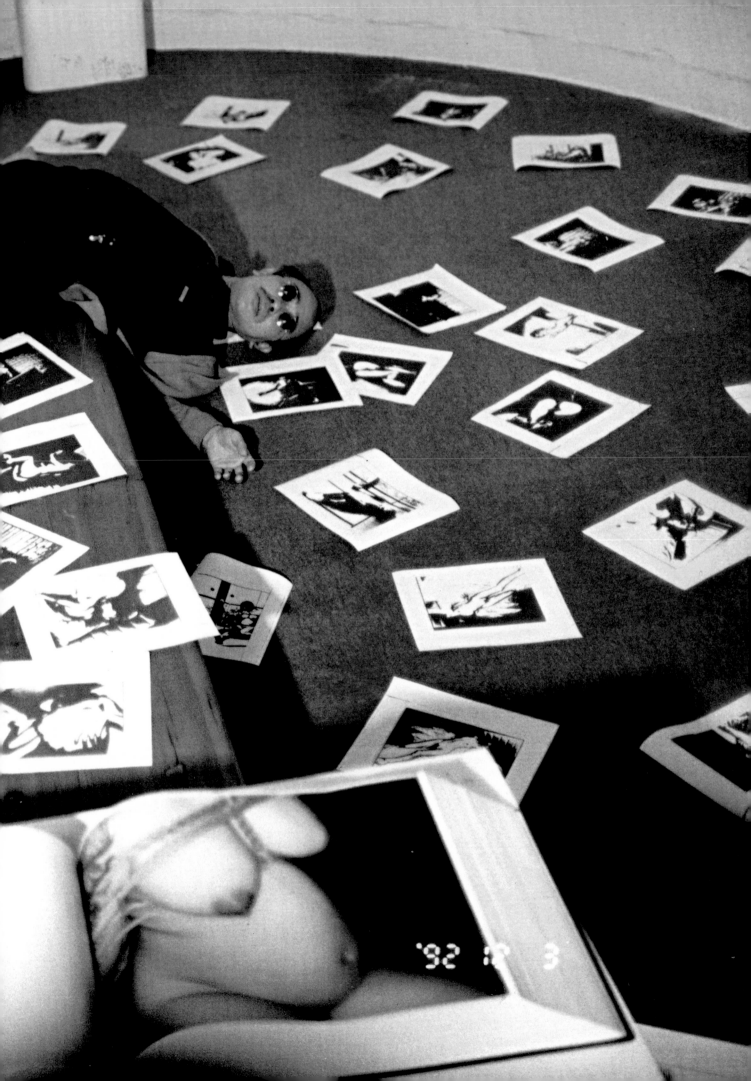

'92 12 3

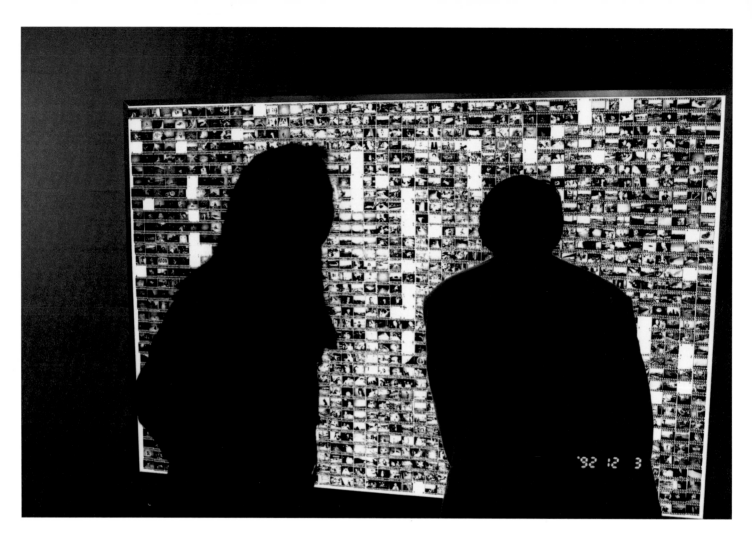

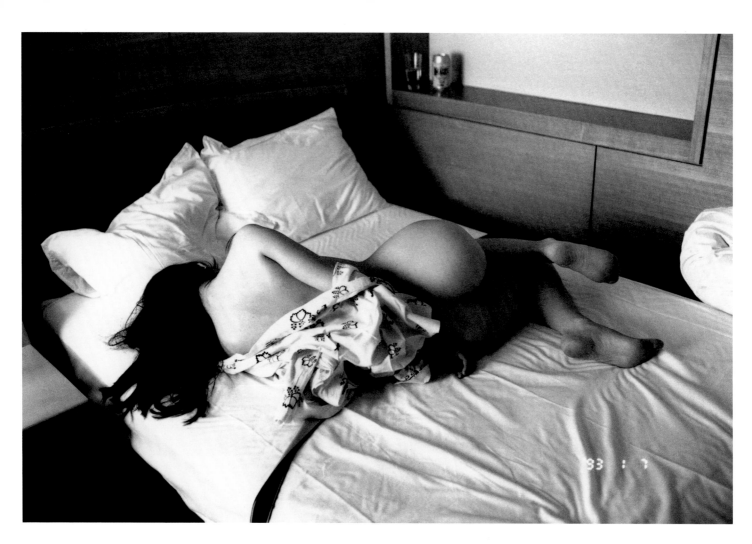

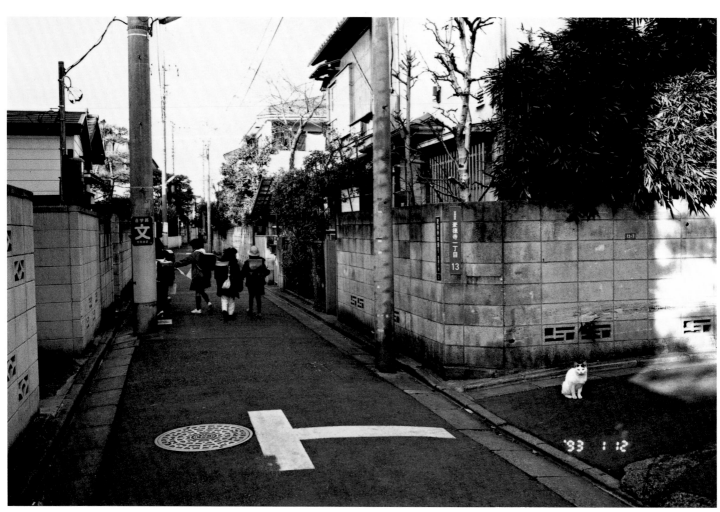

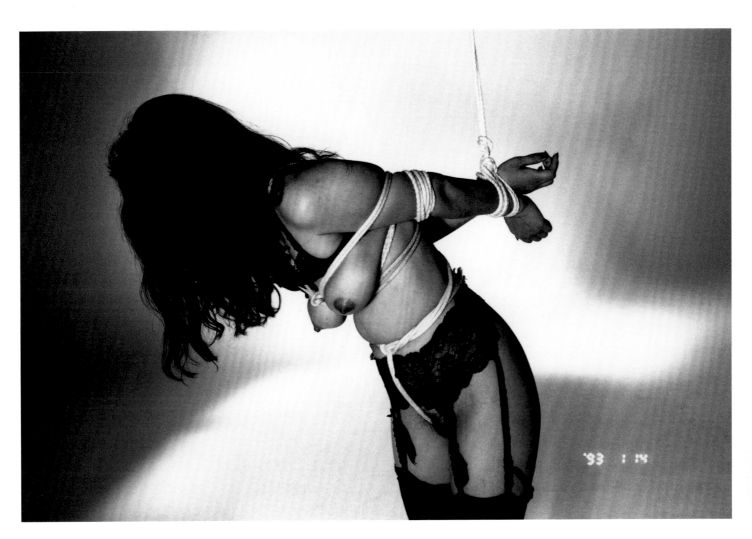

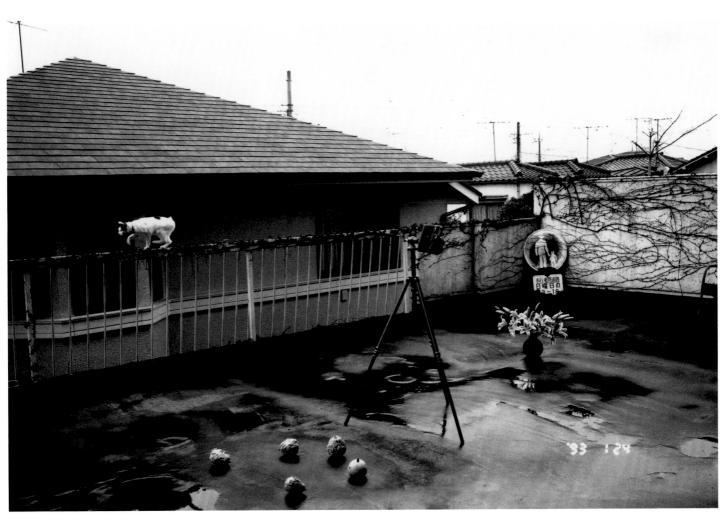

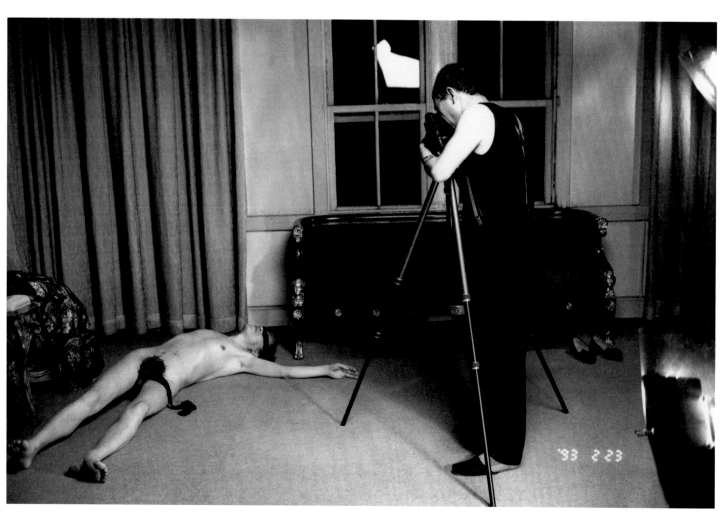

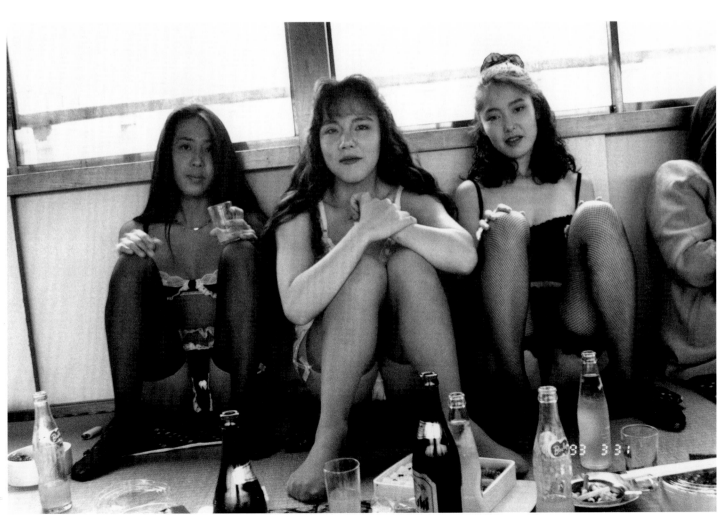

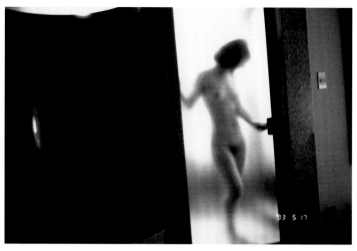

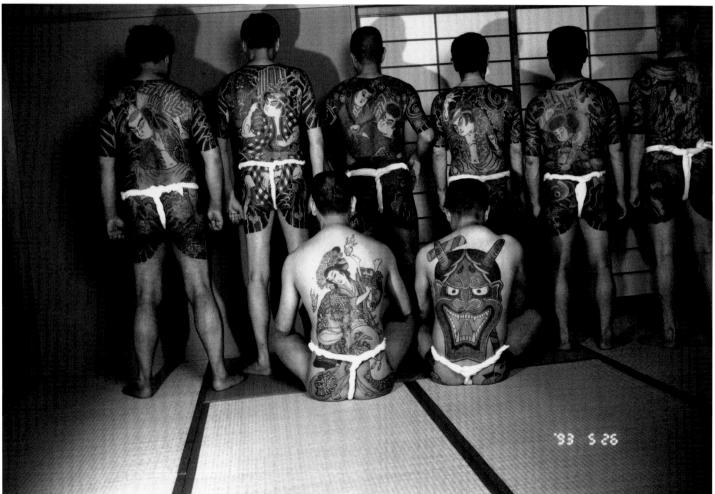

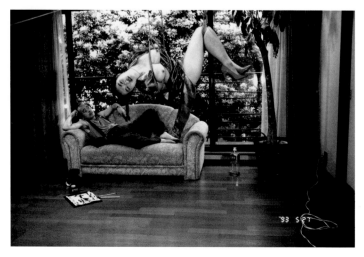

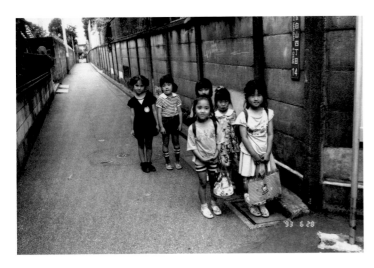

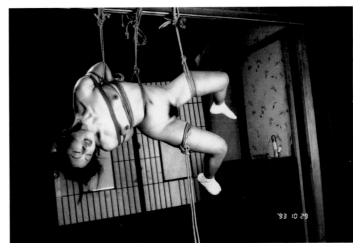

'93 11 22

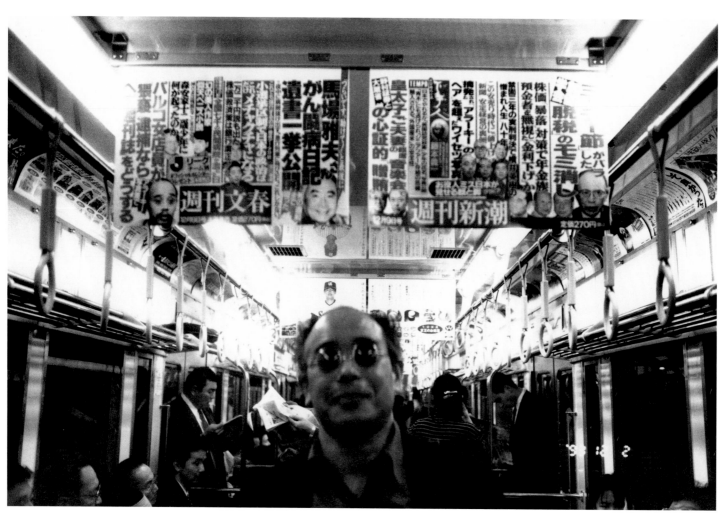

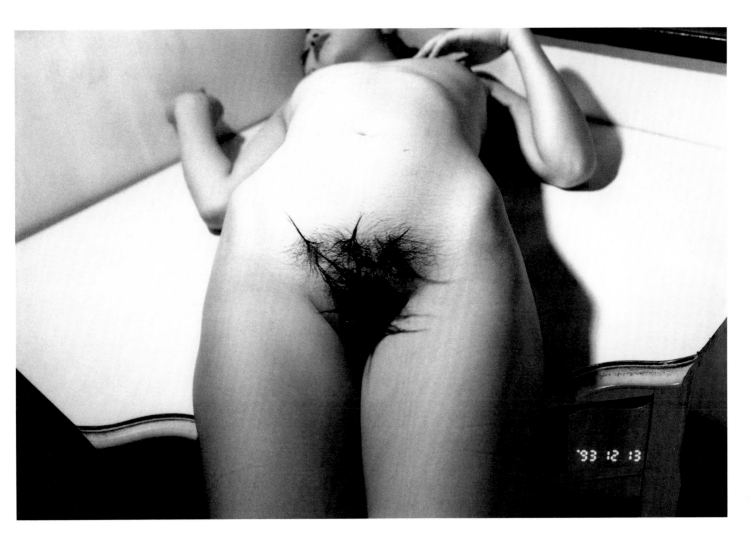

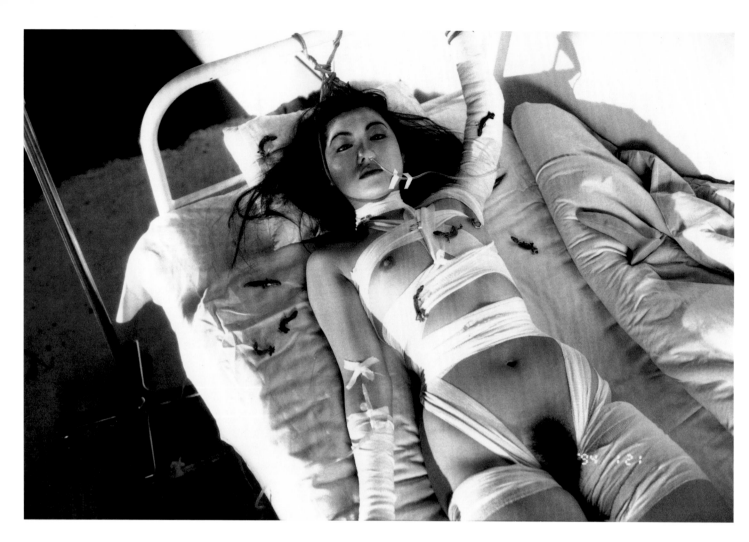

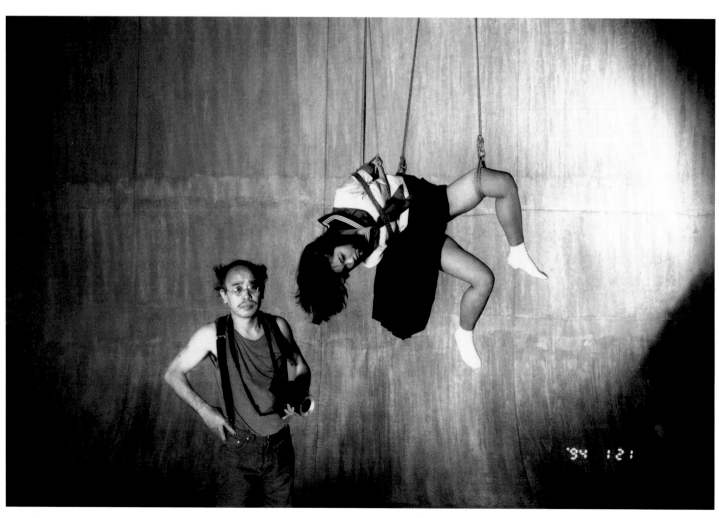

'94 3 15

'94 4 28

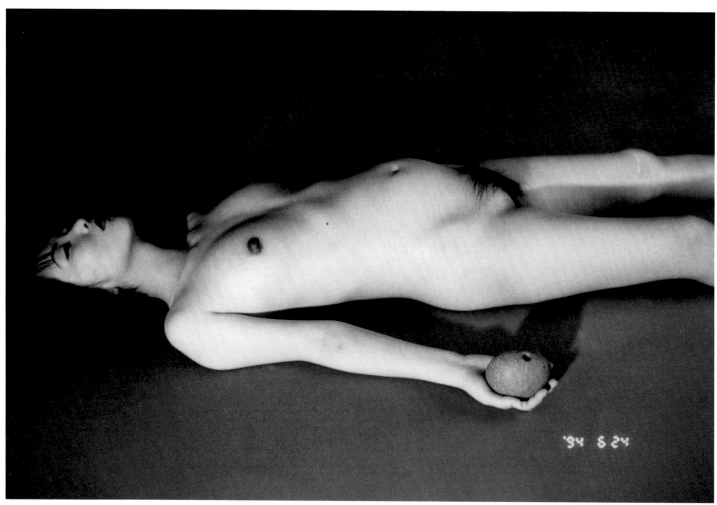

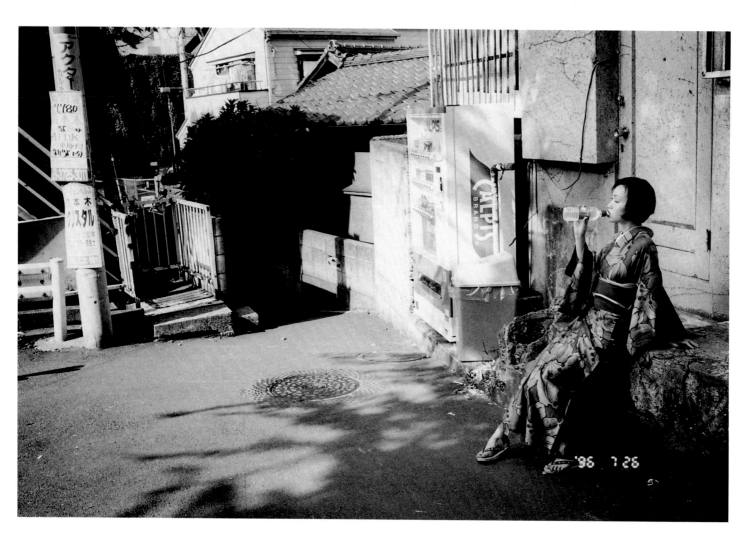

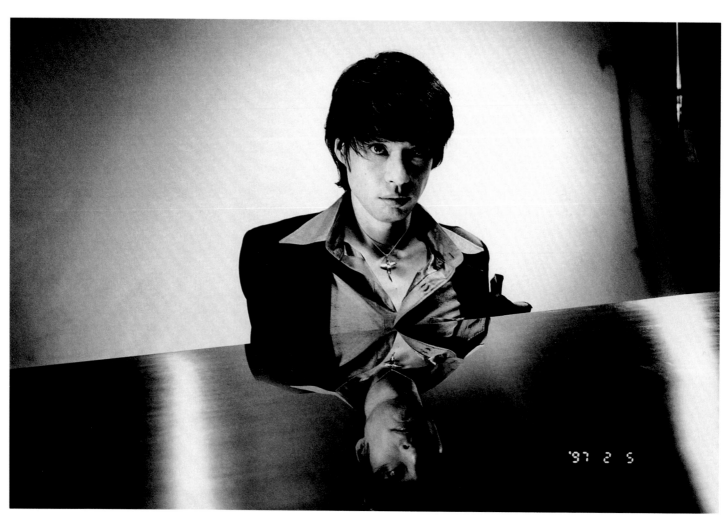

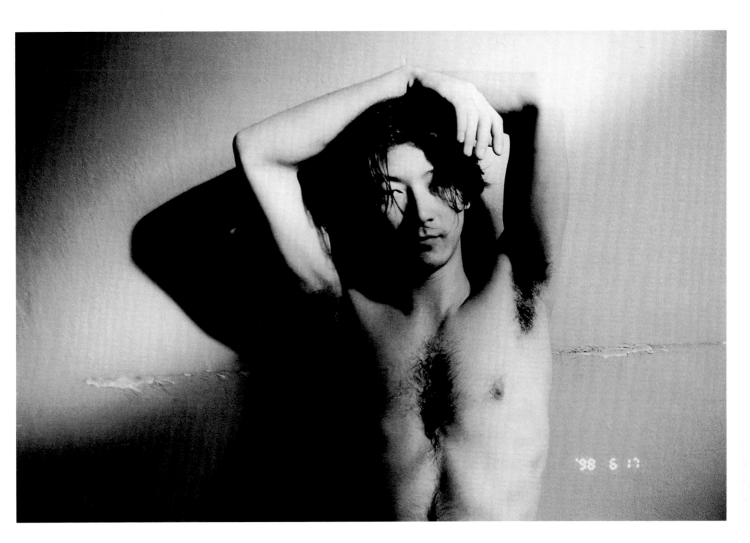

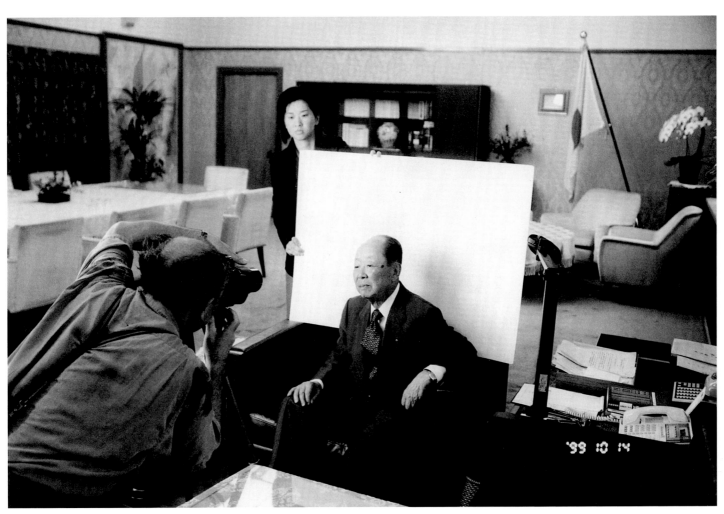

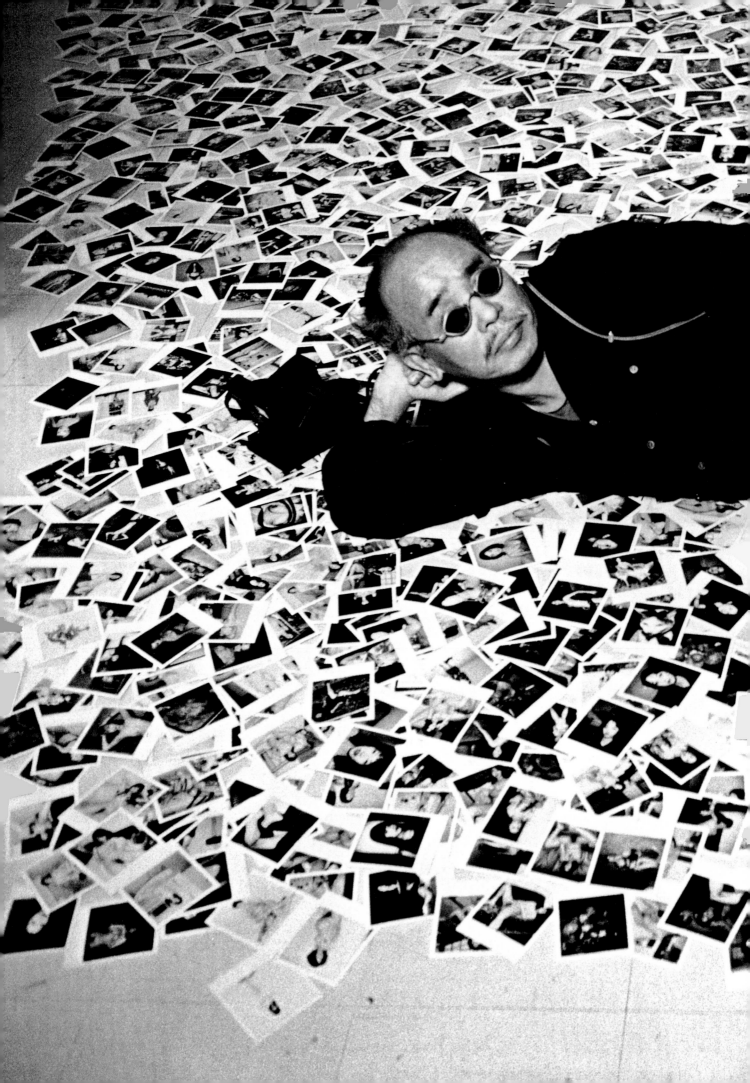

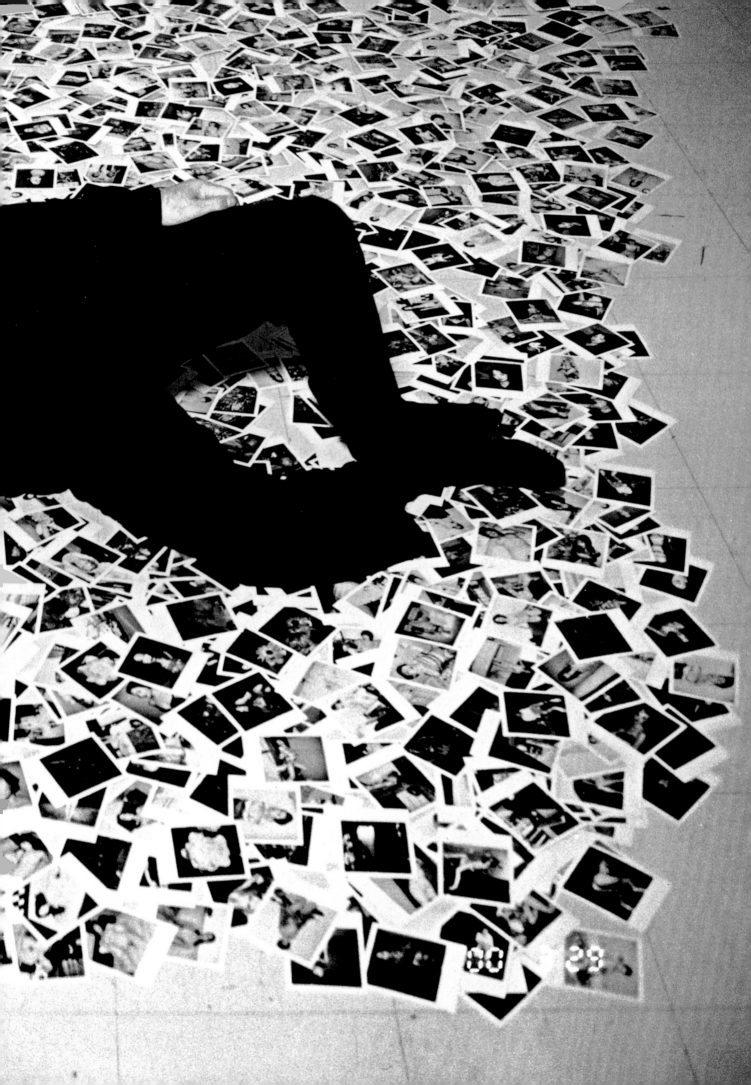

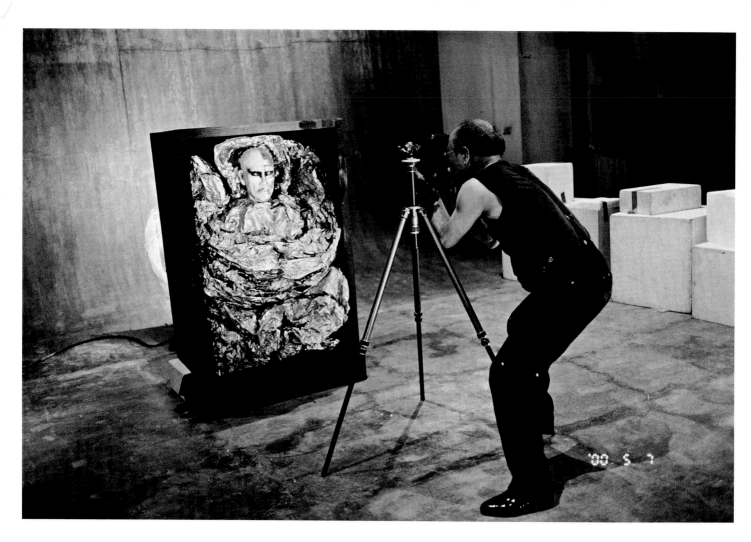

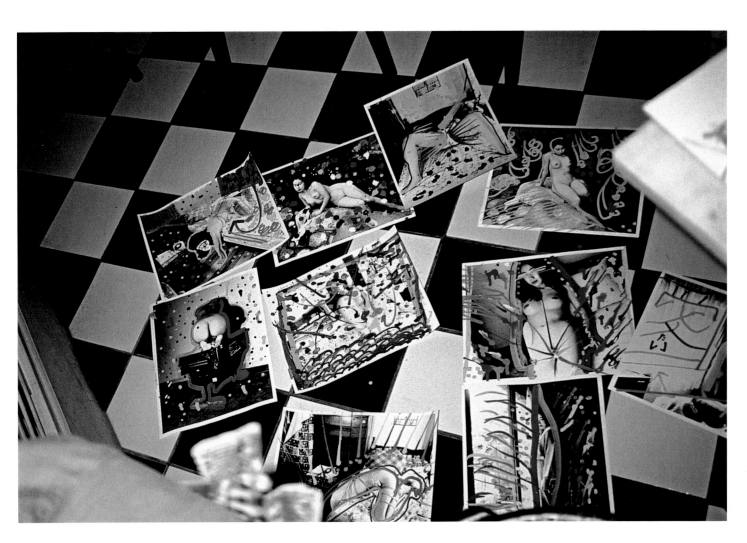

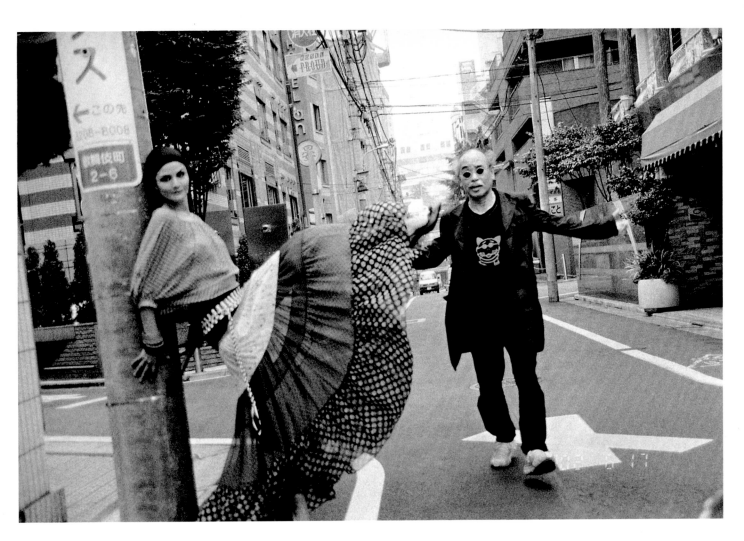

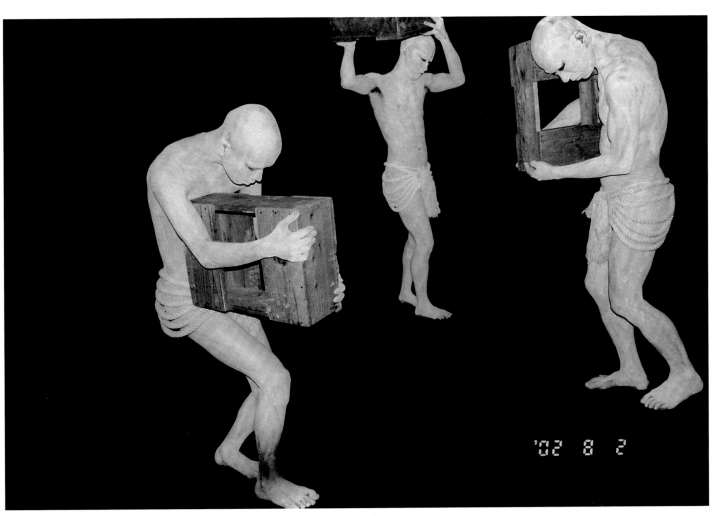

'02 8 2

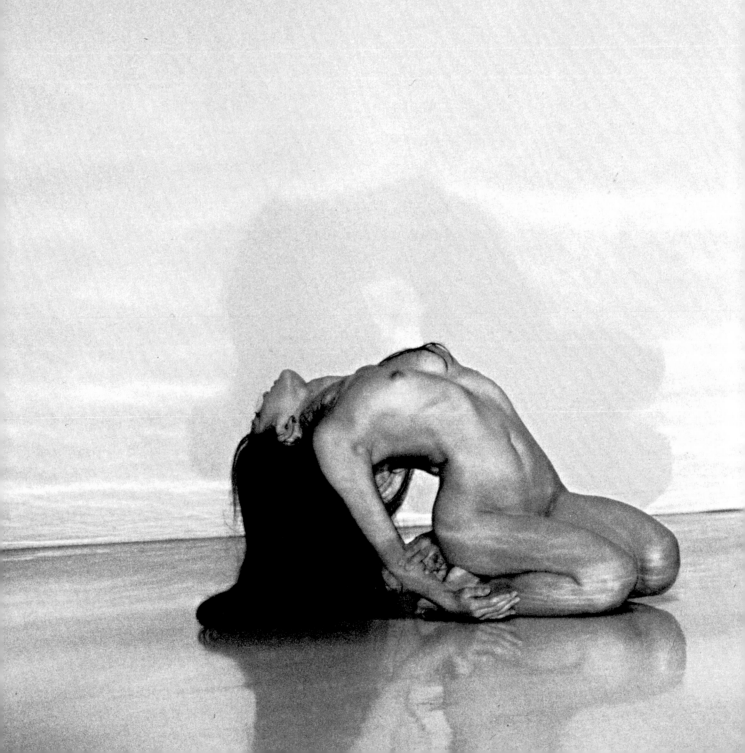

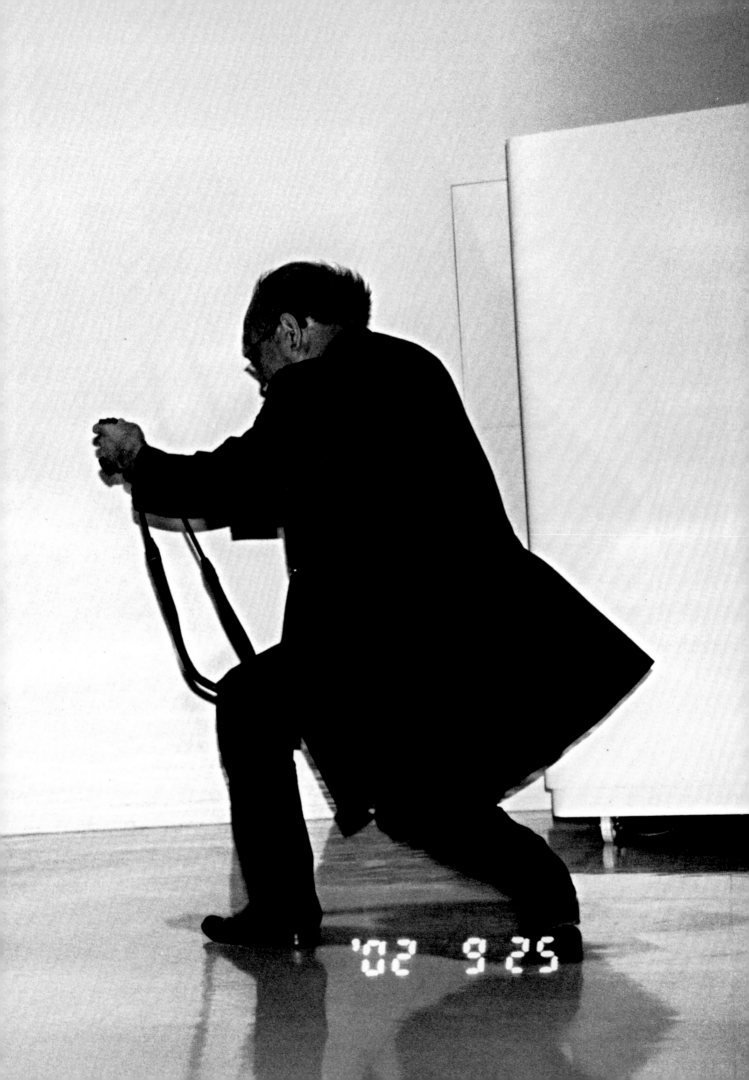

'02 9 25

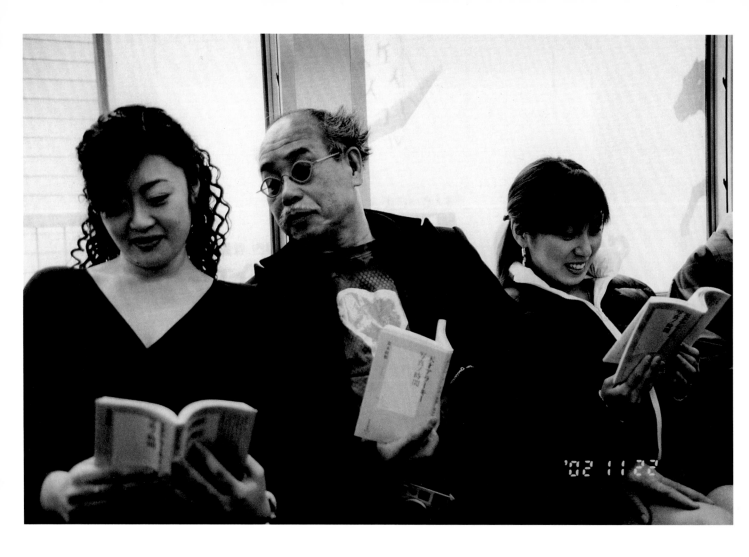

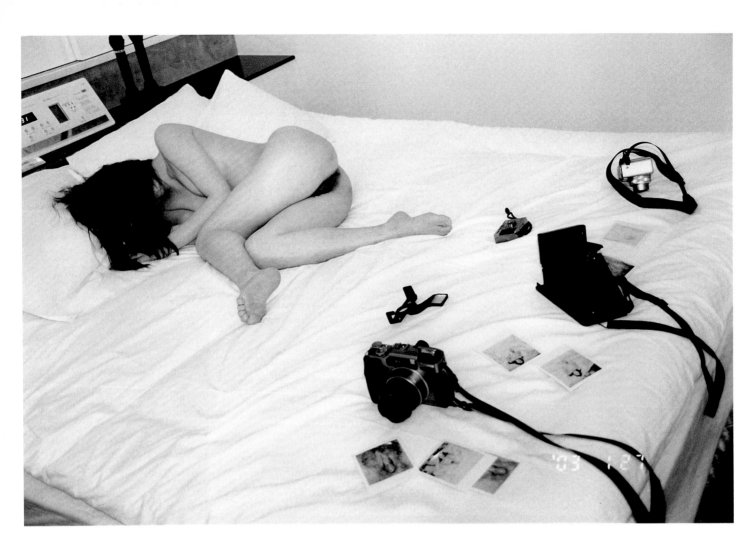

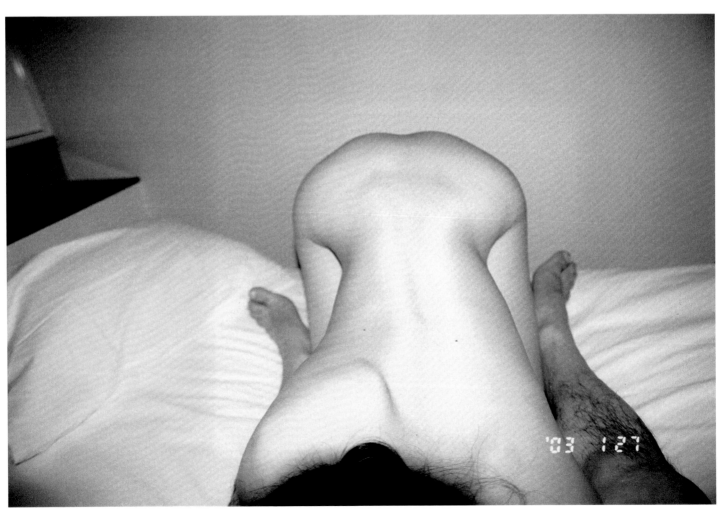

132

TAKING PHOTOGRAPHS WITH
THE MIND'S LENS
—

This is a form of communication, but it has some bearing on the fact that I don't change lenses. It's the same when you're shooting in the city: you come up close or you distance yourself. Although if I say this kind of thing, the market for replaceable lenses is going to collapse!

Zooming really isn't a good idea. It's a brazen-faced way of taking photographs. You impose yourself too much. Zooming has had the effect of breaking the relationship between the photographer and the subject. This kind of pushiness just isn't right.

It may seem like a good idea to take a single camera with a zoom lens when you go travelling, but it's too simplistic. It means that you can't decide on the lens you need for the subject. It means you haven't got your ideas in order. Once you know what you're about, all you need is a single Leica 35 mm camera. This is how it should be done. If you can't do it like this, it means that you're still not up to being a photographer!

Looking back into the past, during the 1980s I used a compact camera,[1] the Big Mini that shows the date.[2] I then used a Minolta that also included the date. Compact cameras with zoom lenses began to appear at the beginning of the 1990s. The Pentax was one of them.[3] I like chatting up a woman I've just met, and, similarly, I'll have a go at anything I come across for the first time.

Whenever I try my hand at something new, I always find it sensationally interesting. But I really didn't feel this way when it came to seeing close-ups like that.

As far as cameras with dates are concerned, I've been consistently using the Hexar 35 mm camera[4], which doesn't have a zoom lens. It's something to do with the physical sensation, the feeling of presence, but it takes much better pictures than cameras with a zoom lens. It's great fun too.

There was a phase when I used to use zoom lenses. But I don't use them today. It depends on where you are, your age, and how you're feeling at the time, but at present I'm devoted to 35 mm cameras.

The lens you use depends on a whole range of factors such as the era and how old you are. If you want to feel really close to someone's face, if you want to feel you're in direct contact with their good qualities, it's best to use a 50 mm camera at a distance of around 50 cm or a metre. I don't like taking people with skew-whiff expressions. I guess I just don't like using the lens for expressive purposes. Photographs aren't about expression with a lens. Absolutely not!

Everybody has different eyeballs, so it's quite possible that there may be people with 28 mm

eyeballs. I don't know. Maybe I think I'm the only person with 35 mm eyeballs, but I really don't know about other people. Everyone has their own height and the size of your prick differs from one man to the next! People's eyes come in different sizes too. There are people for whom 28 mm is standard and there may be others for whom 50 mm is standard.

We're all products, active or passive, of the era through which we've lived. That's why we're all different. Young people are going to have different sensibilities depending on whether they were brought up in the city or in the country. For example, when I was shooting in Yanaka for *Hitomachi*, I came across a really beautiful girl who was still only a primary school pupil. I really fell for her!

I followed her around for a bit like a stalker and she went into a temple. She smiled at me nervously beneath a tree in the temple precincts. She realized I wasn't up to any mischief and she let me take her photo. Her father was looking on at a distance, smiling.

I shot her on another occasion when she'd put on make-up and the kimono I'd bought for her. I suppose it's inevitable, but great places are associated with great faces; it's in places like this that children with wonderful smiles are raised. Conversely, it's smiling faces like these that give a place its interest. A town has its own face of course, formed by its buildings...the buildings and the alleyways seem to reflect people's smiles. That's why, when you look at a photograph, you can usually tell if someone is ill-natured or if a woman has a nasty streak. Photographs tell you everything, even someone's intelligence and IQ.

The important thing is to shoot with an open frame of mind. You mustn't let yourself step back. You mustn't make things too complicated. You mustn't change lenses. You need to take photographs with the lens in your mind!

[1] Compact cameras: the generic name for small, lightweight cameras. Most such cameras are fully automatic and have automated film winding and rewinding functions in addition to a wide variety of functions that enable even beginners to take attractive photographs.

[2] Big Mini: A high-performance, single-focus compact camera released by Konica in 1989.

[3] Pentax: Pentax Zoom 70 Date. The camera used by *Araki on Diary of Dr Phimosis* (Tokyo: East Press, 1994). Contains the diary of the same name for the period between 1987 and March 1994 as serialized in the magazine *Uwasa no shinso*.

[4] Hexar 35 mm camera: the Konica Hexar was a popular high-function compact camera with a wide-diameter lens released in 1992. Used by Araki on *Photo-Maniac's Colour Diary* (Tokyo: Switch Shoseki, released by Futabasha, 1993). The RF released in December 1999 had exchangeable lenses linked to a range finder.

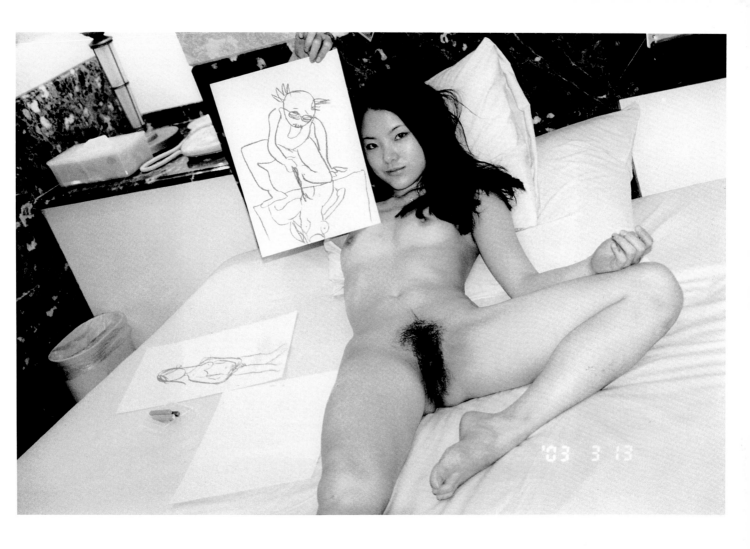

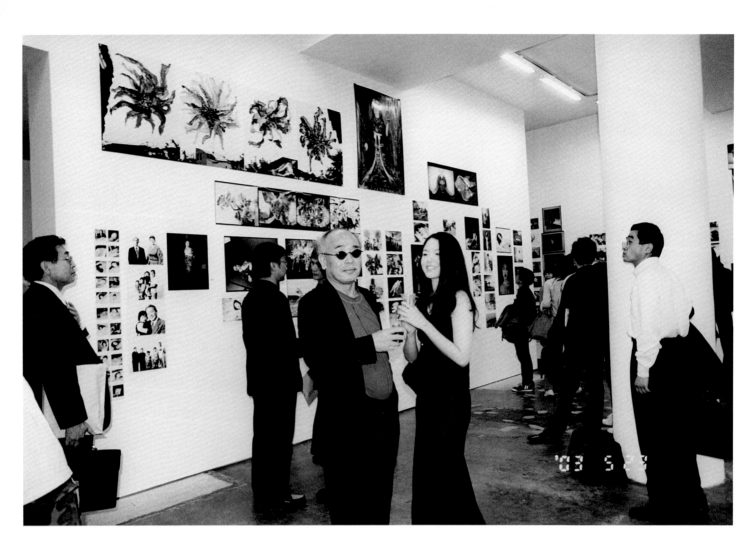

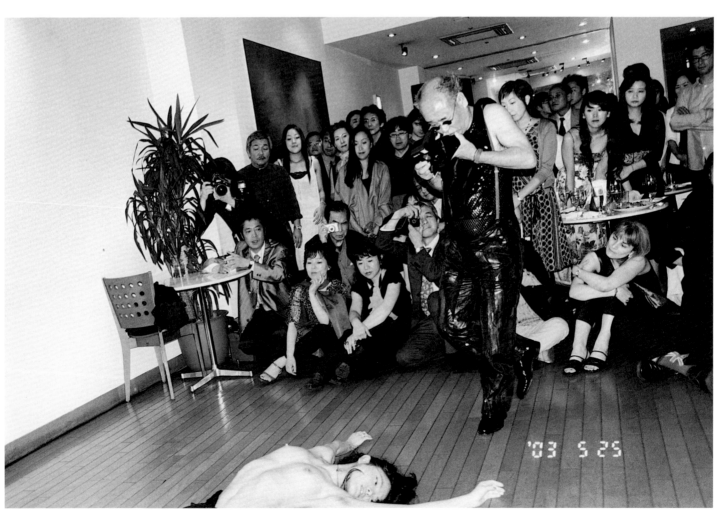

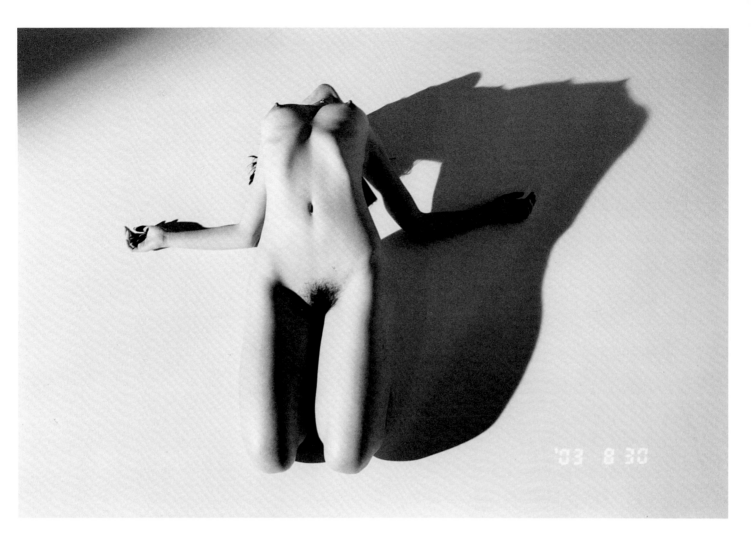

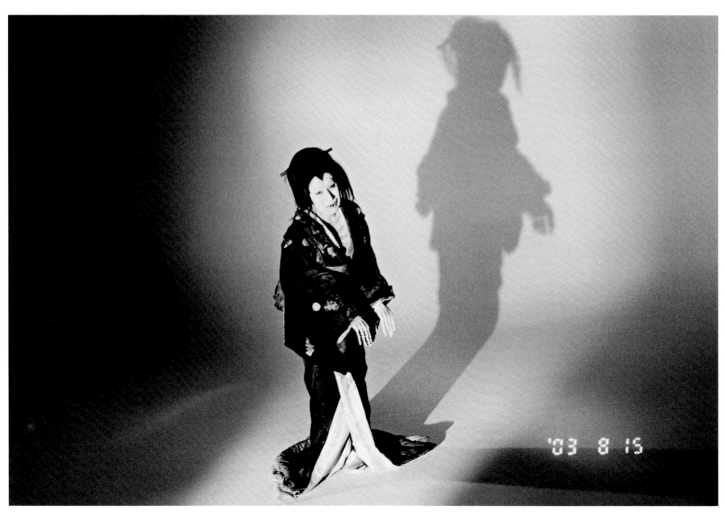

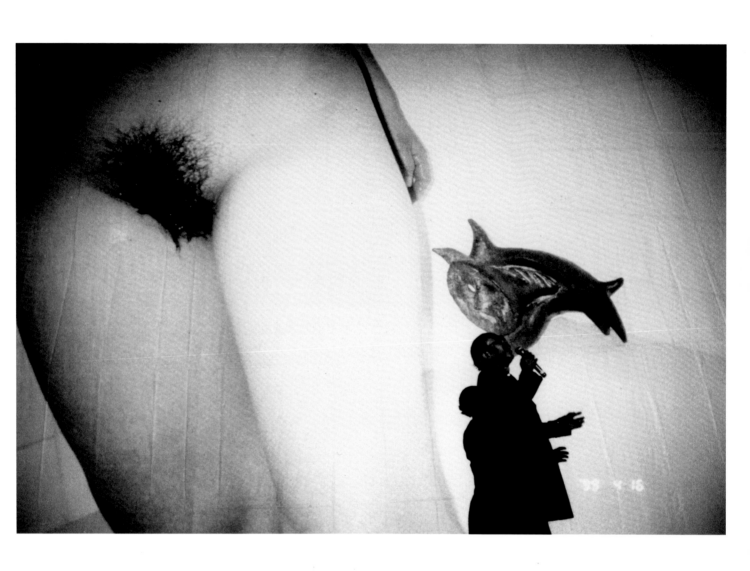

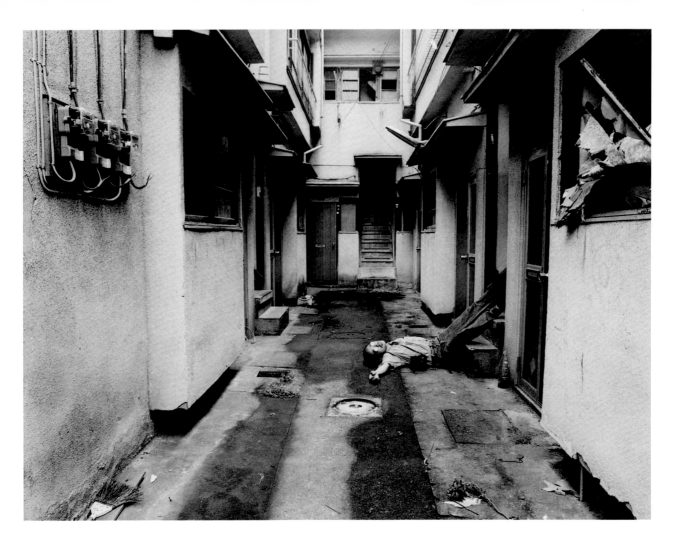

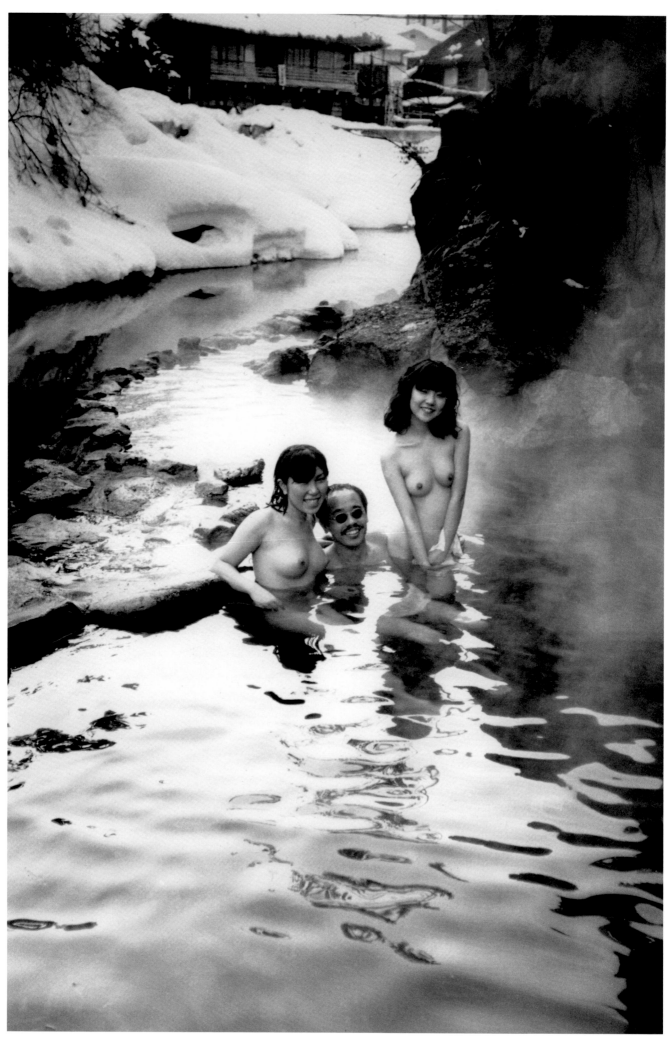

SUICIDE IN KARUIZAWA

ASPIRING TO
IMPERFECT PERFECTION
—

I often try and take a perfect and complete picture but then at the same time deliberately add some kind of imperfection. It's all about how to avoid taking a perfect picture. You know, there's really nothing worse than perfection.

It's quite right to say that people, amiability, smiling faces and the like are wonderful, but these are things that interest me if that's all there is to it. I try to undermine these kinds of feelings and to break down the frame in which they operate.

I suppose it's down to my character. I won't even accept that death constitutes a completion.

Nothing should be completed or brought to perfection, at any time. It's all about a series of attempts to aspire to imperfect perfection. You need to be constantly on the move, never accepting that there's a final port of call. Unless you accept this, everything will be over in a flash.

It doesn't matter if you just go round in circles; the important thing is to feel that you're on the move. Moving is synonymous with being alive. Coming to a halt as a result of achieving perfection is tantamount to dying. I suppose it would be a good thing to have a perfect death, but it all boils down to the fact that we really don't know what perfection is anyway. We haven't a clue.

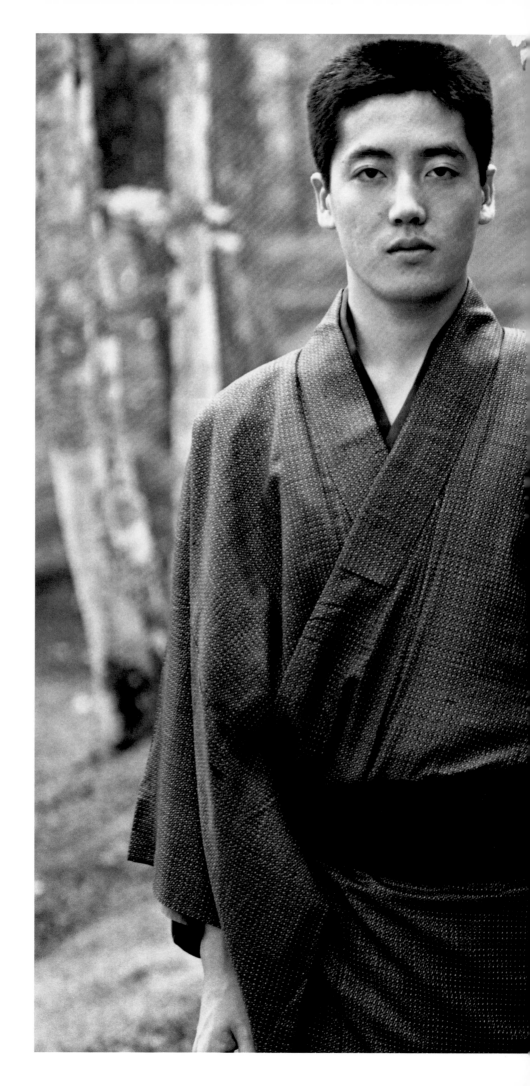

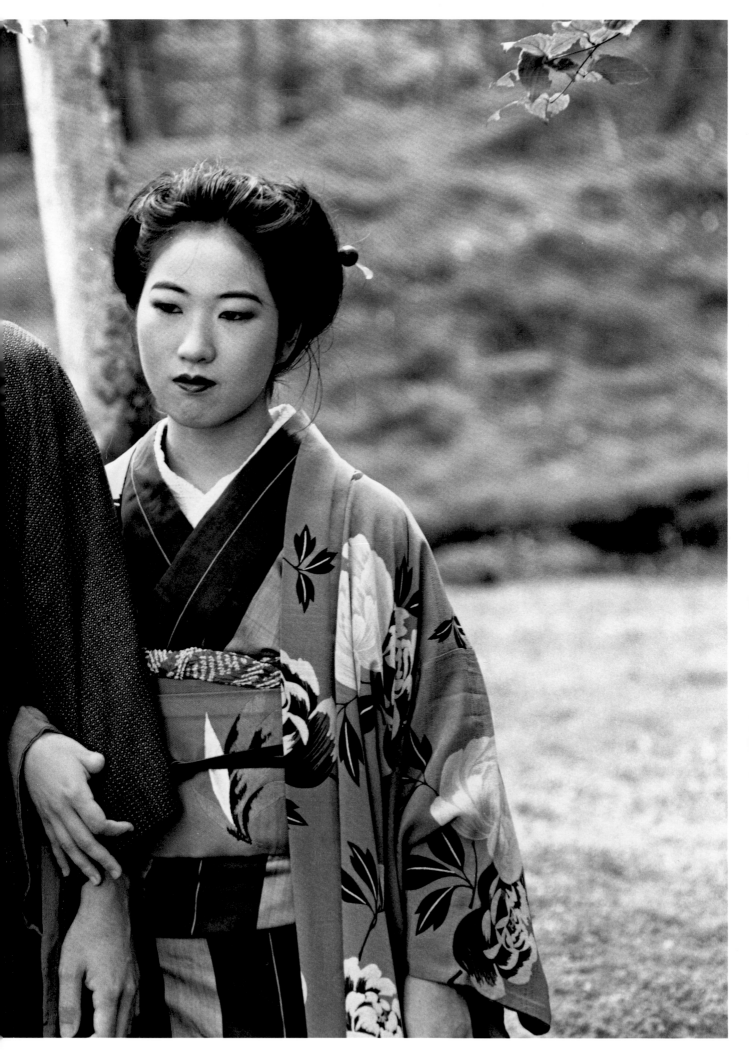

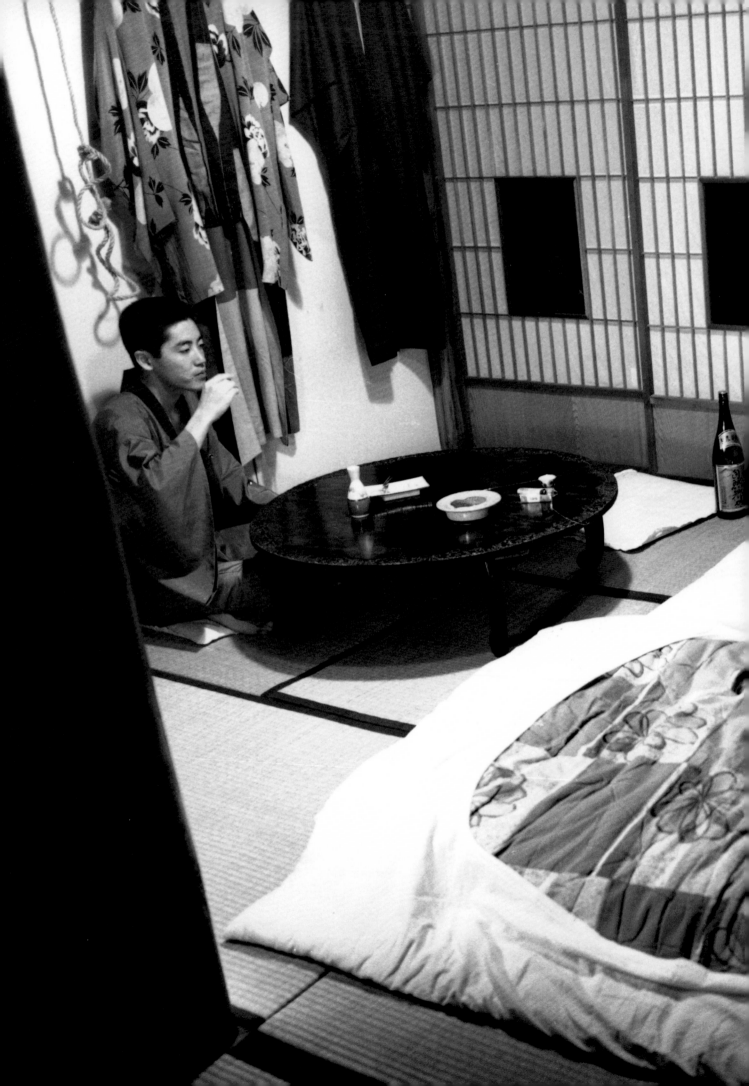

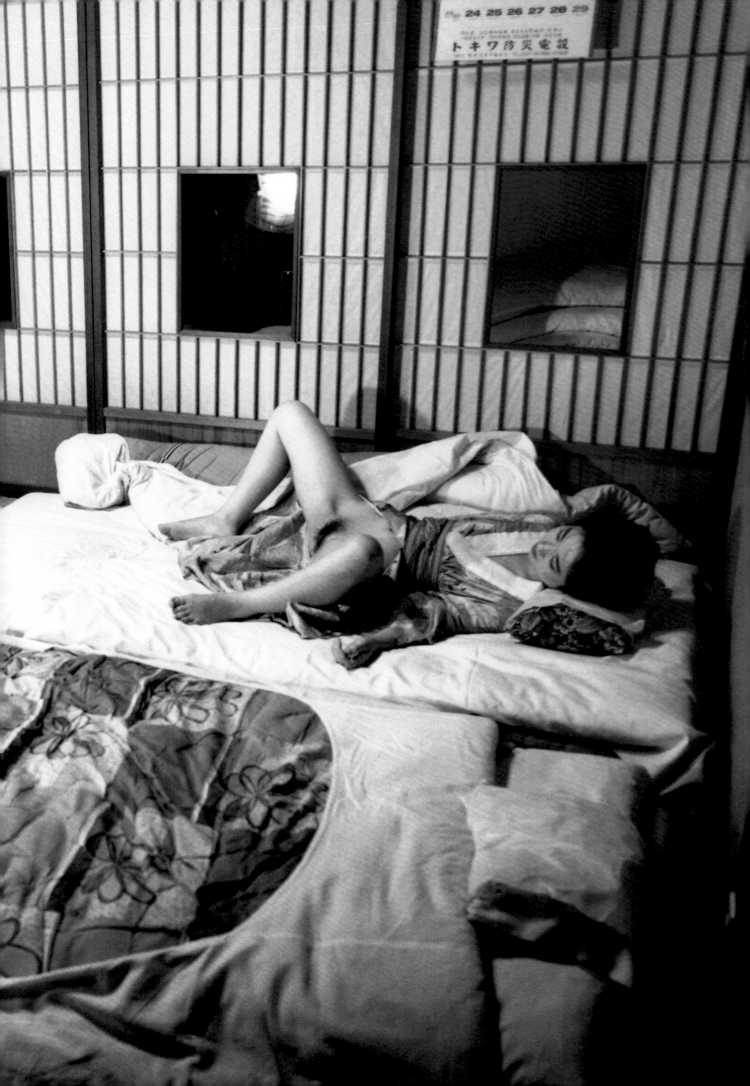

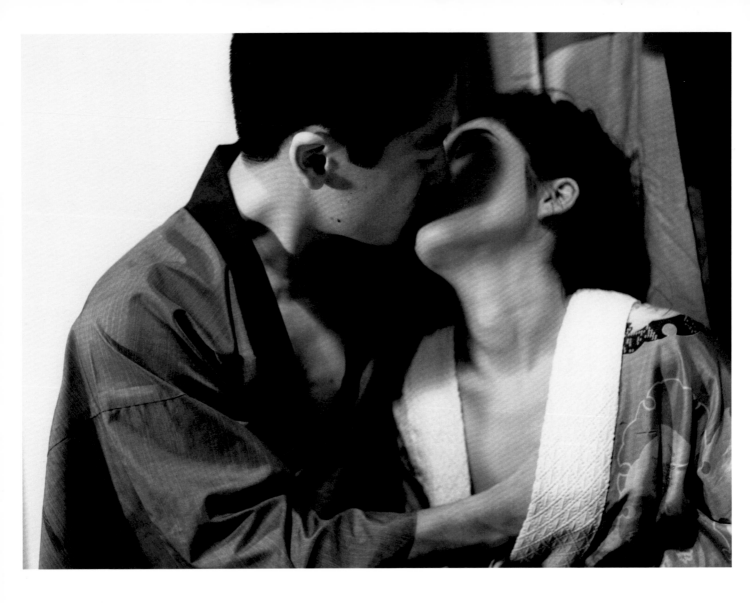

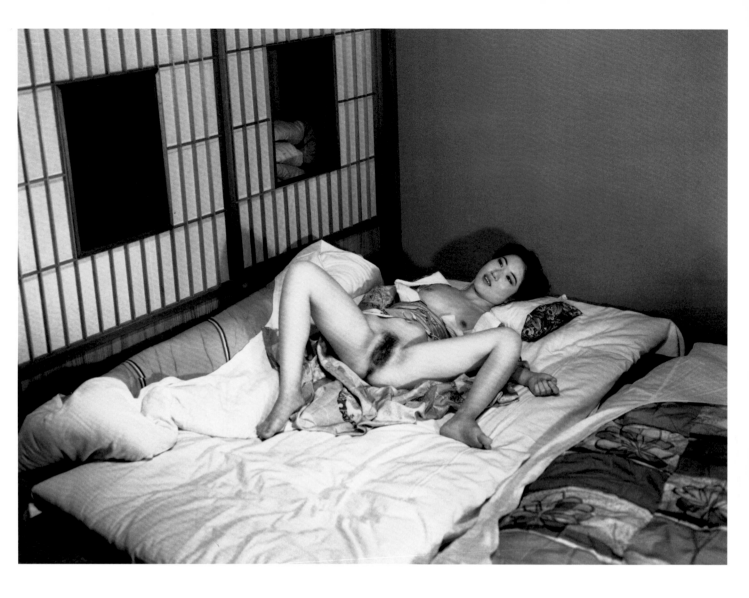

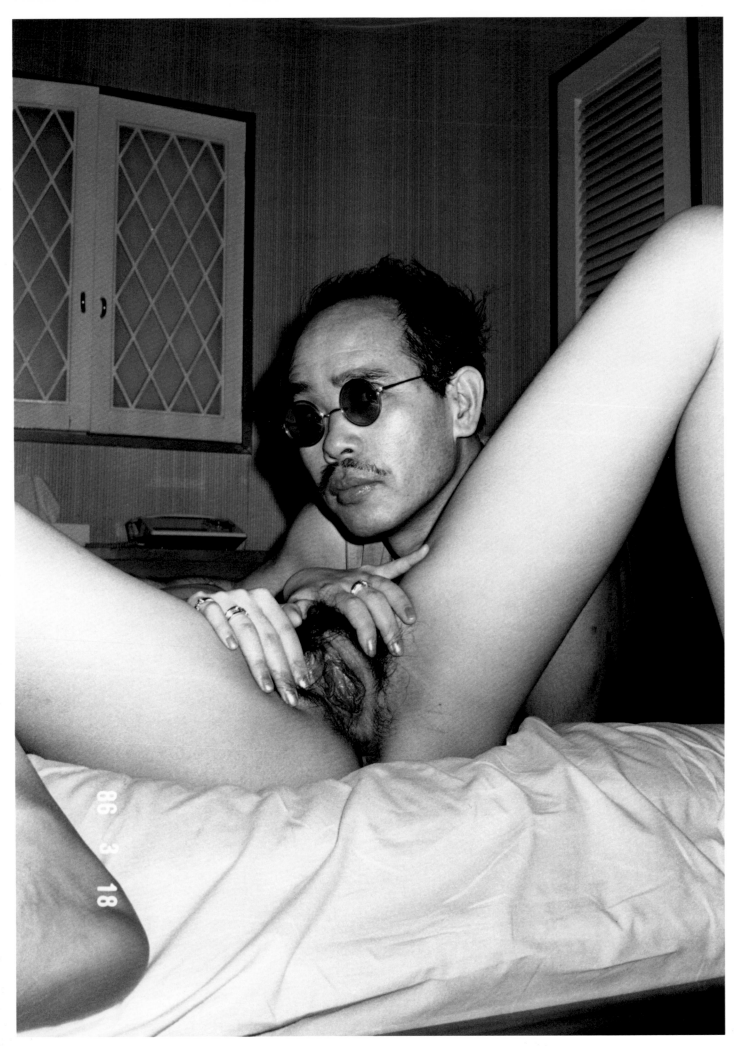

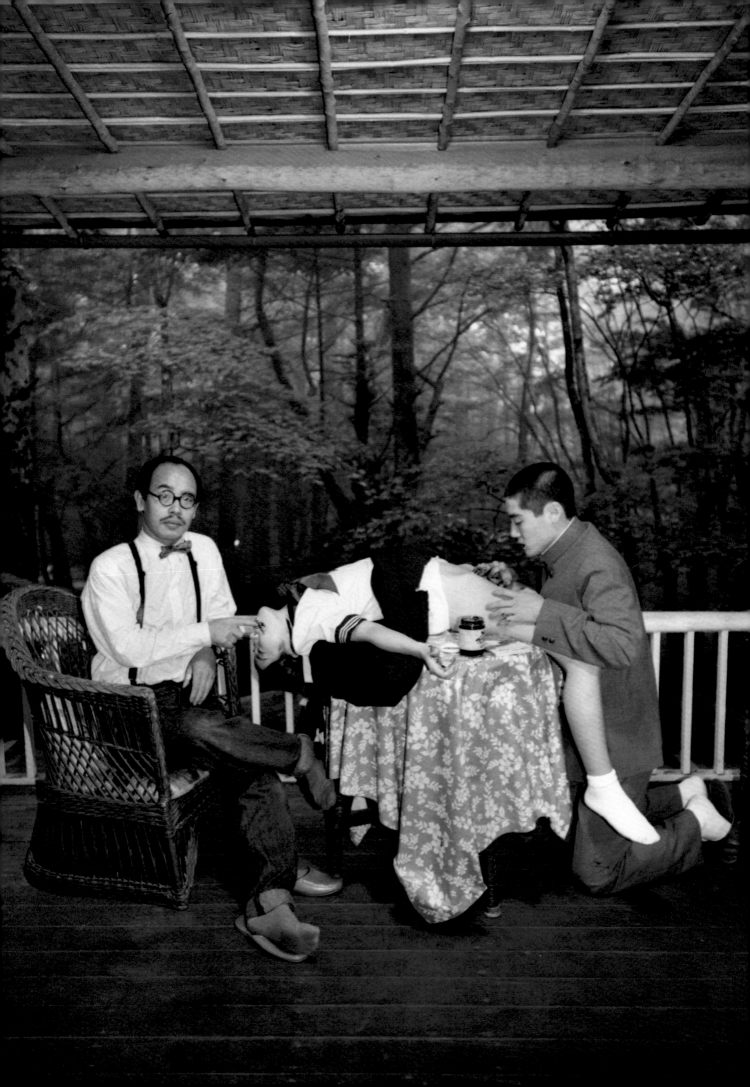

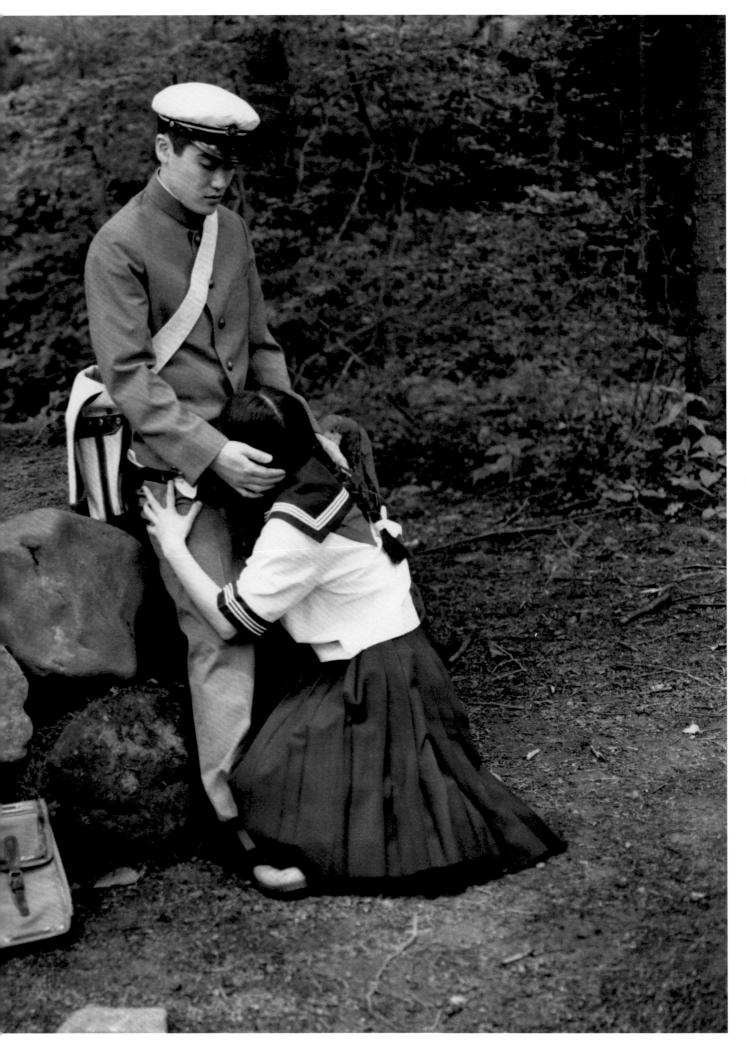

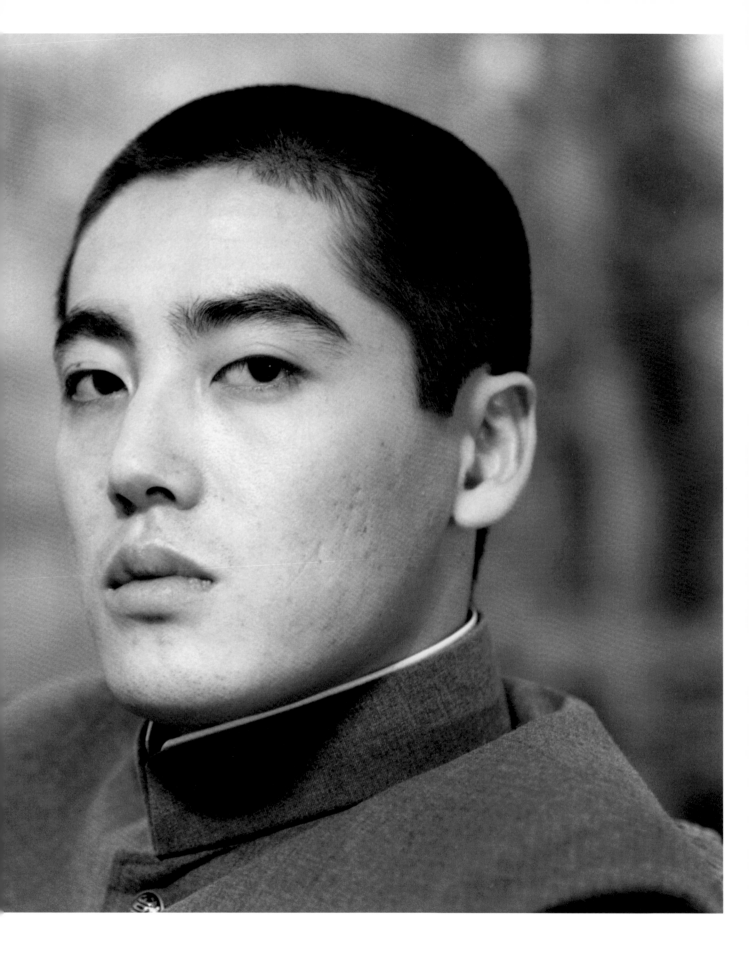

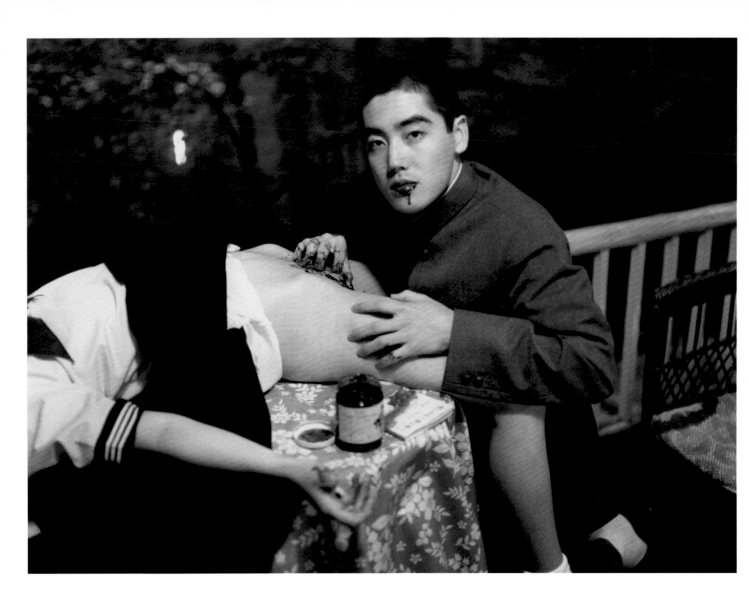

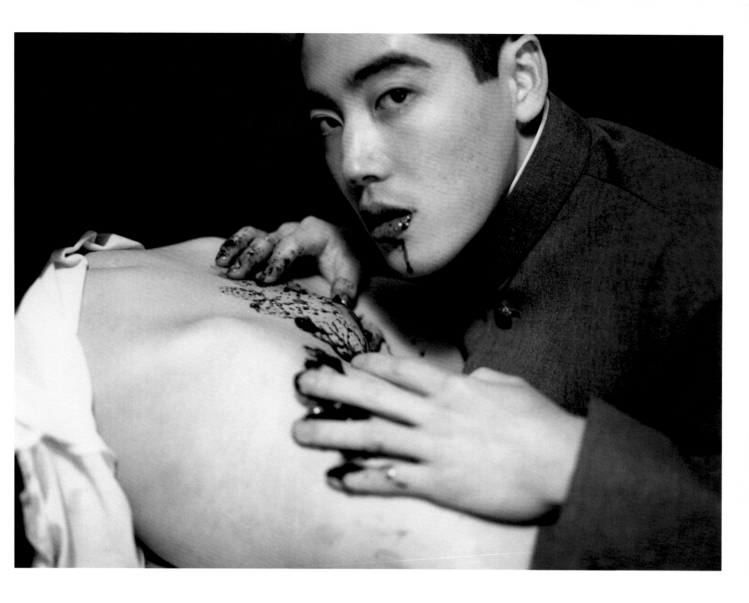

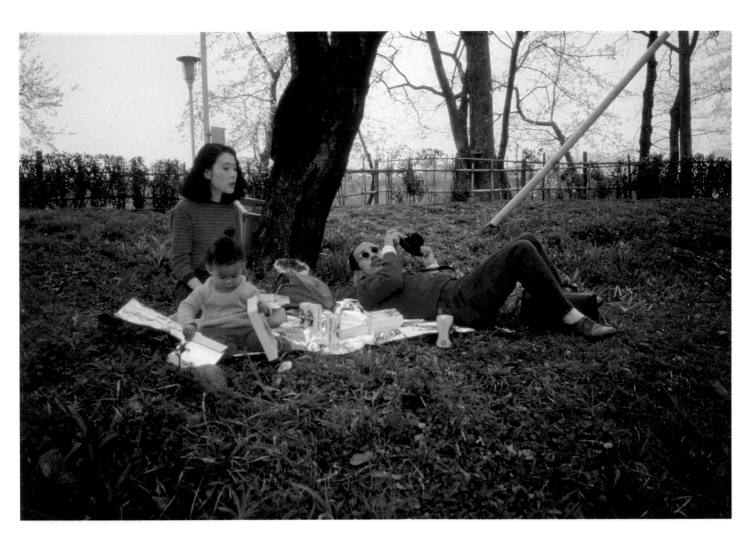

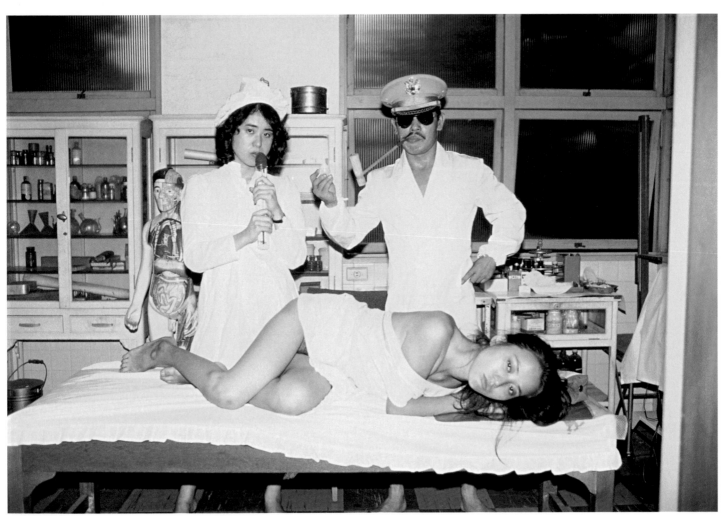

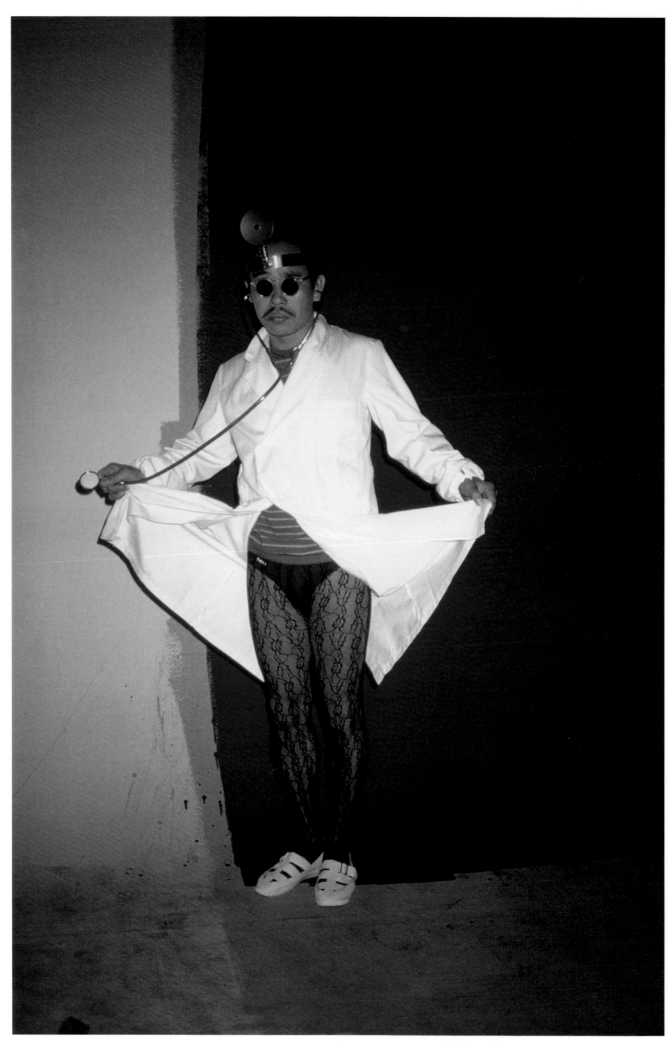

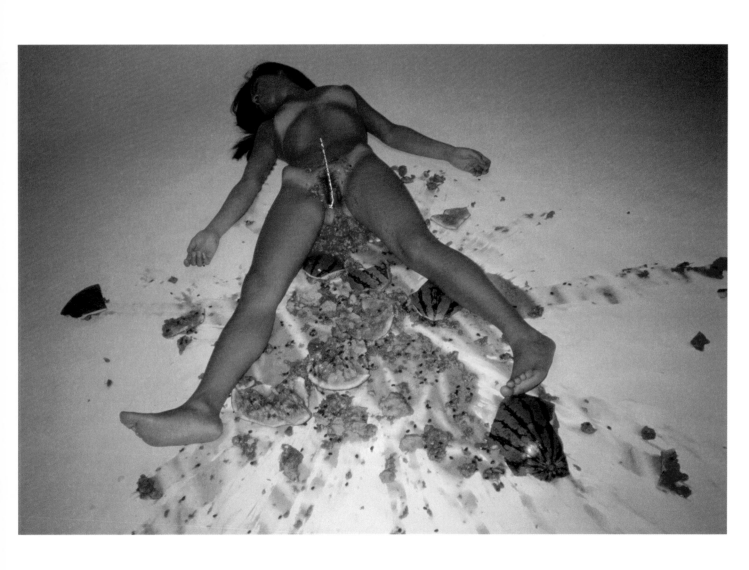

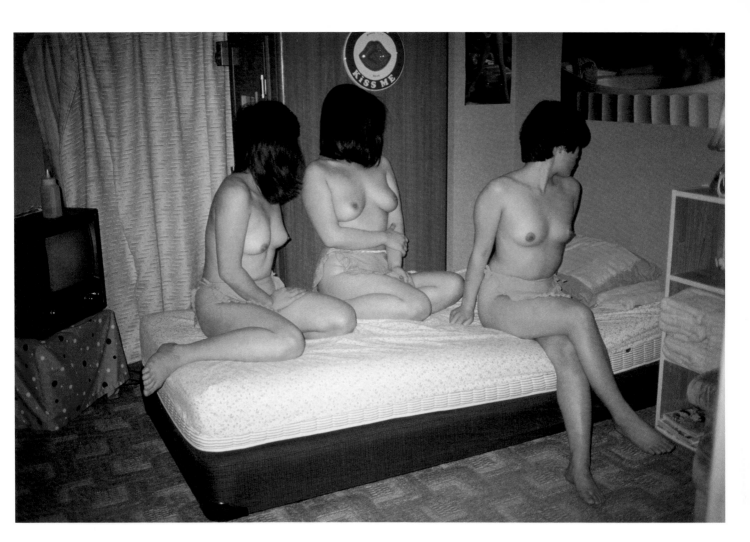

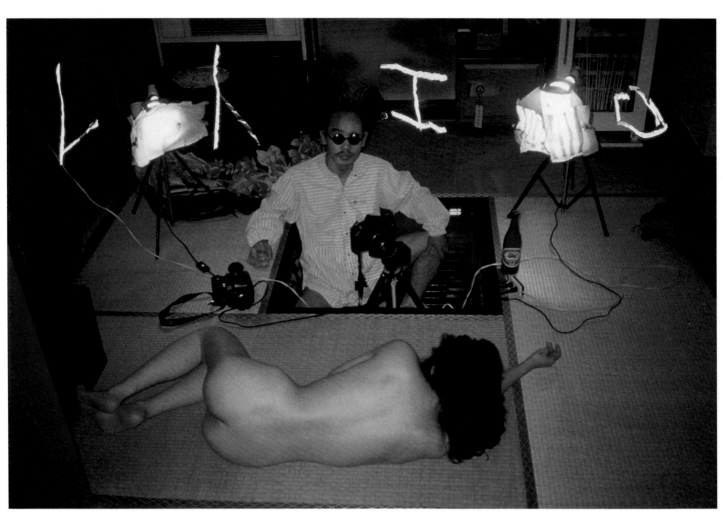

BANQUET

I GET ENCOURAGED
BY MY OWN PHOTOGRAPHS
—

You know, I get very encouraged by my own photographs. It isn't a matter of seeing a photograph of someone in particular; it's simply my own past photographs that give me the incentive to keep going. It's as though I sowed seeds in the past, when I was still young, for my future development. It really gets home to me these days, although it's a bit late by the time you're in your fifties or sixties. But you need the physical energy when you find yourself getting really stimulated. It's no good if you've no longer got the energy left when you feel you've got it in you to do something really worthwhile.

But photography is a tricky business, because you're setting yourself up in opposition to the life of the person you're shooting. You're associating with them on the personal level. The act of using a camera is no big deal, but taking real photographs is a different matter. It's a tough business taking photographs. You see and you're seen.

That's why I don't want to photograph anything that's too serious. You don't want to get too involved. It's a difficult matter being serious about life. When it comes down to it, it's best to photograph subjects that aren't that profound. I'd conk out otherwise.

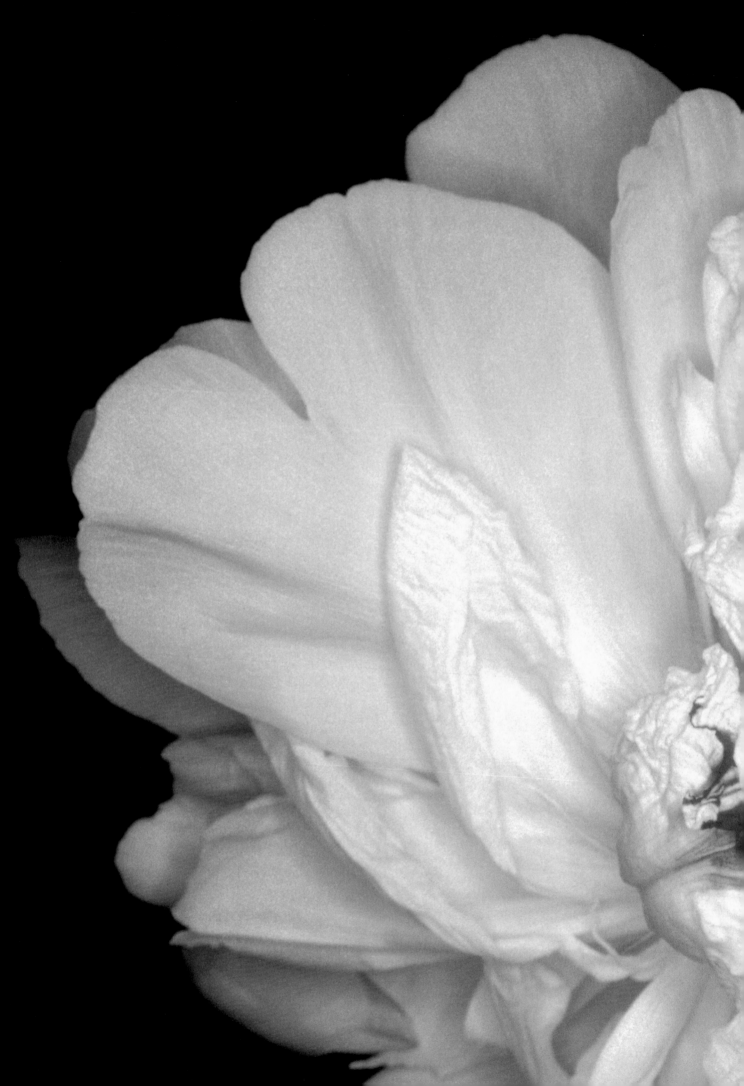

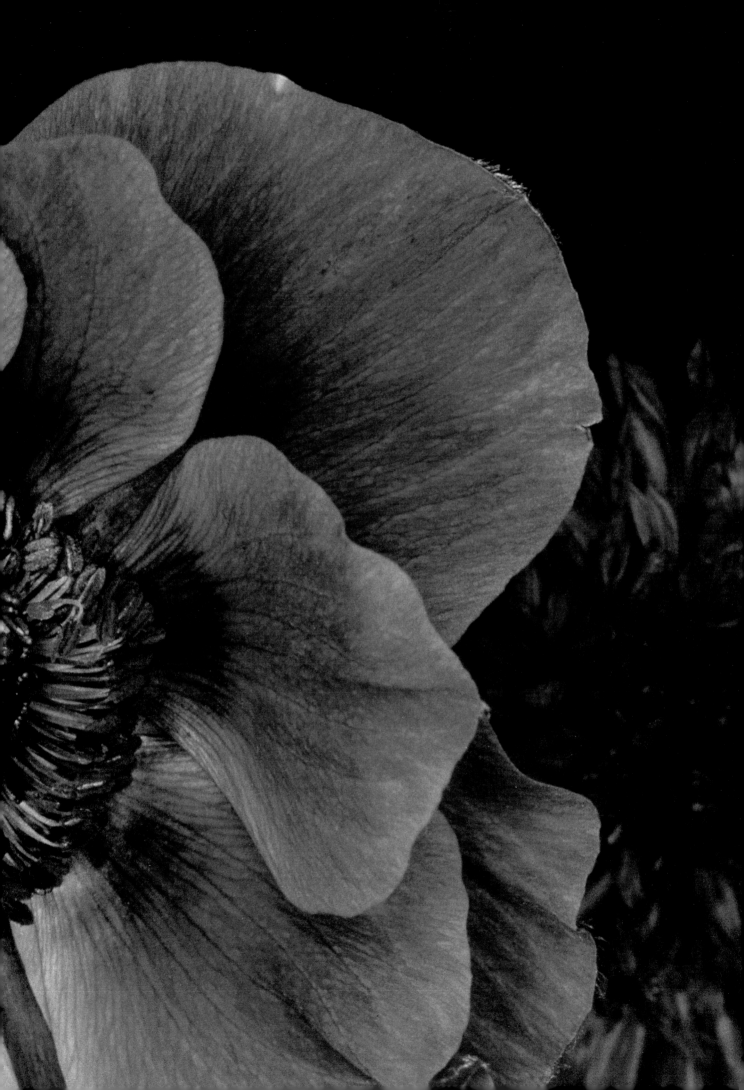

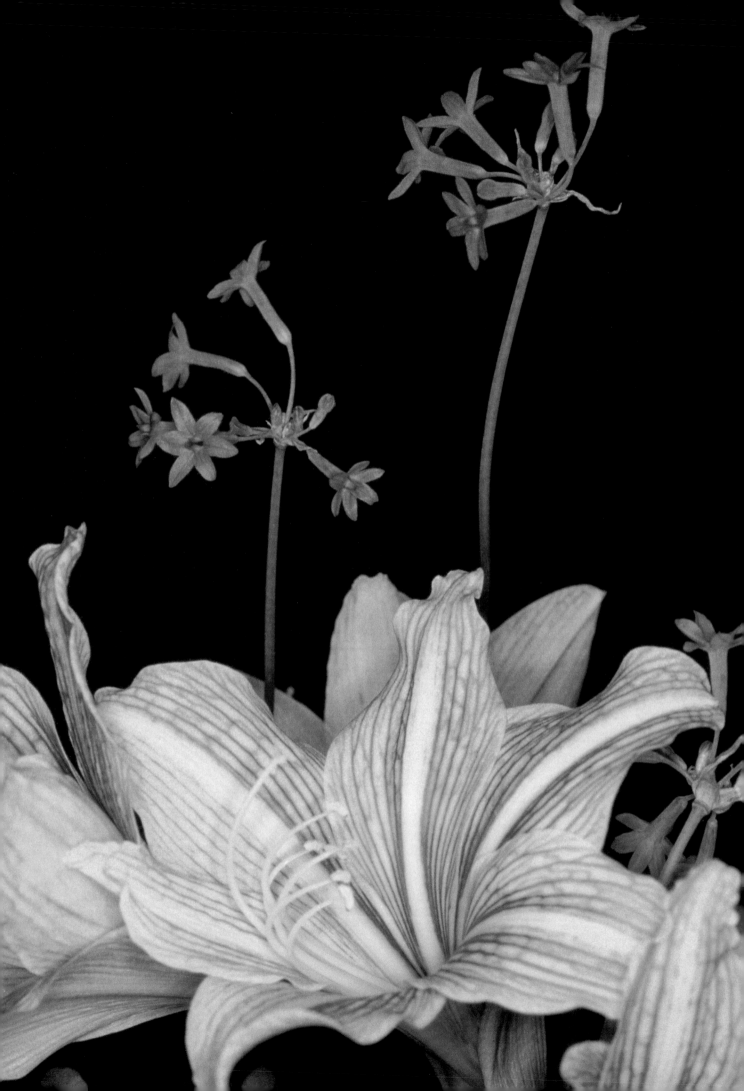

WINTER JOURNEY

'TO OBSERVE LIFE AS
WELL AS DEATH
EMBRACED IN LIFE,
OR LIFE EMBRACED IN
DEATH.
THAT IS THE ACT OF
PHOTOGRAPHY'

'89 6 16

'89 8 16

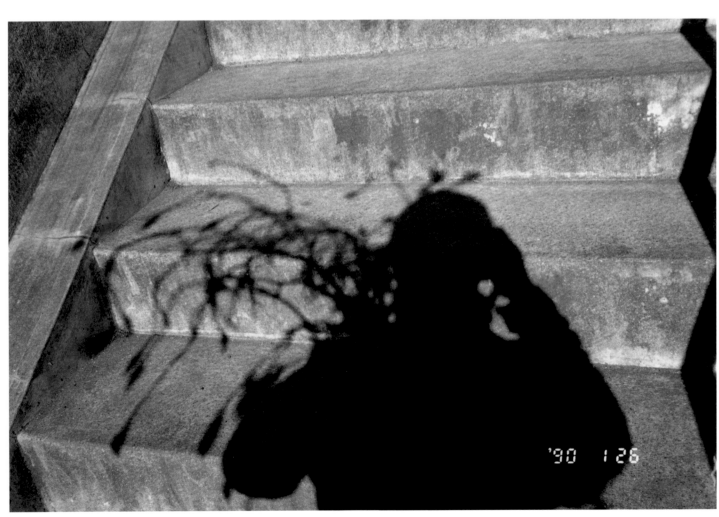

'90 1 26

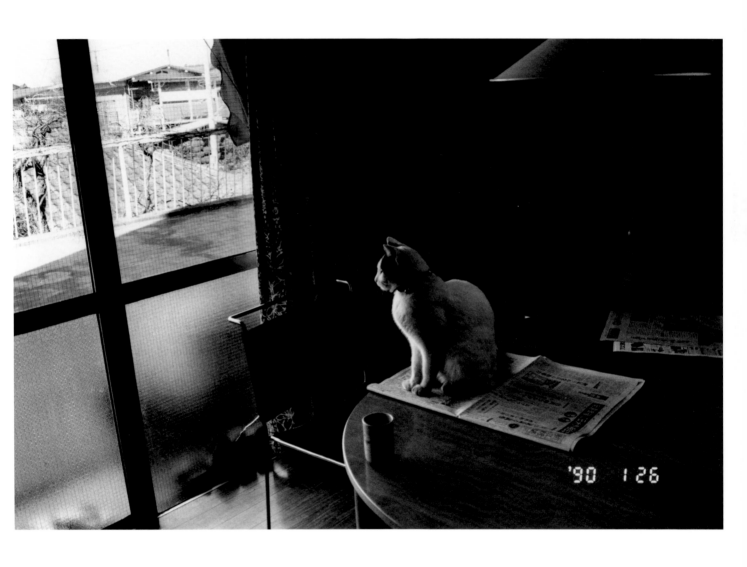

'90 1 26

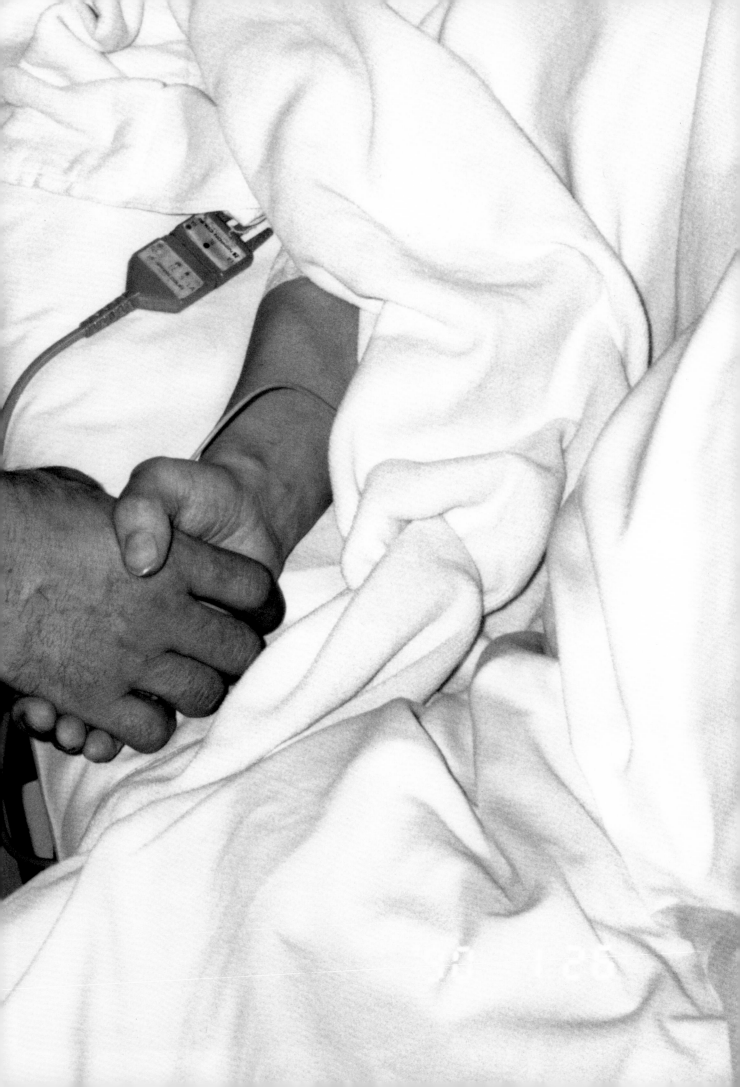

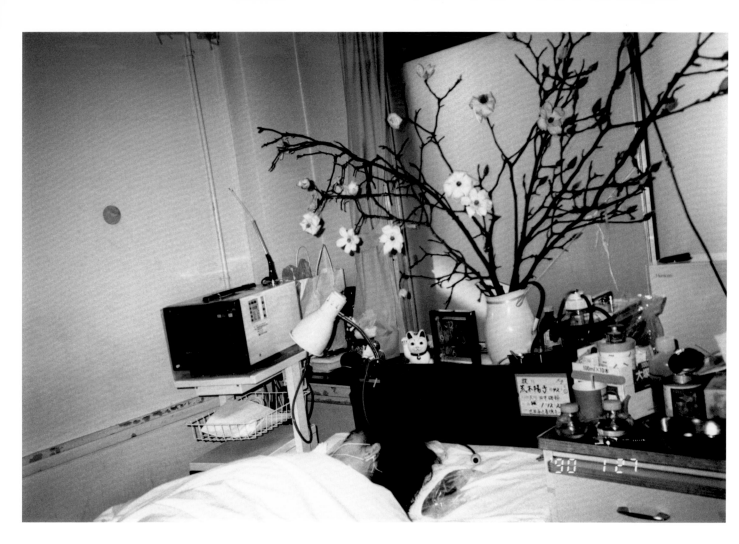

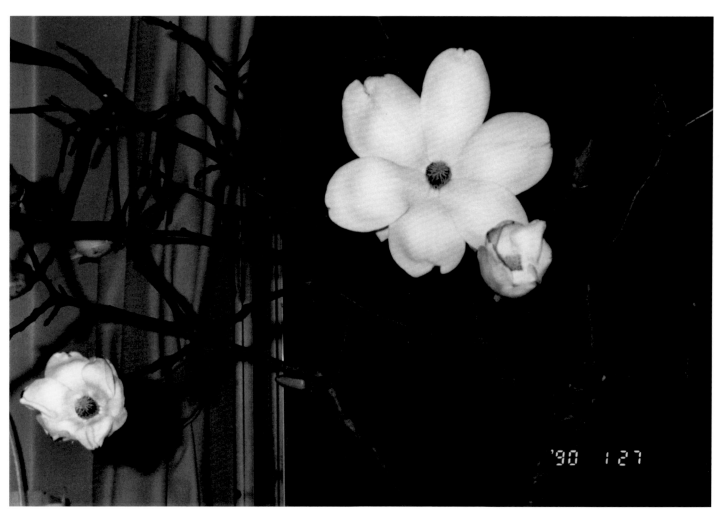

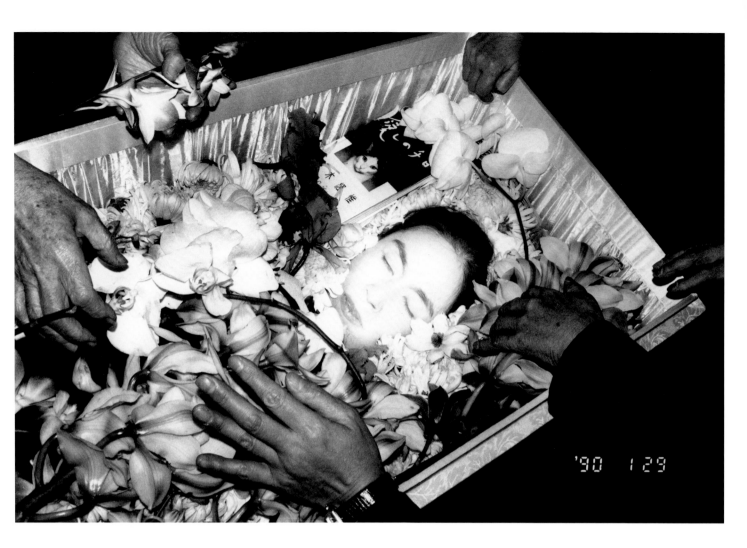

'90 1 29

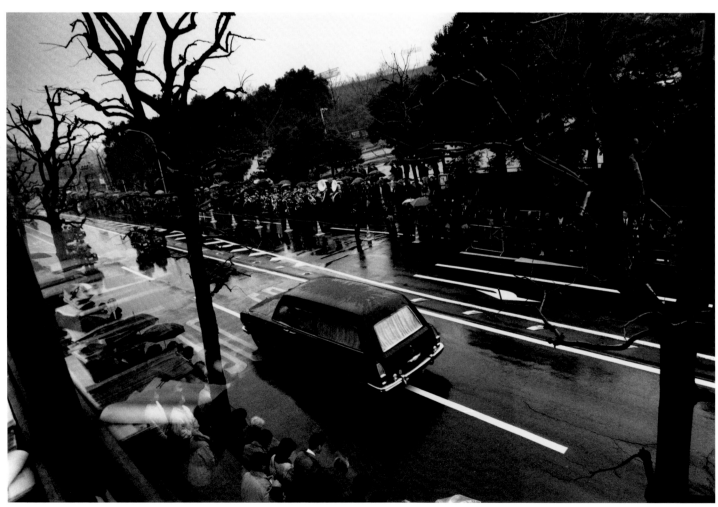

197

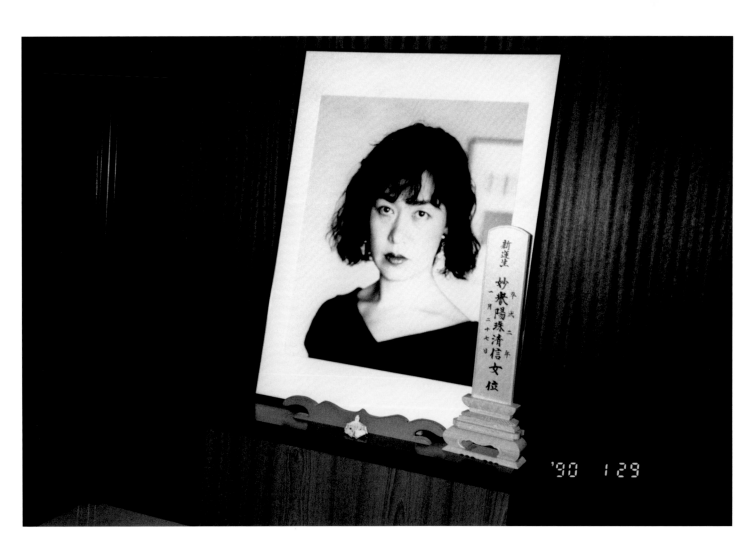

'90 1 29

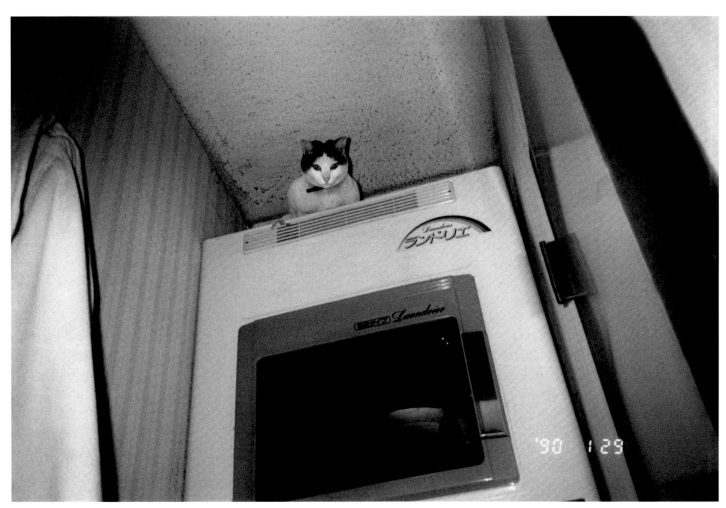

'90 1 29

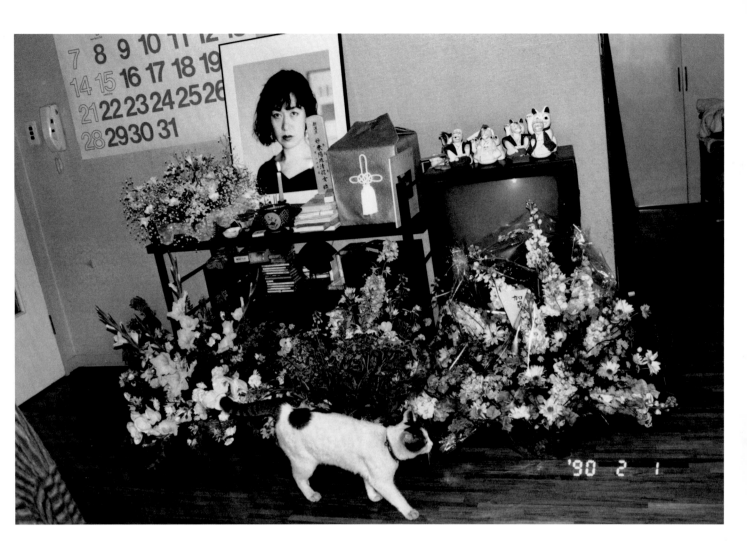

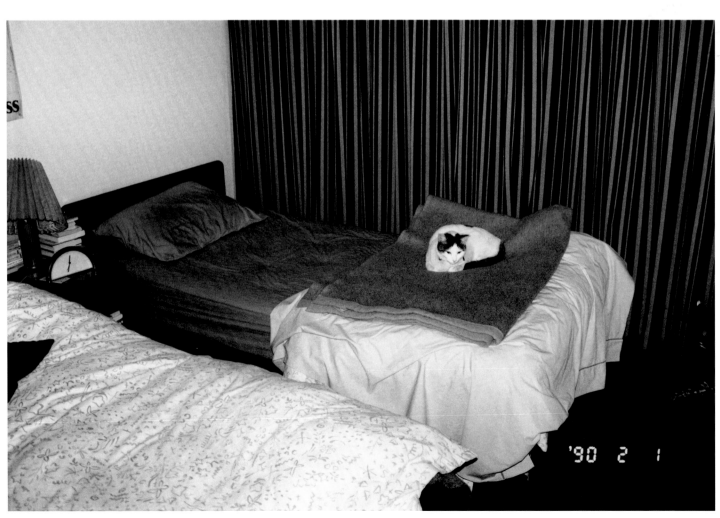

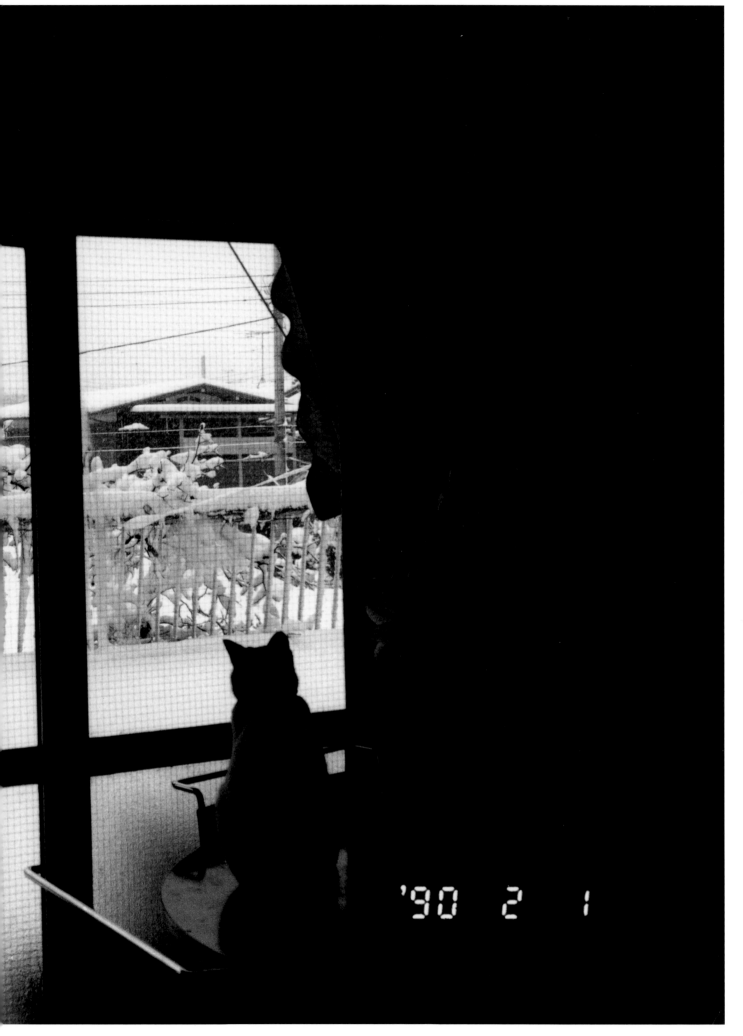

'90 2 1

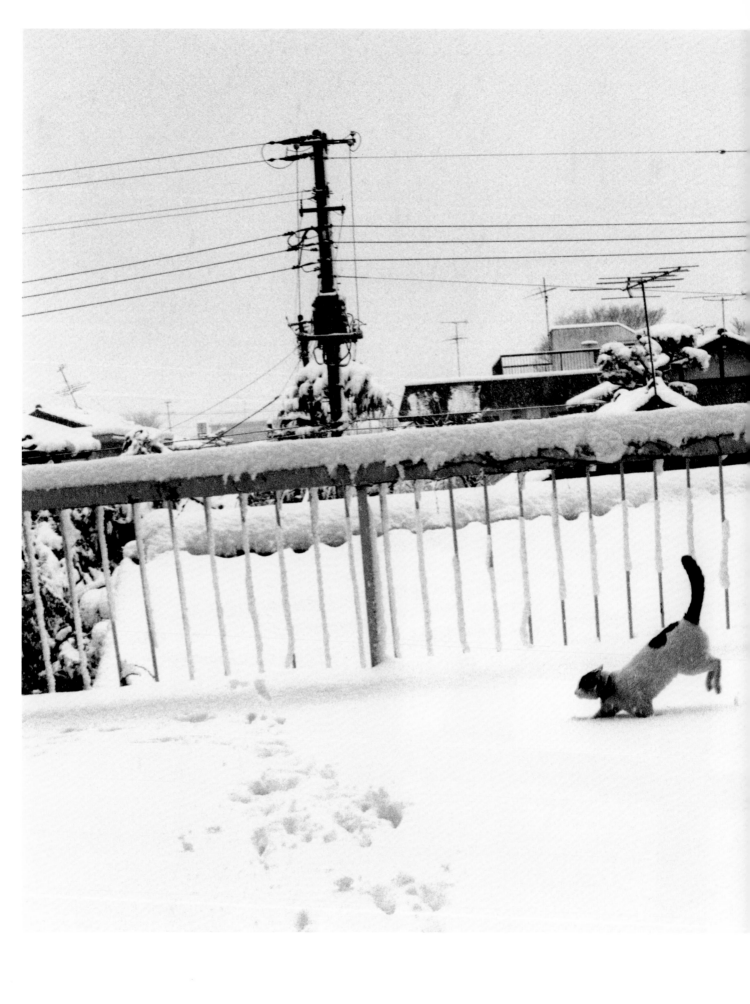

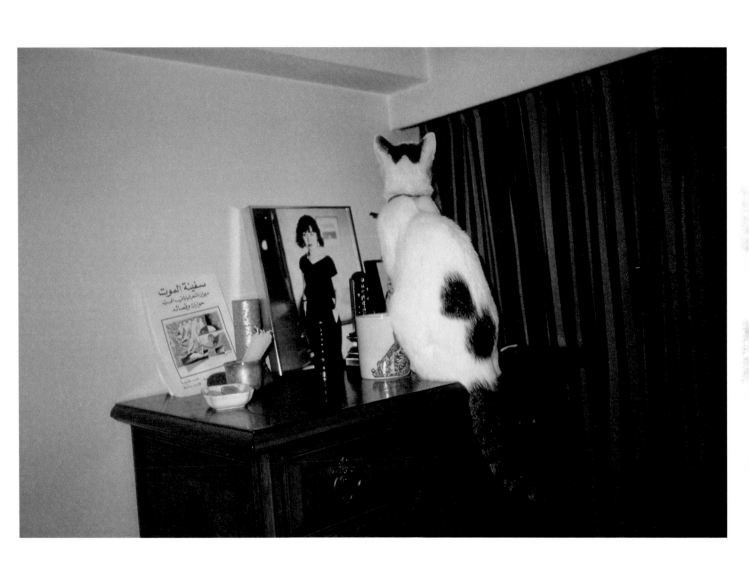

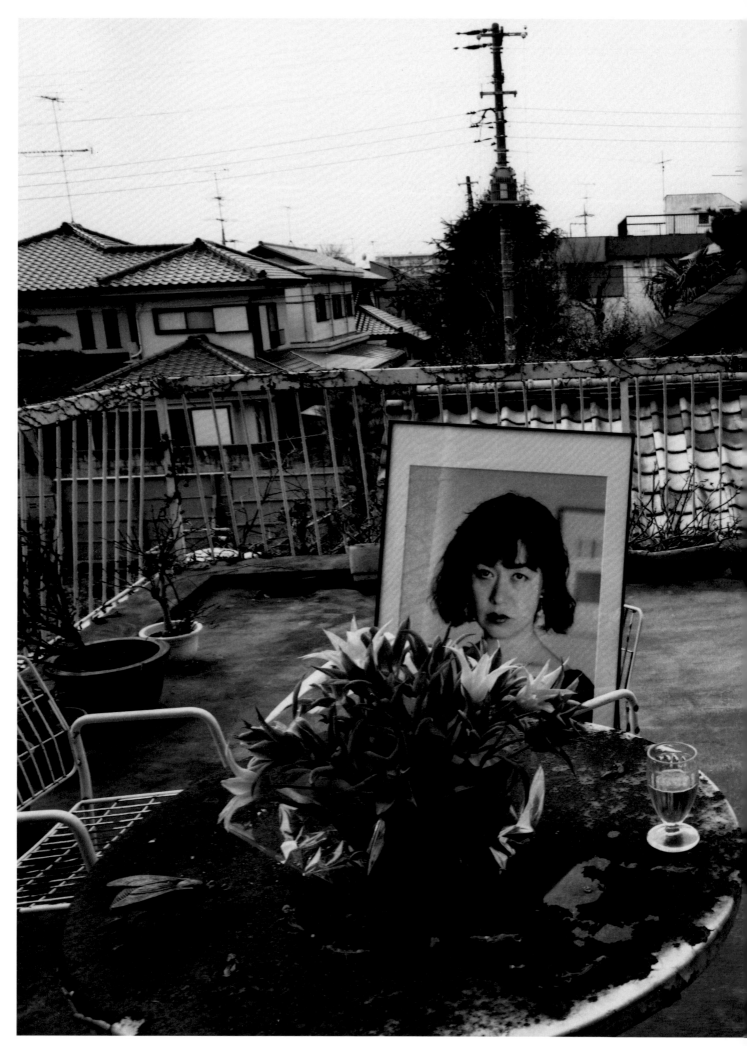

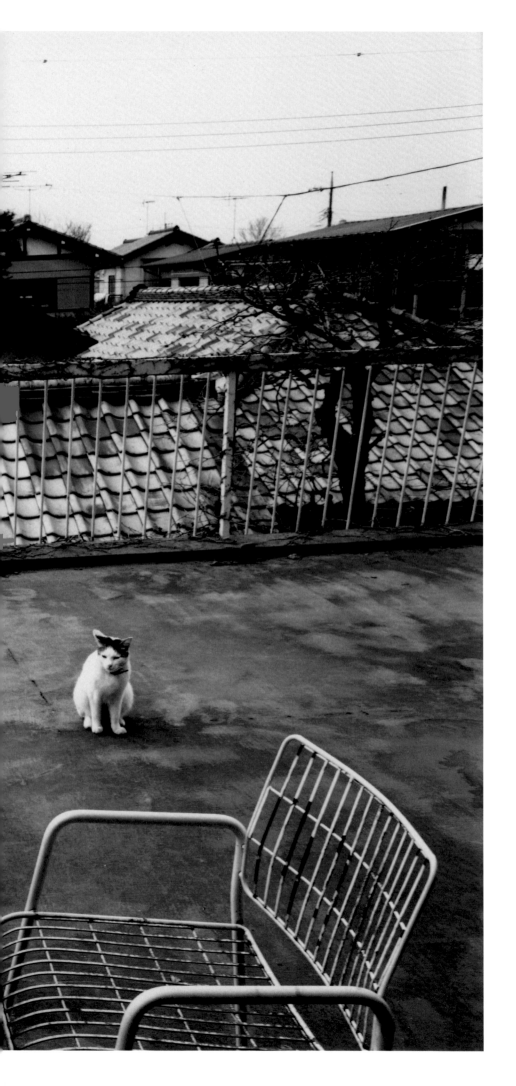

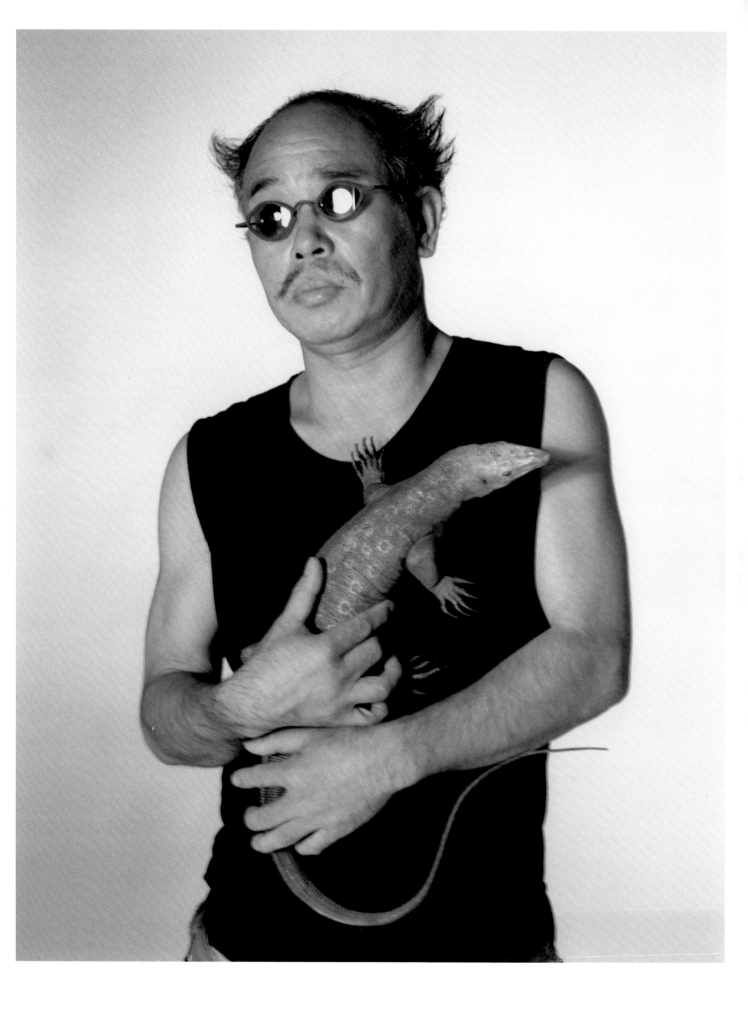

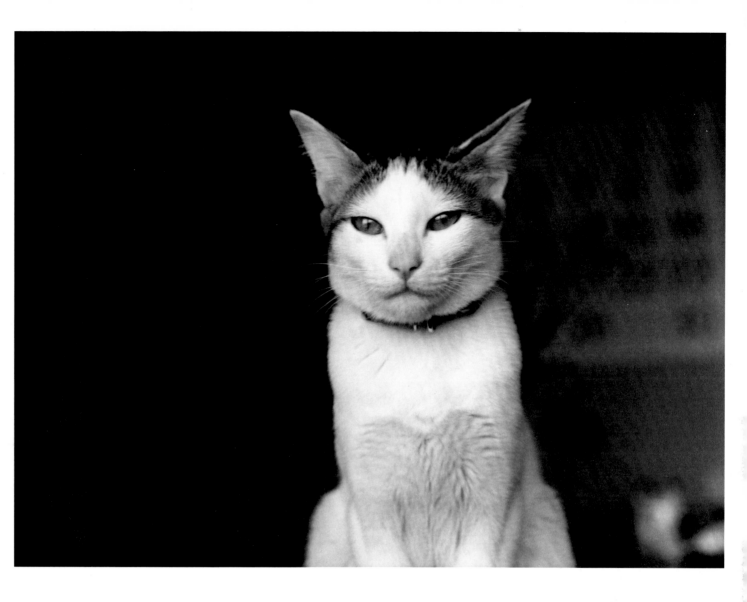

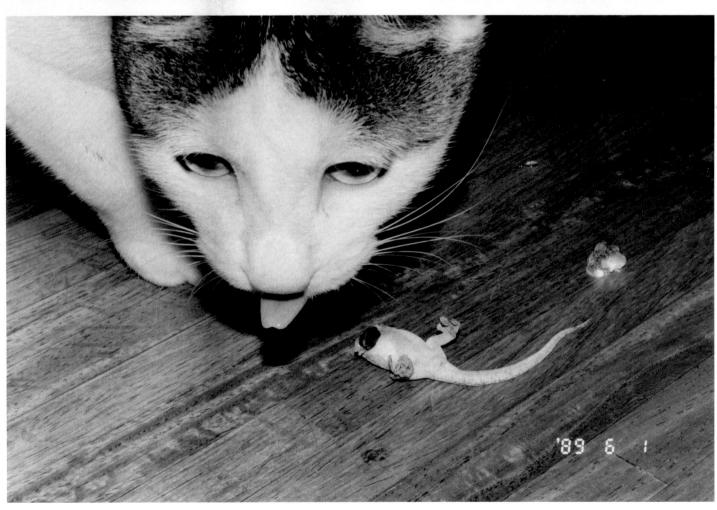

'89 6 1

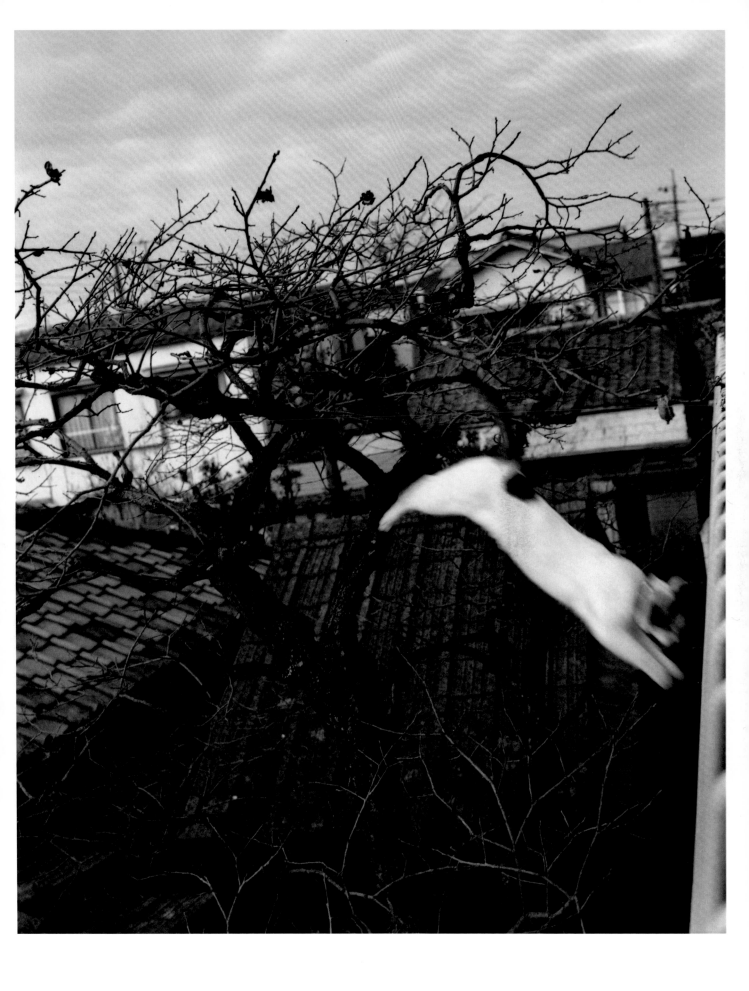

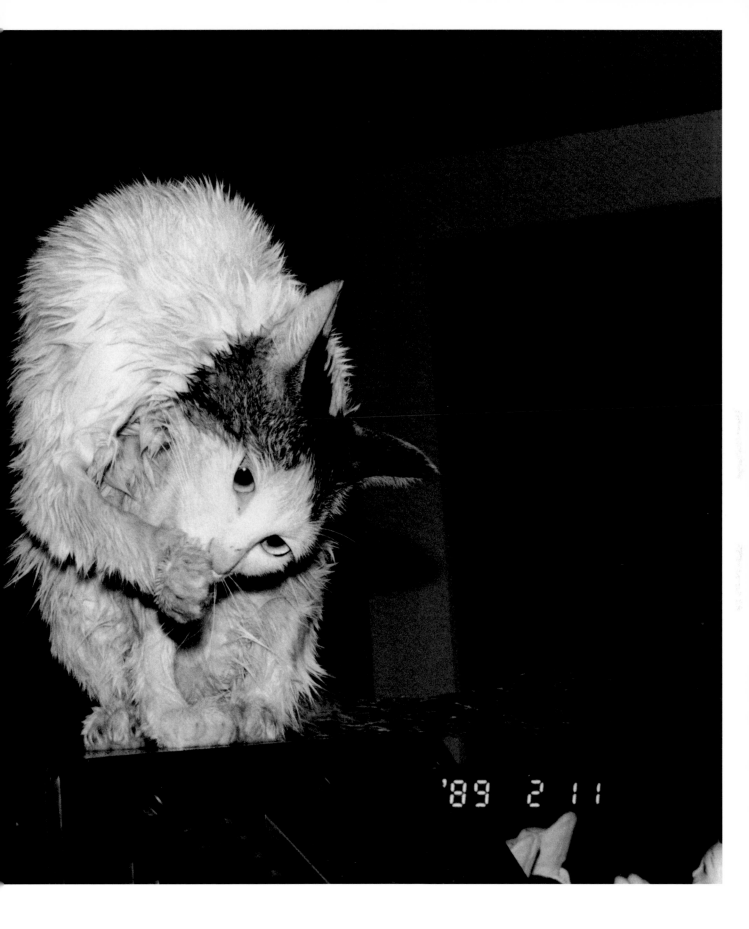

'89 2 11

227

'98 12 14

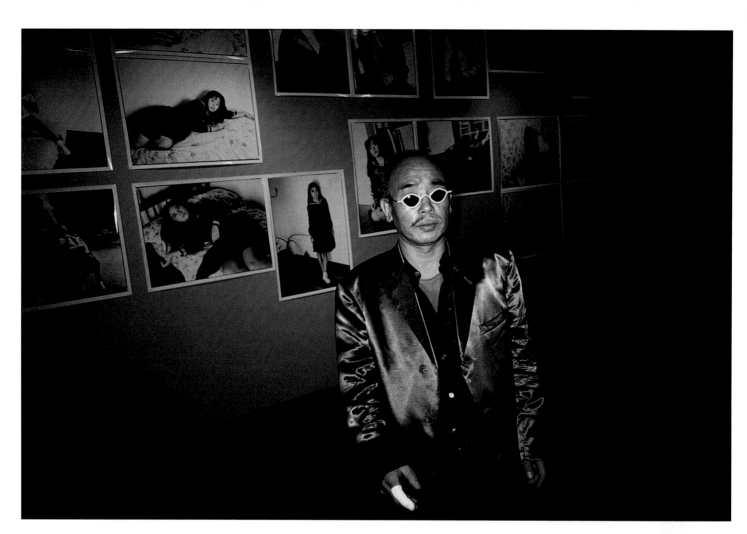

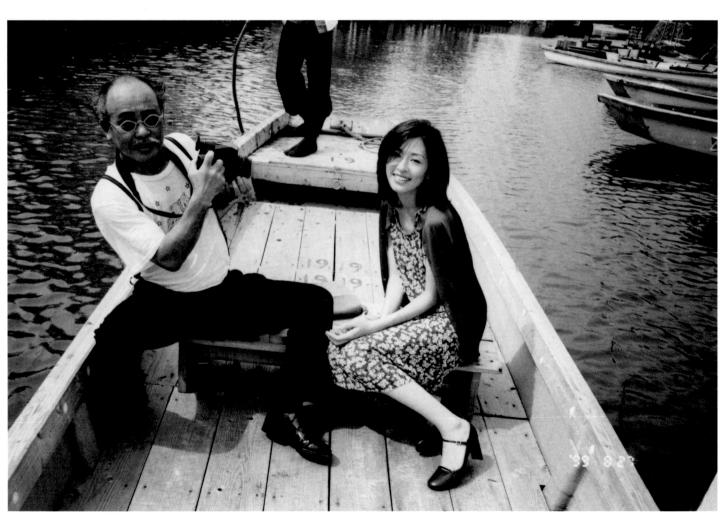

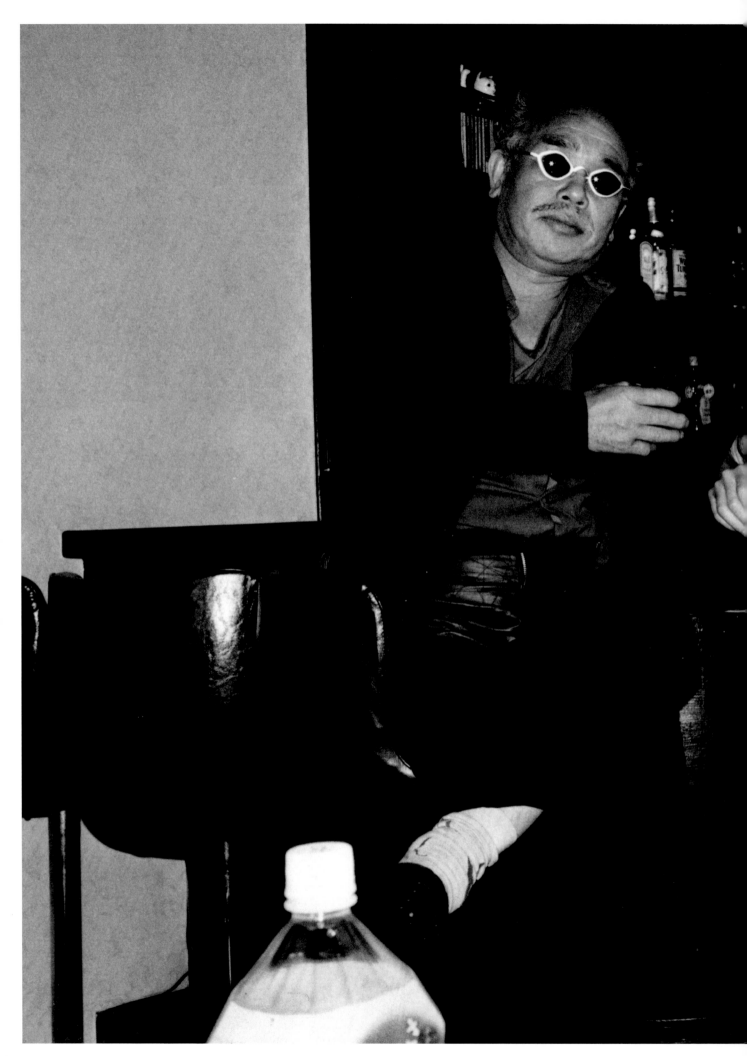

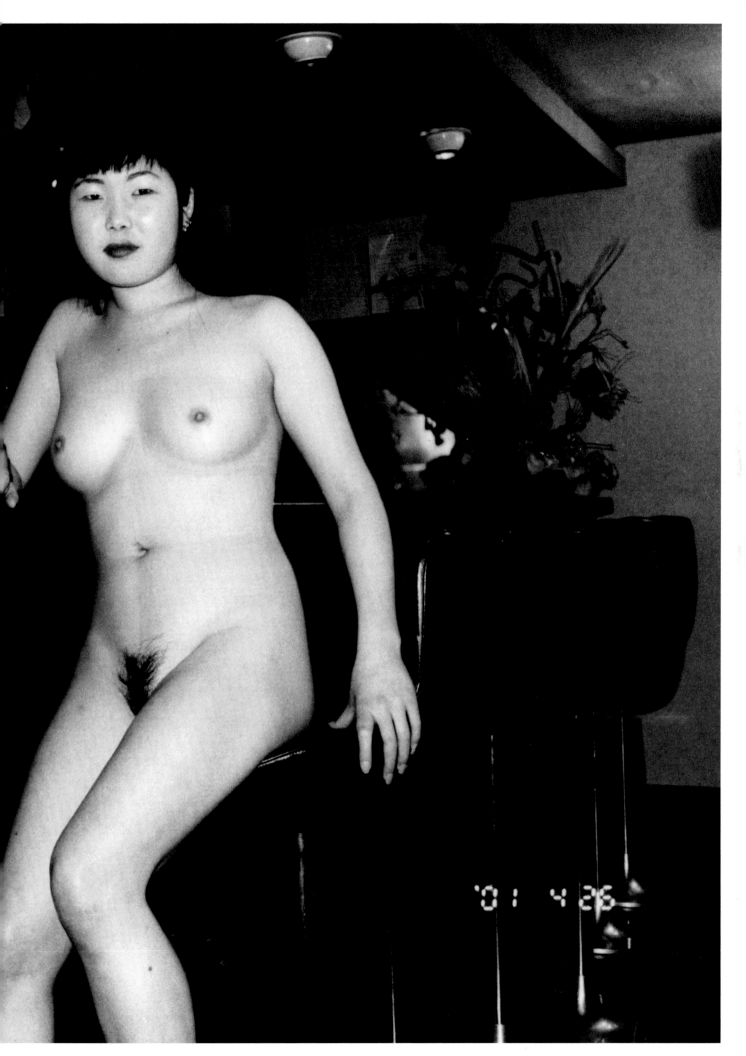

'01 4 26

237

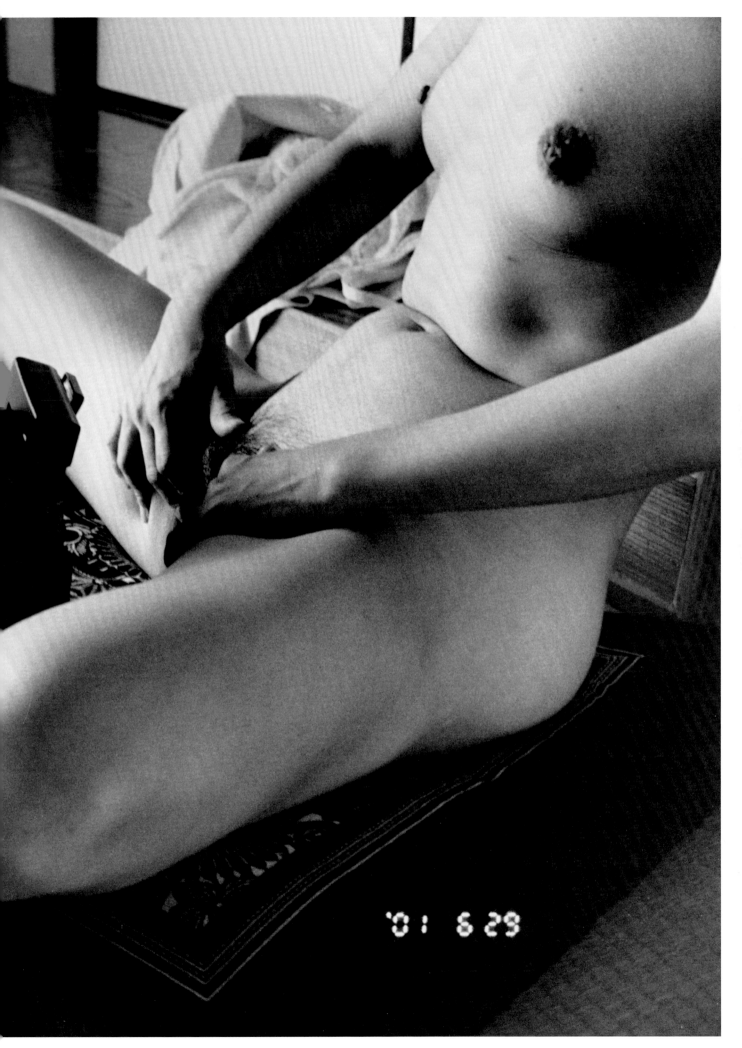

'01 6 29

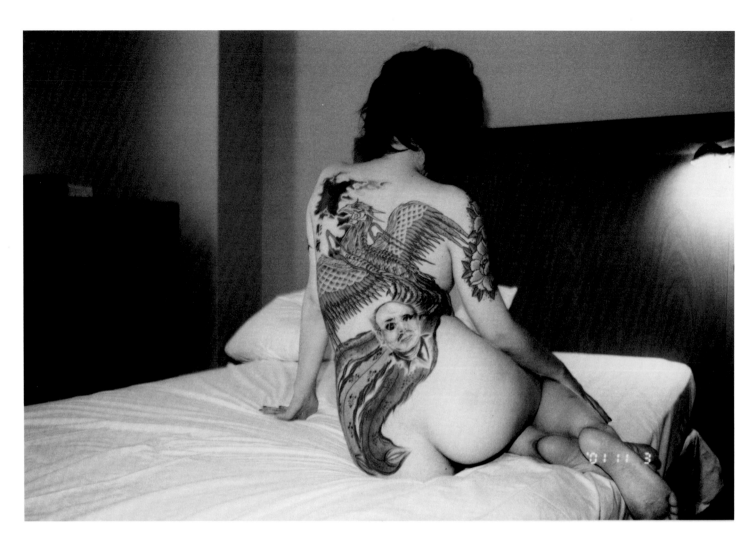

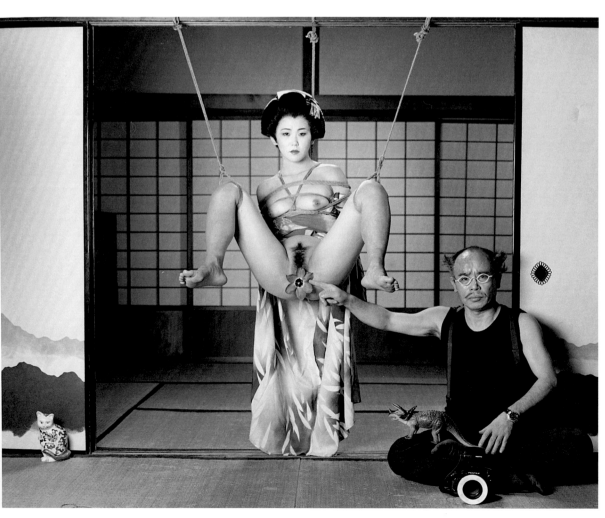

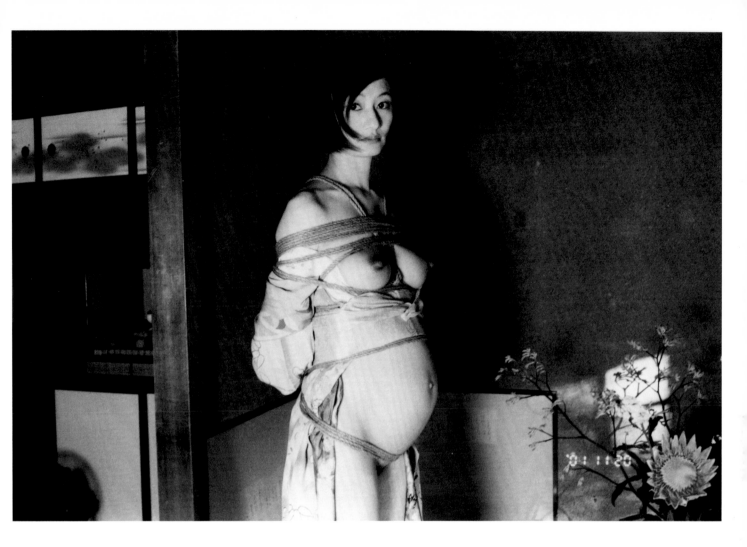

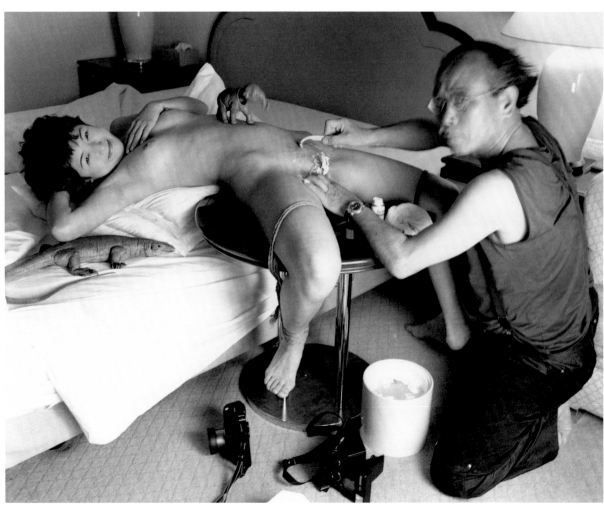

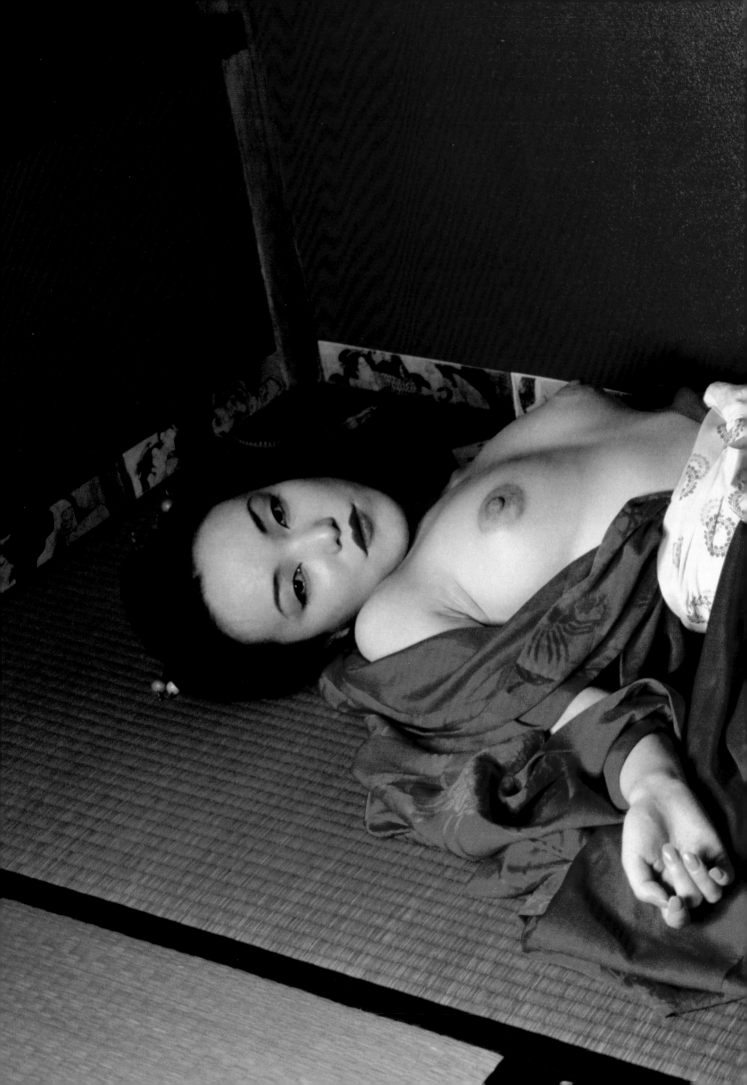

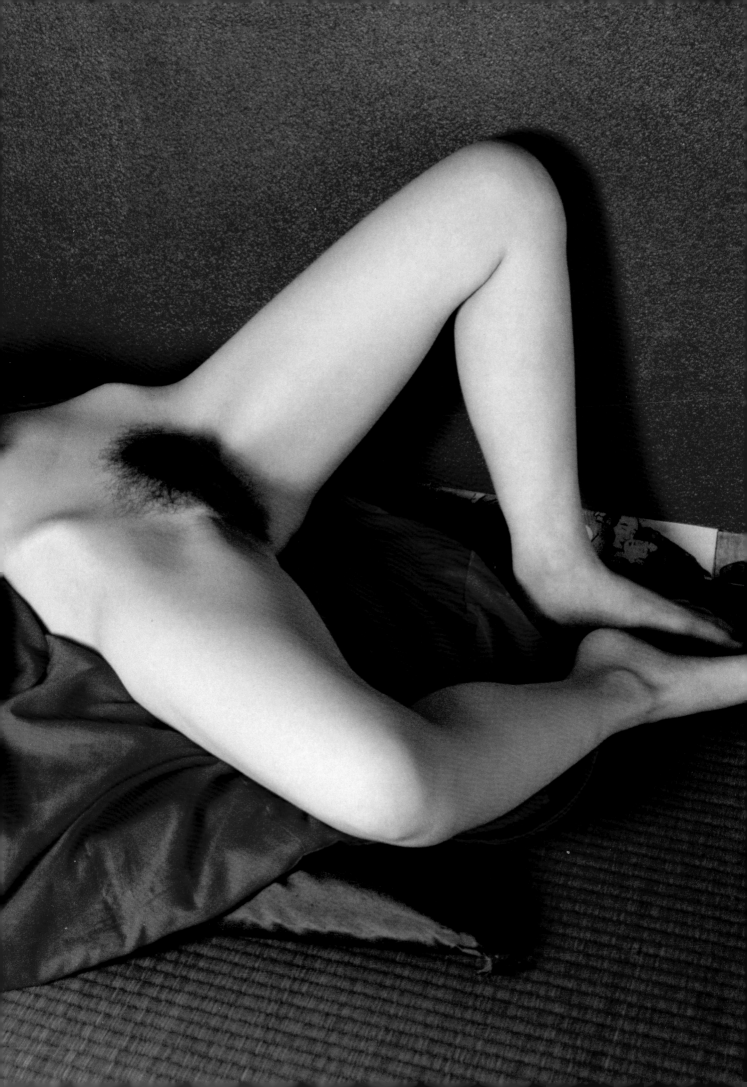

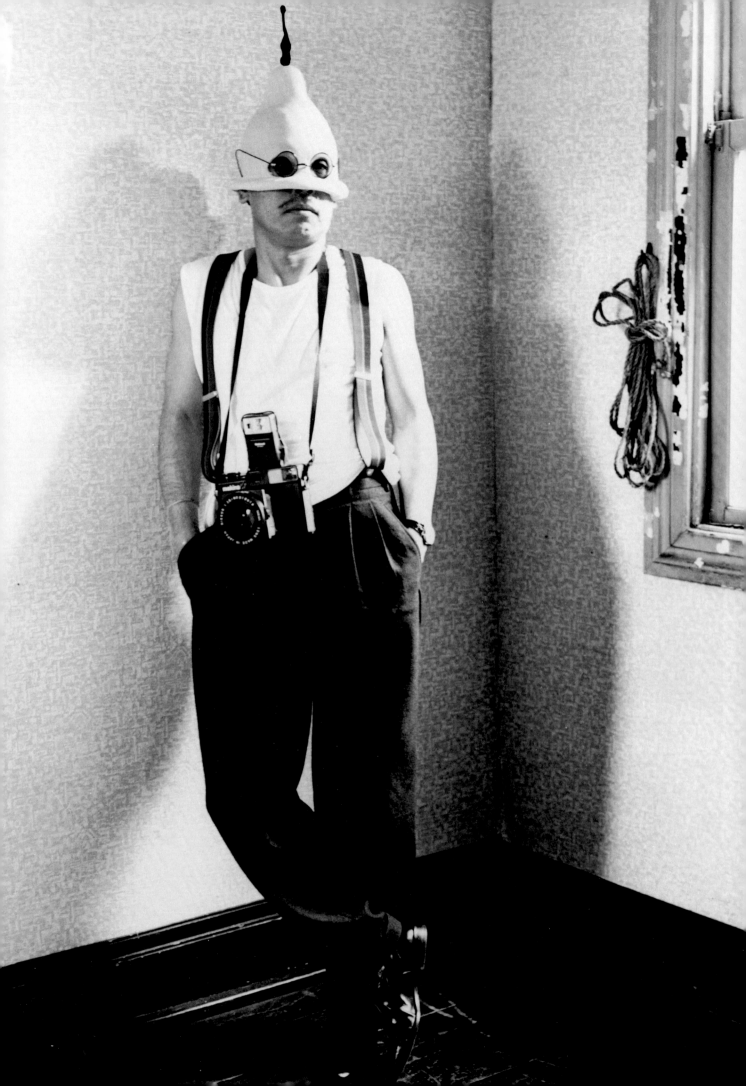

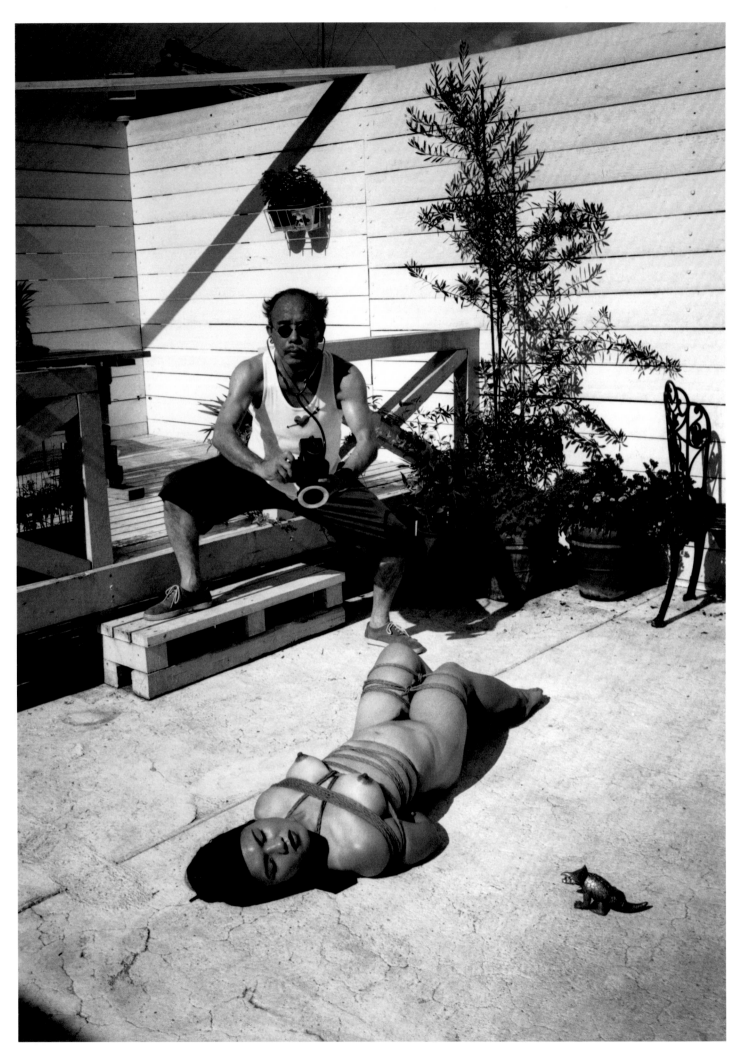

LIFE

IN CONVERSATION WITH ARAKI

THIS INTERVIEW TOOK PLACE IN
BAR ROUGE, SHINJUKU, TOKYO ON 31 JULY 2001

Hans Ulrich Obrist

HANS ULRICH OBRIST:
What was the first picture you took and how did you first get interested in photography?

NOBUYOSHI ARAKI:
As far as I remember, the first photographs I made, going through the whole process including printing, were the ones I took at the time of a school trip. At the Toshodaiji temple,[1] I took a portrait of Takko, a girl I'd secretly fallen in love with. I photographed her leaning against a pillar, far away from my schoolmates.

OBRIST:
How old were you?

ARAKI:
I was in the third year at the junior high school. On the same trip, we went on to Ise shrine,[2] where I photographed a bridge with trees and the girl in the foreground. That was also the beginning of juxtaposing a woman and landscape in my photography.

OBRIST:
So, when did you have your first exhibition and what did you show?

ARAKI:
Somehow I remember I showed those two school trip photographs together at a school exhibition. It wasn't really a formal exhibition but perhaps it was my first show. The first proper exhibition I held was at the Shinjuku Station gallery, where I showed *Satchin and his Brother Mabo*. It was in 1964 or '65.

OBRIST:
At your exhibition in Paris,[3] I saw a fascinating series of your early books that had been privately published. How did those books come about?

ARAKI:
My first publication was in 1970. That year a Xerox machine arrived in Dentsu, where I was working. I used the machine to photocopy my photographs and with these photocopied images I produced seventy editions of *Xerox Photo Album*. I published it privately in twenty-five or thirty volumes, bound in a traditional Japanese style. That was the beginning. Then in 1971 I published *Sentimental Journey* in book form for the first time.

OBRIST:
You must have published over two hundred books already. Am I right in saying that you use books as a medium to convey yourself to your audiences?

ARAKI:
Exactly so. The book is the best medium for me. It's intimate and it will stay with me.

OBRIST:
In that sense, is a book more important than an exhibition?

ARAKI:
The two are completely different things. To me, an exhibition is something like a parade or a festival. But by making a book I can explore a subject in depth and communicate with audiences more effectively. After all, an exhibition runs only for a month or two, but a book stays around for years. A longer exhibition would be a nice idea.

OBRIST:
That leads to another question. In recent years you've been working in a wide range of media including CD-ROM, DVD and the *Arakinema*. It seems there is no hierarchy in the way you use these mediums.

ARAKI:
Each medium has its own charm, so I'd like to explore all these mediums and I'd like to choose the most appropriate medium, according to my feelings or the circumstances of my audiences. Earlier on, I said that a book stays around longer than an exhibition but that may not always be true. For instance, suppose I flash a photograph in front of you now. That momentary image may make a stronger impression on you than a long-life image in a book. After all, it's a question of presentation. Sometimes I feel like showing my image as a single photograph, sometimes in a book or through the *Arakinema*.

OBRIST:
I've seen your book on Seoul,[4] where I guess you're talking about a road movie. Could you tell me about your Seoul project, especially about the road movie aspect, which I hadn't seen in your work before?

ARAKI:
For me, photography, or art, is an encounter. So, anyway I 'move' rather than 'make'. It's the record, or the memory, of my movement. This Seoul project reflects that idea.

OBRIST:
The memory of the movement or the movement of the memory?

ARAKI:
By move I mean moving around between different spaces and times. For instance, to revisit the same place a few years later. In my case it's also to change or shift the method of taking and showing the photographs – for instance, showing them as prints, or in books or in the *Arakinema*. The media and methodology of my work also keeps moving and transforming. So, I would say the overall idea of the Seoul project is not a simply physical movement but a spiritual road movie.

OBRIST:
This leads to my next question about places and speed. You've been photographing Tokyo for a very long time, for many

decades, and despite the great speed of city life in Tokyo, your work is about duration. On the other hand, in recent years you've made many short trips to other cities such as New York, Hong Kong, Vienna, Bangkok, Shanghai, Rome, Naples, Florence, Seoul and maybe Venice and Moscow? When I saw your Seoul book, it looked as if you'd been working there for a year although in reality you'd stayed there only a few days. You're freezing a long period of time within a short period, within a few days' stay. It's a sort of paradox of speed and slowness. What do you think about that?

ARAKI:

I travel to places without preconceptions and with an open mind, so I have a great capacity to receive. I'm eager to accept anything that comes towards me, so what feels like a day to me could feel like a week to someone else. I become completely absorbed in shooting, forgetting everything else. I guess I'm diligent. I know most people would first of all relax at the hotel, take a shower or have a meal at a restaurant. No way! From the moment I step out of the plane or off the ship, I'm ready to shoot. So three days are enough for me to capture a whole country! Just kidding. For others, photography is about choosing what to photograph, but for me it has nothing to do with that. I just release my camera shutter non-stop, while I keep moving from one place to another. This speedy shooting style suits my physical movement and it cuts out any process of selecting or choosing. It's nothing special. It's just the way I am.

OBRIST:

I'm amazed by the impression your work gives of blurring the border between the inside and the outside, and the difference between the photographer and the subject, so that they become immersed in each other. When you look at a cityscape through your camera, do you feel immersed in what you see? I mean a sort of interaction between the photographer and the subject, rather than the camera and the cityscape.

ARAKI:

When I hold my camera, I do feel as if I'm immersed in the subject I'm looking at, and then the subject seems to be coming towards me. The subject and I interact — to and fro. I particularly like going into a crowd and touching the subject. The physical distance between myself and the subject reflects the nature of my relationship to it. So when I'm shooting, I'm engaged in hard labour, and I get really sweaty. I may appear a bit cool towards the subject, whether it's a cityscape or a woman. Sometimes I get too close to a female model, so that I can only focus on her nostril. So then I jump back quickly, and shoot.

OBRIST:

Let's talk about cities. When you visited Vienna, you described it in a newspaper interview as 'the city of death'. How do you feel about other cities you've visited, for instance Shanghai or Bangkok? Which one is the city of life?

ARAKI:

I'd have to think about that. Seoul is soul full!

OBRIST:

Which city do you like most?

ARAKI:

I like Tokyo, but I wouldn't put cities in a hierarchy; each city has its own charm. It's difficult to talk about it verbally. When I photograph a city, I immediately make a book out of it, so you can see my personal feelings about the city in the book. I can't easily put my feelings into words. My feelings slowly ferment during the process of compiling the book, and they become alive when the book is completed. That's the way I work. You really need time to appreciate the charm of a city or a country and I think the image I get when I arrive is superficial.

OBRIST:

We met for the first time nearly seven years ago. At that time you hardly ever went anywhere. What made you start travelling?

ARAKI:

Well, nowadays I can afford to travel first class! No, but seriously, I hated flying economy class. That's why I didn't want to go anywhere. Now people invite me to visit their cities and send me business class tickets! I am serious. When I'm in Tokyo, I move around within walking distance of my base; I move quickly but within a close range. I enjoy it. The movement that requires a ten-hour flight to take you from one place to another is very different. Throughout a flight I keep shooting the movement of the clouds from the window, finishing some maybe ten rolls of film by the time I arrive. I am fascinated by this radically speedy movement, this abrupt change of space. That's why I've been travelling around so frequently in recent years. There is another factor, which concerns the method of my photography. When I photograph, I photograph with words. For instance, when I photograph a Japanese woman, I make her feel high by saying things like, 'Wonderful, You look great!' all the time. Of course I speak Japanese to her. But if I move to somewhere I can't communicate in my own language, how will that affect my photography? Will it make my photography better? Will I be able to communicate with my model without words? I've visited a variety of unfamiliar places to explore these questions.

OBRIST:

What you've just said leads to my next question. When I saw your pictures of Seoul, they looked like work done over a period of a year or so. You've now explained that you took them without verbal communication. If the work was done over a period of, say, three to ten days, how did you do it? How did you meet people and how did you make that book?

ARAKI:

It seems I am a rather disarming person. In Seoul I had no difficulty in communicating with people and getting their trust. Perhaps they found me charming. I do play the clown, after all. Perhaps I am a clown in people's eyes. So I am forgiven for everything. Maybe I amuse people – I can't help it. That's my character.

OBRIST:
When you travel somewhere, do you have a precise plan or do you follow your instincts?

ARAKI:
I follow my instincts. I particularly like to go somewhere out of the blue, and then I hope to meet a stranger, a city and a woman. We have a saying that a random encounter can lead you to perform a good act. If you encounter a good man or woman, it will bring you good luck. Life is a sequence of many small events, rather than one big drama. I just follow the events.

OBRIST:
Like a chain reaction?

ARAKI:
That's right. On the third day in Seoul, I'd hoped I would meet a fantastic woman. But instead I was caught in torrential rain.

OBRIST:
Let's go back to Tokyo. In Tokyo, where you can communicate with words, how do you move round?

ARAKI:
As what I hear is so familiar, I feel a great intimacy. It's often said that if you understand what others say you also understand what they think inside. That's not true. But sometimes the words can be too convenient, and it can be easier to see the inside than the outside. It is just like infatuation. When one is carried away with a love affair, often one can't see the wood for the trees.

OBRIST:
Talking about Tokyo.... I heard that Arata Isozaki[5] has written about you and the city. In fact I met him the other day, and in the course of our conversation we talked about 'invisible cities'. A city is formed partly by invisible elements such as smell, sound, rumours and so on. Do you think these are important factors in Tokyo? As a photographer, what do you think invisible Tokyo is like?

ARAKI:
Invisible Tokyo? You mean, like sexual activities in someone else's house? It's not something one can see by paying. Well, it's difficult. Perhaps one can't be sure whether the visible is the truth or not. I don't know. It's difficult.

OBRIST:
According to Isozaki, Tokyo is a city of rumour.

ARAKI:
That sounds literary. I think Tokyo is a city dotted with something like patches of vacant land, an emptiness. It's hollow at heart.

OBRIST:
Do you mean the loneliness inherent in city life? This morning, I read an article in the *Japan Times* about a *manga* café. People go there to play with computers, cutting themselves off from contact with the outside world and staying in their own world. The article was discussing solitude in urban life, like that. Are you referring to that kind of thing?

ARAKI:
Yes. For instance, the act of sending an email message from this mobile phone is also empty. With people absorbed in technology and disconnected from the world, it's like an empty, desolate land. There are so many things like that, including the Internet.

OBRIST:
Do you use email?

ARAKI:
No, I don't.

OBRIST:
But whenever I see you in this lonely city, you are always surrounded by people. In your professional work, you collaborate with other artists in a variety of fields, such as music and architecture. How do you feel about working with other people?

ARAKI:
Not only artists. No human beings can live alone. There is no joy in living alone. One needs the other. It's not a luxury to work with other people from different fields. It's like one wants to make love with different types of women. Artists – whether they are musicians, painters or architects – cannot work by themselves. Especially as a photographer, I know in reality that one cannot photograph without a subject. Photography is a collaboration with the subject. And I personally don't *like* being alone.

OBRIST:
Amongst various disciplines like music, literature or philosophy, what kind of people are you working with now?

ARAKI:
I don't have so many collaborative projects right now, but I find the *Arakinema* most exciting. We talked about Seoul earlier. I worked with Kenji Nakagami on a project called *Tales of Seoul*,[6] a collaboration between photography and literature. But it wasn't easy. My photographs are very narrative, in a sense, chatty, clashing with Nakagami's words, so I don't think it worked well. Then I tried to work with music. To me, the combination of image and music seemed to work better in order to create a narrative, so I have been working with cinematography and music. I show my images in slides, in cinematic sequences, accompanied by sound. It's a fusion of film and music. That's the idea of the *Arakinema* and that's what I enjoy most at the moment. I find it sensual.

Just like when you have sex, when you express or show something, if there is no sensuality, it's boring.

OBRIST:
Who did the music for the *Arakinema* in Seoul?

ARAKI:
Fumio Yasuda,[7] a young composer. He's just released a CD in Germany. You know, people often put a grand label on this kind of thing – 'A Cross-Arts Collaboration' – but it really isn't necessary. For instance, at the moment you're interviewing me. In the course of this interview, if I say something I have never thought of before, then it becomes a collaboration between us, because, in a sense, it's an idea created by both of us, isn't it?

OBRIST:
Let's talk about music. I got this book[8] today, and I've found a mini CD in it. What is it? I am very curious.

ARAKI:
It's an old nursery rhyme, sung by me. (Araki sings.) *'The girl wearing pretty red shoes was taken away by a foreigner....'*

OBRIST:
Since I came to Japan last Friday, everyone I've met has talked about this book. It seems to have had a big impact on the art world here. How important is your writing in your work?

ARAKI:
Writing is pretty exhausting.... To be honest, this book is a record of a talk show I did.

OBRIST:
Like right now?

ARAKI:
Yes. I used to write a lot but it consumes a lot of energy. In fact, I think spontaneous action often conveys the truth better. In photography an image captured spontaneously tells a greater truth than one produced with calculation. Composing a text requires a lot of conscious thinking. That process can weaken my instincts, so I prefer talking. If I tried to write down what I'm thinking right now, it wouldn't work. But when I talk, especially under the influence of alcohol, my words probably convey more truth. The more I try to write, the further my words get away from the truth.

OBRIST:
Your books often include drawings made directly on photographs. Tell me about this kind of interaction with photographic images as you colour or draw directly on them.

ARAKI:
First of all, to me, colouring photographs is not simply a matter of adding colour to them. There is a more serious context. After my wife's death, I took many photographs of the sky in black-and-white. Then, I wanted to make a book with those photographs. However, when I laid out the prints, those monochromatic images looked so pitiful, so unbearably sad. So I tried to lift my spirits by colouring the monochromatic, dead sky and bringing back life to it. That was the beginning of the idea of colouring photographs. On the other hand, in the case of the *Sex Maniac* series,[9] I got sexually excited by my own photographs of nudes and landscapes. By the way, I am playing with the words 'lust' and 'colour' – both are expressed using the same character in the Japanese language.[10] Anyway, in order to bring back life to women in the photographs, I thought I would need to add the colour of sperm or blood. In my view, photography, especially black-and-white, puts the subject into a syncopic state. So I feel a great desire to revive it and also to violate it. I guess this kind of feeling urges me to colour photographs.

OBRIST:
I noted that your small Polaroid book[11] had also been coloured. Can you tell me about your Polaroid work?

ARAKI:
Polaroid ... the simplest idea – you press a shutter and a picture pops out. It's just a matter of myself and the subject I photograph. What I'm talking about here is the process of photography. Suppose I've photographed my own intimate act. Before it comes out as a finished work, I have to go through a production process, involving an outsider, such as the person developing the film. This process becomes a kind of censorship. However, if I'm free from such an intermediate process, I can explore certain elements further. Of courser the Polaroid company doesn't promote this, but their camera is best suited to photographing erotic, highly intimate scenes. I call these works 'Pola-ero' and this erotic potential is the most fascinating element of Polaroid. Polaroid images are also a bit murky ... kind of unfinished photographs with that vivid, fleshly feeling. I am aroused by that. Also, they're small. You can hide them quickly.

OBRIST:
And that's why the book is so small. There's a chapter called 'To Show or Not to Show'. What do you mean by that? Why 'Not to Show'?

ARAKI:
Let's make it simple. Suppose here's a woman I'm going to photograph. Naturally I photograph her attractive aspects as nicely as possible, but another person in me also wants to photograph her less attractive aspects that she would hate me to photograph. Whether it's beautiful or ugly, I photograph everything, with no hesitation. I tell my model that I'm photographing only her attractive aspects, but in reality I also reveal what she herself thinks ugly, or what she hates and wishes to keep secret. But afterwards I won't show her what I know she doesn't want to see. Something like that. So, I am kind to her.

OBRIST:

Do you mean you don't respect her wishes ...?

ARAKI:

Nope. After my death, lots of scandals will be revealed! Anyhow, photography is not about revealing everything. You keep back the most important things to yourself. A photograph is a mutual secret, and keeping it secret is an intimate communication, a private relationship between myself and my subject.

OBRIST:

This leads to my next question – about your archives. You are extraordinarily prolific. I have no idea how many pictures you have taken, it could be ten thousand or a hundred thousand or a million? Are you cataloguing them? Do you order them by date or by topic? Your work covers all kinds of genres ...

ARAKI:

I haven't been very organized, but I have assistants working on it. Reflecting my belief that photographs are taken by the camera, the images are sorted by the type of camera used – Leica, Pentax or Lomo, the type I've started using recently.

OBRIST:

By the type of camera! I love that! How many types of camera do you use?

ARAKI:

More than ten. When I have a photo-shoot with a charming model, I use five or six cameras at the same time. Big, small, they are all different in character. I like the ones with a good clicking noise.

OBRIST:

Six cameras at the same time! What about this camera? When did you use this one?

ARAKI:

With this one, I've just published *The Fin-de-siècle Photographs*[12] in monochrome, and then *The Beginning of the New Century*[13] in colour. At the moment, I'm working on a big book, Araki by Araki which will be published by Taschen at the end of this year, and will cover a wide range of images and periods.

OBRIST:

But there is already a very big book from Taschen.[14]

ARAKI:

The new one will be even bigger, like a pillow. When I turned sixty last year I felt as if I'd done all I'd wanted to do as a photographer; I'd come to an end of a chapter of my life. So, I've just made a fresh start like a novice photographer, with this toy-like camera, which I'd used in my early years. By the way, I've just seen a screening of a film by Misuzu Kaneko,[15] a nursery rhyme writer and poet. I've done stills for this, because I was fascinated by her poem:

A GOOD CATCH IN THE MORNING GLOW

HERE COMES A RICH HAUL OF SARDINES

A CELEBRATION ON THE SHORE

BUT DEEP IN THE SEA

THOUSANDS OF SARDINES ARE MOURNING

This is a song about a big catch, about life. But in this celebration of life, Kaneko, a girl poet, observes and empathizes not only with life but also with death. I was interested in that. It's what I'm trying to do with photography. To observe life as well as death embraced in life, or life embraced in death. That is the act of photography, I think. That's why I've started a new chapter in my photography at this juncture.

OBRIST:

I like that definition of photography. This is my last question. Although you have achieved so many things, what projects could you not materialize?

ARAKI:

There are very few projects I couldn't materialize but there is one thing I regret. When my wife was still alive, I was commissioned to make a picture book as a Christmas gift. I made illustrations for it and, of course, it was for other people, for sale. When she saw it, she muttered, 'I wish you'd done that for me ...' and her words still stick in my mind. I'm still troubled by this – why couldn't I think of doing it for her, when I could think of doing it as a job. I've managed to do all the projects I wanted but that is my one failure. After all, art is creating something. When one creates a work, in principle it should be an expression of one's affection, a dedication to the person you love most. That's something I regret.

1 Founded by the Chinese monk, Ganjin, in AD 759 at Nara, the first capital of Japan (AD 710–794). The Toshodaiji Temple is one of Japan's masterpieces of Buddhist architecture.

2 Located in Ise, Mie Prefecture, Ise Jingu is one of the greatest Shinto shrines in Japan. With a history that dates back to 3 BC, it is a popular tourist spot visited by over seven million people each year.

3 *Voyage Sentimental* at the Centre nationale de la photographie, Paris (2000).

4 *Seoul: The Novel* (Tokyo: Switch Publishing, 2001).

5 Born in 1931 in Oita, Isozaki is one of Japan's leading architects. Trained under Kenzo Tange, he is known internationally for his Olympic Stadium in Barcelona and the Museum of Contemporary Art in Los Angeles.

6 *Tales of Seoul* (Tokyo: Parco Publishing, 1984); a collaboration with the novelist Kenji Nakagami (1946–92).

7 Born in Tokyo in 1953, Fumio Yasuda is a composer and pianist. He began to collaborate with Araki in 1995, contributing music to Araki's *Arakinema* performances.

8 *Araki Returns from Shanghai* (Tokyo: Korinsha, 1998); includes a CD of Araki singing.

9 Published by Taka Ishii Gallery, Tokyo (2001), in a limited edition of 100, featuring painted black and white prints.

10 See Yuko Tanaka article, pp. 545–9, which discusses the Japanese word for colour and its various meanings.

11 *Nobuyoshi Araki Polaroid* (Tokyo: Okragon, 1997); published in a limited edition of 800.

12 Published by Aat Room, Tokyo (2001) in a limited edition of 2000.

13 Published by Aat Room, Tokyo (2002) in a limited edition of 2001.

14 A Taschen edition of *Tokyo Lucky Hole* (1997). The original Japanese version was published in 1990 by Ota Shuppan, Tokyo. It documents scenes from the red-light district of Kabuki-cho in Shinjuku, in its heyday, before 1985.

15 Born in 1903 in Nagato, Yamaguchi Prefecture, Misuzu Kaneko was a gifted poet and writer of children's songs. She was highly praised by Yaso Saijo, a leading figure of modern Japanese literature. Kaneko committed suicide at the age of twenty-six, when many of her works were presumed to be lost. However, a recent rediscovery of her poems, over 70 years after her death, has generated new interest in her work.

ARAKI & POST-HISTORY

Ian Jeffrey

Nobuyoshi Araki is a post-modernist of an extreme sort. But what do we know about him? The self-portraits tell us that he often wears round-lensed sunglasses and that he has a neatly trimmed moustache. Internal evidence in the pictures points to his often working in a particular courtyard probably at first floor level. In one corner of the space there is a purloined sign showing an adult leading a child; the sort of warning sign you might find next to a school. The wall of the courtyard is covered by a trailing vine, bare in winter and heavy with leaves during the summer. In the courtyard he makes assemblages and installations, sometimes of flowers and plastic dinosaurs. He has a cat too, in black and white; and in one photograph the cat sits on a low table, supported on the back of a crouching saurian carved from wood. In one courtyard scene he photographs a vase of flowers against a white background and there are a dozen or so other vases nearby. In the background sound recordists are at work, as if he were talking at the same time. Perhaps they are there to catch ambient sound? The date of that particular picture is 98.12.8. Araki is a conundrum.

Where exactly do you begin with such a photographer? Patient unravelling hardly seems to be the answer, although it is one possibility. There are easier pictures to begin with, some of city streets, which look as if they might come under the documentary heading. Documentary gives us access to the world as constructed and used by others, and Araki's 'documentary' shots tell us a lot about certain Japanese street scenes: many inscriptions and a mass of wires and paraphernalia. What can you learn from such pictures? Almost anything you want to, if you have the time and patience. But you would really have to know the place to make anything of them, for they provide you with no obvious starting point. In Europe the German photographer Thomas Ruff used to photograph domestic details in very ordinary houses, giving a painstaking account of mediocre fabrics ... almost as if he were a building inspector in a run-down part of town.[1] The point about Ruff's documentary pictures was that they denied photography's time-honoured and sacred mission, which was to uncover or to reveal the truth (*aletheia*, as Heidegger might have had it from the Greek). Likewise Araki invokes the documentary mission, but conspicuously 'fails' to deliver, and almost as if he meant to.

So what is to be made of a typical Araki street scene? The eye rests on it and perhaps moves listlessly about wondering if there is anything to be remarked on, but there probably isn't: a neatly dressed man perhaps and a smart woman on the pavement, but nothing more. Sometimes the pictures are taken at the same place separated by a slight interval which shows that things have moved around slightly: x has moved further down the street and y & z have emerged from a shop or office. None of this sounds very important, yet this is very often the chief subject matter of the naturalistic arts over the past two decades. Vanguard video, as we see it demonstrated in museums and festivals, often concerns itself primarily with the mere passage of time across a scene in which nothing very much may happen: passers-by pass by, and clouds and smoke drift. Contemporary time-based art is sceptical about hierarchy and

emphasis. Perhaps advertising appropriated emphasis and put it to such mundane usage that it lost credibility and standing. Or perhaps we just got tired of being buttonholed by proselytizers and ideologues and turned for relief to the spaces in between, which no one had so far thought of putting to profitable use. So, Araki practises a kind of disinterested documentary style which we have come to recognize recently.

There may, though, be other ways of accounting for these relatively humdrum pictures of daily life. This, the pictures seem to declare, is what Japan looks like at first sight, or on any ordinary working day, but open the door and you will come across scenes of sexual promiscuity, which look as if they might warrant a government enquiry. No other major photographer has ever taken pictures like this on such an extensive scale. Are they of sex workers, models or of people he simply met in the street? And what do his subjects make of his use of his collection of plastic dinosaurs? It is an odd kind of *auteur* pornography in which it is easy to imagine Araki making the arrangements: a flower here, a dinosaur there and an opened packet of Lucky Strike on the table. The sex pictures begin way back and can be seen to advantage and in context in *Personal Diary, Past*, Volume 8, in the extensive twenty-volume *Complete Photographic Works*, published in 1996.[2]

Should we regard *Personal Diary, Past* as the real thing, as a true record of a rake's progress, or as a charade? In one scene, dated 84.9.26, he features himself apparently the worse for wear clutching a Gordon's gin bottle in the company of porno pictures scattered on a tiled floor. Then on 87.9.31 he appears again nursing what looks like the mother of hangovers. But is he ever to be believed? The picture he presents of himself is of a bon viveur and joker living in some contact with actuality, but always aware that his life is mediated by TV and celebrity status. We see him in his own exhibitions and surrounded by his own pictures, and looking sleek and satisfied in restaurants. On 84.11.30 a smiling head waiter presents him with a cut of prime Japanese beef notably interlaced with fat. Yet it is not all plain sailing, for the streets outside can be dull, in fact consistently uninspiring. And sometimes it can be wretchedly cold, as in the winter of 1984. Araki's fantastic life story is enacted in this dismal context, from time to time intensified by illness and death. Towards the end of 1984 he appears looking like an astronaut or experimental specimen displayed on huge scanning apparatus. Early in 1990 his wife of twenty years died, and many of the pictures from around that time look bleak: an overturned vase, a decrepit statue, empty and abandoned spaces.

In *Araki: Viaggio Sentimentale*,[3] a comprehensive catalogue produced for a retrospective exhibition in Prato in Italy in 2000, the last entry in an abbreviated c.v. notes his wife's death in 1990, almost as if nothing had happened in the subsequent decade. The suggestion that she was all-important is confirmed by Volume 11 in the 1996 *Complete Photographic Works*, *In The Ruins*.[4] *In The Ruins* is marked by the same kind of informality that characterizes Araki's extensive diaries. What the diaries have done, however, is to alert us to the likelihood of

meaning and allusion. One picture from the diaries, dated 80. 8. 6, is of an interior with a TV set and speakers near to a doorway. The screen, obscured by the fold between the pages, shows a damaged building with its girders exposed to the air. It looks like a deliberate reference to A-bomb damage at Hiroshima or Nagasaki, and it may be Araki's way of acknowledging history, which otherwise scarcely makes an appearance in his art.

Cued in by this sidelong way of working it is possible to begin to make sense of *In The Ruins*. It centres on a number of painted photographs of apocalyptic skies taken over a fringe of bushes and wires. Taken mainly in late 1989 and early 1990, the images must be a reflection on his wife's illness and death. The vividly coloured skies look angry and portentous, expressive of a state of mind. In one of them a tiny bird sits on a diagonal wire that divides a dark blue from a yellow sky, indicative of night and day or even of death and life. Araki's knack, developed to perfection in *In The Ruins*, is to toy with signs and ciphers. The picture of the bird on the wire is, for instance, very open to interpretation and it proposes that all the pictures can be understood to this degree. Are we, in this case, to take the wires and aerials that border the skyscapes as significant? Are they to be understood as nerves or ganglia and as somehow bearing on life? The idea can't be confirmed but it can't be denied either, especially as many of the other pictures in the set leave themselves open to interpretation. In a picture of a flower head the stigma within the decaying petals might look like a worm in the bud or like a sign of consumption. Araki's tactic is to use the possibility of interpretation as a means of slowing down how we might take the pictures. Aware that something is involved we spend time, where otherwise we would simply pass on or turn the pages at random.

Araki's cat appears from time to time in the book, and indeed there is a whole book devoted to cats. This particular cat, named Chiro, with a dark stain low down on its back, has been Araki's household cat for many years and thus forms a connection with his missing wife, who died in 1990. At the same time the cat has an identity and life of its own and can be seen simply for what it is, quite apart from its powers of allusion. Most of the things he photographs seem to exist in their own right. He photographs two shoes next to each other, his and hers obviously, referring to their former togetherness; but, all the same, photographed in close-up they continue to figure as footwear. And he has knotted the laces too, which is another sign of something, even if only of an urge to order. Altogether *In The Ruins* looks like a report from the material world from where the photographer has from time to time salvaged or added meaning of which we are intermittently aware. Early on, in an undated picture, he shows a glass of beer, brimful and overflowing onto a white table-top. It might be meant as another sign of life, or of contingency as an aspect of living, for the glass didn't quite match the contents. The glass also casts a shadow, probably from studio lighting out of the frame. Overleaf he shows the same scene, but this time he concentrates on the shadow, now beginning to resemble a vial or bottle in which the refracted light looks for all the world like an undisturbed flame rising in the darkness of the shadow. It is as if the apparent flame had caught his eye and proposed the existence of a soul or spirit glowing in the darkness. Thus we are made aware of meaning as it comes into being or the processes involved in imagination. It is less the thought to which we attend than the activity of the mind thinking or making something of what comes its way.

The picture of the imagined flame in the imagined bottle suggests that Araki is carrying out a baroque poetics where it is always the moment of emergence that matters. If this is so, what kind of light does it throw on the countless photographs that seem to go nowhere? All those street pictures, for example – what are they supposed to mean? Dealing with the time in between events, they may refer to an international aesthetic of non-committal, but when we consider all things pertinent to Araki, that hardly seems an adequate explanation. Think of them instead as dealing with the time of 'non-yet'; with all their advertising and notices they point to what will be: the time when the train will run or when you can get maximum satisfaction from Caster cigarettes or from Cabin 85. In between the creative moments of emergence there is all the rest of life to be undergone and a mass of preparatory work if the creative moment is ever to be apprehended. Some of Araki's pictures, even in a collection as explicit as *In the Ruins*, look like uncompleted or even abandoned installations in a studio. Eventually from the chaos something might emerge, or be singled out as significant. One item that recurs on the domestic studio terrace that introduced this essay is a set of dumbbells, signs of training and of future fitness. Even that school warning sign in which an adult takes a child by the hand points to present dangers and to future security.

But it is the quasi-pornographic pictures that will always be most contentious. They have been variously accounted for and excused. In the admirable Prato catalogue of 2000, Araki is introduced as a kind of social worker whose art 'aesthetically explores the fictitious reality of night clubs, of exhibitionism in sex clubs, of the commercialization of the female body'.[5] During the early 1980s in Tokyo there was what the catalogue calls a 'sex-industry boom'. All this may be true, but at the same time something more seems to be at issue. Pornography is, of course, rich in promise of orgasm achieved, but all the same the moment of realization may be disappointing and especially in relation to these pictures, many of which also function as portraits. Portraits suggest personality that we can only get to know with the passage of time, and that we can only get to know more or less, never completely. Character emerges according to context and can be known only as a series of facets. Araki's models from the late 1990s are of this order, despite their physical allures, and like the photographer himself many of them act parts. Some are also accompanied by representatives from Araki's collection of model dinosaurs and lizards, which have a sinister significance, at least to judge from their placement in the commemorative collection *In The Ruins*. The nude studies, that is to say, have to be worked out as records of encounters in which the photographer, with his memories and intentions, intersects with a character often capable of keeping her composure.

Araki's story, as recounted in the diaries, is picaresque. He looks the part: a rogue with a whisky glass. He wears those trademark sunglasses and a swirling scarf. He puts up with the boredom of those ordinary streets, and he encounters tragedy. The story matters because it is shot through with fiction and inventiveness. Araki's major precursors in Japanese photography, Shomei Tomatsu,[6] Daido Moriyama[7] and Takuma Nakahira,[8] were by contrast history artists who took it upon themselves to reflect the moment. They were alert to the state of the nation and to a collective consciousness which had been affected by the war and by the subsequent American occupation. Tomatsu, the senior photographer, returned to wartime themes, taking pictures of bomb damage and of the A-bomb relics in Nagasaki. Araki, born in 1940, remembers the war, but it seems to have played no part in his creative life; and until 1972 he worked for the Dentsu Advertising Agency, where he was part of the new commercial culture. Moriyama, a bohemian amongst Japanese artists, travelled the country and reported on Japan at large, even if it was a ground-level view of the place. Araki, by contrast, seems to have restricted himself to Tokyo. The only wide open spaces on which he has ever reported are clouded and turbulent skies, taken for their expressive value, as personal documents. Takuma Nakahira, an outstanding radical in the photography of the late 1960s and early 1970s, pictured Japan as a ruin briefly glimpsed at what looks like the end of the known world.

Both Takuma Nakahira and Daido Moriyama contributed to the legendary magazine *Provoke*, which only ran for three issues.[9] *Provoke* had radical intentions. Its founders included a manifesto in the first issue: 'Words have lost the material force that once held reality, and they float freely now in air. At such a time, it is for photographers to capture with their eyes the remaining vestiges of reality that words can no longer reach.' The *Provoke* style valued mis-shots: 'no-finder' pictures taken without reference to the viewfinder, 'strobe-fired' images taken when the photographer was blinded by flash, and 'blank-triggered' images, taken by holding down the shutter and turning the film on immediately after loading. Nakahira's view was that photography should affirm the photographer's 'own immediate reality, and no one else's'. Nakahira, one of the founder members, had been taught photography briefly by Tomatsu, but wanted to break with the older man's more studied style. Araki said of *Provoke* that although 'most people paid no attention to it … really it was like a bomb in Japanese photography'. Certainly its vivid informalities seem to have influenced the Araki of the diaries in particular, and the twenty-two pictures from the 'love-hotel' series by Moriyama published in the second issue of *Provoke* are especially relevant. The difference, though, between Moriyama's blurred originals and the Araki of the diaries is one of apparent authenticity. The 'love-hotel' photographs were taken on site and deliberately blurred to conceal the identity of the woman. Araki's pictures, by contrast, have always had an element of staging to them.

Even if *Provoke* was a 'bomb' in photography aesthetics, its influence can be misjudged. It was devised in 1968, at a time of severe unrest in Japanese universities (Tokyo and Nihon universities in particular), and Nakahira was one of those involved in student protests. Paradoxically some of the most expressive pictures of the rioting of 1968–9 were taken by Shomei Tomatsu, whose influence Nakahira had sought to avoid. It is possible to think of the student unrest of this era as just another news event explicable in local terms, but then it must have seemed that it emerged from the *Zeitgeist*, or that it was a political movement to be understood in terms of virus and contagion. It was a kind of universal restlessness induced by a generalized discontent. Tomatsu's pictures of rioting in Tokyo show the streets in blurred movement as if vectored and magnetized. Individuals were caught up in what can look like a psychic weather system. Other pictures by Tomatsu made the same point in 1969: photographs of American B-52 bombers taking off in shuddering noise at an airbase in Okinawa, for instance.

Nakahira's pictures, published in the three issues of *Provoke*, were even more generalized, showing the city at long range and apparently abandoned. He took pictures of distant refineries and street lights to imply radiation and conflagration. His vision of Japan and of the contemporary urban world was informed by an idea of Armageddon or of inter-planetary conflict. Moriyama too, travelling through the country in these years, seems to have shared the same eschatological vision of himself as a threatened survivor in the ruins of civilization. It is notable that it was a shared vision, and some pictures are interchangeable; especially the riot images of Tomatsu and Moriyama, who were expressing a world-wide condition and state of mind, and could be thought of at the time and subsequently as history photographers. They were in the eye of the storm, reporting on and expressing history as it happened. Perhaps they believed that this was the last moment when anyone would participate in universal history. It must have been evident that the spirit of 1968 was metaphysical, or not easily to be accounted for. They were participating in events which couldn't be rightly understood, and this accounts for the fantastic and dreamlike quality of their pictures.

Photographers since the 1930s had been involved in history, and although they are usually referred to as documentarists, they can just as easily be thought of as history artists. In the 1930s and for a long time afterwards their terms of reference were clearly stated. They were humanitarians, democrats and nationalists, and participants in class wars. Even when they became independent in the 1940s, their agendas were established by history. The magnetic field of the photographic imagination in the 1940s and 50s was determined by the Holocaust and by the bombing of Hiroshima and Nagasaki. Even Robert Frank's report on the USA in the 1940s is coloured by Europe's recent darkness.[10] During the 1950s and 60s Tomatsu was a history photographer engrossed by the war and the occupation. But the problem with history was that it changed its emphases imperceptibly. Memories of Nagasaki and of Hiroshima faded and had to be deliberately kept in mind. Photographers, and the rest of us, knew that there was a universal history with its own dynamic points of reference, its own

lodestars which retained their powers to move and guide. All the same, history was hard to deal with, especially for photographers and creative reporters. The popular mood couldn't always be assessed, and it was possible that it didn't even exist. The year 1968 was also a shock to the system, and it familiarized us with the idea of a mystery in the grand narrative. Japanese photographers responded wonderfully to this new *Zeitgeist*, but it was hard to understand, and had to be lived to be comprehended. Moriyama, a bohemian and a Beat photographer, illustrates the process and the predicament to perfection, for he seems to have travelled constantly and to have opened himself to all kinds and degrees of experience. History's pointers and cues, in this new order of events, lay anywhere at all and couldn't be accurately predicted. In the old world, c.1950, history's configuration could be identified, but no longer. To be an effective history photographer, or one whose imagery was widely relevant, became difficult and even impossible. The unrest of 1968 amounted to the death throes of universal history, at least as that had been construed by photographers of the documentary era. The short-lived *Provoke* was photography's last attempt to do justice to the idea of a universal history, but it was caught up in a contradiction: history recounted by photographers pledged to their 'own immediate reality, and no one else's'.[11] It is from this impasse that a new kind of photography emerged, with Araki as its most vivid exponent.

With the disappearance of epic history in the years following 1968, photographers were at a loss. Fragmented history still took place, of course, and more so than ever, but it could make no real claim on our attention. You could henceforth present yourself, as Nakahira proposed in his *Provoke* manifesto, as a strong subjectivity. Moriyama's art from the 1970s is strongly subjective in that he presents himself as subject to all kinds of encounters and distractions. To be effective, though, this kind of photography has to verge on the self-sacrificial, for who can be really interested in a temperate traveller? One option was to continue to report, but to confess that epic history was long gone, and that only residues remained, which could hardly be incorporated into any totality. European artists, using video for the most part, remarked on time-in-between or the time of waiting and paying little attention. A new generation of Japanese photographers evolved what might be called a documentary of bathos, a kind of low-key reportage that remarks on encounters without assuming that they are representative of humanity at large. One of the finest examples of this tendency is Keiko Nomura's 1999 book *Deep South*,[12] in which the photographer records her travels in Okinawa, Masakazu Takei and Saru Brunei. She includes no texts, so we don't know exactly where we are, nor the names of those depicted. Anything we learn we have to find out from close inspection. The pictures are in colour, which is typical of the new tendency, and on a large scale, which enhances their naturalism. Such pictures have an ethical dimension, for we have to ask by what right we take such an intrusive interest in others' lives. The documentarists of the 1940s and 50s were excused here because they were understood to be taking representative pictures touching on the condition of mankind at large. Araki's way around this problem is the evidence that his subjects are complicit, even in the most intimate scenes. He is also principally a photographer in black-and-white, which always cuts down on the sheer materiality of the picture.

Nomura and her contemporaries cope with the lack of epic history by presenting themselves as explorers, almost as innocents abroad. They find friends and are vouchsafed intimacies which have nothing to do with nationhood or with the state of the world. Araki, born in 1940, was never in a position to present himself as a newborn traveller. He is to be understood above all as a creative temperament living in post-history, inspired by the hope that he can bring things to a conclusion or somehow achieve creative closure. He can't, of course, because he has set himself too large a task with his aim of comprehensive coverage. In that case what we witness is the creative effort itself, carried out with whatever materials come readily to hand. There is no way in which he can prepare perfectly, as he could in advertising, for out here in the great beyond, in the new fragmented history, he can never know what it is that is at issue.

1 Thomas Ruff (b.1958). Matthias Winzen, *Thomas Ruff 1979 to the Present* (Cologne: Verlag der Buchnahdlung Walter König, 2001), see section 'Interieur'.

2 *Araki Nobuyoshi shashin zenshu* (*The Complete Photographic Works of Araki Nobuyoshi*), 20 vols. (Tokyo: Heibonsha, 1996–97).

3 *Araki: Viaggio sentimentale*, exh. cat. (Prato, Italy: Museo Pecci, 2000), includes texts by Filippo Maggia and Bruno Cora and an extended interview with Araki.

4 *In The Ruins*, vol. 11, *Araki Nobuyoshi shashin zenshu* (*The Complete Photographic Works of Araki Nobuyoshi*), op. cit.

5 *Araki: Viaggio sentimentale*, op. cit., from a short introductory text printed on the outer cover.

6 Shomei Tomatsu, b.1930: see Ian Jeffrey, *Shomei Tomatsu*, series 55 (London: Phaidon, 2001).

7 Daido Moriyama, b.1938: see Kazuo Nishii, *Daido Moriyama*, series 55 (London: Phaidon, 2001).

8 Takuma Nakahira, b.1938: for an introduction to Nakahira, see *Degree Zero – Yokohama*, exh. cat. (Yokohama Museum of Art, 2003).

9 November 1968, March and August 1969. For a discussion of *Provoke* see Kazuo Nishii, *Daido Moriyama*, op. cit., pp. 6–9.

10 Robert Frank, *Les Américains* (Paris: Robert Delpire, 1958), republished as *The Americans* (New York: Grove Press, 1959), with a foreword by Jack Kerouac. Many of the American pictures can be seen in Robert Frank, *Storylines* (Göttingen and London: Steidl Publishers and Tate Enterprises, 2004).

11 Kazuo Nishii, *Daido Moriyama*, op. cit., p. 7, from an original text in *Provoke* magazine.

12 Keiko Nomura, *Deep South* (Tokyo: Little More, 1999).

FACES

MY LABORATORY

—

Whether you're dealing with advertising or whatever, creating something has to begin with documentation. Documenting is all about grasping the essence of a human being.

A documentary record involves continuous intense observation. It's also about discovery and excitement. I find it pretty hard to focus my eyes on anything in real life, and it's only through the camera lens that I can really get focus intensively on something. The first page of my research on the human species concentrated on middle-aged women, who hold a particular fascination for me. If you photograph middle-aged women strolling along Ginza and lay the photos on a blank sheet of paper, you get works of art in their own right created as it were by the women themselves. You can discover the essence of middle-aged women. There's no one quite as dramatic as middle-aged women.

I have an old-fashioned conviction that authenticity can only be created by people who are themselves authentic. I'm always going on about how we need first and foremost to get away from the fake.

PHOTOGRAPHS
DON'T PORTRAY THINGS
JUST AS THEY ARE

—

Another thing is that photography is an extremely private business. That's its major attraction. It's something that must absolutely be done together with another person. You meet someone and want to talk to them. It's this feature that's the attraction of photography.

Photography isn't just about taking a good shot: it's about wanting to project images outwards. It's essentially about insertion, about penetration!

It's fine so long as you don't hurt the other person; you just go ahead and push forward. On the one hand there's the overpowering aspiration, the desire to take photographs, and then there's the desire to show people things, to show them secrets. These desires are there inside the photograph, inside the camera. There's this desire to spread your work, to make people aware, to convey what you're doing, and it's this desire that motivates you to take photographs. This is the mass media aspect of photographs, the exhibitionistic aspect. I came up with this idea in advance of Marshall McLuhan,[1] although we didn't express ourselves in the same way!

You do one bosh job after the other, then you give it one more go. You look at what you've done and you can suddenly see out beyond to the other side. By aiming at this effect, I feel like I've actually been involved in literature all the time!

It's strange but I feel that there's a kind of literary side to my work. It's the same with painting: it's a matter of taking your brushes and blasting forward! Painting is dead easy! Well, no, it isn't. For me, painting and photography are instantaneous arts. Each depicts a specific moment. And they're both about seeing.

But it's about what you see. If you look thoroughly, if you're able to look really thoroughly, you realise that anybody could do this kind of thing. What I mean is that sketching isn't a matter of creating an exact likeness. It's about sketching your feelings.

If you're only interested in creating a likeness, you might think that all you have to do is take a photograph, but photographs really aren't likenesses at all. They both do and don't resemble their subjects. You might think that photographs depict things as they really are, but a camera doesn't create a real likeness. There's nothing to be ashamed about therefore if you draw a picture and it doesn't resemble its subject.

When it comes to photography and photographers, in my case, since I'm a man, I look at a woman of around fifty and I need to be able to imagine in my own mind everything about her past. I can feel that here's a person who has really lived her life to the full, and her past life becomes visible. It's the past that's important when you're doing a portrait of someone aged fifty or sixty. People say that a person's face shows who they really are, and I think that's absolutely true.

[1] Marshall McLuhan (1911–80), Canadian writer, analyst of mass media; Araki may be referring to *The Medium is the Masses* (1967).

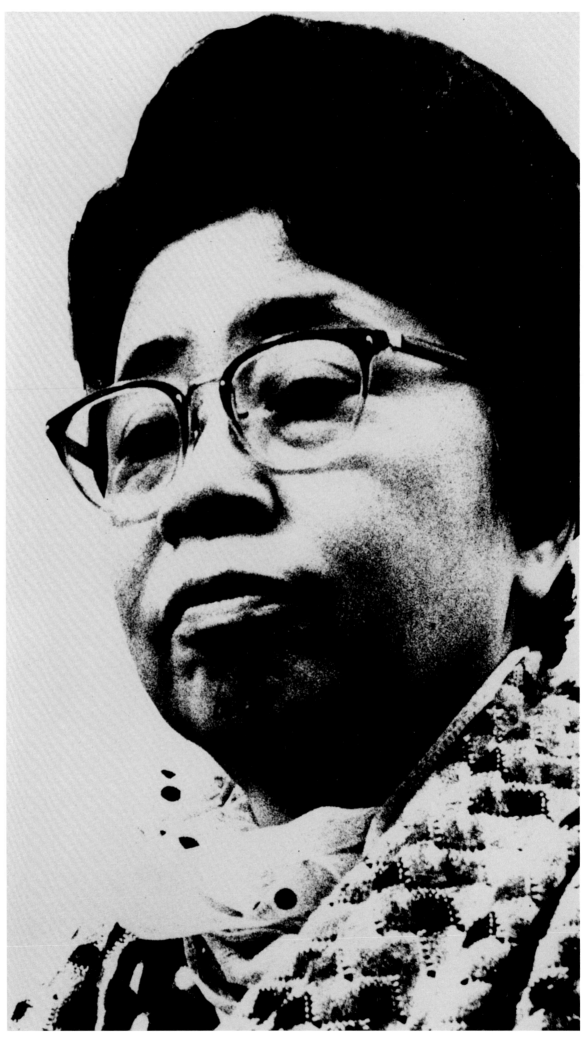

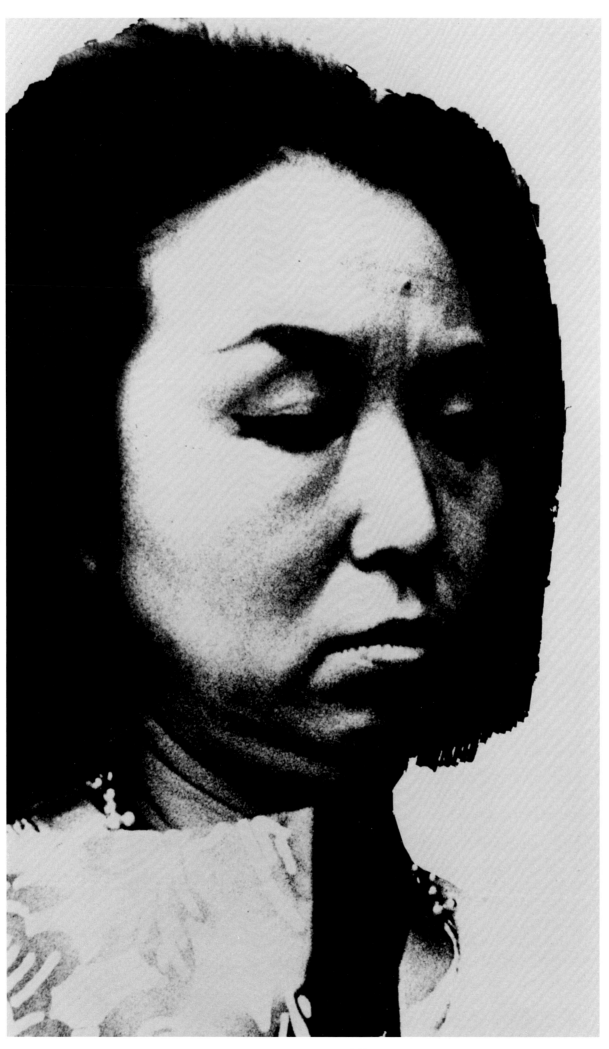

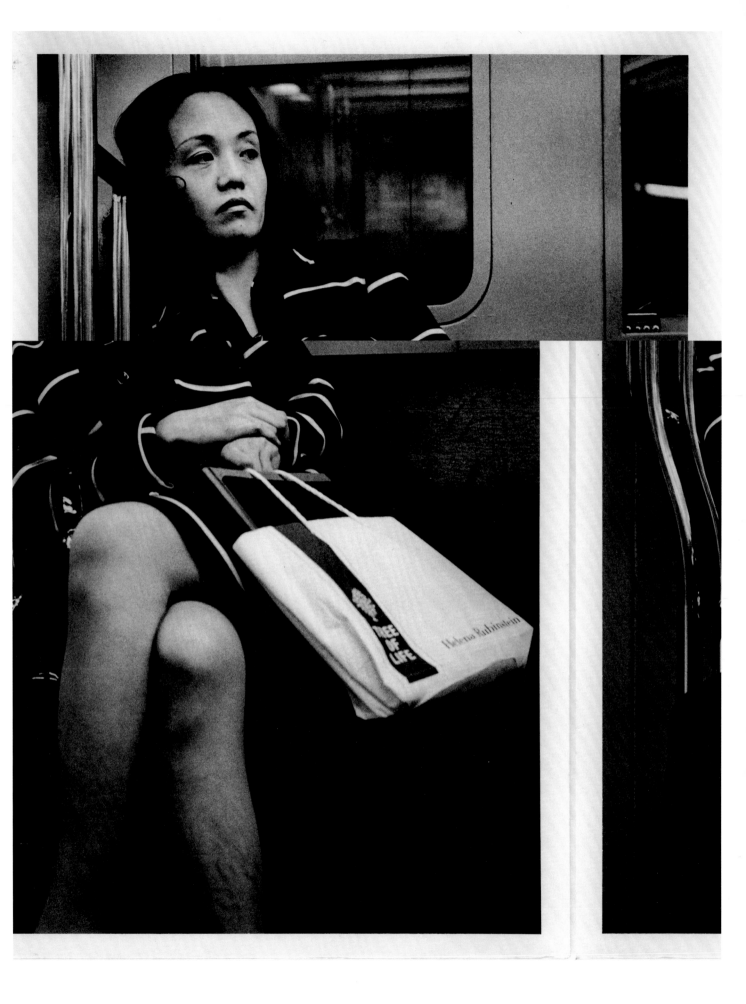

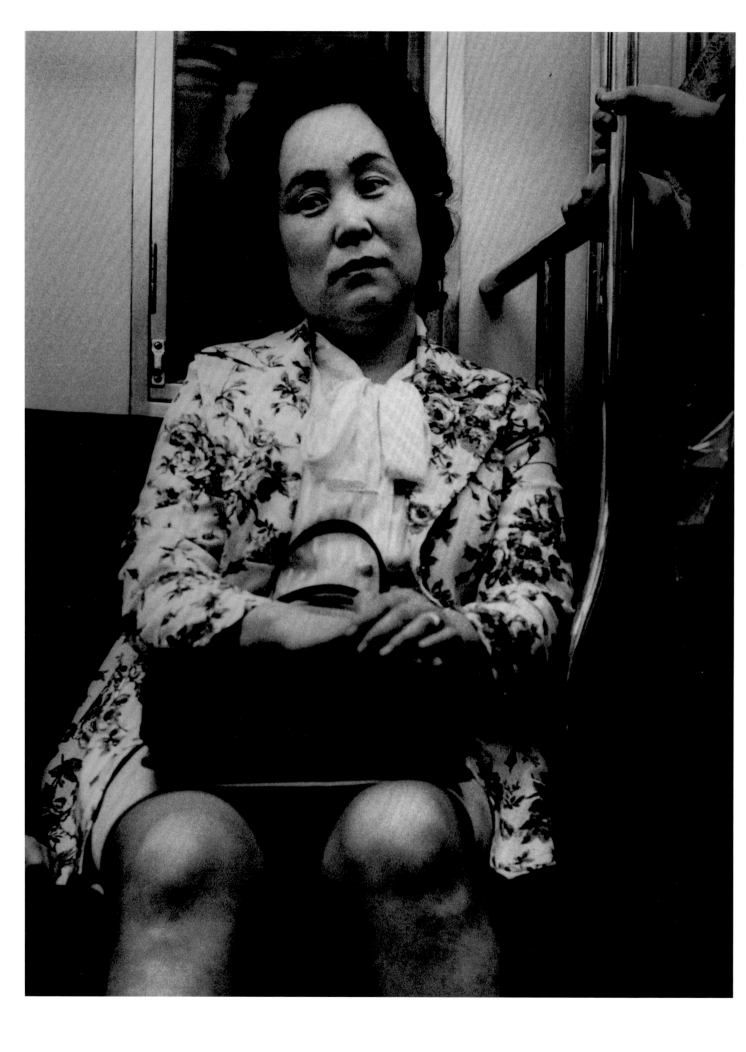

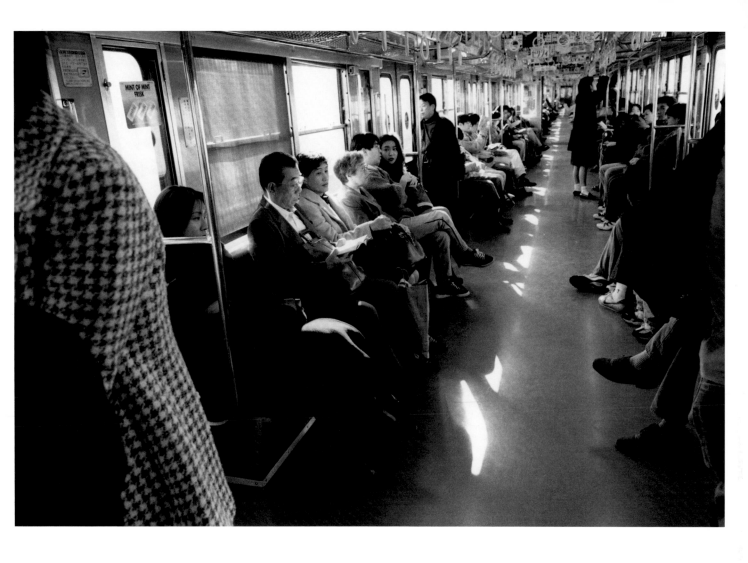

'I'M INTERESTED
IN PEOPLE WHO FIGHT,
BE THEY MEN OR
WOMEN.
MY PHOTOGRAPHS ARE
IN THEIR OWN WAY
A FIGHT BETWEEN MY
SUBJECT AND MYSELF.'

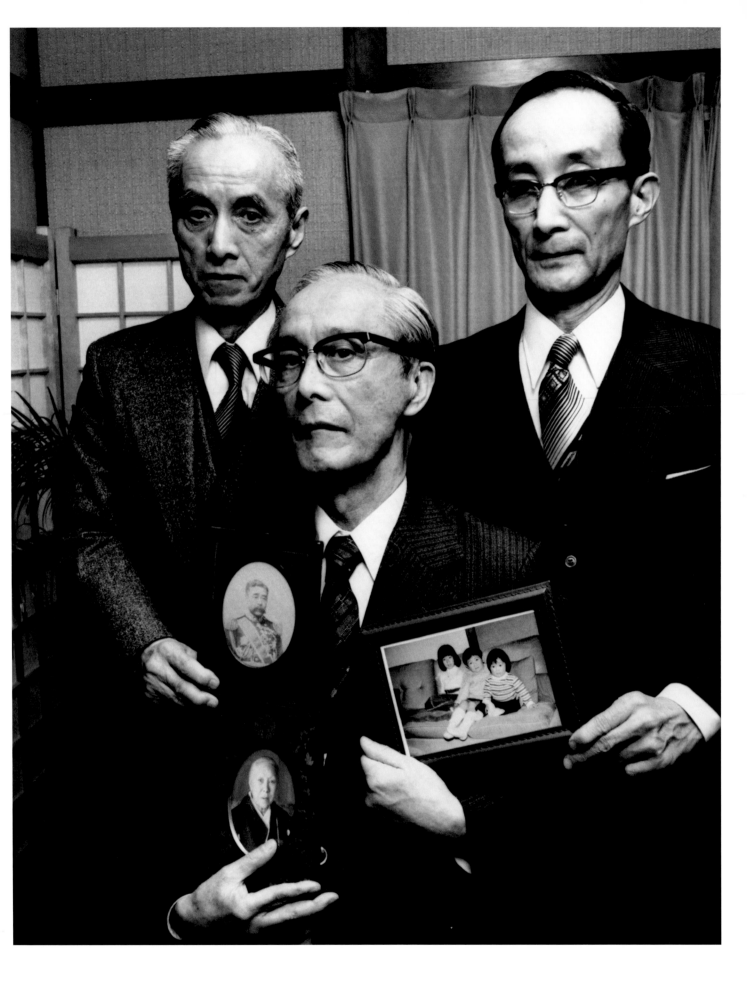

277

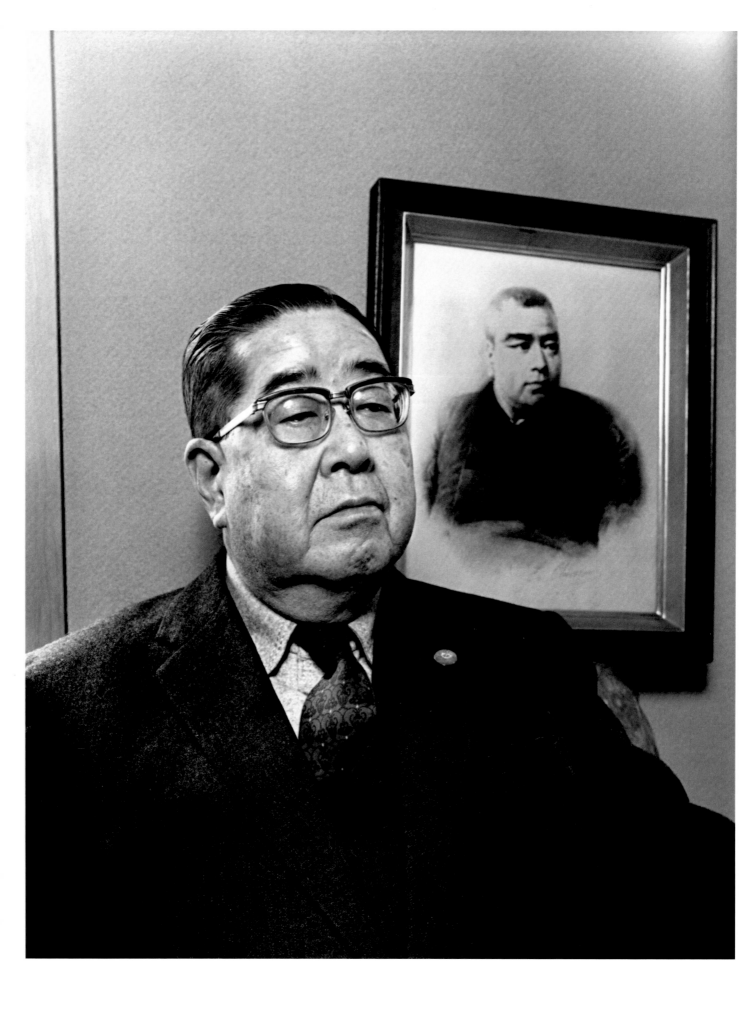

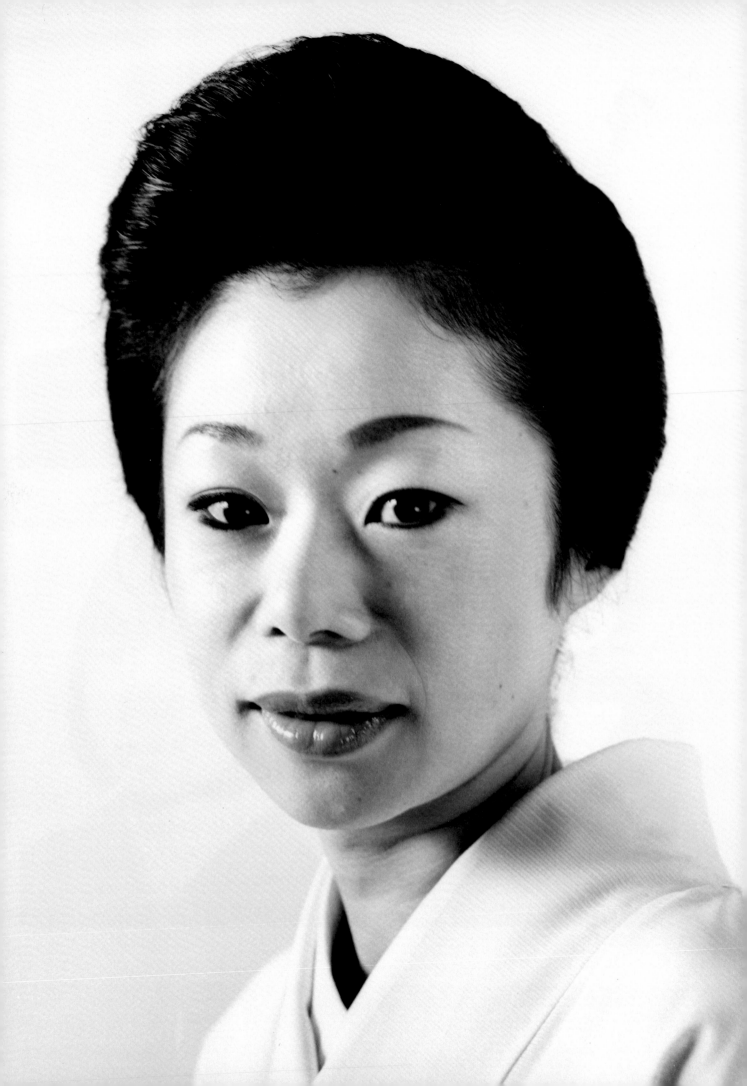

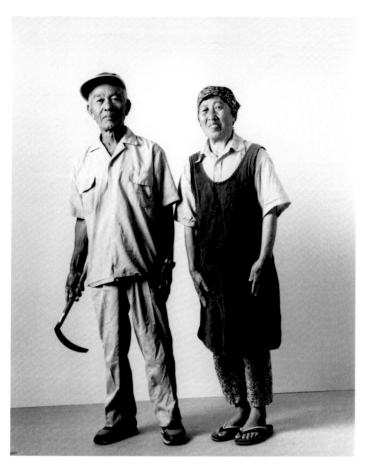
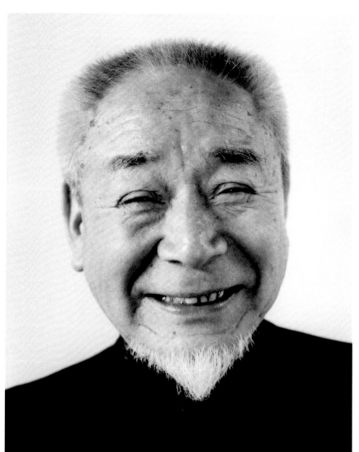
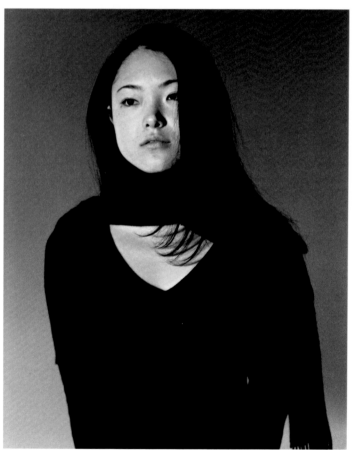

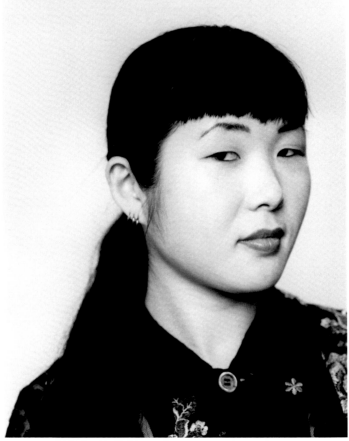

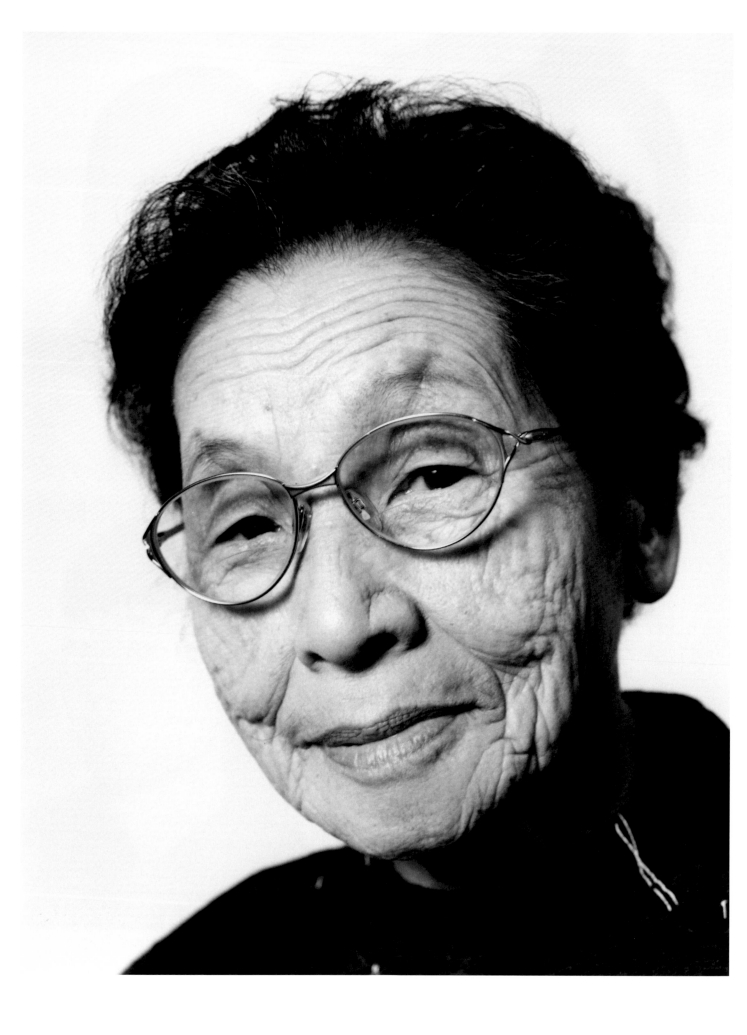

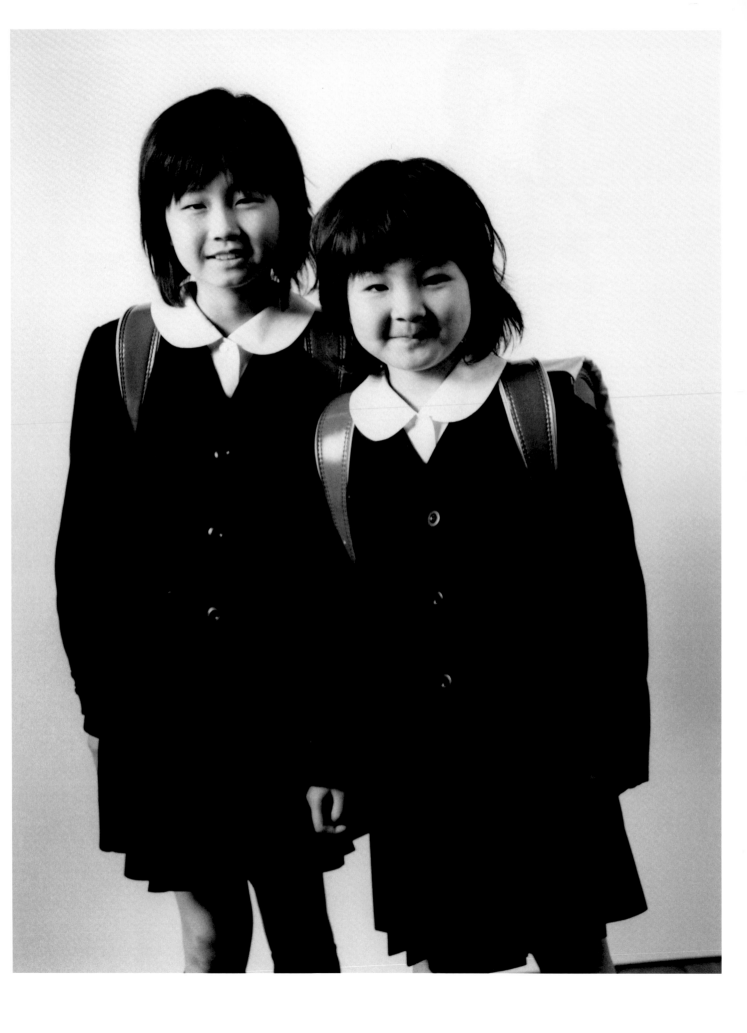

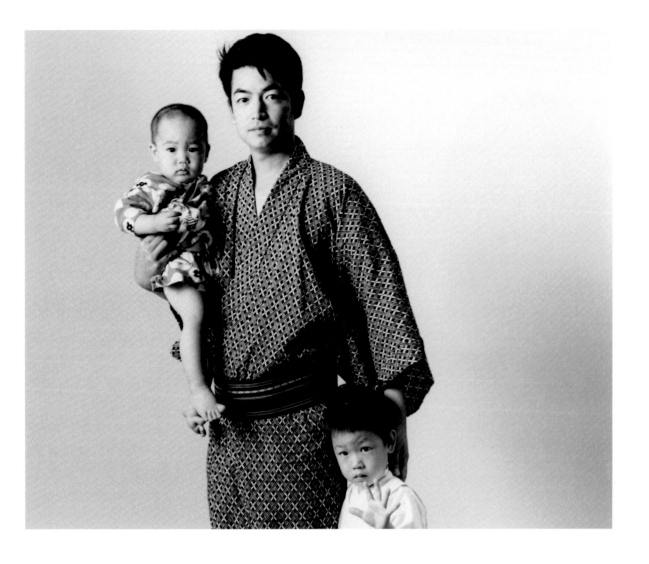

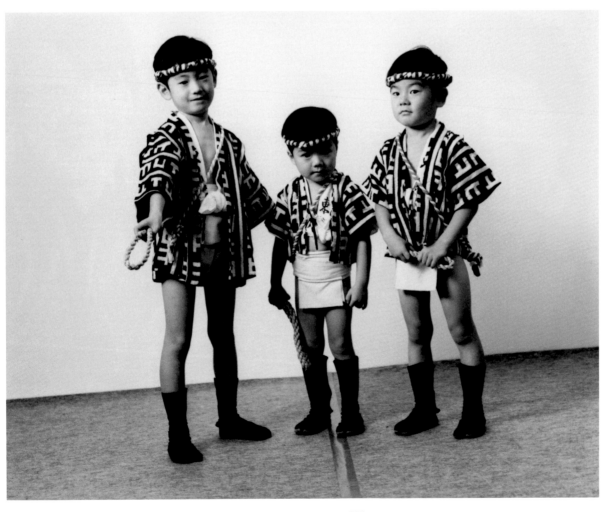

EROS

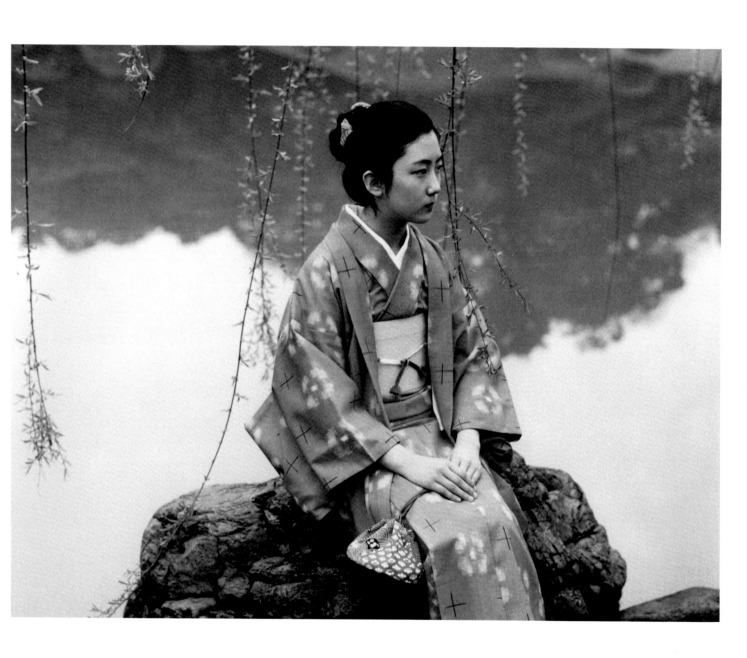

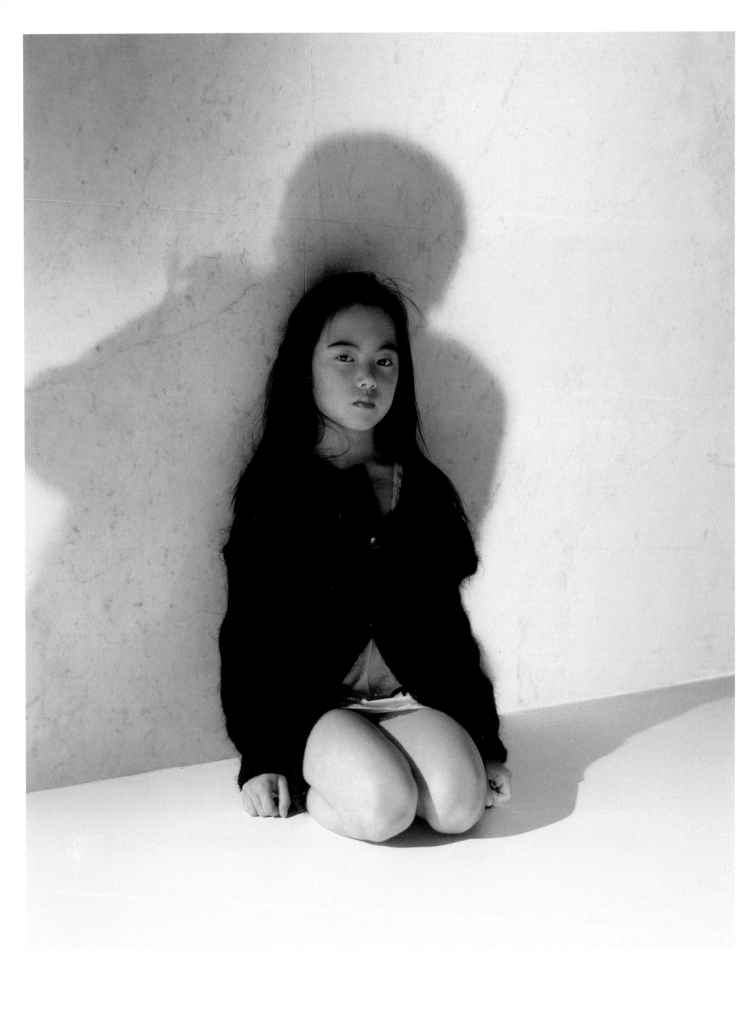

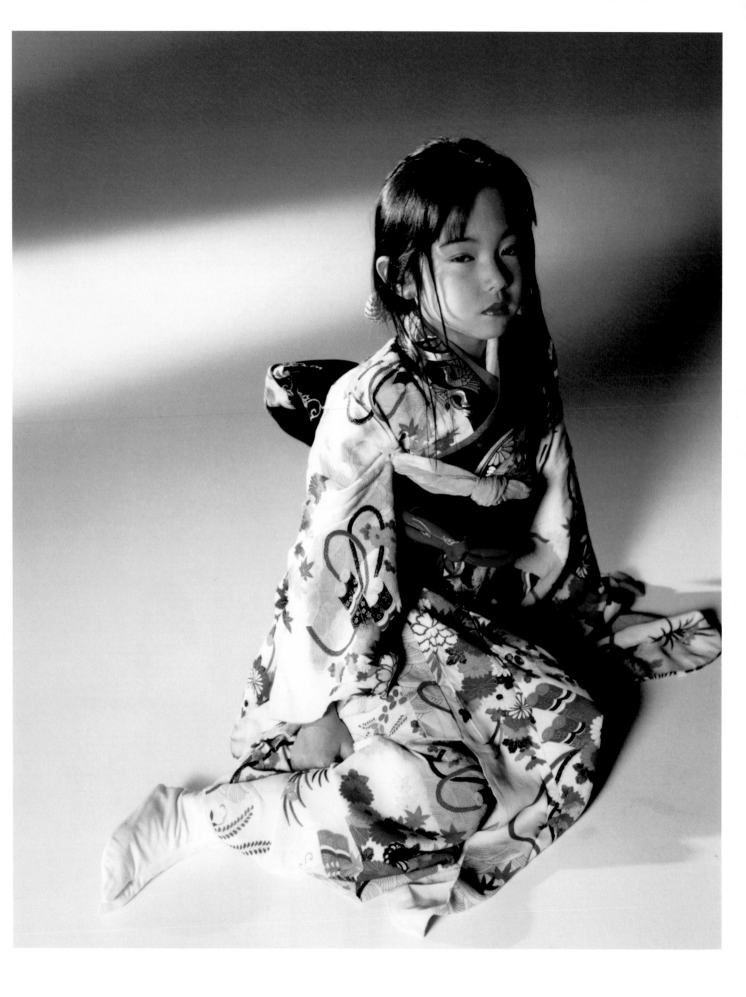

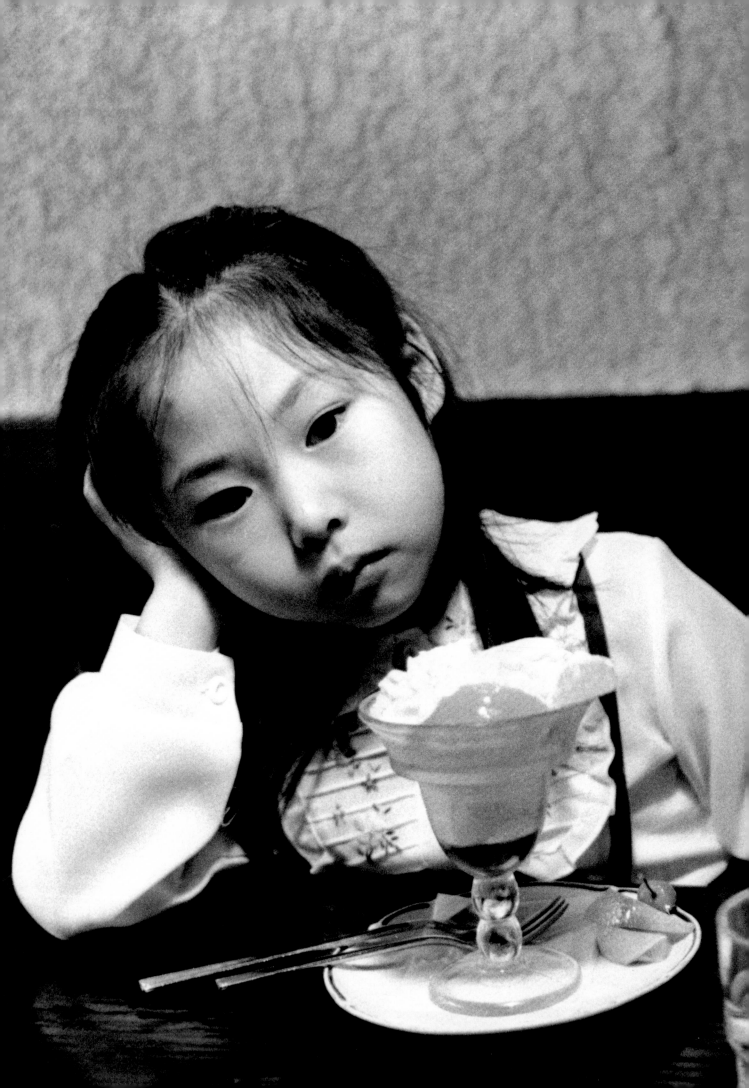

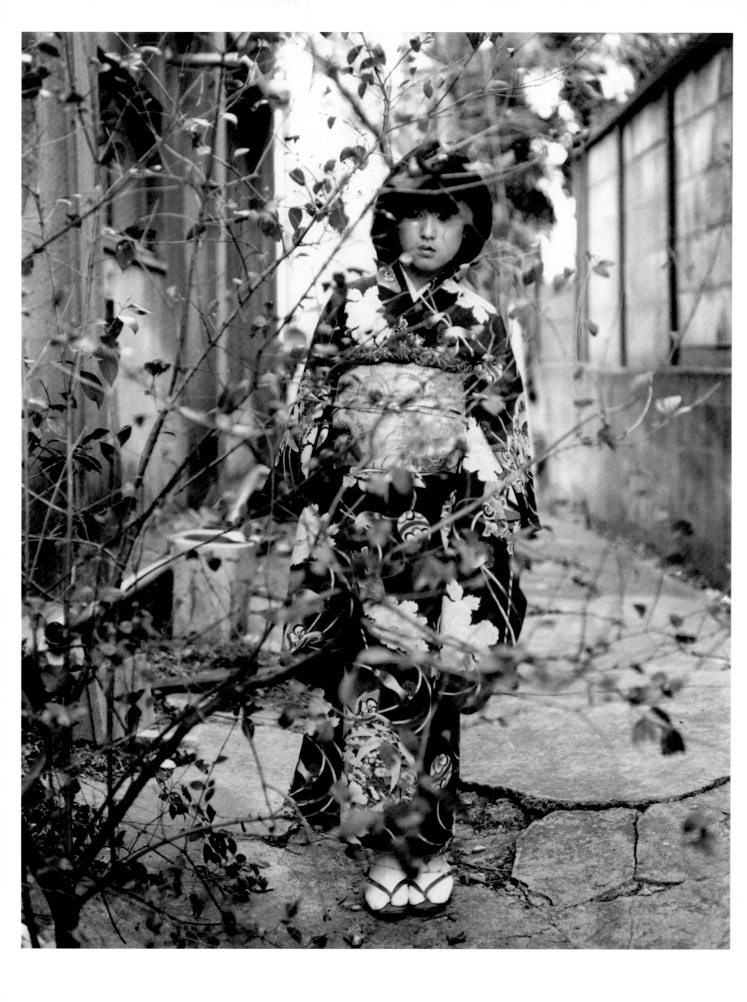

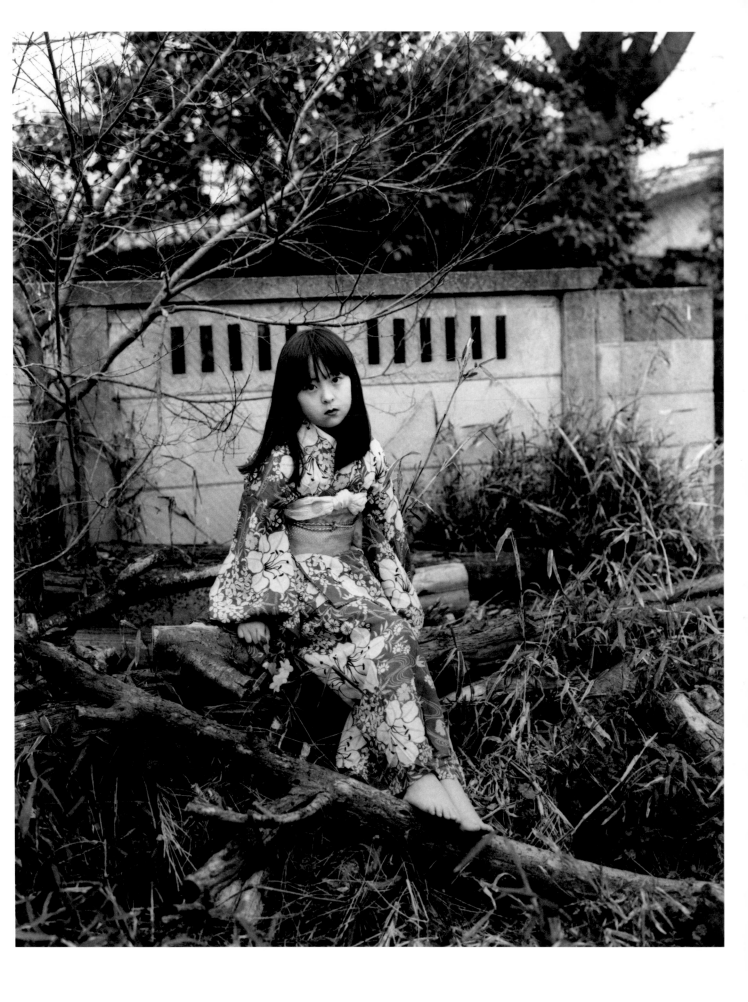

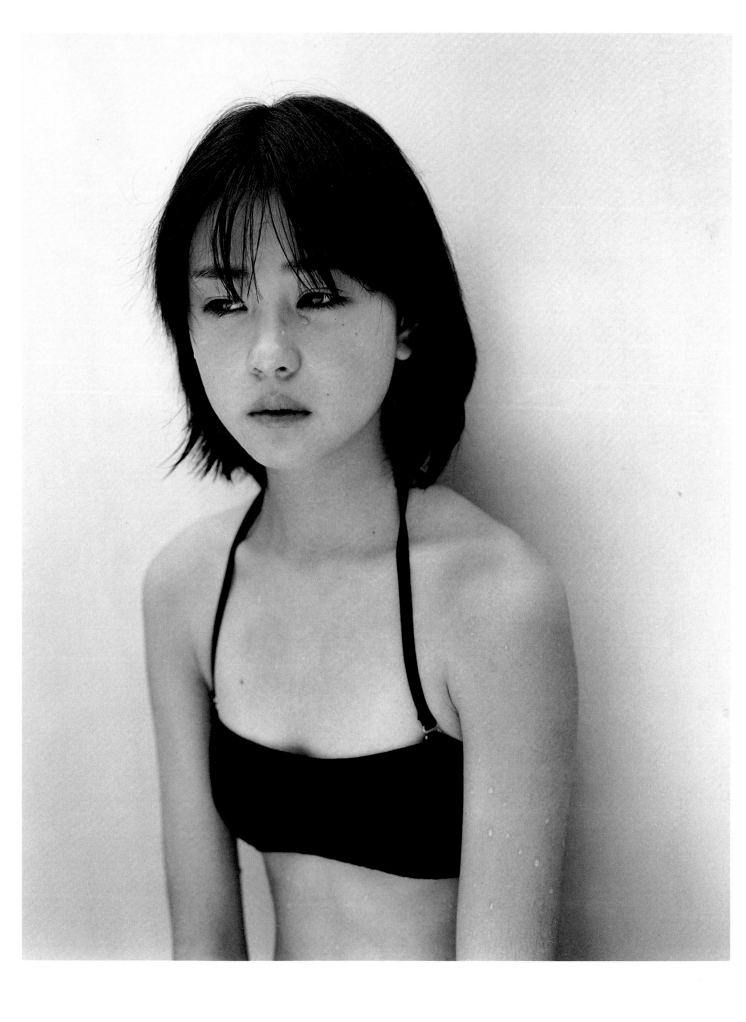

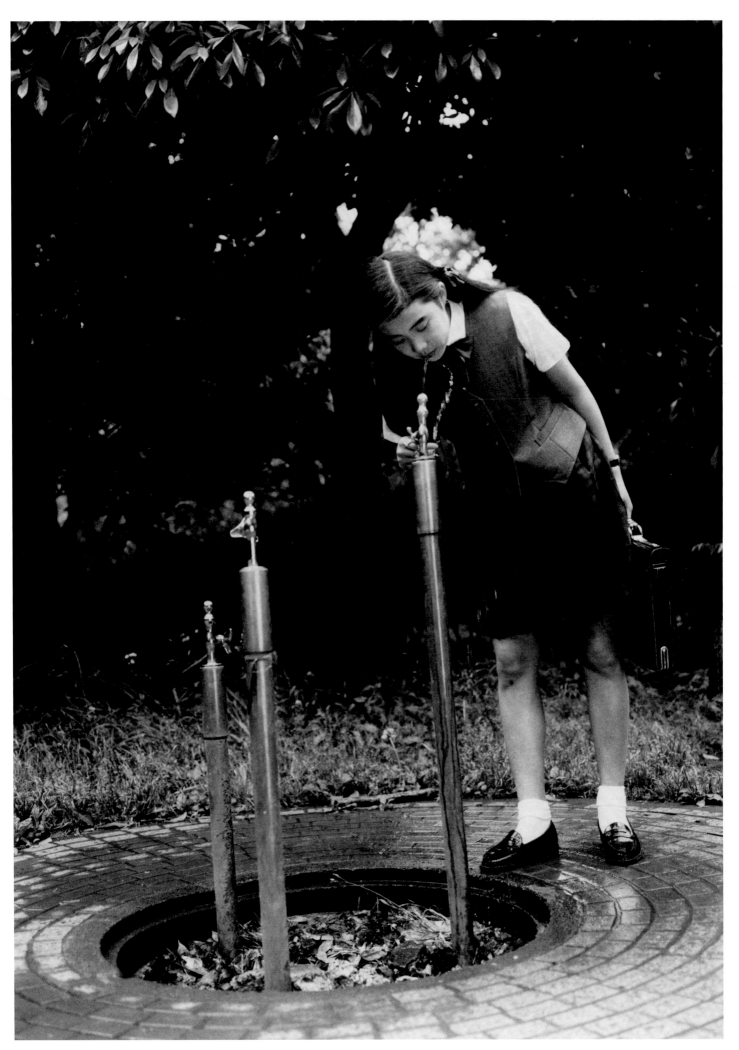

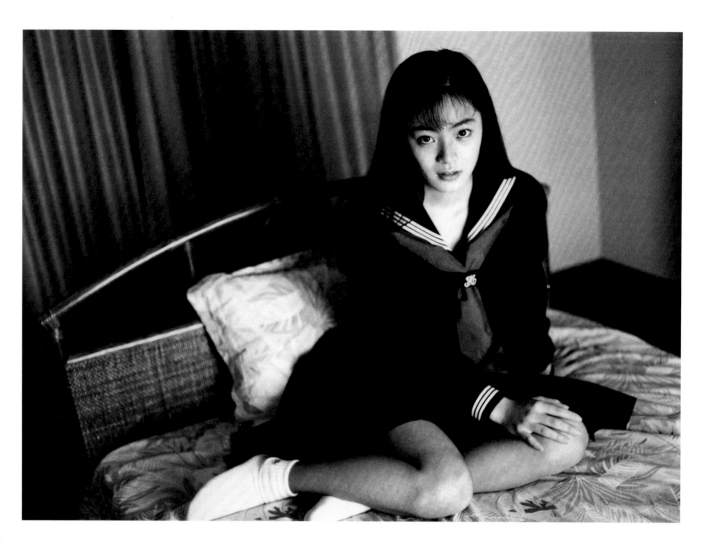

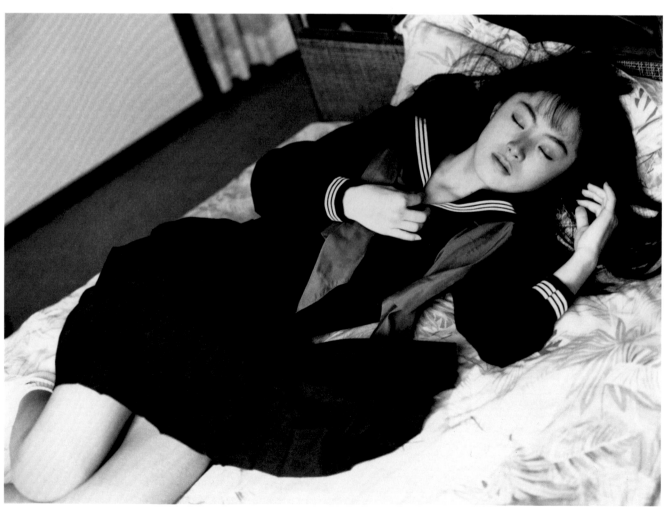

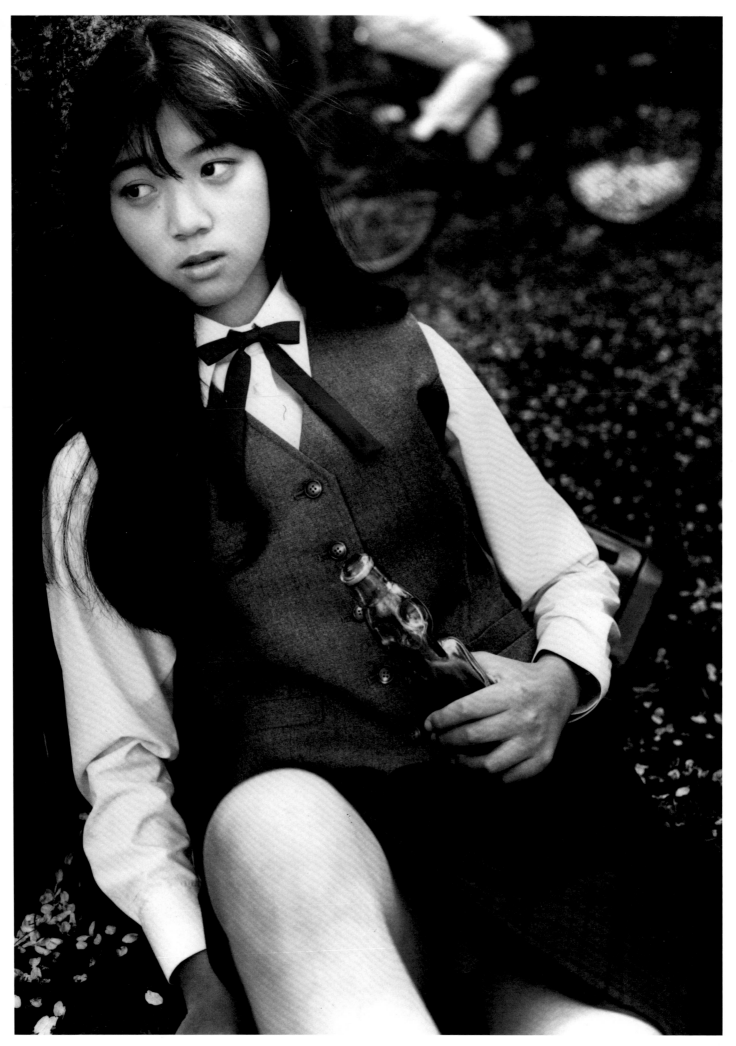

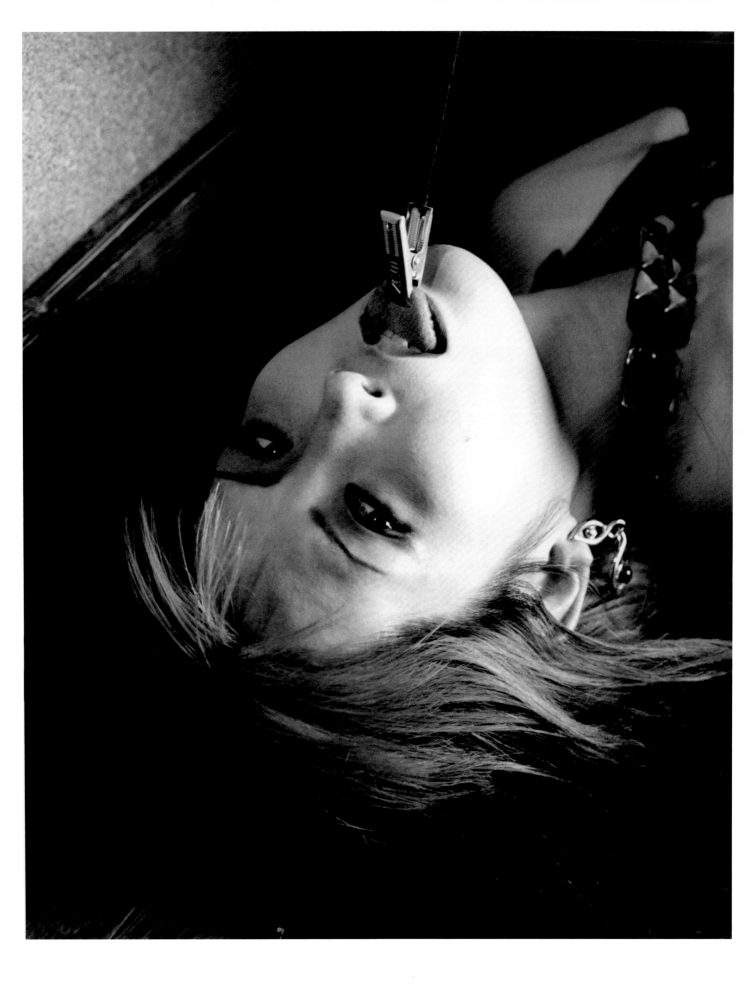

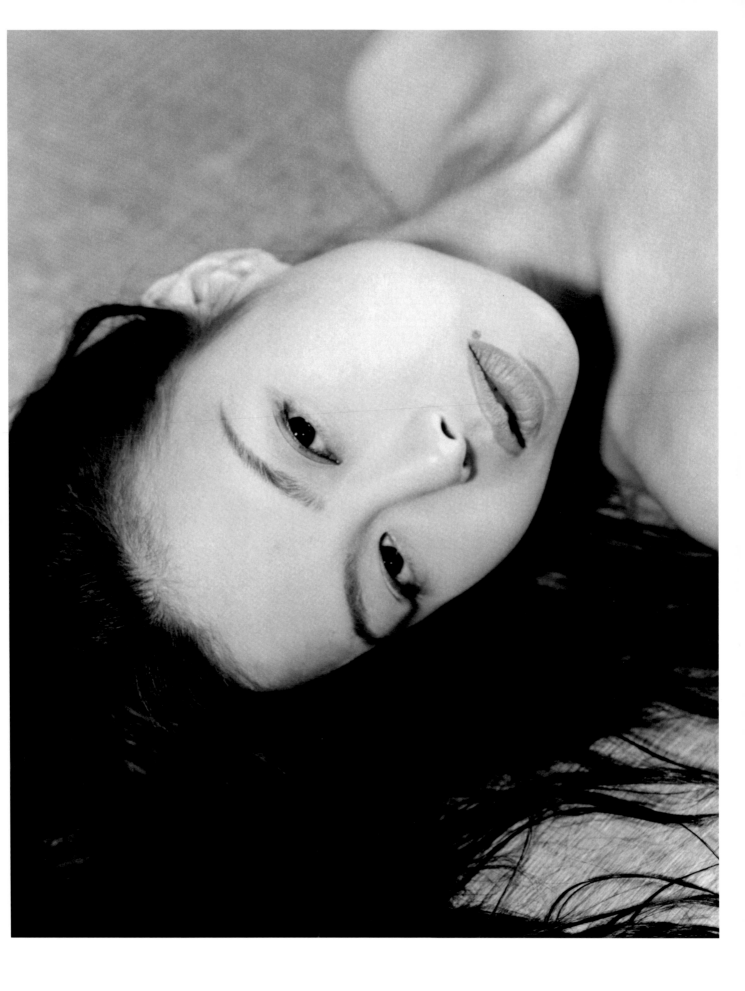

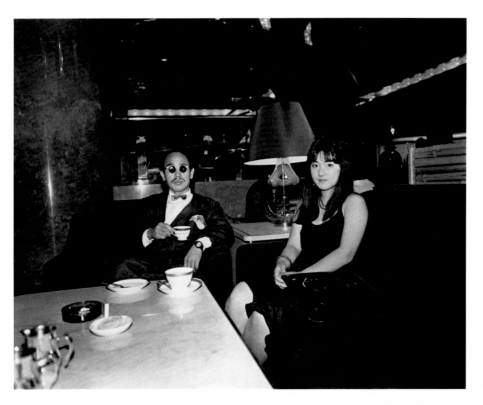

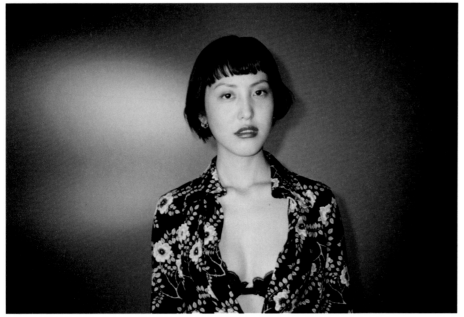

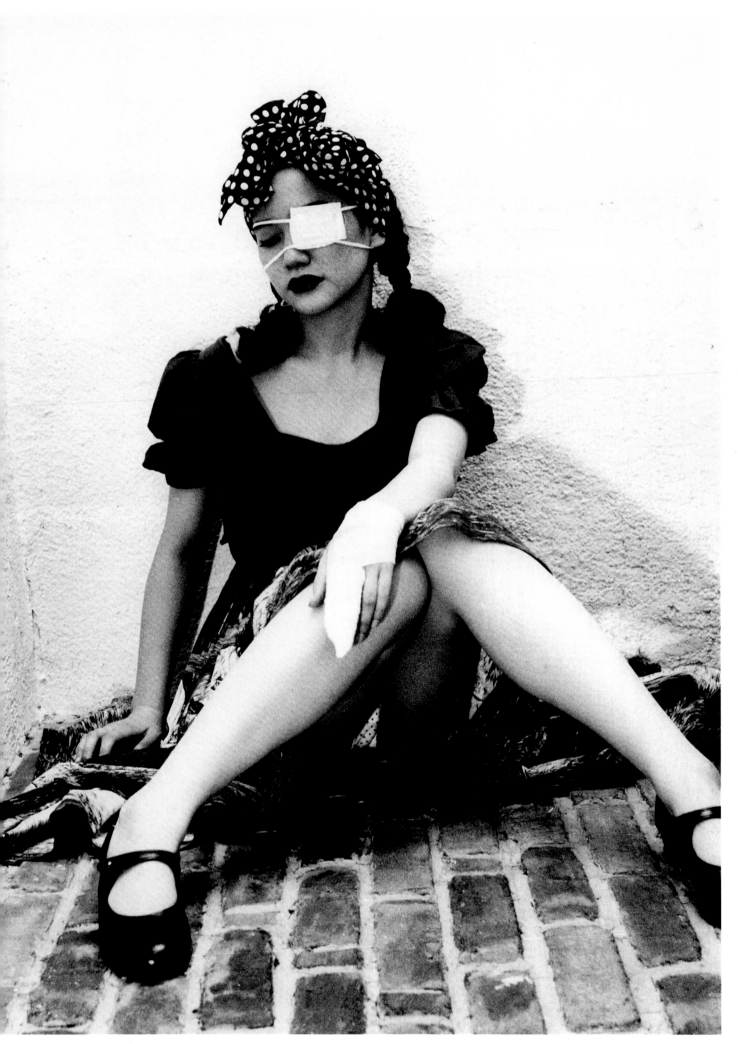

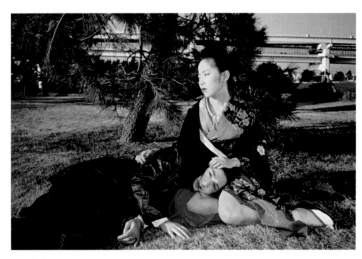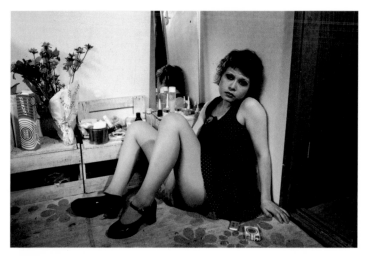

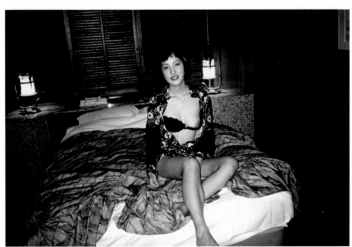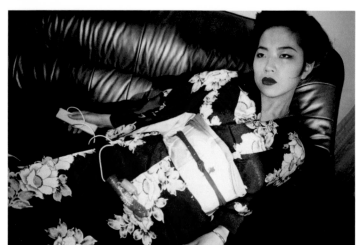

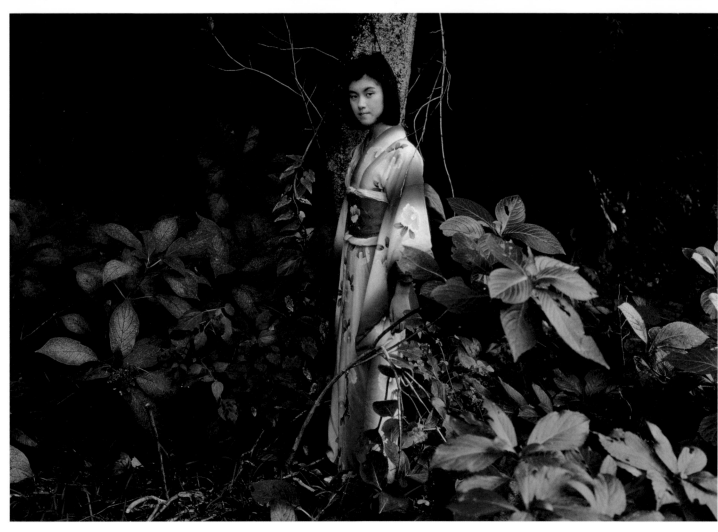

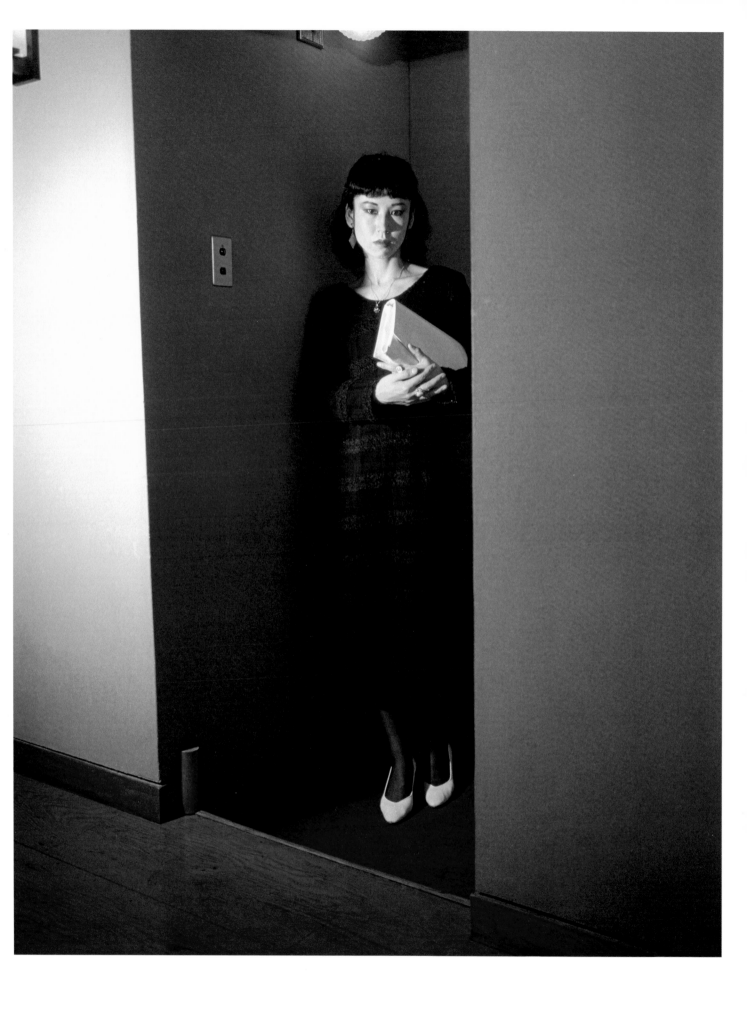

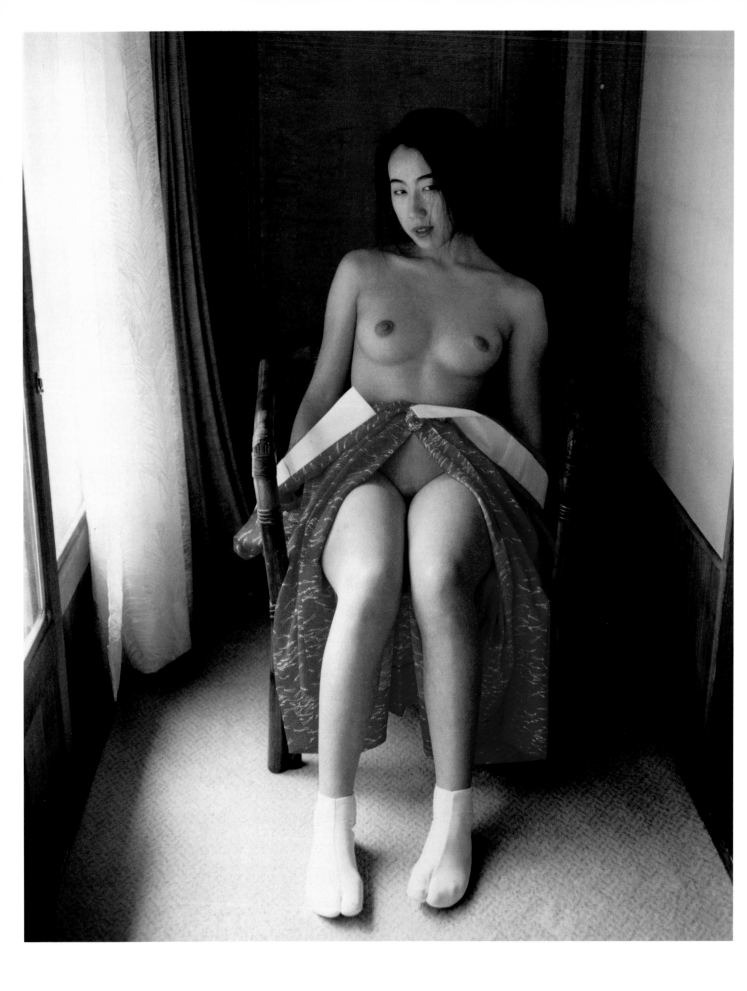

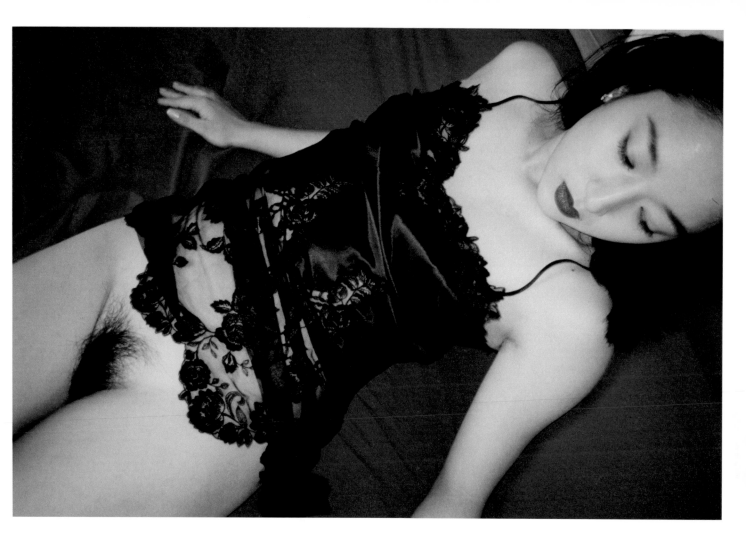

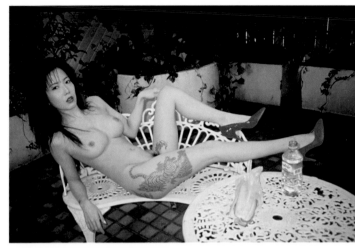
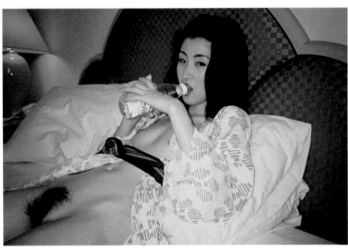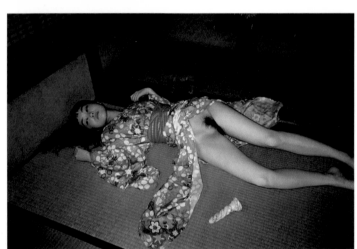
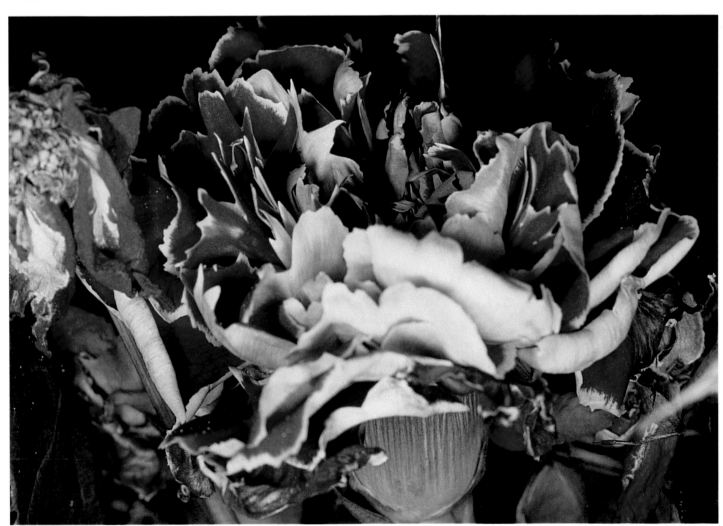

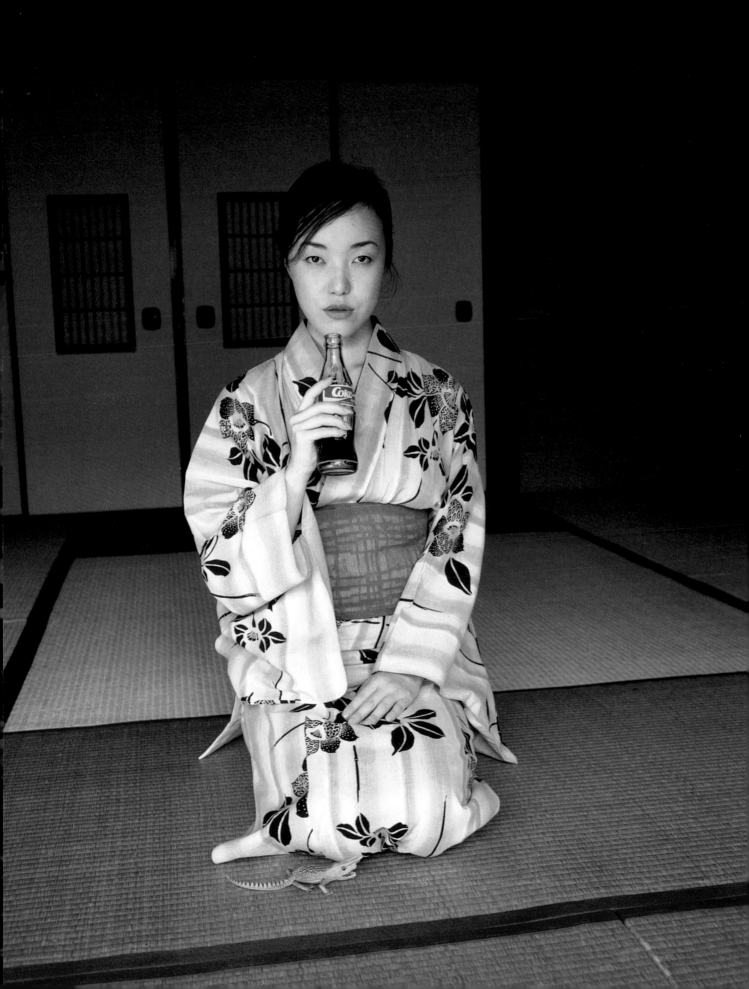

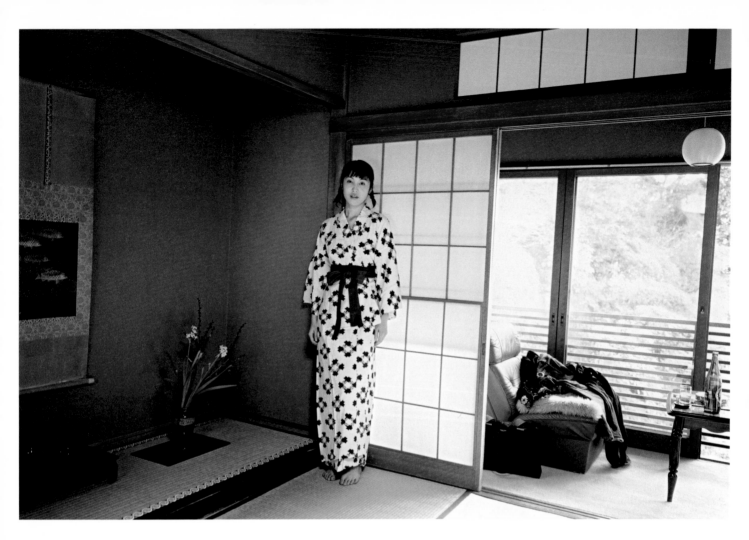

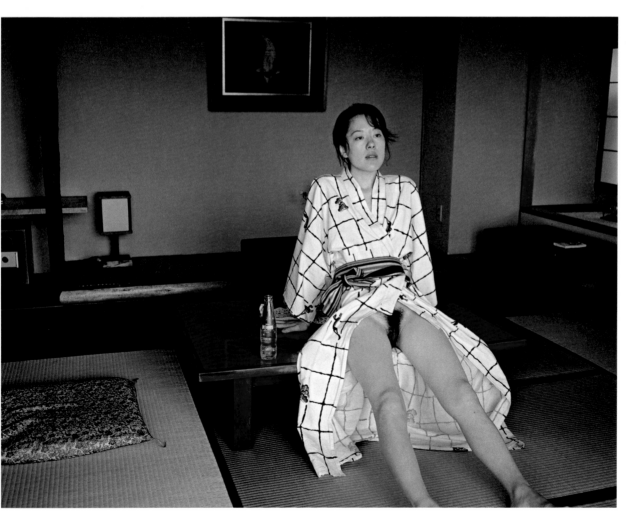

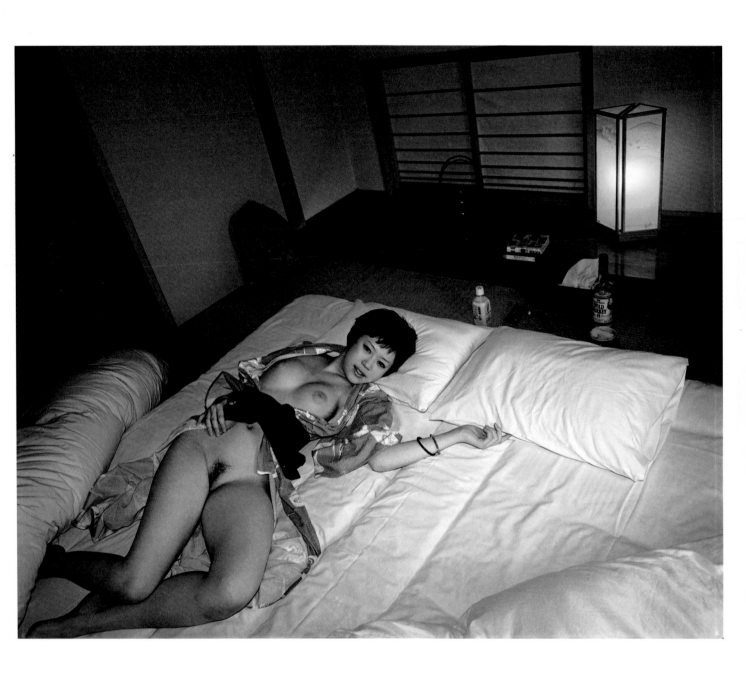

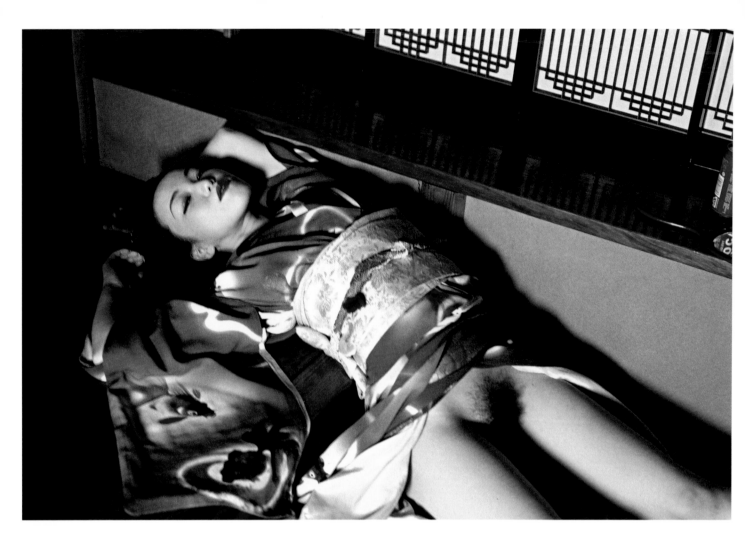

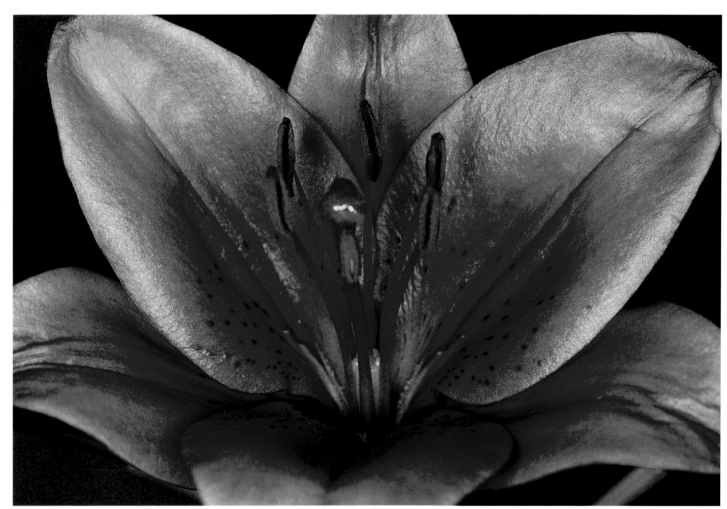

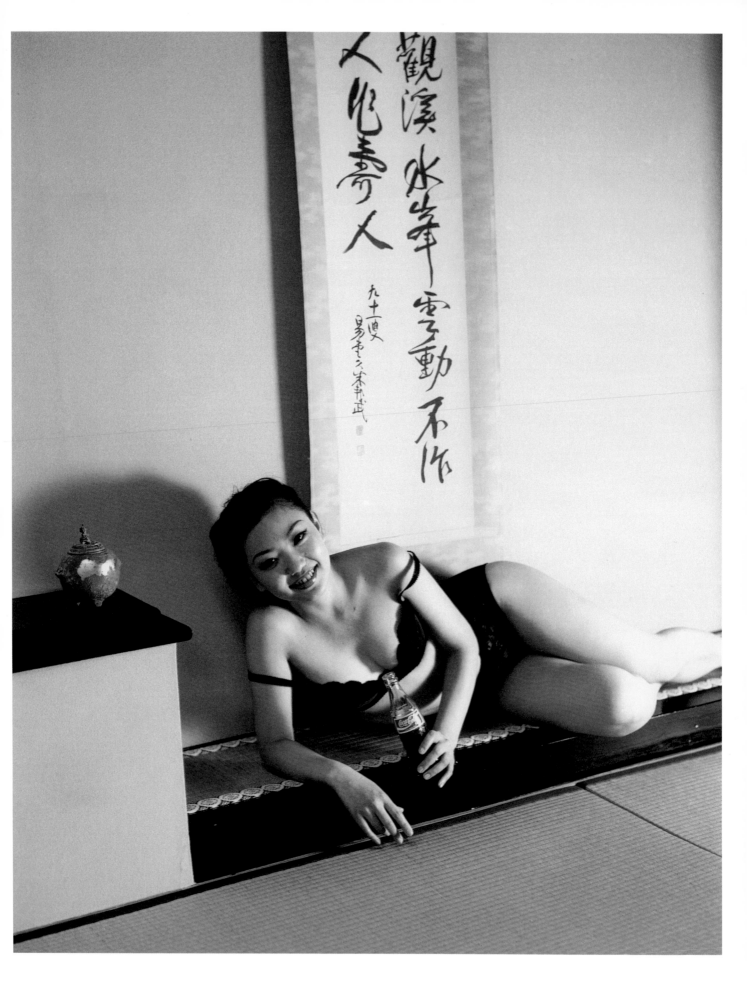

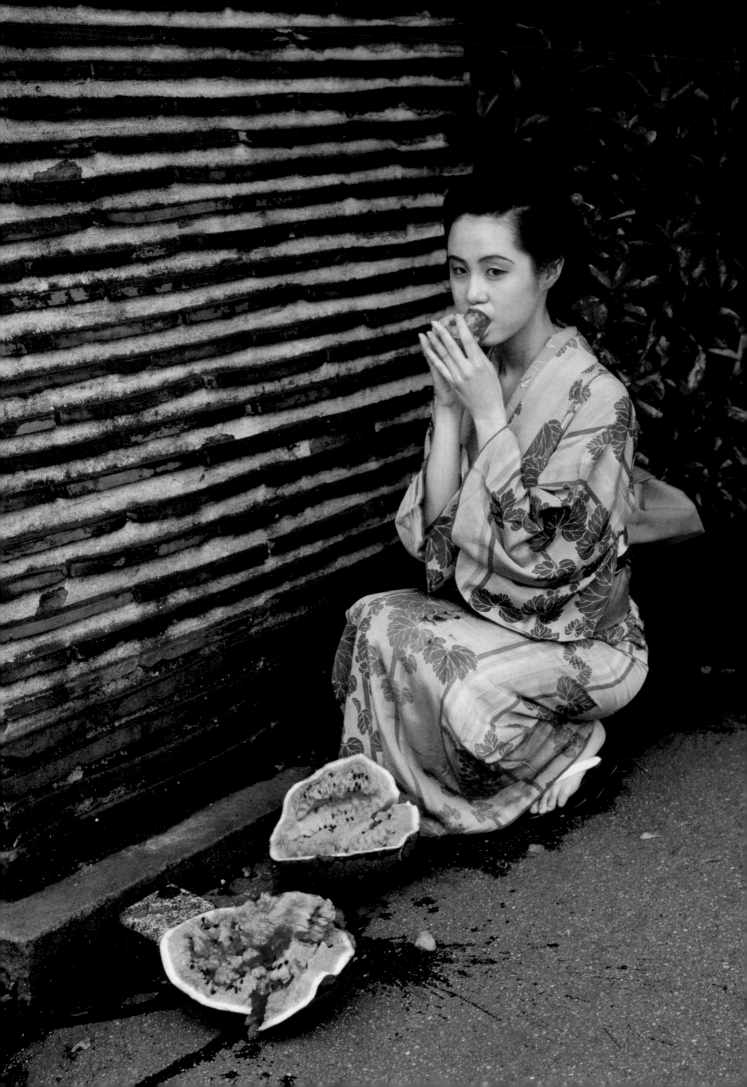

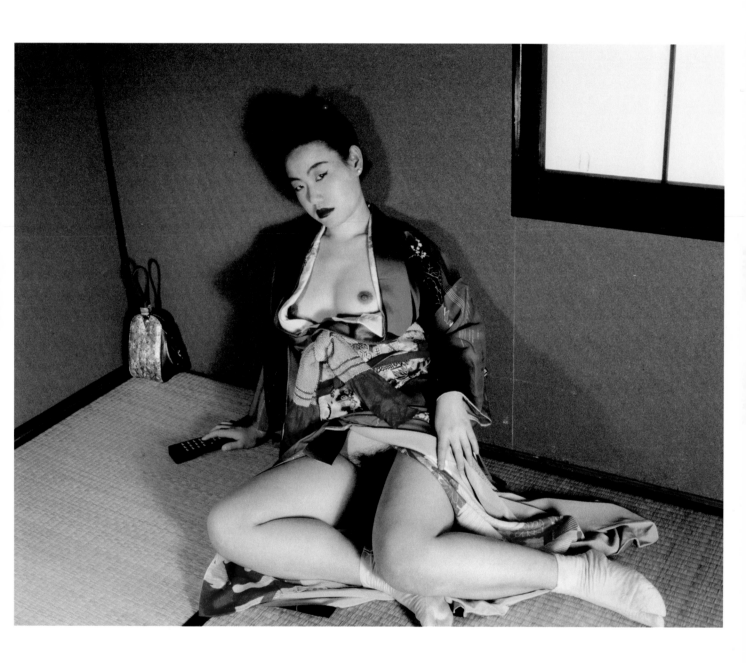

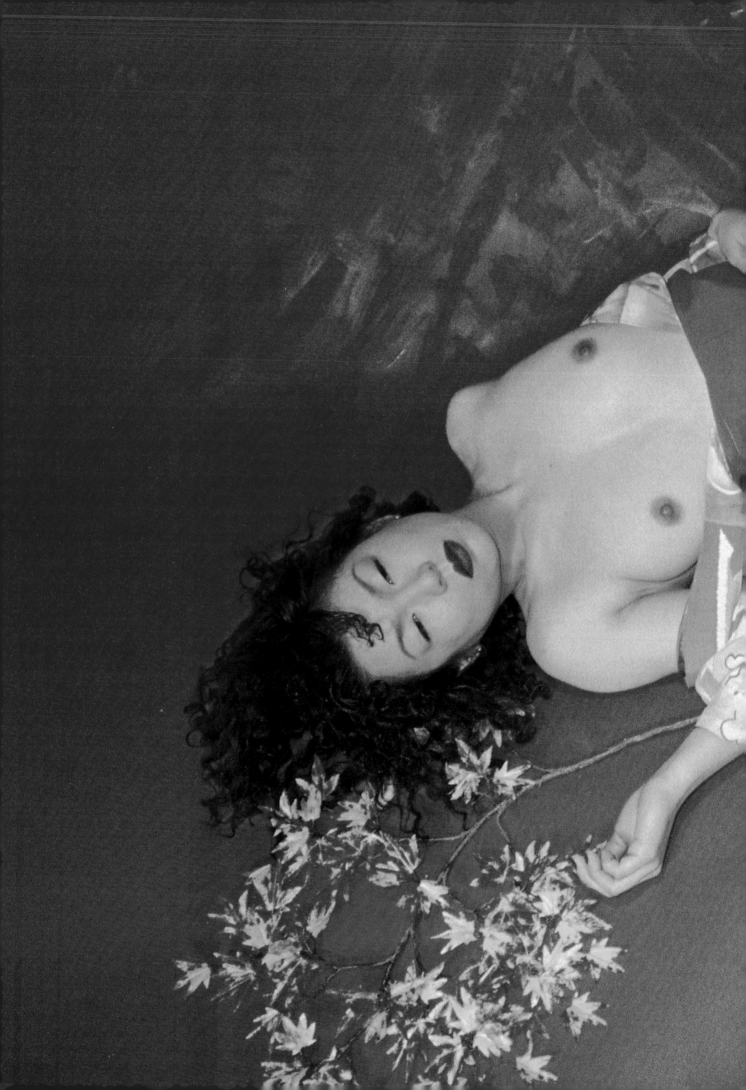

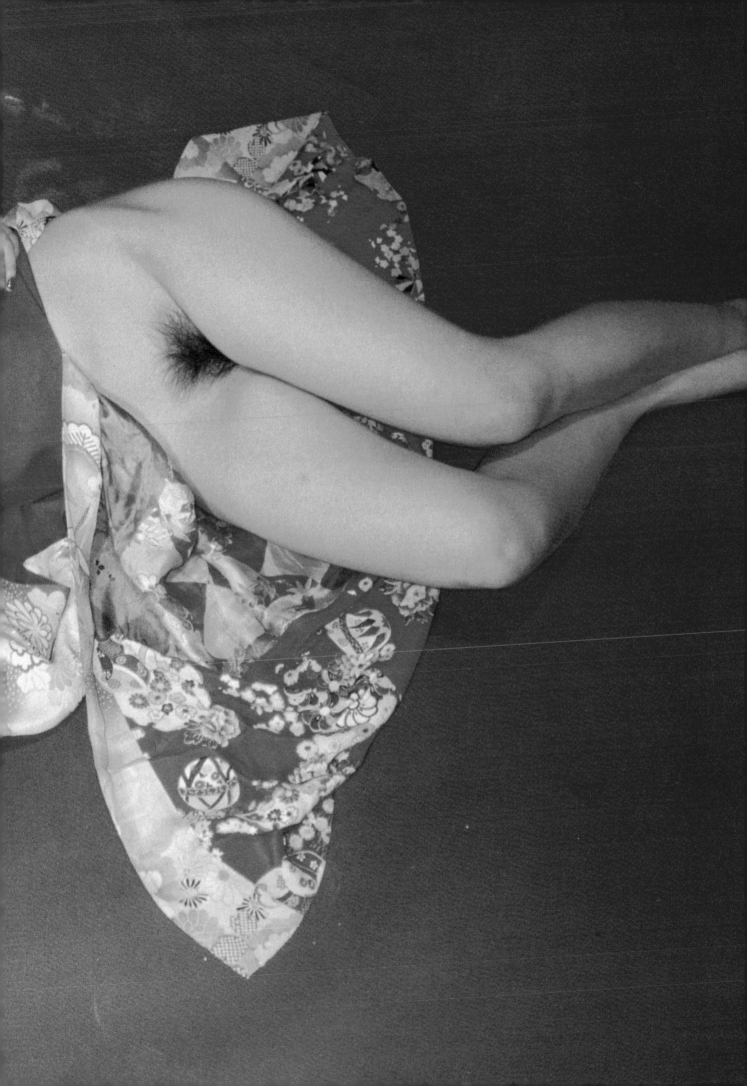

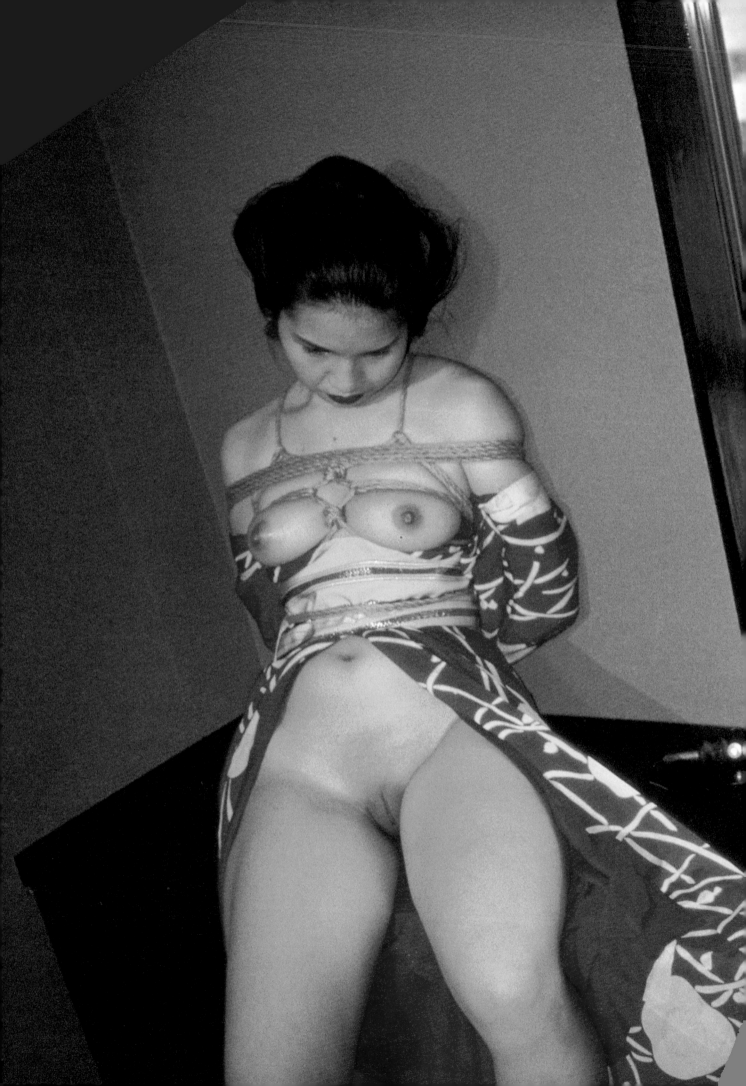

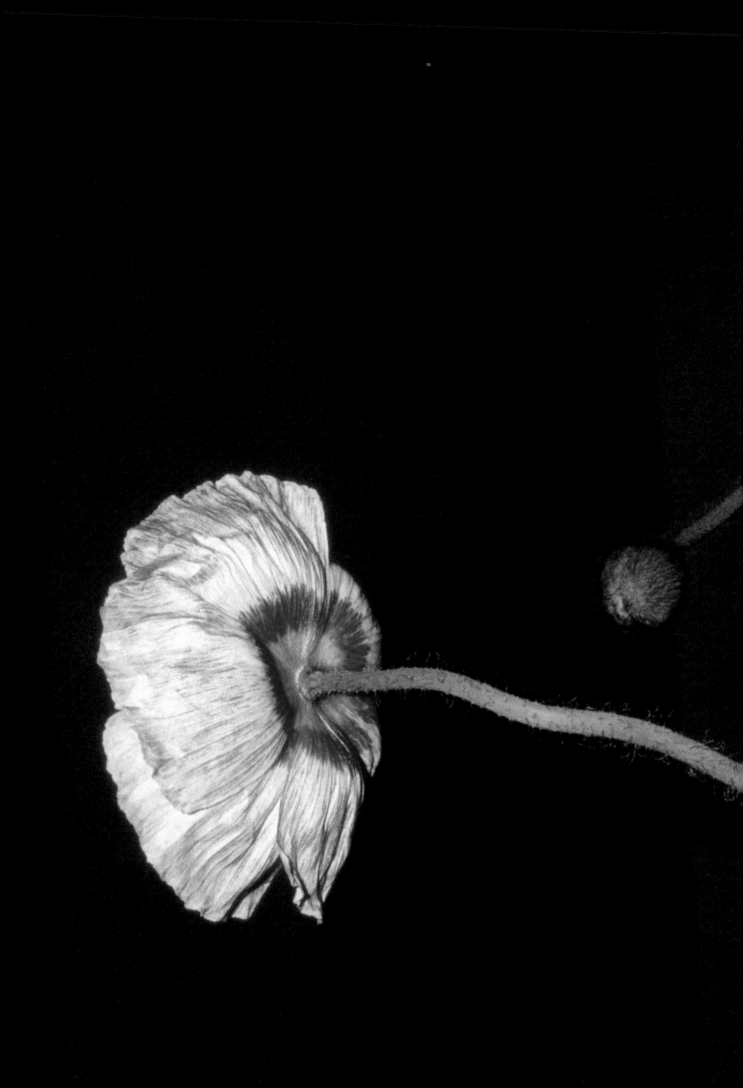

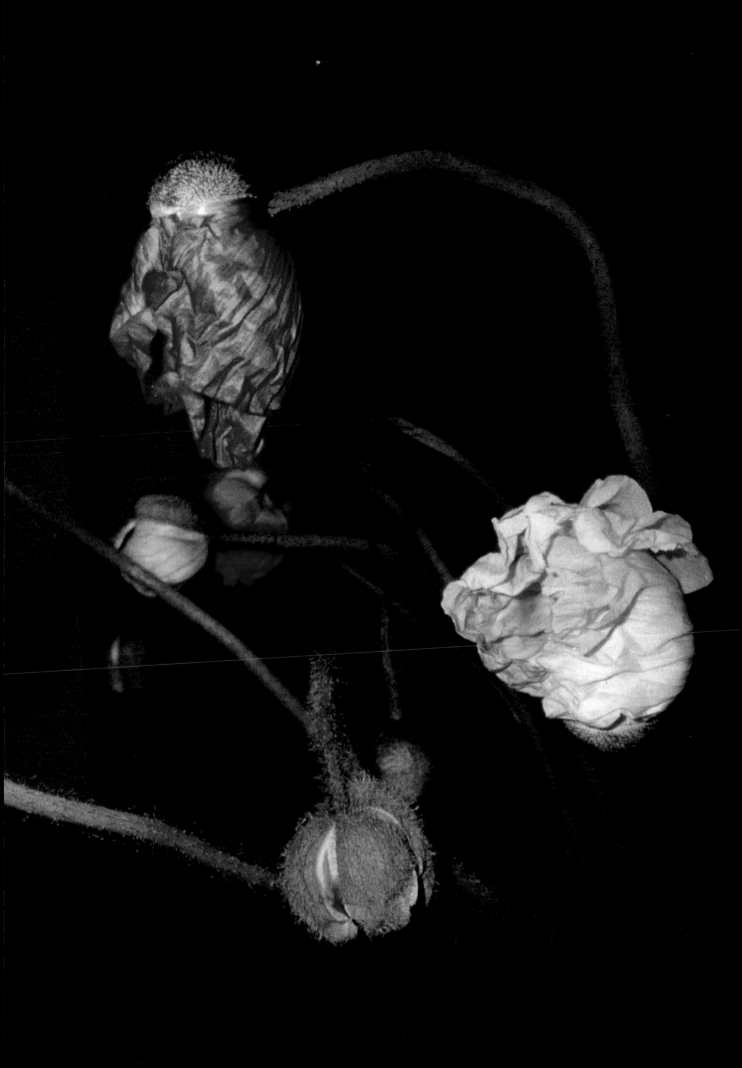

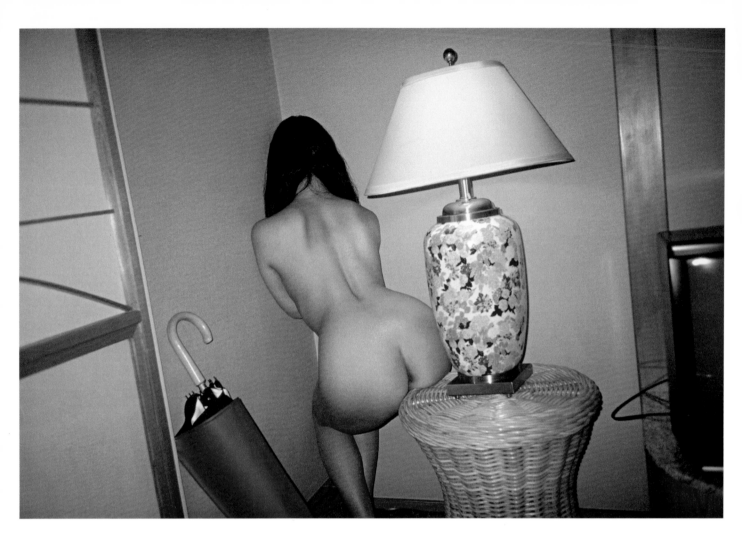

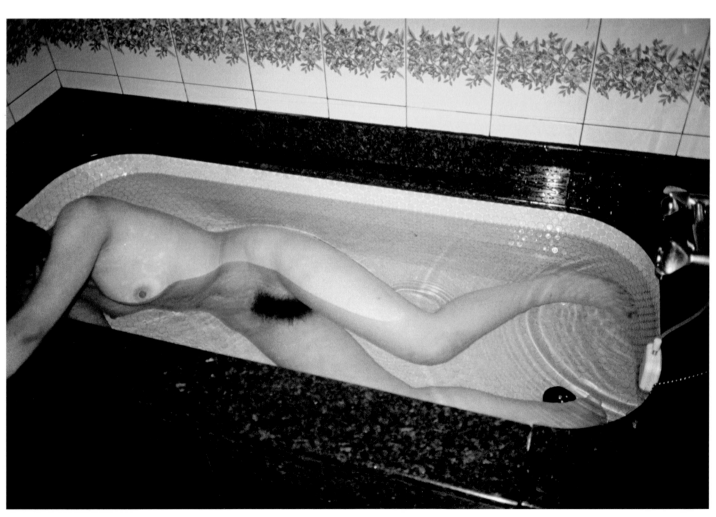

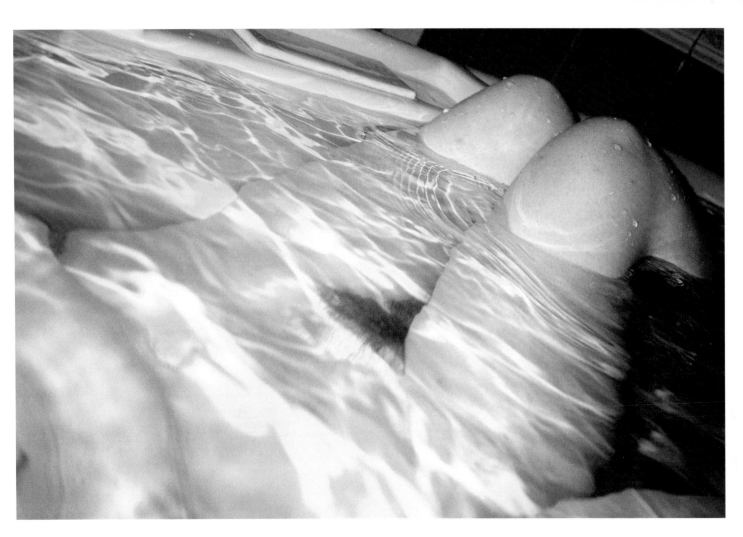

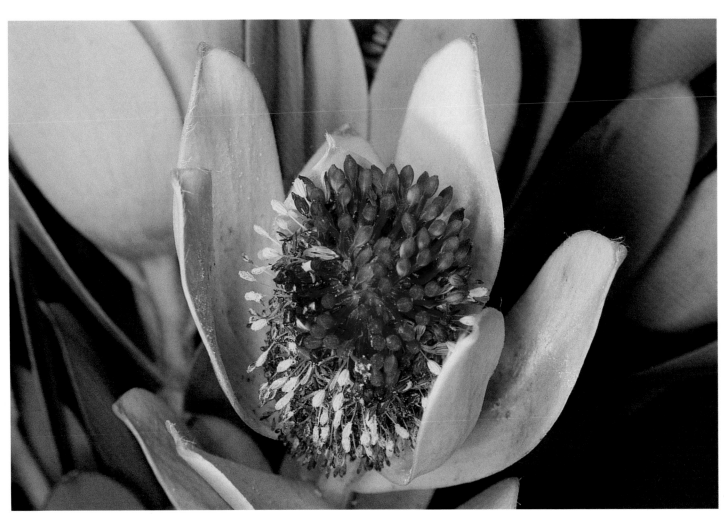

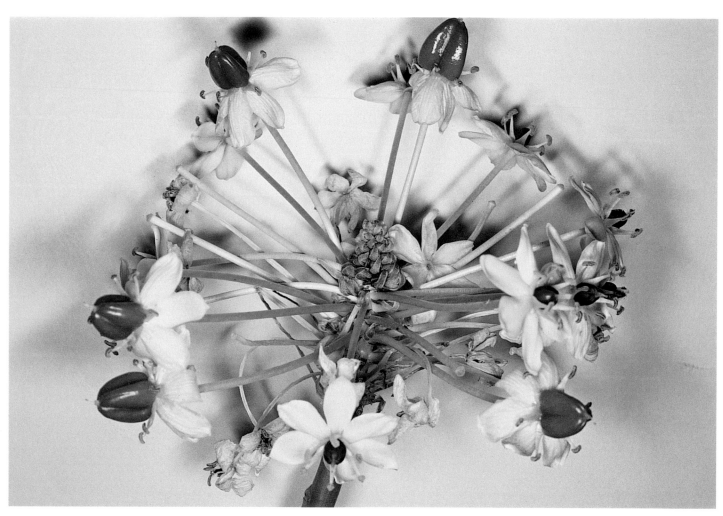

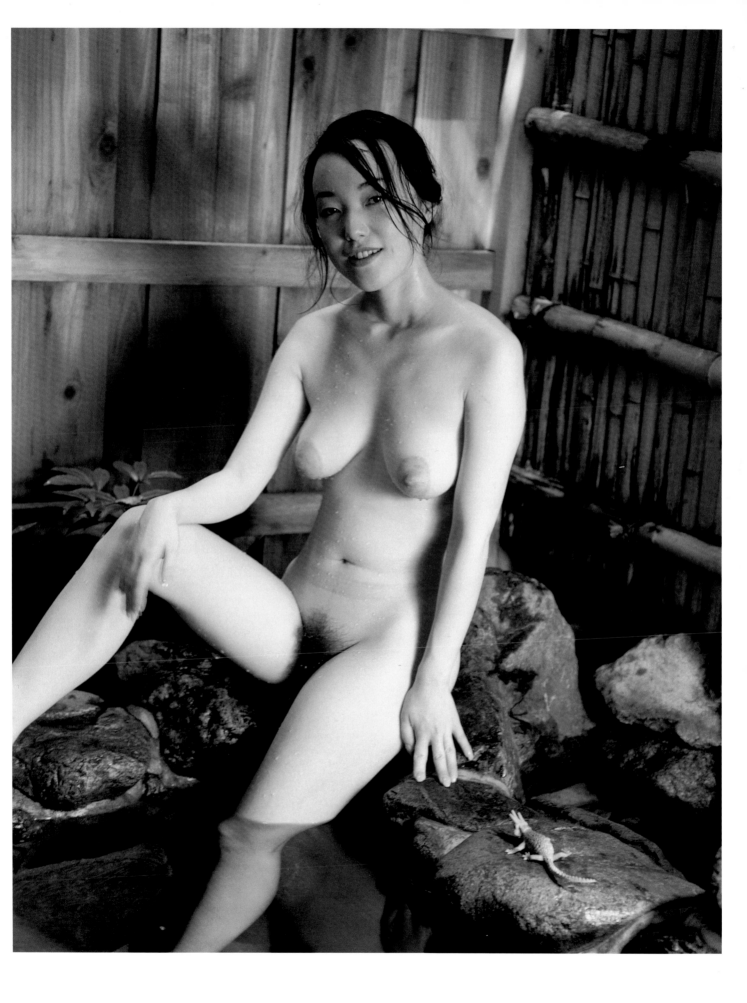

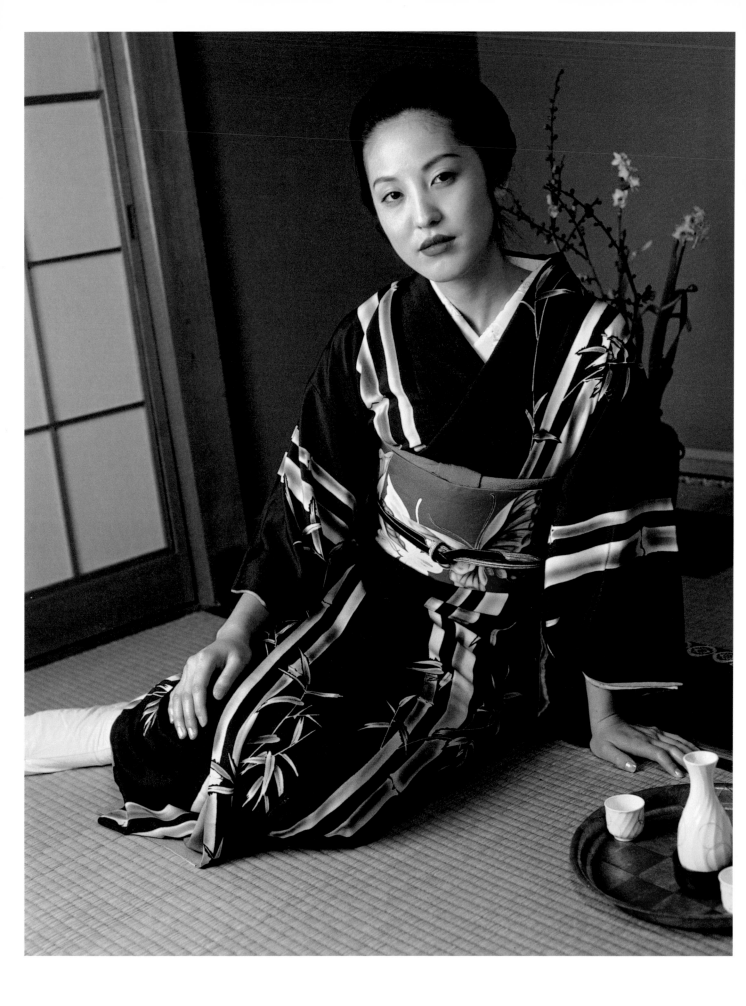

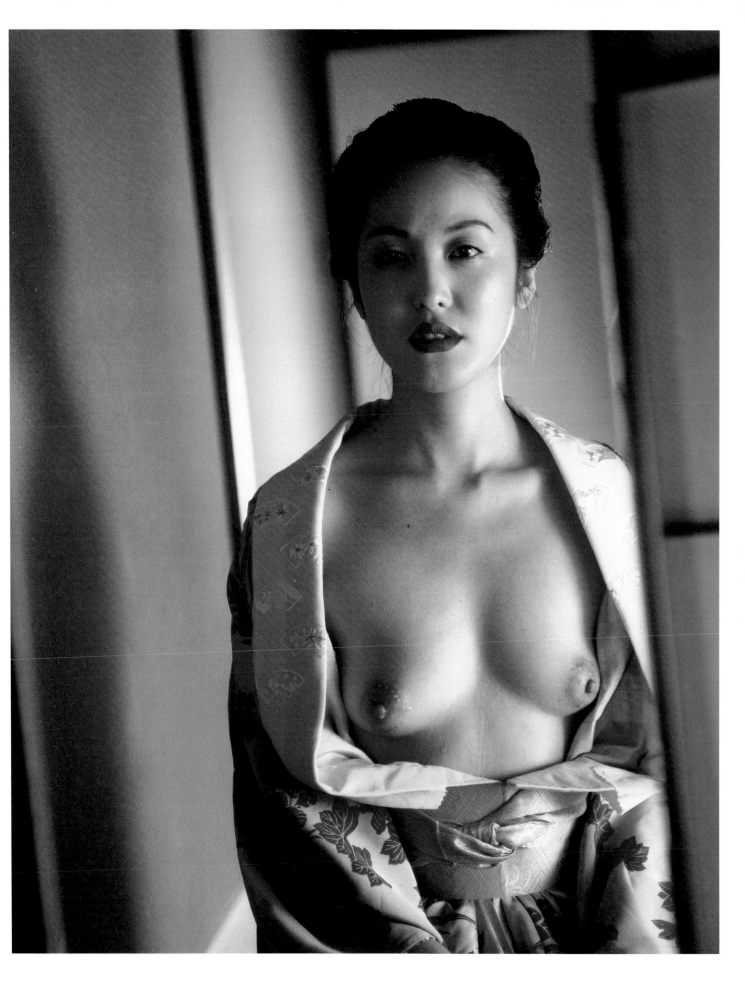

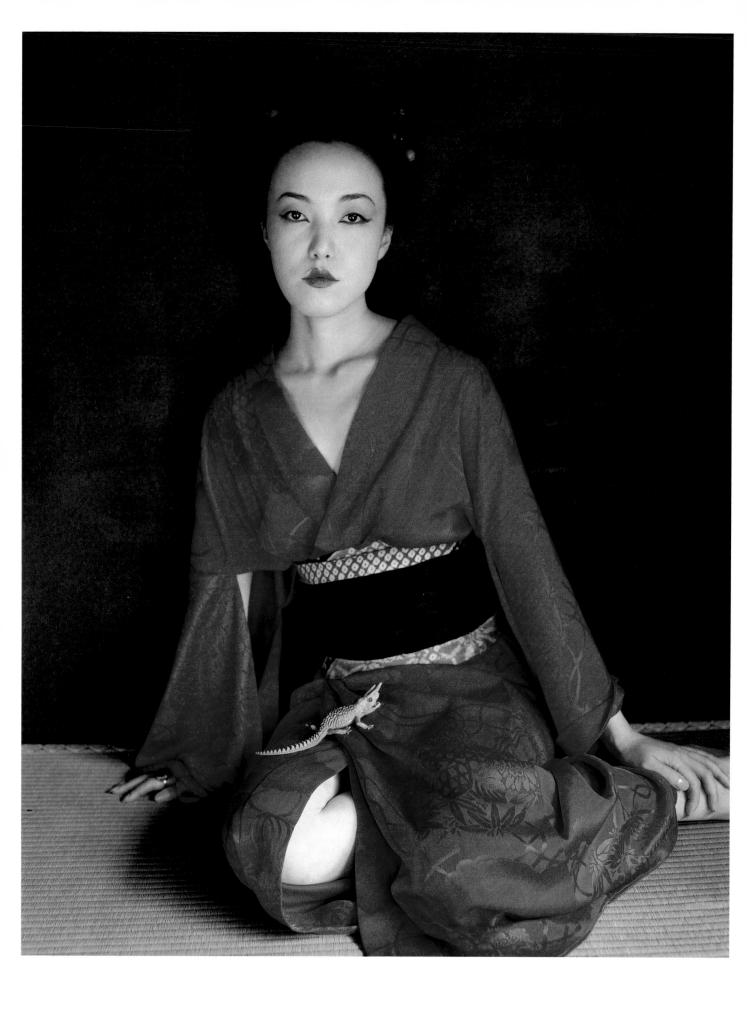

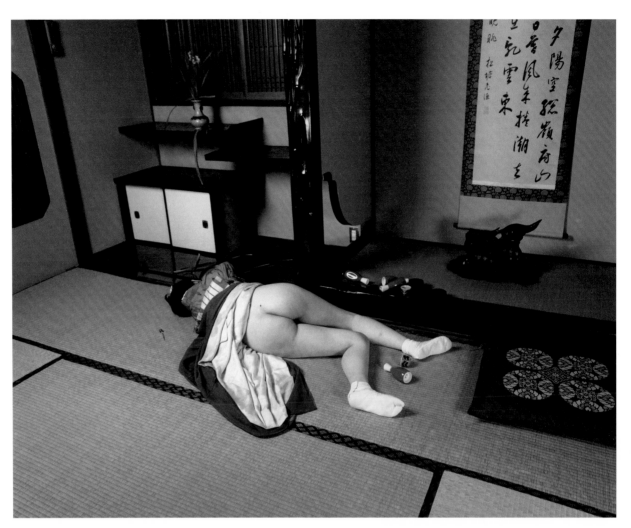

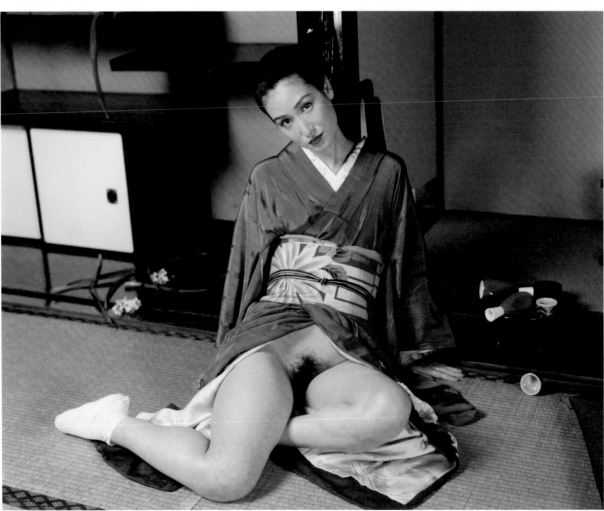

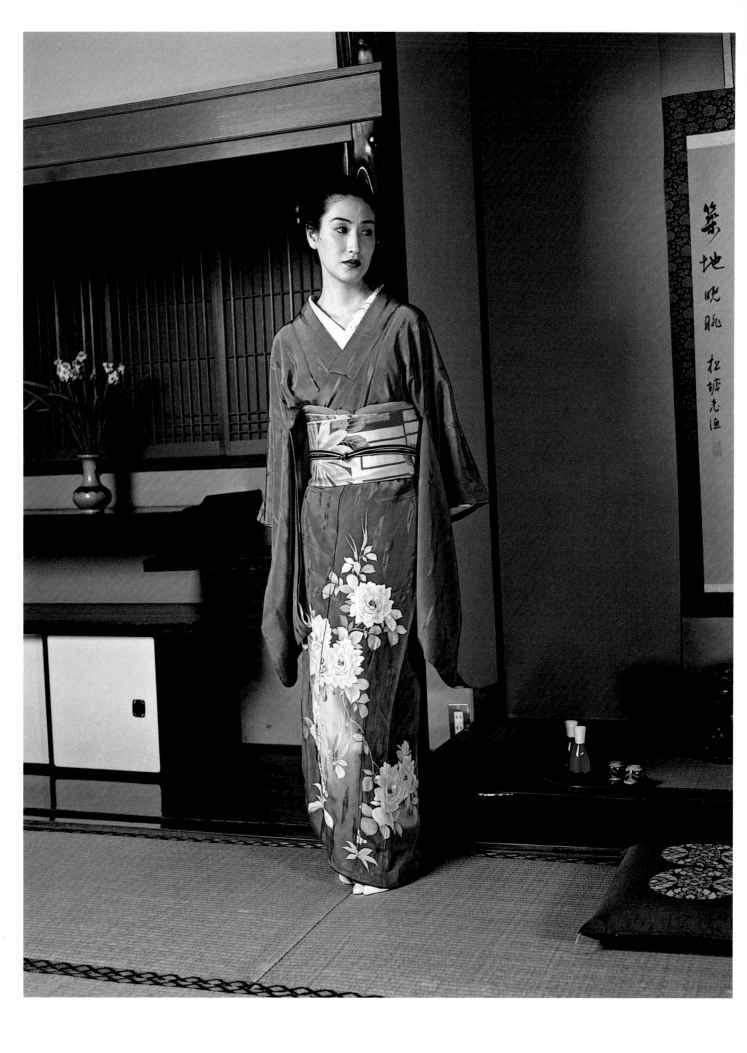

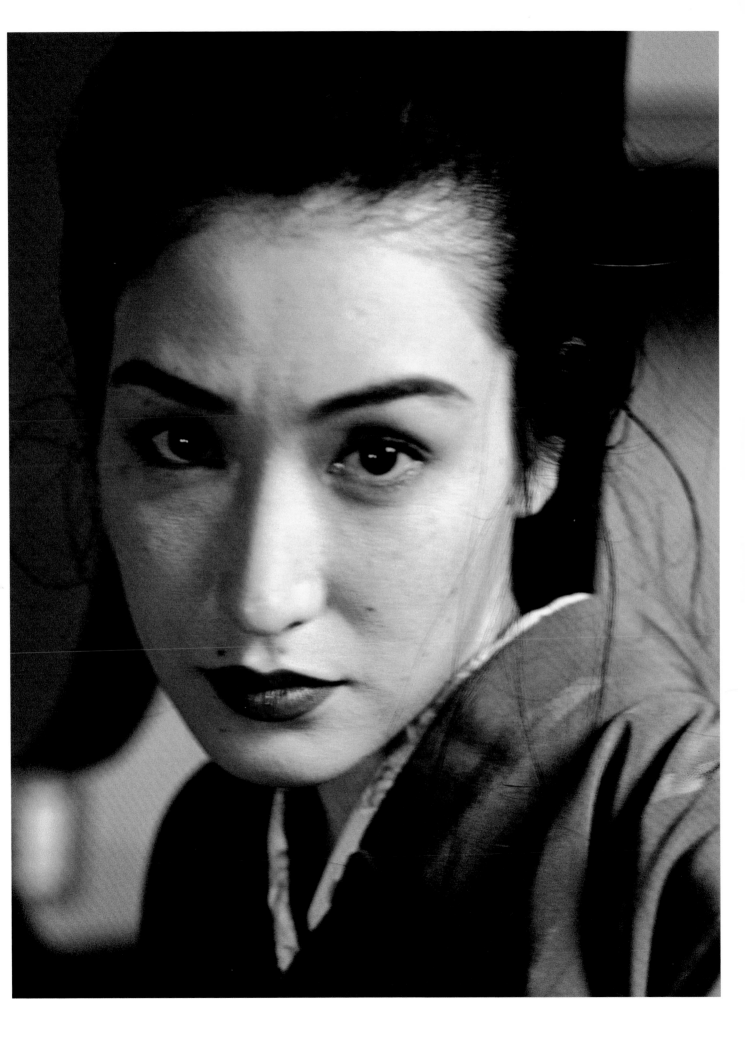

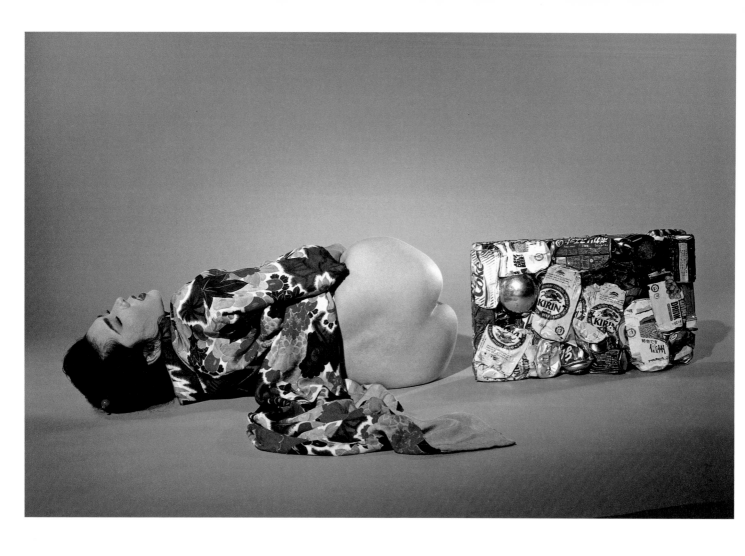

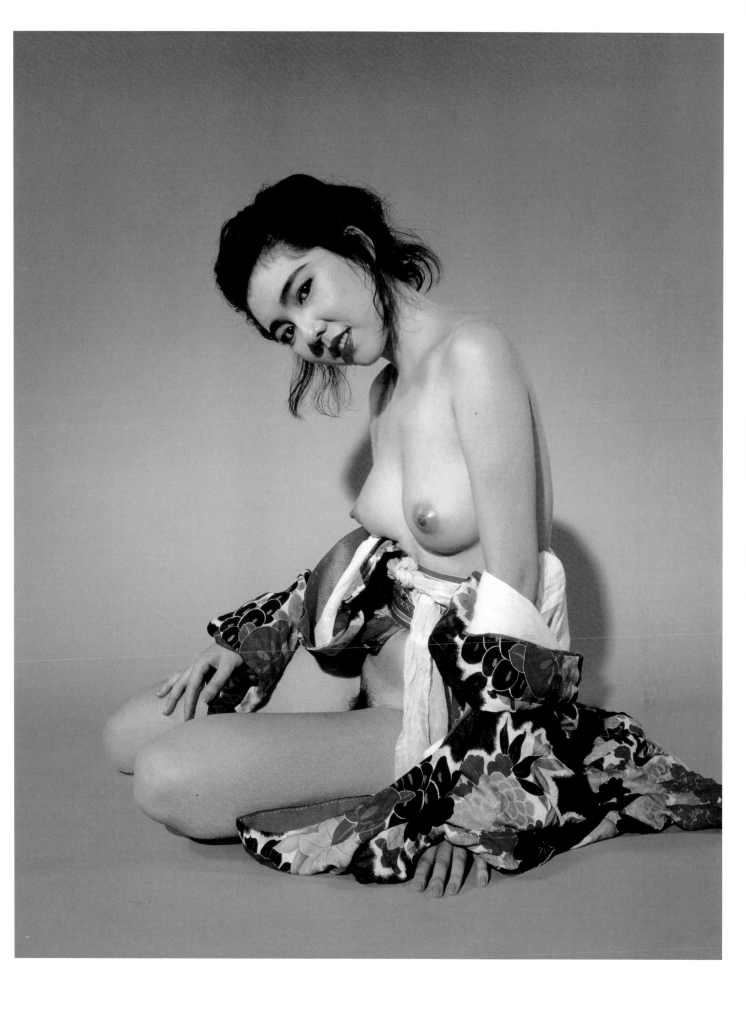

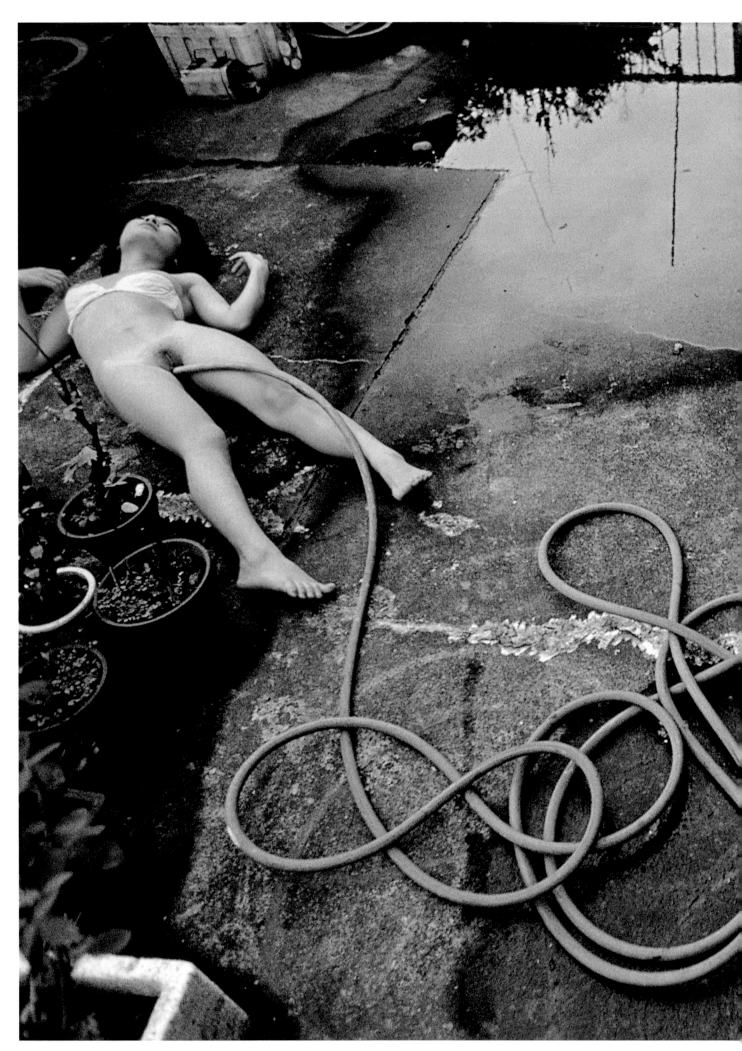

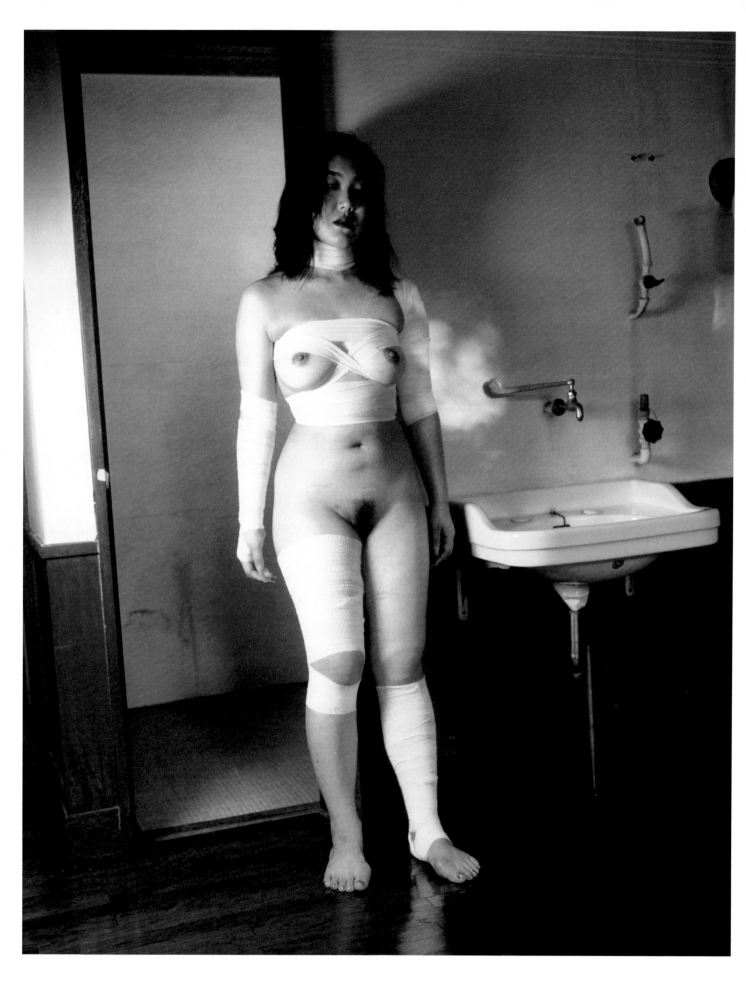

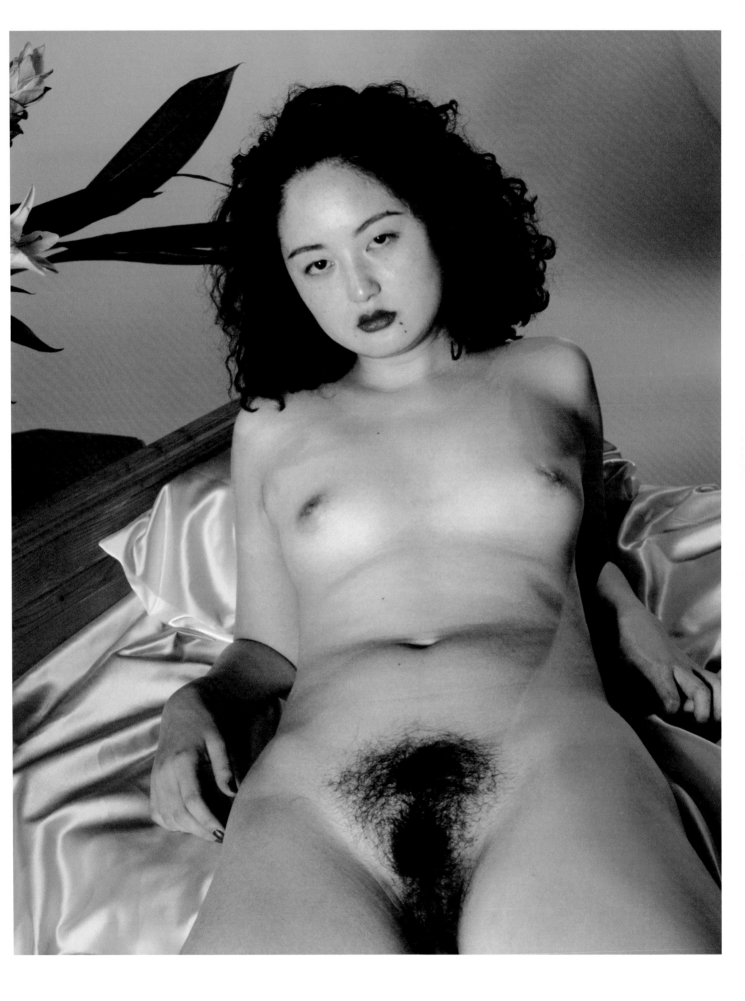

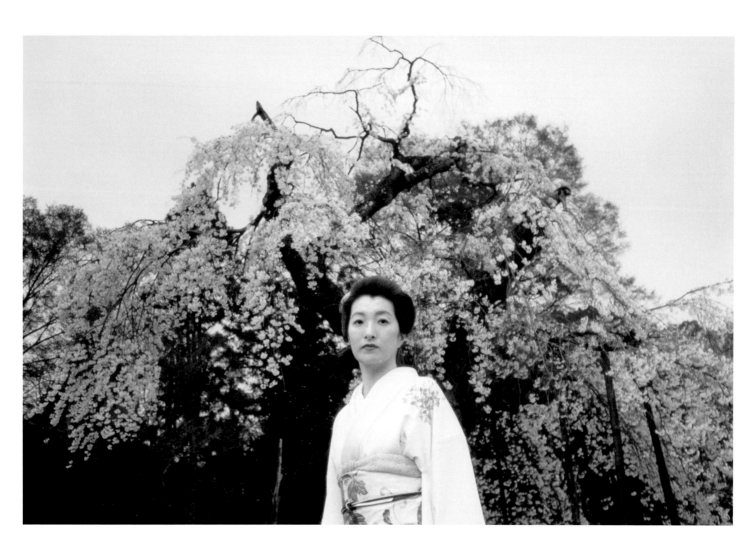

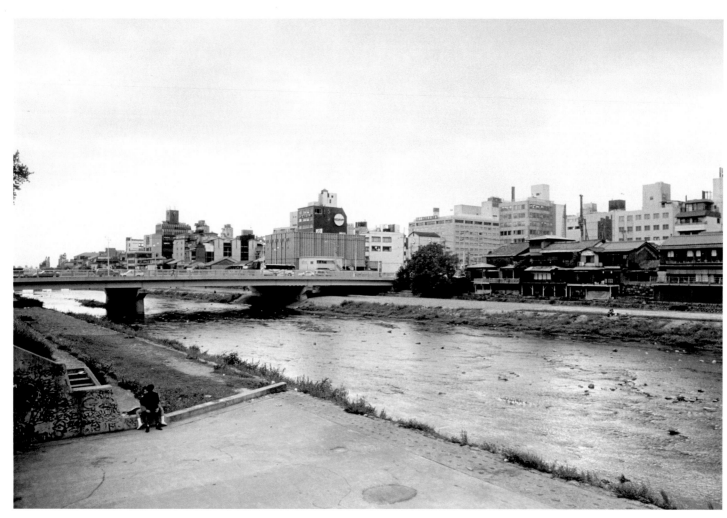

KYOTO WHITE SENTIMENT

ART IS ALL ABOUT
DOING WHAT YOU SHOULDN'T
—

A book entitled *Reproduction: 'The Age of Photography'* appeared recently.[1] It reminded me of the past, those days when you still weren't allowed to show pubic hair in a photograph. I decided to keep widening the range of expression that was permitted. For instance, I'd take photographs in which the models would open their legs wide in an explicit manner.

Since you couldn't show pubic hair, you most certainly weren't allowed to show genitalia. Well, I didn't particularly want to show genitalia just for the sake of it, but I did want to make people aware that I was taking those sorts of photographs. You have this sense of what you want to do at any particular time. I was interested to see how it would be possible to show this kind of thing. It's really no fun to see your work blacked out. What I did was to reproduce black-and-white reproductions with colour film. You then cut away the offending area. You're left with blue if you cut away the top layer of the film. You get a blue film; that's the title.

I was determined to let people see what I was doing, and that was the starting point for the photographs. I wouldn't have felt any enthusiasm if I hadn't felt that way. You need the powers-that-be, the police, to tell you not to get up to pranks and what not to do. There's no incentive to do anything if you're given free rein to do whatever you like in the first place. Art's a strange business, but essentially it's all about doing what you shouldn't do. That's absolutely it! This is where it all starts from, absolutely!

I inevitably feel that I want to do whatever I'm not allowed to do. Art's all about seeing how much of the real world you can really expose and bring to light. But I guess there's still a surprising amount that I cover up. There's still a long way to go!

[1] The official title of this book is *The Reproductions of Nobuyoshi Araki and Akira Suei: 'Shashin Jidai'* (Tokyo: Bunka-sha, 2000). Akira Suei met Araki at the beginning of the 1980s and founded the photography magazine *Shashin Jidai* in 1981.

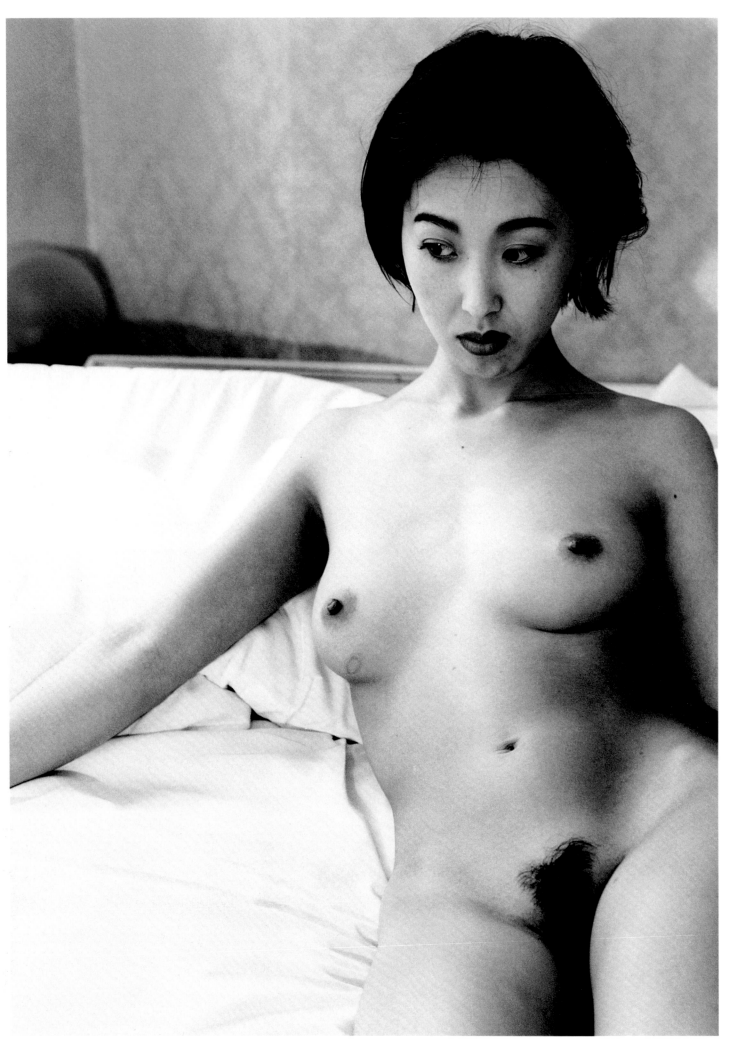

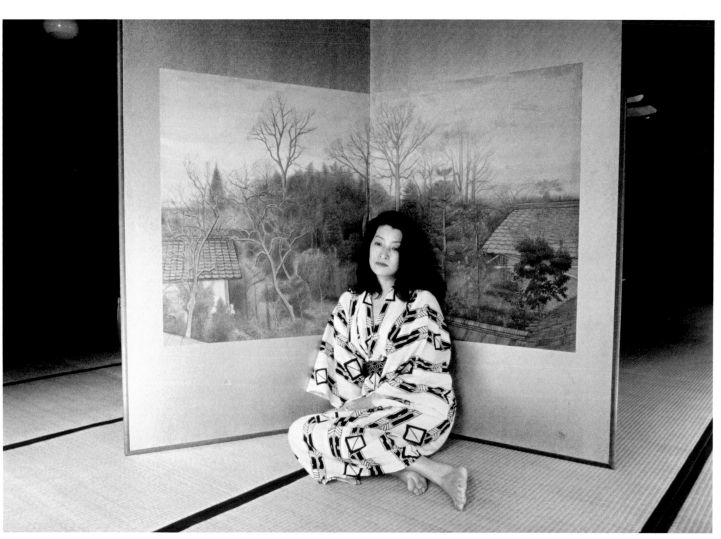

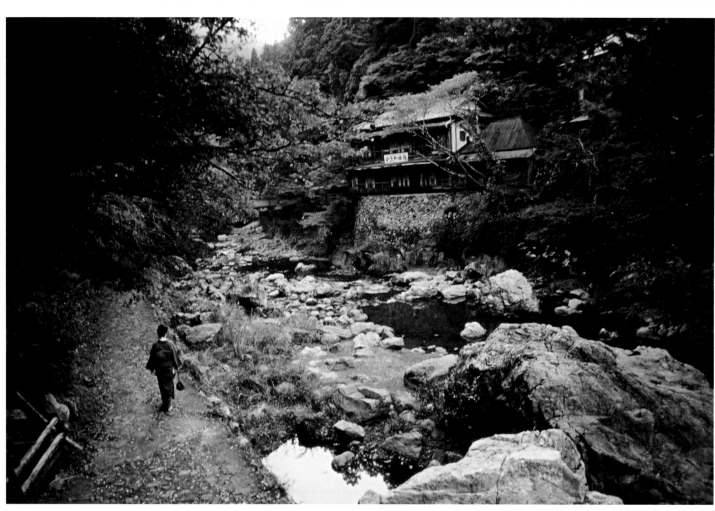

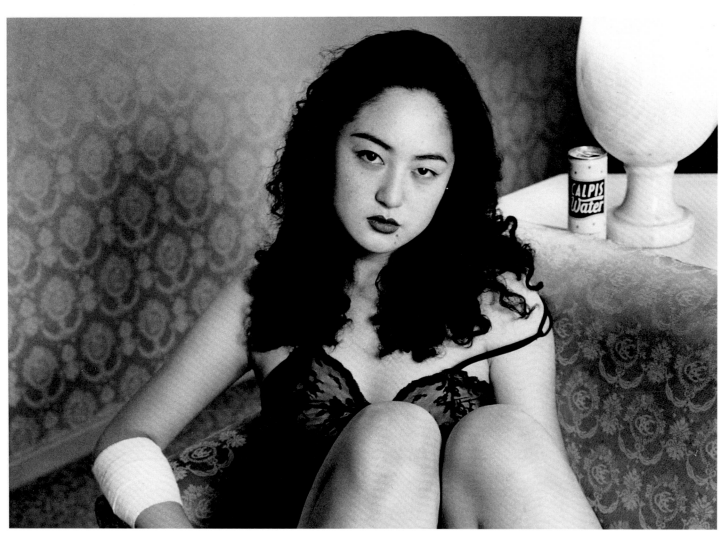

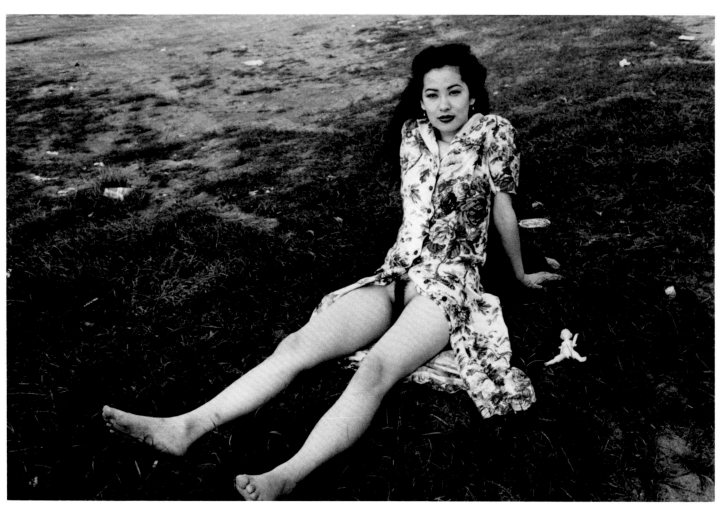

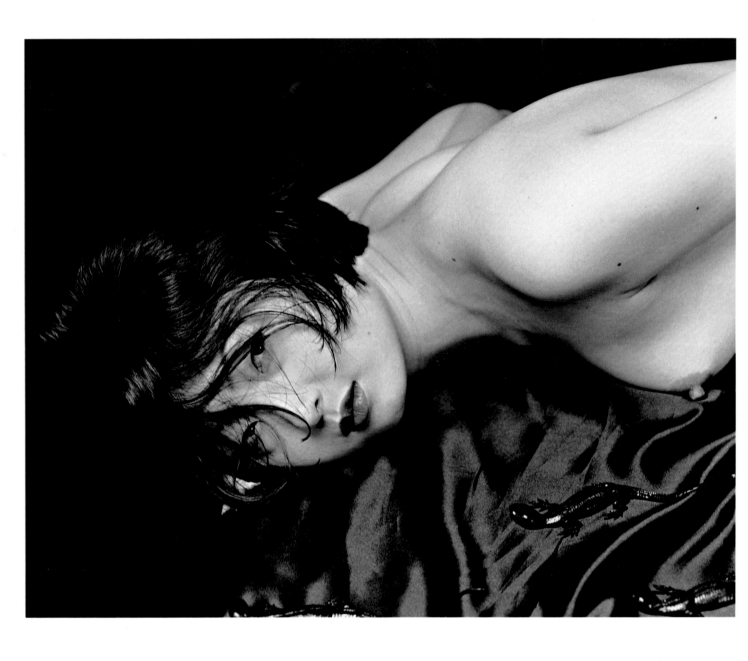

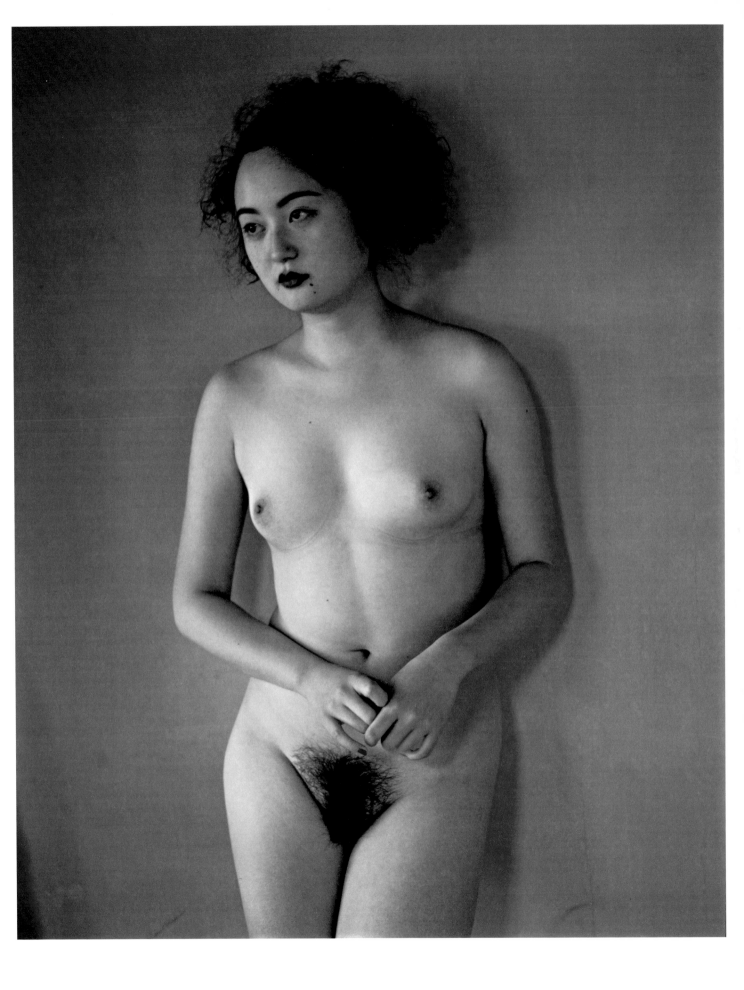

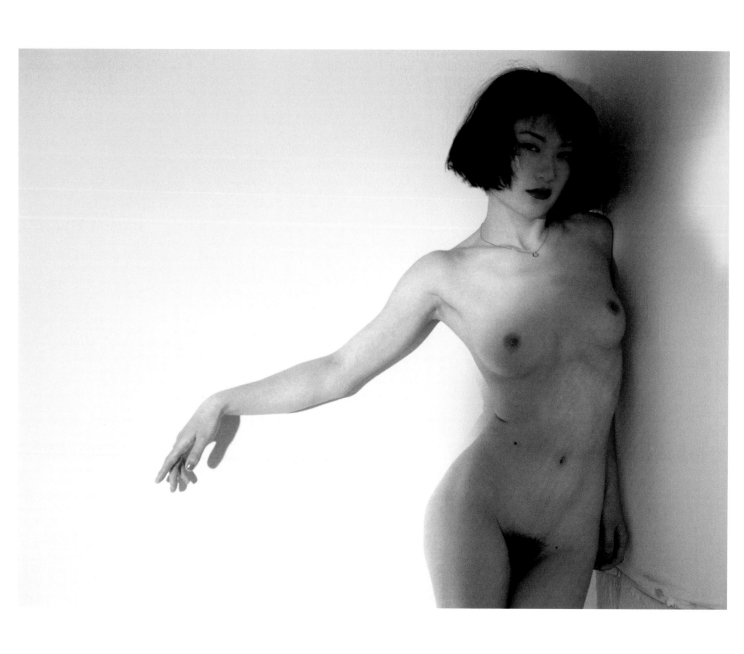

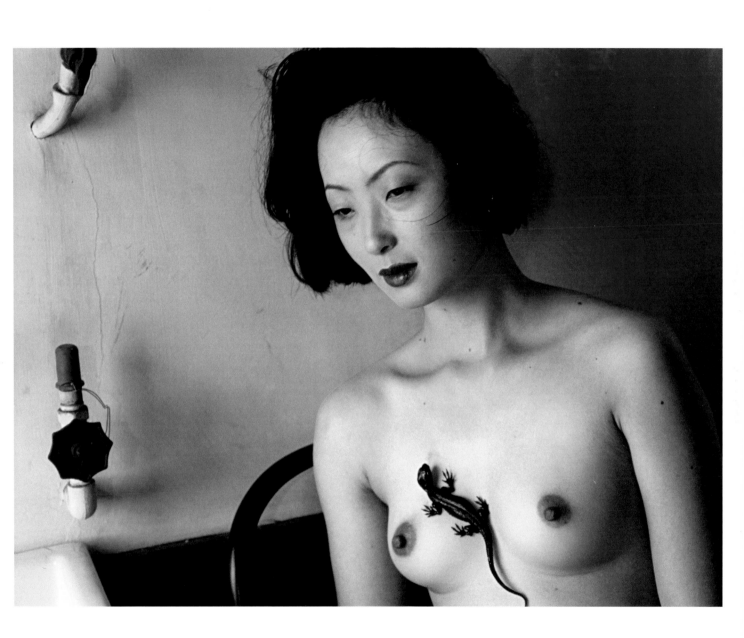

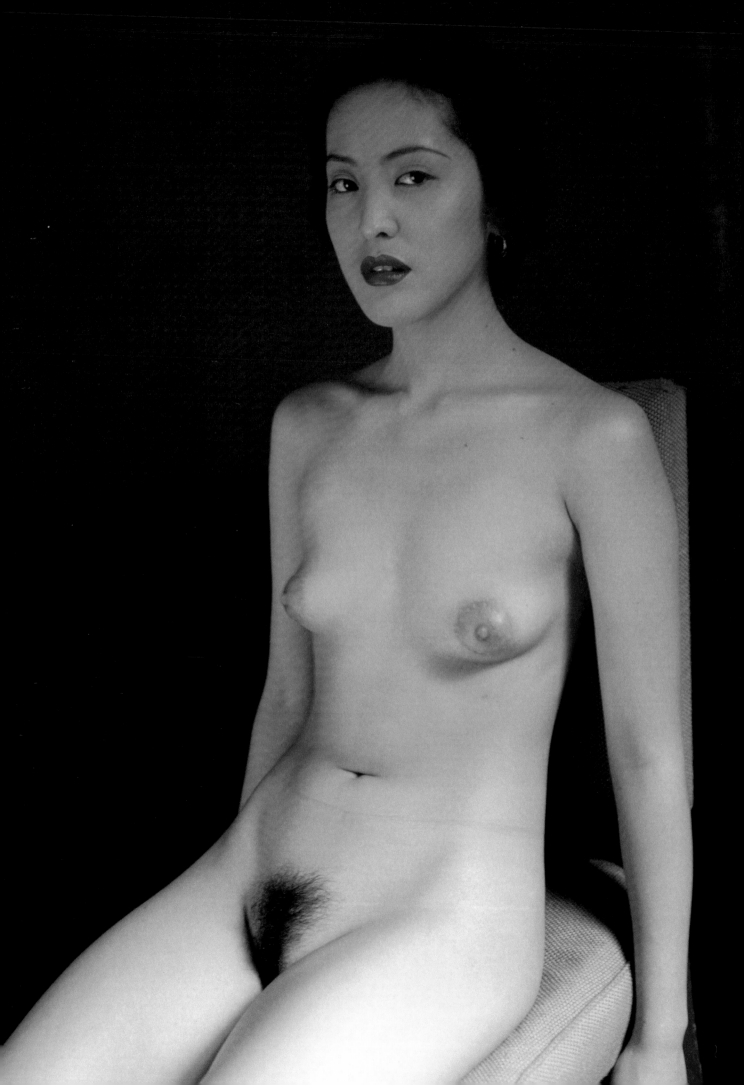

A'S LOVERS

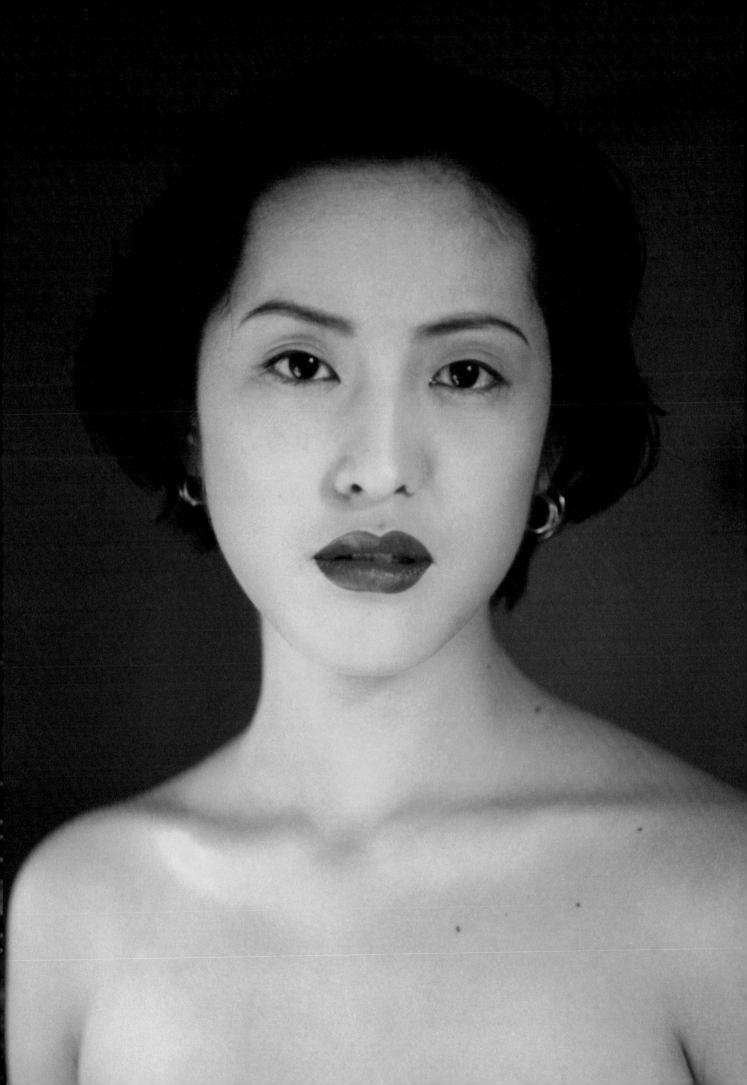

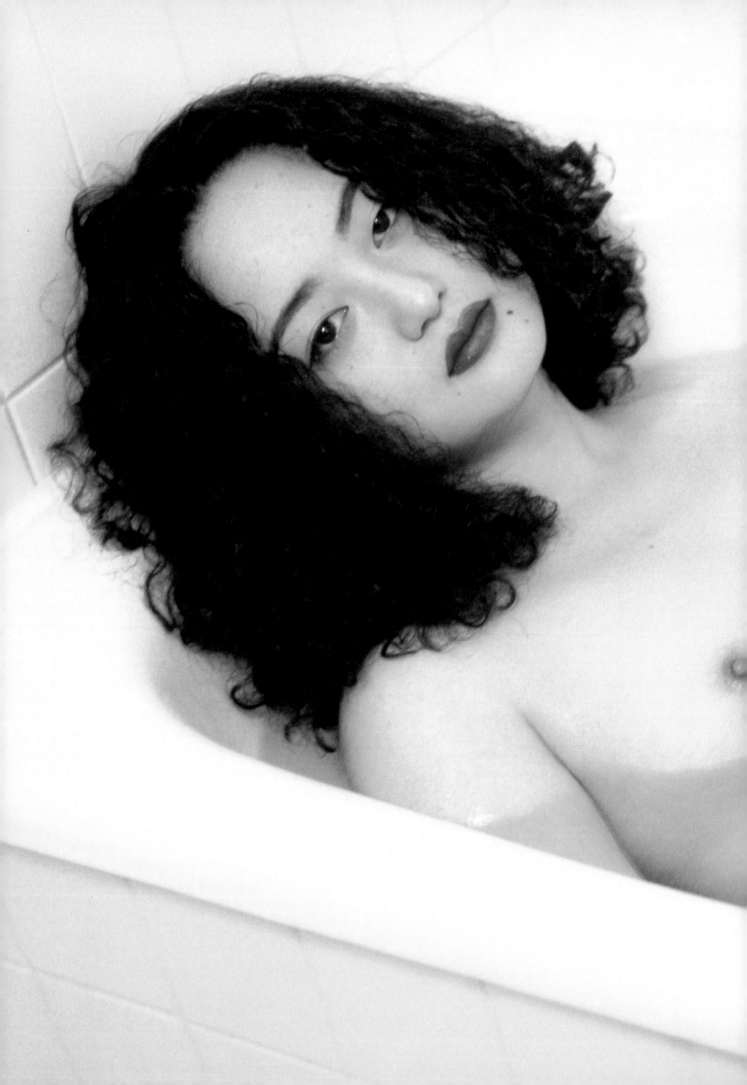

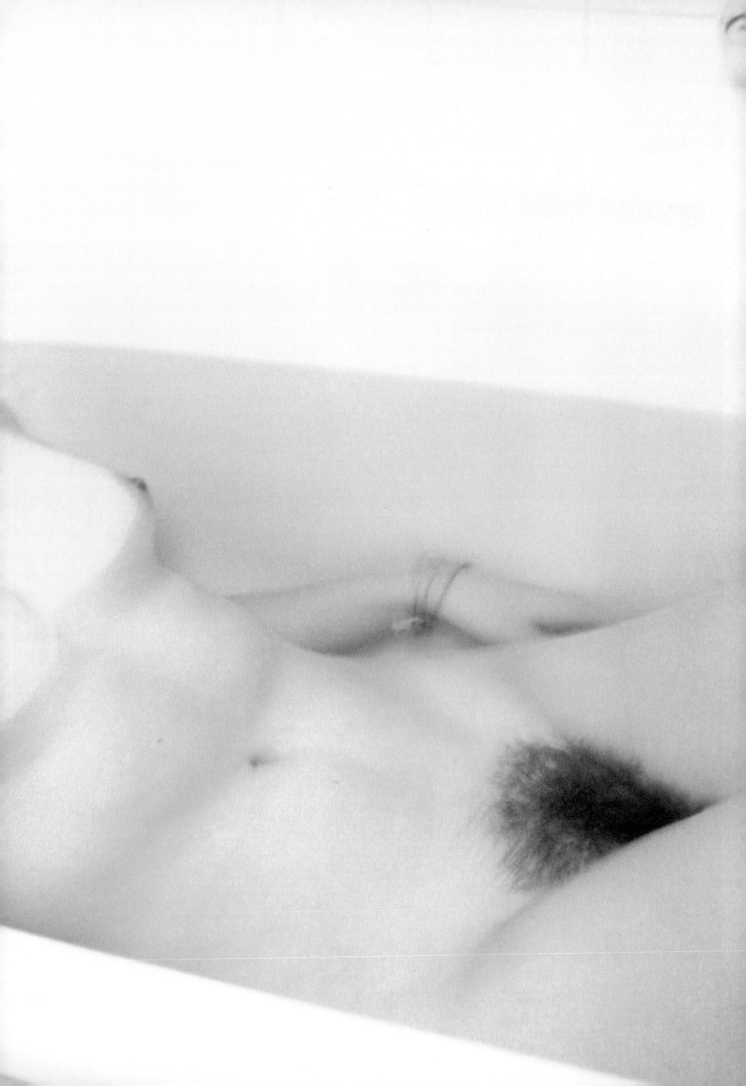

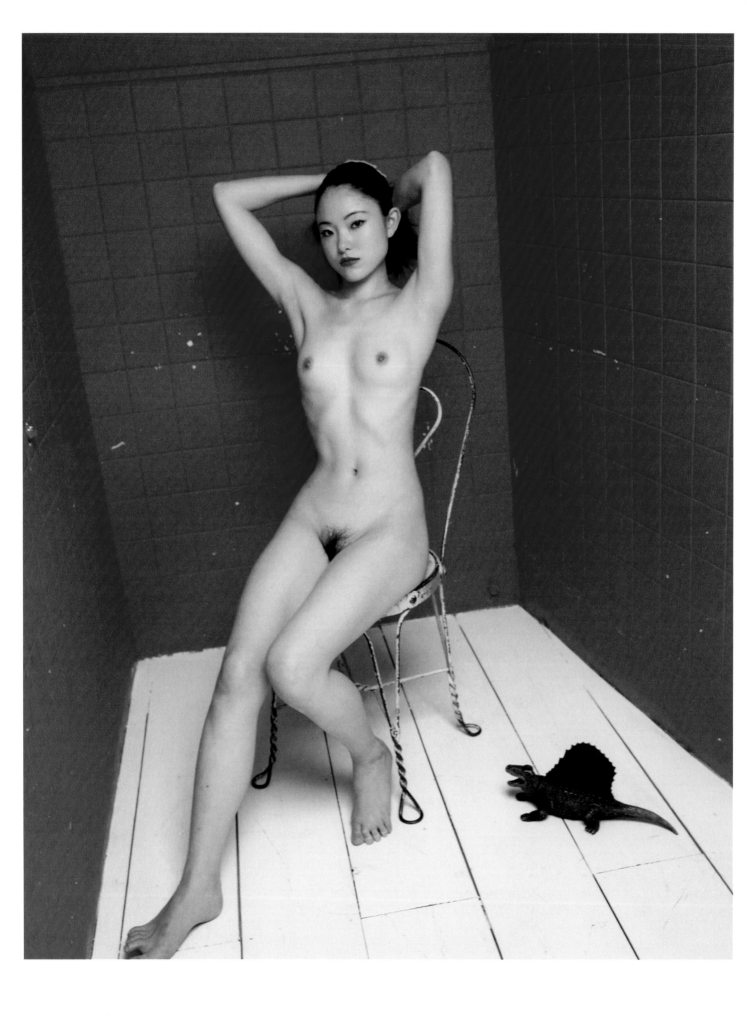

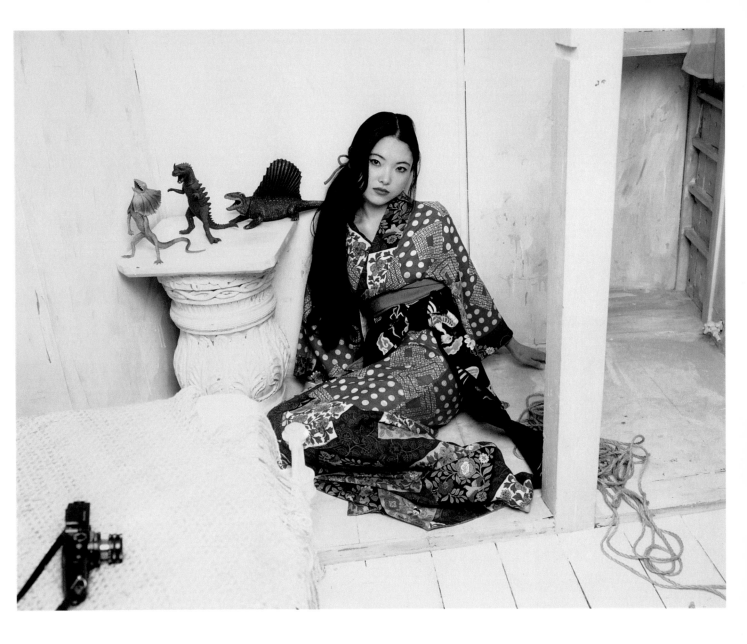

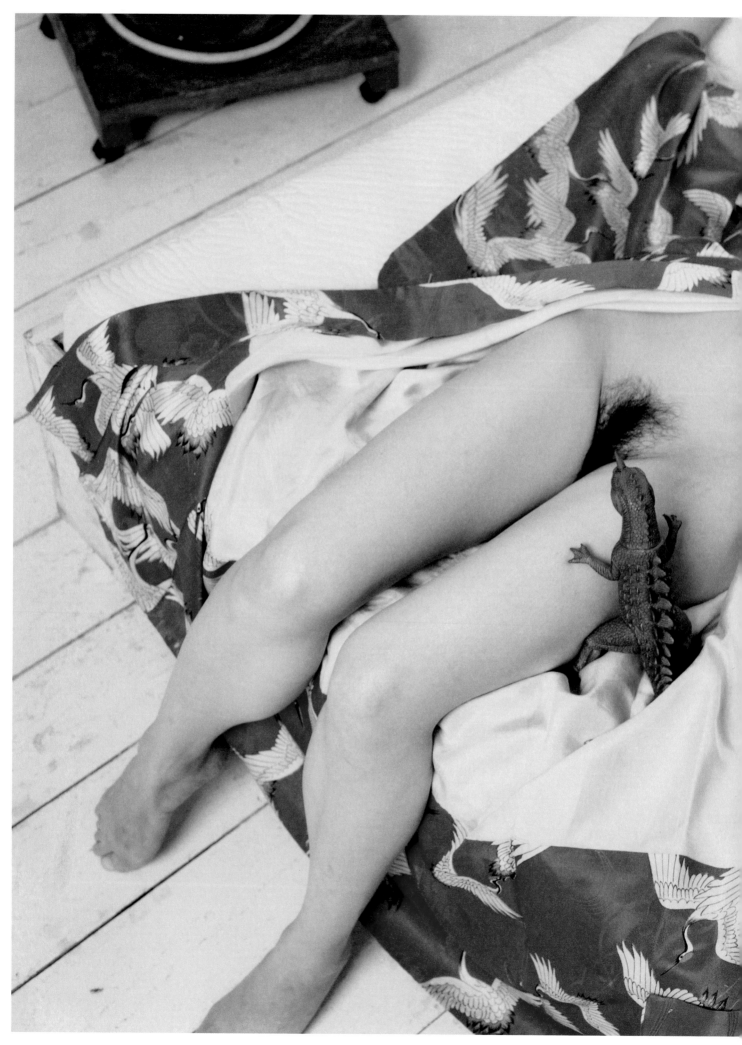

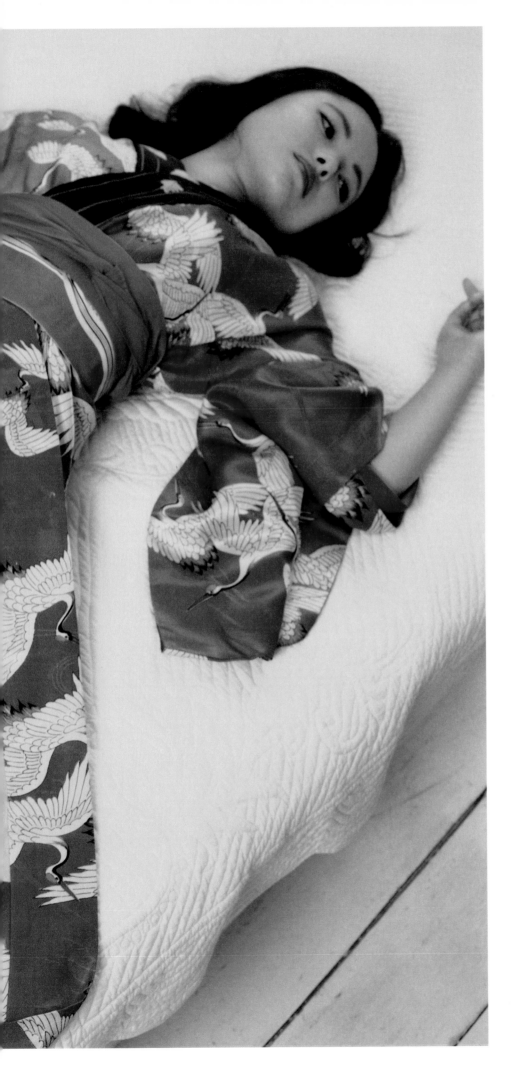

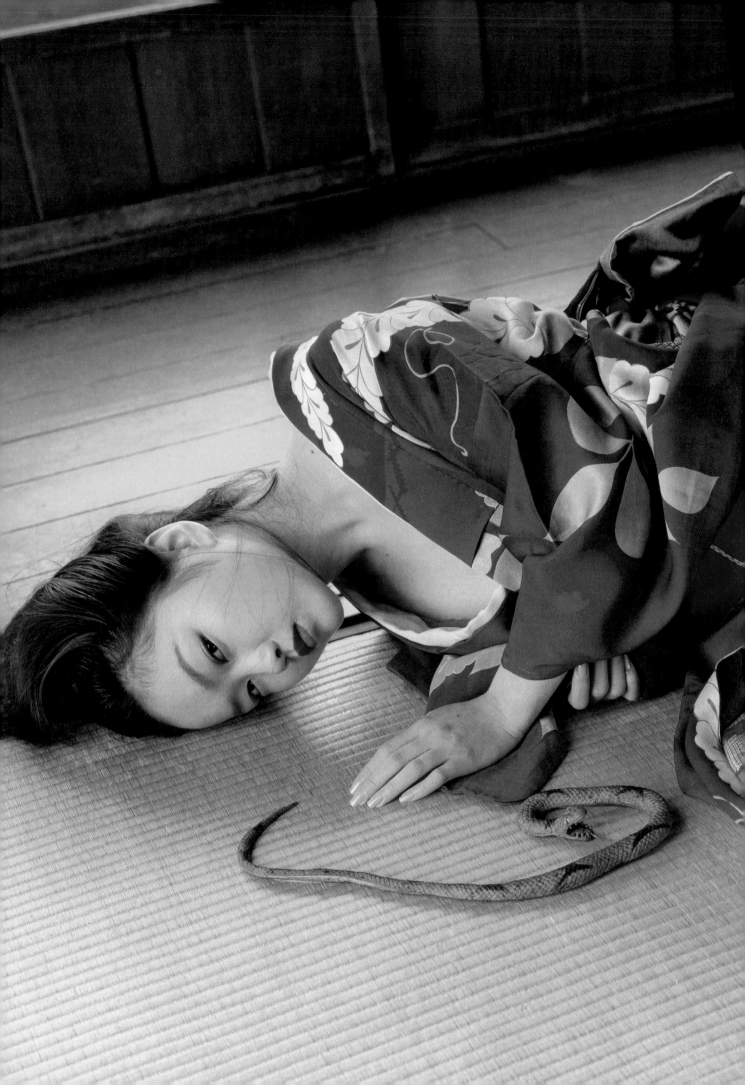

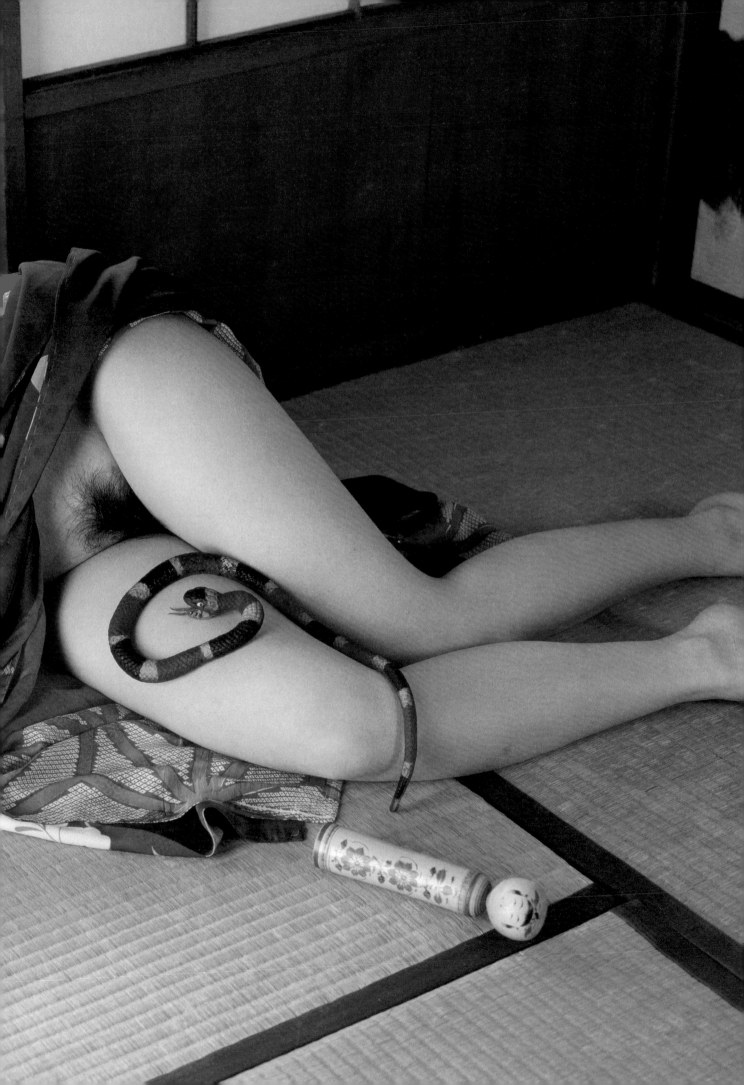

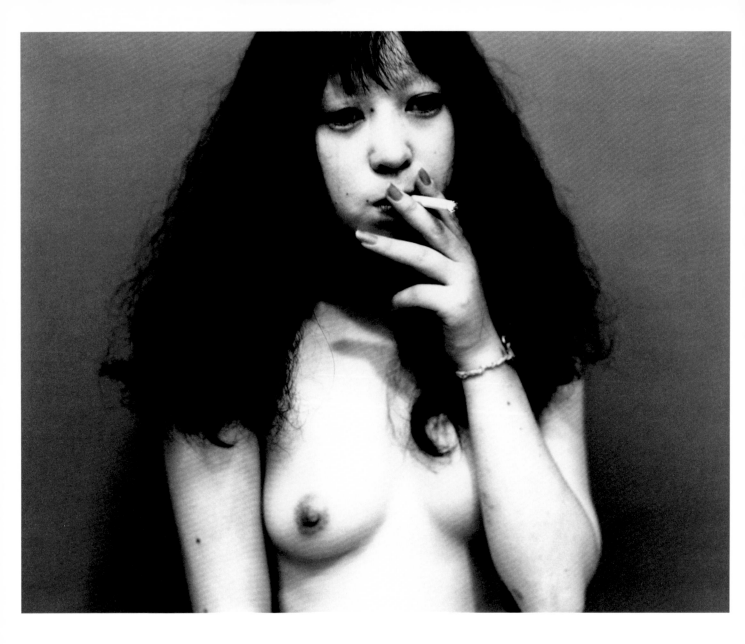

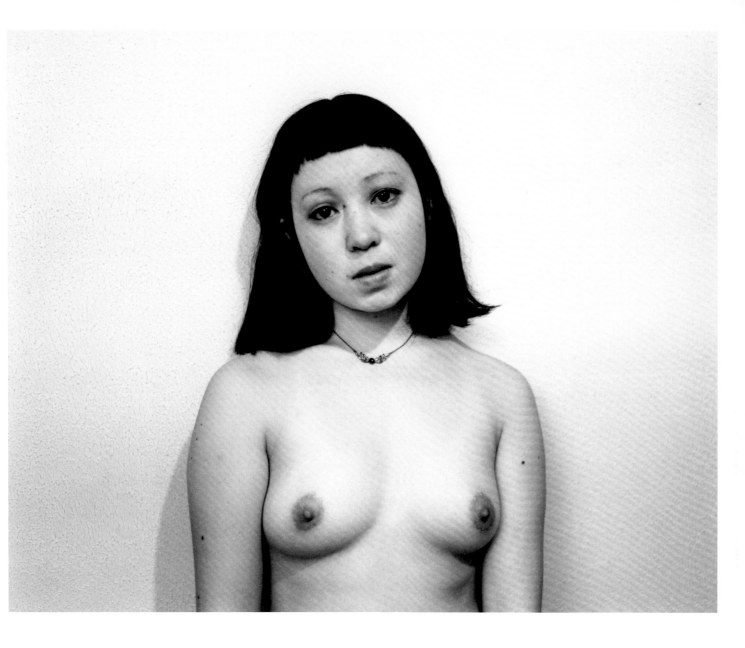

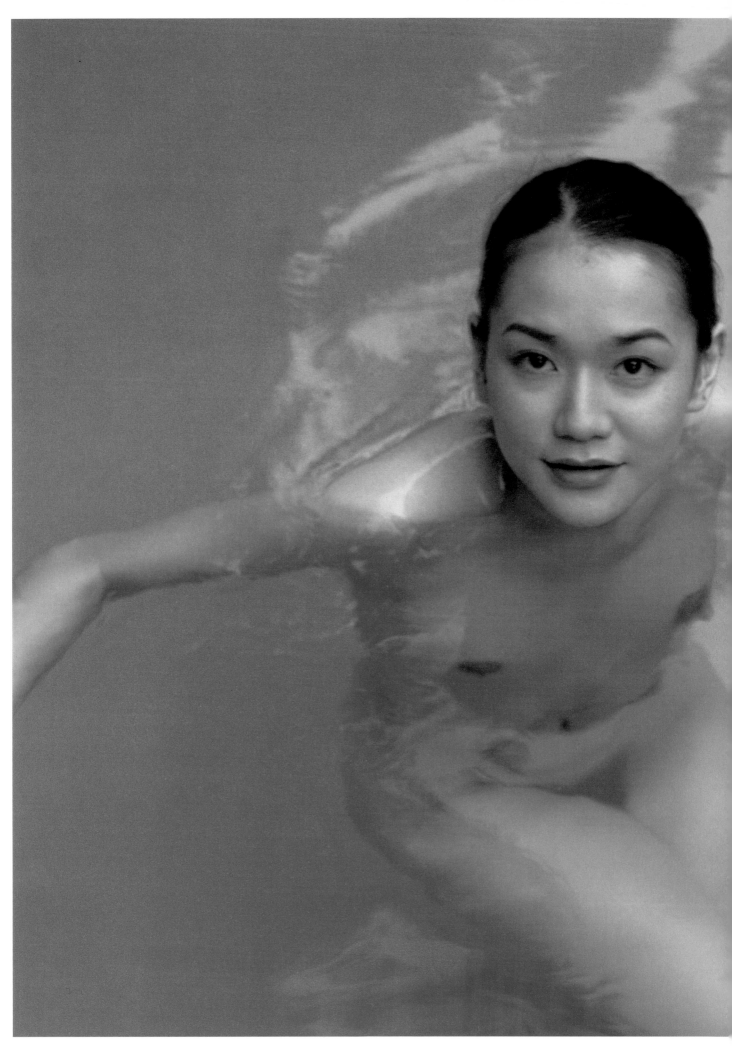

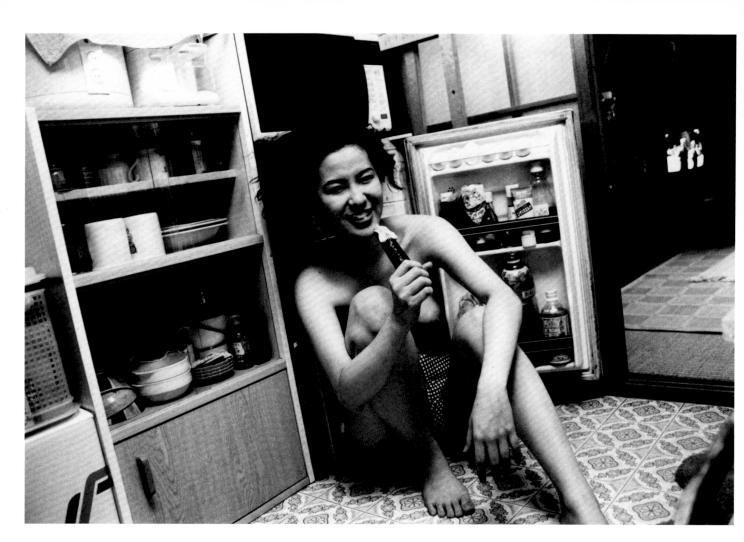

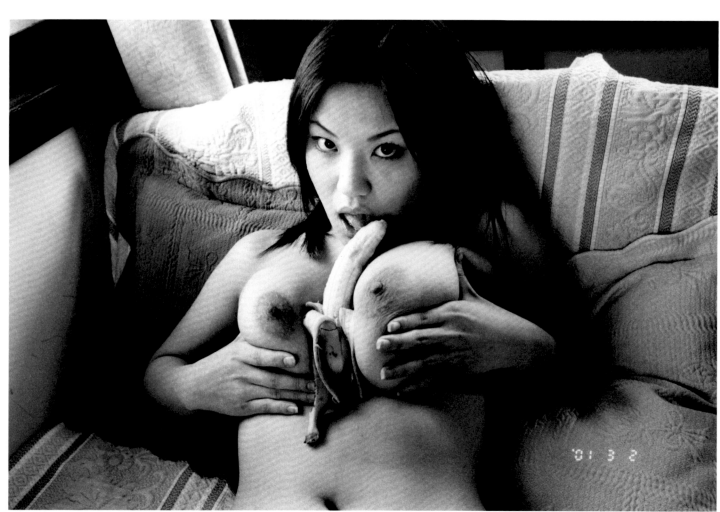

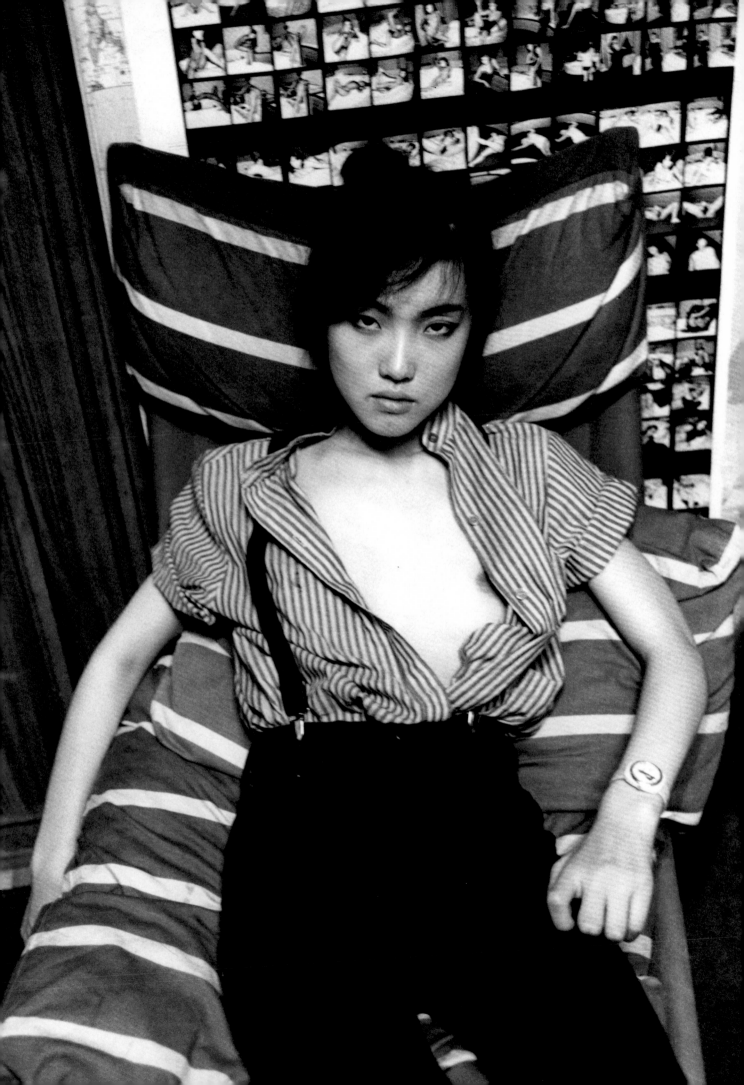

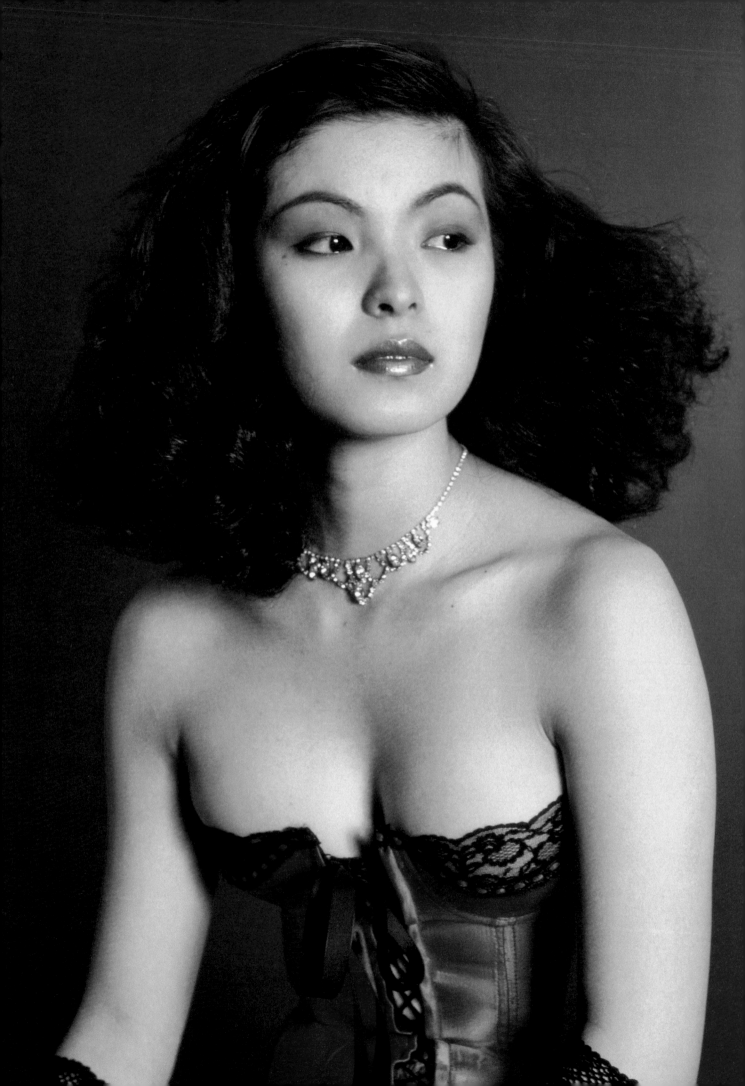

'BETWEEN A MAN
AND A WOMAN IS A
CAMERA.'

PHOTOGRAPHY IS
ALL ABOUT COLLABORATION
—

PHOTOGRAPHY IS A *MÉNAGE À TROIS!*

A photograph is a kind of interview; perhaps you could say that it's the same as an interview. The idea is to draw something out of the subject. This is the point of an interview. In other words it's not about expression so much as appearance. The aim isn't to express something to do with the subject but to draw something out of him.

I take the approach that people are essentially good by nature, and so I do whatever I can to draw forth the positive characteristics of my subject. I don't focus on their negative features. Photographing someone isn't like painting a picture when the artist depicts the face of his subject as he imagines it. That kind of approach is no good for a photographer. You have at least to pretend to be modest and self-effacing!

Having a photograph taken isn't about adapting; you need to feel you're actually being violated. It's a kind of buffoonery. Perhaps you might describe it as a type of catabolism between two people. The photographer and his subject work together to come up with something that neither of them have noticed before. It isn't a question of the photographer merely taking a photograph: it's a collaboration between the photographer and the person being photographed. If you want to use words like invention and creation, they need to include these kinds of ideas. Photography is a joint enterprise. If you include the camera, there are three partners in crime. That's why I think of it as a *ménage à trois*!

Photography is life itself. It's the starting point for life. You can't live entirely by yourself. To be by yourself is a lonely business. No one finds life interesting in the absence of other people. That's the way people are. More or less has nothing to do with it. We all need someone.

That's what it's all about!

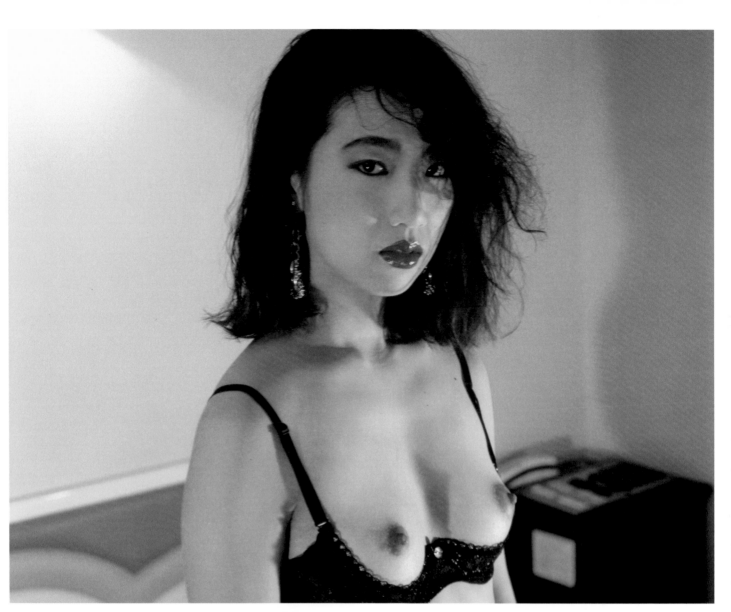

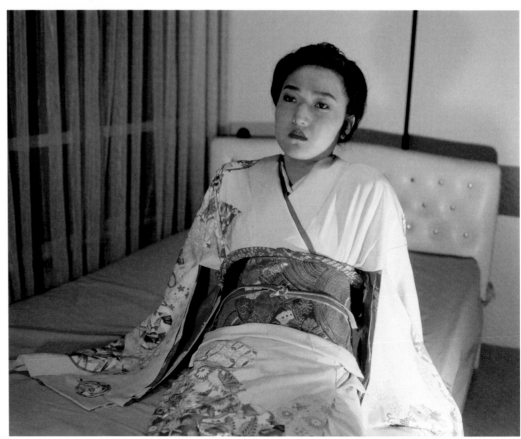

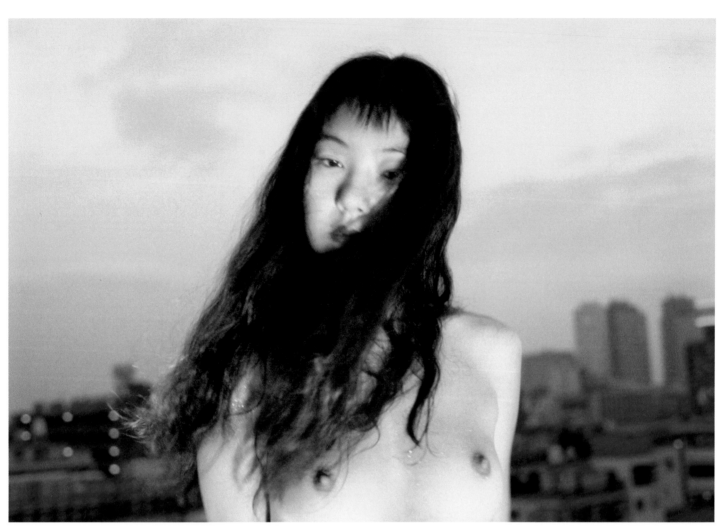

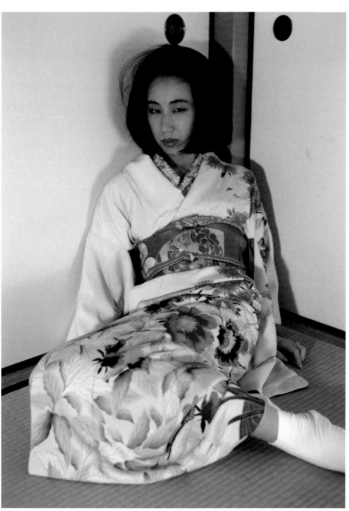

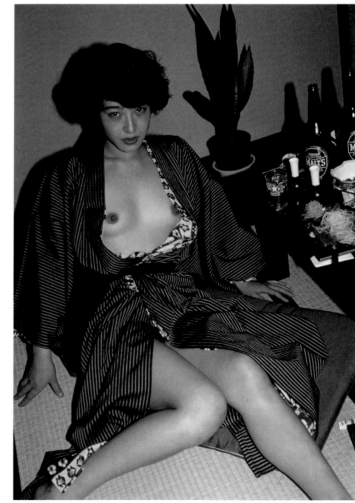

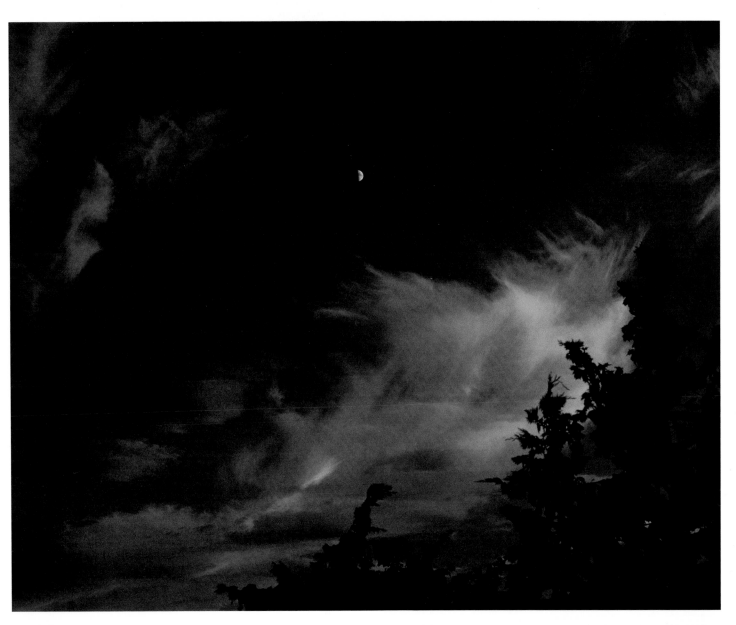

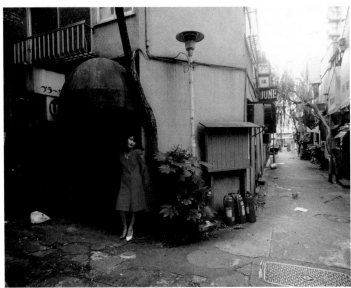

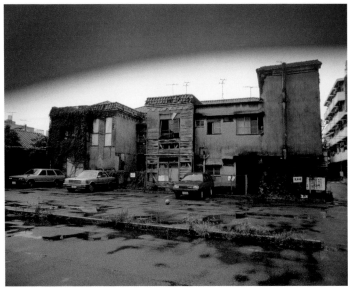

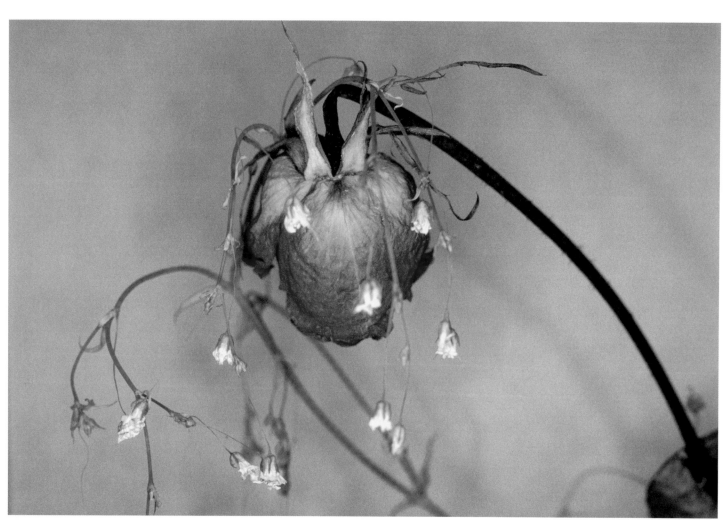

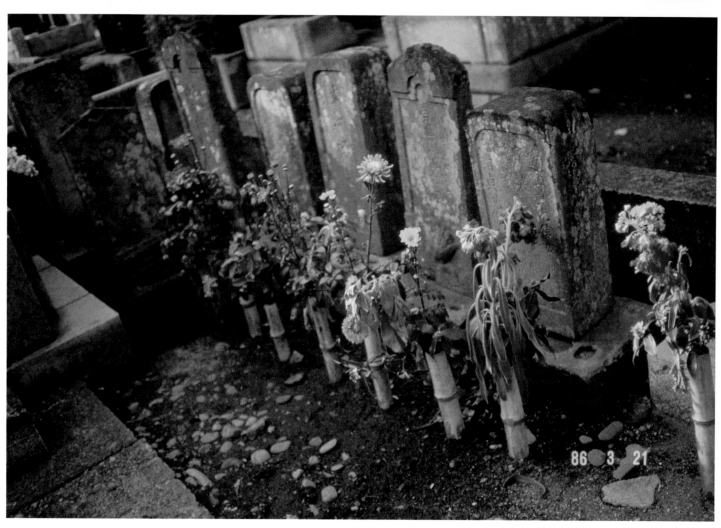

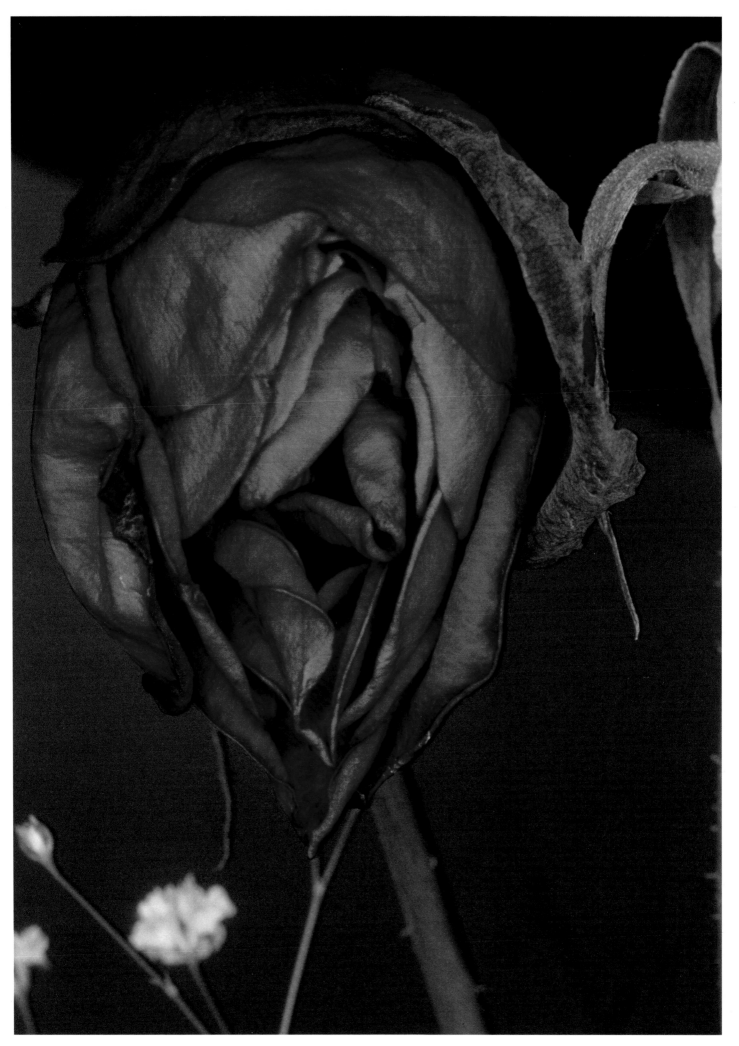

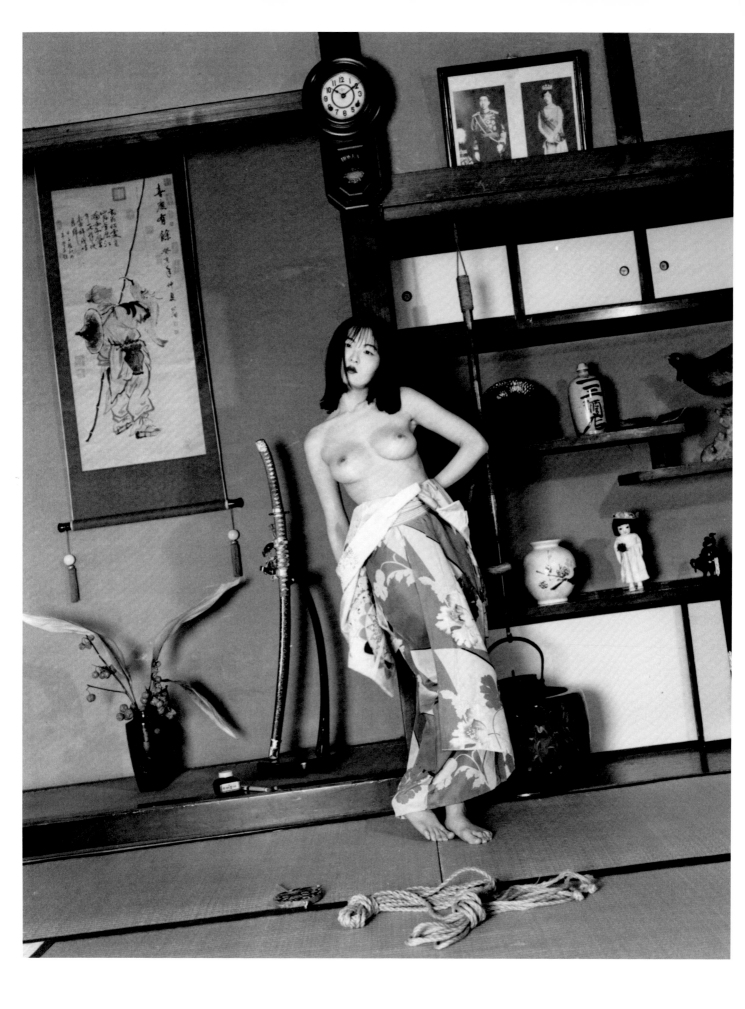

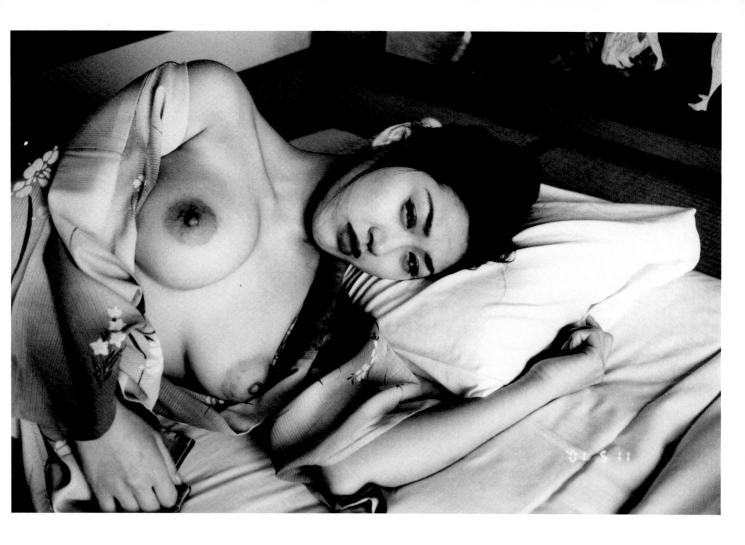

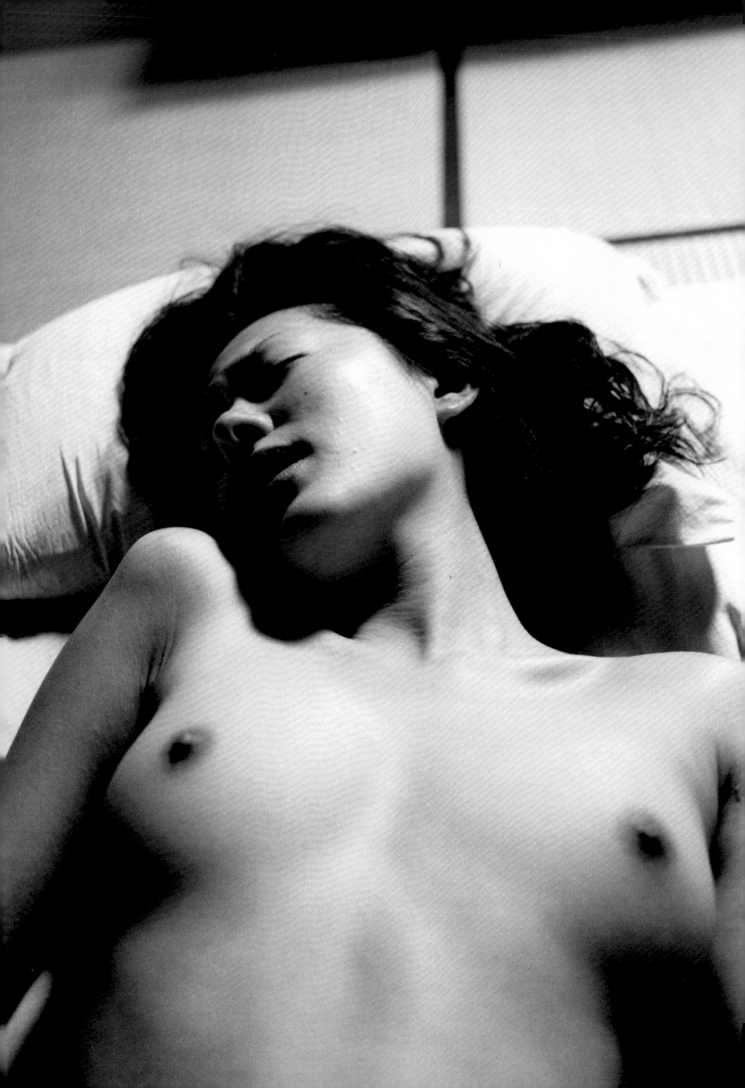

LOVE
IN WINTER

RELEASING THE SHUTTER IS
AN ACT OF BETRAYAL

—

The light from a flash unit, even artificial light, is the real thing. It's not just light from the sky. Nature is scary. Natural light is all well and good, but I just don't think that nature all on its own is particularly interesting. I want to play mischief with it.

I wouldn't go so far as to say that I want to destroy light, but I feel I want to mix it in some way. What I really want to do is to mix natural light with artificial light, to cross them, to blend them. If you think of natural light as light emanating from God, artificial light is light in the form of noise. You can't feel at ease without it. I can't relax myself when there isn't something going on in the background! That's why I feel the same way about light.

I try and get the lighting I use in the studio close to natural light. But I make sure that there's a subtle afterglow rather than just taking the light as it comes. You can get this sensation of being enveloped all of a sudden in light, but the effect you get when you use flash isn't the same. I try to get a more wistful feel.

I get by with tungsten,[1] but if it looks as though it's going to be too gentle and refined, I'll use a flash to destroy this feeling. The most important things are framing and flash.

I'm not talking about smashing ordinary concepts by means of framing. Photographs should be completely honest. But I want to get away from a sense of perfection in my photography, to create the impression that a good photograph isn't a photograph at all.

Photography is life itself as far as I'm concerned. The act of taking photographs every day with the date on them is what living is all about for me.

When I'm on an assignment for a magazine, I'll add elements that are likely to please the readers. This kind of spirit of service is essential. I can't just take photos that appeal to me. I couldn't for example just shoot people's faces and nothing else. That would be out of the question. It would just be too ordinary.

Well, it's a tricky occupation. After all, what you're doing is betraying people by releasing the shutter. You really are. It's not all like this, but this is certainly one side of the photographer's job.

[1] Tungsten: a white metal used in the filaments of light bulbs. Araki is referring here to the light emanating from light bulbs made of tungsten which he uses as light sources when photographing. The light temperature of the light source is between 3,200 and 3,500 degrees. Colour film made to obtain the best possible colour balance under tungsten lighting is known as tungsten-type film.

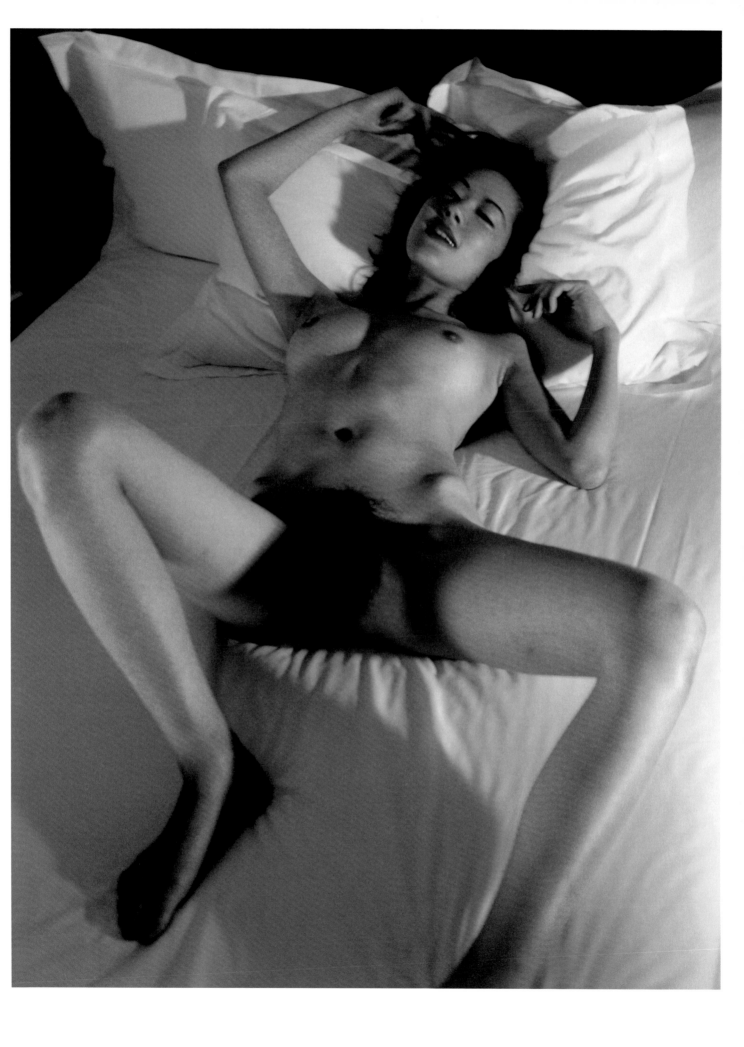

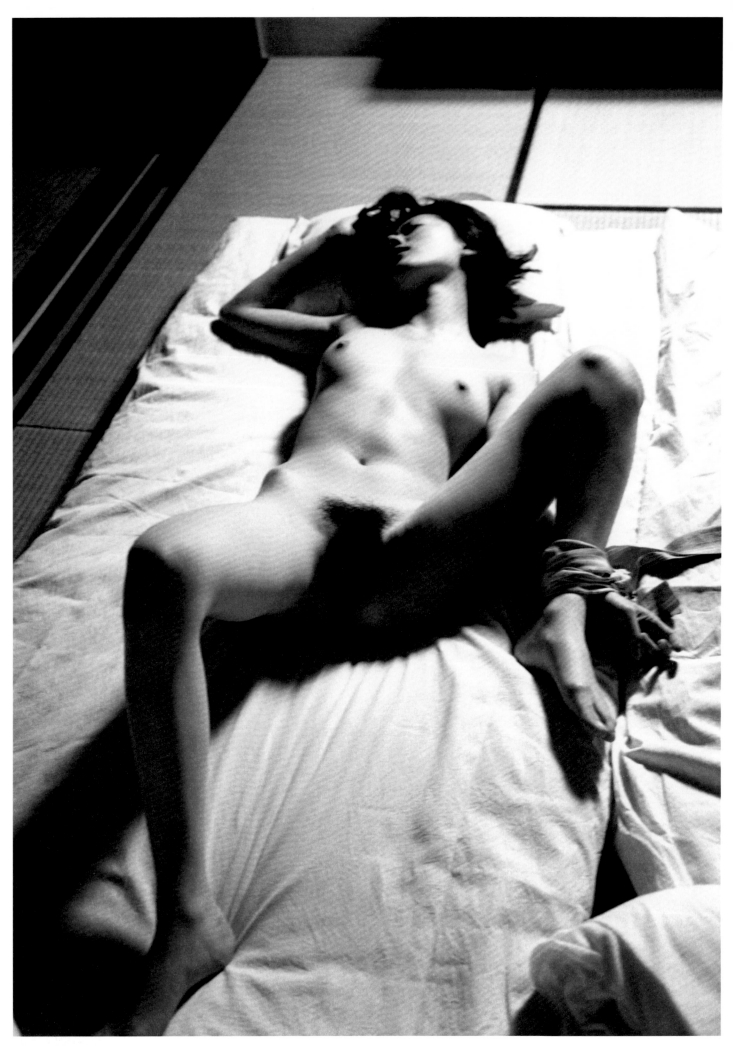

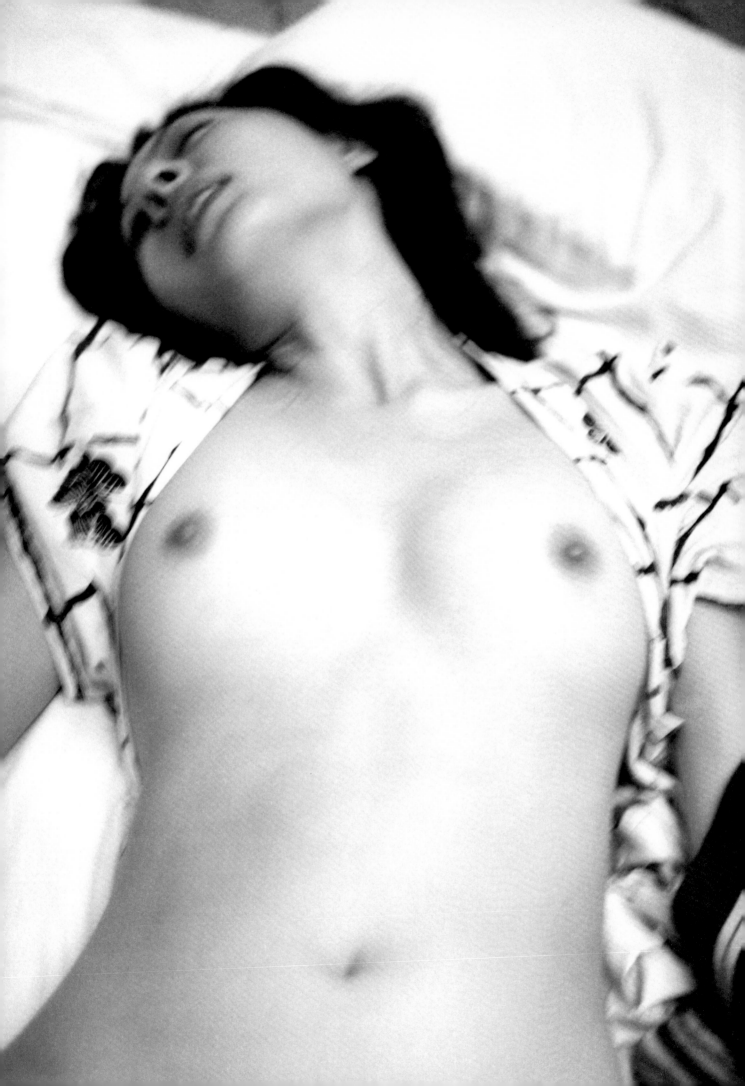

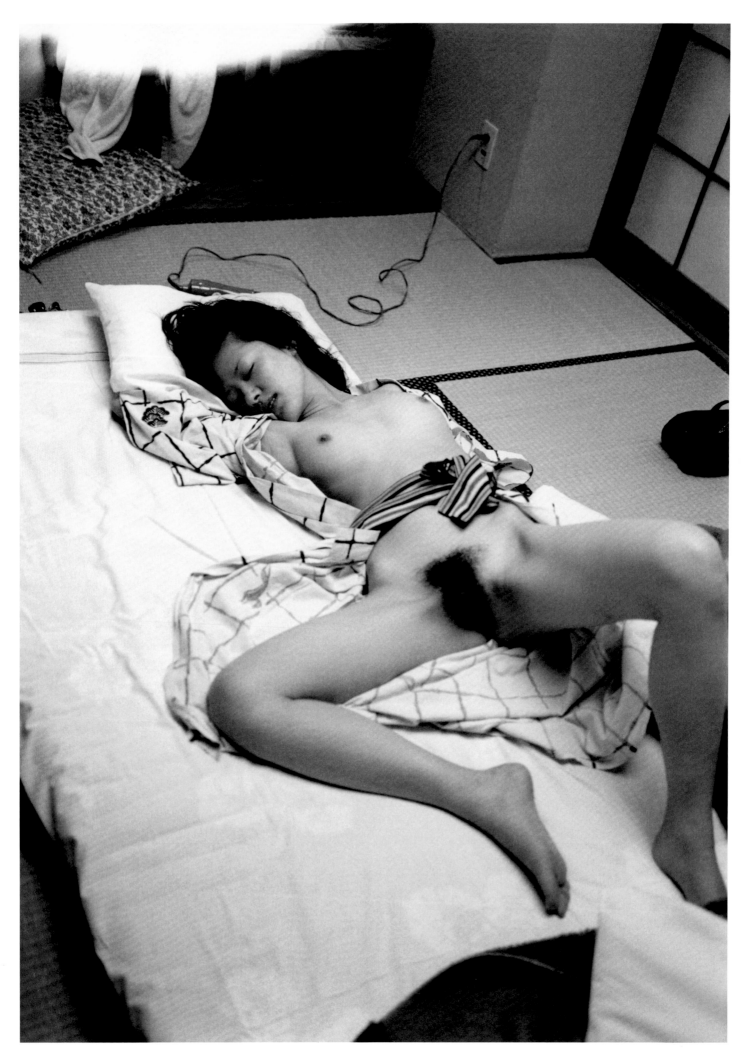

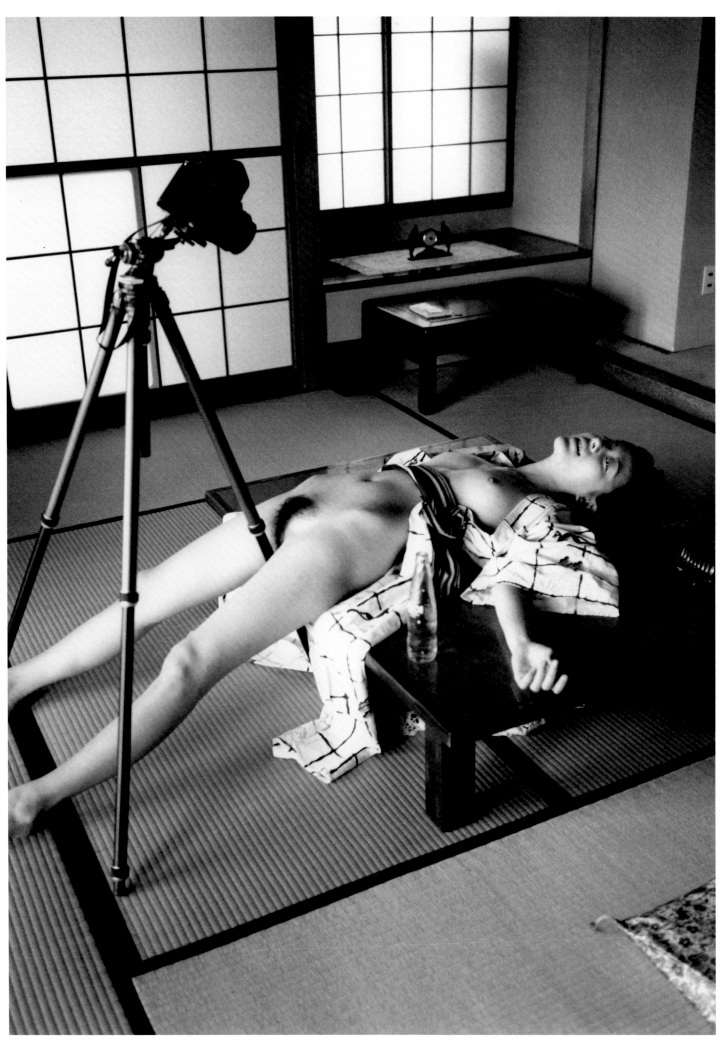

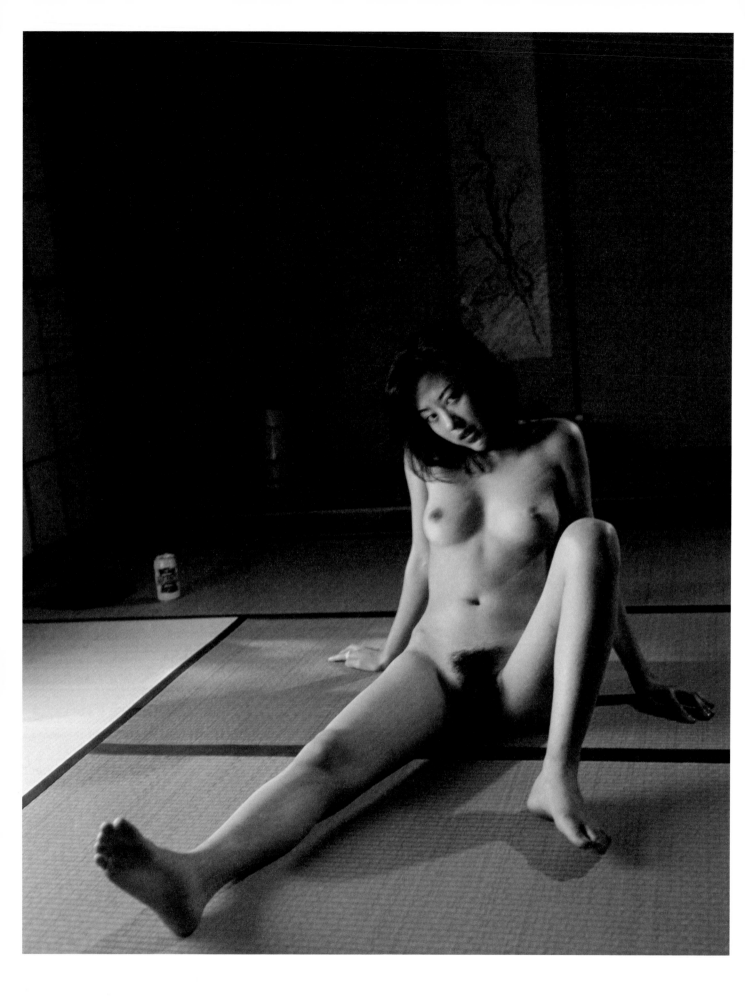

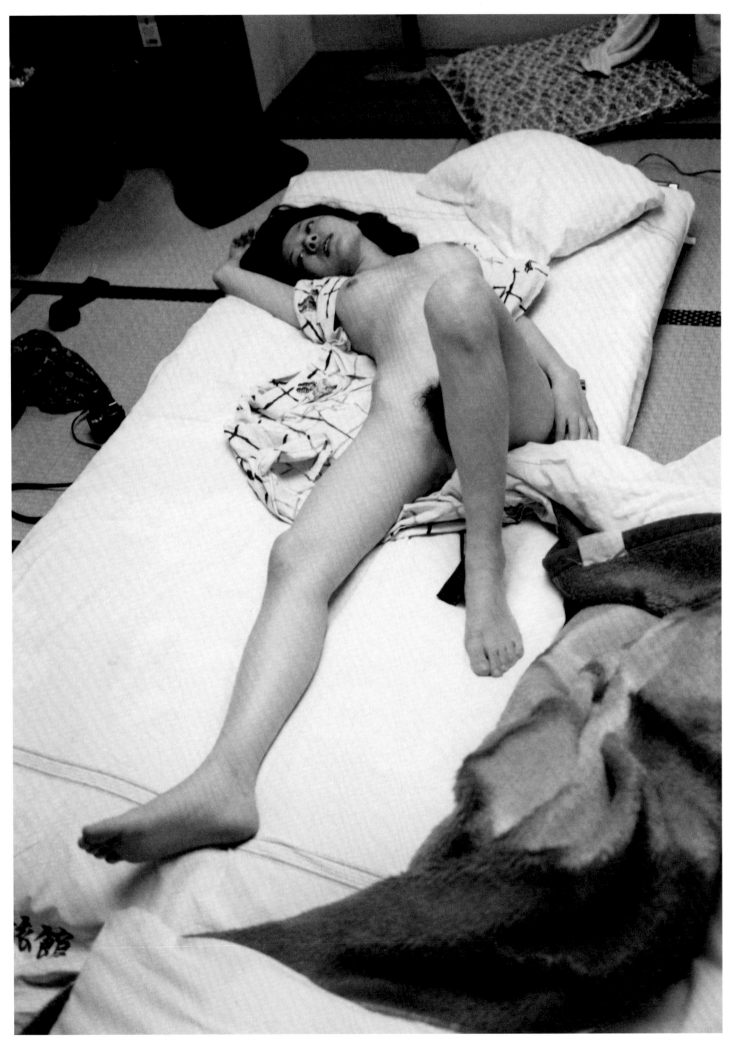

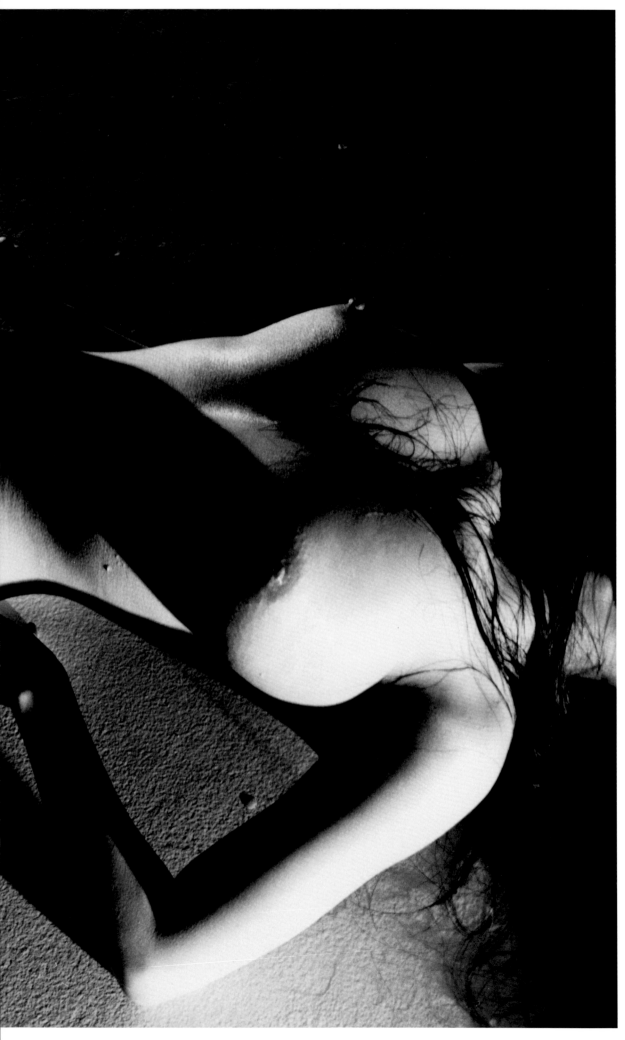

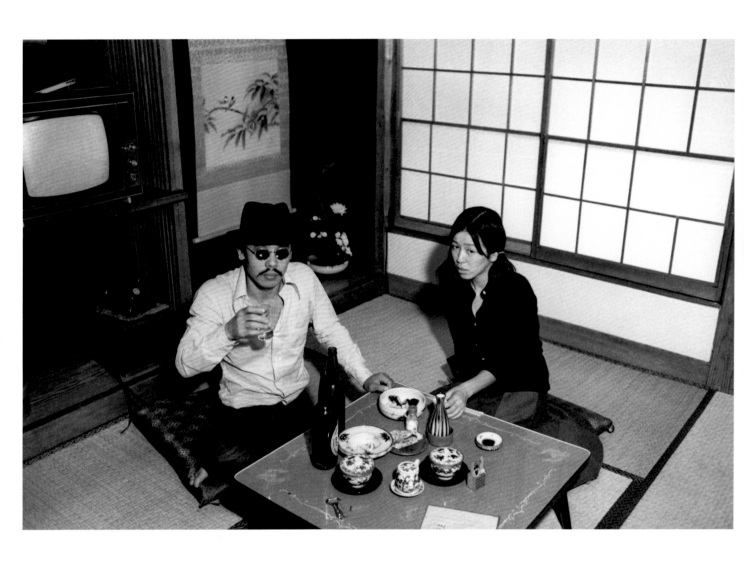

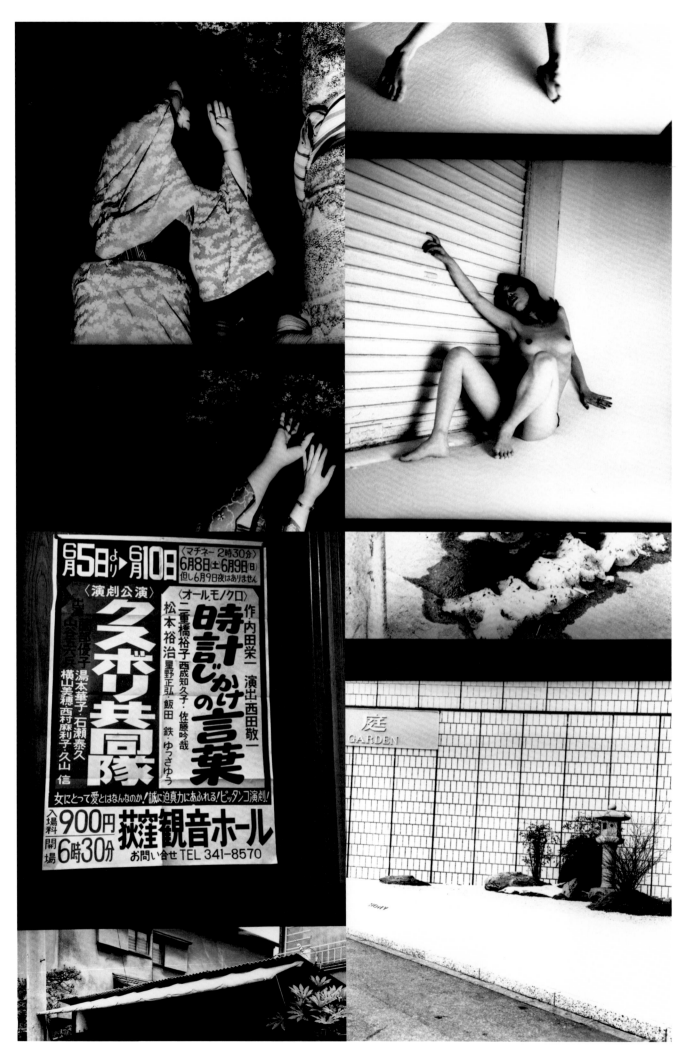

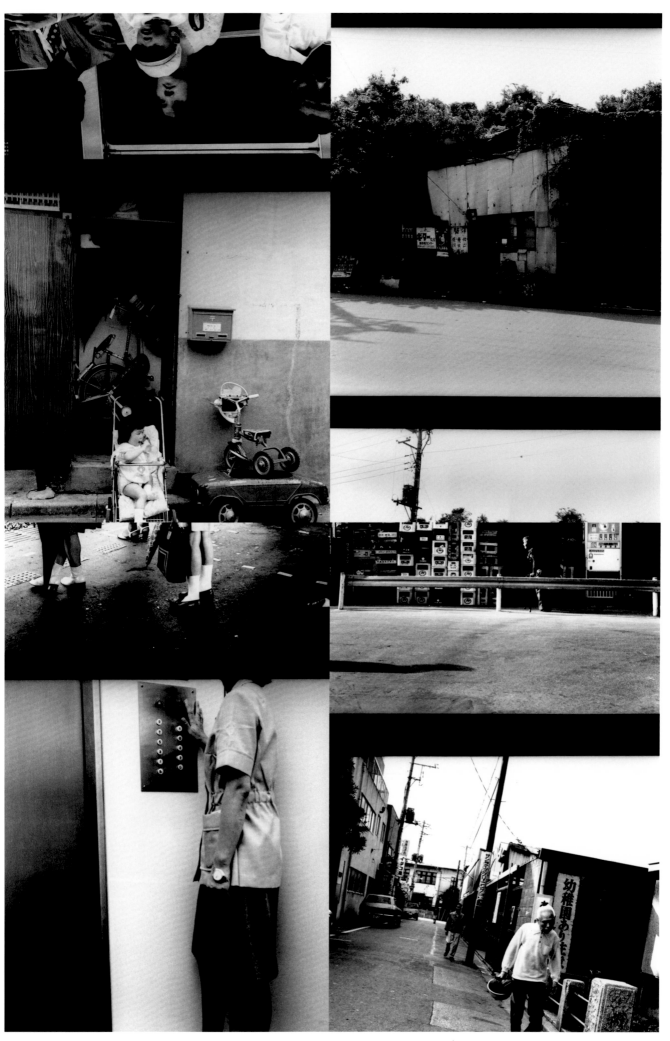

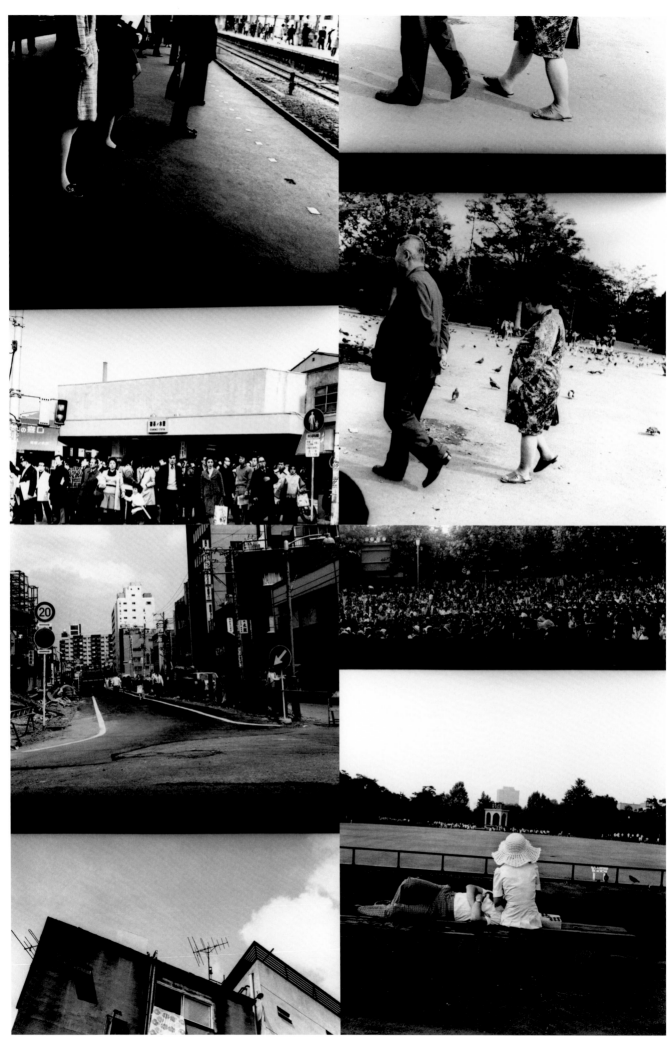

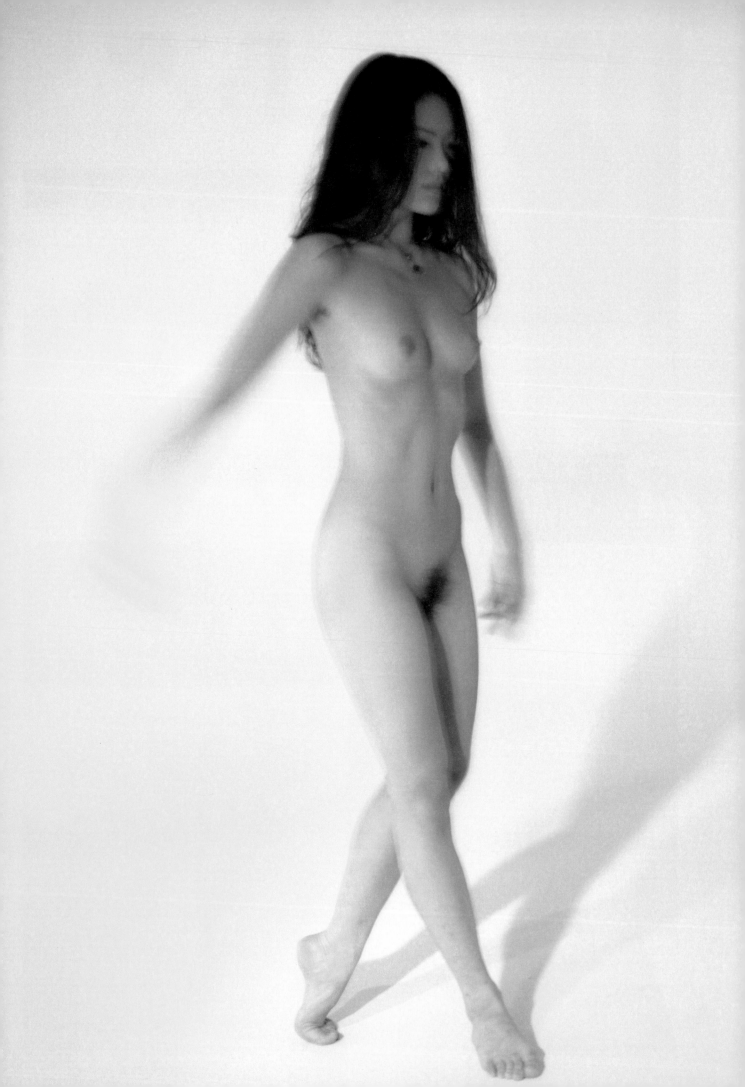

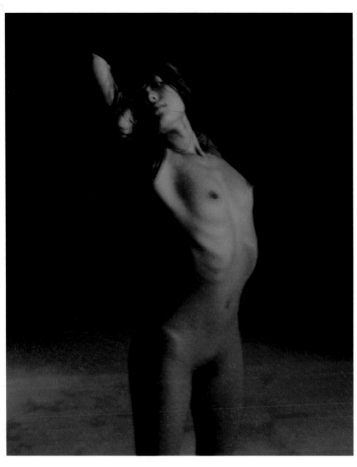
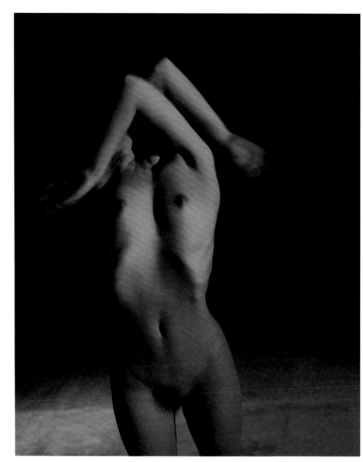
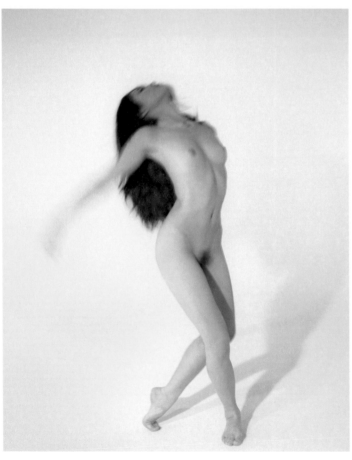
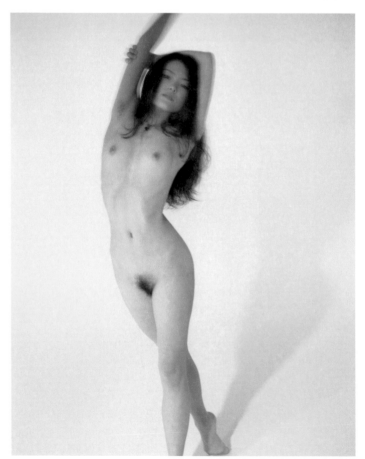

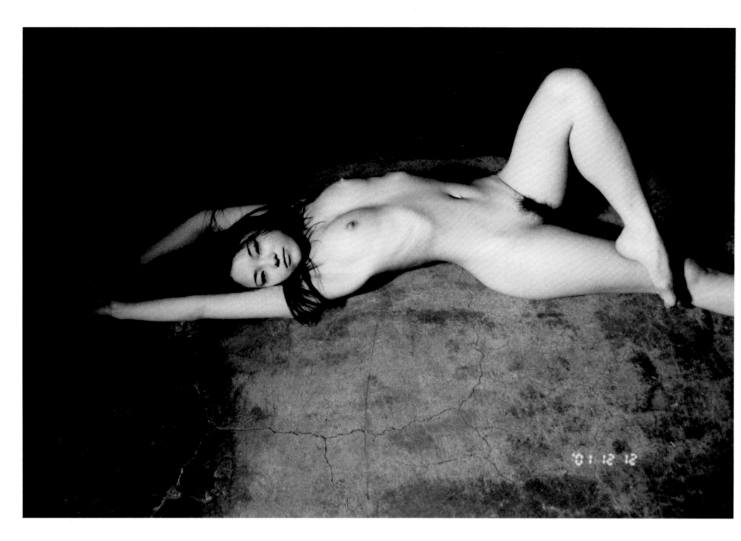

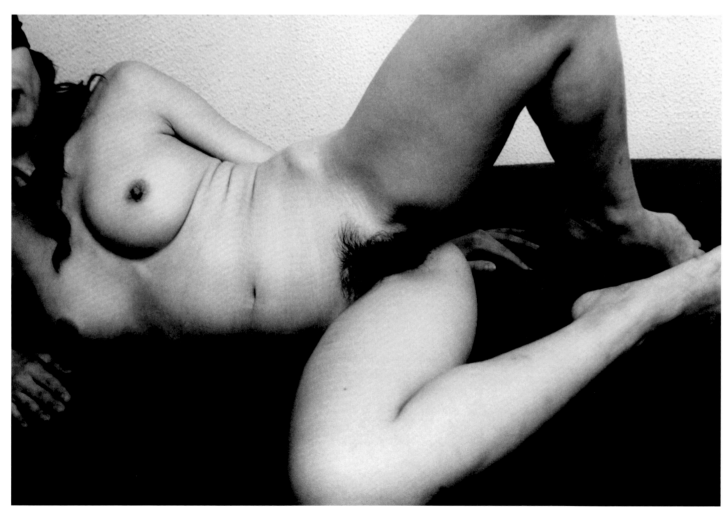

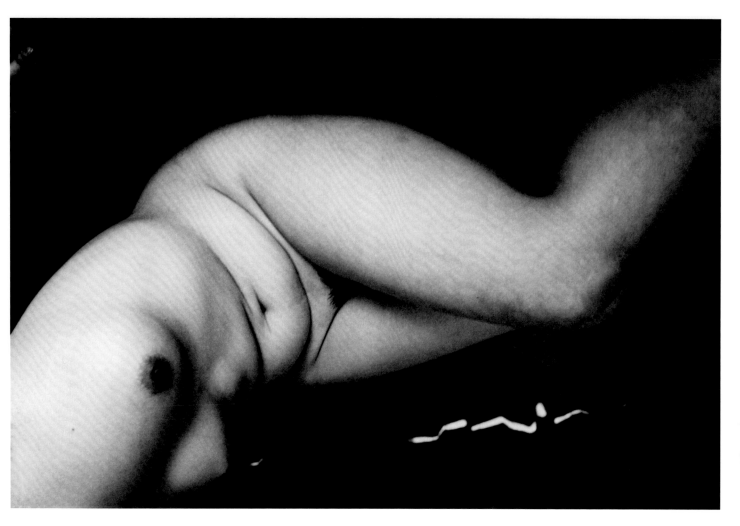

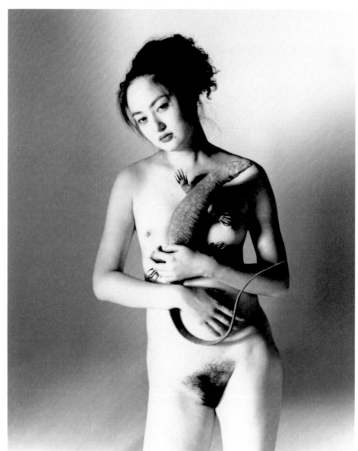

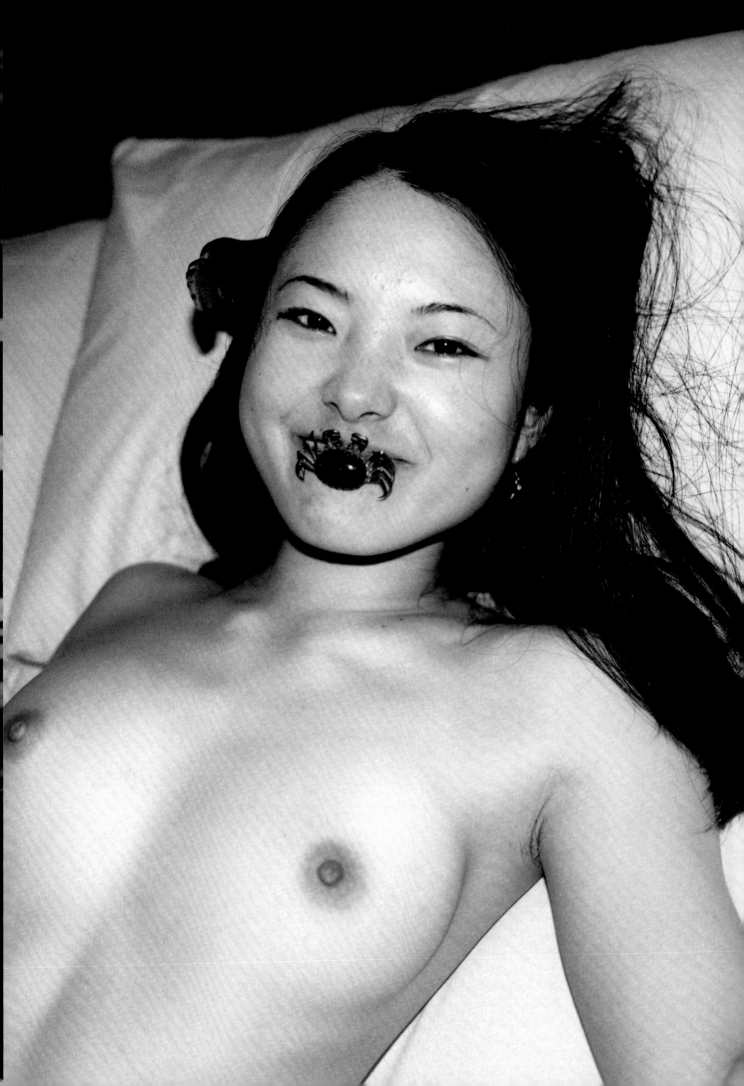

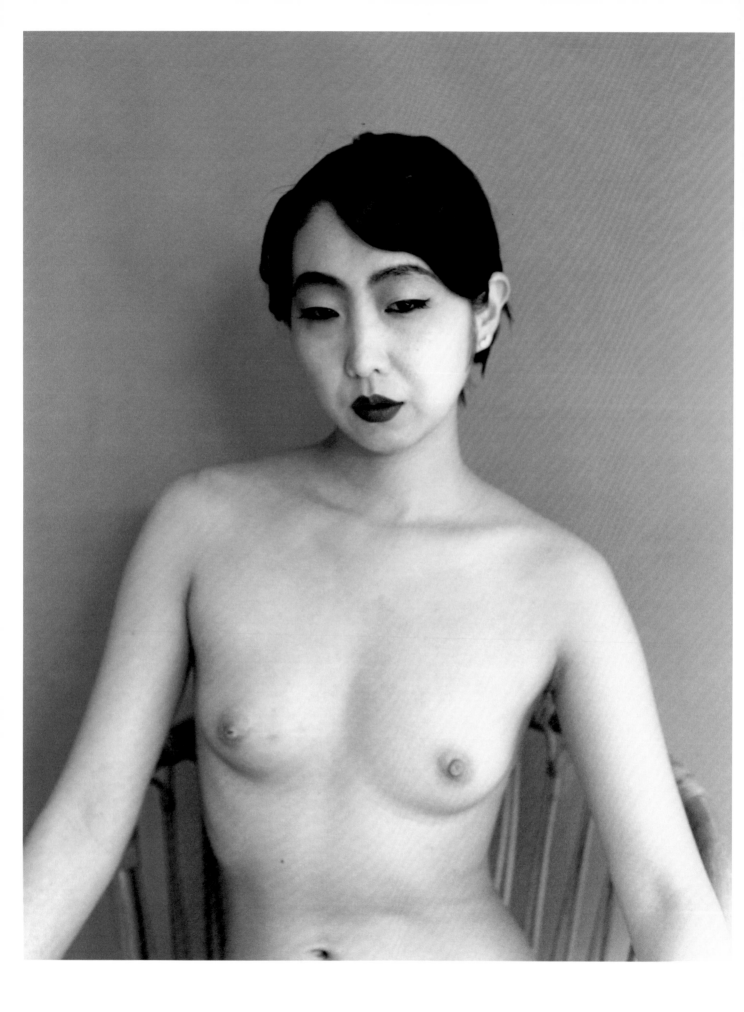

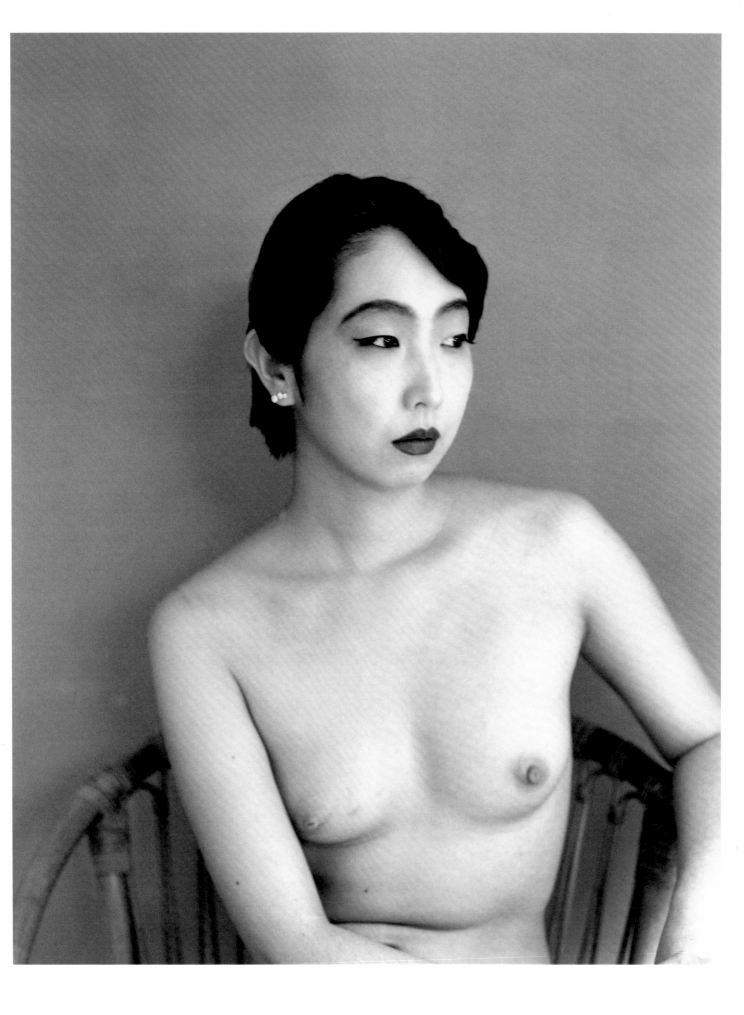

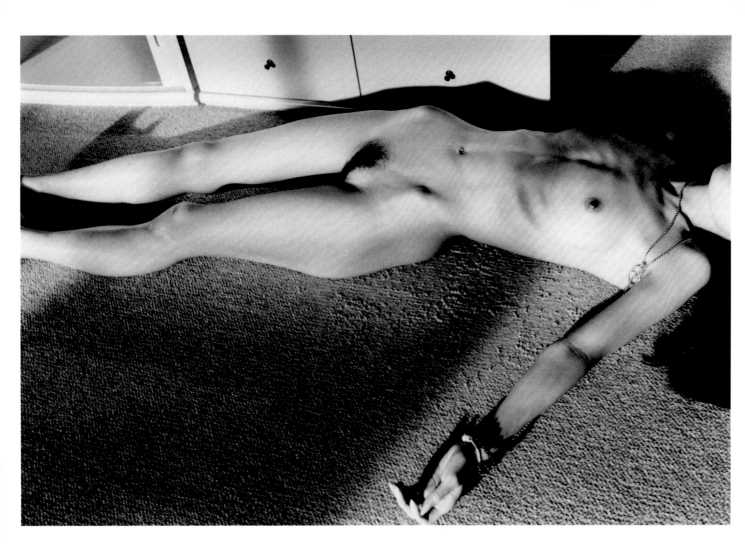

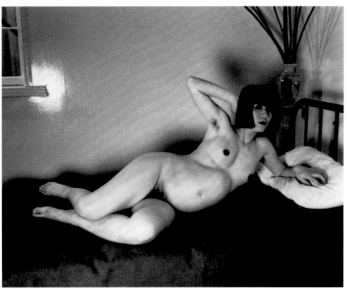

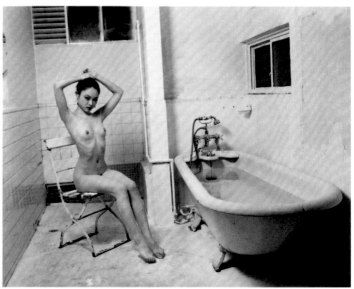

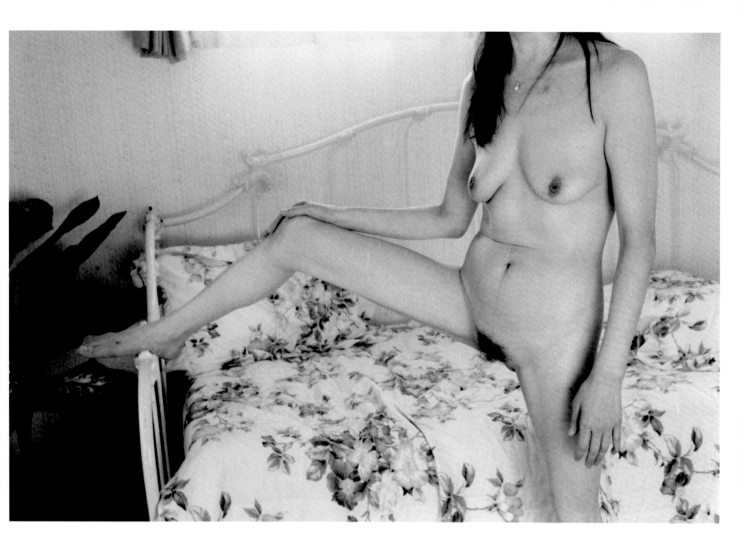

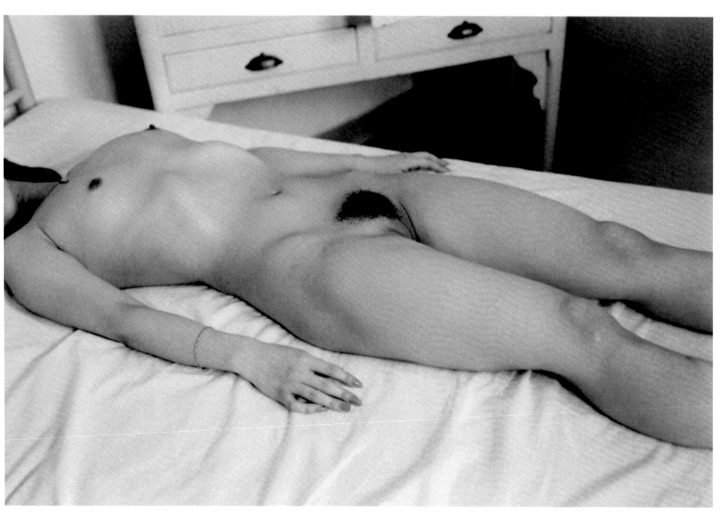

PHOTOGRAPHS SHOULD
BE WET
—

When you use a Polaroid, whatever you take comes out as a real photograph. Even if you cock it up, you still get a photograph. This is what I like about it.

For instance, you have a choice of whether or not to use a flash when you're shooting in a dark environment. If you shoot without a flash when you'd have been better to have a shot with a flash, the face will ended up blurred. But it sometimes happens that you get a much more interesting shot as a result. This really appeals to me.

You can end up with a duff shot, with nothing at all in the picture, with a jet black picture, or with something odd appearing in the picture, but, even when this happens, a Polaroid picture really feels like a proper photograph. I find this attractive. That's why I intend to mix photos that come out properly with other photos that are blurred and indistinct at random. Like a photographic mandala.

A Polaroid is very personal: it's mine, it's mine and yours, it belongs to both of us. Photography won't expand without such elements. What I'm saying may sound a bit trite. But the question is how to intoxicate another person with such triteness and ordinariness. It's really very simple. There's no love involved but it feels good. That's trite.

You take a colour photo with a Polaroid and there's no sense of it being grainy; it's all wet and slippery. It makes you want to touch it. I like that. You use this camera and it has the effect of bringing to the fore what you want to see and touch.

In contrast, photos taken with a digital camera have none of this wetness. Photographs should be wet. Digital photographs feel dry and lifeless. What's more, you can immediately get rid of them and then retake them. Far too sissy for my liking!

I've done it many times. I reckon I could produce a collection of digital photographs. I'd decide which ones to delete and I'd select each photograph rigorously. I reckon the interest of a digital camera lies in your being able to delete what you've done. It must be great fun to take an unbelievably good photograph and then delete it an instant so that nothing remains behind. The memory of the photograph will then remain mine alone. Perhaps in this sense a digital camera is even more personal than a Polaroid.

For instance, let's assume you go and have it off with someone in a love hotel. You take photos of each other; you look at each other's photos and you get aroused. Then when you leave the hotel, you erase the lot. This is really cool! What's so cool about it? It's cool to do something so wasteful!

Well, whenever something new comes out, there are always various pleasures that come in its wake. We all have a taste for luxury.

PHOTOGRAPHS ARE SEASONAL

—

With Polaroid shots, you don't actually print them yourself. I'm actually very good at creating prints, but I've always left the developing process up to other people. I feel that it's a good idea to leave things up to others and not to try to dominate everything yourself.

Way back in the past I used to use a 6 x 7 single-lens reflex Pentax with a tripod, and I'd take very precise shots, perfectly framed and with perfect shading. They'd reveal my genius to the full.

But then I began to wonder if it wouldn't be a better idea to leave things more up to the camera itself. I felt that it would be better to have recourse to the strong points and the weak points of the camera. It was about then that the Plaubel Makina appeared. With this camera, you focus with the viewfinder and it keeps you on edge. The framing is pretty chaotic, and it's a camera that really demands a bit of effort. You really feel you're taking a photograph.

I've always felt that the photo that isn't a work in its own right is much closer to what photography is all about. That's why I gave up developing my own photographs. I take them normally and get them developed mechanically. I don't print them myself either.

I guess it must have been about ten years ago, but I began a series entitled 'Shashin shijo shugi' in a photographic magazine.[1] I wrote that it was the Makina that made me most aware of photography as such. The title of this series was based on one of my silly puns, the phrase seeming on the surface to mean 'photography for photography's sake', but, in the way I wrote it, actually meaning 'my personal beliefs about photography'.

But the magazine editors began to get complaints from the manufacturers. They didn't like the fact that I was concentrating solely on the Makina. They apparently said that they'd withdraw their advertising if the magazine didn't stop my series. Several companies apparently said this. The magazine had to decide whether to continue my series and fork up or to lose their advertising revenue.

Needless to say, they plumped for the advertising.

I thought 'Damn this!' and decided to continue using the camera regardless, which I did for more than ten years. I've decided to produce an anthology of work I've done using this camera. I got other people to print my work in those days, but I thought I'd do it myself this time.

People may well take me to task for saying something different from what I've said in the past, but all I can say in response is that photography is a seasonal business. So much depends on how you're feeling physically and mentally at any one time. That's all there is to it. So I decided to have go at printing myself for once. Once I say that, it's strange but I really feel like giving it a go. Printing, that is.

This is because it seems to me now that developing, printing and all this sort of work is all closely bound up with the photograph itself. I feel a bit like a pendulum. On one side of the pendulum is this feeling that I'm happy with a pretty haphazard approach, and on the other side is this determination to take really good photographs. I'm constantly wavering between these different approaches.

[1] *Shashin shijo shugi: The postscript to Personal Belief in the Supremacy of Photography* (Tokyo: Heibonsha, 2000) contains the following passages: 'As far as I recall, it was around the beginning of the 1980s that I started using the pun on *shashin shijo shugi* based on the double meaning of the word *shijo* ("supremacy" and "personal feelings"). Looking at my "Tokyo Diary 1981–89", there's a reference to the Makina 6 x 7 on 10 October 1982 and a reference to "my personal beliefs about photography" on 2 December.' 'The Plaubel Makina has been released, and I feel that this is the camera best suited to shooting the present. I've decided to use this camera on an everyday basis, and I take it with me wherever I go. Well then, as for "my personal beliefs about photography". I began a regular series in the magazine *Kamera Mainichi* with this title. It ended after just three submissions because it was getting in the way of other manufacturers.'

The idea of "personal sentiment" or "private feelings" present in the term *shashin shijo shugi* gives this Araki pun an important role in understanding his personality and work.

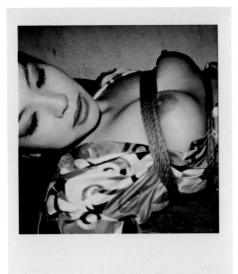

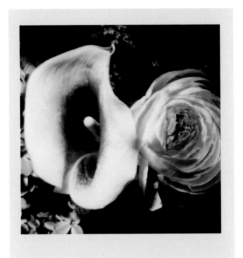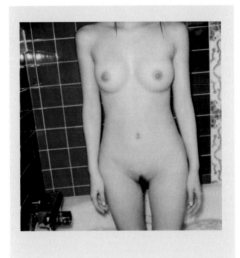

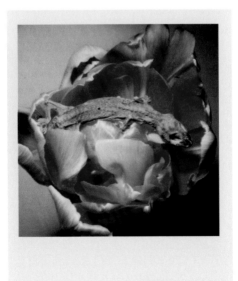

 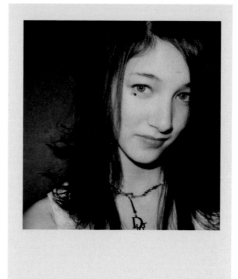 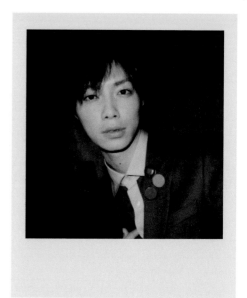

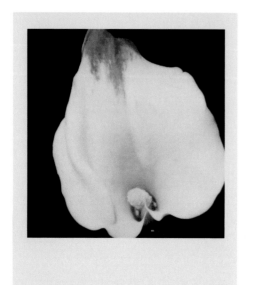 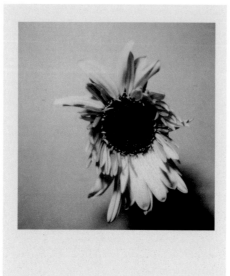

416

 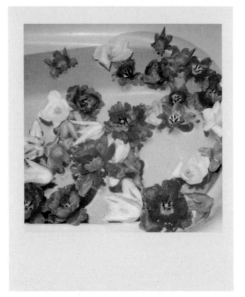

 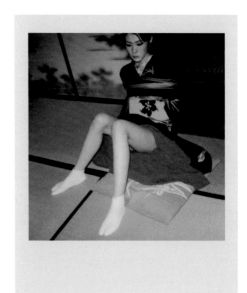

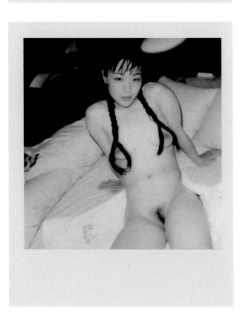 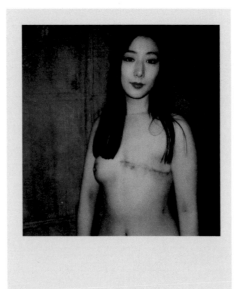 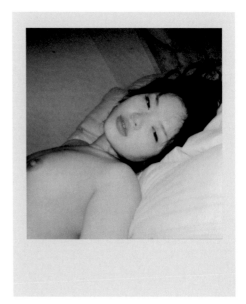

 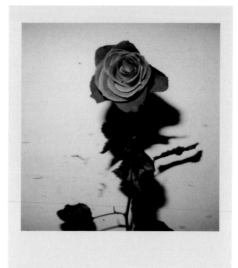 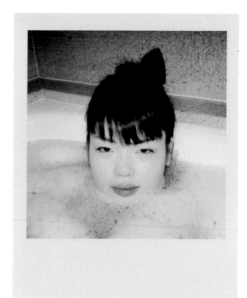

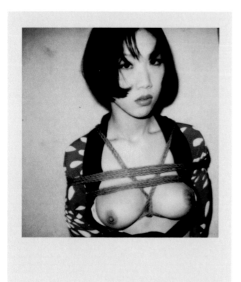 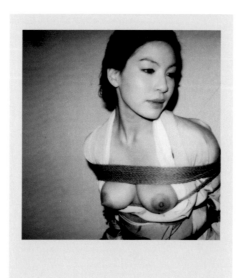 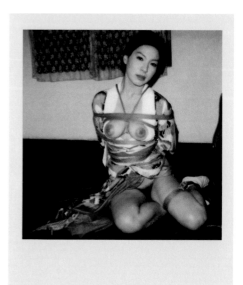

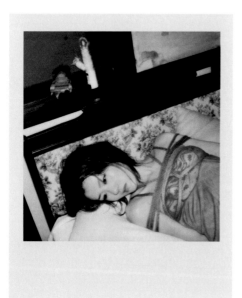

 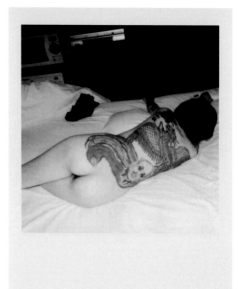

 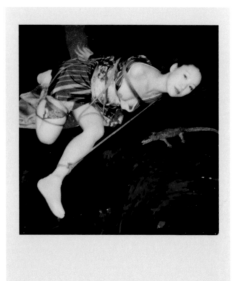 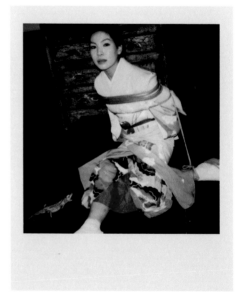

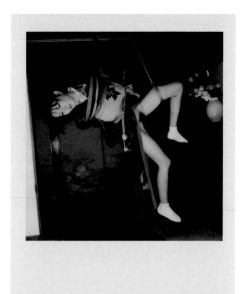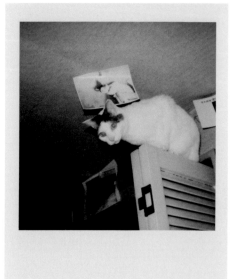

TOKYO

TOKYO
LUCKY HOLE

ENSURING THAT THE TRUTH
REMAINS UNSEEN!
—

The best course of action is to establish links with things in your immediate vicinity and then move forward sluggishly from there. If you continue from points you've noticed, you find that various photographic techniques emerge of their own accord. Methodology is something that appears naturally after you've actually started working. The best thing is just to follow up on your ideas as they occur to you.

Photographs are much more dramatic and their content is much weightier when there's no real incident involved. A real fire is nothing like as interesting as conflagration occurring in your own mind! Photography is better able to express things like this. When an incident occurs, it isn't able in the long run to reach down deep within, simply because of the force of the surface impression created by the incident. Although that's not to deny that the surface has its own inner quality.

This means that if a photographer comes up with a bad photograph, it's the photographer himself who's to blame. It's down to a lack of training and experience. This is the extent to which you find yourself being exposed in your own photographs. Put bluntly, taking photographs lays bare all the photographer's own secrets. I find this hard to endure and so I try to hide these personal aspects. Really. Just like putting on a sheath to cover up your penis from view. The thing is to ensure that the truth remains invisible!

In this sense I suppose you might consider that the real purpose of technique is to obscure the truth. Taking a good photograph perhaps isn't really a question of using technique. Cameras these days do virtually everything for you on the technical level. Under these conditions, technique is all about hiding yourself or hiding the truth. Technique is a way of fooling people.

It's really a question of technique on the level of personal relationships. Photography entails a variety of techniques, but, on the most basic level, taking a photograph is a matter of forming relationships with other people. People used to think that the subject of a photograph should be seen objectively and any relationship between the photographer and the subject should be set aside, but it seems to me now that the relationship between photographer and subject should be deepened. Rather than refusing to incorporate feelings, I feel it's better to base your work on feelings.

Young people these days always strive to see things from a distance. They try to give the impression that what they're shooting has nothing to do with them, or they try to photograph the mood of the age. I always try to see the young generation in a favourable light, but I get the impression – although I may be wrong – that they're repressing their emotions.

Looking at the work of young photographers, I feel that although they'd like to use their cameras to put all their feelings into their work, they're doing all they can to suppress these feelings. Women seem to get across a more slapstick feel. I don't quite know how to describe it, but their photographs seem to have a lighter edge.

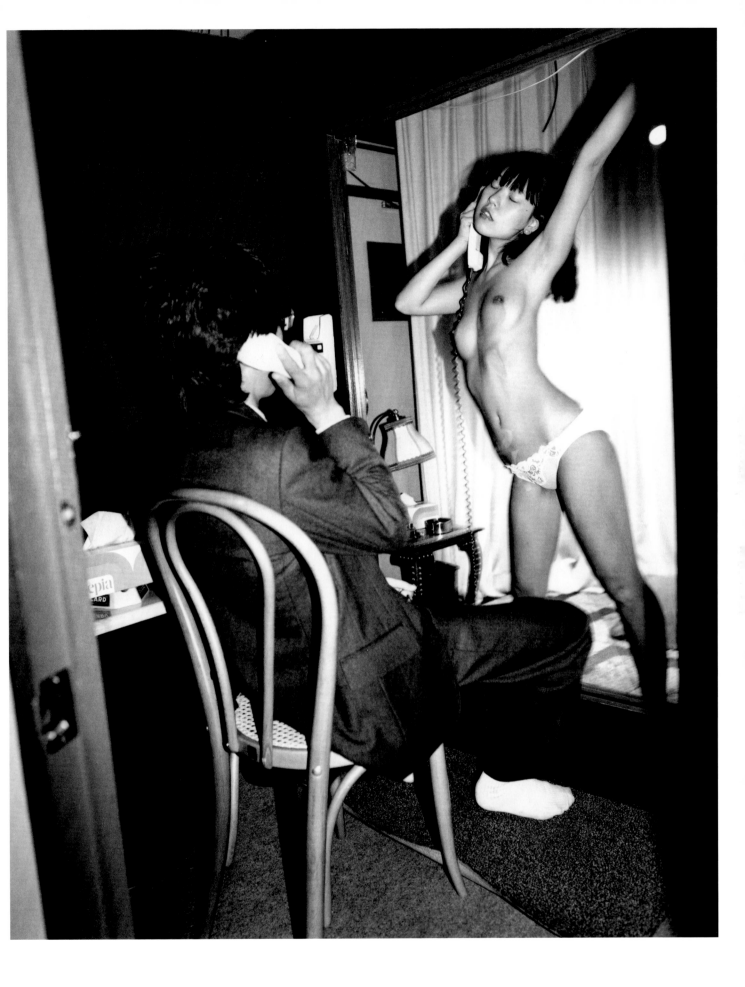

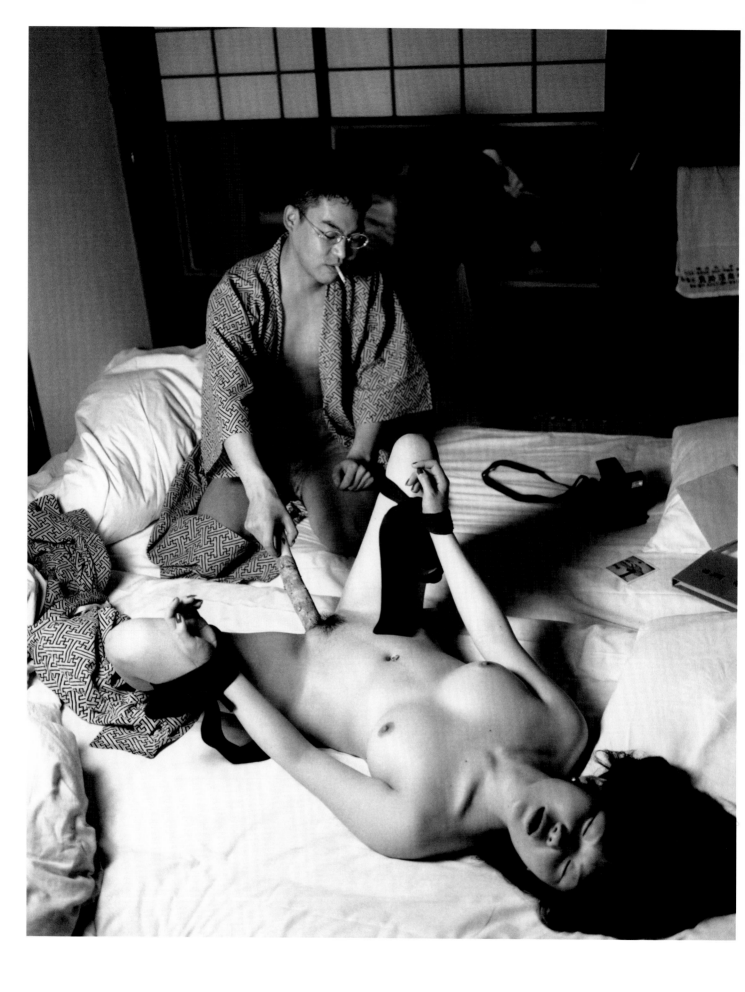

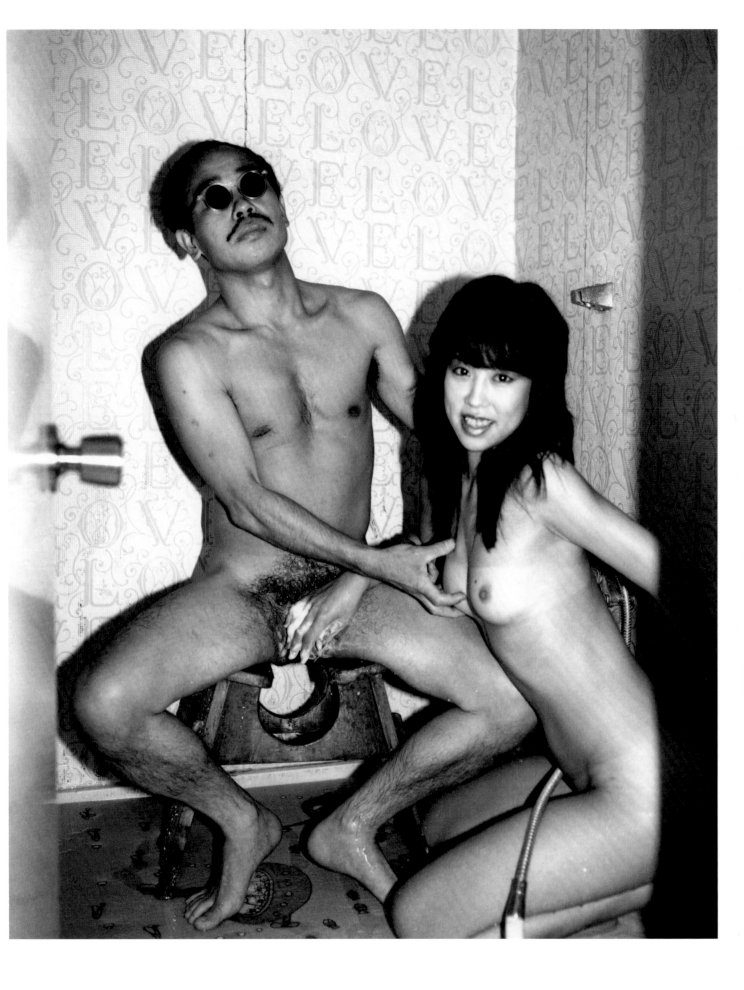

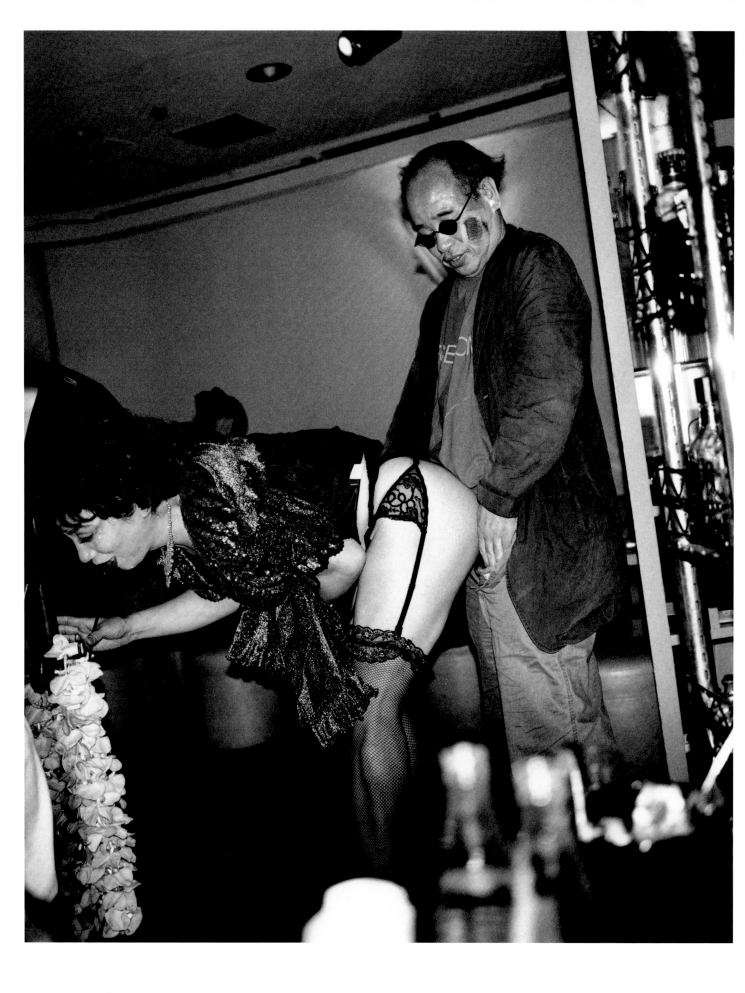

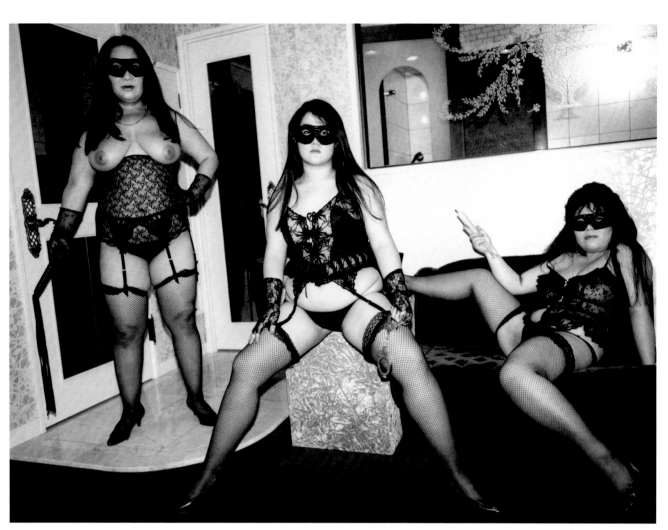

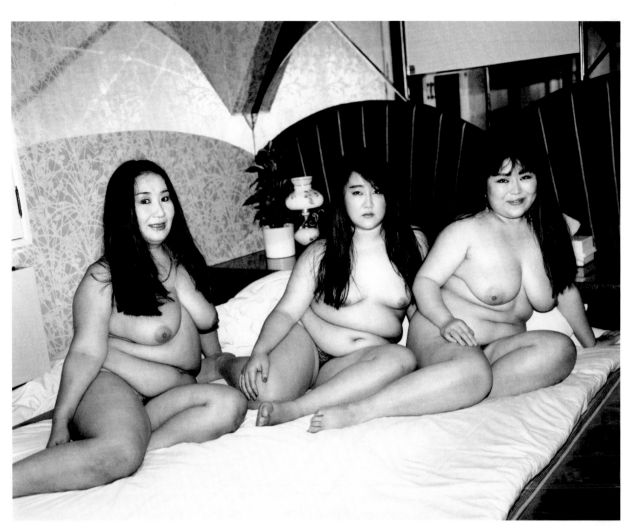

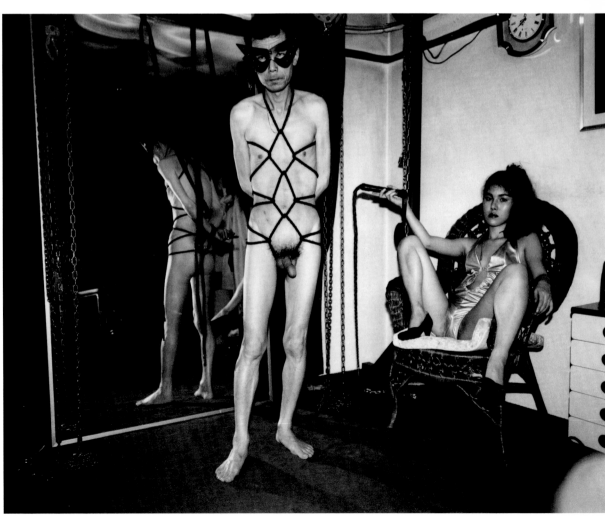

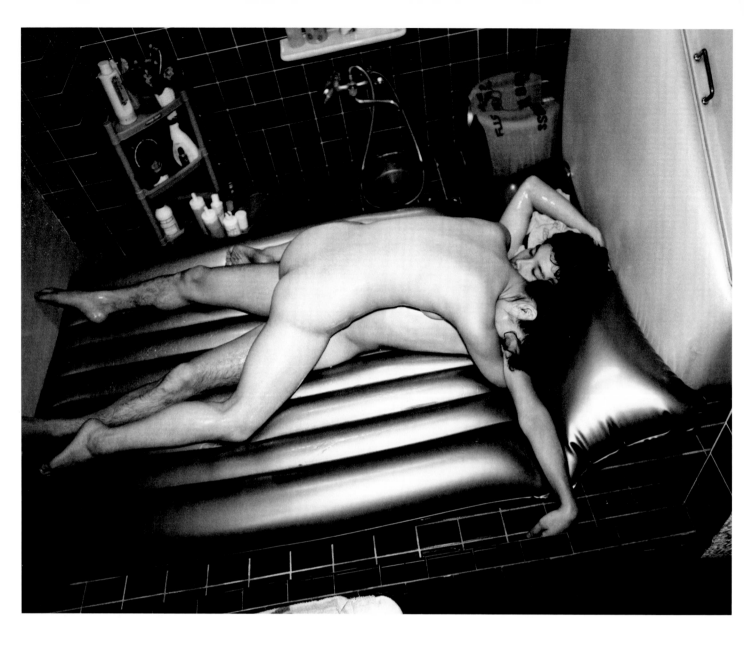

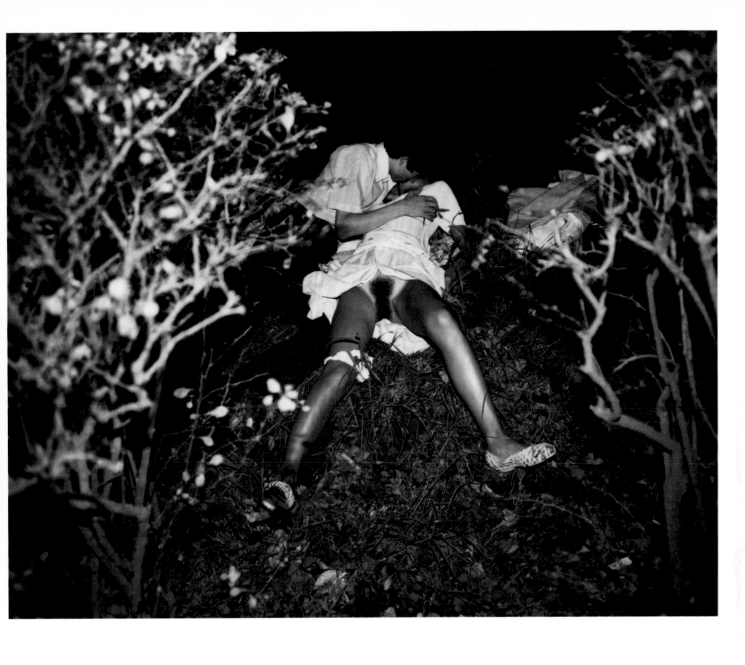

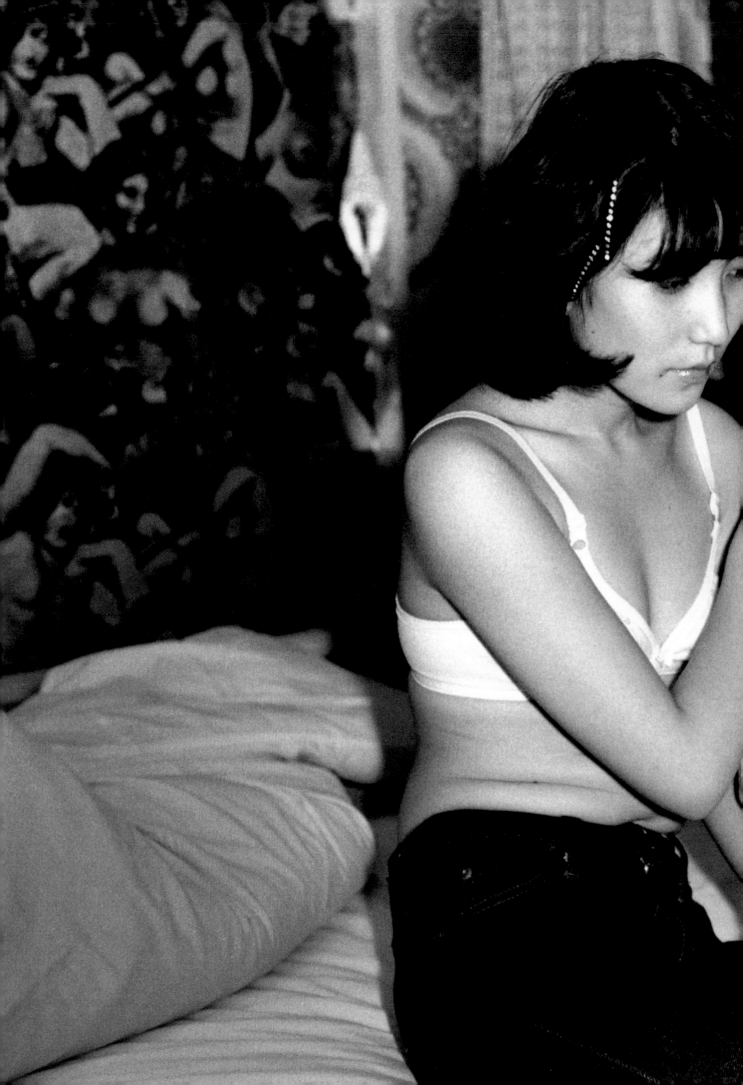

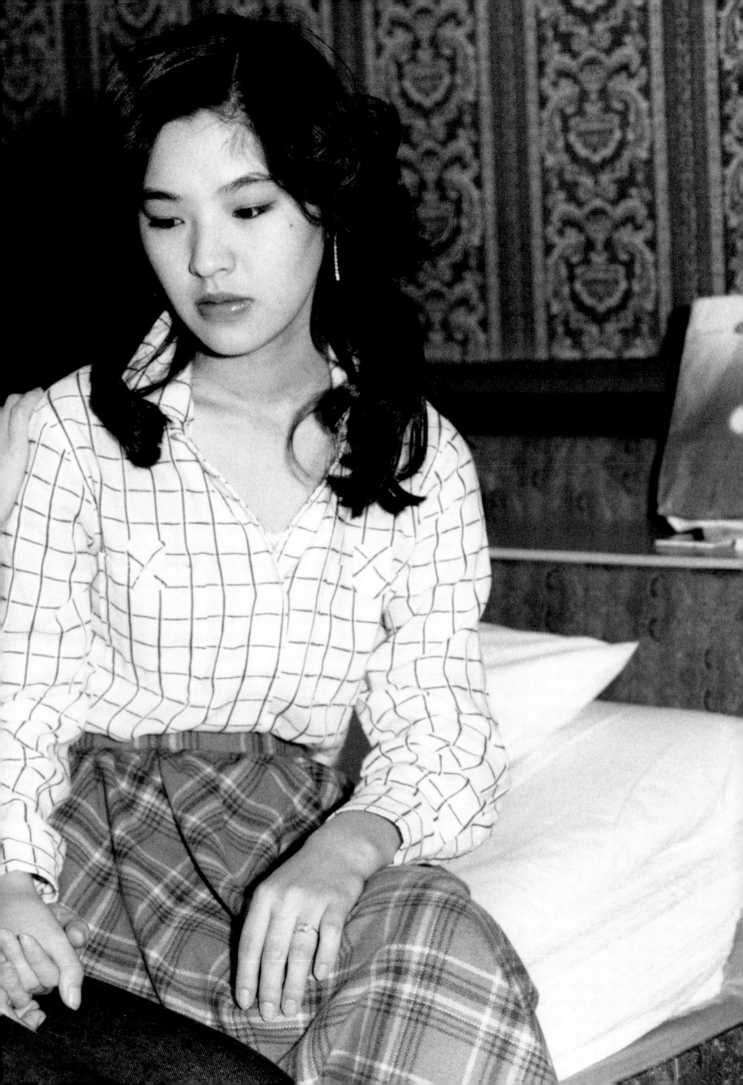

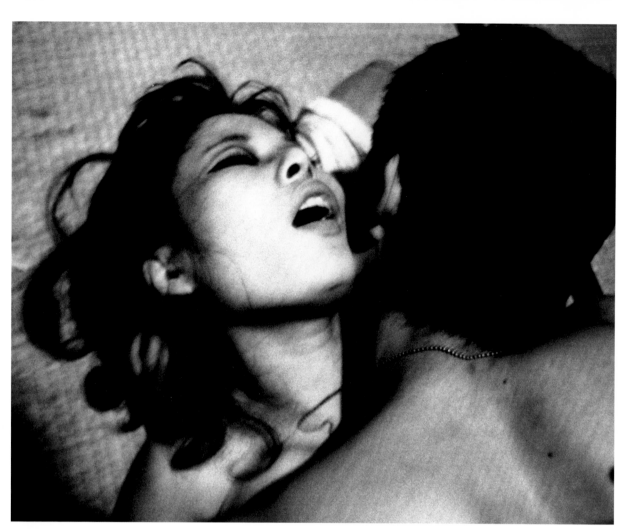

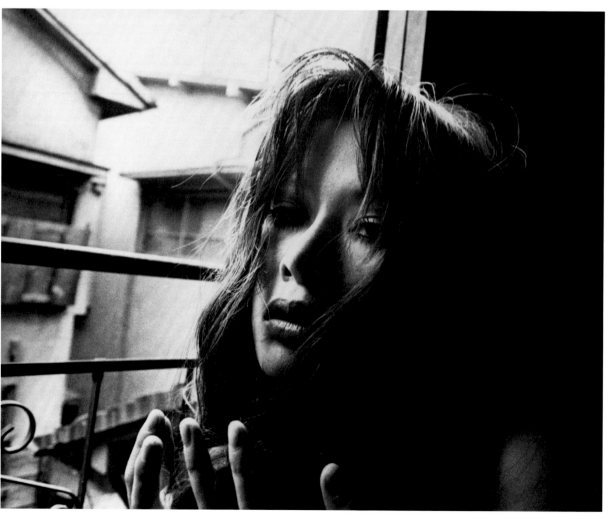

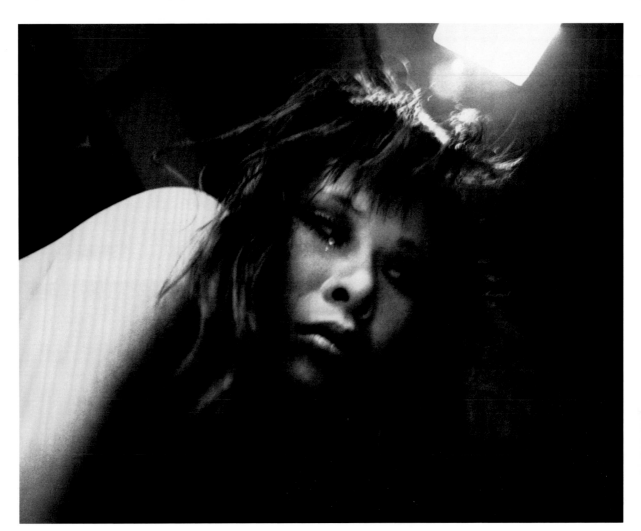

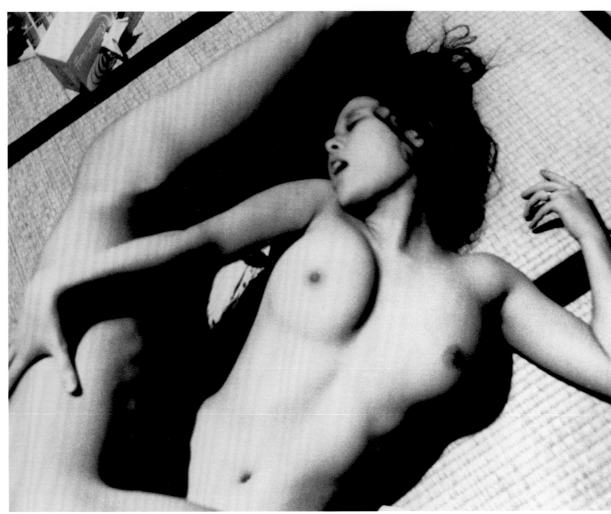

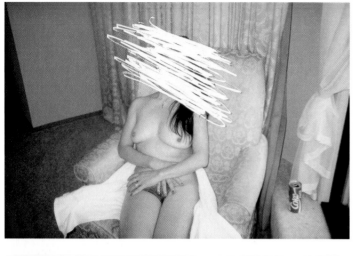 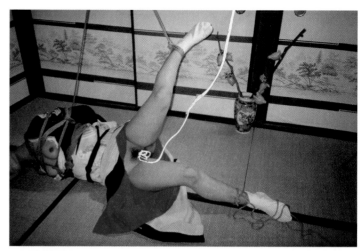

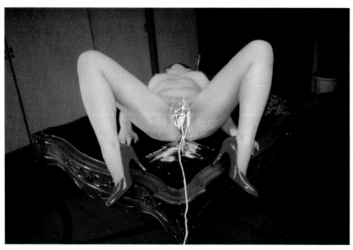 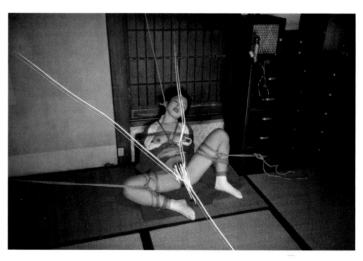

 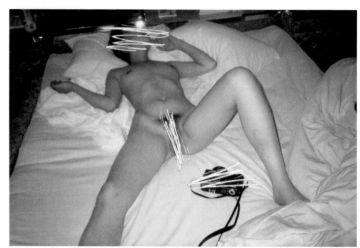

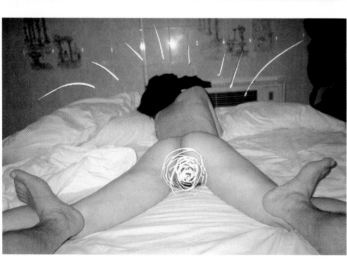

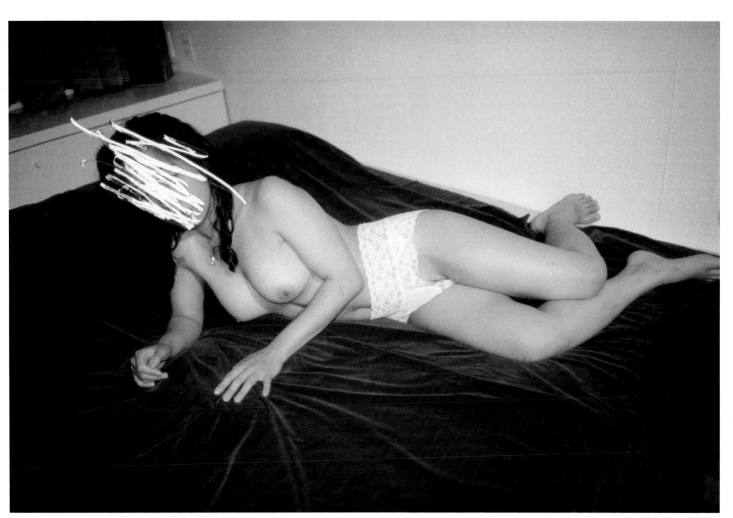

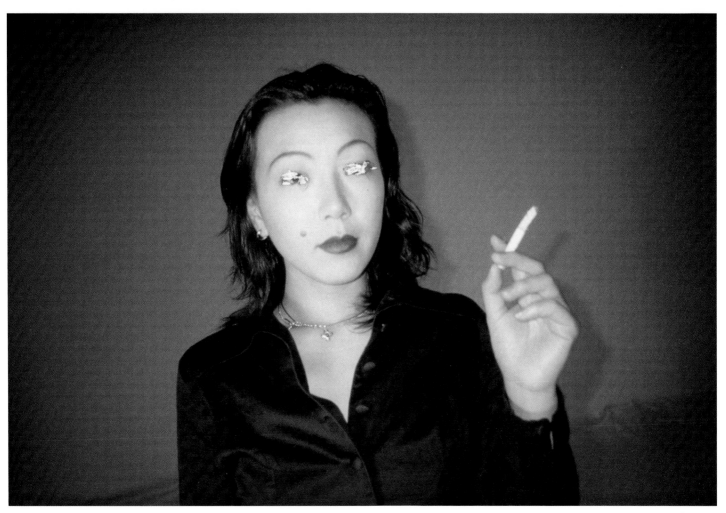

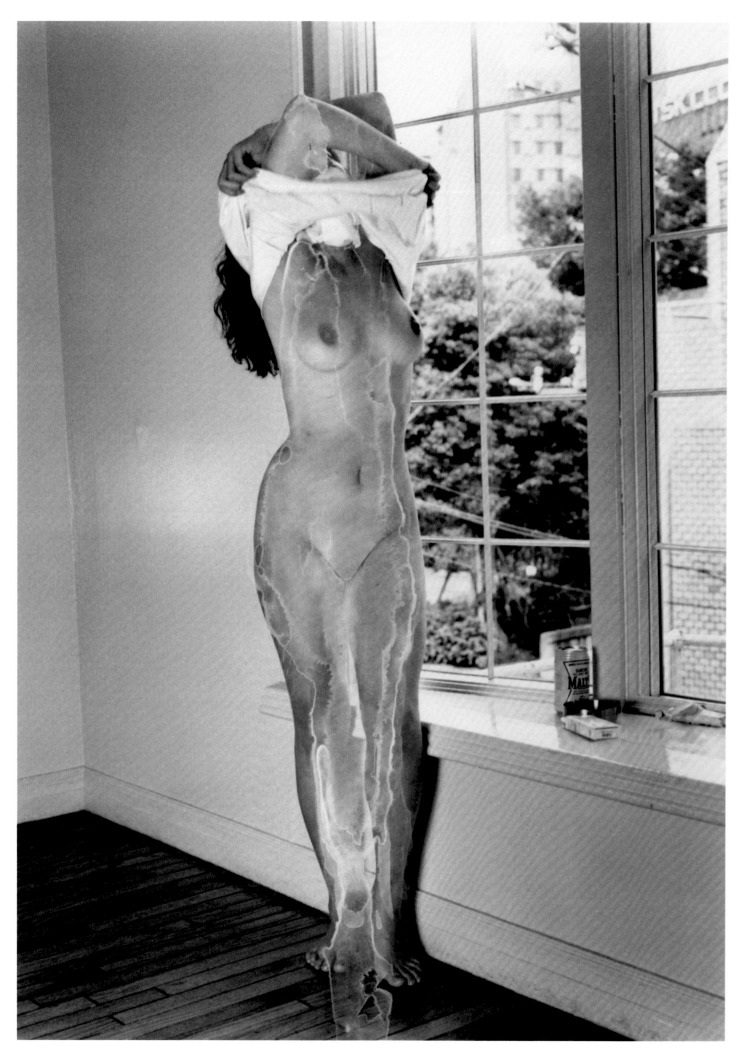

SPERMACO

DIFFERENT PLACES,
DIFFERENT WOMEN, DIFFERENT MEN
—

With different places, different women, different men, you often find that a photograph reveals positive features that you hadn't noticed yourself. You're exposing people, bringing them out into the open, and it's the job of the photographer to reveal to the subject, to the other person, aspects of themselves that they might never have been aware of before. This is what photography is all about. You show a guy how attractive his wife is. He has it off with her every day but he's never noticed how great she is, simply because he can't stand back and see her from a distance!

Changing location is a kind of journey in its own right. There's something important, basic, nostalgic about travel. It's because of this that you feel so excited and cheerful when you travel. For example, when you travel, you might end up in some place that has the warmth of the womb. It certainly doesn't seem like somewhere you're visiting for the first time. Before you know what's happened, you arrive somewhere you seem to have experienced before and you get really excited. You feel you really have to whoop it up. It's really stimulating both mentally and physically.

The best journeys last around a week to ten days. You can get impressions like these if you travel for about a week. That's why I always try to stay somewhere for around a week when I travel. Ten days is about the limit as far as I'm concerned. If you want to spend a long time somewhere, you need not ten days but ten years. That's how I feel anyway.

If you're going to change your life, you need to change your man, change your woman, change your location. If you want to change your photographs, you need to change cameras. Changing cameras means that your photographs will change. A really good camera has something I suppose you might describe as its own distinctive aura.

There are differences even between 35 mm cameras. Each model is completely different. I may go for a single-lens reflex camera or take a camera that fits in my pocket. A difference as insignificant as that results in different photographs. That's what's so amazing about cameras. Little cameras are great fun, like tiny artists in their own right.

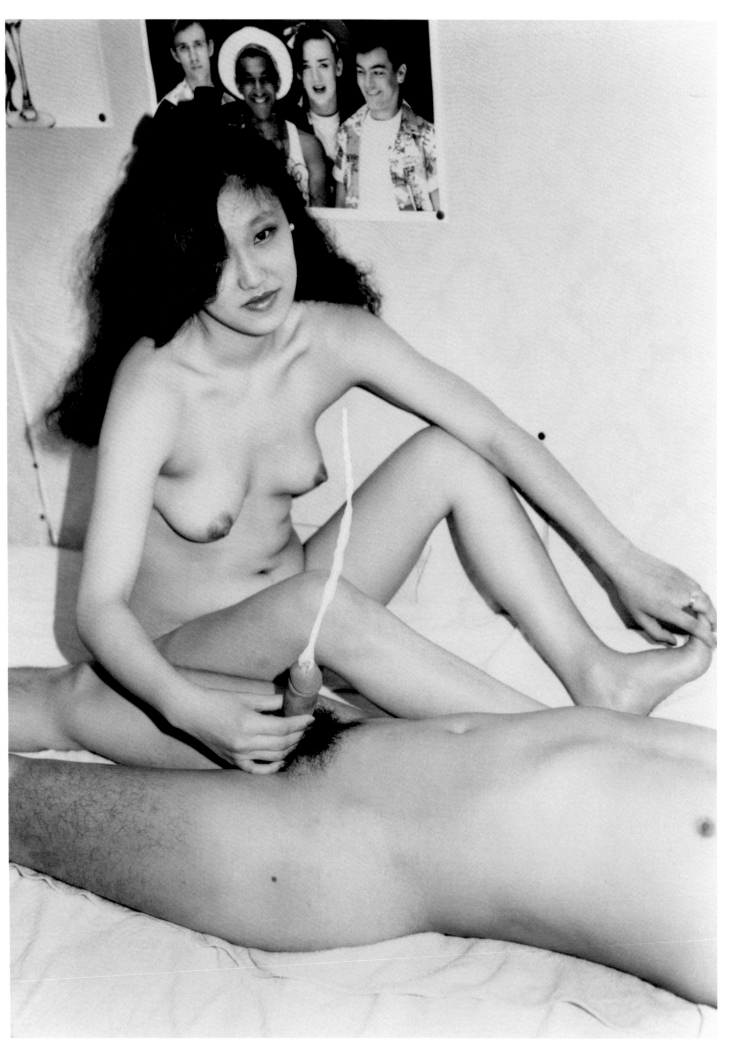

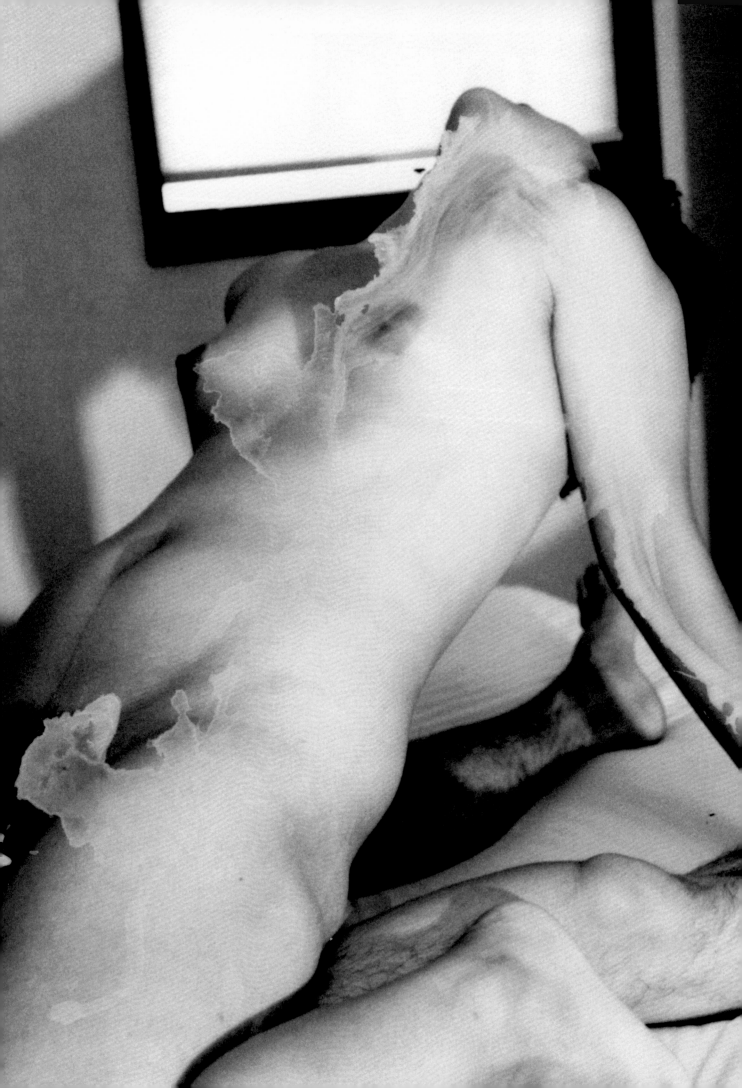

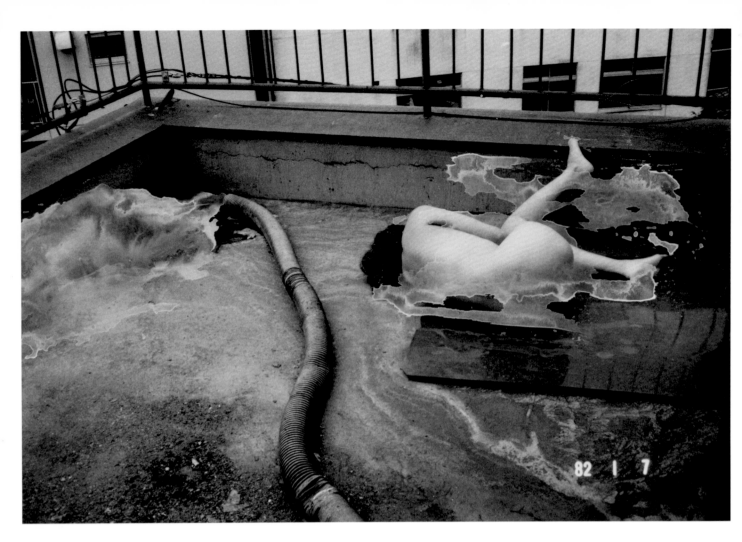

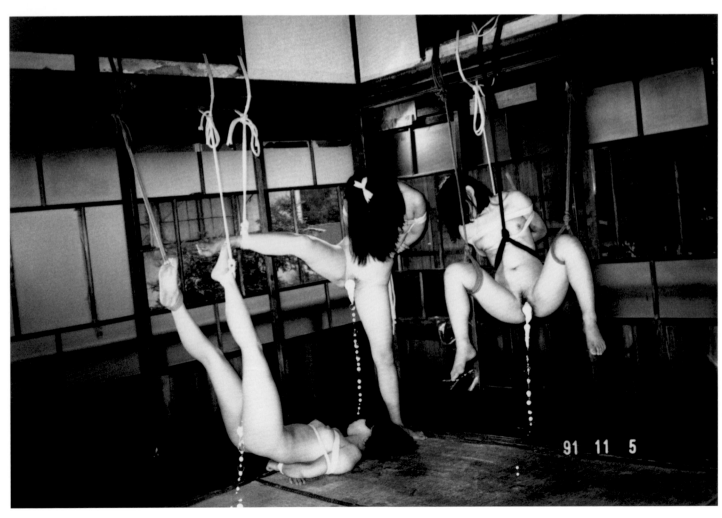

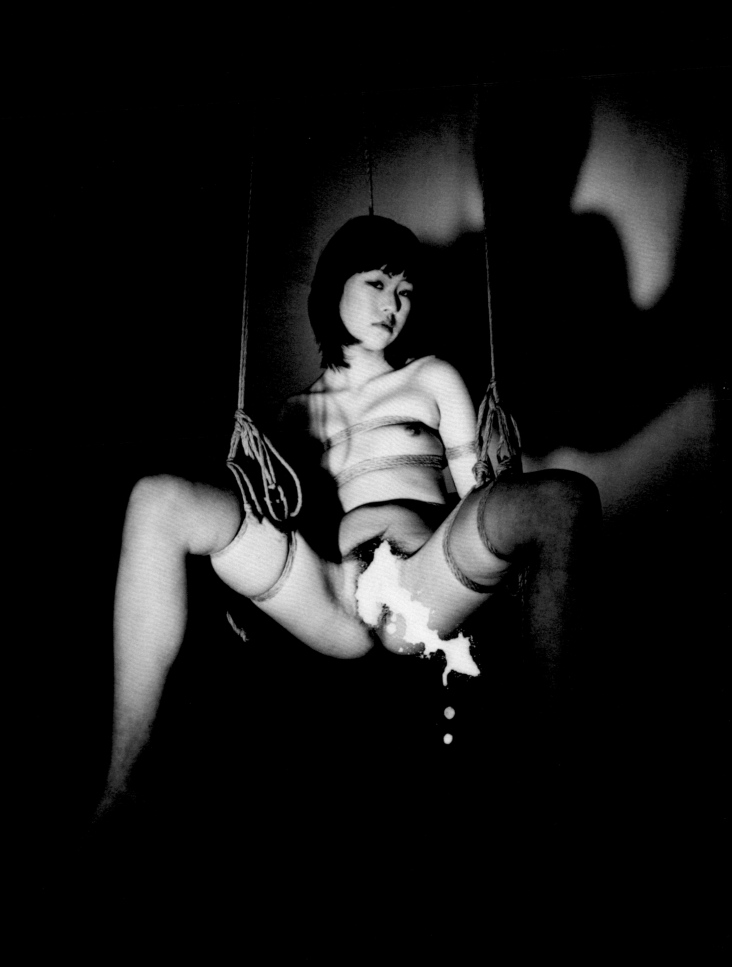

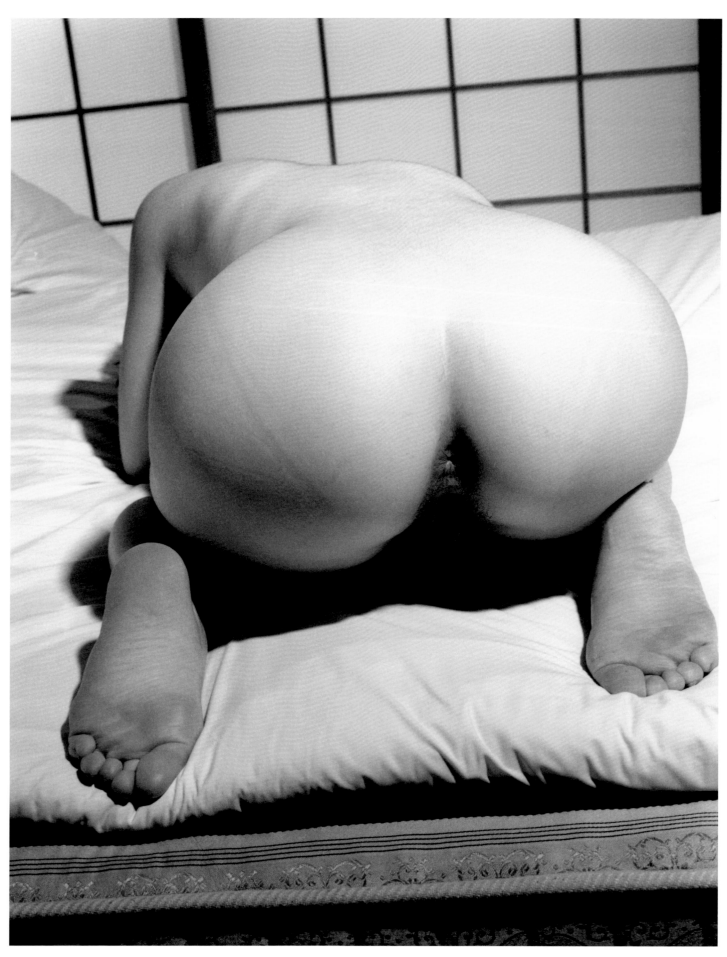

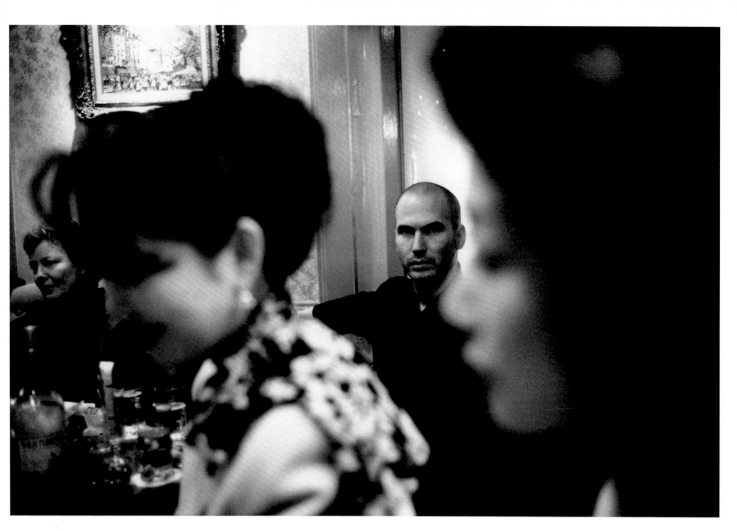

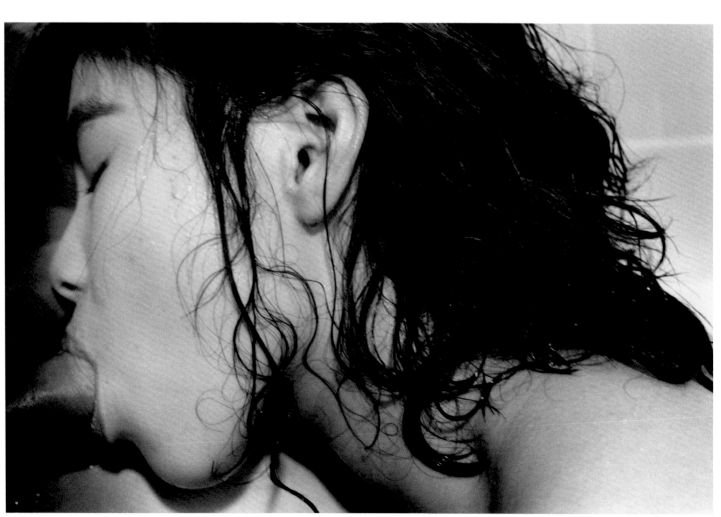

TOKYO NUDE

PHOTOGRAPHS ARE TAKEN
WITH THE BODY
—

I feel like my body is a kind of camera. When I take a picture, my eyes become like a camera lens. That's why I don't rely too much on the camera mechanism or fiddle around with lenses and settings.

A lens is part of the camera mechanism, and changing lenses means that you're thinking about the camera itself. But I'm completely oblivious of the camera when I'm shooting because I feel like I'm actually inside it. Or perhaps I feel that there's a camera inside me or that I'm a camera myself.

So I tend not to change lenses and instead approach closer to the subject or move away from the subject in a physical sense.

What I mean is that photography is all about movement. You have to be on the move. Most people when they take photographs remain stationary and change lenses to suit the position from where they're shooting. But that's not the way to do it. That's where the problem lies.

Moving away from the subject of lenses for a moment, when I'm shooting I'll often go and whisper something in the model's ear, suggesting that she does this or that, and I then go back to the camera.

That's the secret to getting a girl to look her best. You have to go and chat her up!

It's no good saying things like 'That looks great!' or 'Your neckline looks wonderful!' from a distance. You have to get up close and let her feel you close by. That's the secret!

This applies to the way you speak as well, but physical contact is really important. When you're shooting an actress or a model, she'll get her hair made up and after that they'll be constantly fiddling around to make sure that it stays in place. But I'm completely against this. I'm always coming forward to mess her hair up and see that it doesn't remain in place. I do this myself.

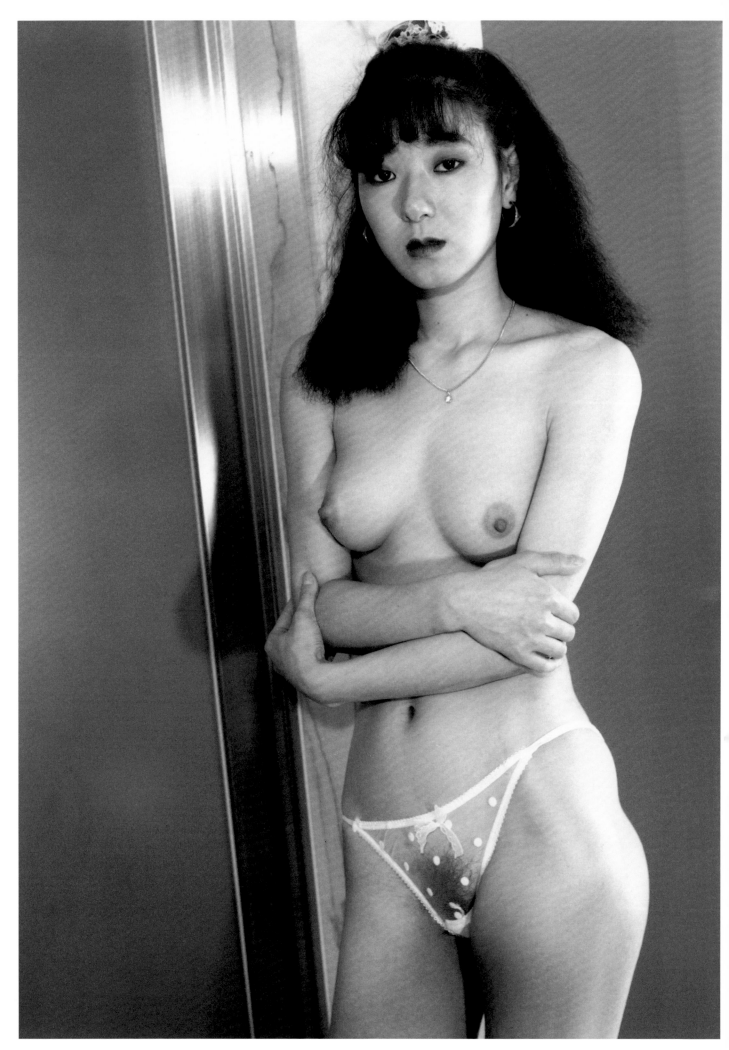

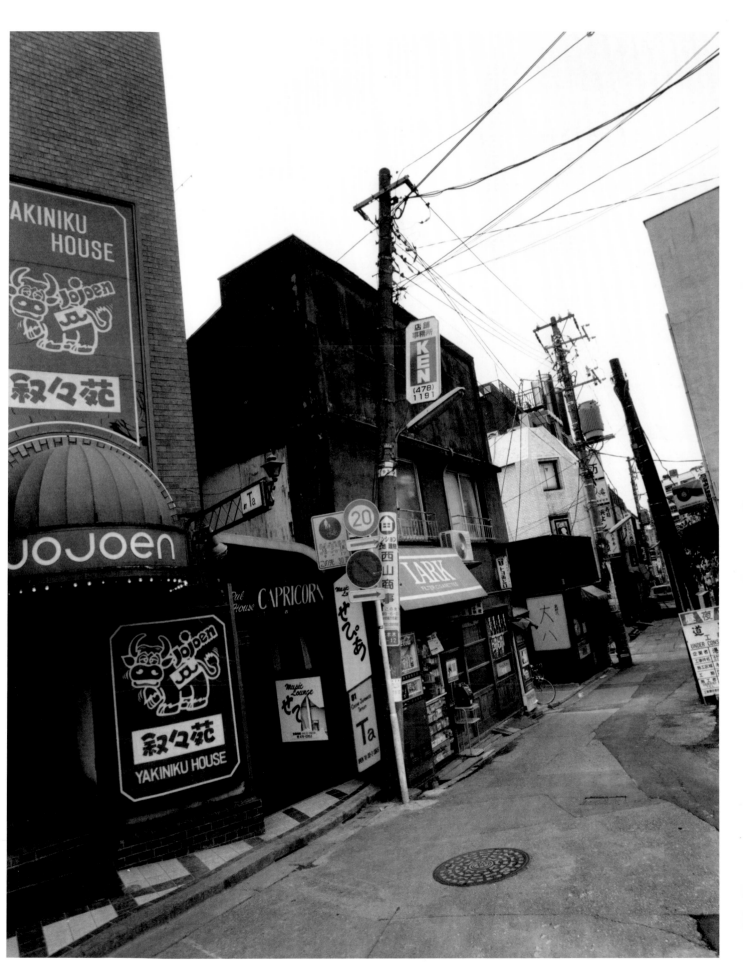

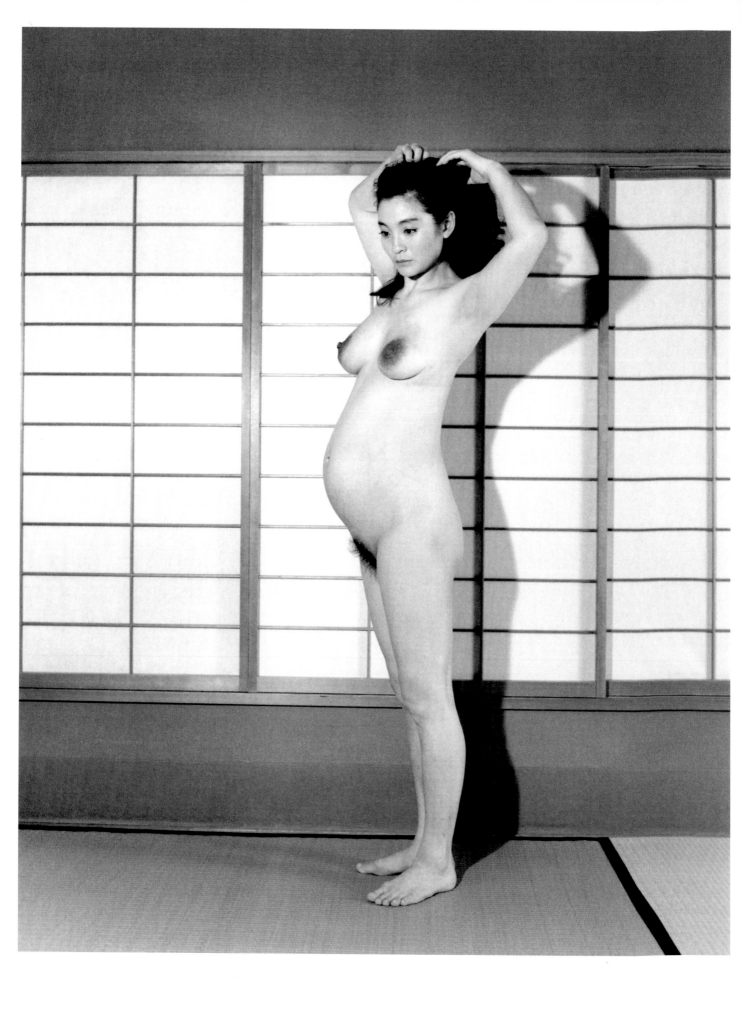

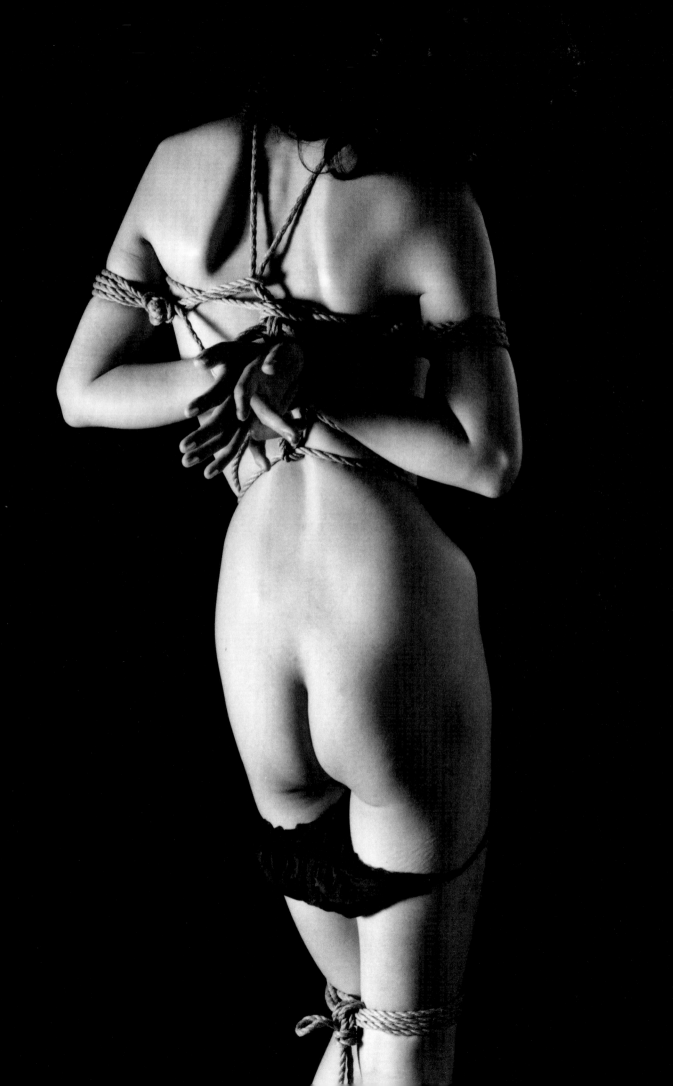

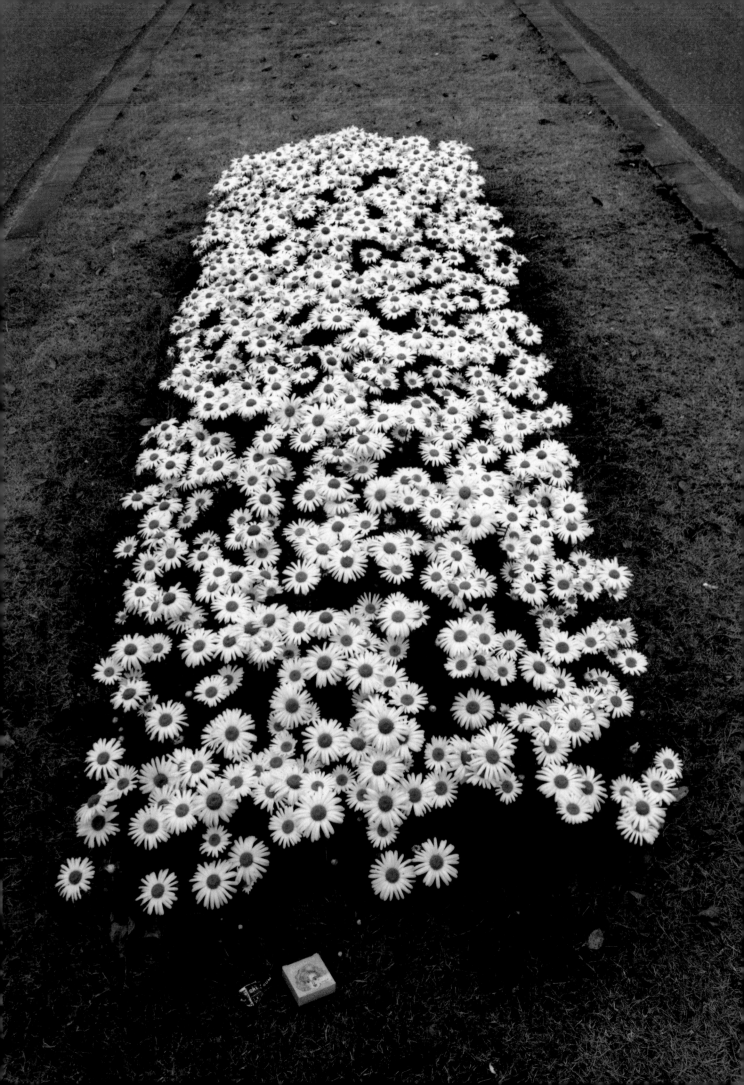

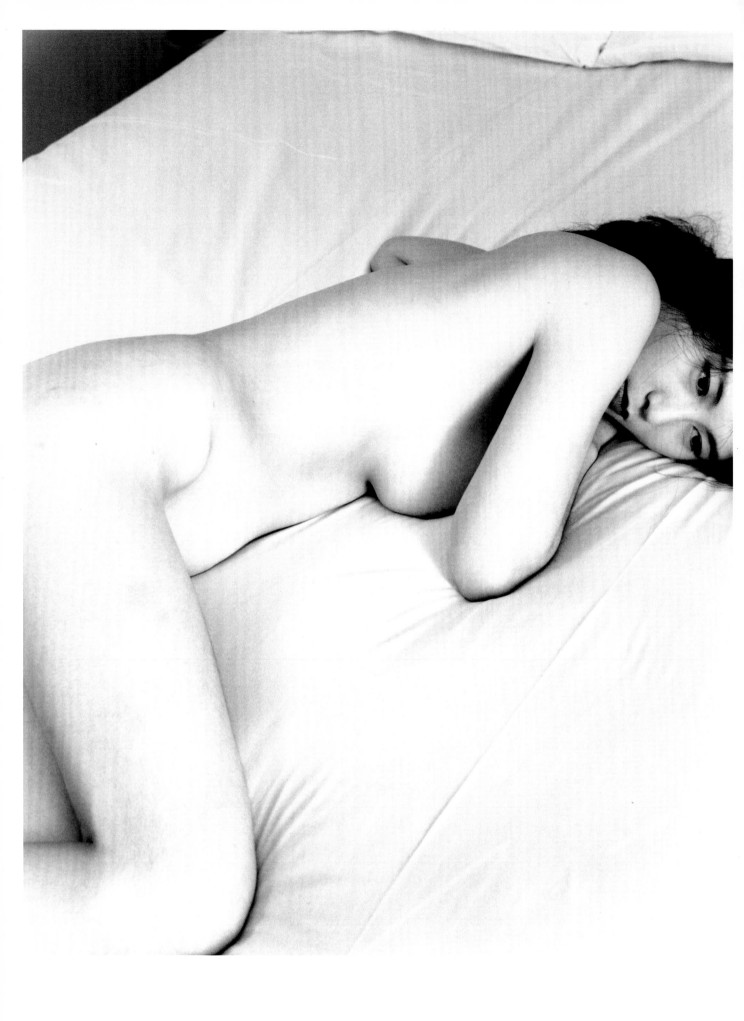

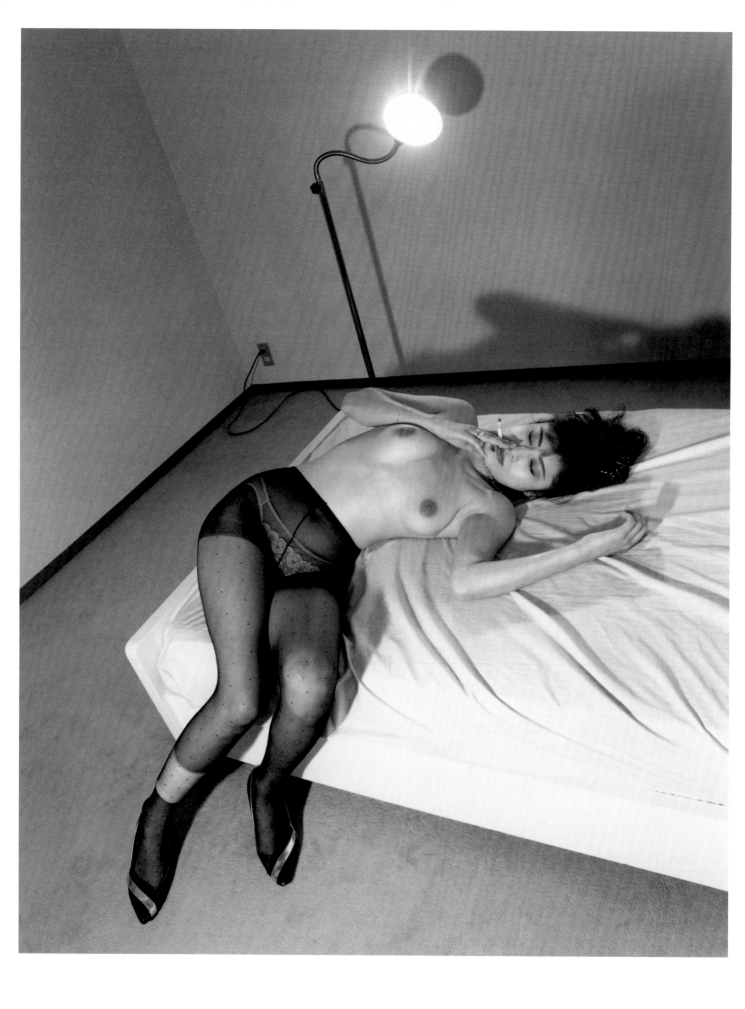

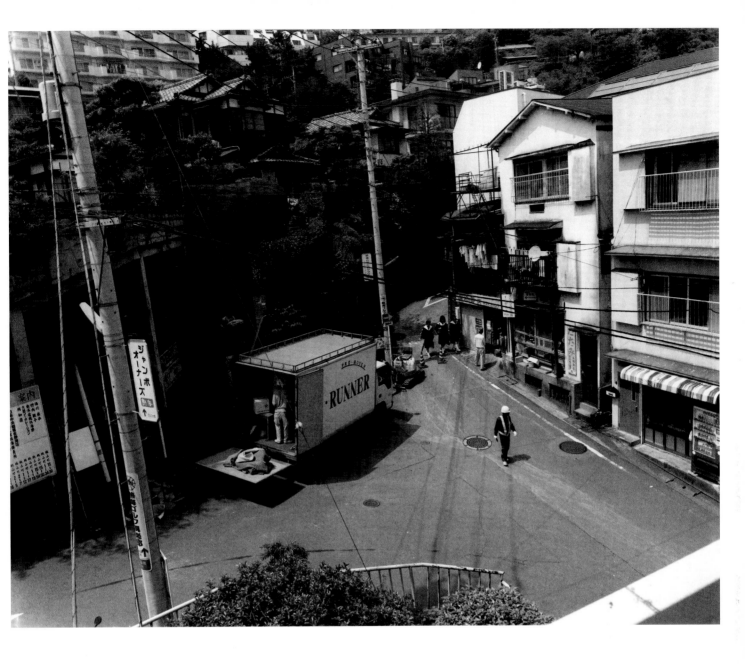

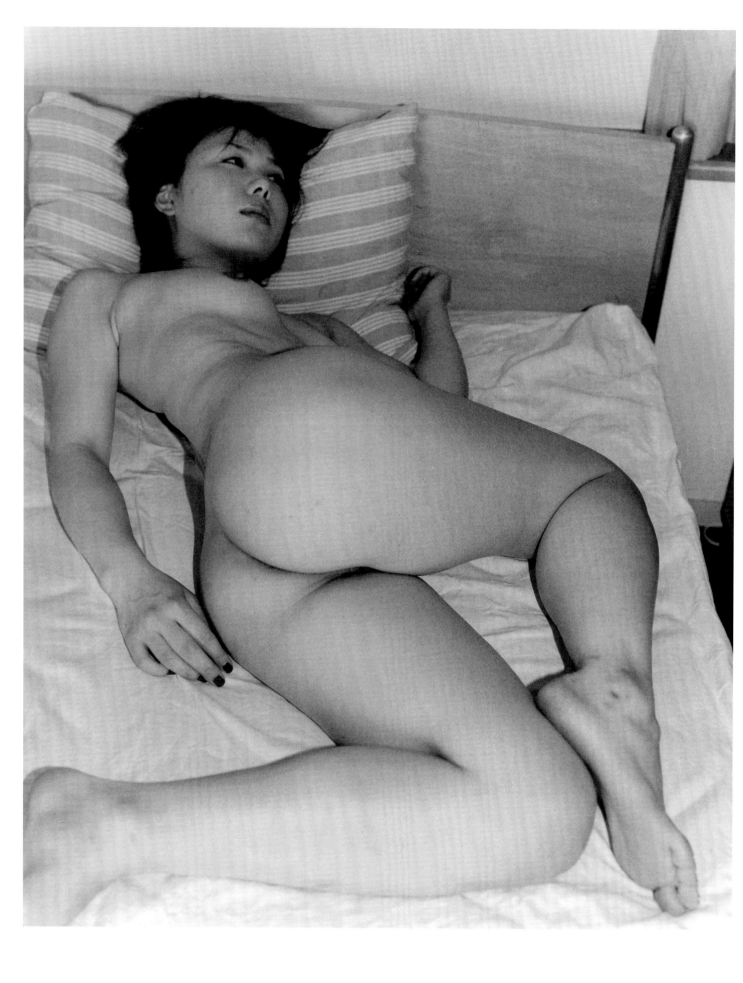

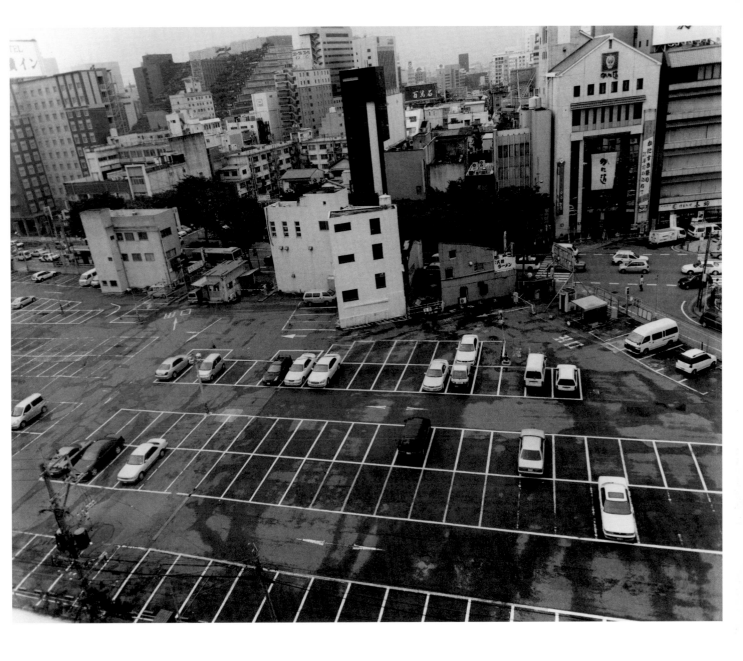

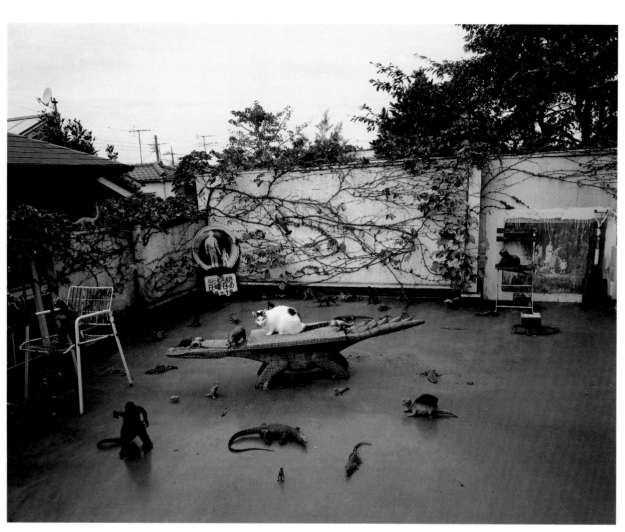

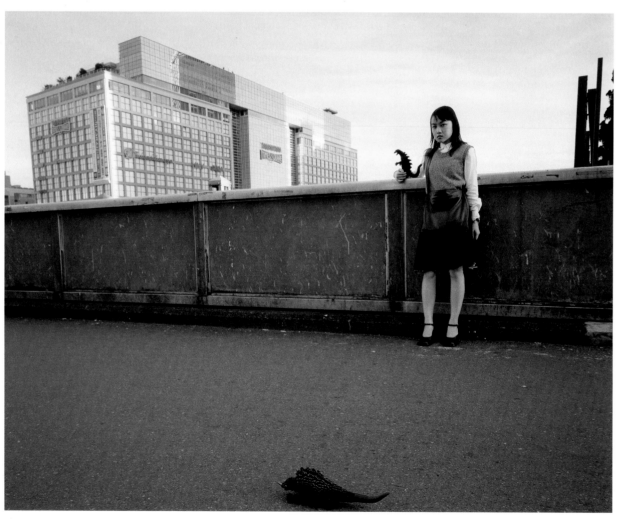

A'S
PARADISE

A STRAIGHT LINE OF VISION
IS MY BASIC PRINCIPLE
—

Ginza is basically a stylish district. But there are too many cars parked on the side of the road blocking pedestrians. You just have to go along Namiki-dori: it's full of cars parked on both sides of the road totally blocking your view of the area itself. There's a word *ginbura* that's still in use today,[1] and it makes you realize how important it is to be able to walk around Ginza. A city isn't a city without cars, but all the same …

You just need to look at the sophisticated expressions of the people, and even the vehicles – the trucks used by film crews, taxis and the Mercedes-Benzes that people travel around in these days – to see that everything looks classier and seems to have a higher line of vision. There are real differences in this angle of vision. We don't all look at the world with the same line of vision. No way. Just as we're all different heights, we all see the world from a different angle. Tall people see the world in a surprisingly indulgent light. Short types have more respect for the world!

I try to avoid taking photographs from either above or below. I'm horizontally orientated. It's particularly important not to look down. But, that said, you shouldn't look up either. It's liable to get a bit Hitlerian! Just take a look at those photographs that show Hitler. They're all taken from below. You never see photographs of people being looked down on and, as it were, chastised by Hitler. Photographs take on a completely different meaning when they're taken from above from when they're taken from below. That's the defining feature of a photograph. But I always try

to keep a straight angle of vision with a horizontal orientation. You get the best results that way. Anyhow, that's my basic principle.

I feel it's fine to leave developing my photographs in the hands of other people, and there are people who worry that is too restrictive and means that any emotional content won't come over. They wonder what I'm doing using such underhand methods. That's what makes it tricky. You have to try to get across the emotional content while doing things so that this content isn't felt. Getting it across is a difficult business and so I've acquired a reputation for being cold and unfeeling. But, look here, all you need to do is grip my prick. Just see how hot it is!

It's difficult to convey emotional content deliberately, but it's much like sweat: it'll come out regardless. Getting it across is more difficult than getting it out. Not getting it across is a result of smugness; maybe I've been onanistic recently!

[1] *Ginbura*: from around 1930, following reconstruction of the district after the Great Kanto Earthquake of 1923, Ginza came to be the location of many fashionable department stores and cafés, and it became a focal point especially for young women. *Ginbura*, meaning to stroll along Ginza window-shopping, became a trendy new term at this time. Another term that came into use at around this time reflecting the decadent mood of urban entertainment and behaviour was *ero-guro-nansensu* (from 'erotic, grotesque nonsense').

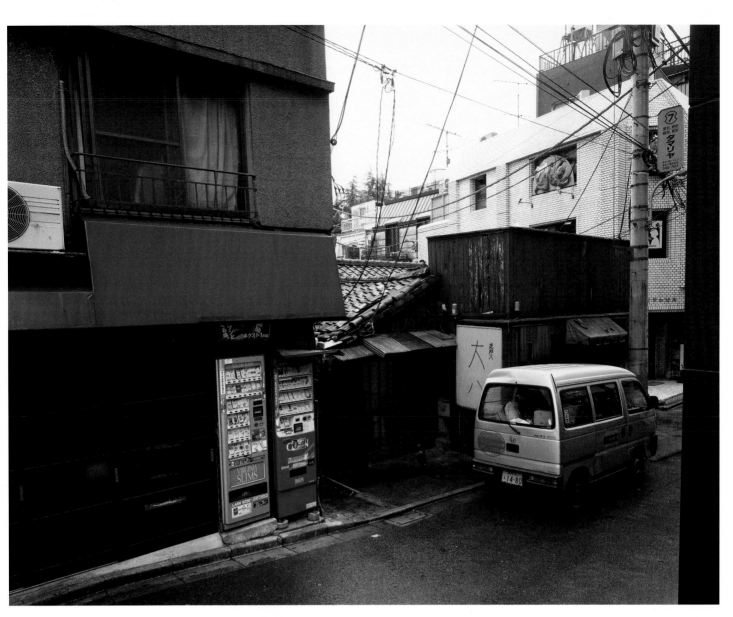

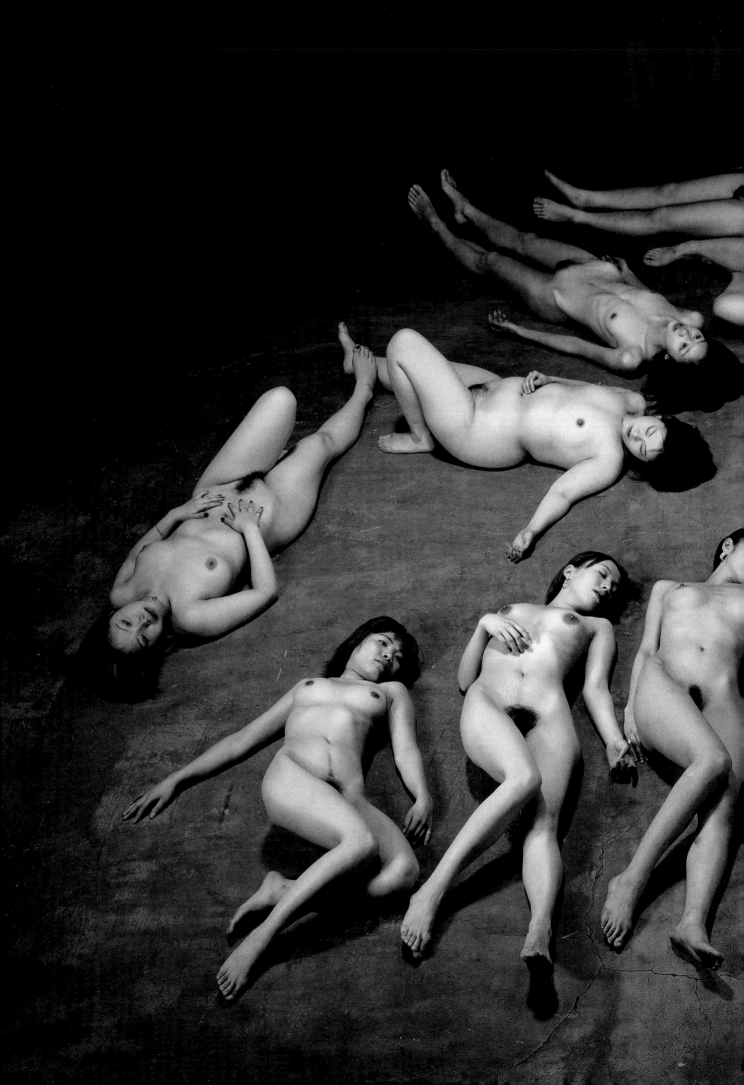

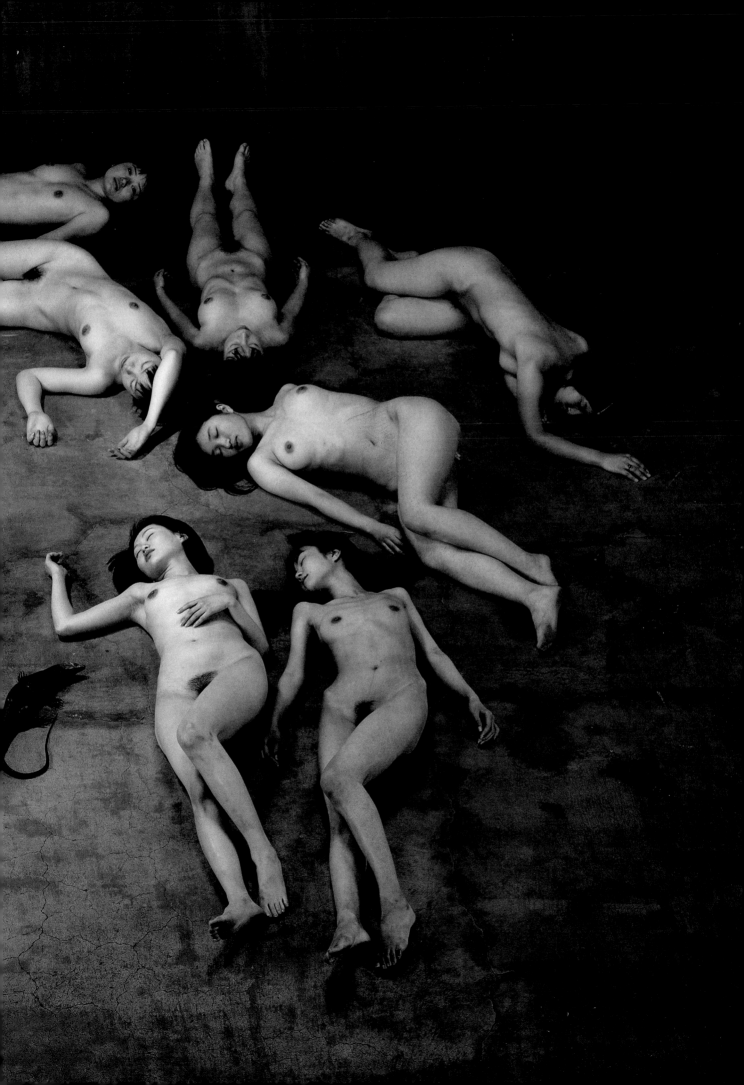

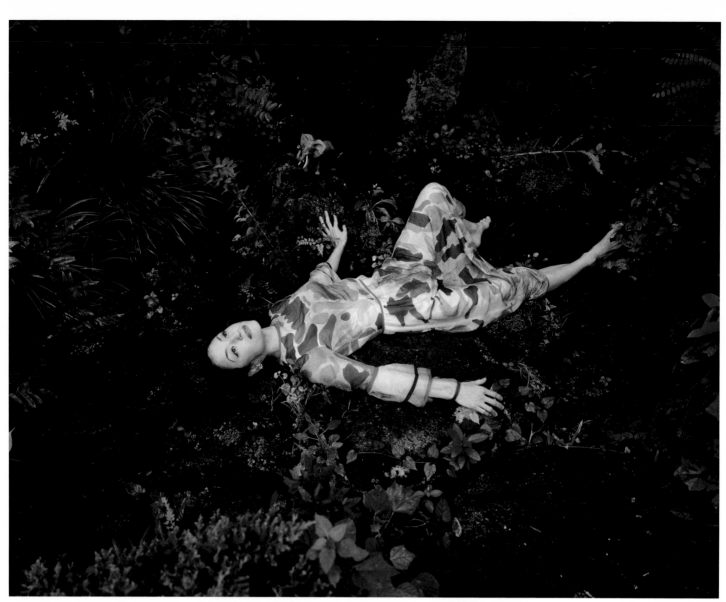

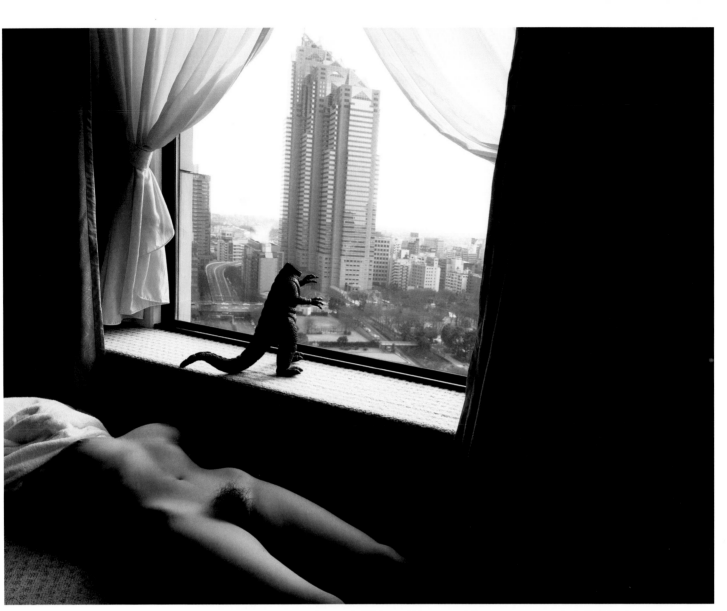

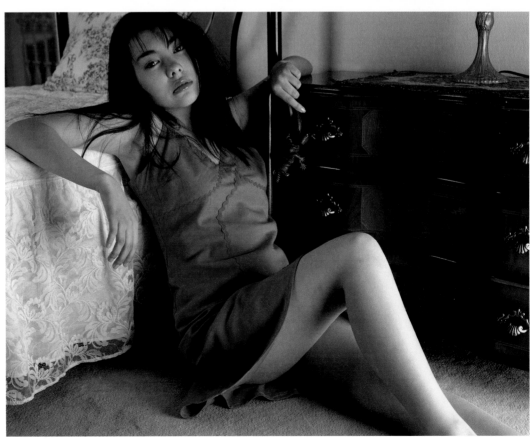

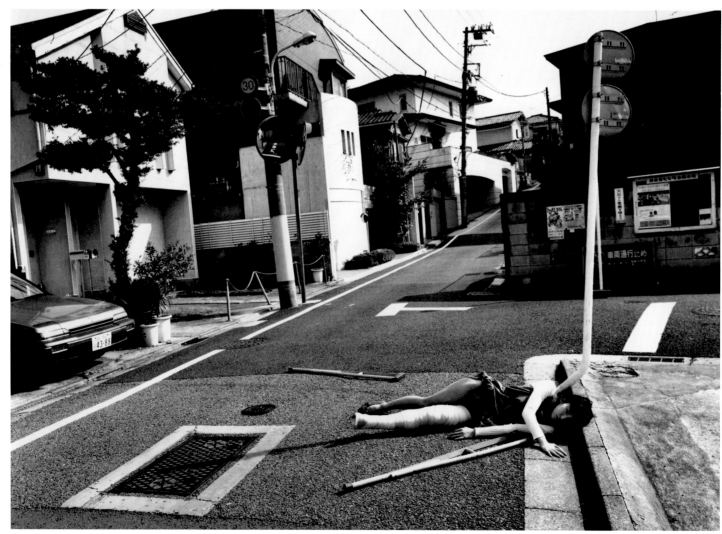

TOKYO STORY

THE TYPE OF CAMERA
DEPENDS ON WHAT YOU'RE PLANNING
TO SHOOT

—

When I go abroad to photograph a particular place, I realize that I'm only going to be able to scratch the surface of what I'm seeing, and in cases like this I'll use a camera like the Contax G2.[1] This is the camera I normally use when I travel overseas. I also often take a compact TC1.[2]

I went to Taiwan recently and took a vertical Fuji 6 x 4.5 camera with me. This was my second trip to Taiwan and I had a good idea of what the place was all about. You have no idea of what's going on when you visit somewhere for the first time.

In Europe, when I go to Paris I'll take a Leica with me. I went to Paris for the first time a long time ago, but I got the impression that the city was the vibrant heart of the world. You need to use a Leica because it lets you achieve exactly the right movement and timing. You get this added feeling of warmth when you use a camera that behaves like this. With a G2 you can shoot automatically in an instant, but the end product is just too literal.

I sometimes shoot on the spur of the moment, but when I don't do this it's because I think it's very important to coordinate the timing. You must first focus and then set the exposure. These are the actions you have to carry out when you're using a Leica. There's an exposure meter in the M6,[3] but it was different before. Well, I don't see anything wrong with an exposure meter at least.

The long and the short of that is that the Leica requires effort and nimble fingers. You feel that this kind of effort will give rise not so much to a sense of warmth as to something of some kind or another. There are cameras that let you move from one thing to another in an instant and other cameras that keep you there chatting for a while. These are the kind of relationships you establish with different cameras.

[1] Contax G2: An advanced version of the G1 camera that appeared in 1994. Focusing speed and accuracy, shutter speed and flash tuning speed, have all been increased.

[2] TC1: An autofocus compact camera using an M-ROKKOR 28 mm f. 2.8 mm used by Minolta CLE.

[3] M6: A 24 x 36 mm format 35 mm range finder camera. A camera with 0.58 finder magnification was added in autumn 2000 to supplement the existing 0.85 and 0.72 models.

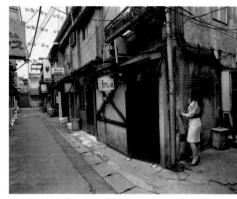
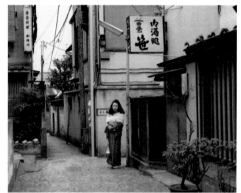

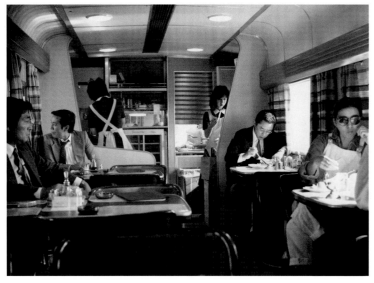

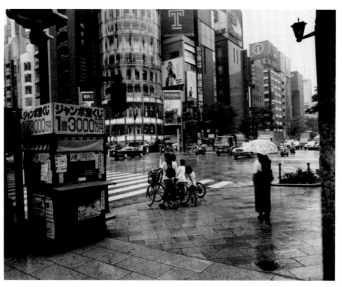

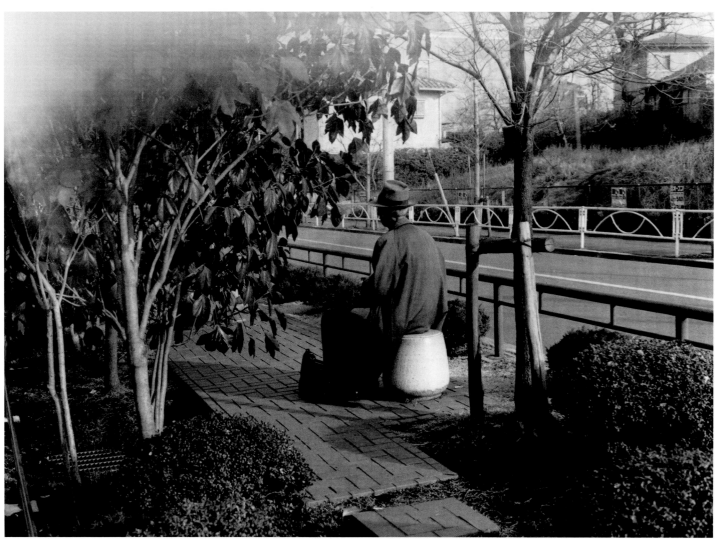

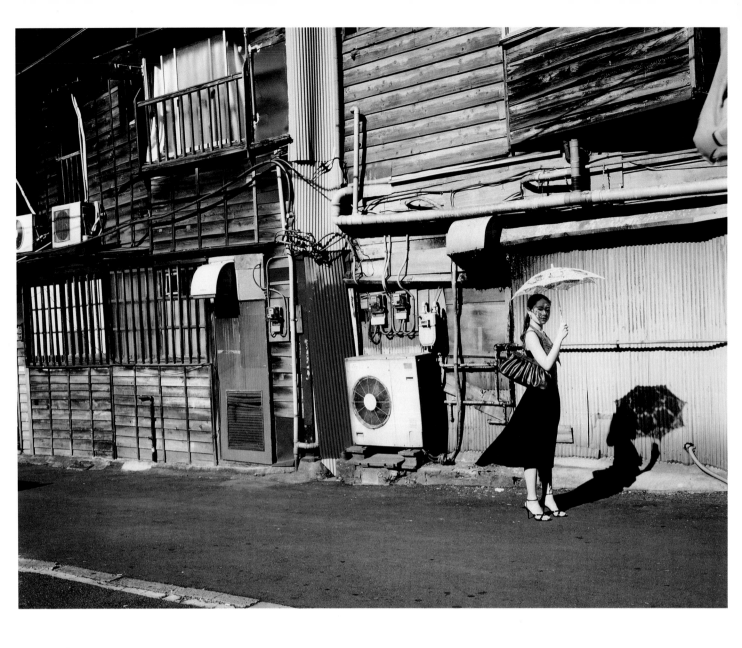

CITIES, TOWNS, STREETS

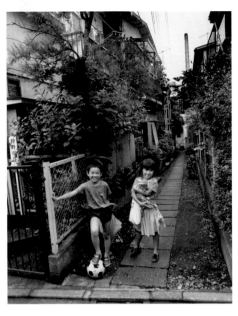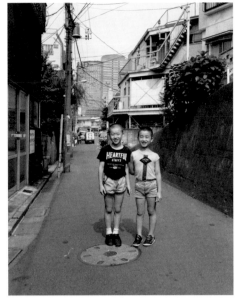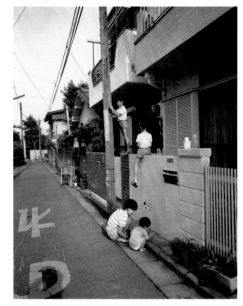

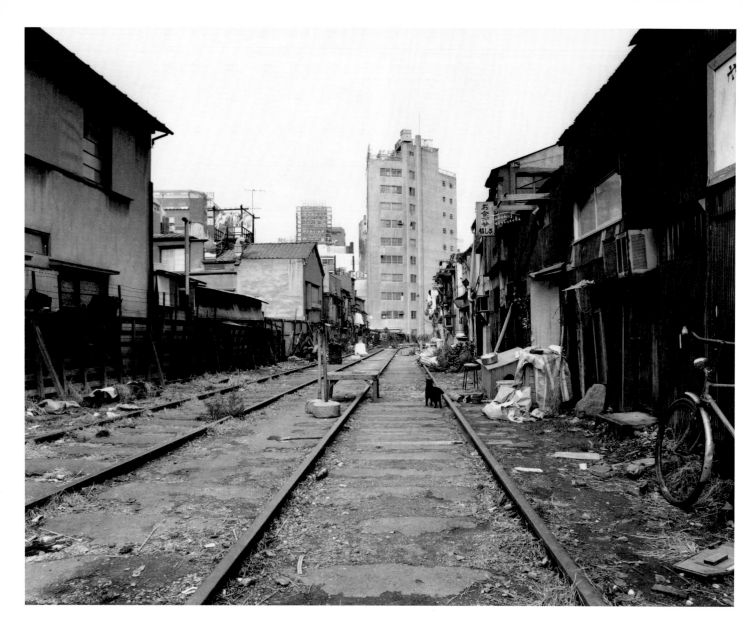

TOKYO, IN AUTUMN

Husband:
This is the 'Golden-gai' area of Shinjuku.
These are the broken tracks of the Metropolitan
Electric Railway.

Wife:
This is a pedestrian precinct these days.
You entered from the main road and there was
a kind of depot there.

Husband:
I was mad about Atget and Evans[1] in
those days. I guess it was because I used to like
photographing details of the city. I'm not
remotely interested in whether it's dirty or in
doing a photo-documentary.

TOKYO, IN AUTUMN

—

(INTERVIEW WITH KOTARO IIZAWA)

KOTARO IIZAWA:

As far as separating yourself from the times is concerned, *Tokyo, in Autumn* shows ordinary scenes from life in Tokyo. These photographs date from 1972, the year you left Dentsu.

NOBUYOSHI ARAKI:

That's right. I took my camera with me. This was the first time I had photographed the city streets alone with a camera mounted on a tripod. It takes a long time to set up a tripod. From around that time I felt physically involved in shooting time as well as space. I felt that you shouldn't just let things pass by.

It was originally a scrap album with the title *Tokyo no aki*. When I'd finished taking all the photographs, I changed the title to *Tokyo wa, aki* with a comma. I tend to be pretty unyielding by nature, and I used to say that I don't feel as if it's autumn, but in reality it was autumn so I called the book *Tokyo wa, aki*. There's a subtle difference between the meanings of the particles *no* and *wa* in Japanese.

Leaving Dentsu, I felt a bit lonely and had this feeling that I might be setting out for winter. Every day, after Yoko had gone out to work part-time, I'd eat the breakfast she'd made for me, then I'd attach the tripod and leave home with my 6 x 7 camera to photograph different parts of Tokyo. I pretended to be Eugène Atget in Tokyo. Atget supposedly got by on milk, bread and sugar, but I'd at least get a proper breakfast!

IIZAWA:

Tokyo, in Autumn consists of photographs on the left page and conversations between you and Yoko on the right page. Did you often discuss photography with Yoko?

ARAKI:

No, I'd never really discussed it with her. The first time was when I produced this book. When I said something or other, she'd immediately pick up on it. She'd pick on me for saying the same old nonsense over and over again. She'd get me on a sore spot. How shall I put it? There was this subtle distance between us, or perhaps I should say it was the way she related to me – it wasn't the same as if she'd been an ordinary editor. There was this sense that we could say absolutely anything since we had this understanding of one another.

I sometimes said some smart things. Things usually go well when I'm with an attractive woman. I'm able to say things that I can't normally get out even though they may be in my mind. It's only when I'm with an attractive woman that I'm able to get out whatever talent I may have.

Everyone is intrinsically a genius. We all have God-given abilities. It's not possible to drag them out by yourself; you need someone to extract them from you. It may be your mother or your father. It may be your lover or your wife who brings them out from within you. People usually say that it's God who brings out abilities

and creates genius. I find that it's the woman I'm fondest of, the woman I'm in love with who plays this role. It's the abilities extracted from you by a woman you love that are the strongest. It may well be Yoko who has drawn my genius out of me. What I'm saying now is aimed at high school readers! Well, that's how I feel anyway.

It would be true to say that the life of A (Araki) began when I met Yoko. That's because my life is all about photography. I love photography to the extent that I feel it was she who made my life like this. If I didn't have photography, I'd have absolutely nothing. My life is all about photography, and so life is itself photography. It was my father who taught me how to take photographs, but it wasn't he who did the most to bring out my talent. My dad might get angry to hear me say this though.

IIZAWA:
So it was your father who laid the foundations for your work?

ARAKI:
That's right.

IIZAWA:
It's a kind of power that pulled you up from nothing?

ARAKI:
I suppose you could say he got me doing various things.

IIZAWA:
So it was Yoko's influence. The explosive work you were doing around 1970 was a result of her influence.

ARAKI:
Without me being aware of it. It wasn't a question of having anything definite in mind; I just kept on photographing her. If I hadn't wanted to, I wouldn't have continued. It's no easy matter to continue shooting someone all the time from the moment you've met them until the moment you die.

IIZAWA:
The main impetus for this great explosion was your marriage to Yoko. This brought out all your energy …

ARAKI:
Yoko operates with different values and on a different scale. I don't mean to say that she trusted me and I don't know if she was really fond of me or not, but she showed this toleration towards me, although she never put it into words.

She may well have had motherly instincts towards me. Shomei Tomatsu used to say that I was a kind of Sun Wu-K'ung (the Monkey King)[2] type of figure dancing around in the palm of the scholar-monk Xuanzang[3] in the form of Yoko.

IIZAWA:
So, Yoko was a mother, a partner, a man and a woman?

ARAKI:
That's right. I'm happy with that. She was a girl, and at the same time a prostitute. It was she who turned me into a genius. There are various women now who are continuing to make a genius of me. It's still not over. I'm going to transcend 'Genius Ararchy'. I'm going to be a super-genius!

[1] Eugène Atget (1856–1927), French photographer famous for street scenes, particularly without any human presence. At this time, Araki was also inspired by Walker Evans (1903–75), American photographer of unsung everyday subjects.

[2] The Monkey King, a character from Chinese mythology; he accompanied Tripitaka (see footnote 3) on his great journey into India and used his magical powers, which included riding on a cloud, to protect the priest from endless dangers; the Monkey King is both hero and fool, a combination that may appeal to Araki's sense of self.

[3] In the seventh century AD, the people of China were deemed to have fallen into immoral ways and Xuanzang, also known as Tripitaka, a priest and Everyman figure, was sent by the government into India to fetch holy Scriptures that would provide the necessary moral guidance.

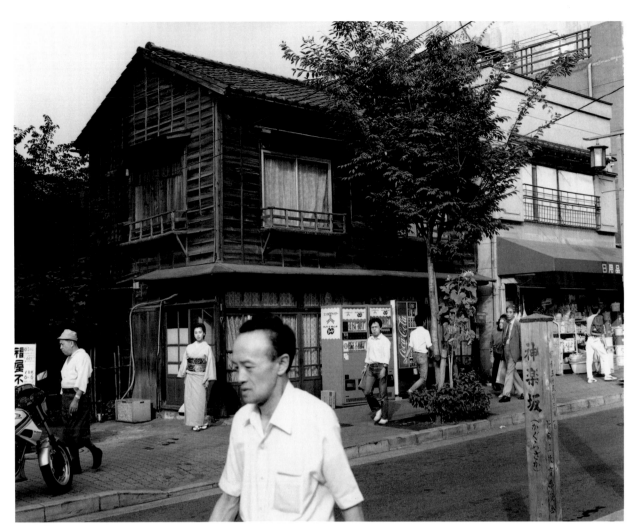

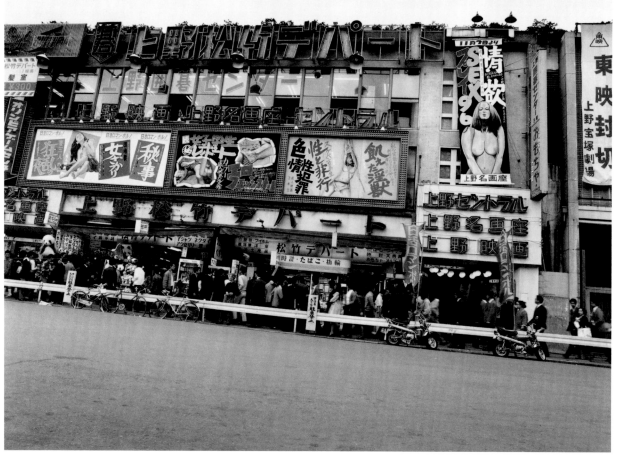

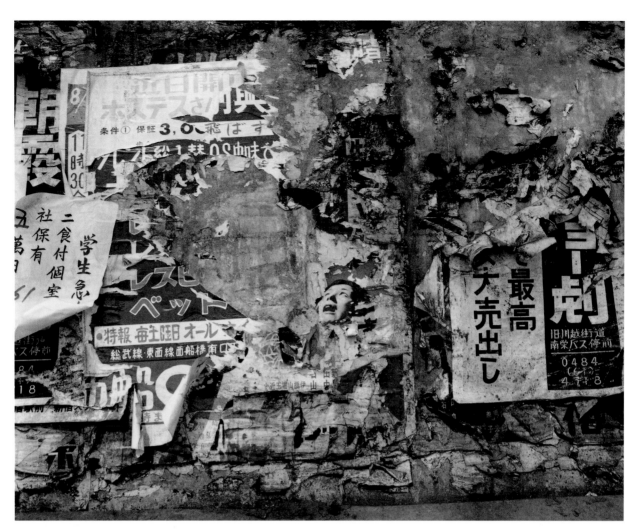

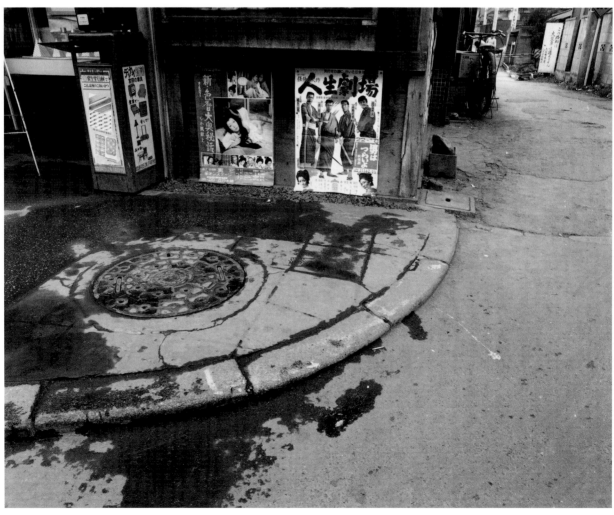

ハムサラダライス
200

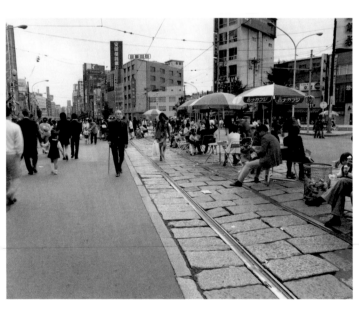

HITOMACHI

THE RICHNESS
OF LOCAL COMMUNITIES SHOWS
IN THE SMILING FACES OF
THEIR RESIDENTS

—

The communities that feature in *Hitomachi* are home to all kinds of people, for example a box-maker and a tinsmith who've been practising their respective crafts for several decades. People like these understand exactly what I'm trying to do. One of these craftsmen was a joiner who didn't want to let me leave after I'd met him. He thought of me as a craftsman just like himself, but in my case with a camera as my tool. I really appreciated this sense of identification among fellow-craftsmen.

People like these treat me as one of their own. They're able to suss me out immediately, and I'm able to see deep into them too. Neighbourhoods such as these may not be economically well off, but their real wealth lies in the people themselves. It may seem out of place to talk about wealth in such a context, but it's these people with their smiling faces and the smiles on the face of the streets themselves that are the true wealth of these neighbourhoods.

It's when a community has an older generation like this that young people emerge with smiles on their faces. It's great to see the smiles on the faces of the youngsters who rush around delivering outside orders of noodles, sushi and the like. Young people take real pride in their jobs. They don't look down on what they do, nor do they have any inflated ideas about their work. I really felt this while I was working there.

It's wonderful to see a youngster looking over his shoulder in the middle of his newspaper delivery round on a snowy day. There are youngsters with great smiles on their faces in these sorts of areas.

CITIES, TOWNS, STREETS

—

Hitomachi[1] is a real achievement. I've done all kinds of things in the past, but even I can come up with something like this when I feel like it. But until now the urban environment and society have always featured large in my work because I've been concerned mainly with happiness in the big city. But *Hitomachi* isn't like this at all.

This is how it turns out when you're dealing with human beings in the raw. I get a bit self-conscious even now. That's the human touch! You get a bit self-conscious when you take a real photograph!

I once did a book called *Tokyo Nekomachi (Tokyo, City of Cats)*[2] and so they got me to call the new book *Hitomachi (People Streets)*. I used a Leica on this one. You need a Leica if you're going to shoot real life and happiness. Kind-heartedness, life and people: it all boils down in the long run to love and affection. The Leica has just the right lens, shutter noise and style to make it go perfectly with this kind of feeling. Like I said before, the Leica makes its presence felt in an incredibly reserved way. You get the impression that even the subject of your photo looks calmer and gentler.

It looks really refined and expensive as well. That's another thing I like about it. With a cheap and shoddy camera all you can take are cheap and shoddy photographs. The photographs you take are a reflection of the camera you're using!

I always say that you need to dress and to adjust yourself to reflect the mood of the environment where you're intending to shoot. It's all a question of your state of mind. You need to blend in with the environment when you are shooting, but on the other hand you mustn't allow yourself to identify too much with the local people. When it comes down to it, you're inevitably going to be an outsider in this environment. You need to feel like a traveller, both in and out of contact at the same time. How shall I put it? You mustn't let yourself get too involved, but it's this that's really difficult.

Local neighbourhoods can't be equated with urban environments. You just have to look at those housing estates you find in the suburbs: there's no real sense of close community in such places. Local neighbourhoods have a kind of nostalgia that everyone seems to dislike. They represent not

so much a return to the womb as a return to something undefined in the past. There's something incredibly feminine about this.

But individual neighbourhoods have their own distinctive differences. Minowa, where I grew up, and Yanaka and Nezu, which provided the setting for *Hitomachi*, are all very different. Minowa is a bit savage and brutal. It seems to be on the very edge of Tokyo, as if you'll soon be completely out of the city. Compared with Minowa, Yanaka and Nezu seem denser and more sensuous.

This may well have something to do with the lay of the land. Yanaka and Nezu are both situated on slopes. This is something I like about them. There's no intimacy in places located on the flat. Yotsuya, Araki-machi and Kagurazaka are all set on slopes. These neighbourhoods situated on slopes put you in a good mood, and before you know it you're traipsing all over the area. They're usually full of temples and cemeteries that also help to convey the sense of community.

I go to Minowa now and then. Whenever I go, I notice that more and more of the old houses are being pulled down. My home when I was a child has now been turned into a parking lot. It's seeing this transformation that means that whenever I go to places like Nezu and Yanaka I feel this sense of warmth and humanity. That's not to say though that Minowa wasn't also once a warm and caring environment.

1 *Hitomachi* (*People Streets*; Tokyo: Junposha, 1999) was created jointly by Araki and Mayumi Mori. Consisting of photographs and text, the book is a record of twelve months in the Yanaka, Nezu and Sendagi districts of Tokyo.

2 *Tokyo Nekomachi* (*City of Cats*; Tokyo: Heibonsha, 1993). In the postscript to this book, Araki writes: 'Once the cats disappear, Tokyo will fall into ruins. Miao!… Today is A's 53rd birthday. I cleared up my room to get ready for a birthday party and I found copies of the magazine *Anime* in which *Tokyo Nekomachi* was serialized in 1990 and 1991. Now for a break.'

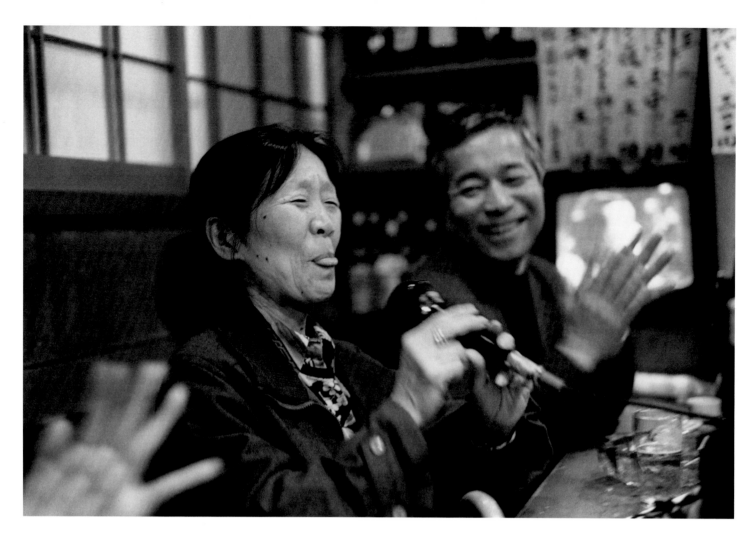

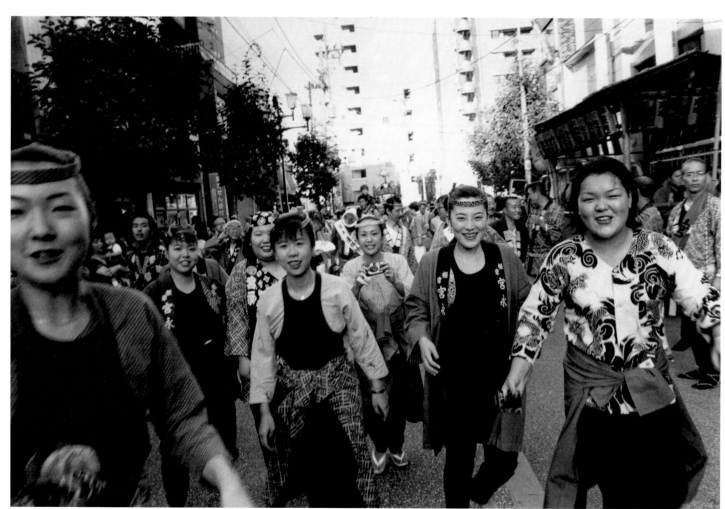

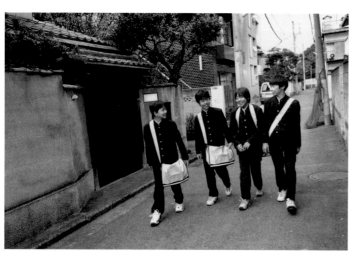

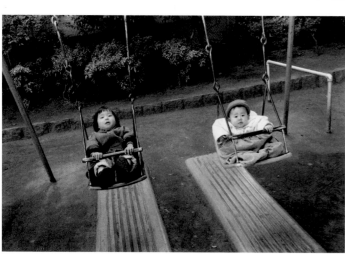

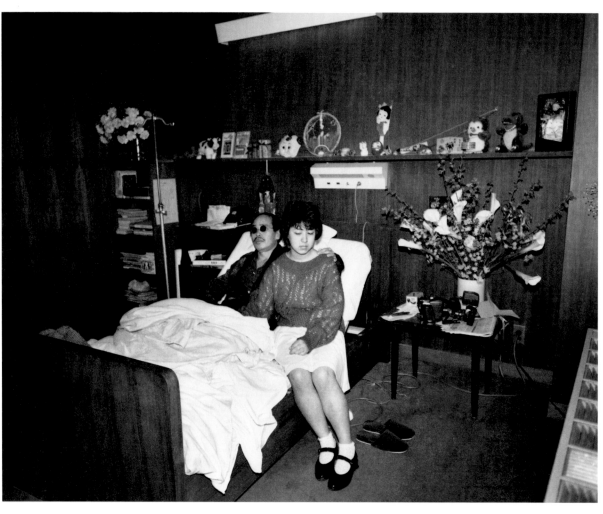

THE NARRATIVE IS PRESENT
IN THE SUBJECT
—

In *Hitomachi*, there are photos with blurred focuses and unsteady outlines because I had to use really slow shutter speeds at night. There's obviously going to be blurring if you leave the shutter open. The book contains plenty of photographs like these.

But this is really quite natural. It's no good if you try and get everything into focus on the screen. It's important to focus on the mood and feeling at the time, on tangible and intangible things that are present at the moment you're taking a shot.

There's complete correspondence here between what I say and what I do! But we can't have this! It really won't do to have complete conformity between words and deeds!

When it comes down to it, if you don't feel some kind of affection for your subject, you're not going to be able to extract any sense of affection from the subject. Absolutely not. The photo on the last page of *Hitomachi* is really good, don't you think?

The woman in this photo is most likely a housewife or a company employee moonlighting as a hostess, and the man on the right is probably a regular at the club where she works. He's completely besotted with her. Although she's got kids of her own, the woman looks unbelievably kind and considerate.

In this case, it was essential to focus on the middle ground and not to probe any deeper. I took this one in a place by the side of Shinobazu Pond in Ueno. It wouldn't have been any good if the girl was talking to the man or if one of them was looking at the other. The girl would have to be looking towards the pond. I thought I'd just have to wait for the ideal moment and then press the shutter instantaneously. That's how I took this one.

It seemed to me that this was the kind of relationship that ought to exist between a married couple. It's really heart-warming to see. She's enveloped in his warmth and understanding. Well, anyway, that's the kind of narrative I dream up in my own mind.

I just mentioned the word 'narrative', but it seems to me that the subject of a photograph possesses its own narrative from the outset. This is exactly what a photographic subject is all about. But the photograph has to bring this narrative vividly back to life. That's what a good photograph, an interesting photograph, is all about.

It's quite possible that, without being aware of it, I've been shooting stories that have no connection with reality whatsoever. It may seem a bit odd, but I sometimes go on about photographic novels. Photography is a scary business.

FOCUSING ON
FEELINGS AND MOODS
—

In the case of *Hitomachi*, I felt simultaneously that I was putting the finishing touches to the 1990s while standing at the start of a new era. As a photographer, although I shouldn't really say as a human being, I felt that I had to do some awful photographs. It would all be over if I didn't do something really bad. I felt I'd really age. *Hitomachi* was all a bit too inspiring!

But you might think that plain, nondescript photos such as these are pretty much useless, but girls who came to see the exhibition said they thought that these were the best. It makes you want to give up! They say they like the dull and unassuming texture, the anonymous-looking people who appear in the photographs. To put it obliquely, there's this sense that you're not actually looking at a photograph, but you realize at the same time that it is indeed a photograph. But you'll come to a dead end if you go too far along this path. From now on I may well take more and more photographs of really bad, evil-looking types!

TAIPEI
SHANGHAI
SEOUL
BANGKOK

'WHAT IS IMPORTANT
IN PHOTOGRAPHY
IS TIME,
THE TIME I HAVE
SHARED WITH
THE PEOPLE IN THE
CITIES I VISITED.'

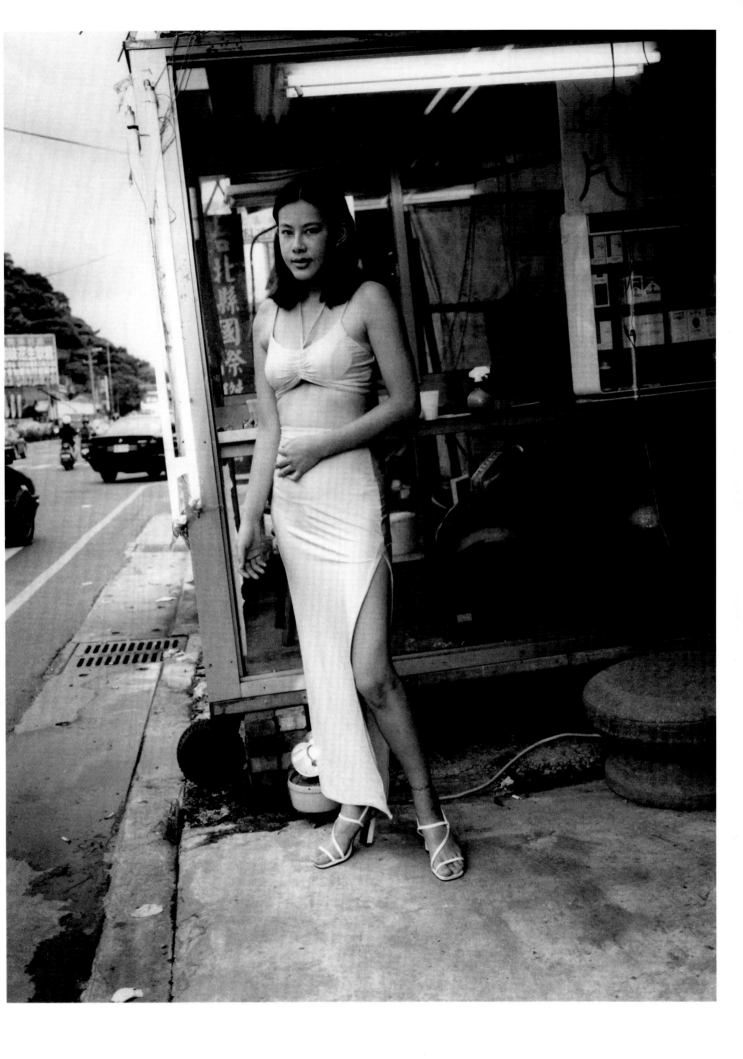

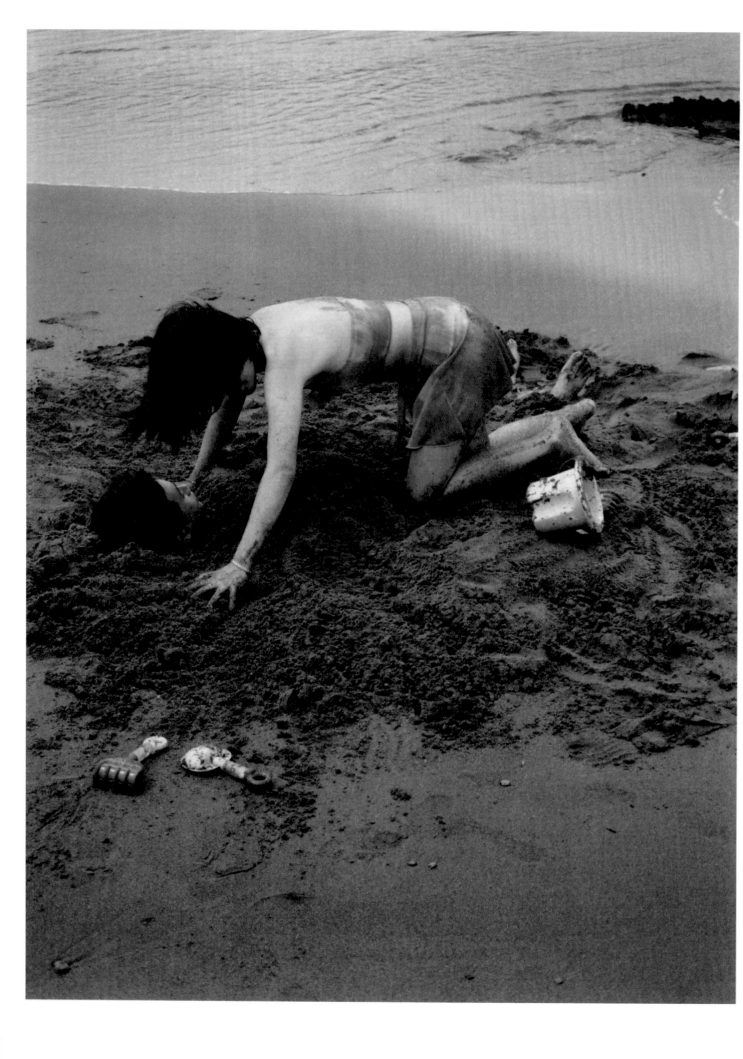

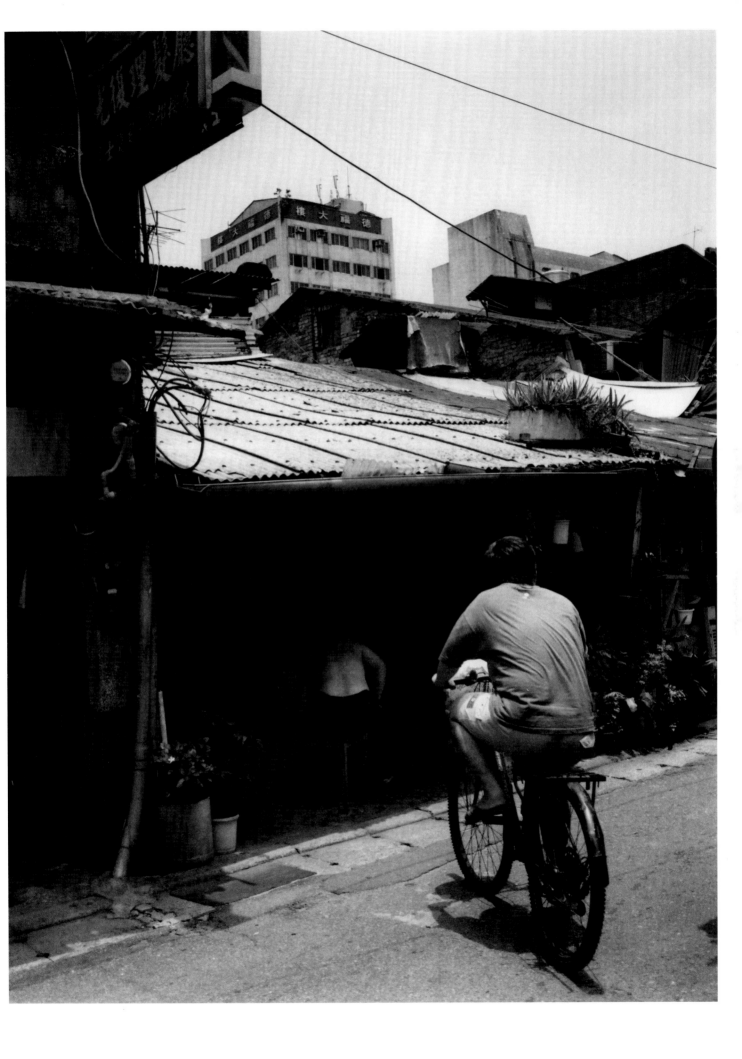

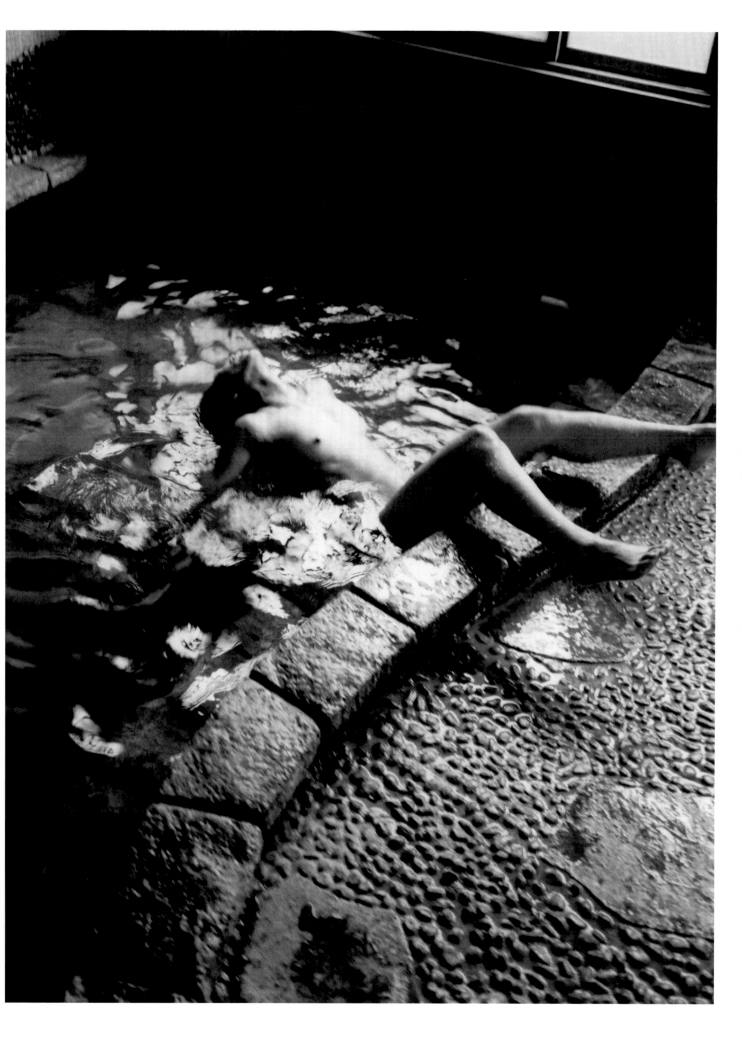

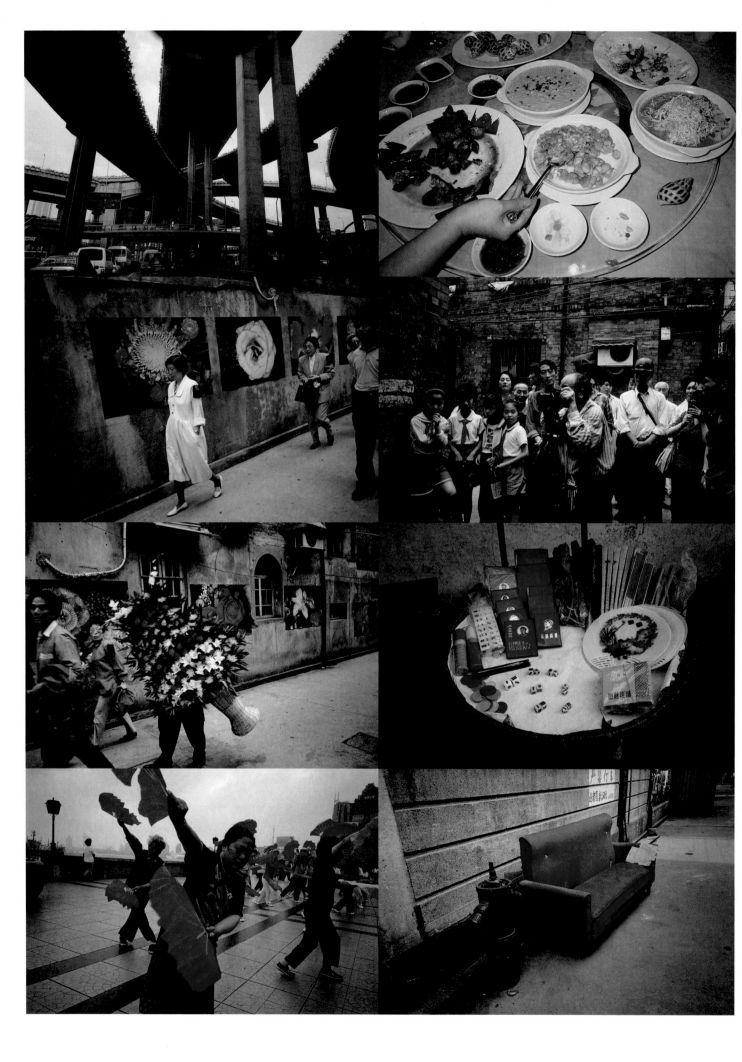

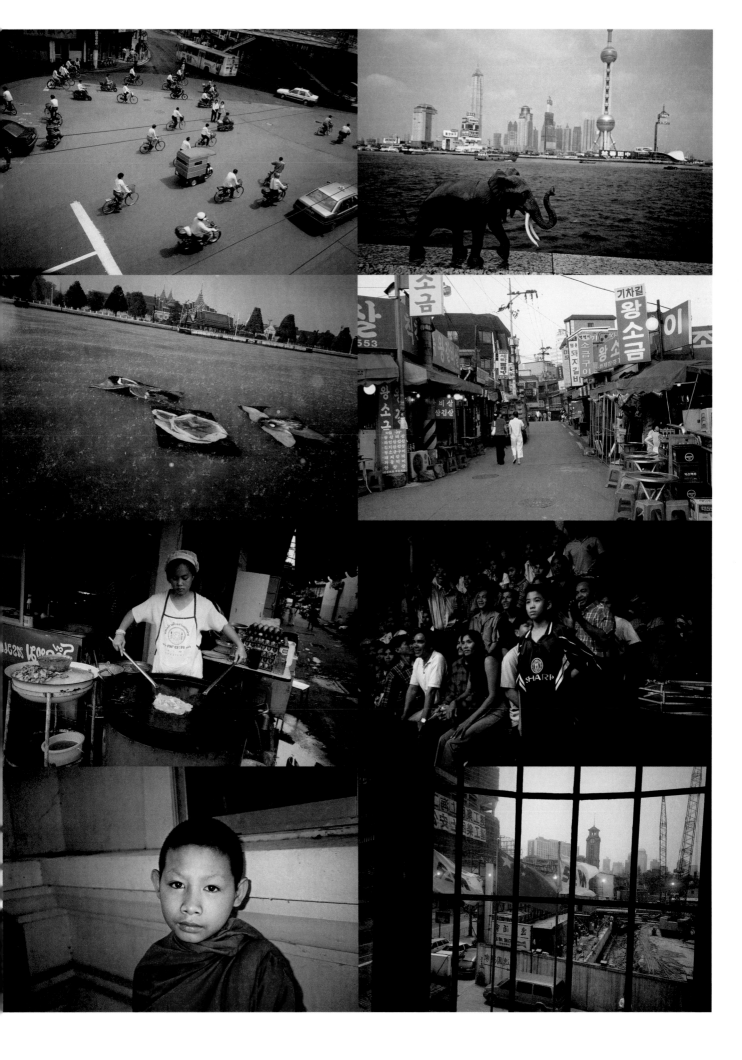

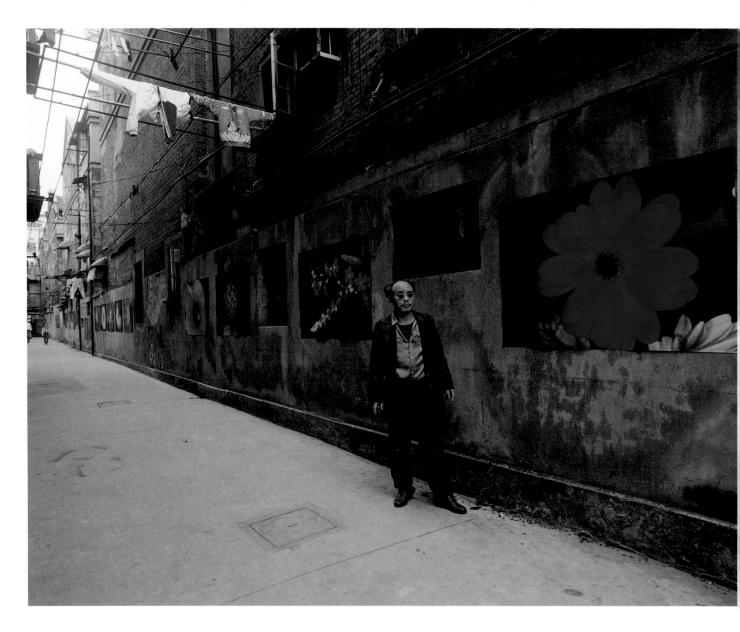

DEATH

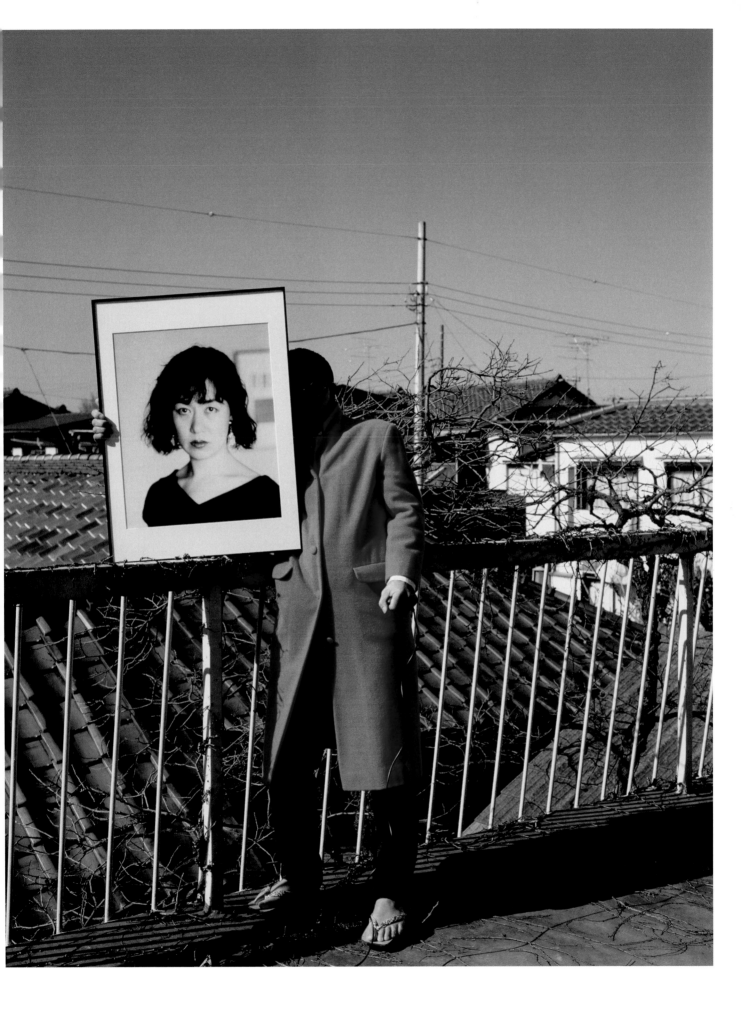

JAPAN IN ARAKI'S WORLD

Yuko Tanaka

What notion of Japan does the viewer gain from the varied images present in Araki's photographs? Various elements in Araki's works may be brought to light by examining the meaning of several of the linguistic and cultural concepts that run through traditional Japanese aesthetics. In this article my aim is to reveal how the concept of 'Japan' is concentrated in Araki's world by examining linguistic terms that define the Japanese spirit, the Japanese cultural context within which erotic pictures (shunga) were enjoyed, methods for the visual representation of the concept of impermanence, and the meaning of flowers and flower arrangements (ikebana) from the standpoint of ritual.

BASARA, KYO, IRO: THE IDIOMS OF ARAKI'S WORLD

Nobuyoshi Araki's photographs immediately bring to mind three terms associated with traditional Japanese culture – basara, kyo and iro.

The idea of basara encompasses the meanings of disarray, outlandishness and wilfulness. In music, for example, it means performing in free rhythm, disregarding the metrical structure of a piece. During the Edo period (1600–1867), the word basara appears, developing to the notion of kabuki and implying a lack of restraint verging on the outlandish, as in the kabuki style of theatre that still exists today. Kabuki has further overtones of stylishness, sophistication and urbanity, while basara suggests a rough-hewn vitality, and it is precisely this latter quality that characterizes Araki's photographs.

A second cultural notion is captured in the Sino-Japanese kanji, or character, that we read as meaning kyo, frenzy. Kyo is the antonym of sei, meaning correctness, and implies a failure to observe social order and mores. In the context of traditional culture it is used in compounds such as kyogen (the kyogen comedy sketches), kyoka (comic tanka poems), kyoshi (comic Chinese-style poems) and kyobun (humorous prose), and is employed especially in the humorous sense of parodying anything original and authentic. Araki's photographs manifest the spirit of kyo, which invites raucous laughter. Araki himself uses the word shakyo, written with two kanji meaning copy and frenzy (and note that the Japanese word for photography, shashin, is written with two kanji meaning copy and reality), and refers to himself sometimes using the artistic name Shakyojin (jin meaning person). The meaning here is more than 'to go into a frenzy' or 'to become frantically absorbed'; it includes a sense of non-conformity.

From ancient times, Japanese people have had recourse to laughter as a means of rebelling against conventional forms. This tradition has been lost in modern times under Westernization, but occasionally some Japanese artists will allude to it, perhaps in response to non-conformist Western art. Nobuyoshi Araki is one such artist. The works he creates in this idiom are by no means avant-garde in the Western sense; indeed they are essentially Japanese, particularly in their use of laughter in the context of iconoclastic deviation from accepted norms. Araki also incorpo-

rates laughter into his treatment of sex. Both laughter and sex are manifestations of a vital force that can be called on to exorcise miasmata. Japanese shunga or 'spring pictures' – erotic ukiyo-e prints – were also known as warai-e or 'laughter pictures', and were considered to possess talismanic properties that both protected soldiers on the battlefront and prevented fires in the home.

Furthermore, Araki's work features a distinctly Japanese use of pathos in iconoclastic contexts. Pathos has always been part of the Japanese aesthetic. In the Edo period, it figured in almost all genres of traditional vocal music accompanied by the shamisen (a traditional stringed instrument). It also contributes to the aesthetic ideal of iki, with its meaning of sophistication and stylishness tempered by resignation in the face of the inconstancy and ephemerality of existence. Pathos is thus the distress we feel when confronted by impermanence.

There was originally no noun in Japanese to denote romantic love. The concept of love – ai – did of course exist, but it referred more to the natural affection and fondness of parents for their children. Related concepts were those of Buddhist compassion – jihi – for one's fellow man and Confucian philanthropy – jin. Romantic feelings were subsumed in the concept of koi, which was distinct from ai. The word koi always included the notion of sexual relations. A new term for love, ren'ai (combining the two kanji read separately as koi and ai), came into use during the Meiji era (1868–1912). The word was added to the Japanese vocabulary of human relationships under the influence of the West, to refer to relationships between men and women with the focus on the emotional aspect and not necessarily incorporating a sexual element. But even today, the Japanese equivalent of the phrase 'I love you (ai shite iru)' has still by no means taken root in Japan and is liable to sound embarrassing when actually uttered.

Another Japanese word used to express the idea inherent in koi is iro. Iro is the standard word for colour, but at the same time it refers to all phenomena that can be perceived by the senses. For instance, the term koshoku (to take pleasure in iro) was used for a long time in Japanese literature to mean on the one hand well-versed in music, painting and the other arts, while on the other as a term of admiration for both men and women with a strong sense of vitality and interest in sexual matters. The word shikijo (iro sentiments) is the feeling of sexual arousal, and irogoto (iro matters) means love affair. Shikido (the way of iro) refers to the ultimate pursuit of romantic relations. And finally, in a Buddhist context, the most famous line from the Prajnaparamita or Wisdom Sutra, reads in Sino-Japanese shiki [iro] soku-ze-ku ('all sensual perceptions [iro] are void').

Iro can thus refer to sexual energy, a form of energy that manifests itself in sound and colour but that is essentially impermanent and vanishes in an instant. It cannot be said to possess a real existence, and indeed it may not have even existed in the first place.

When I see Araki's photographs, I sense all these concepts of basara, kyo and iro, of vitality, iconoclasm, a sense of frenzy and non-conformity, laughter and sex, pathos, colour sound, transient sexual energy, life and death, and they become jumbled up in my mind.

NEVER ALONE

But there is something absent – something that we never sense and that we can be sure will never surface, namely violence.

Araki has produced many series of photographs of bondage as part of his commercial assignments. But among all these countless photographs of women in bonds, not a single one conveys an atmosphere of violence. They may well have been created to appeal to people with a fascination for sadism, but there is no inherent sadism in them. Nor is there any trace of loneliness or isolation in the women depicted in the photographs; indeed the photographs emit a mysterious aura of serenity. Araki's women always remind me of the women who appear in *shunga* erotic prints.

Shunga, the genre of erotic prints in the *ukiyo-e* manner, have clear characteristics. *Shunga* are pictures of couples engaged in sexual intercourse rather than nude pictures of women posing alone. They show men having sex with women or other men, but women are not exhibited as objects to be devoured by the lewd male gaze. Nor are there any examples of women enticing men from within the picture; there is always more than one person involved. In Araki's nudes and bondage photographs, as in the *shunga* tradition, there is invariably someone else there, unseen but watching, in addition to the subject herself. Although depicted alone, she is never alone; awareness of the proximity of another person is evident in her eyes. That other person is usually Araki himself. Indeed, he often makes an actual appearance. He describes his photographs as 'a collaboration between the subject and the photographer'. Photography is all about living, and the starting point for Araki's photography is the realization that people cannot live alone. He says that his intention is to create relationships. Rather than distancing himself emotionally from his subjects, he strives to deepen his relationship with them as he takes his photographs and to incorporate the consequent emotions into his work.[1]

Although the genre of *shunga* depicts sexual intercourse, very little interest is shown by *shunga* artists in the naked female body. In most cases the women are depicted wearing several layers of kimono and underwear. But two parts of the body invariably remain exposed: the genitalia and the face. Recent research has shown that the size of the genitalia and the size of the face are almost identical in *shunga*, suggesting that they were considered to be of equal importance. While other parts of the body tended to be neglected by *ukiyo-e* artists, they took great care in their depiction of each single pubic hair, of each stray wisp of head hair, and of the protagonist's facial expression and narrowed eyes. In Araki's work too, what one remembers is not the sculptural physical beauty of the body but, first and foremost, the subject's face. One's image of the body is drawn along by the powerful impression created by the face. The genitalia have their own expression and the body itself follows in their wake: an expression not craving attention from or enticing the viewer; an expression that emerges from the relationship with the photographer. There is no sense of wretchedness occasioned by violent assault, no sense of voracious, impoverished lust, but merely bondage overshadowed by a mysterious serenity.

As images based on and growing out of relationships rather than being images created by a disinterested observer, Araki's photographs fall within the genre of *shunga* as it has developed in Japan since the medieval period. They might even be classified within a broad definition of *ukiyo-e* art. One easily accessible example from the vast heritage of *ukiyo-e* are Sharaku's portrayals of *kabuki* actors. Sharaku made no attempt to depict his subjects either formalistically or objectively. He would watch a *kabuki* performance, absorbed in the action taking place on the stage and with the roles played by the actors. He would sketch specific moments in motion, moments of the essence of the drama. One of Sharaku's most famous *kabuki* actor prints, for instance, *Edobei, Servant of Otani Oniji III* (see p. 549), depicts the moment immediately before a murder takes place. Sharaku went into the theatre and depicted the characters who appeared on stage. He was not after a detailed representation, a still image or a portrait. He was responding to the genre of *ukiyo-e*, a form of art that was created to portray not only the relationship between the characters appearing in the picture but also the relationship between the artist and his subject.

THE MUNDANE AS A CONTINUUM OF MOMENTS: IMPERMANENCE

Araki's photographs have interesting frames. At the edge of a picture there may be people without heads or faces, and an overview of the vast assemblage of Araki's everyday photographs, might suggest that these deprivations are the chance consequence of taking so many snapshots. But Araki's willing affirmation of such shots is surely not fortuitous.

Long before the invention of photography, *ukiyo-e* artists of the Edo period used these trimming techniques, most notably Hiroshige in his landscapes. Hiroshige depicts figures from behind or from the side and cuts off a third or in some cases a half or more of their bodies. He depicts horses showing only their rumps and legs. In one work a fishmonger has finished buying supplies at the fish market and he rushes past so fast that our eyes hardly have time to catch him. Hiroshige portrays him in the final moment before he disappears from the scene, by showing a part of his pail and the tuna he has bought (see p. 549).

When Japanese prints first began to arrive in Europe in the second half of the nineteenth century, Impressionist artists including Monet and Whistler immediately began to borrow these trimming techniques. The boat in Monet's *On the Boat* of 1887 is cut down the middle by the edge of the picture in the *ukiyo-e* manner. Degas uses the snapshot method to depict figures from behind at the side of the picture and moments backstage as in his images of dancers.

Why did *ukiyo-e* landscape artists develop this technique that bears more than a cursory resemblance to failed snapshots? What actually comes to mind when we view an *ukiyo-e* picture? From the fragment of the pail and the fish in Hiroshige's picture, we can surmise that the fishmonger has just passed our field of vision. We picture him in our mind's eye rushing past. The trimming thus

creates a sense of motion in a stationary scene. Movement stands at the root of Japanese culture. Things do not remain stationary for a single moment. Time passes and everything changes. If painters and photographers cannot portray solidity and permanence, they must show us motion and change. From the earliest years of Japanese civilization to the present day the Japanese creative impulse has focused on constant change, decay, death and rebirth. What else is there to express? Historically, the question reflects the Buddhist-influenced sense of the transience and emptiness of life that occupies a key position in Japanese culture, and that elicits feelings of poignancy and sorrow in Japanese people.

Transience is not just expressed in single pictures or photographs. Hiroshige assembled a collection of pictures entitled *One Hundred Famous Views of Edo*, consisting of snapshot-style *ukiyo-e* pictures. As well as depicting the remains of a vanishing Edo in a spirit of nostalgia, his pictures are put together in a continuous temporal sequence. During the Edo period the sequence was based on the progression of the seasons, no doubt under the influence of picture scrolls and folding screen pictures.

Araki's series consist of a vast quantity of snapshots. But, in our era, he does not arrange them in the order of the seasons, he replaces the seasons in their formal function with his own inner order. It is of no significance whether there is a story involved or not. The important point is that images cut away from reality in the form of snapshots are reassembled in accordance with Araki's own psyche. Moments of impermanence change into memories that will never fade in Araki's mind and are then taken over by us, the viewers. *Shiki-soku-ze-ku*: all sensual perceptions may indeed be void and every moment may pass by as if it has never happened, but the raw remnants of vivid memories that remain in Araki's mind will be securely handed on.

I wonder why tears well up in my eyes whenever I leaf through *Sentimental Journey/Winter Journey*, which Araki put together in 1991.[2] I am not Nobuyoshi Araki. But I somehow sense the universality of human life and death; these images are projected and transmitted not by means of a standard formula such as the cycle of the four seasons but by a transient human being, who was present at the time but who may well have changed by the next year. There is here a universality that is rooted in but yet transcends the individual. Herein lies the pathos.

On second thoughts, the title of this collection is *Winter Journey*. Snow is white and cold, sad and warm. Perhaps the seasons have crept in here too.

BILLOWING VITALITY IN
THE FACE OF DEATH

I discovered the face of Yukio Nakagawa[3] among Araki's enormous quantity of snapshots. I felt convinced: Araki's flowers are *ikebana* flower arrangements. There are two main traditions of *ikebana*, which both remain entrenched today. One tradition is rooted in animism, in the idea that flowers and plants, as living things, are gods. It was once thought that everything standing on the ground

is a potential medium – *yorishiro* – through which the gods can pass; the equation between flowers and gods has existed in Japan since ancient times. There are echoes here of the 'tree of life' concept common all over the world.

The other tradition has its origins in China and in the idea of offering flowers to pay respects to deceased ancestors in front of the family altar and tomb. It rejects the idea that flowers are symbols of life and gods in their own right, and chooses to cut them and bring them into the home as decoration. This *ikebana* practice developed in the context of Buddhist offerings during the medieval period, when Buddhism flourished in Japan.

In modern *ikebana* the forms of the Buddhist offering are still observed, although the religious element has been wholly expunged; flowers are arranged for aesthetic enjoyment or for the pleasure of guests. Furthermore, the animistic approach is based on primitive ideas of plant life and involves setting oneself up in opposition to the vital forces of flowers. Here one's own being is called into question, and it is this idea that is pursued to the ultimate degree by Yukio Nakagawa. Araki's photographs confront the life of flowers.

In contrast to *ikebana* artists, Araki has extinguished the borders between photographing flowers and painting flowers by mixing in colours (including the varied implications of the word *iro* explained above). In Araki's hands, flowers look like the human face, the naked female body or the female genitalia; the border between flowers and people disappears. Whereas *ikebana* artists use flowers to confront life and death in the natural world, Araki employs them to break through every demarcation line. Carrying the burden of emptiness – *ku* – he gives rise to sensual perceptions – *shiki* – and he shows vividly real (withering) flowers to the background of death.

Araki's photographs stir up the cauldron of life while fixing their gaze on death, and in this sense they are manifestations of the traditional Japanese approach to life and death. Seeing Eros in one's heart and seeing the proof of life in one's own death. This does not imply any positive affirmation of death, but it does imply the idea of anticipating decay and of living with the burden of death and in contemplation of death. These are the notions of Japan that I sense in the life and photographs of Nobuyoshi Araki.

[1] See *Genius Ararchy: Method of Photography* (Tokyo: Shueisha Shinsho, 2001), pp. 16–18.

[2] Published by Shinchosha, Tokyo, in 1991, the volume combines *Sentimental Journey* (1971), a documentary of Araki and Yoko's honeymoon, with a photographic diary of the period before and after Yoko's death.

[3] Born in 1918, in Marugame, Kagawa Prefecture, Yukio Nakagawa is a leading avant-garde flower-arrangement artist. He was initially trained in the Ikenobo-school style but became independent in 1951 to pursue his own individual style. Nakagawa collaborated with Araki in 1997 for a joint exhibition at the Koyanagi Gallery, Tokyo. He also participated in the exhibition, *Etre nature*, at the Fondation Cartier pour l'art contemporain, Paris, in 1998.

Hiroshige, *Nihon Bridge and Edo Bridge*, 1857

Sharaku, *Edobei, Servant of Otani Oniji III*, 1794

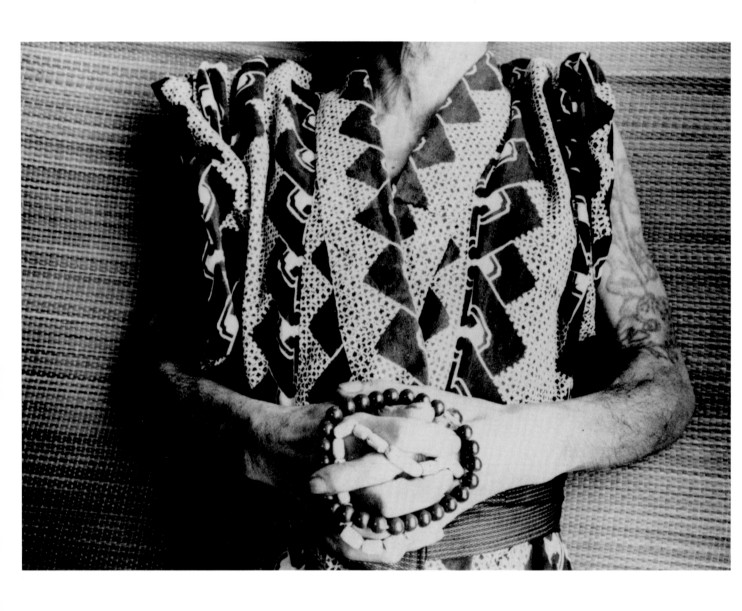

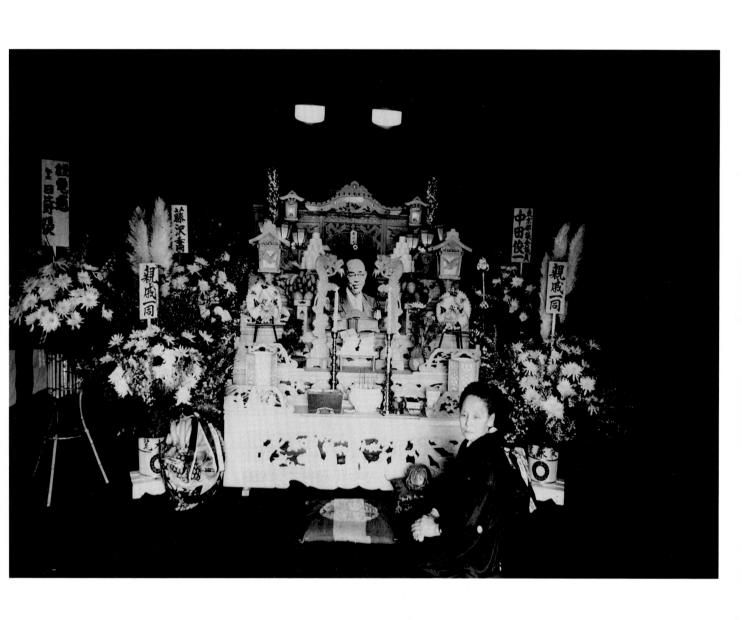

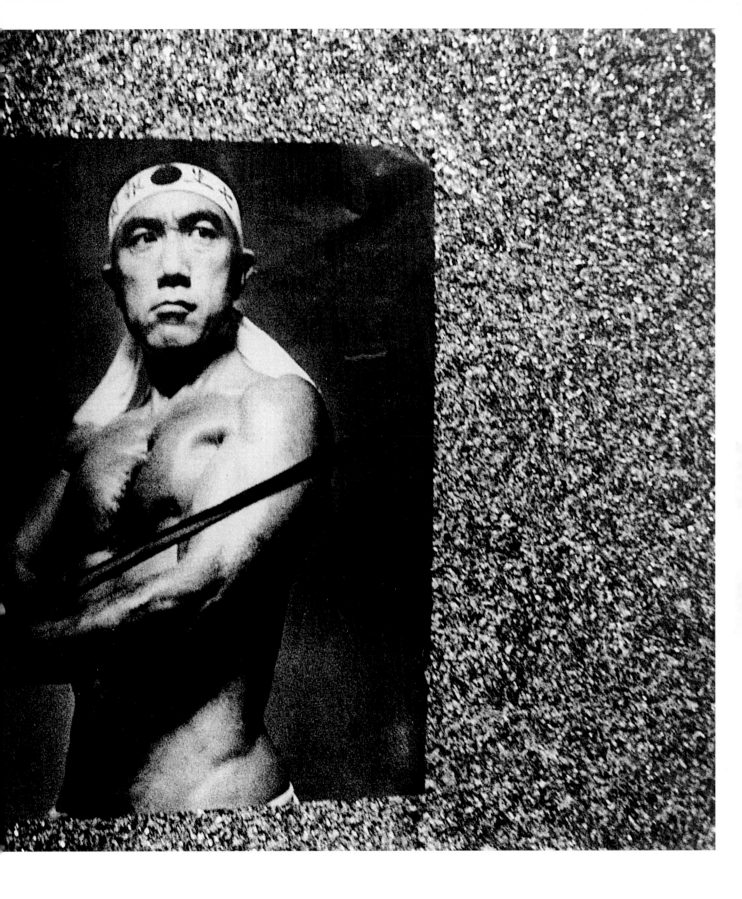

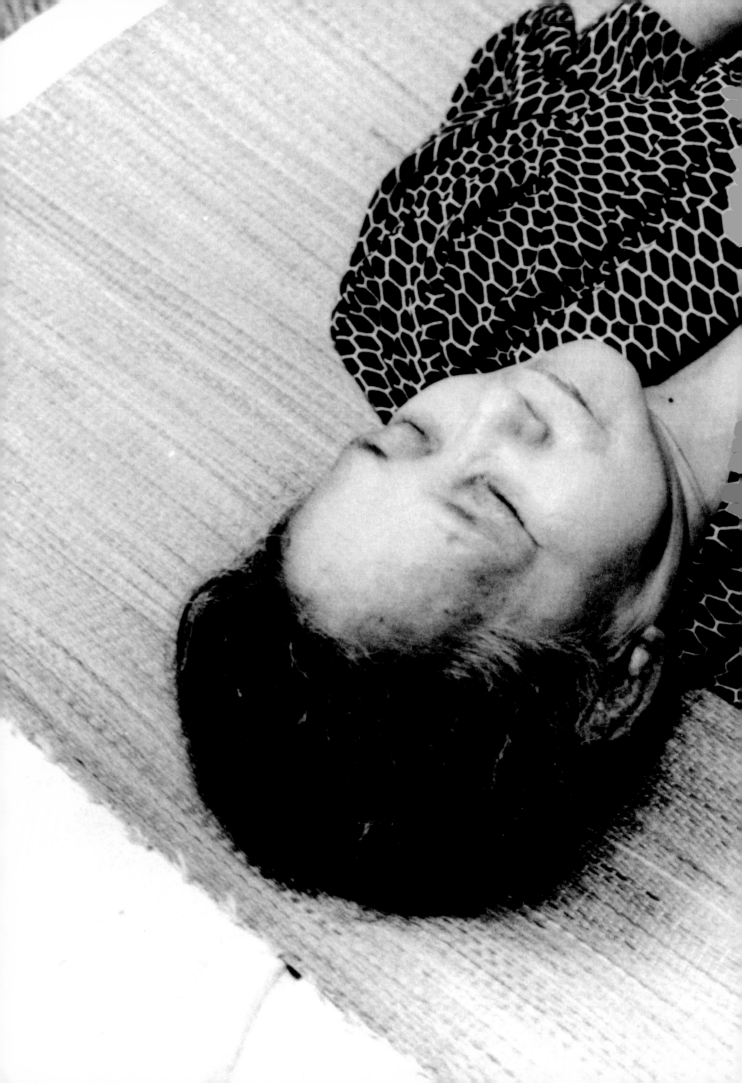

MY MOTHER'S DEATH,
OR AN INTRODUCTION TO HOME PHOTOGRAPHY

—

Death is a sad business. The death of one's mother is particularly sad. My mother died of angina pectoris at 9.27 on the morning of 11 July 1974. On the previous evening she'd complained of pains in her shoulders and upper and lower back. She'd also been complaining about the ringworm of the groin that she'd received treatment for the previous summer but that still hadn't cleared up. She'd called the doctor on countless occasions and received injections. She said she was hurting all over, but nobody had any idea what was at the root of her complaints. She'd been to the surgical and dermatological departments of hospitals and then gone on to the internal medicine department, where Dr Ida had given her various injections, all to no avail. She'd then complain about pain in the places where she'd been injected. In the typical tone of voice of a woman from Gunma prefecture, she'd say she was experiencing pain because the medicine wasn't going round her body or because her blood had stopped circulating. I'd gently massage her shoulders and back, since these were the areas she said hurt the most. For the first time in my life I felt I was being the dutiful son. I certainly hadn't shown much in the way of filial piety to my father, so I thought I'd make up for it now by being extra dutiful to my mother.

Since leaving Dentsu I hadn't given her anything in the way of pocket money and I hadn't visited her that often either, despite her living only three minutes away, walking at a leisurely pace, from our flat. As an 'art' photographer, I was at last beginning to get commissions for commercial work, and I was reckoning on earning a fair amount that summer. I'd planned with my wife Yoko to use this money to take her on a trip somewhere.

My mother got married on 28 August 1933, and she'd run a *geta* (wooden clog) shop in Minowa for a good forty years. After my father had died, one of my younger sisters and my younger brother came to live close to her out of concern for her well-being. With the help of this sister, she continued to run the *geta* shop. It seems to have been great fun for her: she wouldn't sell to customers she didn't like or she'd say nasty things about them. It was this combination of the spirit of Gunma with that of traditional Tokyo that enabled her to continue in this strong-willed, uncompromising vein. I suppose you might say that filial piety is all about constantly making your parents troubled and concerned, but I don't think that's quite it. This is really no more than an excuse on the part of children, and there are no excuses, especially as far as mothers are concerned. Being dutiful to your parents is all about giving them lots of pocket money, treating them to good food, sometimes going to a high-class restaurant and getting them to fumble around with a knife and fork to eat a steak, talking to them, in other words to come into direct contact with them in places where you can see them with your own eyes.

It's no good just sending your parents photographs of yourself with your wife and kids at New Year or whenever. A son who is prepared to stand in a queue for 24 hours to get special tickets for some event or other while constantly thinking about his mother: that's the filial piety that a son ought to show. Filial piety is shown by a man who goes to see his mother in the company of his reluctant wife holding his baby in his arms and with a gift for her in one hand and a pair of nappies in the other. When I was putting together photographs for use at my mother's funeral, I looked at my mother's photo album that she kept at her place of work and I stopped thinking that photographs had no role to play in filial piety. Photographs I'd taken of her grandchildren and photographs of my sisters' wedding ceremonies were stuck in the album along with photographs taken during trips she'd made with local friends and acquaintances. I can imagine how, in the breaks between work, she may have got out this album and seen herself looking so happy amidst the smiling faces of her grandchildren or seen herself with her well-rounded figure standing next to her daughters in their bridal costumes and thought how happy she was. This made me think that perhaps photographs could indeed serve the ends of filial piety. I can't imagine that the trips she made with her neighbourhood friends were really that much fun. In the commemorative photographs, my mother often looks sullen while everyone around her is smiling and laughing. I expect these trips were actually a bit of a bore. Perhaps she went on them just to make sure she retained her physical strength: 'I'm OK now, so I guess I'll be good for another five years.' But the shadow of death can be seen on her face in a photograph taken in front of the Joren-no-taki waterfall in Izu, in which she's standing next to an old lady who runs a paint shop…

My mother uttered a brief gasp, and that was that. My younger brother was the only person with her when she died. She died in an instant feeling my brother's presence, his physical warmth and the touch of his chunky hand and listening to his voice. The scene ended. My brother gently fanned her to give her air. My mother… That was the scene. A momentary gasp – neither a word nor a cry – brought the scene to an end. Mother was dead. I placed my hand on her still warm breast. I couldn't take away my cold hand. I touched one of her nipples in a way that nobody would notice. I felt a pang of unease and began to weep.

I was the chief mourner. Although I was supposedly thirty-four years old, I was a photographic artist with next to no experience of the world. With assistance from a male relative and people from the local neighbourhood association, I made the arrangements for the funeral and I immediately began to look through my mother's photograph albums. I was a bit concerned because I hadn't taken that many pictures of her while she was alive. Masahisa Fukase,[1] as one might expect, has already taken funeral photographs not only of his parents but also of himself and his wife Yoko. All that remains now is to die for the sake of the photographs. But one really should not make such jokes. A photographic album is a photographic collection par excellence. Apart from the portraits, the editing and the layout of an album are usually far superior to those of any published collection of photographs. My mother's album, which she had herself fastidiously edited and laid out, is infinitely better than the *Wisconsin Death Trip* that Masahisa Fukase brought back from New York as a gift. My mother exists in this album. One of her albums has the following legend printed on one of the middle pages: 'Any bitter experience that we live through becomes a pleasant memory.' On one page of this album there's a photo of my father a year before he died, posing with his hand on the 'Ancient Bell of Supreme Virtue' at the Denpoin temple in Asakusa. Then there's a photo of the smiling face of my niece, the daughter of my eldest brother, who himself died within two years of my father's death. There's a photo of my youngest sister in bridal costume and a

Polaroid shot of my mother taken by me at my youngest sister's wedding ceremony. These four photos have been stuck into the album in random positions. I felt very moved at seeing this page alone. I decided to use this Polaroid shot of my mother as a funeral photograph. The task of reproducing the photo involved attaching all the close-up rings to an Asahi Pentax 6 x 7 camera, and it got me into the same spatio-temporal world as my mother. The image of my mother appearing from out of the haze retreated back into the haze only to re-emerge yet again.

This space-time was on a higher level than video, movies and photographs. I occupied the same spatio-temporal world as my mother. I boarded a train as usual holding the funeral photograph that I'd created in the darkroom at my studio in Kagurazaka, and I returned to Minowa while gazing on the portrait in my usual train. After getting back, I made a silly pun about having framed the portrait in a gold (kin) frame because her name was Kin, but it really wasn't anything to laugh about. I began to shed a tear again myself as I got caught up in the tears of my mother's other relatives, children and grandchildren and the women living in the neighbourhood. I took some more photographs of her before she was placed in the coffin. I touched her again. She was still warm. I wanted to photograph her nipples and her pubic hair, but the kids were staring at me intently as I worked, and it proved impossible for me to take any such photographs. The funeral photograph that decorated the altar gave the impression that she was still alive. Perhaps funeral photographs are substitutes for life. Lots of people turned up for the wake at the Jokanji temple, as they had earlier on the deaths of my father and elder brother. It was a pretty good show for an old girl who'd done nothing except run a local clog shop. My younger brother lay down with her body in front of the altar. If she'd had any savings, they'd all have been my brother's. (She'd never used a penny of the pocket money she received from her daughter and sons with the exception of

me and had saved up all the money to pay for my younger brother's wedding.) I was so tired that I went soundly to sleep, even without the soporific of sex.

On the morning of the funeral, I sat in the loo with the squitters wondering whether I ought to take in my camera, as I gazed on the 'purification salt' that I'd received at the time of Ihei Kimura's funeral and was placed on the display stand in the toilet. I don't have much *gravitas* at the best of times, but it seemed to me I'd have even less if I turned up with a camera dangling around my neck. What's more, I was supposed to be the chief mourner. I left the toilet after deciding to abandon the idea of taking any photographs. It was at last time for the funeral. I'd had just had a crap, but I wanted to go again. The reading from the sutras began and the smell of incense gradually became stronger. Kineo Kuwabara,[2] Shomei Tomatsu[3] and Masatoshi Naito[4] had turned up. There was still no sign of the chief mourner's wife, who was being held up by the costume rental people. There seemed to be a surprisingly large number of young people around; surely they can't all have been mother's youthful paramours – I suppose they were chums of my younger brother. The chief mourner's wife finally turned up. She seemed to have put on her kimono in too much of a rush; the white neck-band was showing rather too much, but she looked pretty good all the same. The chief mourner's wife did the ceremonial bow, while the chief mourner stared at his mother on the altar to the accompaniment of the monk's miserable chanting and while fidgeting around trying to suppress the squits. The funeral photograph was just a photograph.

When I kick the bucket, I expect this photograph will appear in a grand collection of my photographs that Heibonsha will no doubt publish. Once you're dead, you end up as the string of Chinese characters that constitute your posthumous name. But it was a good photograph. Since I was the chief mourner, I then had to deliver an

address to everyone present. I realized I'd have to be serious for once. I thought I'd say something poetic or something that would affect people emotionally, but, on the other hand, I shouldn't be too prim and proper. I thought I'd end off with something florid like 'I'm sure I'll never forget the green of these trees, appearing in the gaps between the rain during this, the rainy season'. But I wondered if this wouldn't be putting on excessive airs. Just as I was thinking such thoughts, the chanting of the sutra came to an end, the incense was extinguished. It was now time to put the nails into the coffin. I broke up the bunch of flowers presented by Norimitsu Yokosuka and looked at and touched my mother's face, buried amidst the flowers placed there by her children. I touched her cold cheeks and regretted not having brought along a camera. It seemed to me like the first time I had seen my mother looking so content. I stared at her closely. There was something there that exceeded reality. It was the visage of death. Being the superb second-rate photographer that I am, I was itching to take some photographs. I continued to stare intently. My body became a camera and it seemed as if I were continuously pressing the shutter. The sound of nails being struck with pebbles rang out through the humid air of the rainy season. It was like music.

Having fumbled my way through my address, my wife, behind me, teased me by saying how good my speech had been. Looking at the streets as we followed in a car immediately behind the hearse made me regret once again not having brought my camera along. We entrusted the cremation to Hakuzensha Co. Ltd., who had similarly disposed of the remains of my father and elder brother. Seeing my mother emerge with a blast of hot air in the form of a tiny residue of bones, I again regretted having left my camera behind. This was something I really should have photographed. When I put the larger of the remaining bones in the funeral urn together with my wife, I sensed how much I wanted to photograph these bones, these remnants of my mother. There was a certain amount of photographer's self-interest involved here. This feeling may well have been a manifestation of my own human failings. But that's neither here nor there. As a calculating photographer, I feel absolutely no regrets whatsoever. I wanted to take photographs. I wanted to take photographs in my own self-interested mode. My mother's death amounted to a critique of my work as a photographer while at the same time providing me with an object lesson.

[1] Masahisa Fukase (b. 1934), photographer; he began to photograph his wife and family in the 1960s, heralding the idea of 'personal' photography, along with Araki.

[2] Kineo Kuwabara (b. 1913), photographer and influential editor of photographic magazines such as *Camera*, *Sankei Camera* and *Camera Art*. Born in Shitamachi, he shares the same interest with Araki in street scenes of Tokyo; he had a joint exhibition with Araki, *Love You Tokyo*, at Setagaya Art Museum, Tokyo, in 1993.

[3] Shomei Tomatsu (b. 1930), internationally acclaimed photographer and one of the shapers of post-war Japanese photography. His issue-based works question the meaning of photography: document versus art; individual versus society; Japanese culture versus Americanization.

[4] Masatoshi Naito (b. 1938), photographer particularly known for his interest in anthropology and bizarre images of Japanese country folk.

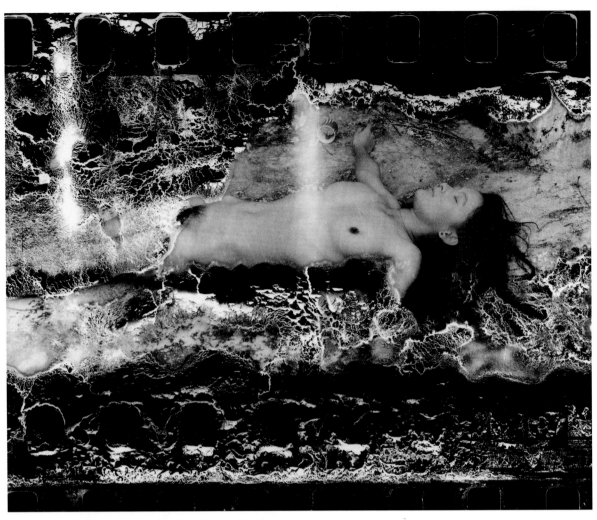

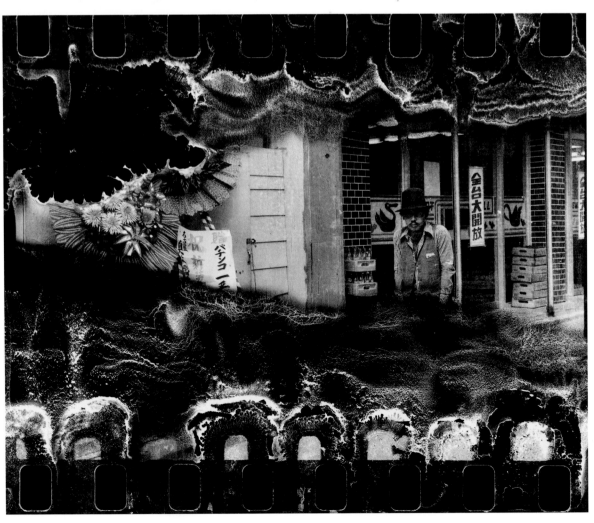

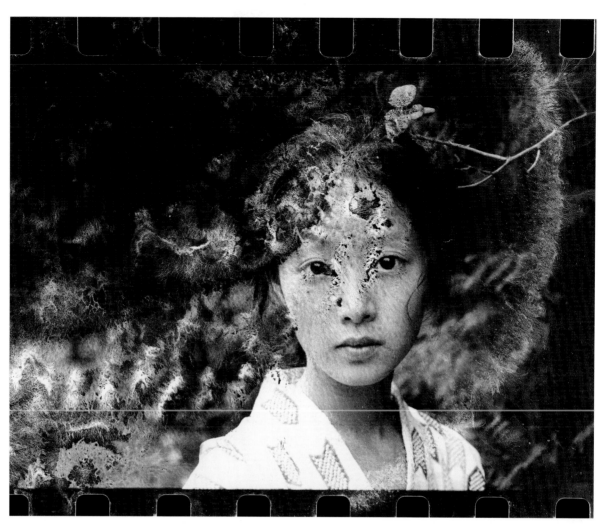

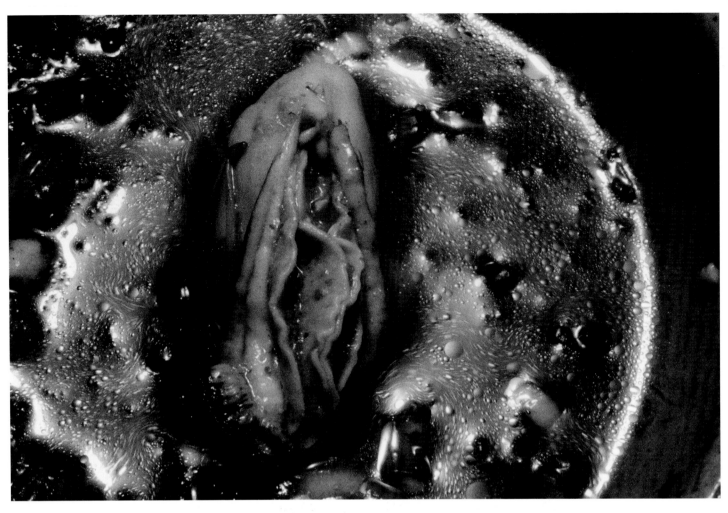

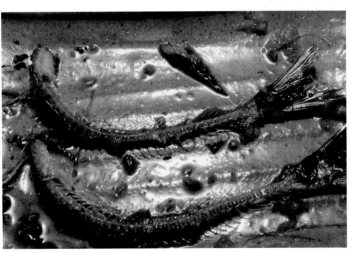

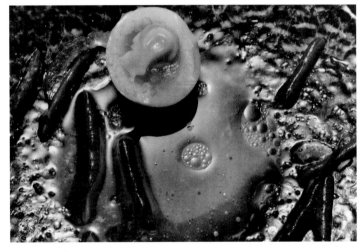

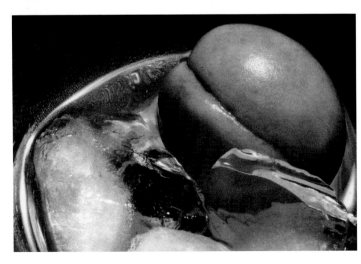

EROTOS

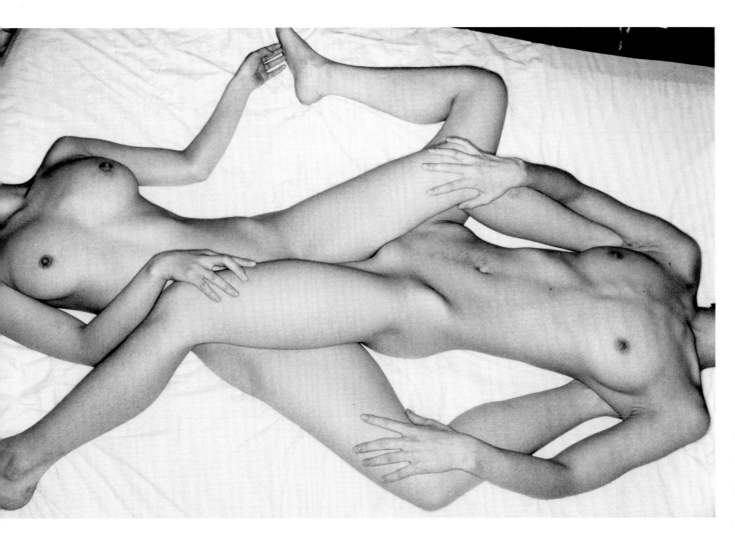

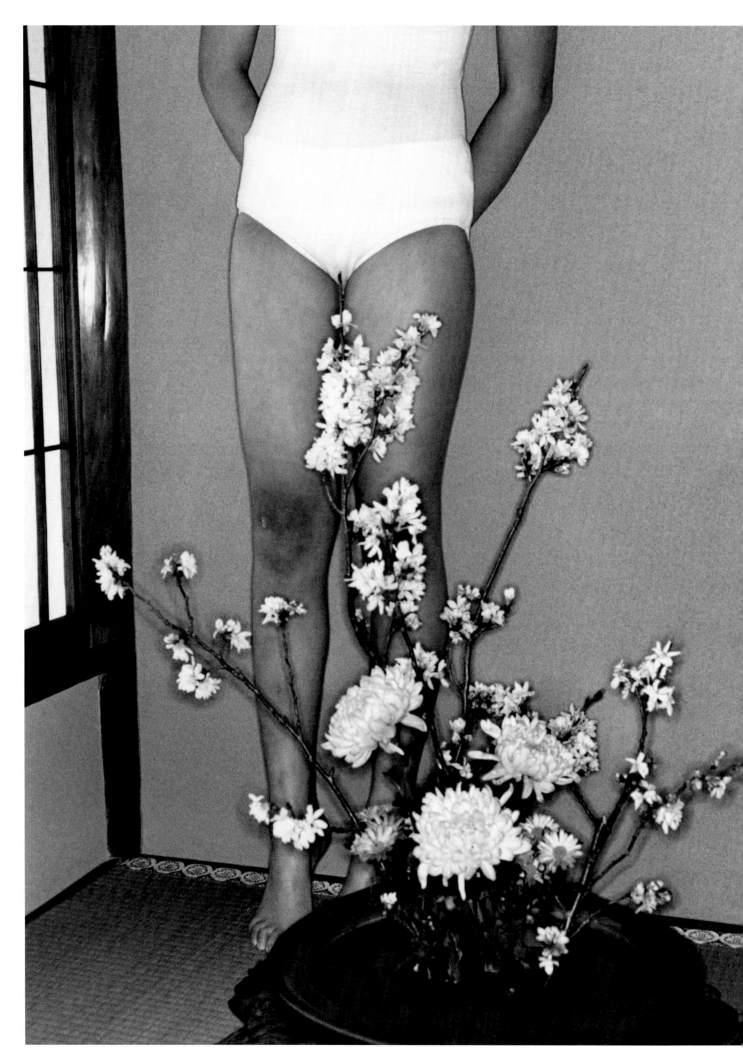

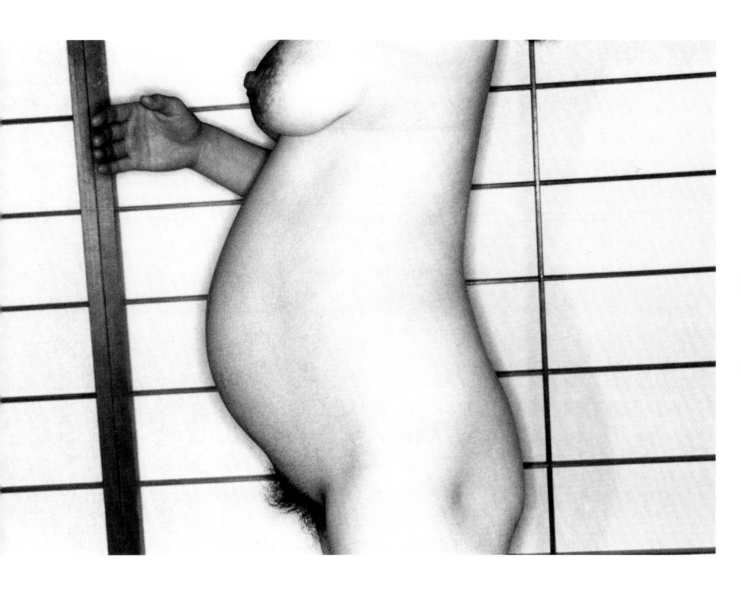

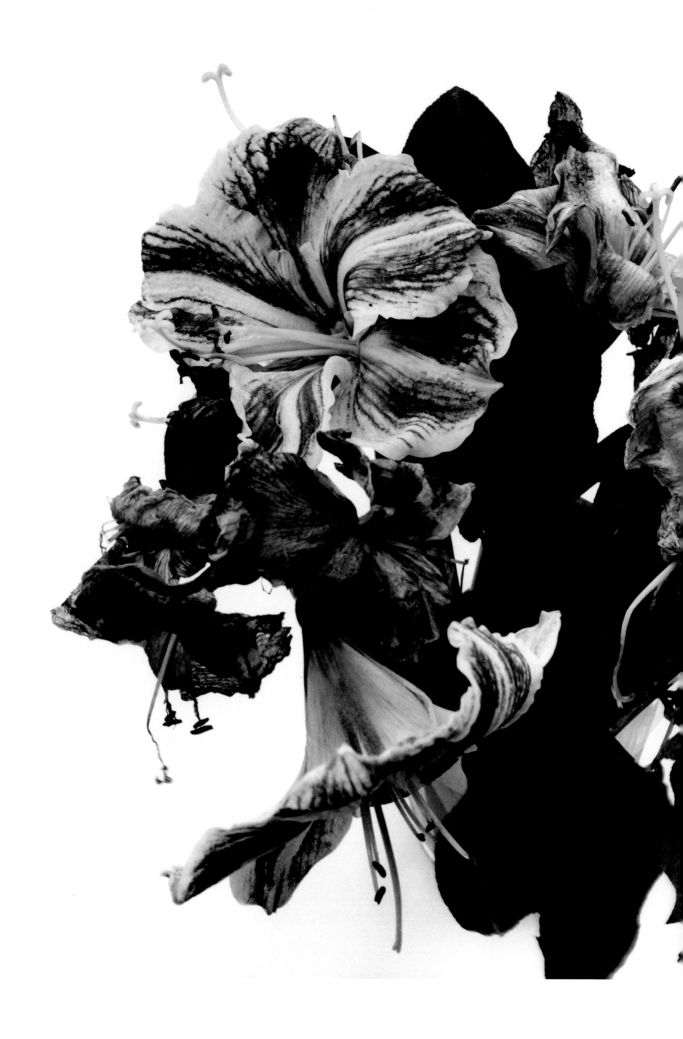

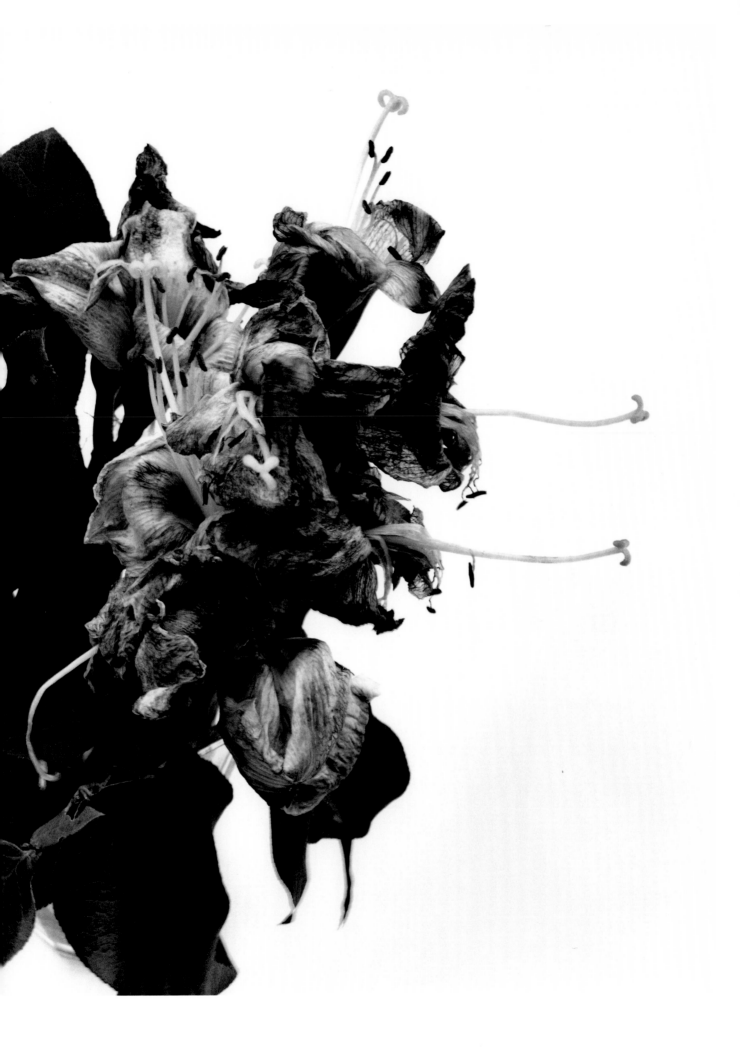

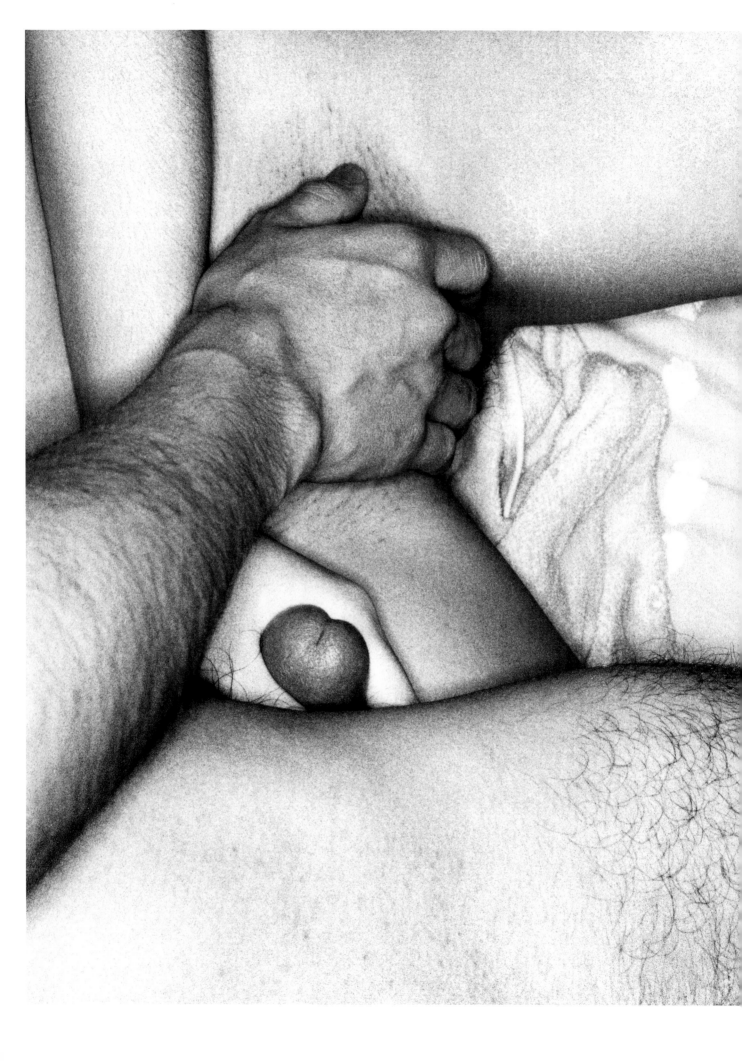

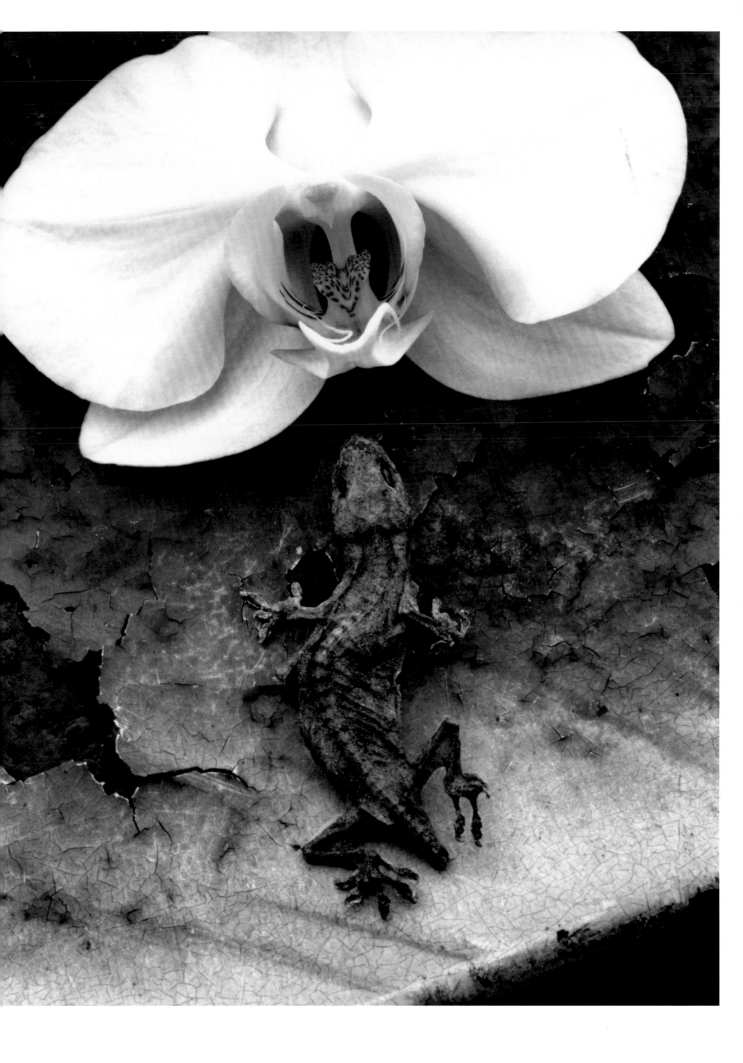

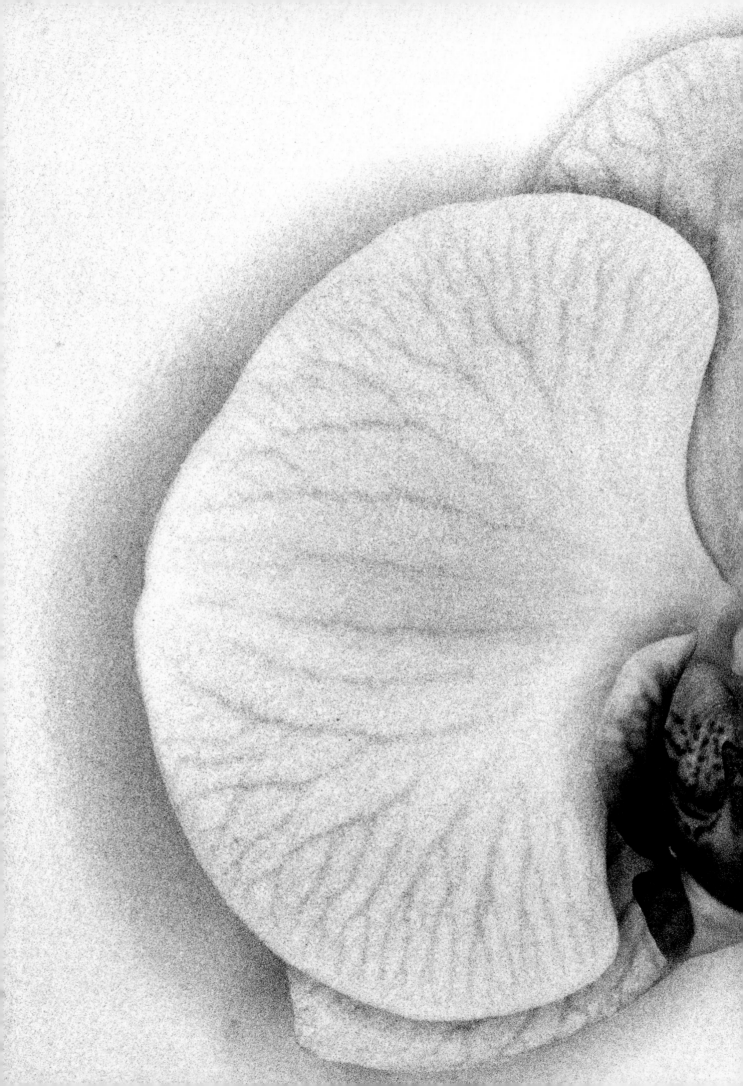

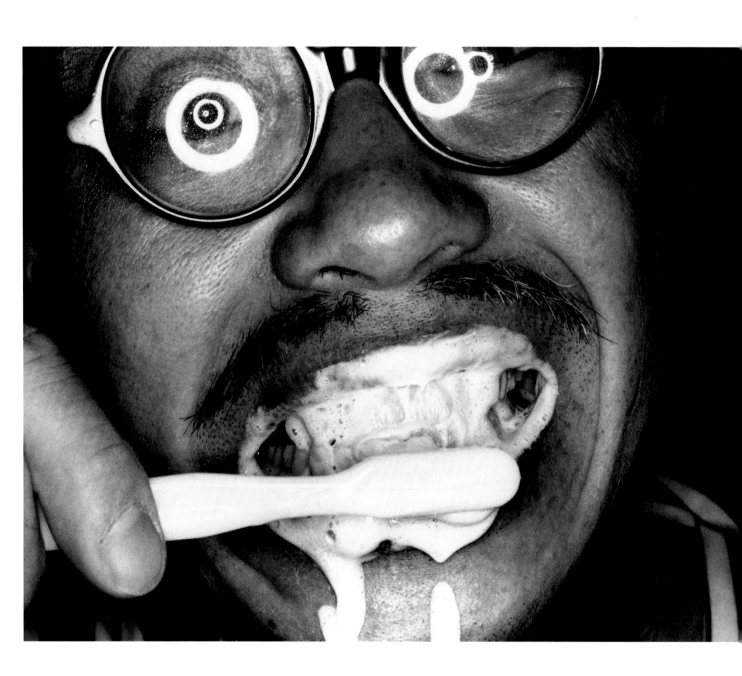

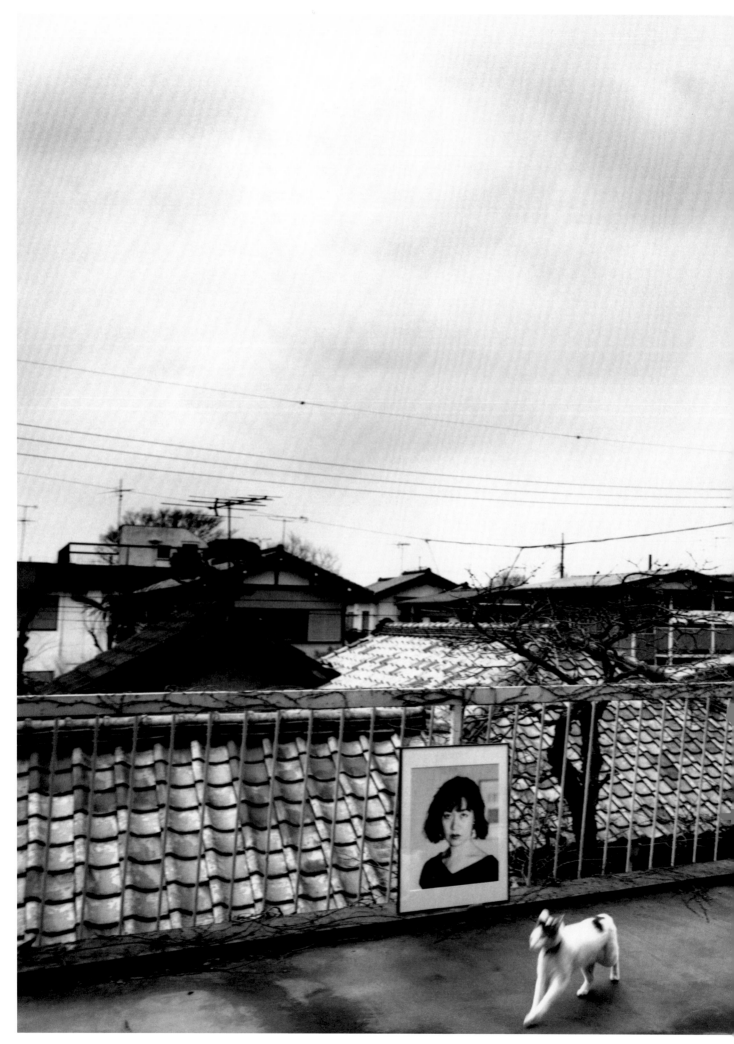

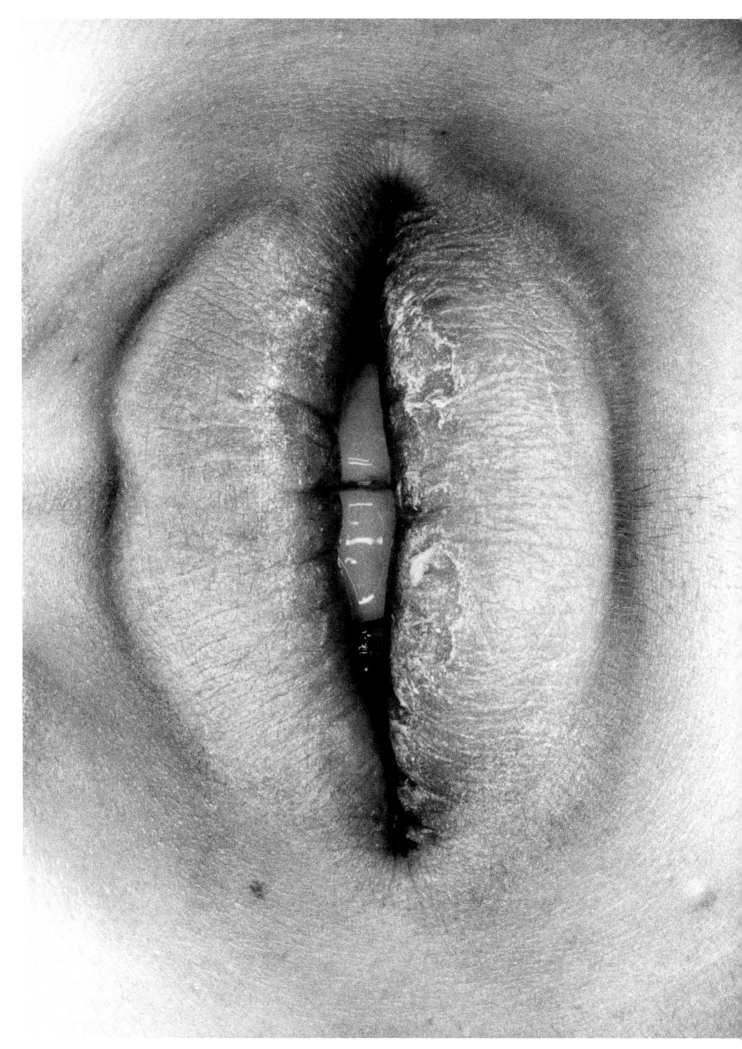

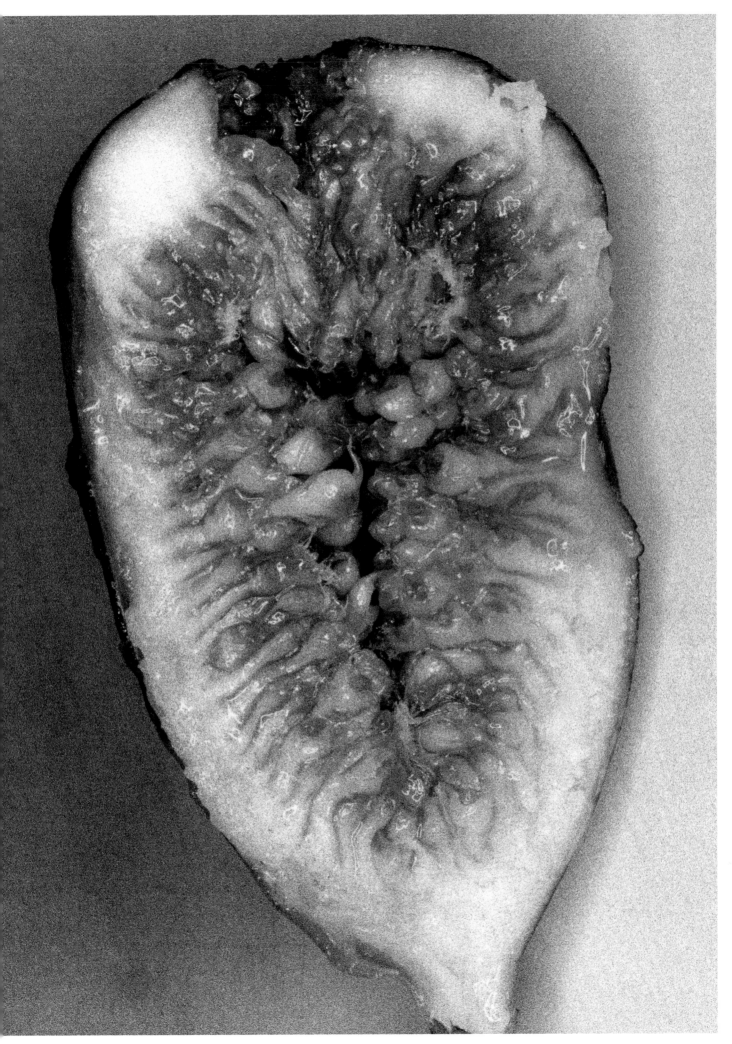

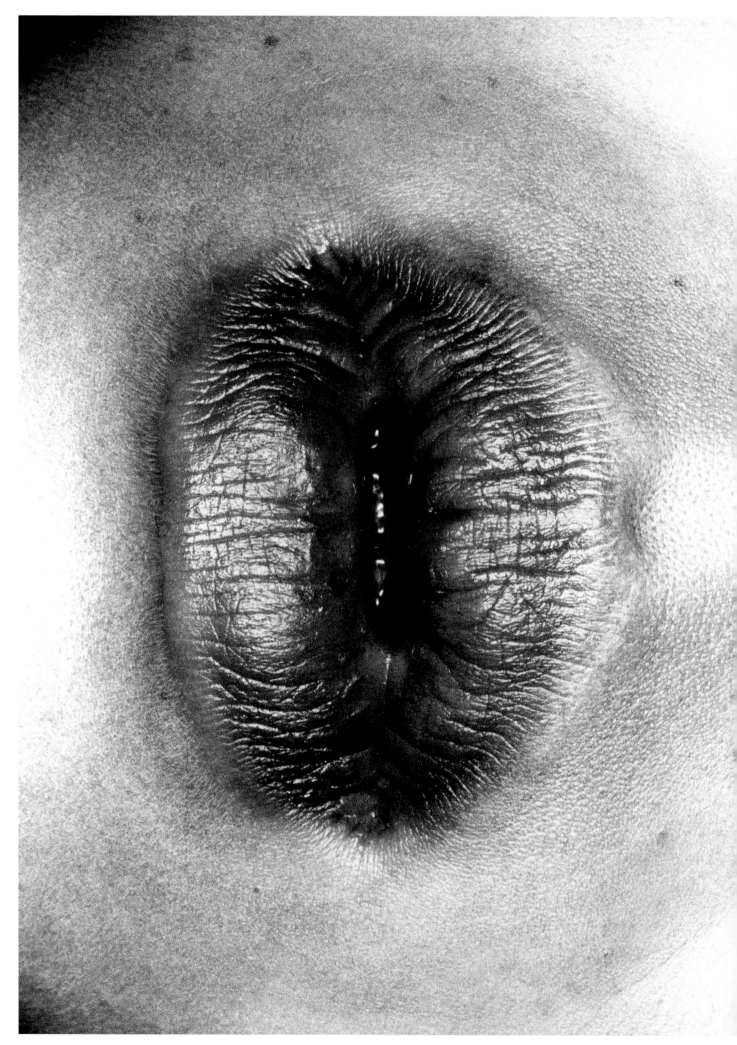

KINBAKU

(TO THE OTHER WORLD)

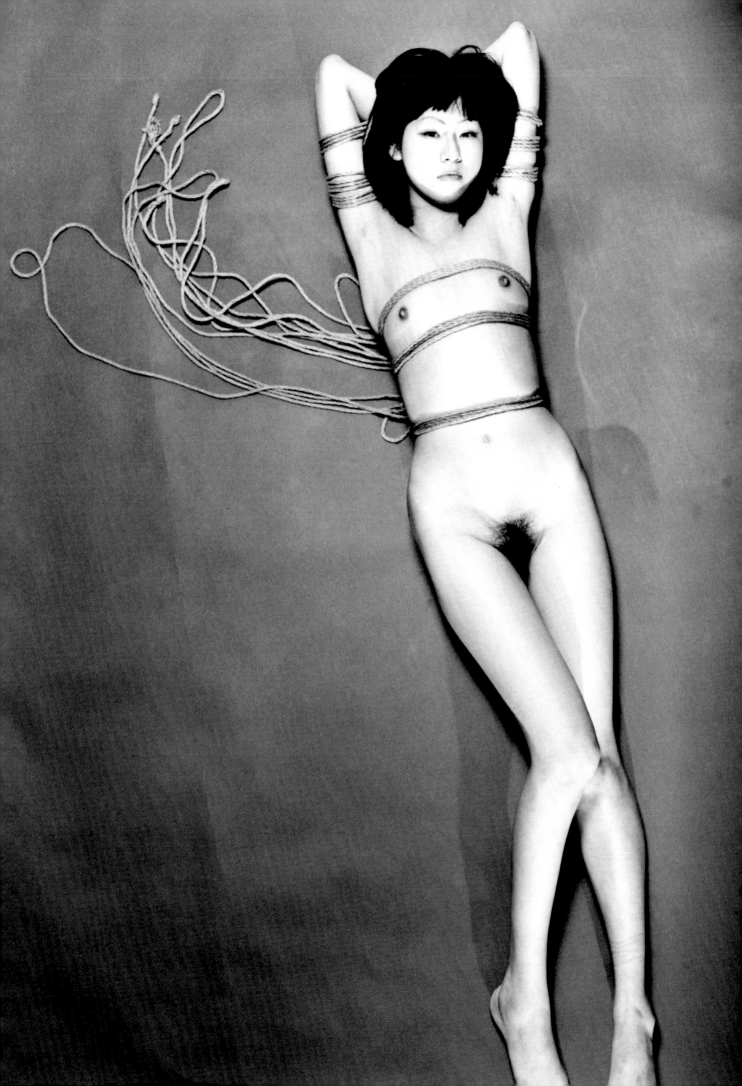

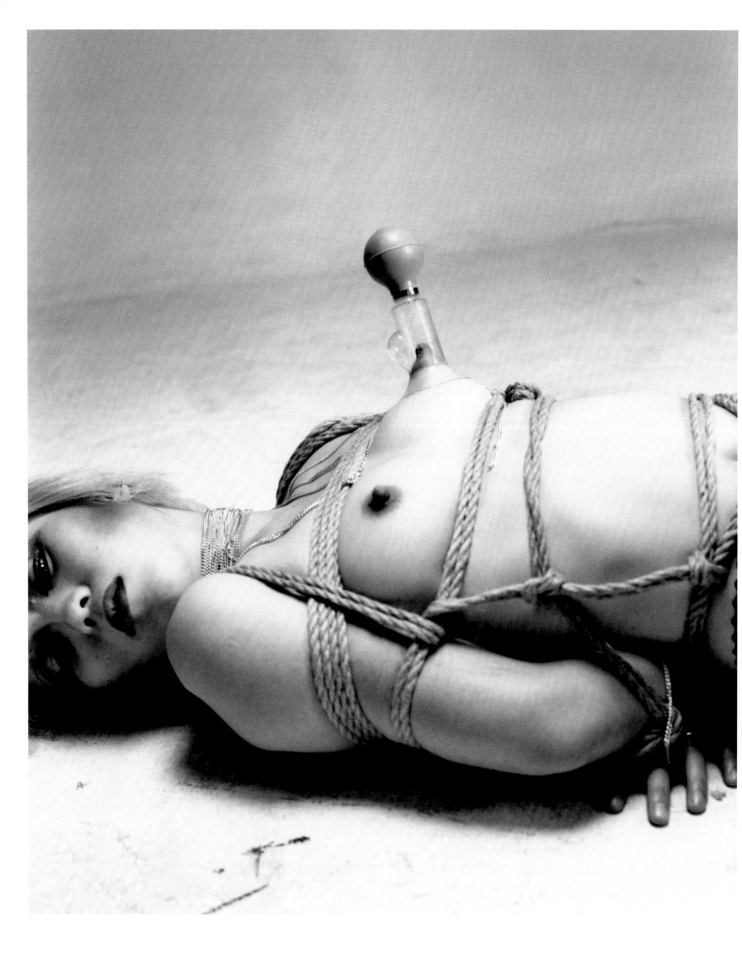

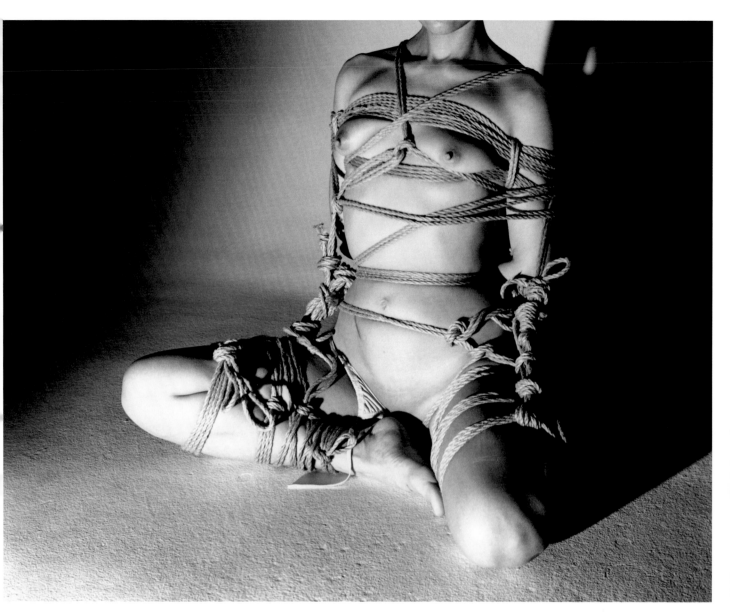

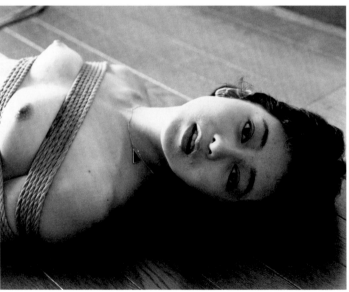

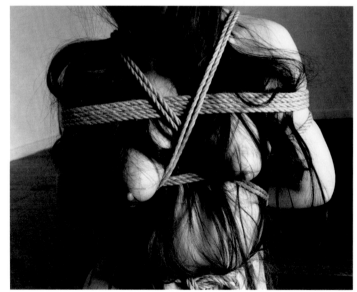

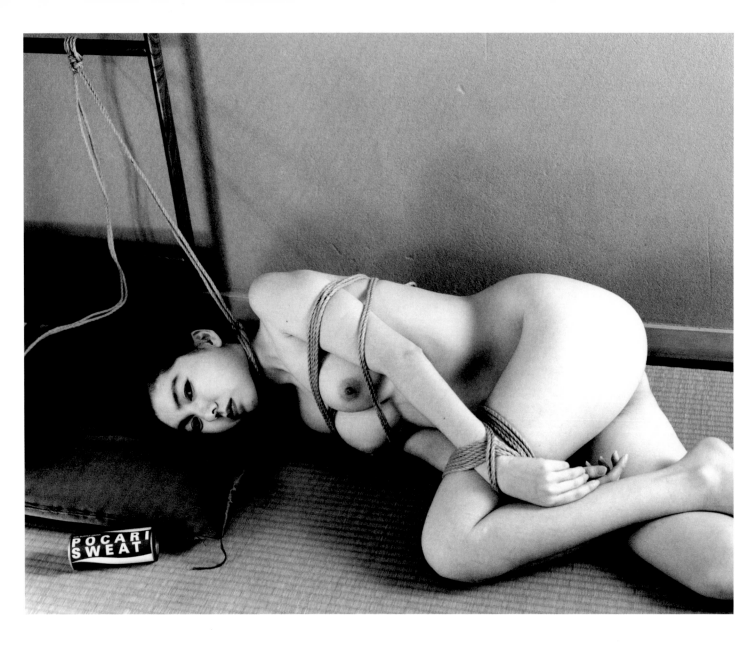

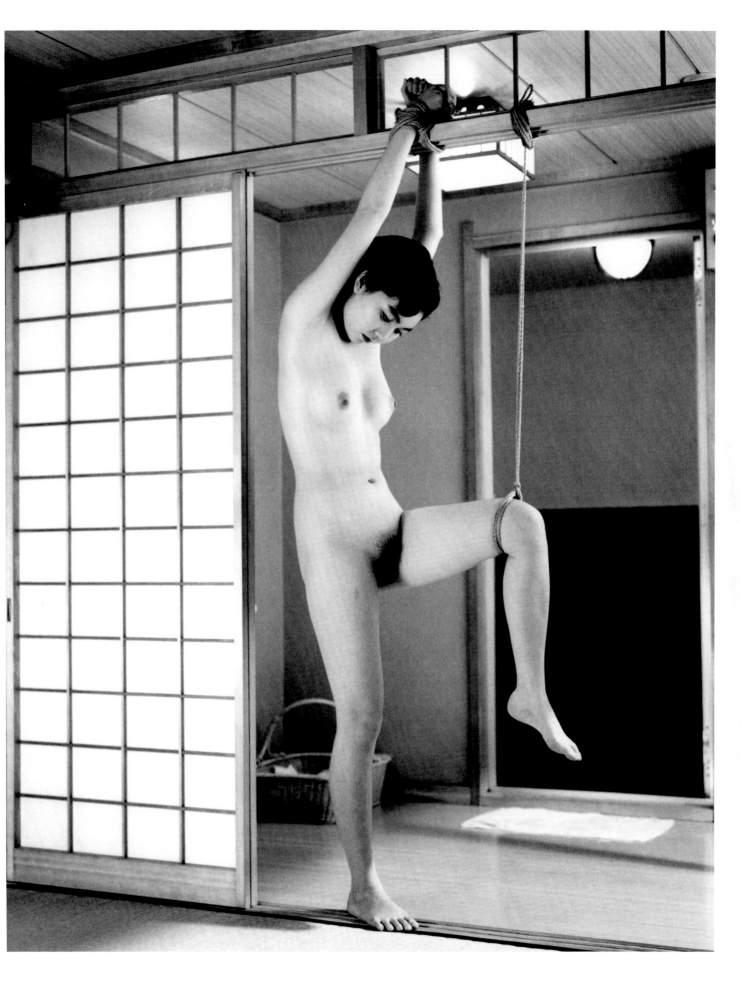

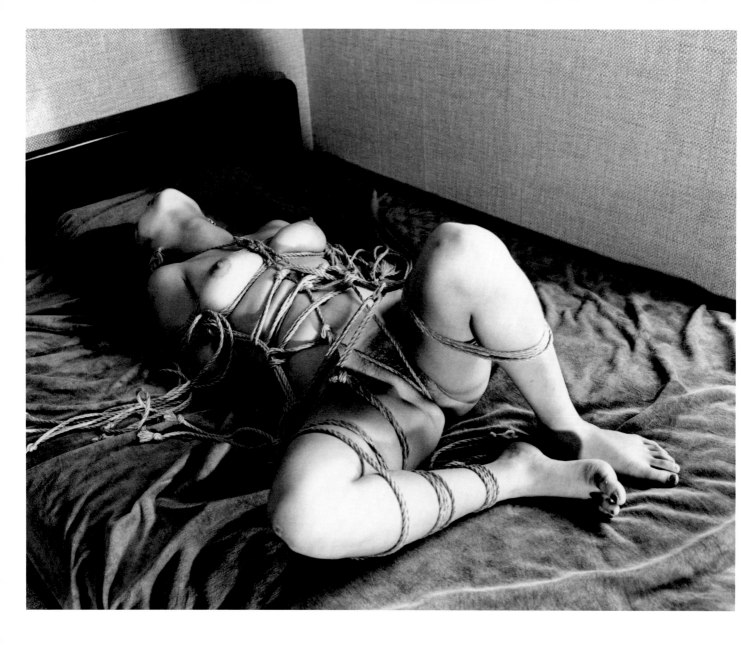

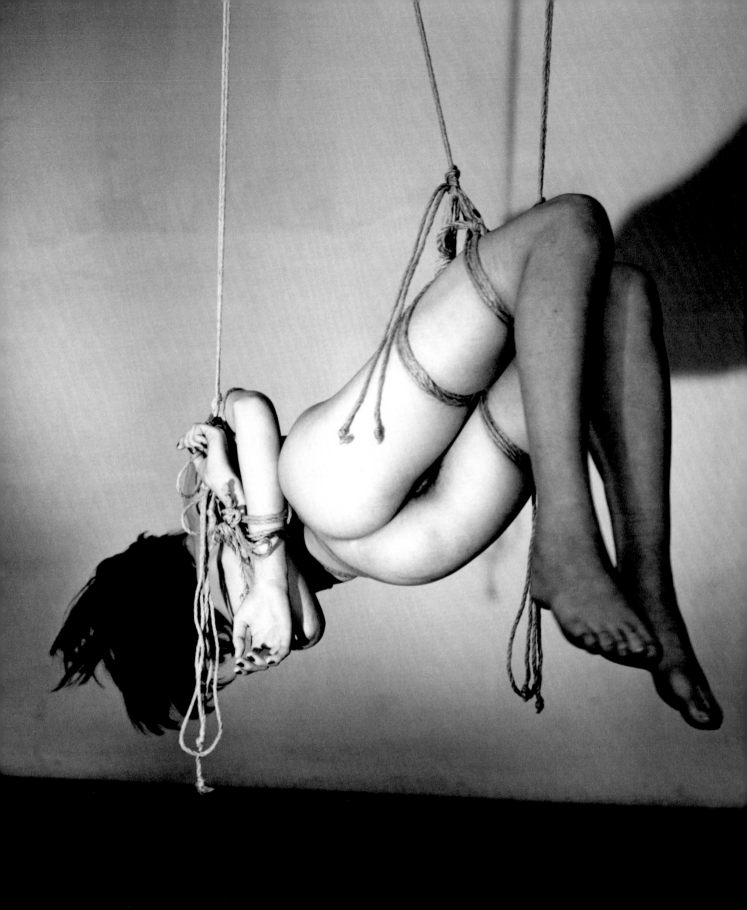

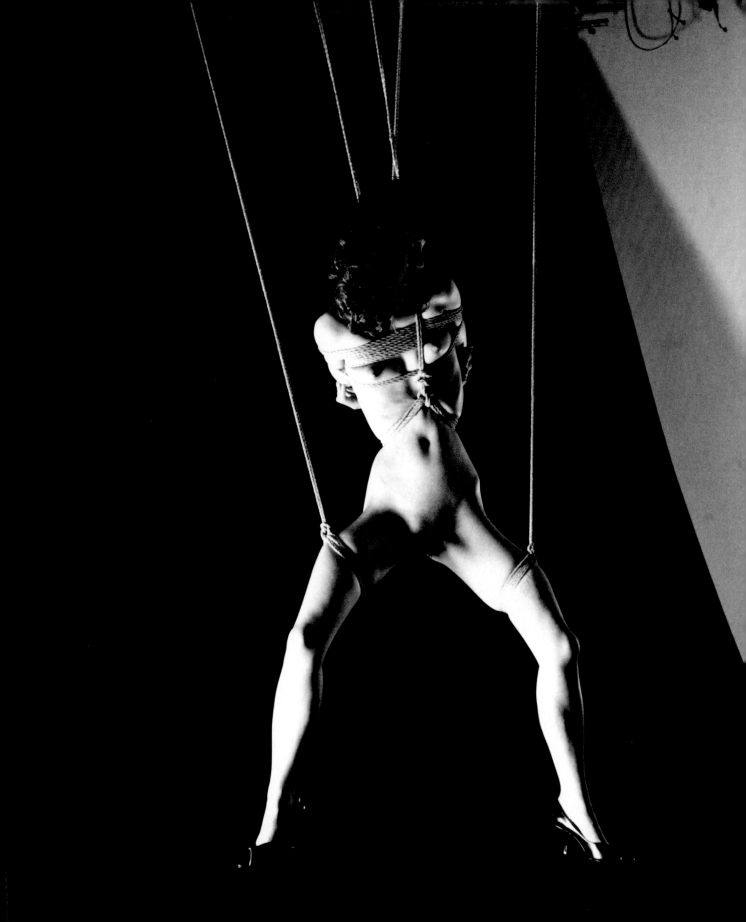

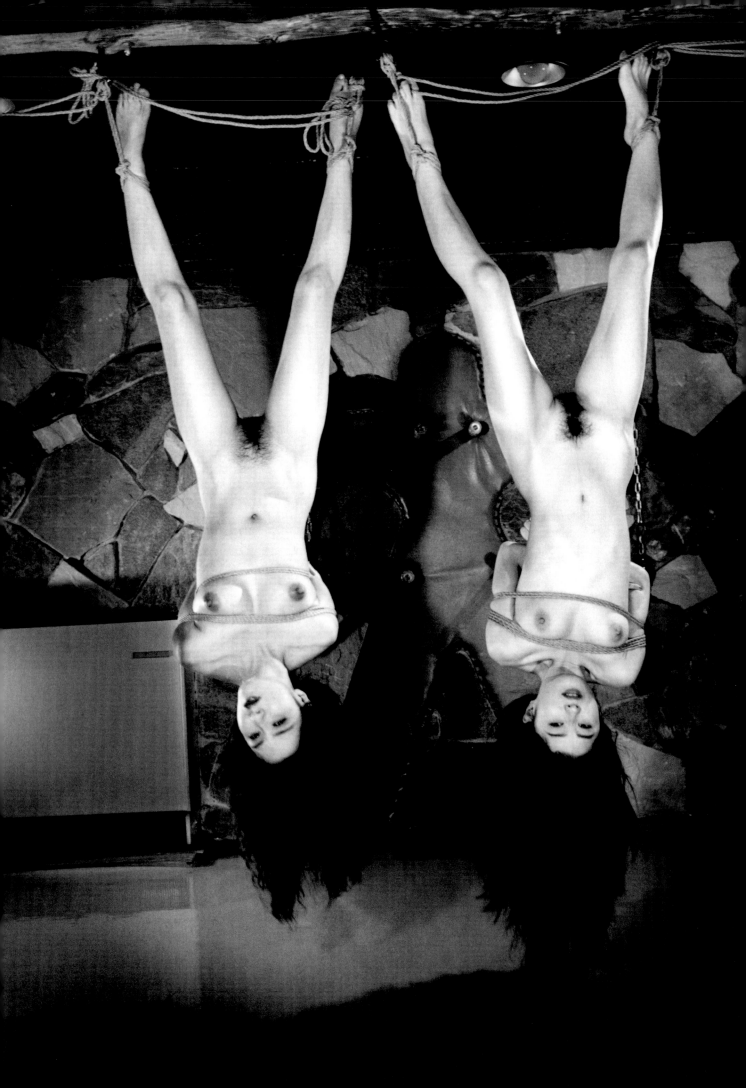

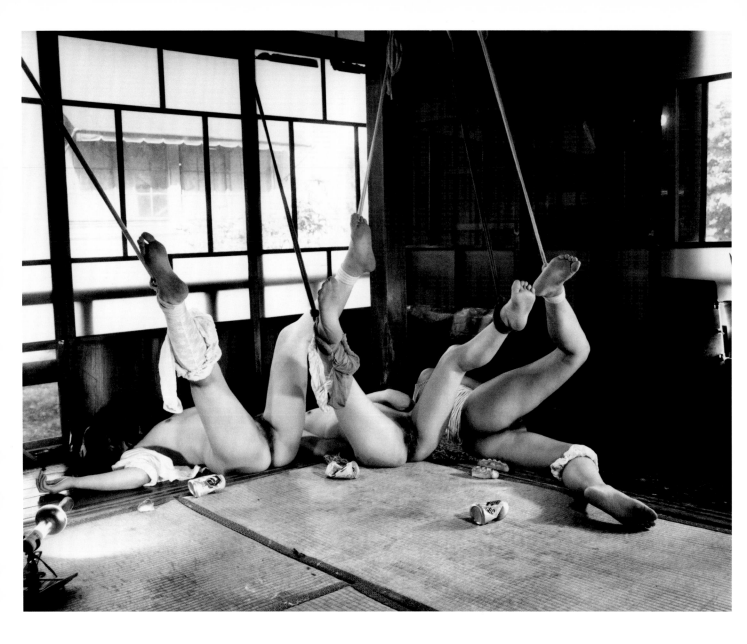

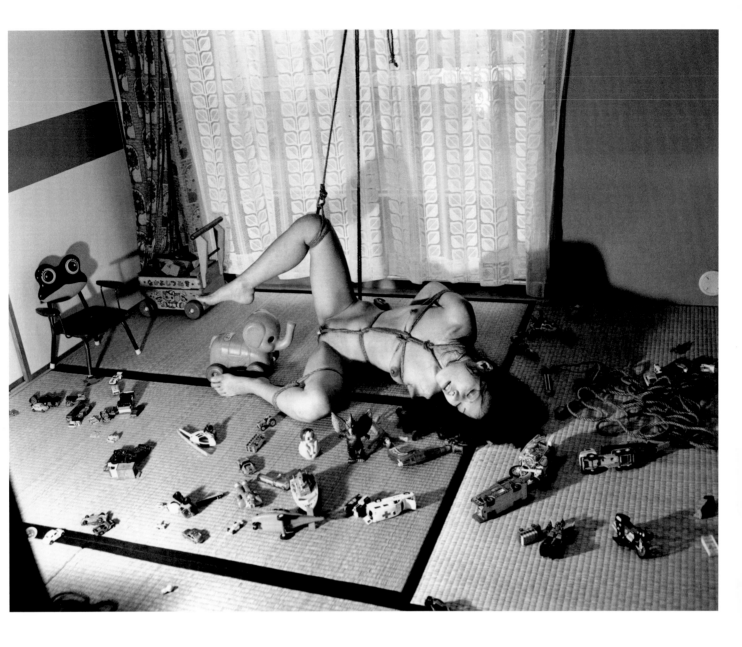

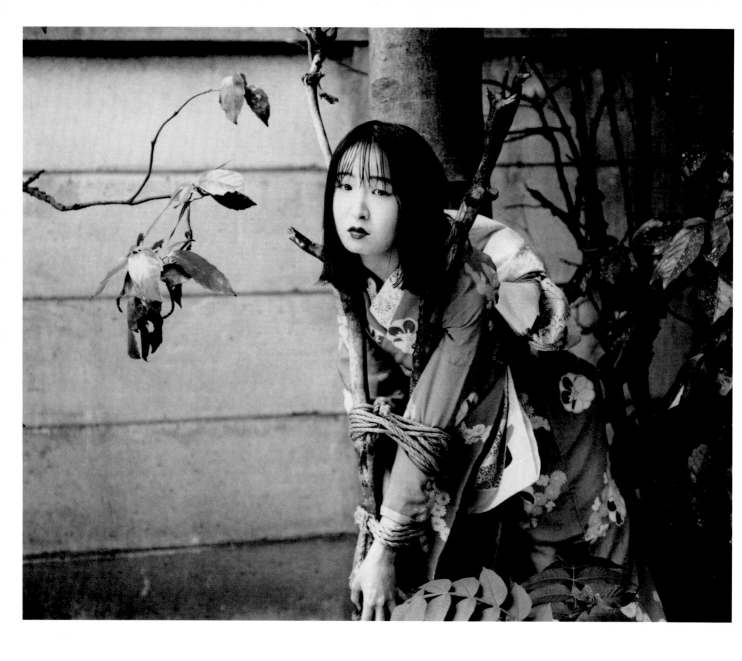

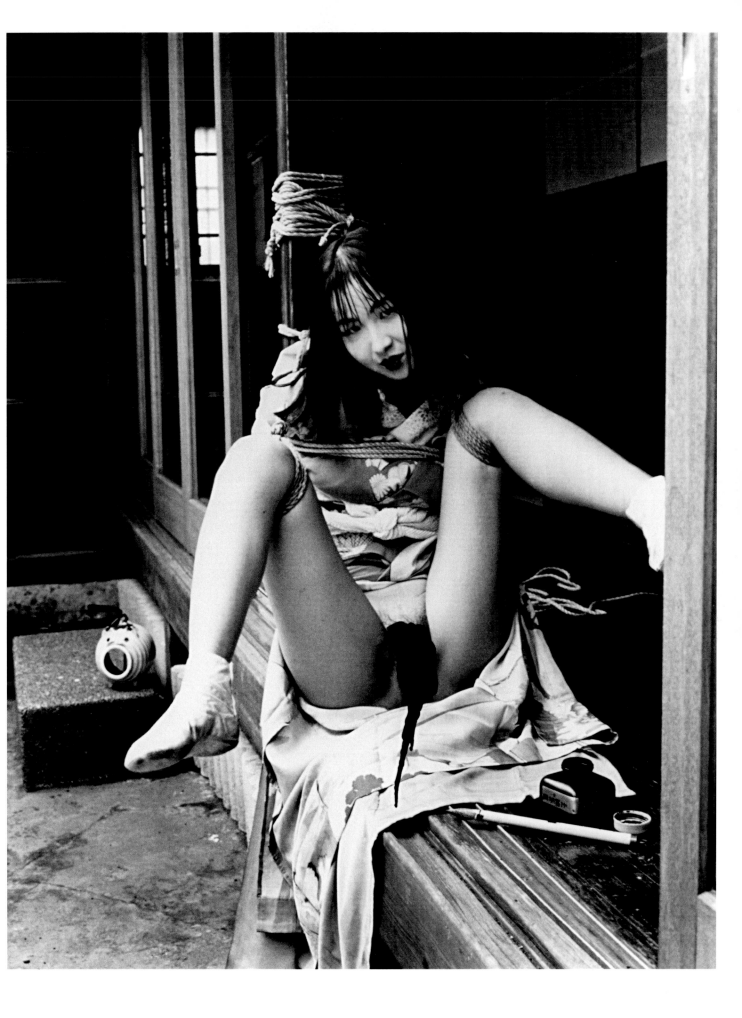

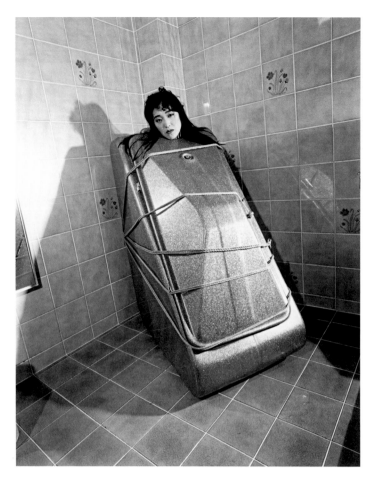
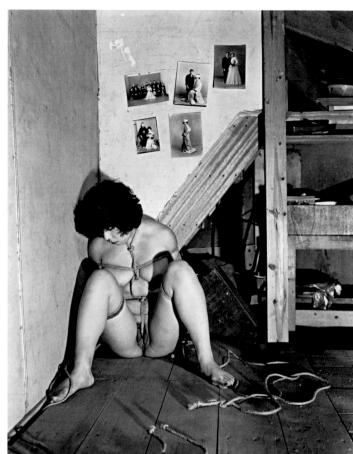
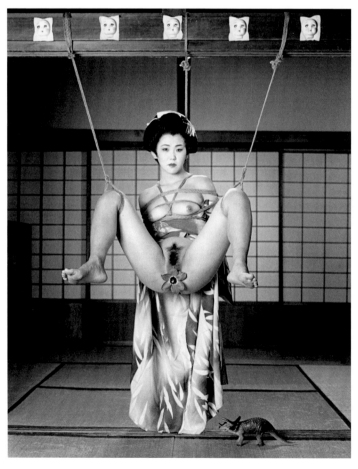
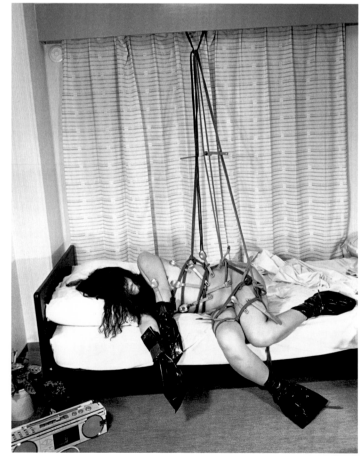

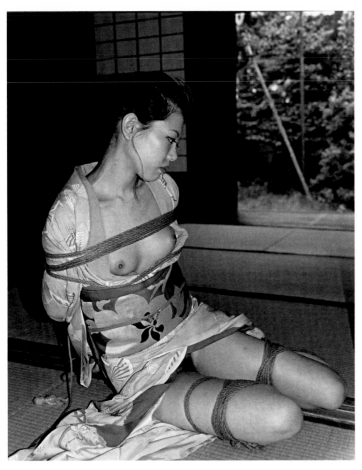

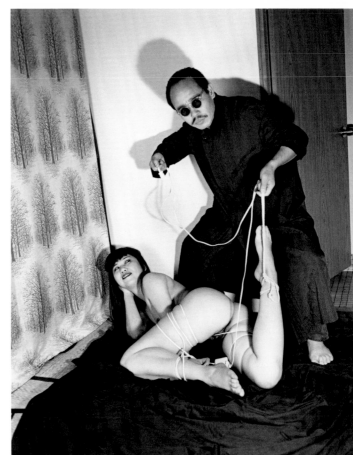

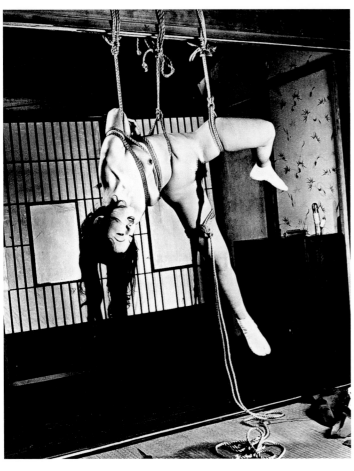

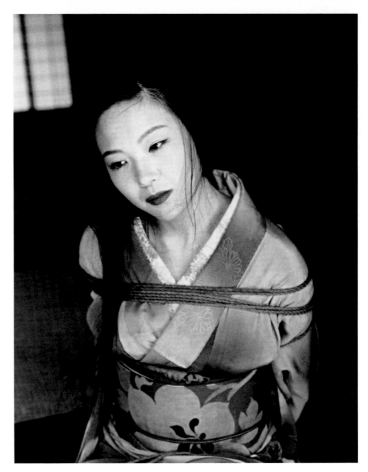

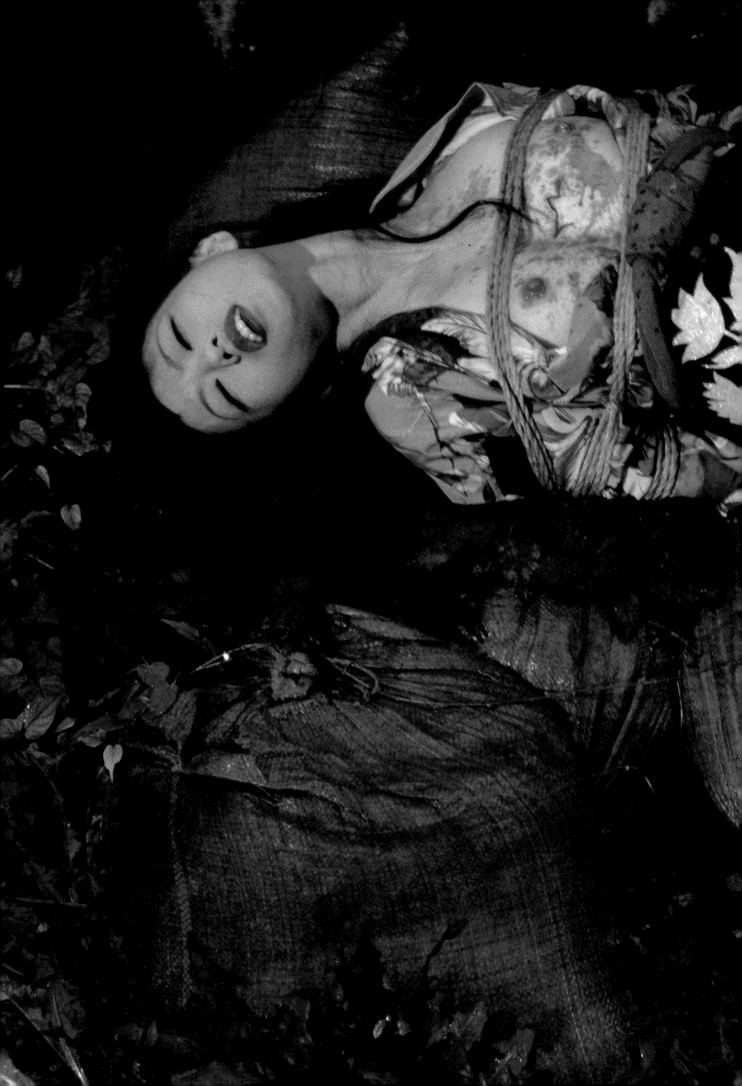

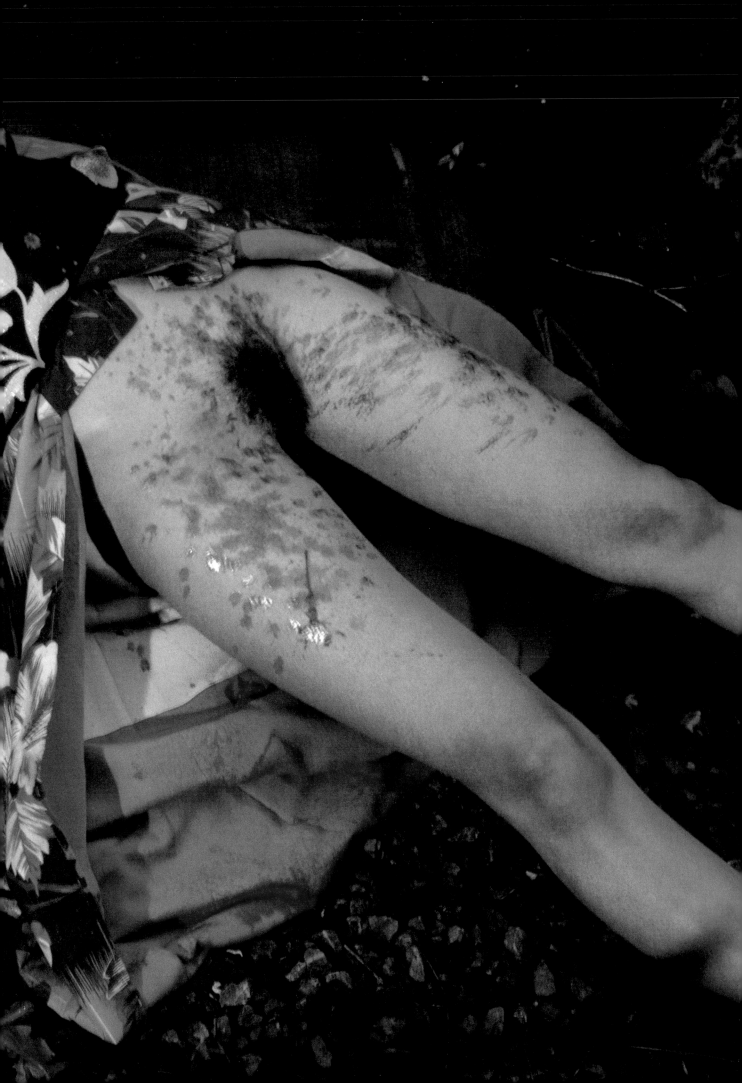

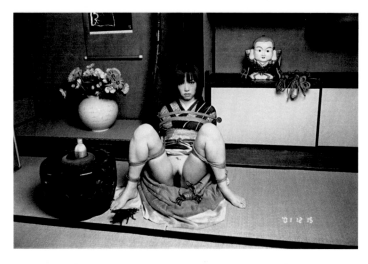

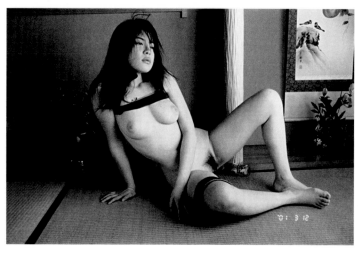

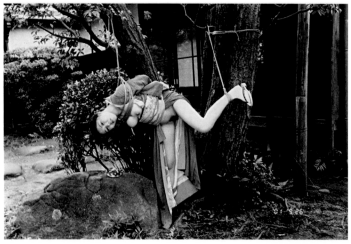

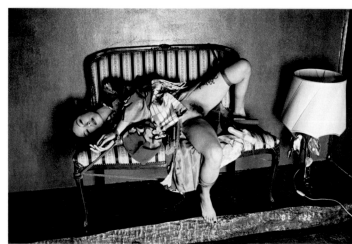

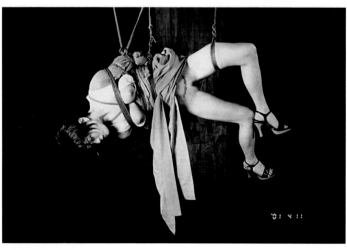

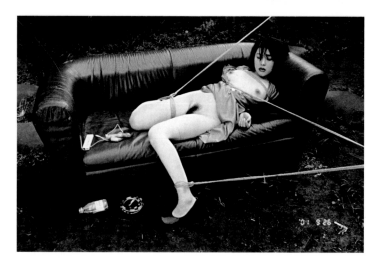

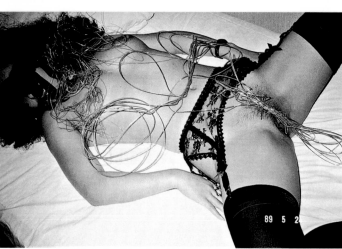

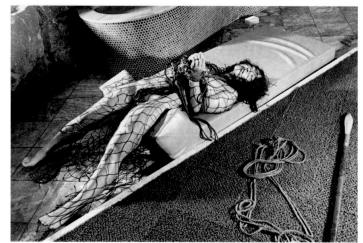

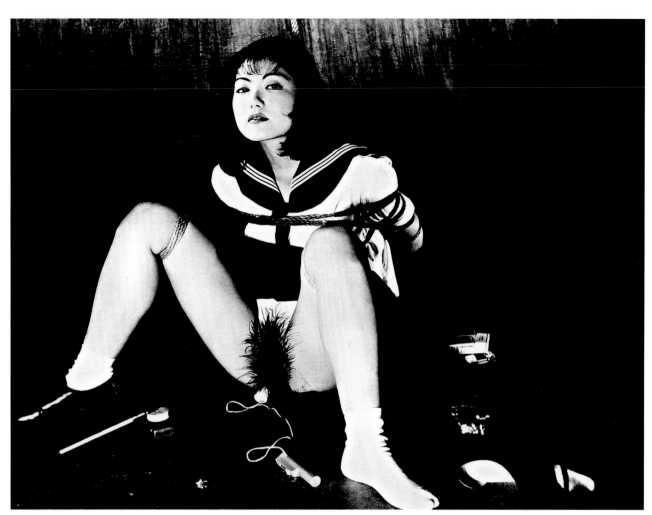

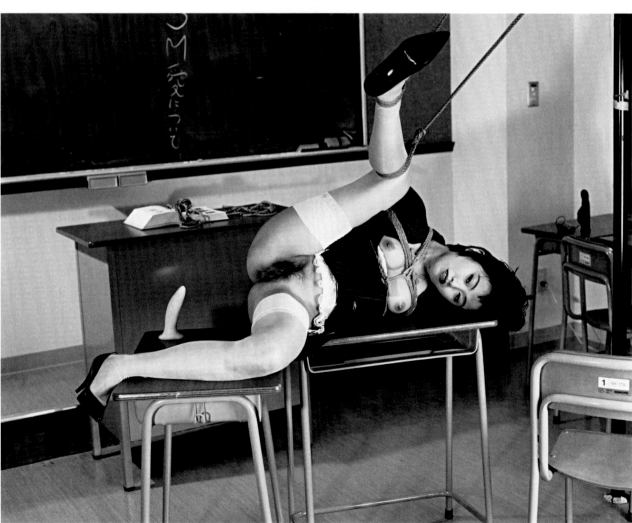

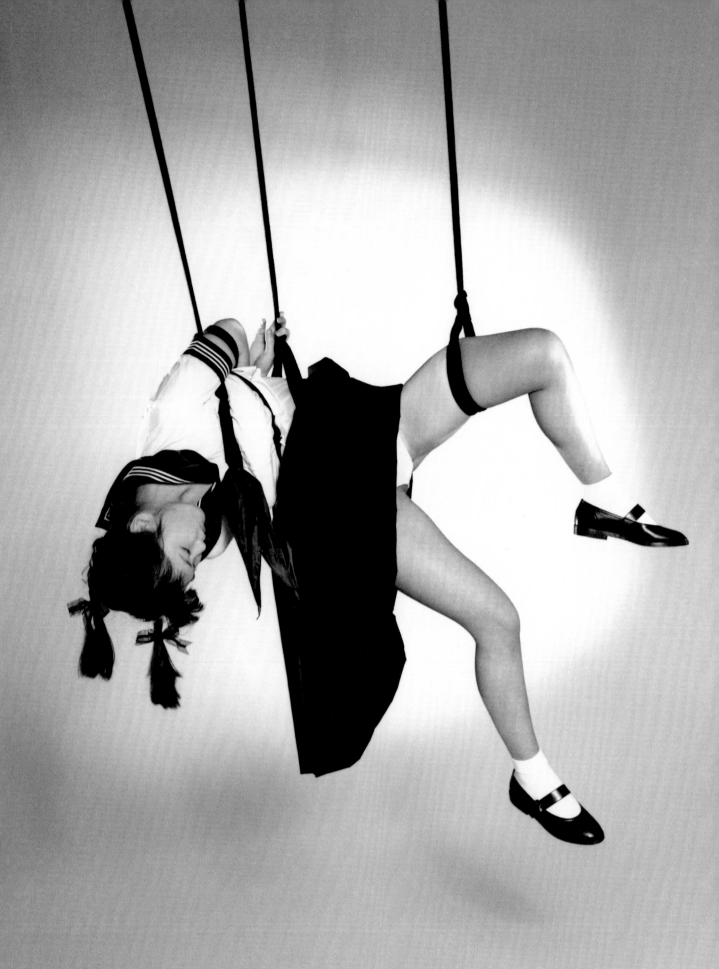

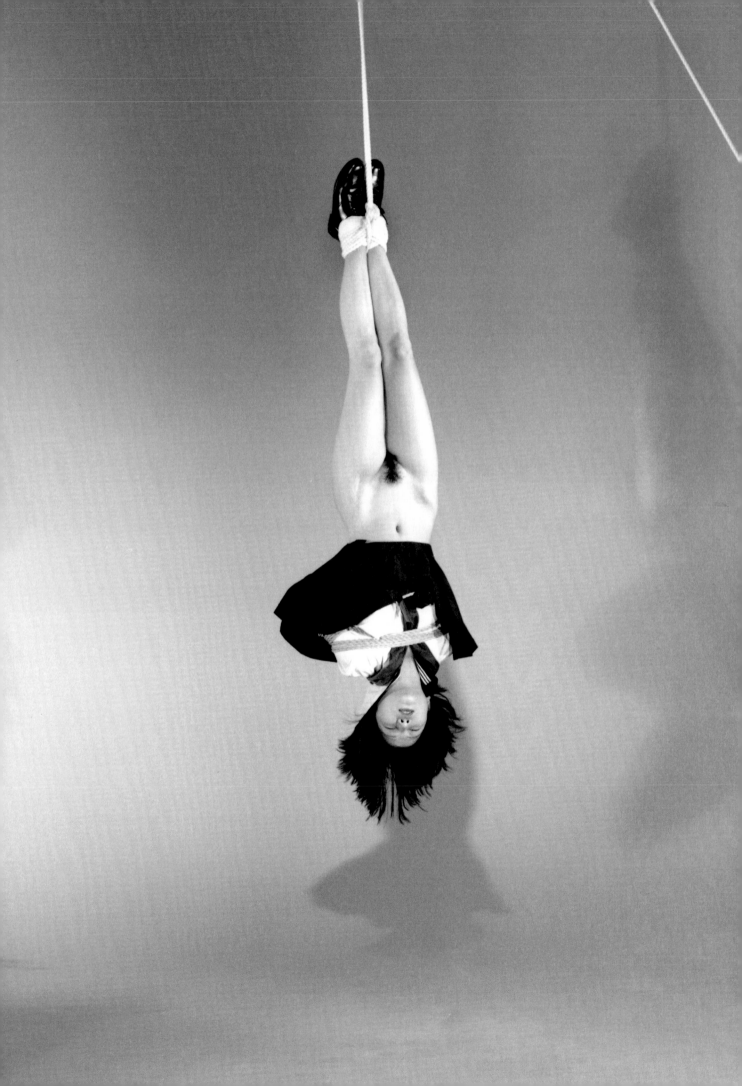

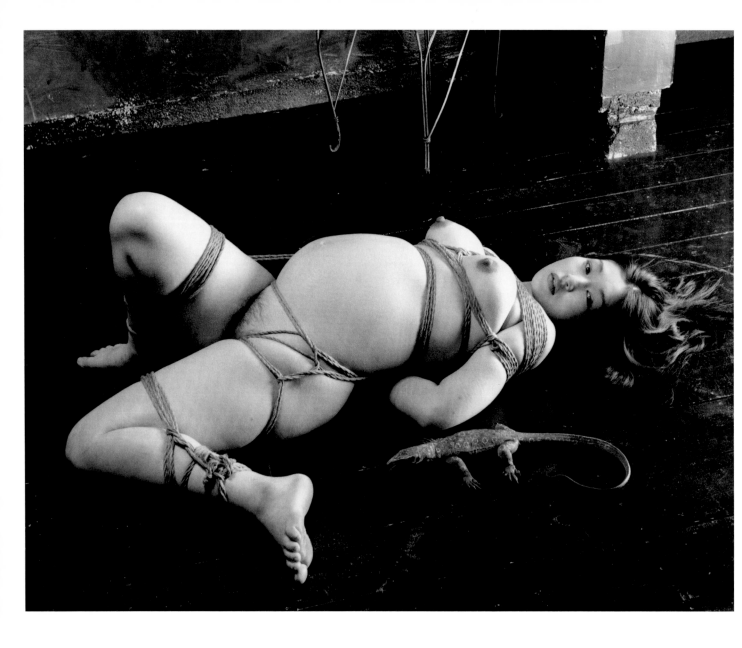

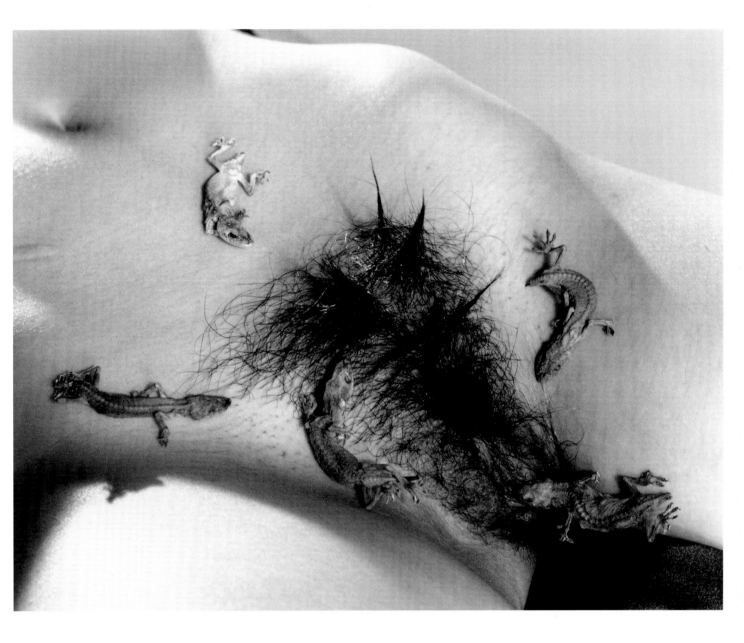

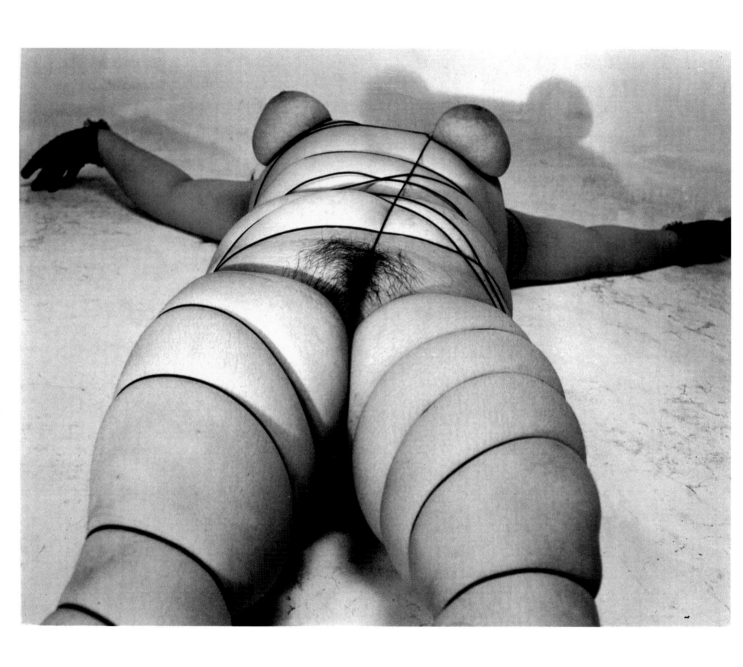

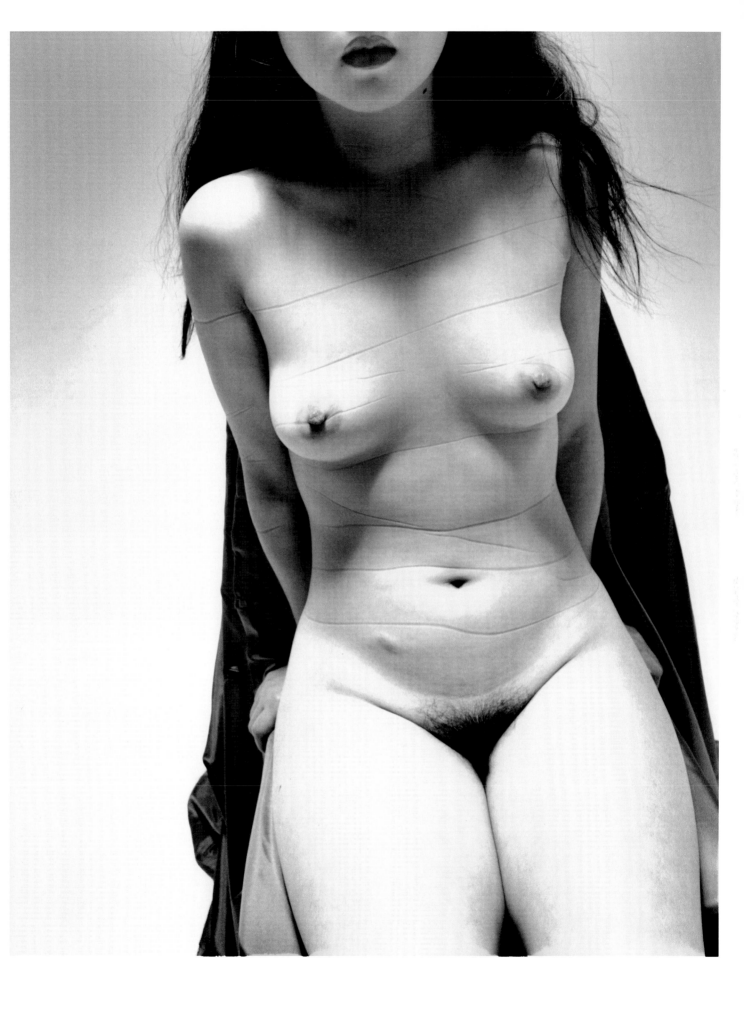

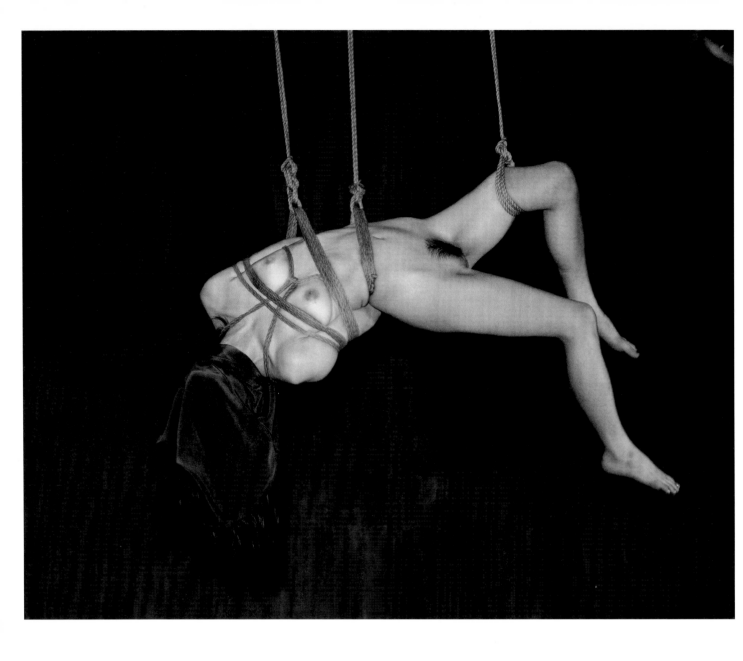

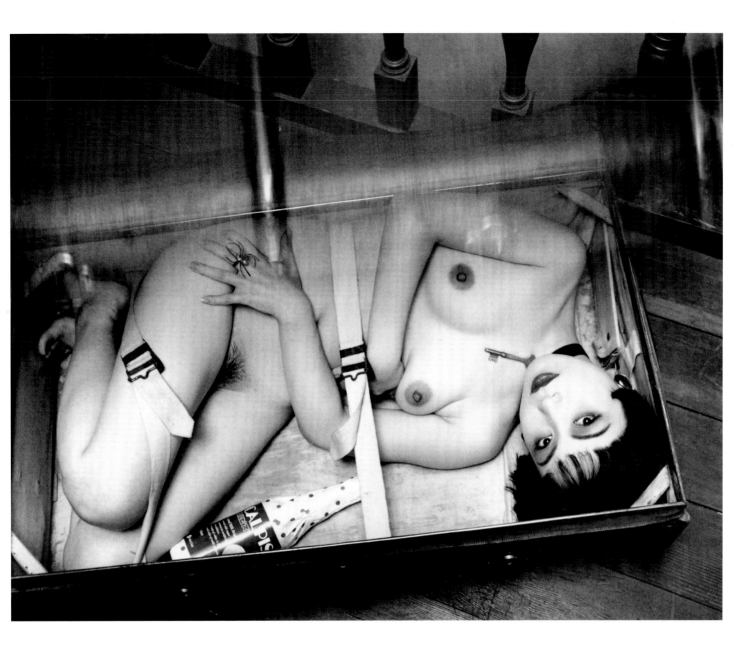

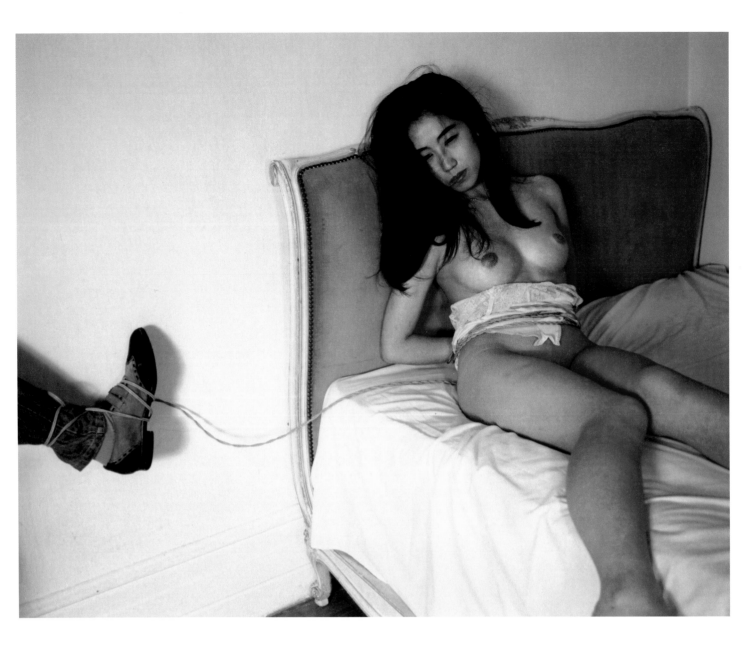

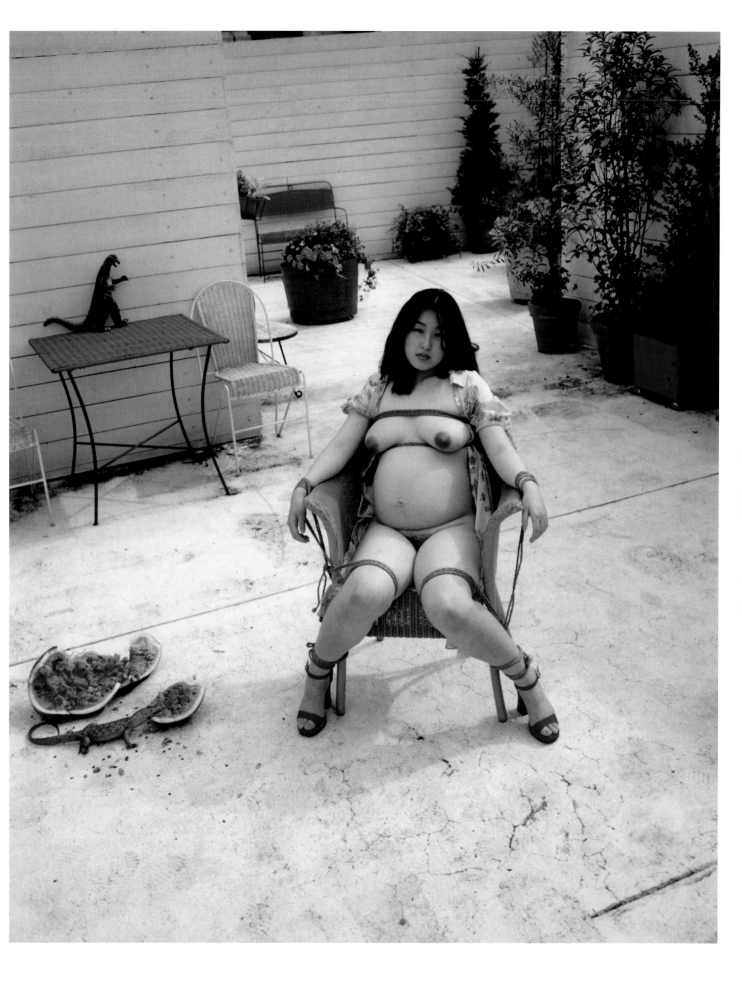

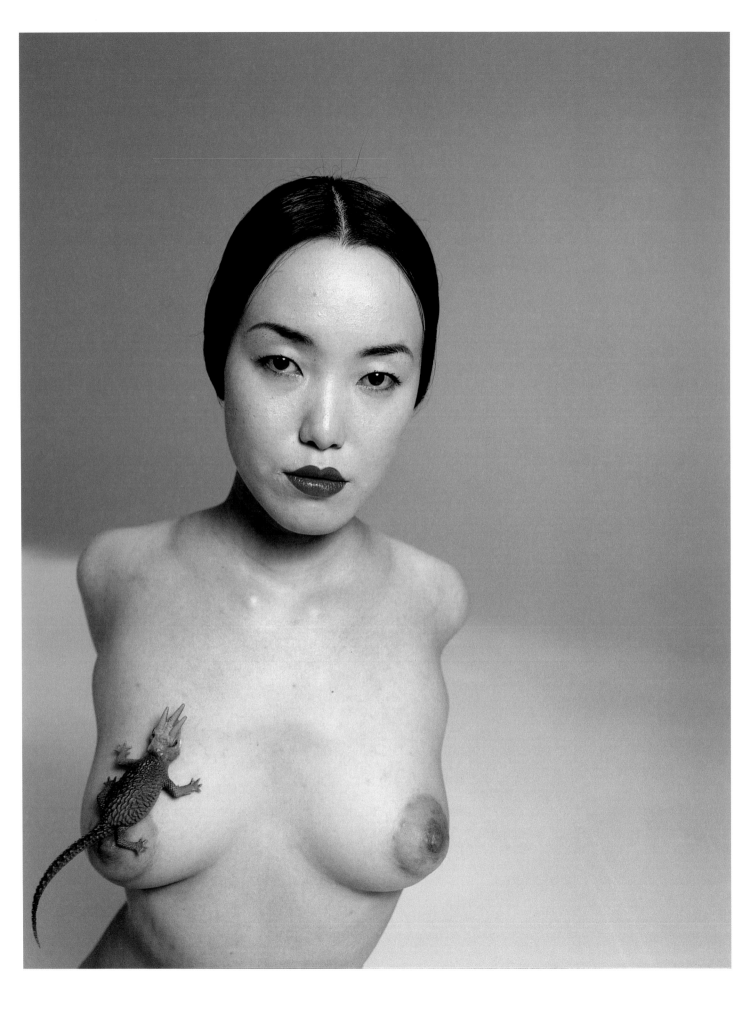

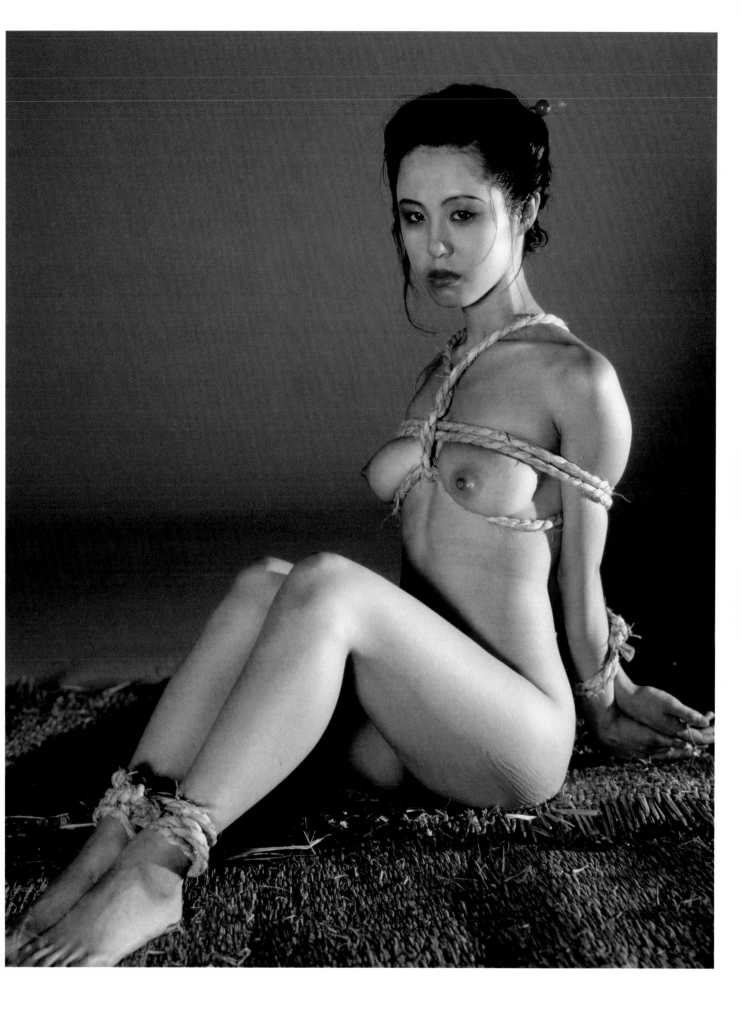

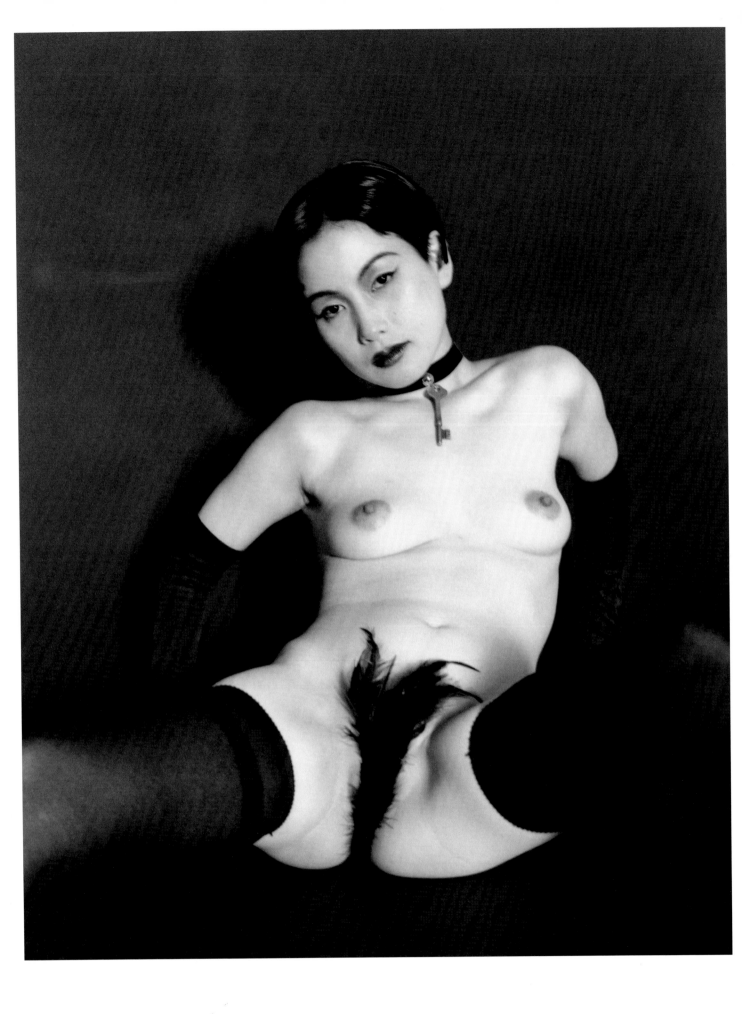

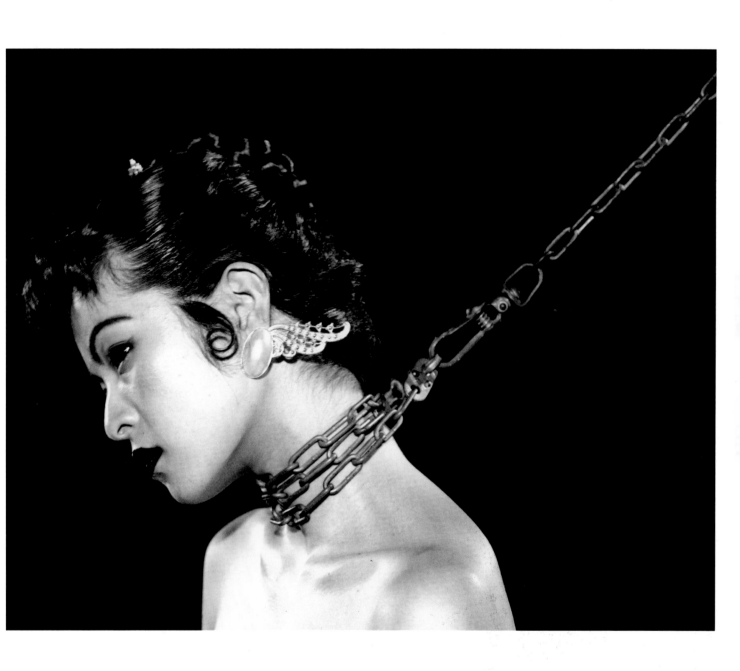

629

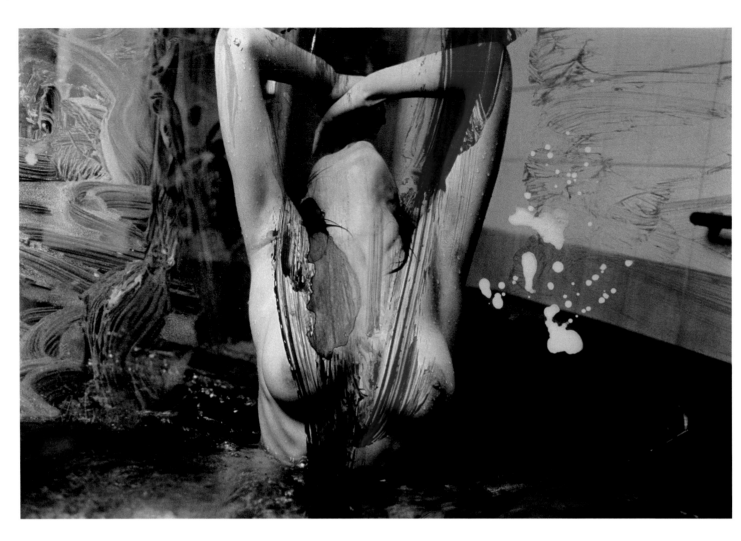

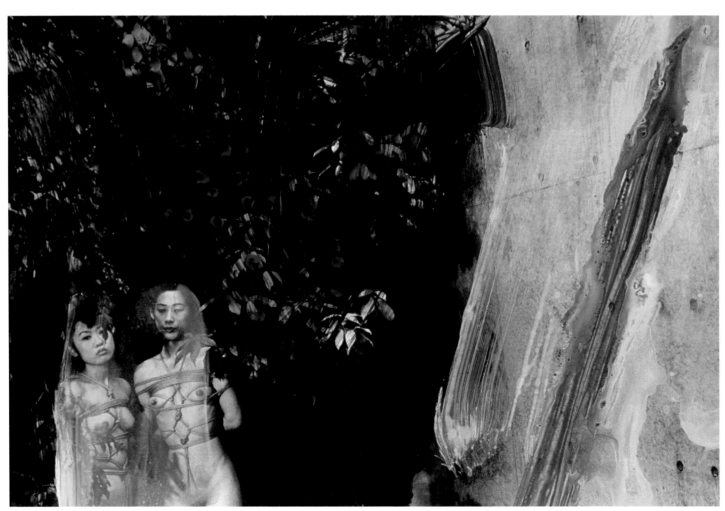

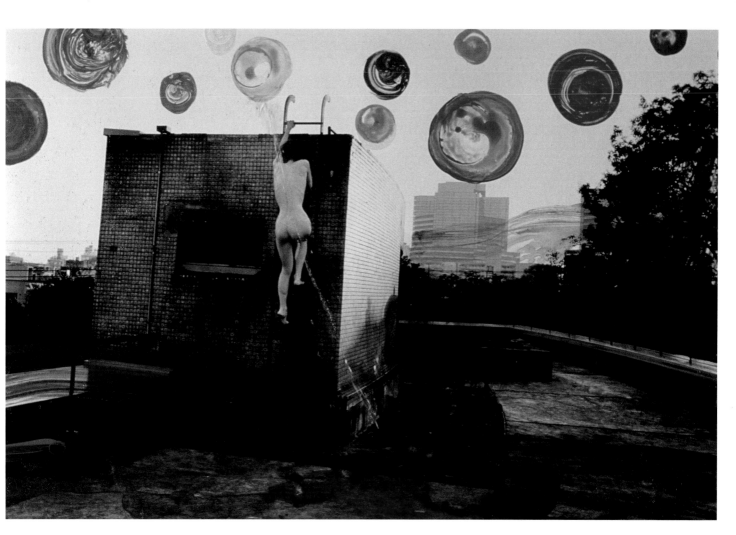

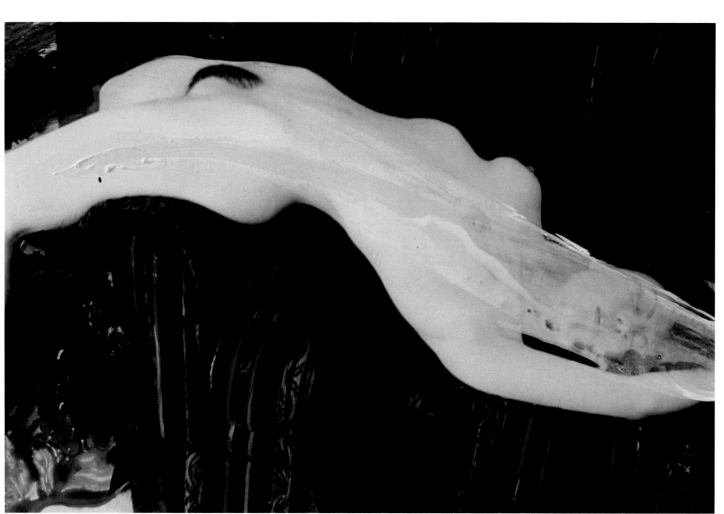

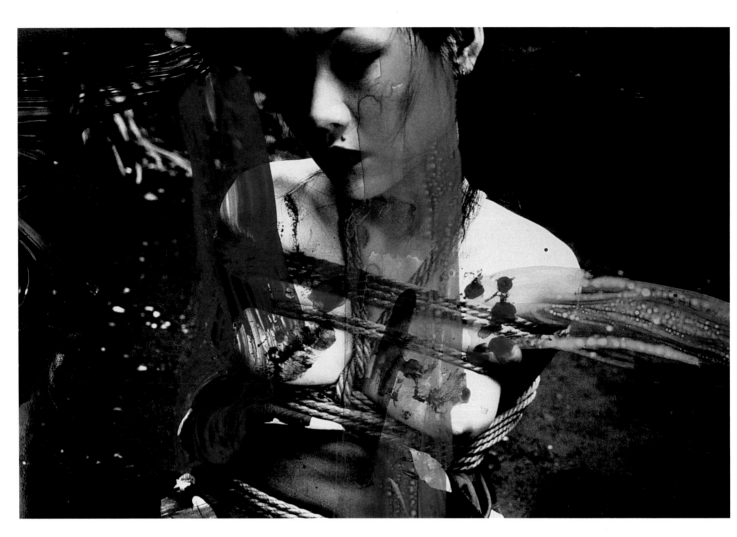

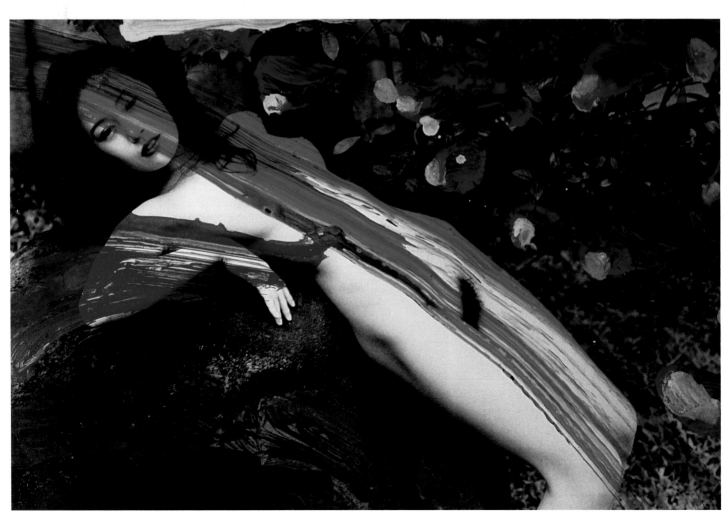

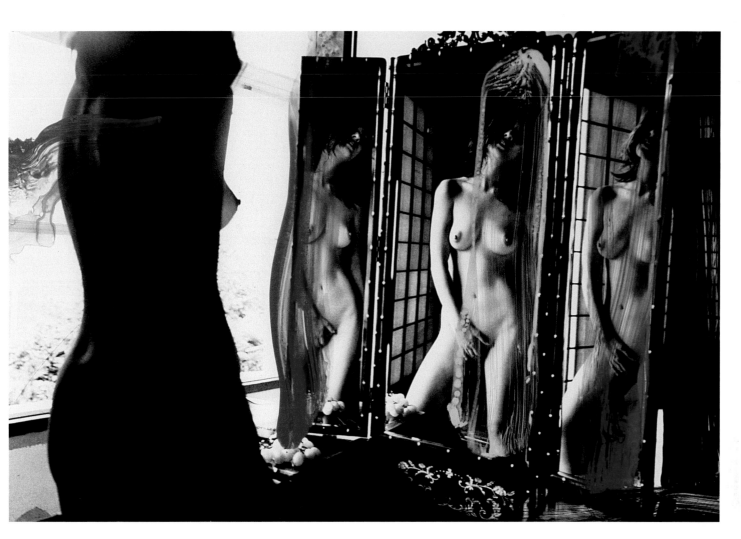

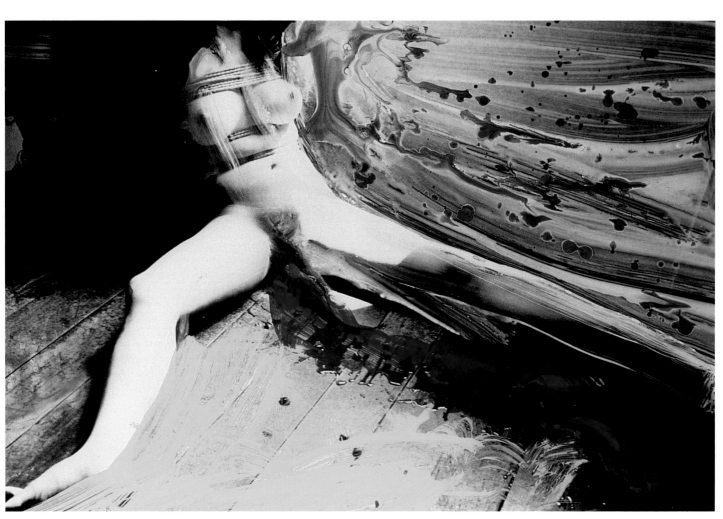

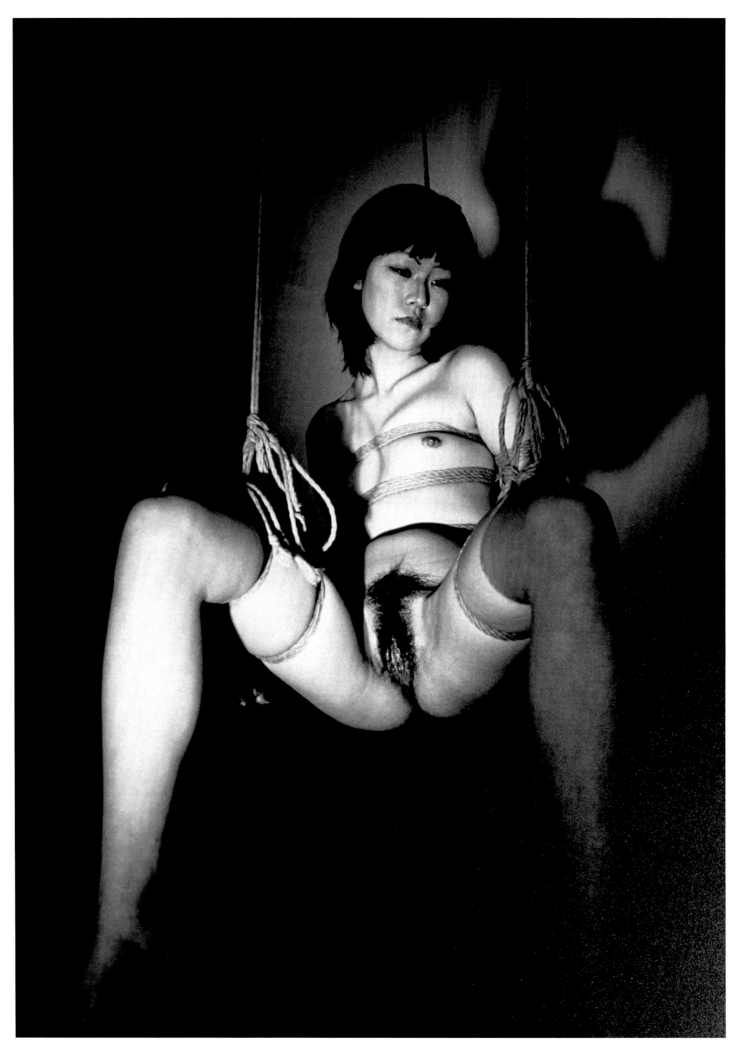

RIVER BETWEEN LIFE & DEATH

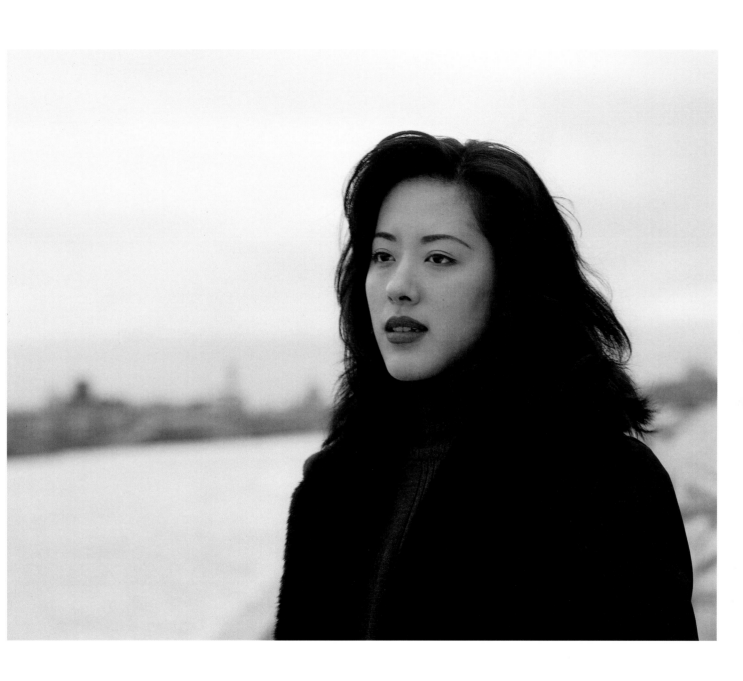

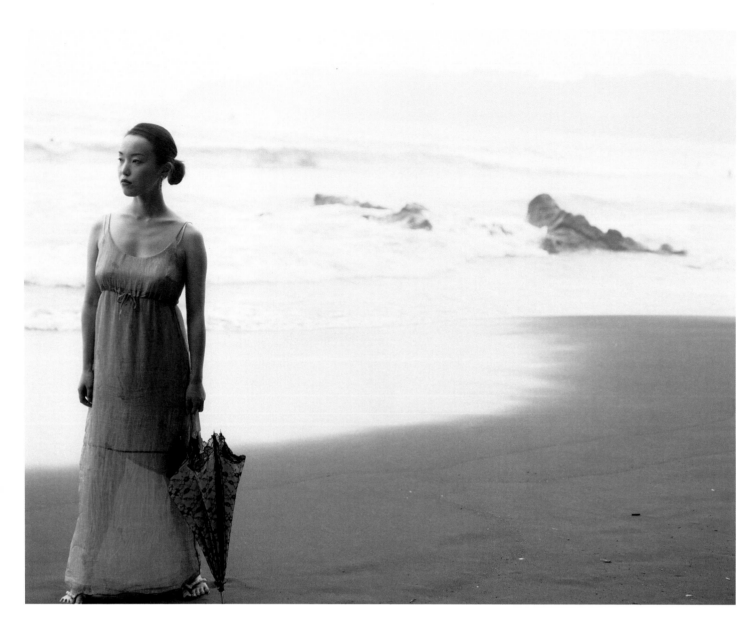

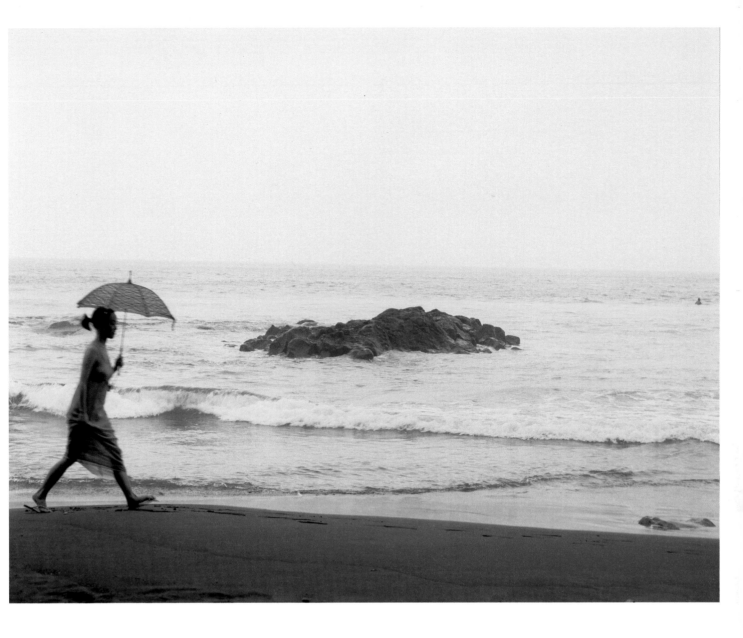

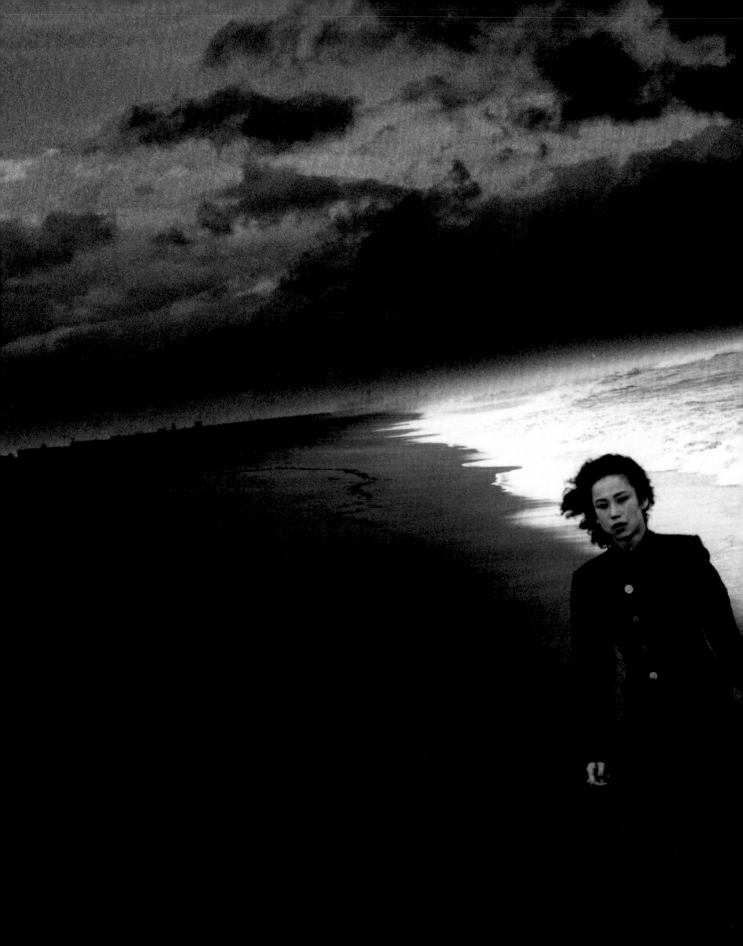

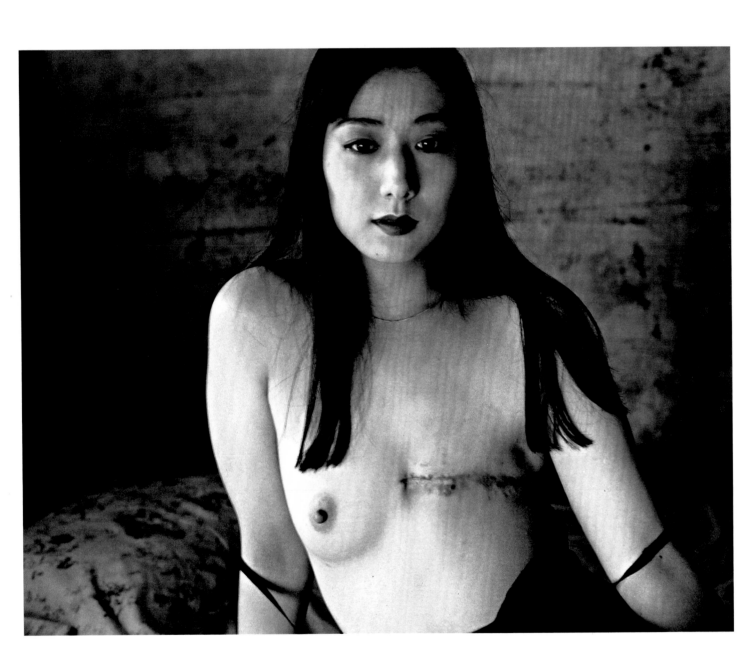

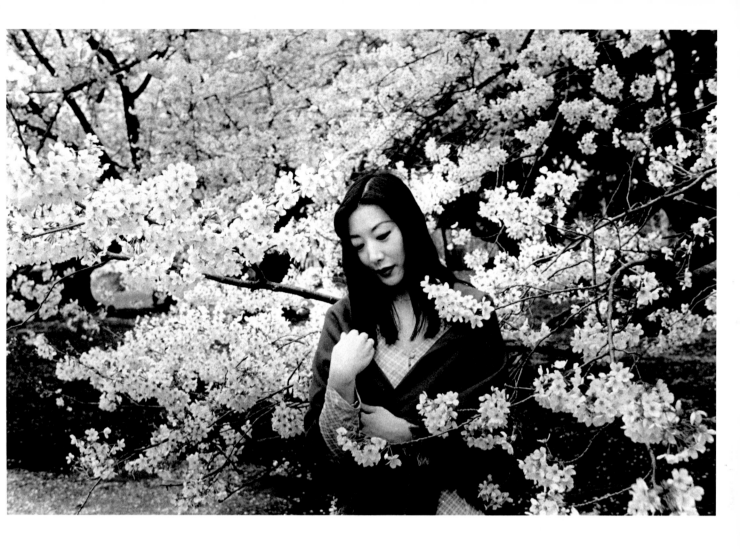

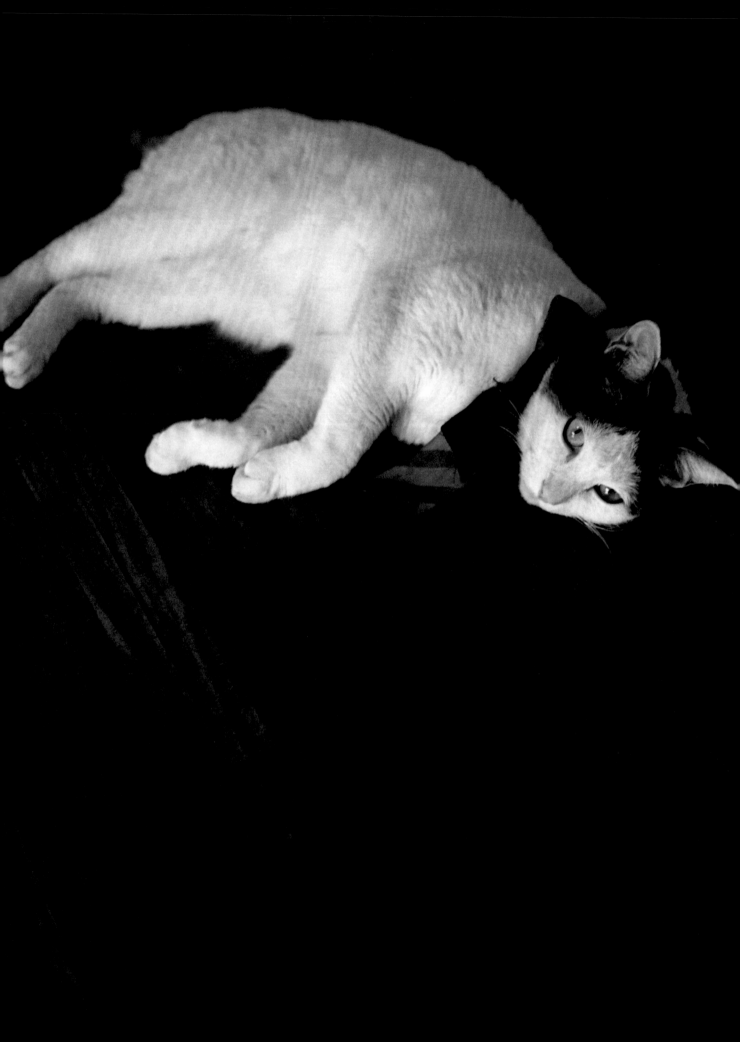

'WHILE LOOKING THROUGH THE FINDER,
THE CLICKING NOISE OF MY CAMERA'S SHUTTER STOPS:
AT THAT MOMENT I FEEL AS IF I BECOME CLOSER TO
THE VOID — THE REALM OF DEATH.

PHOTOGRAPHY IS GOING TO AND FRO BETWEEN LIFE AND DEATH.'

THE DEATH OF SOMEONE
DEAR TO YOU
MAKES YOU TURN TOWARDS LIFE
—

Having reached my sixtieth birthday, I tend to get rather tired but I'm still eager to give it a go. I find my work interesting and I feel I'm moving in a more and more interesting direction. People seem to forgive me anything. It's all very well if people let you get away with anything, but respect isn't what I'm looking for.

You can get away with anything once you've hit sixty: rape, debauchery or anything else you care to name! But I'm an intellectual; I couldn't rape anyone. If I actually had a go, I can't imagine what excuse I'd offer if I couldn't get it up!

That would be a really hopeless situation, highly uncool. You get in the right situation and the woman gives you the go-ahead and shuts her eyes, then you find you can't get it up. Really uncool. At the slightest provocation women these days will put pen to paper or appear on some TV chat show. They'd say something about Araki being all words and no deeds and make some remark about me having a camera with the date on it! That's the unexpected twist. You get a photograph taken. That's the blissful thing about being a photographer.

I'm talking a load of nonsense, but what I really want to say is that life is all about living. In my case, the energy for living doesn't come from anything complex and difficult like saying you love somebody. I find that my vitality increases enormously when someone close to me dies. I thought of writing something about this recently, but I eventually abandoned the idea.

But it's true. When someone dear to me dies, I find myself turned towards life. I intended to write about how this experience makes you realize what a wonderful thing life is, but I found it a bit embarrassing and wasn't able to write anything. Being a photographer who shoots and then reveals your own comicality. You want to show things to other people.

There's no way I could be that cool anyway. Sweating copiously while I'm shooting, taking advantage of the situation to cast a spell and fiddle with a girl's tits after licking my fingers, saying that my fingerprints are going to show up. It wouldn't be particularly cool for a grand maestro to engage in this kind of thing. But that's the kind of thing I like doing. Pranks like this. There's no particular reason. That is the reason. That's exactly what reasons are.

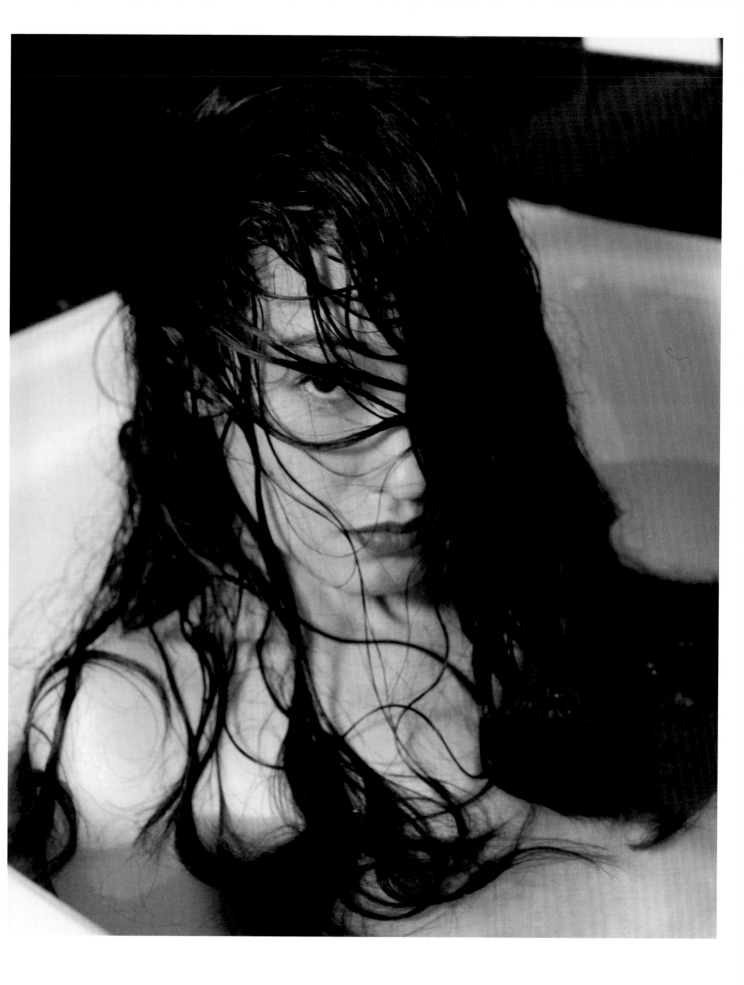

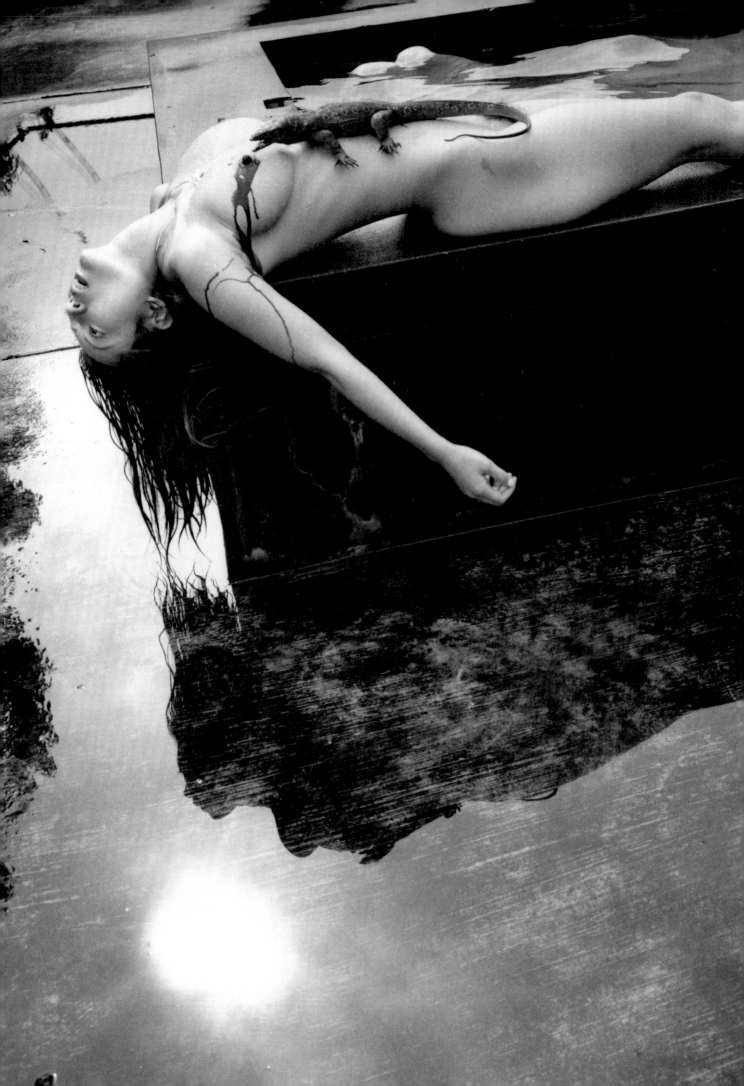

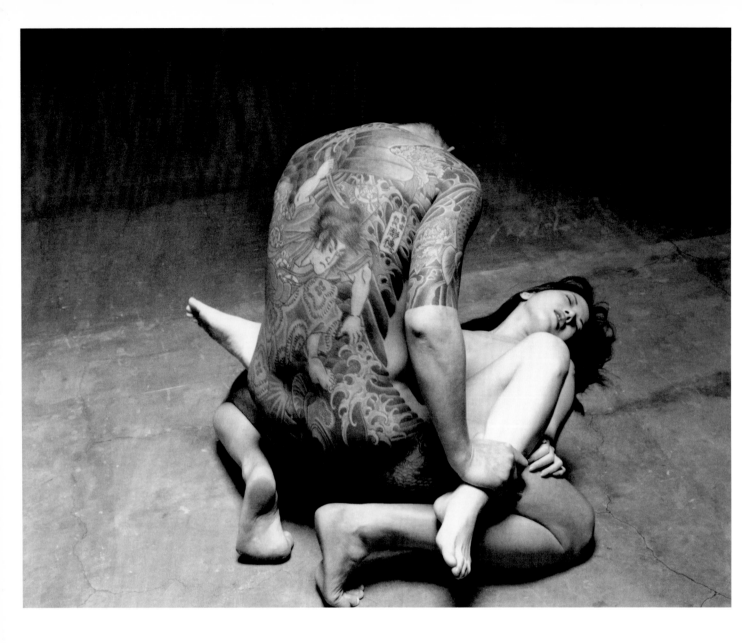

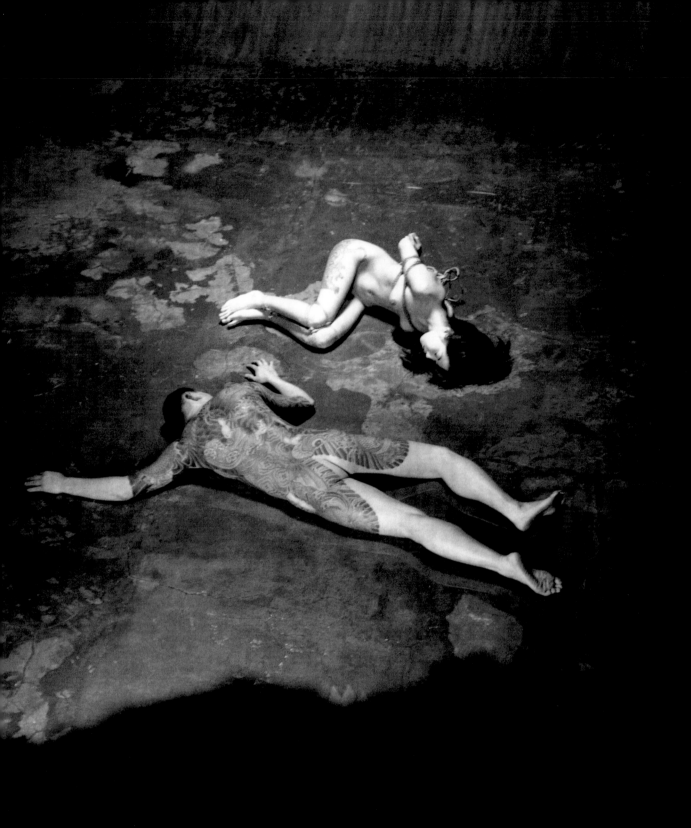

PHOTOGRAPHING THE SKY

—

AFTER MY WIFE DIED, I SPENT THE TIME PHOTOGRAPHING THE SKY.

These photographs of the sky were presented at the Skyscapes exhibition held at the Gallery Verita in Hiroo between 7 July and 11 August and dedicated to my late wife.

7 July was our wedding anniversary: the seventh day of the seventh month, and we were seven years apart in age. Although we're apart I've pledged to go and see her once a year. 11 August was the day she went into hospital with a fibroid and I took some photographs of her after making her laugh by punning that the disease would soon be cured if she immediately (*shikyu*) gave up drinking (*kinshu*)! That was the last time I saw her smile.

After her operation on 16 August, they found she was suffering not from a fibroid but from a malignant cancer of the womb. I was told it couldn't be cured with current medical science and that she had six months left at the most. I just couldn't bring myself to tell her.

The *Skyscapes* exhibition included photographs of the sky taken from her hospital room bearing the date 16 August and went on to views from the balcony taken on her birthday, 17 May. The sky-scapes were presented not only in photographs but also through the mediums of video, painting, silkscreens and sculptures.

Around ten in the morning on 26 January, just as I was shaving, a woman doctor rang to tell me that her condition had suddenly deteriorated. I rushed to the hospital but she was already in a coma when I arrived. I wanted to say something to her, so I whispered her name in her ear. She responded by faintly uttering my name, after which there was just the sound of her breath, a kind of crying noise. I held her fingers tight, and she grasped mine in response. We remained holding on to one another for I don't know how long. Then, at quarter past three in the morning, a miracle occurred: Yoko suddenly opened her eyes wide. She was glowing. I got up on the bed and photographed her over and over again. This was our first duo performance for a long time. She couldn't stop talking after this. I suggested she should get some rest rather than tire herself by talking so much, but she said that sleeping would make her feel lonely. So she continued to chatter away, sometimes like a little girl, at other times like a baby.

The following article appeared in the 14 July 1990 evening edition of the *Asahi Shimbun*:

—

(Araki's) wife Yoko died in January earlier this year. His most recent works created since his wife's death have all been photographs of the sky. Because monochrome photographs on their own would be simply too depressing, Araki has painted portraits of his wife on the pictures in vivid colours with special paints. In the NHK television programme *Kinmirai shashinjutsu* (Photography Techniques for the Near Future) broadcast last month, Araki mentioned his collection *Sentimental Journey*, which gave him a kick-start as a photographer. The photographs in *Sentimental Journey* are records of his honeymoon following the couple's marriage in 1971. One item in this collection shows Yoko, curled up like a foetus, taking an afternoon nap in a boat. Araki says that this image combines with his wife's current situation, now that she has returned to the state of nothingness that prevailed before she was born. In his own words, 'a prologue is also an epilogue... I have this feeling that she's been reborn'. The photographs on show at this exhibition convey Araki's overwhelming sense of loss. His words hint at the succour and the realm of enlightenment that he has accessed through a single photograph.

—

Just before she died, she shook her head numerous times as if to reject the prospect of her imminent death. Yoko finally passed away at eleven in the morning on 27 January 1990.

Every time I watched the video of Mahler's *Kindertotenlieder* after she'd died, I found myself reduced to tears. There are tears in Yoko's eyes as I painted her on a photograph taken on the balcony of our flat with our cat Chiro napping on 17 May.

I painted my own self-portrait on the breadboard that Yoko always used to use. I cut off some of my pubic hair and stuck it on the breadboard to represent my hair in the portrait. I then hanged myself in the portrait with one of Yoko's *obidome* [a string used to support an *obi*]. The finished object gained the title 'Having lost his wife, A commits suicide by hanging, 7 July 1990'.

I'm still photographing the sky.

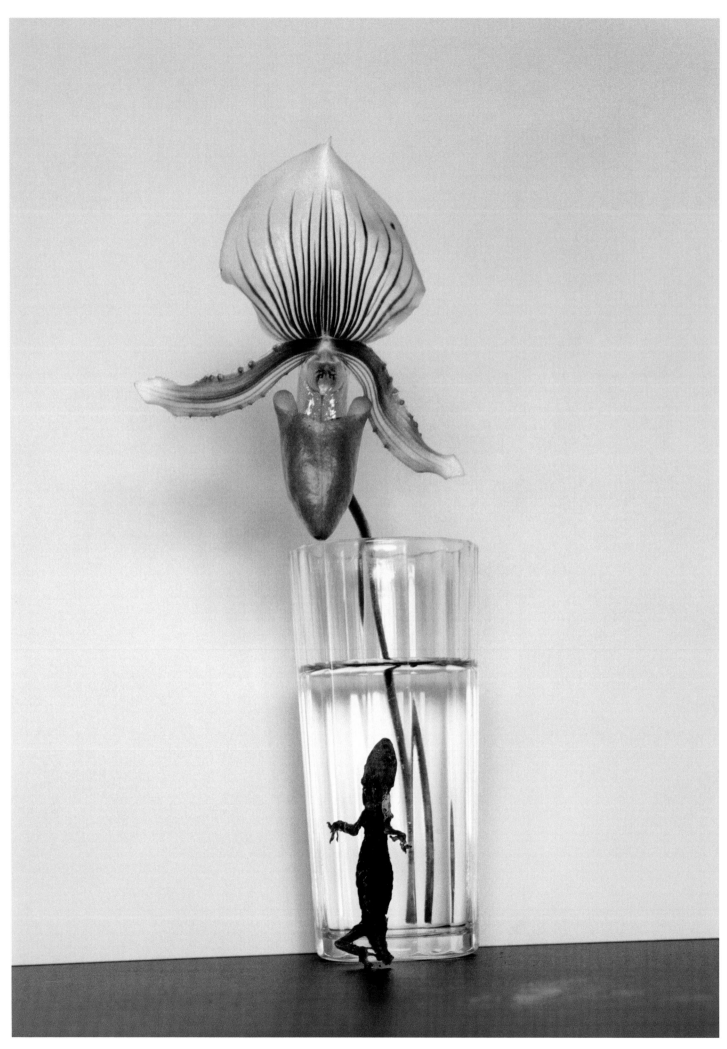

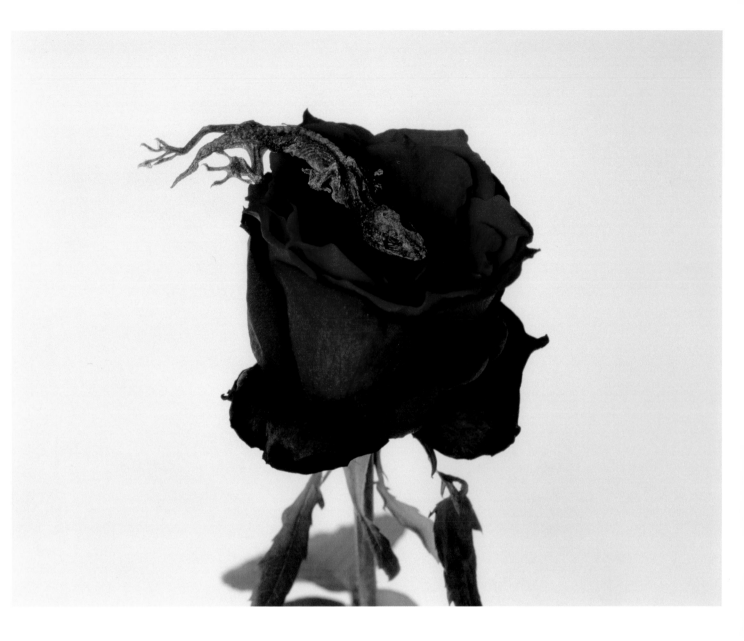

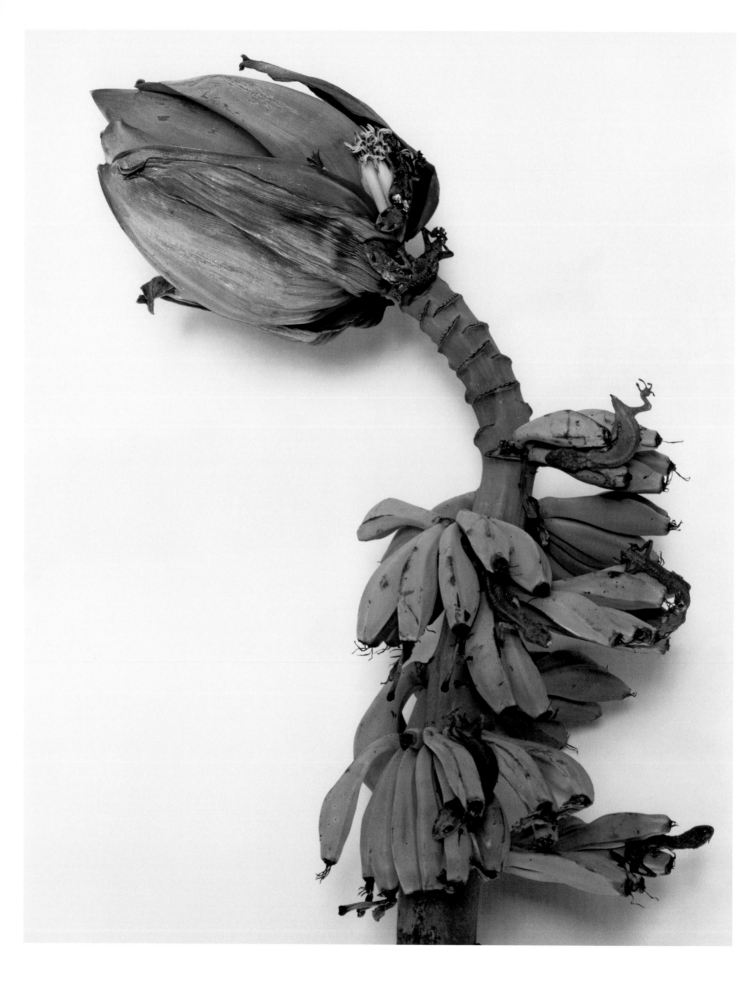

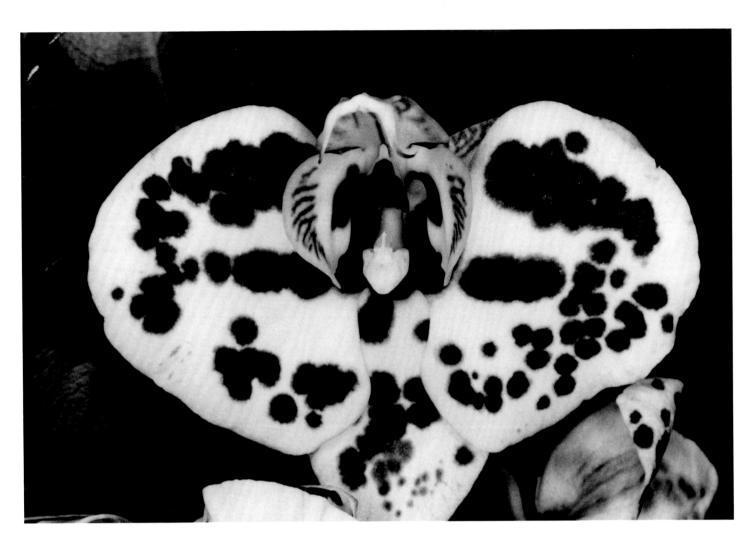

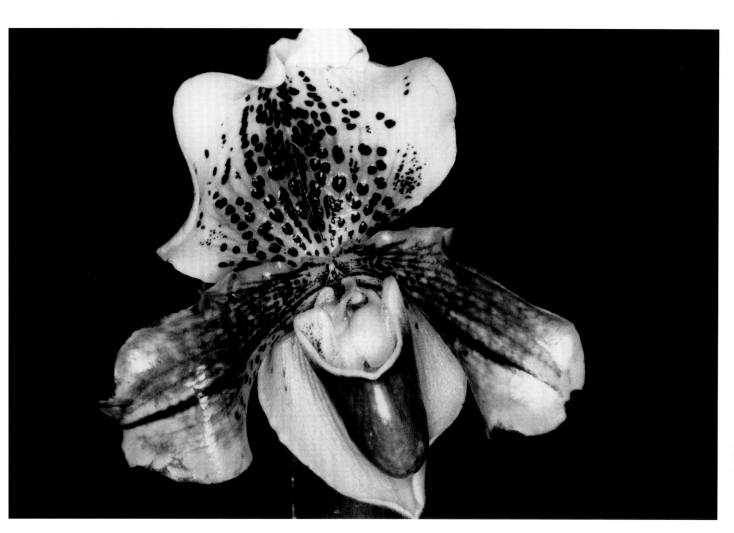

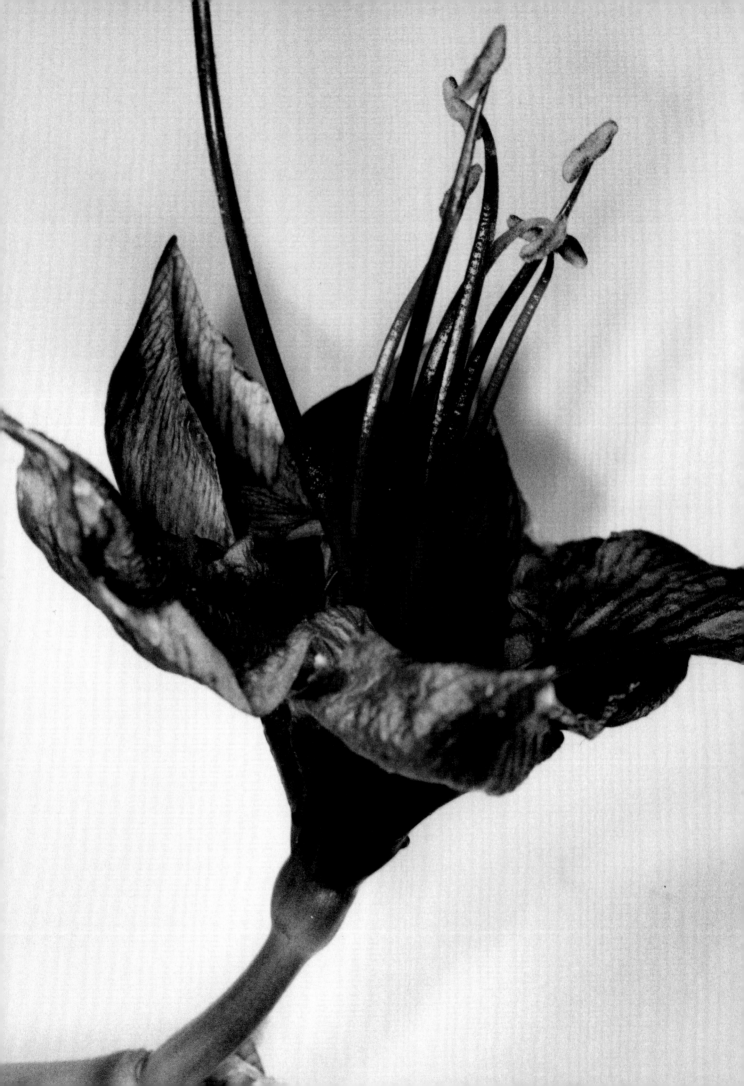

KU

(VOID)

'89 1 1 12

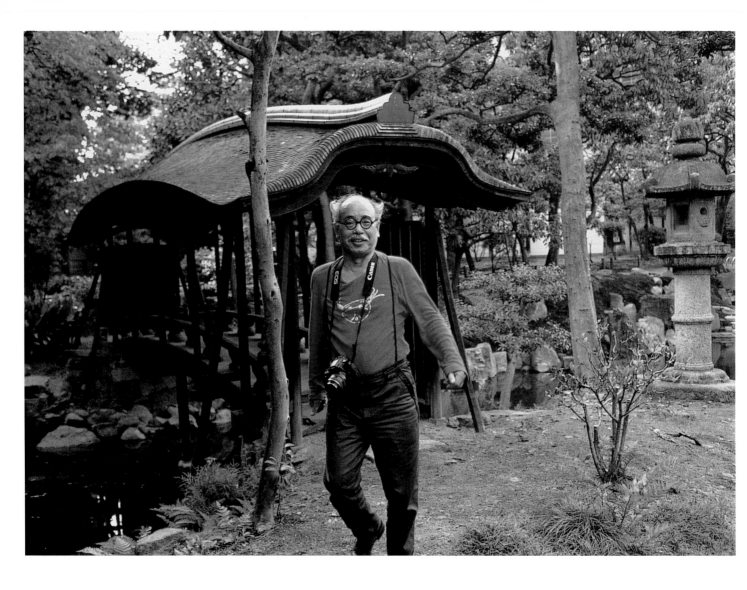

BIBLIOGRAPHY

Compiled by Kotaro Iizawa

A complete bibliography of books produced by, or in collaboration with, Araki.

1970

XEROX PHOTO ALBUM
(Zerokkusu shashin-cho)

Privately published in 25 vols., Tokyo
(edition of 70)

A series of limited edition photographs made on
an office Xerox machine at Dentsu, without
authorization, containing all the seeds of Araki's
future development as a photographer.

1971

OH JAPAN!
(Oo Nippon)

Miki Shuppan, Tokyo

An ill-starred collection of photographs that
got lost in the shadow of the more important
work *Sentimental Journey* and to which almost
no reference is made; it consists of nude
photographs put together in collage-style.

SENTIMENTAL JOURNEY
(Senchimentaru na tabi)

Privately published, Tokyo (edition of 1,000)

Araki's true photographic debut.
No matter how often one sees this work, it
retains the power to draw one strongly into its
narrative. Of the more than a hundred
anthologies of photographs that Araki has
produced, this is generally considered his best.

SENTIMENTAL JOURNEY:
OKINAWA SEQUEL
(Zoku senchimentaru na tabi, Okinawa-hen)

Privately published, Tokyo (edition of 1,000)

Fragmentary images photographed on a visit to
Okinawa while working for Dentsu. Published
as *Anthology of Photographs by Nobuyoshi
Araki, Vol. 2 (Araki Nobuyoshi shashin shu 2)*,
it is completely unrelated to the earlier
Sentimental Journey.

BATHING BEAUTIES
(Mizugi no yangu-reditachi)

Privately published, in collaboration with the
members of Fukusha-shudan Geribara 5, Tokyo

Featuring a parade of women clad in swimming
costumes together with their names and phone
numbers, one wonders if anyone actually took up
the offer.

1973

TOKYO

Fukusha-shudan Geribara 5, Tokyo

Divided into two parts, pictures juxtapose crowd
snapshots above with nude models in a variety of
compromising poses below; a pioneering work in
the 'Tokyo commentary' vein using photography.

1976

JOURNEY TO TOKYO
(Tokyo e no tabi)

Gendai Camera Sensho 13, Asahi Sonorama,
Tokyo

An anthology from *Nobuyoshi Araki's Practical
Photography Seminar (Araki Nobuyoshi no
jissen shashin kyoshitsu)*, featuring photographs
published between January and December 1975
in the magazine *Asahi Camera*, and writings on
photography penned specifically for this book.

1978

BETWEEN A MAN AND A WOMAN
IS A CAMERA
(Otoko to onna no aida ni wa shashinki ga aru)

Byakuya Shobo (new edition reissued by
Ota Shuppan, 1991), Tokyo

This early collection of Araki's writings and
photographs includes several important texts
and conversations, particularly an essay,
'The Death of my Mother, or an Introduction
to the Technique of Home Photography'.

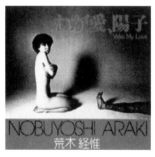

YOKO, MY LOVE
(Waga ai, Yoko)
Sonorama Shashin Sensho 7, Asahi Sonorama,
Tokyo

Materials relating to Araki's meeting with Yoko,
their honeymoon, records of their early married
life and the first published writings by Yoko
Araki as an essayist, ending with an essay by
Kineo Kuwabara, 'On the Original Version
of *Sentimental Journey*'.

DRAMATIC SHOOTING!:
'ACTRESSES'
(Gekisha 'Joyutachi')

Byakuya Shobo, Tokyo

This first collaboration with Akira Suei features
photographs of more than twenty women based
on the idea that 'women are all actresses',
together with writings mixing fact and fiction.

1980

NOBUYOSHI ARAKI'S
PSEUDO-REPORTAGE
(Araki Nobuyoshi no nise ruporutaju)

Byakuya Shobo, Tokyo

An outstanding collection of photographs that
established Araki's unique world, incorporating
skilful parodies of the documentary style and
subtle interaction with writings that veer off
towards the erotic.

NOBUYOSHI ARAKI'S
PSEUDO-DIARY
(Araki Nobuyoshi no nise nikki)

Byakuya Shobo, Tokyo

A photographic diary incorporating images taken
with a compact camera that shows the date.
The companion volume is *Pseudo-Reportage*.
Dates are manipulated at random and bear little
relation to reality, the first clear manifestation
of Araki's blurring of fact and fiction. The
book ends with an essay by Masaaki Hiraoka,
'Pursuing the Enigma of Nobuyoshi Araki'.

1981

SONGS OF A SENTIMENTAL
JOURNEY IN PURSUIT OF WOMEN
(Onna ryojoka)

Hokusosha, Tokyo

A collection of writings serialized in the magazine
Shosetsu Gendai between January and December
1979 discussing the theme of women and travel.

ESSAYS ON PHOTOGRAPHY
(Shashinron)

Tojusha, Tokyo

An anthology of Araki's most important essays
since 1965, when he was working for Dentsu,
concluding with '*Rakusha (pleasure shots)*
live', which features photographs of the
cabaret dancer 'Milene' and her friend 'Chako'
at a love hotel.

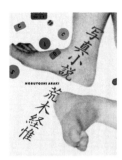

A PHOTO-NOVEL
(Shashin shosetsu)

Shueisha, Tokyo

Araki's world, mixing fact and fiction, is displayed in a novel consisting of photographs and text, including a commentary in the form of a discussion with the novelist Taeko Tomioka. The superb arrangement of photographs employs continuation, interpolation and dissimilation.

NOBUYOSHI ARAKI: A PHOTOGRAPHIC LIFE
(Araki Nobuyoshi: Shashin seikatsu)

Special August edition of *Asahi Camera* magazine, Asahi Shimbunsha, Tokyo

Araki's extraordinary life as a photographer brought into relief in ten chapters featuring scenes from love hotels, and so on, with an outstanding photo-montaged portrait of Araki, computer-generated by Tsunehisa Kimura, on the front cover.

A PHOTO THEATRE: TOKYO ELEGY
(Shashin gekijo: Tokyo ereji)

Tojusha, Tokyo

Originally scheduled for publication in 1972, these extreme images of sex and violence in 'photo-scenarios' were edited by Araki himself. The book concludes with essays by Toshiharu Ito and Kazuo Nishii.

ARAKIN Z

Mirion Shuppan, Tokyo

An anthology of bondage photographs originally serialized in *S&M Sniper*. The drama of flesh and emotion arising from active and passive bondage presents an archetype for Araki's photographic work. Araki continued to contribute regularly to *S&M Sniper* until 1994.

PSEUDO-DIARY OF A HIGH SCHOOL GIRL
(Jokosei nise nikki)

Hachiyosha, Tokyo

A photographic diary of Araki's first production as a film director, including the scenario and still photographs. The film was released by Nikkatsu on 27 November 1981.

A TALE OF IKONTA
(Ikonta monogatari)

Byakuya Shobo, Tokyo

An anthology of contact prints taken between autumn 1980 and spring 1981 with Araki's favourite Ikonta camera, which he inherited from his father.

PLEASURE SHOTS IN LOVE HOTELS
(Rabu hoteru de rakusha)

Byakuya Shobo, Tokyo

This live record of scenes shot by Araki at love hotels is an enjoyable example of Araki's narrative technique, with illustrations by Kazuhiro Watanabe.

ROMANTIC PHOTOGRAPHY: MY ALICES
(Roman shashin: watashi no Arisutachi)

Seirindo, Tokyo

A collection of contributions to the column *Romantic Photography*, serialized in the *manga* magazine *Garo*, presenting the techniques of Araki's world in a variety of forms. The *Romantic Photography* column continued until January 1985.

1982

MIDORI

Tankisha, Tokyo

Midori is the name of the beautiful young girl who appears in Higuchi Ichiyo's classic novel *Takekurabe*. This series of portraits (no nudes) explores the idea that Midori has grown up to work in a massage parlour, transferring the setting from the Meiji period to contemporary Japan.

MY LOVE AND SEX
(Waga ai to sei)

Sojusha, Tokyo

Conversations between the writer Seiko Tanabe and Araki, admirers of one another's work, with photographs by Araki.

SENTIMENTAL EROTIC ROMANCE: LOVERS
(Senchimentaru ero roman: Koibitotachi)

Byakuya Shobo, Tokyo

An anthology of the popular column featured in magazines such as *Weekend Super* published by Byakuya Shobo. The content is essentially a continuation of *Dramatic Shooting!: 'Actresses'* and features photographs and writings.

ARA-KISS LOVE CALL

Parco Shuppan, Tokyo

A series of conversations with Yoko Kirishima, Hiromi Ito, Midori Kiuchi, Sawako Aida, Jun Togawa and Kazuko Komori. Stimulated by Araki's eloquence, each of his partners comes up with risqué remarks. Book design by Mizumaru Anzai.

'SENTIMENTAL JOURNEY' — THE 10TH ANNIVERSARY
(Junenme no 'Senchimentaru na tabi')

Tojusha (republished with new binding by Chikuma Shobo in 1992), Tokyo

Records Araki and Yoko's month-long journey in June 1981 to France, Spain and Argentina to commemorate their tenth wedding anniversary, combining Yoko's writing and Araki's snapshots.

THE TRUTH ABOUT NOBUYOSHI ARAKI
(Araki Nobuyoshi no shinso)

Supplement to the magazine *Uwasa no shinso 1* Tokyo

A documentary and varied record of Araki's explosive activities during this period. Includes a photogravure frontispiece 'Ararchy and Fujio Akatsuka vs. Tamiko Minami: Hard Core Reality', magazine articles, discussions and commentaries on Araki.

THE WORLD OF NOBUYOSHI ARAKI
(Araki Nobuyoshi no sekai)

Summer edition of *Bessatsu Shinpyo*, Shinpyosha, Tokyo

A documentary record that complements *The Truth about Nobuyoshi Araki*, concluding with a chronology of Araki's career compiled by Akira Suei.

I'M PHOTOGRAPHY
(Watashi ga shashin da)

Mure Shuppan, Tokyo

Based around photographs taken by Katsumi Takahashi for a feature in Mainichi Club, this book ends with a chronology entitled 'A Comprehensive History of Ararchism, 1940–82' and a long essay by Kazuo Nishii, 'Nobuyoshi Araki as an Ascetic on the Path of Kannon, the Bodhisattva of Compassion: Photographs without Soul'.

ARAKI'S STORM OF LOVE
(Ai no Araki)

Shashin Jidai Bunko 1, Byakuya Shobo, Tokyo

An encounter between Taeko Hori, a model who bottles up her madness within, and Araki. A high level of tension pervades the whole collection of photographs. Ends with a conversation with Taeko Hori entitled 'From Eulogy of Love to a Tempest of Love' and an essay by Kiyobumi Uesugi, 'Nobuyoshi Araki: Constant Flights of Fantasy'.

1983

LOVE SCENES

Men's Camera Love No.1, Keibunsha, Tokyo

The first release in the pocket-size series; well-crafted.

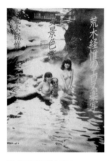

NOBUYOSHI ARAKI'S EROTIC PLEASURE SHOTS: A JOURNEY IN SEARCH OF FEMALE SCENERY
(Araki Nobuyoshi no erosu rakusha: onna-geshiki tabi)

Kodansha, Tokyo

A collection of popular columns from the magazine *Shosetsu Gendai* that appeared between July 1980 and November 1982. 'A Journey in Search of Female Scenery' was the first in a series based on travels throughout Japan with women as the recurring motif. The second was 'Sentimental Journey – the 10th Anniversary', a record of travels with Yoko, and the third was 'Female Scenes in Tokyo', a word and picture essay on Tokyo.

NOBUYOSHI ARAKI LIVE
(Raibu Araki Nobuyoshi)

Special September edition of *Shashin Jidai* magazine, Byakuya Shobo, Tokyo

A second-anniversary edition of the magazine *Shashin Jidai* devoted entirely to Araki, featuring three articles, 'Landscapes', 'Girls' Friends' and 'A Photographic Life', and a conversation with the photographer Kishin Shinoyama entitled 'Heated Debate!! The Enemy is in the Honnoji Temple!!'

1984

OH, SHINJUKU!
(Shinjuku yo!)

Seihosha, Tokyo

A 'jam session' including writings by Yasunori Okadome, editor of the magazine *Uwasa no shinso*, and photographs by Araki, examining the rapidly changing customs of Shinjuku.

TALES OF SEOUL
(Monogatari Souru)

Parco Shuppan, Tokyo

A novel by Kenji Nakagami and dynamic and inspired photographs by Araki. Araki's Seoul seems reminiscent of post-war Tokyo, the world in which he grew up. The book is structured and bound by Ri U-hwan.

THE WORLD OF YOUNG GIRLS
(Shojo sekai)

Byakuya Shobo, Tokyo

Photographs of young girls serialized under the title 'Girls' Friends' in the magazine *Shashin Jidai*. These mainly staid portraits make the viewer feel like standing to attention and suggest aspects of Araki's photographs of young girls that remain enigmatic. Includes an unusual essay by Taeko Tomioka entitled 'Women called *Girls*'.

THE NIGHT OF NOSTALGIA
(Nosutarujia no yoru)

Byakuya Shobo, Tokyo (edition of 1,000)

The first restricted edition of Araki's photographs to appear for a long time. Published as a wedding anniversary gift for Yoko, the combination of Yoko's stories and Araki's photographs presents an intimate view of the couple's married life.

A PERSONALISED VIEW OF TOKYO'S PROSPERITY
(Shisetsu Tokyo hanjoki)

Chuo-koronsha (republished by Chikuma Shobo in 1992), Tokyo

These meanderings through Tokyo with Nobuhiko Kobayashi serialized in the literary magazine *Umi* between June 1983 and May 1984. The neutrally portrayed views of Tokyo as the city moving towards the 'bubble' era are well known.

TOKYO, IN AUTUMN
(Tokyo wa, aki)

Sanseido (republished with a new cover by Chikuma Shobo in 1992), Tokyo

An important anthology that presents prototypes of Araki's vision of Tokyo. After leaving Dentsu and going freelance in 1972, Araki began to traipse through the streets of Tokyo with an Asahi Pentax 6 x 7 and Neopan SS film. The felicitous encounter between city and photographer presents a vision of Tokyo full of warmth, immediacy and detail, and the images are published here with a commentary in the form of a conversation with Yoko.

PHOTO-MANIAC'S MURDER CASE
(Shashinkyo satsujin jiken)

Omoshiro Suiri Bunko, Sakuhinsha, Tokyo

A full-length mystery novel, attributed to Araki, involving celebrities from various fields appearing under their real names. Araki admitted later that the work was ghost-written.

1985

LANDSCAPES 1981–84
(Keshiki 1981–1984)

Special March edition of *Shashin Jidai* magazine, Byakuya Shobo, Tokyo

An all-colour Araki feature reproducing his 'Landscapes' column from the magazine *Shashin Jidai*. Araki's risqué activities during the early 1980s are depicted in a prodigious number of photographs.

TOKYO PHOTOS
(Tokyo shashin)

Special September edition of *Shashin Jidai* magazine, Byakuya Shobo, Tokyo

An Araki feature issue commemorating the fourth anniversary of *Shashin Jidai*. All the photographs were taken during the single month of May.

ARAKI'S EROTIC TOKYO DIARY
(Araki no Tokyo shikijo nikki)

Special July edition of *Shashin Jidai* magazine, Byakuya Shobo, Tokyo

An all-star performance from Araki and Akira Suei, including an 'Accessible Commentary' by Suei.

I-NOVEL
(Shishosetsu)

Byakuya Shobo, Tokyo

An anthology of photographs to commemorate the actress and writer Izumi Suzuki, who committed suicide in February 1986. A plan to publish a novel by her together with photographs by Araki in 1971 fell through. *I-Novel* makes use of the original layout for this earlier book. The mood of the era is transmitted through the medium of languid flesh.

1987

ON TERRITORY NO.1
(Teritori ron No.1)

Shichosha, Tokyo

A reconstruction of a joint work with the poet Hiromi Ito originally serialized in the poetry magazine *Gendai-shi Techo* between February 1984 and November 1985. The book is put together in an almost violent manner, with no apparent links between the poems and the photographs.

TOKYO DIARY 1981–95
(Tokyo nikki 1981–1995)

Special May edition of *Shashin Jidai* magazine, Byakuya Shobo, Tokyo

Among the special features contained in *Shashin Jidai*, this has the clearest concept, making free use of the photographic diary with compact camera method. Note the '1995' in the title, implying that he has already taken photographs in the future!

IN RAPTURES
(Yoishirete)

Byakuya Shobo, Tokyo

Along with *The Night of Nostalgia* (1984), another anthology of photographs dedicated to Yoko. Published on her birthday on May 17, it includes stories by Yoko and photographs by Araki.

1988

GIRLS' STORY
(Shojo monogatari)

Mother Brain (reissued under a new cover by Ota Shuppan in 1990), Tokyo

A collection of photographs of young girls, a field that occupies an unusual position within Araki's work. Unlike his previous work in this vein, *The World of Young Girls* (1984), these photographs are of women close to maturity rather than young girls. The restrained and subdued expression is distinctive.

1989

OUR JOURNEY OF LOVE
(Aijo ryoko)

Magazine House, Tokyo

A record of travels in Japan consisting of writings by Yoko and Araki's photographs and essay. The happy, smiling faces seem conversely sad today.

TOKYO STORY
(Tokyo monogatari)

Heibonsha, Tokyo

An important work presenting the full measure of Araki's narrative gift and the perspicacity he brings to bear on fine detail. His concern for private visions combines with the scenery of Tokyo as an era was drawing to a close. The volume concludes with a commentary by Araki himself and a full chronology of his work.

TOKYO DIARY
(Tokyo nikki)

Fiction Inc., Tokyo

A reconstruction of Araki's daily record 'Photographic Life' from 16 February 1981 to 1 July 1989 (the day the Showa Emperor died) serialized in the magazines *Shashin Jidai* and *Shashin Sekai*. The things, people and ideas that constantly pass through the vortex which is Araki are densely packed into this book.

ON PHOTOGRAPHY
(Shashin ron)

Kawade Shobo Shinsha, Tokyo

A volume of photographs with a particularly hard and simple quality in the context of Araki's publications as a whole. The prototypes of Araki's expressive language gradually emerge from the fragmentary images. The book begins with a noteworthy commentary by Takaaki Yoshimoto.

PURE LOVE —
PHOTOGRAPHIC NOVELS
(Junjo shashin shosetsu shu)

Mirion Shuppan, Tokyo

Bondage photographs first serialized in *S&M Sniper* with 'novels' by Saburo Kawamoto, Shinichi Nakazawa, Katsuhiko Otsuji, Teruhiko Kuze, Hiroshi Aramata, Yayoi Kusama, among others. Araki wanders effortlessly into the mysterious realm of lyrical S&M photography.

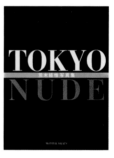

TOKYO NUDE

Mother Brain, Tokyo

Combining the talents of Araki and Suei, each double-page spread juxtaposes a nude photograph and a fragmentary scene of everyday life in Tokyo. Turning the pages, the reader becomes enveloped in a sense of erotic travel within the womb.

BLUE METEORITES
(Aoi inseki)

Kyuryudo, Tokyo

An anthology combining photographs by Araki, with poems and drawings by the dancer Saburo Teshigawara and a critical essay by Toshiharu Ito.

1990

CHIRO, MY LOVE
(Itoshi no Chiro)

Heibonsha, Tokyo

A collection of photographs of Chiro, the Araki household's beloved cat. Delightful days spent with the cat are gradually darkened by the shadow of death cast by Yoko's stay in hospital. A copy of this work was placed inside Yoko's coffin.

THE FIRST YEAR OF THE HEISEI ERA
(Heisei gannen)

IPC, Tokyo

A work in the photographic-diary style, practised since *Nobuyoshi Araki's Pseudo-Diary* of 1980, but with a heavy and dark note as it records the year – 1989 – when both the emperor and Yoko died. Araki no longer plays around with the date, and the collection tells of days with no precedent in his life.

FOTO TANZ

IPC, Tokyo

A collaboration of dance and photography put together with the dancer Saburo Teshigawara, following on from *Blue Meteorites* (see above); the frequent use of close-ups reinforces Araki's empathy with the dancer.

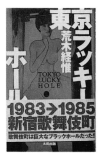

TOKYO LUCKY HOLE

Ota Shuppan, Tokyo

A record of the red-light district of Kabuki-cho in Shinjuku when it was at its most lively, before the enforcement of a new law regulating adult entertainment businesses in 1985.

CATOPIA, CATMANIA
(Nekonotopia, Nekonomania)

Ota Shuppan, Tokyo

A version in novel form of the TV programme *Catopia, Catmania* broadcast on 2 May 1990 in the NHK special 'New Wave Drama' series (script by Ichiro Fujita and Jun Kimura; novel by Akira Tamura); it includes 36 photos of cats taken by Araki.

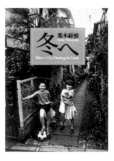

TOWARDS WINTER
(Fuyu e)

Magazine House, Tokyo

A collection of photographs to round off 1990, a highly eventful year for Araki. Views of Tokyo towards the end of the year are reborn as scenery from the other world. It ends with a discussion with Sawako Aida entitled 'Dialogue: Towards Winter'.

1991

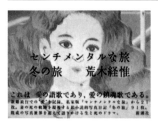

SENTIMENTAL JOURNEY/ WINTER JOURNEY
(Senchimentaru na tabi: Fuyu no tabi)

Shinchosha, Tokyo

When Yoko died, Araki said the 'first round' of his career had finished. By combining *Sentimental Journey* (1971), effectively Araki's debut work, with *Winter Journey*, a photographic diary of the period before and after Yoko's death in one volume, Araki signals the end of the first round of his career and the start of the second. A meditation on the subject of death, Araki's captions and photographs powerfully draw the viewer into the drama of birth, death and rebirth.

THE PEACH ORCHARD
(Momo no sono)

Ota Shuppan, Tokyo

A sober collection of photographs of fifteen girls, aged between 17 and 19, taken in 1986 and '87, in a studio in black-and-white; the expressions and poses assumed by the girls as they entrusted themselves to Araki are striking.

JEANNE

Shinchosha, Tokyo

Reconstruction of a 1965 work; photographs are stuck directly into four scrapbooks. The close-cropped model Gemi appears as Marie Falconetti, the leading actor in Carl Dreyer's 1928 film *The Passion of Joan of Arc*, and presents a drama of love and death.

LOVE
(Ren'ai)

Futabasha, Tokyo

A collection of photographs of bogus love featuring the actress and model Karen Kirishima; her neurotic-erotic expression is skilfully represented.

LAMENTS: SKYSCAPES/INTIMATE VIEWS
(Kukei/Kinkei)

Shinchosha, Tokyo

Two variations on the theme of the death of Yoko. In *Skyscapes*, coloured inks are added to 'sky' photographs, and in *Intimate Views*, are shots of various objects linked to her memory taken on the balcony of their house; the two volumes establish Araki's capacity to internalize death and respond to it with his full physical force. There is a poem by Gozo Yoshimasu entitled 'The Painted Horse in the Sky', commentaries by Kotaro Iizawa and Arturo Silva, and, in *Intimate Views*, a detailed chronology compiled by Akihito Yasumi.

COLOURSCAPES
(Shikikei)

Magazine House, Tokyo

A full-colour collection, unusual for Araki, where he throws off the shadow of death, realizing that colour and sensuality are the keys to a return to life and sexuality. It includes a preface by the poet Shuntaro Tanigawa entitled 'White Clouds floating in the Blue Sky'.

ON THE MOVE: SKY WITH NABI DANCING
(Ido: Nabi no mau sora)

Switch Shoseki Publishing Division, Tokyo

Exhibition catalogue, *On the Move*, 14 April to 12 May 1991, Egg Gallery, Shibuya. It dynamically conveys the earthy side of Seoul in twenty photographs taken the previous summer.

PHOTO-MANIAC'S DIARY
(Shakyojin nikki)

Switch Shoseki Publishing Division, Tokyo

For this photographic record, partly in colour, Araki uses the art name *Shakyojin* (or photo-maniac) in imitation of *Gakyojin* (obsessive, or maniac, artist), used by the *ukiyo-e* artist Katsushika Hokusai. Its light-hearted mood marks a new beginning for Araki.

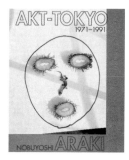

AKT-TOKYO

Camera Austria/Forum Stadtpark, Graz

Exhibition catalogue for European touring exhibition, *Akt-Tokyo*. Curated by Seiichi Furuya, a Japanese photographer living in Graz, and Manfred Willmann, it presents a distinctive interpretation of Araki's work.

STREETS IN PRIMARY COLOURS
(Genshoku no machi)

Shinchosha, Tokyo

This collection of bogus documentary photographs with a title borrowed from Junnosuke Yoshiyuki's novel of the same name, records 'momentary acts of love' blurring fact and fiction and is set in Osaka in midsummer.

THE FLOWER SHOP
BEHIND THE CEMETERY
(Bochiura no hanaya)

Magazine House, Tokyo

A collaboration with the poet Ryuei Senba, featuring high-voltage nude photographs.

ANGELS' FESTIVAL
(Tenshi-sai)

Taiyo Shuppan, Tokyo

A large format anthology of colour nude photographs from the 1980s taken for magazines such as *Shashin Jidai* showing how Araki has incorporated variants into the idea of 'between a man and a woman is a camera'; edited by Toshiharu Ito with book design by Seiichi Suzuki.

THE BANQUET
(Shokuji)

Magazine House, Tokyo

Every human desire has a place in Araki's photographs. Leftovers at the dinner table convey the eroticism and sadness of appetite.

TOKYO FINE DAY
(Tokyo-biyori)

Chikuma Shobo, Tokyo

Yoko's essays 'Tokyo Fine Day' (published in the July to September 1989 issues of *Shiso no kagaku*) and 'The Warmth of Sunflowers' (published posthumously in the February 1990 issue of *On The Line*) are combined with subdued autumn views taken with a Leica after her death.

PHOTO-MANIAC'S COLOUR DIARY
(Shakyojin iro nikki)

Switch Shoseki Publishing Division, Tokyo

Following the same format as the 1992 *Photo-Maniac's Diary* of 1992, this photographic diary has a more sensuous atmosphere because of the use of colour in all the photographs.

NEW WORLD OF LOVE
(Ai no shinsekai)

Tokyo-Sanseisha, Tokyo

A collaboration combining an essay by Kei Shimamoto portraying girls living in the world of the sex trade with Araki photographs using a female S&M practitioner as the model. Tomoaki Takahashi made a film based on this book in 1994.

CONFIDENTIAL — HIGH SCHOOL
GIRLS IN UNIFORM
(Seifuku no (maruhi) shojo)

Byakuya Shobo, Tokyo

Portraits of high school girls from the 'Tokyo Lycéennes' series that appeared in the magazine *Super Shashinjuku*. There are no nudes, but a sense of powerful eroticism emerges from the angles of vision and the poses assumed by the girls.

URBAN HAPPINESS
(Toshi no kofuku)

Magazine House, Tokyo

A collection of articles serialized as 'Urban Happiness' in the magazine *Da Capo* in 1992, including photographs of new towns on the outskirts of Tokyo and an Araki-style exposition of what happiness means to city dwellers. Araki exhibits real genius when he photographs children. The book ends with 'Diary of Happy Photography', an article by Akiko Nikaido.

LOVE AFFAIRS
(Joji)

KK Bestsellers, Tokyo

A collection of nude photographs of the actress Mari Shirato. A solid achievement with a clear emotional content, but Araki's work looks more inspired when he works with anonymous models.

LOVE YOU TOKYO

Setagaya Museum of Art, Tokyo

Exhibition catalogue to accompany duo show *Love You Tokyo* curated by Naohiro Takahashi and featuring Kineo Kuwabara and Araki. The work of these two photographers born and raised in a traditional working class district of Tokyo intertwined convincingly in this outstanding exhibition. Araki showed work related to Tokyo in chronological sequence from 1963 to 1992.

TOKYO, CITY OF CATS
(Tokyo Nekomachi)

Heibonsha, Tokyo

A city in which cats live is the original form of Tokyo for Araki. This collection put together from the series of the same name published in the magazine *Anima* between April 1990 and December 1991 is characterized by his freely expanding and contracting camera work.

AFTER THE WAR
(Shusengo)

AaT Room, Tokyo (limited edition of 1,000)

Araki's first limited edition since 1984, consisting of photographs taken with a 6 x 6 camera between 16 August (the day after the End-of-the-War Memorial Day in Japan) and 3 September in 1973, freely laid out as contact sheets, the flood of images ushering forth memories lost over twenty years.

THE PAST
(Kako)

Byakuya Shobo, Tokyo

A companion anthology to *After the War* consisting of 789 black-and-white photographs taken in 1973 and colour photographs taken in 1993. It shows how photographs are able to bring the past into the present while at the same time removing the present into the past. Edited by Akira Suei.

EROTOS

Libro Port, Tokyo

Rounding off 1993, Araki's second explosive year, this collection breaks into a new realm. The idea of metaphorical images of female genitalia covering the world is unfurled with overwhelming force.

1994

I-PHOTOGRAPHS
(Shi-shashin)

Asahi Shimbunsha, Tokyo

Araki's method of photographing the relationship between the personalized subject and the world, cultivated since the appearance of *Sentimental Journey* in 1971, is crystallized here.
The restrained book design is by Seiichi Suzuki and the concluding essay 'Personal Relationships' is by Eimi Yamada.

FAKE LOVE

KK Bestsellers, Tokyo

A collection of photographs and a poster featuring the singer and actress Yui Asaka under her real name Aki Kawasaki.

I-DIARY
(Shi-nikki)

AaT Room, Tokyo (limited edition of 1,000)

A companion volume to *I-Photographs*, this collection more successfully conveys Araki's sensibility. But what melancholy scenes and people!

ARAKITRONICS

Fuga Shobo, Tokyo

The companion to a photographic anthology *Arakitronics* released on CD-ROM. Araki took 3,000 shots over two days of this incandescent erotic performance from the model Mash, who had just turned twenty.

JUNKO

KK Bestsellers, Tokyo

A collection of nude photographs of the actress Junko Mihara, revealing the incompatibility of model and photographer. Poor content.

OBSCENITIES
(Waisetsu shashin)

Supplement to *Déjà Vu* magazine, Photo Planet, Tokyo

A collection of photographs put together on the basis of *Arakinema*, first performed at the 1994 'Photography and Obscenity' symposium

(Studio Ebisu, Tokyo). The institution of 'obscenity' is blown apart by Araki's self-censorship of some colour photographic images. His message is summed up in his statement to the symposium that 'obscenity is beautiful'.

NOBUYOSHI ARAKI X INTERNATIONAL GENIUSES
(Araki Nobuyoshi x Sekai-isai)

H₂O Company, Tokyo

Exhibition catalogue for *Nobuyoshi Araki x International Geniuses* held at the Spiral Hall, Tokyo, in August 1994. Works by several of the world's foremost photographers such as Helmut Newton and Jeanloup Sieff seemed to pale into insignificance beside Araki's nudes.

ARA-KISM

Sakuhinsha, Tokyo

Writings by Araki from 1960 to 1990 compiled and edited by Toshiharu Ito including a selection of interviews. An essential collection for any assessment of Araki's work.

DIARY OF DR PHIMOSIS
(Hokeitei nichijo)

East Press, Tokyo

A photographic diary serialized in the magazine *Uwasa no shinso* between January 1987 and March 1994. Less written material and more photographs than in the earlier *Tokyo Fine Day*. The title is a corruption of the novelist Nagai Kafu's celebrated journal *Diary of Dr Heartbreak*. The materials from around the time of Yoko's death are particularly poignant.

THEORY OF PHOTO-DIVINE
(Shashinron)

Libro Port, Tokyo

A selection of conversations with Eimi Yamada – a writer, and previously one of Araki's models, Masatoshi Nagase, Toshiharu Ito and Keiji Ueshima.

EROS ON THE EASTERN BANK OF THE RIVER SUMIDA
(Bokuto Erosu)

Kobunsha, Tokyo

A collection of nude shots of the actress and writer Yuko Mizushima based on Nagai Kafu's celebrated novel *Marvellous Tales from the Eastern Bank of the River Sumida*. A skilful combination of scenery and nude photographs against a background of traditional *shitamachi* downtown areas of Tokyo such as Asakusa and Mukojima.

TOKYO LOVE

Ota Shuppan, Tokyo (and Scalo, Zürich)

A collection of photographs taken for a joint exhibition with Nan Goldin entitled *Tokyo Love* held in November at The Ginza Art Space, Tokyo. Goldin shot young social outsiders such as lesbians, gays and body-piercers, while Araki, as a contrast, photographed one hundred teenage girls in a studio.

TOKYO STYLE
(Tokyo-fu)

Byakuya Shobo, Tokyo

Reportage on the sex trade in Shinjuku, Ikebukuro, Roppongi and Asakusa, serialized in *Playboy* magazine in 1992. Reconstructed as a continuation of *Tokyo Lucky Hole* under the editorship of Akira Suei.

A NEW WORLD OF LOVE: CINE-PHOTOGRAPH SAWA
(Ai no shinsekai: Shashin-eiga Sawa)

KK Bestsellers, Tokyo

A collection of nude photographs with the actress Sawa Suzuki, star of the Toei film *Ai no shinsekai* (A New World of Love), directed by Tomoaki Takahashi. Araki attempts a fusion of photographs and cinema (i.e. cine-photography) with the frequent use of consecutive scenes.

MARVELLOUS TALES OF BLACK INK
(Bokuju Kitan)

AaT Room, Tokyo (limited edition of 1,000)

A limited edition of photographs issued by AaT Room collected from the popular column of the same name in the magazine *S&M Sniper* between November 1992 and August 1994. A highly tense series, enhanced by the appearance of *Shakyojin*, the photo-maniac himself. The title derives from the fact the models' genitalia were touched up with black ink.

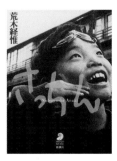

SATCHIN

Shinchosha, Tokyo

A volume in the *Photo Musée* series issued by Shinchosha from October 1994 onwards. Constructed from the remaining negatives of Araki's debut work *Satchin*, it reveals the dynamism with which Araki enters the world of children, and which is the starting point for his photographic work.

1995

WOMAN WITHOUT A PRESENT
(Genzai no nai onna)

KK Bestsellers, Tokyo

A collection of nude photographs with images of bondage, featuring the model Ai Hamahoshi, who was Miss Japan in 1994.

'A' DIARY
(A Nikki)

Libro Port, Tokyo

A photographic diary series using a panorama camera. Although the photographs date from 1994, they incorporate the figures '95', referring to the year of publication. Araki explains that 'I've been so busy recently that I've even taken photographs in the future.'

NOBUYOSHI ARAKI À LA FONDATION CARTIER POUR L'ART CONTEMPORAIN

Contrejour hors-série 1, Paris

A collection of magazine-style photographs published as the catalogue for the solo exhibition *Journal intime* held between April and June 1995 in Paris. Includes a commentary by Gabriel Bauret and an interview with Kotaro Iizawa.

CHASTE MASTER DATCHO
(Dotei Datcho-kun)

Libro Port, Tokyo

Araki's first book of paintings includes the 'Sexy Young Girls' series featuring colouring on photographic print paper.

FATHERS ON CHILDREN'S DAY
(Kodomo no hi no papatachi)

Photography Exhibition Executive Committee, Harajuku

Published to coincide with the *Satchin's Summer* exhibition held in August 1995 at La Forêt Museum, Harajuku, this collection combines black-and-white prints shot on 5 May (Children's Day) 1968 and colour photographs shot on 5 May 1995 at the Kodomo-no-kuni leisure park in Yokohama.

ENDSCAPES
(Shukei)

Privately published, Tokyo (limited edition of 1,000)

An anthology drawn from several series including 'My emotional landscape beginning on 30 November 1971, or physiological space A' and 'Not so much an emotional landscape as a tactile landscape or a broken landscape B', created in 1971. The pasty, broken images resulting from the emulsion dissolving through high-temperature developing might well be thought of as pristine Araki landscapes. Published on 15 August (End-of-the-War Memorial Day) 1995.

OKINAWA: PASSIONS
(Okinawa retsujo)

Shinchosha, Tokyo

The second long photographic novel following *Streets in Primary Colours* (1992) charts an explosion of amorous power under Okinawa's dazzling summer sunlight.

JOICHIRO TATSUYOSHI VS. NOBUYOSHI ARAKI: PHOENIX JOE
(Tatsuyoshi Joichiro vs Araki Nobuyoshi: Fushicho Joe)

KK Bestsellers, Tokyo

A photographic duel between the former WBC bantamweight world champion boxer Joichiro Tatsukichi and Araki.

TOKYO NOVELLE

Kunstmuseum, Wolfsburg

Exhibition catalogue for Araki's solo exhibition *Tokyo Novelle* held in the German city of Wolfsburg. A powerful collection of photographs including items that could not be publicly displayed in Japan.

TOKYO SEX
(Tokyo-sei)

Core Magazine, Tokyo

A large collection of documentary photographs of the Tokyo sex industry to commemorate the tenth anniversary of the Entertainment and Amusement

Trades Control Law. An enhanced version of *Tokyo Lucky Hole* (1990) with a huge volume of photographs. One of Araki's seminal contributions to the genre of sex-related photography.

1996

THE COMPLETE PHOTOGRAPHIC WORKS OF NOBUYOSHI ARAKI
(Araki Nobuyoshi shashin zenshu)

Heibonsha, Tokyo, 20 volumes:

1. Naked Faces *(Gansha)*
2. Bodyscapes *(Rakei)*
3. Yoko
4. New York
5. Chrysalis *(Shojo-sei)*
6. Tokyo Novel *(Tokyo shosetsu)*
7. Sentimental Travelogue *(Ryojo)*
8. Private Diary 1980–1995 *(Shi nikki, kako)*
9. Private Diary 1999 *(Shi nikki, seikimatsu)*
10. Chiro, Araki and Two Lovers *(Chiro to Araki to futari no onna)*
11. In Ruins *(Haikyo de)*
12. Dramatic Shooting and Pseudo Reportage *(Gekisha to nise ruporutaju)*
13. Xerox Photo Albums *(Zerokkusu shashincho)*
14. Obscenities and Marvellous Stories of Black Ink *(Waisetsu shashin to Bokuju kitan)*
15. Death: Elegy *(Shi no erejii)*
16. Erotos
17. Sensual Flowers *(Kain)*
18. Bondage *(Kinbaku)*
19. A's Lovers *(A no aijin)*
20. Sentimental May *(Senchimentaru na gogatsu)*

A bold, ground-breaking anthology presenting a full picture of Araki's world. Published in twenty volumes over two years, it consists of both previously published and unpublished photographs, and photographs specially taken for this series.

FAKE LOVE
(Giai)

KK Bestsellers, Tokyo

A solidly assembled collection of nude colour photographs featuring the actress Yuko Ishiwa.

CITY OF FLOWERS
(Hana no machi)

Kawade Shobo Shinsha, Tokyo

A collaboration with Ryuichi Tamura. Tamura's poems are combined with Araki's photographs of flowers taken in the city streets.

NOVEL OF FAR MEADOWS
(Tono shosetsu)

Fuga Shobo, Tokyo

Conflict arose between the office of the model Tomoko Fujita and the publisher concerning the inclusion of nude photographs, and this collection was withdrawn from release.

FLOWERS
(Hana)

Nishimura Gallery, Tokyo

Exhibition catalogue for *Flowers*, a solo exhibition at the Nishimura Gallery, Tokyo, in April 1996. A collection of colour photographs of flowers shot in the balcony studio at Araki's now famous apartment at Gotokuji in Tokyo, with the brilliance and the eroticism of the flowers creating a powerful impact.

VAGINAL FLOWERS
(Kain)

Jatekku Publishing, Tokyo

A collection of black-and-white photographs published to coincide with a solo exhibition at the Gallery Eve, Tokyo, in June; includes a preface by Kunio Iwaya.

YAKO

Fuga Shobo, Tokyo

A collection of nude photographs of the budding actress Yako, with particularly erotic bondage photographs.

KYOTO WHITE SENTIMENT
(Kyoto hakujo)

Shinchosha, Tokyo

The third in the series of long photographic novels; an adult mood is emphasized more than in the previous two works.

NOVEL PHOTOGRAPHS
(Shosetsu shashin)

Recruit, Tokyo

A collection from the column 'Novel Photographs', published in the magazine *Da Vinci* between 1994 and 1996, consisting of photographs of women and quotations from books; begins with a discussion with the writer Eimi Yamada on 'Novels and Photography'.

KINDNESS ISN'T LOVE
(Yasashisa wa ai ja nai)

Gentosha, Tokyo

Features poems by Shuntaro Tanigawa in the form of a monologue together with black-and-white photographs by Araki.

ARAKIGRAPH

Kobunsha, Tokyo

A new edition of the 1985 *A Legendary Radical Magazine* (*Maboroshi no kagekishi*), when the Araki and Suei partnership was at its most lively.

SHIKIJO: SEXUAL DESIRE

Edition Stemmle, Zürich

Exhibition catalogue for a solo show featuring colour copies held at the Museum für Moderne Kunst in Frankfurt. This was the first hardback book published outside Japan featuring Araki's photographs.

TRAVELLING GIRLS
(Tabi shojo)

Kobunsha, Tokyo

A collection of photographs taken over three years in the course of travels with nine young girls intended for use in posters for a campaign for Japan Railways – 'Youth 18 Tickets'. The photographs demonstrate Araki's ability to get his fellow travellers to relax.

1997

TOKYO LUCKY HOLE

Taschen, Köln

A Taschen version of *Tokyo Lucky Hole* as thick as a telephone directory. Includes extreme images that could never be published in Japan.

LOVE RELATIONS
(Ren'ai kankei)

Kawade Shobo Shinsha, Tokyo

Snapshots of couples taken by Araki in Tokyo between summer and Christmas 1996, together with portraits of couples taken at the Araki Photo Studio, which opened for one day on Valentine's Day 1997. Full of a sense of happiness.

TOKYO COMEDY

Korinsha Shuppan, Kyoto

The Japanese edition of the 1997 solo exhibition at the Wiener Secession in Vienna. Features many of Araki's most important works over the past few years centring on photographs of bondage, and shows evidence of Araki's boundless energy.

FLOWER RONDO
(Kakyoku)

Shinchosha, Tokyo

A compendium of Araki's flower photographs, displaying his passion for and absorption in this subject.

DEAD REALITY
(Shigenjitsu)

Seidosha, Tokyo

Enlargements of negatives from a 1974 visit to Okinawa, on a project involving the Workshop Photography School. Dust and corrosion had corrupted the negatives, and 'personal reality' had changed into its Japanese homophone 'dead reality'. The work first appeared in the January 1996 edition of the magazine *Eureka* in a feature on Araki.

BECOMING A GENIUS!
(Tensai ni naru!)

Kodansha Gendai Shinsho, Tokyo

A narrative autobiography based on four long interviews with Kotaro Iizawa. The secrets behind the emergence of 'Genius Ararchy' and Araki's unique ideas about photography are expounded at length.

NOBUYOSHI ARAKI POLAROID

Oktagon Verlag, Köln

A collection of Polaroid photographs issued in a limited edition of 800, making best use of the distinctive erotic texture of Polaroid photographs and their exquisitely vivid colouration.

TOKYO KANNON

Chikuma Shobo, Tokyo

A collection of photographs of pilgrimages to temples enshrining the Bodhisattva Kannon made with Hinako Sugiura, serialized in the magazine *Chikuma* in 1995 and 1996. Blessed with the ideal travelling companion, Araki succeeds here in resurrecting the exquisite sense of vitality that characterizes his photos of urban environments. 'The mere presence of Hinako Sugiura gave a mysterious, other-worldly feel to the physical location.'

SUMMER NOVEL
(Natsu shosetsu)

Heibonsha, Tokyo

A collection of photographs originally taken for a solo exhibition, 'Ararchy Retrographs', at the Hara Museum of Art at Shinagawa in Tokyo in the summer of 1997. 'Memories of a summer day' in which the past intermingles with the present and the mundane with the extraordinary.

FUYUGOI: LOVE IN WINTER

Bunkasha, Tokyo

A collection of nude photographs featuring the actress Kazue Otake, combining the model's delightful manner of stripping with Araki's skills as a narrator.

THE COMPLETE LITERARY WORKS OF NOBUYOSHI ARAKI
(Araki Nobuyoshi bungaku zenshu)

Heibonsha, Tokyo, 8 volumes:

1. Tokyo Love Affair *(Tokyo joji)*
2. Sentimental Erotic Romance
 (Senchimentaru ero-roman)
3. Erotic Journey to Views of Women
 (Jokei irotabi)
4. Pleasure Shots in Love Hotels
 (Rabuhoteru de rakusha)
5. Anthology of Writings on Photography
 (Shashinron shu)
6. The Introduction to a Conversation with Araki
 (A kaiwa nyumon)
7. Selected Records: The Diary of Hokeitei
 (Tekiroku: Hokeitei nichijo)
8. New Novels *(Kakioroshi shosetsu)*

Araki's 'Literary Works' are taken from the enormous volume of material he has submitted to magazines and included in his photographic collections. Much of this material had not been printed in book form before, and it provides evidence of Araki's talent as an author of popular fiction.

CERAMIC VIEWS
(Tokei)

Shogakkan, Tokyo

A collection of photographs in which Man Arai, Machi Tawara, Yuko Matsumoto, Iori Matsumoto and other writers and poets take on the challenge presented by pottery. But the most outstanding contribution is perhaps Araki's own piece on the subject of the female body.

VISIONS OF JAPAN: ARAKI NOBUYOSHI

Korinsha Shuppan, Kyoto

The first in the *Contemporary Photographers* series published by Korinsha Shuppan under the supervision of Toshiharu Ito. A new version of *Angels' Festival* of 1992.

ARAKI IN VIENNA
(Araki in Wien)

Korinsha Shuppan, Kyoto

A collection combining *Komodon Goes to Vienna*, which was photographed backstage at the solo exhibition *Tokyo Comedy* held the previous year at the Wiener Secession, and *Tokyo Paradise*, which includes new images of Tokyo supplementing the photographs used at the time in *Arakinema*. Conveys the enthusiastic welcome accorded to Araki in Europe after an absence of sixteen years.

TAIPEI

Korinsha Shuppan, Kyoto

A collection of large photographs taken for exhibition at the Taipei Biennial held in June 1998; it includes black-and-white nudes taken at the Grand Hotel in Taipei looking down on the city and a series of lively colour scenes depicting the city itself.

BLACK MOULD
(Kurokabi)

Bunkasha, Tokyo

A collaboration with the actress and author Yuko Mizushima, combining her writings with Araki's Polaroid nudes.

RAINY DAY: ICHIKAWA SOMEGORO

Media Factory, Tokyo

A collection of black-and-white portraits of the *kabuki* actor Ichikawa Somegoro. The interconnections between the model and city views are presented with exquisite timing.

PHOTOGRAPHING THE GODS
(Shashin)

Nihon Chiiki Shakai Kenkyujo, Tokyo

A collection of photographs and writings published to commemorate the thirtieth anniversary of the Shinto Current Events Research Group and the tenth anniversary of the Heisei Shinto Research Group. Features photographs by Araki and a series of essays entitled *My Gods* (*Watashi no kamisama*) by thirty-four ethnologists and others active in a variety of fields, including Juro Kara, Ken'ichi Tanigawa and Taryo Obayashi. A somewhat odd combination. With a solid content reminiscent of *On Photography* of 1989, the features of Araki's photographic style are all here as he attempts to summon forth the gods from the other world.

NOBUYOSHI ARAKI'S PASSIONATE LOVE TALK
(Araki Nobuyoshi no netsuretsu rabu rabu tooku)

Futabasha, Tokyo

A series of conversations originally featured in the magazine *Shukan taishu* between 1 November and 31 December 1982. An uninhibited exhibition of sexual energy in conversations with captivating women, including Miwa Takada, Tomoko Matsushima and Kazuko Matsuo.

EROTICISM OF MARRIED WOMEN: 1/X
(Hitozuma erosu: 1/X)

Futabasha, Tokyo

A selection of nudes featuring twenty-five married women originally created for serialized inclusion in the weekly magazine *Shukan taishu*. The women seem to relish being photographed, and the excitement of the occasion is vividly conveyed.

SUMMER SEX

Sukora-sha, Tokyo

A large collection of nude photographs with the actress Yuna Natsuo as the model.

COSMOSCO

Shogakkan, Tokyo

Records of photo sessions covering eight years featuring Cosmosco, a girl whom Araki met in Sapporo in 1991 when she was seventeen. As in most of Araki's work, it mixes fact and fiction, and the overall impression is somehow bittersweet.

NAKED NOVEL
(Hadaka shosetsu)

KK Bestsellers, Tokyo

Photographs of twenty fashionable nude models, including Madoka Nagai and Jun Kusanae.

ARAKI RETURNS FROM SHANGHAI
(*Shanhai-gaeri no Araki*)

Korinsha Shuppan, Kyoto

Another in the overseas location series, following Vienna and Taipei. Natural photographs of Shanghai backstreets taken on a visit to the exhibition *Sur-Everyday-Life* in May 1998. The images include an ordinary pair of boots and a random funeral procession. Araki states that 'wherever you go, it's the things you see immediately around you that are the most interesting'. Includes Araki's own commentary and a CD.

NOBUYOSHI ARAKI'S TECHNIQUE OF PHOTOGRAPHY
(*Araki Nobuyoshi no shashinjutsu*)

Photo Libre 5, Photo Planet, Tokyo

An introduction to Araki's photographic technique edited by Akihito Yasumi. Features discussions with Chikashi Kasai, Takashi Honma and Nick Waplington.

NOBUYOSHI ARAKI: TOKYO NOSTALGIA

Photology, Milan

Exhibition catalogue for solo show, *Tokyo Nostalgia*, at the Galleria Photology in Milan. The colour photographs of women shot between the 1970s and the 1990s include many images that could not be published in Japan.

NOBUYOSHI ARAKI: SHIKIJO TOKYO, MARKETPLACE OF EMOTIONS

Edition Stemmle, Zürich

A companion volume to *Shikijo: Sexual Desire*, published in 1996. The upper half of each page depicts flowers while the lower half is based on the Dead Reality series. Includes a commentary by Ulf Eldmann Ziegler entitled 'A Complex Character: Nobuyoshi Araki's Photography'.

1999

MODEL DIARY
(*Nikki no otehon*)

Shogakkan Bunko, Shogakkan

A collection of contributions to Araki's 'Diary of Dr Phimosis' featured in the magazine *Uwasa no shinso* between January 1989 and July 1995, including excerpts from the diaries of several illustrious names in the history of early modern Japanese literature, such as Nagai Kafu, Kajii Motojiro, Takamura Kotaro and Masaoka Shiki.

MEN'S FACES
(*Otoko no Kao*)

Bungei Shunju, Tokyo

A collection of portraits of middle-aged businessmen taken in the new Shinjuku urban centre and the Marunouchi district to provide an ending for the NHK (Japan Broadcast Corporation) drama *Course on the Remodelling of Middle-Aged Men* of 1998. A version of *Satchin* using middle-aged men.

TOKYO NOSTALGIA
(*Tokyo Nostalgy*)

Heibonsha, Tokyo

Photographs collected for a novel put together as a supplement to *The Complete Literary Works of Nobuyoshi Araki* (see above). Consisting of photographs taken since the mid-1980s with a 6 x 4.5 camera, sixteen on each double-page spread, with consideration given to the flow of one photograph to the next and the overall structure of each page. An experiment in combining photography and cinema of a type that Araki had undertaken from early on in his career.

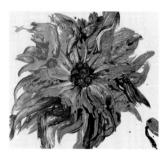

ROLLING STONE
(*Ryuseki*)

Hysteric Glamour, Tokyo

A large collection of photographs measuring 36.4 x 31.4 cm (14 x 12 in), planned and published by clothing manufacturer Hysteric Glamour. The cover features a flower picture painted by Araki on printing paper. The arrangement of black-and-white snapshots gives an overall sense of passing through the urban environment.

TALES OF SPRING SNOW
(*Shunsetsusho*)

Photo Planet, Tokyo

A collection of photographic stories serialized in the photography magazine *Déjà-vu bis*. The title takes its lead from two celebrated novels by Tanizaki Junichiro, *Shunkinsho (A Tale of Shunkin)* and *Sasameyuki (Fine Snow: The Makioka Sisters)*.

ANDERSEN: KYOTO PILGRIMAGE
(*Anderusen, Kyoto junrei*)

Media Factory, Tokyo

A collaboration with the French literature scholar Yukoh Deguchi. A casually shot travel record of a visit to Kyoto that succeeds nevertheless in revealing the depth and beguiling attraction of the city. Cover design by the novelist Natsuhiko Kyogoku.

ARAKI NOBUYOSHI: SENTIMENTAL PHOTOGRAPHY, SENTIMENTAL LIFE

Museum of Contemporary Art, Tokyo

Exhibition catalogue of an Araki retrospective held between 17 April and 4 July at the Tokyo Metropolitan Museum of Contemporary Art. The exhibition featured more than 1,000 works from twenty-two series, ranging from *Sentimental Journey* to the most recent work *A's Paradise*. Includes contributions from the architect Ettore Sottsass, the writer Setouchi Jakucho and the fashion designer Issey Miyake.

SPECIAL SELECTION! CLIMAX 99
(*Tokusen! Kuraimakkusu 99*)

Magazine House, Tokyo

A joint production with Morihiro Nagata. 'Climax' was a popular column in the magazine *Da Capo*, running for eighteen years and featuring juicy passages from erotic novels combined with Araki's nude photographs.

RUNA: SEXUAL MISCONDUCT IN THE HEAVENLY CASTLE
(*Runa: Tenjo inko*)

Bunkasha, Tokyo

A collection of photographs taken over three days of the teenage actress Runa Nagai, including school uniform portraits, Polaroid shots and scenes at spa resorts.

BANGKOK PHOTOGRAPHY EXHIBITION: THE ADVENTURES OF TOMYAM
(Bankoku shashin hakurankai: Tomuyamu-kun no boken)

Shodensha, Tokyo

Photographic records of a stay in Bangkok in 1998. Featuring principally snaps of Bangkok's entertainment quarter, the collection is pervaded by a colourful, syrupy and intense mood.

I GO SOUTH
(Ore, nanshin shite)

Shinchosha, Tokyo

A collaboration with Koh Machida, where the novelist's repetitive and rhythmical style perfectly matches Araki's cloying photographs. Osaka provides the stage. Machida himself appears in the photographs as one of the leading characters.

INAUGURAL ISSUE OF ARAKIGRAPH: SUICIDE AT KARUIZAWA
(Arakigurafu sokango: Karuizawa shinju)

Kobunsha Library, Kobunsha, Tokyo

Items from the 'Arakigraph' series featured in the magazine *Gekkan Hoseki* in 1985 appear with the first and second parts of one of Araki's most significant achievements, *Suicide at Karuizawa*. The romantic novel structure in the manner of the early twentieth century enhances the sensual scenes.

NOBUYOSHI ARAKI: ALIVE

Taipei Fine Arts Museum, Taipei

Exhibition catalogue for *ALive* show at the Taipei Fine Arts Museum, autumn 1999. In the photographs shot in various Asian cities, including Taipei, Okinawa, Tokyo, Osaka, Bangkok, Seoul, Shanghai and Hong Kong, all barriers seem to melt away, resulting in the appearance of energetic life forms.

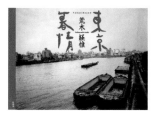

NOSTALGIA FOR TOKYO
(Tokyo bojo)

Shinpusha, Tokyo

A rearrangement of photographs of Tokyo in 6 x 7 format originally taken for *A Personal View of Tokyo's Prosperity*, the collaboration with

Nobuhiko Kobayashi that appeared in 1984. Full of a sense of nostalgia for areas of Tokyo such as Ginza, Aoyama, Yanaka and Jinbocho, as they once were. Again, the starting point for Araki's photographs of the urban environment is the naked, unadorned city.

ARAKI'S LOVE FOR TARO
(Araki no Taro ai)

Kobunsha, Tokyo

A collection of photographs paying homage to the artist Taro Okamoto, who died in 1996, including photographs of the Solar Tower created for the Osaka Expo in 1970 and Okamoto's sculptural objects as viewed by Araki; incorporates some nude photographs, but has a generally restrained content.

PEOPLE STREETS
(Hitomachi)

Junposha, Tokyo

A collection of specially taken photographs based on strolls around traditional areas of Tokyo (Yanaka, Nezu, Sendagi) with the writer Mayumi Mori, according to whom 'the time I spent with Ararchy was a joy, and I'm sure that this feeling was shared by everyone we met in these areas.'

FINE DAYS FOR CATS
(Neko-biyori)

Heibonsha, Tokyo

A book of postcards drawn from the earlier photograph collections *Beloved Chiro*, 1990, and *Tokyo, City of Cats*, 1993. 'On fine days and on rainy days, anywhere there's a cat is paradise.'

SKYSCAPES

Vertrieb Codax Publishers, Zürich

Photographs of the sky, which plays the most enigmatic role among Araki's photographic series. Araki's sky is not something separate from the world of people, containing as it does telegraph poles and buildings seen at the edge of the picture. Includes an essay by Akihito Yasumi with a title 'No hell below us, above us only sky' borrowed from John Lennon's 'Imagine'.

2000

GRAND DIARY OF A PHOTO-MANIAC
(Shakyojin dai-nikki)

Switch Publishing, Tokyo

A photographic diary compiled, with a dated compact camera, since Yoko's death.
An overwhelming quantity and variety of people, ideas and things pass through Araki as a medium. 'From death to life: feelings for life pushed me in the direction of obsessive photography.'

POLA-IVACY

Shobunsha, Tokyo

The title is an Araki-style portmanteau word combining 'Polaroid' with 'privacy'. Araki attributes a 'whiff of secrecy' to his Polaroids taken in the intervals between work. Polaroids taken by Araki since the 1980s are here compiled and edited by the bookbinder Koga Hirano.

PERSONAL SENTIMENTALISM IN PHOTOGRAPHY
(Shashin shijo shugi)

Heibonsha, Tokyo

'A photographic collection to commemorate the sixtieth anniversary of Araki's birth.'
A chronological selection of 201 photographs from among 5,000 taken by Araki with the Plaubel Makina that he had used as his workaday camera since the 1980s. Also a chronological record of one of Araki's favourite female models, Muse, who featured in his photographs for several years.

FIGHTING MEN
(Kakuto otoko)

Wani Magazine Co., Tokyo

Photographs of ten professional wrestlers including Kazushi Sakuraba, Alexander Otsuka and Kazuyuki Fujita. Includes fully nude photographs and conveys an impression of the force of highly polished physiques. 'I'm interested in people who fight, be they men or women. My photographs are in their own way a fight between my subject and myself.'

ARAKIGRAPH VOL.2: SPA ROMANCE
(Arakigurafu daini-go: Onsen romansu)

Chie-no-mori bunko, Kobunsha, Tokyo

The second in the 'Arakigraph' paperback series following *Suicide at Karuizawa* (1999). Overnight trips to hot spas with Araki's favourite girls are covered in two parts, one taken at Odawara and the other at Yugawara. Includes haiku written under the pen-name Kitobi (Glans Penis Fire): 'In the winter light / The radiance of white skin / Dark glasses'.

FROM PURE PHOTOGRAPHS TO STYLISH PHOTOGRAPHS
(Jun-shashin kara iki-shashin e)

Shohakusha, Tokyo

A collection of discussions divided into three parts entitled 'Tokyo and Landscapes', 'Photography and Literature' and 'The Body and Eros'. Araki's partners in the discussions are the critic Saburo Kawamoto, the actor Naoto Takenaka, the French literature scholar Yukoh Deguchi, the photographer Kishin Shinoyama, the critic Yuzo Tsubouchi, the writer Miri Yu, the columnist Chinami Shimizu, the writer Ryu Murakami, the critic Shunsuke Serizawa, the photographer Miyako Ishiuchi and the cartoonist Fumi Saimon.

ARAKI

Photo Poche, Nathan, Paris

Published as Volume 86 in the Photo Poche photography collection edited by the Centre National de la Photographie in Paris. Includes many of Araki's most important works with the emphasis on his early work. Foreword by Alain Jouffroy.

TOTALITARIANISM, SECTIONALISM
(Zentaishugi, bubunshugi)

Gadget Random 1, Ekusupurante, Tokyo

A gadget book containing a single nude photograph split up into thirty-six postcards, a commentary booklet and an audio CD. A manifestation of Araki's belief that the essence of photography is all about coming and going between the whole and parts.

JEUNES FILLES D'ARAKI
(Koi Shoju)

Magazine House, Tokyo

Excerpts from *Tokyo Date*, serialized in the magazine *Popeye* between June 1998 and April 1999. Photographs of teenage girl celebrities photographed in various places around Tokyo.

ARARCHY'S PORTRAITS: 101 WOMEN FROM TOYAMA AGED FROM 0 TO 100
(Araakii gansha, Toyama no josei, zerosai kara hyakusai made no hyakuichinin)

Fukuoka Camera Museum, Fukuoka

Araki photographed 101 girls and women aged from 0 to 100 in the course of a single day for the exhibition *Women of Toyama* held to mark the opening of the Musée Fukuoka Camera Centre, designed by Tadao Ando at Fukuoka-machi in Toyama prefecture. According to Araki, he 'experienced the whole passage of a woman's life in a single day'. This project was the starting point for the subsequent 'Faces of Japanese People' project.

SHINO

Graphic-sha, Tokyo

A photographic record assembled over ten years of Shino, a slim-faced model with a figure ideally suited to wearing a kimono. Her somewhat stiff expression gradually relaxes to take on an ecstatic quality. A collection that shows Araki's devotion to his favourite model.

100 FLOWERS, 100 BUTTERFLIES
(Hyakka hyakucho)

Kodansha International, Tokyo

A collection of photographs of girls clad in one hundred costumes designed by Yoshiki Hishinuma, featuring amateur models and conveying a tangible sense of eroticism.

ANTHOLOGY OF PHOTOGRAPHS OF NAKAMURA KANKURO: HOKAIBO
(Nakamura Kankuro shashinshu: Hokaibo)

Homu-sha, Tokyo

Photographs of *kabuki* actor Nakamura Kankuro taken in the vicinity of the Kaminari-mon Gate in Asakusa, Tokyo, with Kankuro dressed in the comic role of Hokaibo. Passers-by surprised and delighted to find themselves suddenly in the presence of a popular actor and photographer are incorporated into the images, resulting in an interesting performance record.

REPRODUCTIONS: NOBUYOSHI ARAKI & AKIRA SUEI'S 'SHASHIN JIDAI'
(Araki Nobuyoshi, Suei Akira no fukusha: 'Shashin Jidai')

Bunka-sha, Tokyo

A collection of 'Reproductions' drawn from the pages of the photography magazine *Shashin Jidai*, created between 1981 and 1988 by the team of Araki and the great editor Akira Suei during their heyday. An article by Suei entitled 'The Lead-up to *Shashin Jidai*' and a discussion between the two men entitled 'The Concept is Suei' offer valuable background information on the creation of this prodigious magazine.

JAKUCHO AND ARARCHY: DISCUSSIONS ON PHOTOGRAPHY FOR THE NEW CENTURY
(Jakucho x Araakii: Shinseiki e no fototoku)

Shinchosha, Tokyo

A complete edition of the articles written by the novelist Setouchi Jakucho for the weekly magazine *Shukan Shincho* between July 1998 and August 2000. Photographs by Araki are attached to Setouchi's composition 'Love Letter', which begins 'Dearly beloved Ararchy…'

ARAKI: VIAGGIO SENTIMENTALE

Centro per l'Arte Contemporanea Luigi Pecci, Prato

Exhibition catalogue for Araki retrospective at the Centro per l'Arte Contemporanea Luigi Pecci in Prato, Italy. Divided into eight parts: 'Painted Flowers', 'Tokyo Nostalgia', '90s Diary', 'Polamandara', 'Araki's Paradise, Araki's Lovers', 'Close Range', 'Sentimental Journey' and 'Viaggio in Italia' (the last created specifically for this exhibition).

ARAKI: 'TOKYOMANIA'

Edition Mennor, Paris

Exhibition catalogue for solo show held at the Gallerie Kamel Mennour in Paris. It consists of 1990s nudes and images of bondage, but is somewhat haphazard and disorganized in terms of content. Preface by Germano Celant.

2001

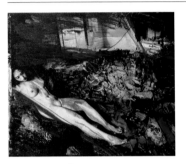

FIN-DE-SIÈCLE PHOTOGRAPHY
(Seikimatsu no shashin)

AaT Room, Tokyo

A limited edition of 2,000 issued by Araki's own office, AaT Room. Well-worn content, including a random selection of nude bondage scenes, streetscapes and portraits, but the many winter photographs and images of ruins leave a somewhat icy impression.

SADNESS
(Ai)

Futabasha, Tokyo

A collection of nude portraits of the actress Toshiko Tsuyama. She engages actively in the project, but the image of her somewhat fading looks creates a distressing impression. Includes a large number of bondage images.

SEOUL: THE NOVEL
(Shosetsu Souru)

Switch Publishing, Tokyo

Araki visited South Korea for the first time in 1982 to take photographs to go with a novel by the late Kenji Nakagami and subsequent visits in 1985, 1986 and 1991. He revisited Seoul in 2000 with the aim of finding a girl he had met by chance during his visit in 1991. This collection includes snapshots he took on that occasion. Past and present converge to create a narrative about the Korean capital of this country often thought of in Japan as being geographically close but emotionally far away.

WOMEN OF THE SEX TRADE
(Fujo)

Bauhaus, Tokyo

A trademark Araki project featuring nude portraits of 69 women working in the sex trade in and around the Shinjuku area of Tokyo. Records of their meetings with customers outside the establishments where they work and letters from the women are included and seem both poignant and kind-hearted.

GENIUS ARARCHY:
METHOD OF PHOTOGRAPHY
(Tensai Araakii: Shashin no hoho)

Shueisha Shinsho, Shueisha, Tokyo

Theoretical musings on photography serialized in the magazine *Youth and Reading* between January 2000 and February 2001. Araki speaks frankly about the secrets of his creative style ('I don't like it when things are too determined'; 'Personal feelings aren't simply about kindness and consideration'; 'Keeping a straight gaze is the basis for all I do'), aided considerably by the sophisticated responses of the interviewer, Susumu Watada.

GENIUS ARARCHY'S
ONCE-IN-A-LIFETIME NUDES
(Tensai Araakii no ichigo-ichira)

Shueisha Mook, Shueisha, Tokyo

A magazine-style book edited by *Business Jump* magazine containing 400 nudes and an at-the-scene photographic report. A very dynamic production that gives the impression of returning to the *Shashin Jidai* period of the 1980s.

GENIUS ARARCHY:
VIGOUR PLEASE!
(Tensai Araakii: Genki chodai!)

Shueisha Mook, Shueisha, Tokyo

A small magazine-style book released at the same time as *Genius Ararchy's Once-in-a-Lifetime Nudes* consisting of around 1,000 items. Available with a CD which includes Araki singing 'The Red Shoes' and 'Night with a Hazy Moon', along with the voices of others describing at-the-scene conditions.

ALL WOMEN ARE BEAUTIFUL
(Subete no onna wa utsukushii)

Daiwa Shobo, Tokyo

This volume of previously published writings considers women from the standpoint of a photographer and bears the subtitle *Genius Ararchy's Theory of Attractive Women*.

PHOTOGRAPHY
FOR A NEW CENTURY
(Shinseiki no shashin)

AaT Room, Tokyo

A collection of photographs issued in a limited edition of 2,001 by AaT Room. The companion volume to *Fin-de-siècle Photography*, it consists of vivid 6 x 7 colour images. There are plenty of bold open-legged poses from the nude models. It ends with a self-portrait taken at the *Novel Seoul* exhibition held at Aoyama Spiral in Tokyo.

MISUZU

Kinokuniya Shoten, Tokyo

A collection of still photographs taken for the film *Misuzu* directed by Takumi Igarashi and modelled on Misuzu Kaneko, the writer of nursery rhymes from Yamaguchi prefecture. Although Araki claims he's not interested in taking still photographs for movies, his work here is carefully executed.

ONCE AGAIN, TO PHOTOGRAPHY
(Futatabi, shashin e)

AaT Room, Tokyo

A collection of photographs issued in a limited edition of 2,001 by AaT Room featuring black-and-white images taken with a compact camera between June and August 2001 and bearing a dedication to Kazuo Nishii, the photography critic and editor of the magazine *Camera Mainichi*, who had died that year. The title refers to the idea of succeeding to Nishii's legacy.

UTAIME: SINGING MAIDENS

Bauhaus, Tokyo

A collection of photographic portraits of 19 young female singers including Ringo Shiina, Nao Matsuzaki, Bonnie Pink and Aco, some previously published in the magazine *Thrill* and some taken expressly for this volume. Although the photographs were taken to order, Araki manages to set his stamp clearly on them.

GRIEF
(Urei)

Futabasha, Tokyo

The 'final' collection of photographs created to mark the retirement of the legendary adult video and pornography actress Hitomi Kobayashi. Produced in the well-worn manner with the same crew and the same book designer (Henriku Morisaki) as the previous *Sadness*.

ON THE FAR SHORE
(Higan nite)

AaT Room, Tokyo

Another limited edition issued by AaT Room, this collection of 1,000 mainly colour photographs taken with a compact camera is dedicated to Masaru Uchida, the former editor of *Anima* who had been involved in the production of *Tokyo: City of Cats* (1993) and had died suddenly that year. A spiritual other-worldliness as suggested by the title pervades.

2002

L'AMANT D'AOÛT
(Hachigatsu no aijin)

Shogakkan, Tokyo

A soft-porn collection featuring the model Komari, who had studied in New York and was engaged in the fashion business in Paris. Her bewitching coquettishness is portrayed in a variety of situations, including a pose with the base of her kimono open at the front in the manner of an *ukiyo-e* print.

TOKYO DIARY
(Tokyo nikki)

Demadosha, Tokyo

A new complete version of the *Tokyo Diary* originally published in 1989 by Fiction Inc. with the addition of the diary serialized in the magazine *Shashin Sekai* between 8 January and 31 May 1989. Another illustration of how Araki was dashing forward during the 1980s. The names of the cast of characters are printed in the margins to help the reader.

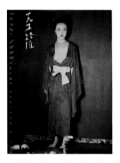

A WOMAN CALLED KOMARI
(Komari to iu onna)

Intermedia Shuppan, Tokyo

A companion volume to *Lamant d'Août*, the focus here is on the kimono pose; quotations from Nagai Kafu's celebrated work *Marvellous Tales from the Eastern Bank of the River Sumida* provide an added touch. Although relatively short, this volume has a penetrating content.

LAST YEAR
(Kyonen)

AaT Room, Tokyo

A limited edition of 2,002 released on 1 April 2002 (April Fool's Day). A series of black-and-white photographs dated between 3 January and 31 December 2001 with alternating photographs of open-legged nude models and images of the sky.

JAPANESE FACES: OSAKA
3-1, 3-2, 3-3
(Nihonjin no kao: Osaka 3-1, 3-2, 3-3)

Kinokuniya Shoten, Tokyo

The first instalment of the 'Japanese Faces' project involving a series of photographic portraits of twenty-first-century Japanese people from all over the country, started in January 2002. The faces of 1,000 people photographed in Osaka are included here in three volumes. The portraits incorporating blurring and shaking create a powerful impression; the 'Photography Notes' at the end of the volumes include lively conversations between Araki and his models.

ARARCHY'S LOVE TIME, VOLS.1 & 2
(Araakii no koi jikan Vols. 1 & 2)

KK Bestsellers, Tokyo

The first and second issues in the photography series *A-Ravu*. An imaginative collection of nude photographs featuring five adult video actresses.

POLISH GENIUS ARARCHY'S EYEBALLS
(Tensai Araakii no me o migake)

Heibonsha, Tokyo

An anthology of Araki's thoughts on photography compiled in response to a request from Akiko Takehara, professor at Wako University and formerly a fellow student of Araki's at Chiba University. It was apparently Takehara who enlightened Araki on McLuhan's media theory. The title of this volume is taken from a response to the question 'What do you do when you get up in the morning?' 'I polish my eyeballs. Just like I brush my teeth every morning.'

MARCH FOR OPENING UP THE NATION
(Kaikoku maachi)

Jitsugyo-no-Nihonsha, Tokyo

A collaboration with Seiji Fujii. Reports on the lives of immigrants from the Philippines, China, Korea, Thailand, Russia and Brazil and other countries, who live and work in Japan, supplemented by Araki's dynamic photographs. Serialized in the magazine *JN* between April 2001 and March 2002.

THIS YEAR'S LOVER
(Kotoshi no aijin)

Continental Boeki, Sapporo

Exhibition catalogue for a solo show held between 4 and 18 July at the Continental Gallery in Sapporo. Contains almost entirely photographs specifically taken for this exhibition, in accordance with Araki's desire to show only new works in his solo exhibitions. Most of the images are taken with a compact camera showing the date.

SCENERY
(Keshiki)

Intermedia Shuppan, Tokyo

Drawn from *Scenery*, the popular series featured in the magazine *Shashin Jidai* between 1981 and 1987, this fascinating material receives somewhat overbearing treatment by the designers Shin Sobue and Satoshi Abe, but the explosion of abundant energy still comes across. Chief editor Akira Suei contributes an essay entitled 'Leave Everything Else up to Suei'.

ARAKI

Taschen, Köln

A comprehensive and weighty 'Sumo' book that includes almost all Araki's most important works from his debut work *Satchin* to the nudes and flowers of the 1990s. The ordered arrangement based on individual series detracts from the inherent chaos of Araki's creative universe. Many pages (mainly those showing female genitalia) were censored in the Japanese edition.

ARARCHY'S LOVE SHOTS
(Araakii josha)

KK Bestsellers, Tokyo

The third instalment in the series of paperback photograph anthologies features nude shots of seventeen girls. Almost the same content as the previous two volumes.

A FLORAL LIFE
(Hana jinsei)

Kahitsukan, Museum of Contemporary Art, Kyoto

Exhibition catalogue for solo show at a gallery in the Gion district of Kyoto; an anthology of photographs based on the theme of flowers from *Amaryllis* of 1967 to recent works, including *Painted Flower* of 2001, which was created by dripping paint in primary colours onto petals and *Floral Picture*, where Araki takes on the challenge of drawing rather than photographing flowers.

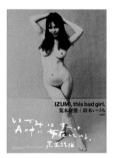

IZUMI, THIS BAD GIRL

Bunyusha, Tokyo

The definitive collection of photographs featuring the writer Izumi Suzuki, who was Araki's muse during the 1970s and early 1980s, and who committed suicide in 1986. Her skin, almost un-Japanese in its whiteness, her sensuous figure and her enticing, melancholic expression, gave her an aura that enthralled Araki. He has said that Suzuki will always live in his memory and sensibility.

GENIUS ARARCHY:
THE TIME FOR PHOTOGRAPHY
(Tensai Araakii: Shashin no jikan)

Shueisha Shinsho, Shueisha, Tokyo

This second volume of Araki's thoughts on photography in the paperback series published by Shueisha consists of articles serialized in the magazine *Seishun to dokusho* between March and August 2002, with extensive additions. The large number of on-the-spot reports on specific shoot locations convey a strong sense of immediacy.

SUICIDE IN TOKYO

Baldini & Castoldi, Milan

Exhibition catalogue for the Araki show in the Italian Pavilion at the Venice Biennale site, beginning with the *Suicides at Karuizawa* and going on to include *Tokyo Nude, Lamant d'Août* and *Polaroid*. The selection is dominated by 'geisha' images of the type popular outside Japan and concludes with a discussion with Filippo Maggia.

LOVE IN TOKYO

H₂O Company, Tokyo

A catalogue for the fashion designer Chisato Tsumori consisting of photographs of top model Helena Christensen taken in a studio and in the streets of Shinjuku's Kabuki-cho. Araki himself makes a special appearance.

NOVEL SEOUL, STORY TOKYO

(Shosetsu Souru, monogatari Tokyo)

Ilmin Museum of Art, Seoul

Exhibition catalogue of a solo show at the Ilmin Museum of Art in Seoul, 15 November 2002 to 23 February 2003, consisting of photographs of Seoul and Tokyo taken since the 1980s and images from the *Erotos, Flower, Kinbaku* and *Food* series; includes the *God's Sky* installation comprising 1,000 Polaroid photographs.

2003

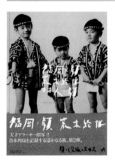

JAPANESE FACES: FACES
OF FUKUOKA
(Nihonjin no kao: Fukuoka no kao)

Nobuyoshi Araki 'Japanese Faces' Project, Tokyo

The second instalment in the 'Japanese Faces' project carried out in October and November 2002 and now released by the Nobuyoshi Araki 'Japanese Faces' Project. The stage is now Fukuoka, where Araki photographed the faces of 500 people in close-up.

HARLOTRY
(Inbai)

AaT Room, Tokyo

A limited edition of 1,000 released on April Fool's Day. A black-and-white photographic record extending from 1 January to 31 December 2002; the form and content are well worn and the impression is of rather more nudes than usual.

ARAKI BY ARAKI:
THE PHOTOGRAPHER'S
PERSONAL SELECTION

Kodansha International, Tokyo

A definitive anthology comprising several thousands of photographs endorsed by Araki, including his most important series arranged in chronological order from *Satchin* of 1963 up to *100 Flowers, 100 Butterflies* of 2000.

JAPANESE FACES:
FACES OF KAGOSHIMA
(Nihonjin no kao: Kagoshima no kao)

Nobuyoshi Araki 'Japanese Faces' Project, Tokyo

The third instalment in the 'Japanese Faces' series executed in June 2003 to commemorate the forty-fifth anniversary of the *Minami Nihon Shimbun* newspaper presents photographs of the faces of 500 people from Kagoshima and Amami; the impact is enhanced by the succession of faces with strong southerly features.

TOKYO TRAVEL DIARY

(Tokyo tabi nikki)

Waizu Shuppan, Tokyo

A collection of black-and-white photographs taken specifically for this book in the Otsuka, Shinjuku, Asakusa and Meguro districts of Tokyo, featuring Uiko Fujino, an actress who appeared in the 2003 film *Travel Diary of a Disappearance*, directed by Isamu Yamada and based on an essay by Yoshiharu Tsuge. Skilful stripping by the model, herself a former stripper, ensures an exciting session. It concludes with a commentary entitled 'Operators for Questioning' by Kazushi Suzuki.

HIKARU IN THE WIND
(Kaze Hikaru)

Futabasha, Tokyo

A collaboration between Hikaru Hoshikawa, with her 100 cm (39 in) bust, and Nobuyoshi Araki, with his 63 years, resulting in a lively and happy collection of photographs; includes Araki's sketches of the model made in the intervals between shooting.

MEGUMI OKINA

Shinchosha, Tokyo

A monthly magazine-book series in which popular photographers shoot various actresses and entertainers. Araki was assigned to shoot the popular actress Megumi Okina. In this series nudes were not allowed, but Araki took advantage of this limitation to portray the inner eroticism of Okina. The daring presentation, using water and other environments, is particularly effective.

TOKYO SUMMER STORY
(Tokyo natsu monogatari)

Waizu Shuppan, Tokyo

A dynamic collection of almost 400 photographs consisting entirely of snapshots of street scenes taken from taxi or car windows. The idea is that by 'framing time', both the streets and the people in them will begin to seem as if they are floating in mid-air. The book opens with a dedication to Yasujiro Ozu, the celebrated film director of *Tokyo Story*, and Araki's observation that 'Tokyo is a story'.

MON JOURNAL D'ÉTÉ

Edition Kamel Mennor, Paris

Exhibition catalogue for a solo show held in October and November 2003 at a gallery in Paris. The black-and-white prints have been painted over in primary colours and cover a wide range of genres, including landscapes, nudes and diaries.

2004

BETRAYAL
(Uragiri)

AaT Room, Tokyo

A limited edition of 1,000 released on 1 January. Labelled as a 'Selection of 100 Nudes of Married Women', the book is a by-product of the popular column 'Eroticism of Married Women', but it gives the impression of being a rather malicious collection. The images of naked middle-aged women minus their heads, with drooping breasts and wrinkles are ostentatiously exposed in what amounts to a secret betrayal of his models by the photographer.

PAINTED FLOWERS
(Shikijoka)

Switch Publishing, Tokyo

A large-format collection released in a limited edition of 1,000 with signed ink-jet prints attached to the appendix. Primary colour paints dropped onto petals transform them into weird objects that seem to enshrine the essences of life and death. The volume ends with a discussion called 'On Flowers' with the photographer Daido Moriyama.

LES MISERABLES
(Mujo)

AaT Room, Tokyo

A collection of photographs released in a limited edition of 1,000 on 25 May (Araki's birthday). In the same manner as *Betrayal*, the photographs convey a sense of sarcasm and scorn, consisting of a succession of nudes chosen precisely because of their awkward poses and expressions; perhaps this is Araki's caustic criticism of his own work.

BREASTS ARE FLOWERS
(Chibusa, hana nari)

Waizu Shuppan, Tokyo

A collection of nudes featuring as the model the poet Minori Miyata, who underwent a mastectomy after contracting breast cancer; a tranquil atmosphere characterizes the book, which includes short verses by Miyata:

From the wound
In my breast
Greenery
Puts forth new shoots
Like the memento
Of a lost love

DIARY OF DR PHIMOSIS: THE END
(Hokeitei nichijo: kan)

Village Centre Shuppan-Kyoku, Tokyo

A collection from the photographic diary *Hokeitei nichijo* serialized in the magazine *Uwasa no shinso* between 2001 and 2003 together with manuscripts in Araki's own hand; the free-flowing calligraphy bears witness to days spent in excess.

MAY, WHEN EVEN MORPHINE HAS NO EFFECT
(Moruhine mo kikanu gogatsu)

Basilico K.K., Tokyo

A collection of vertically orientated photographs specially taken for this volume arranged in almost chronological order. Turning the pages while reading the commentary, contained in a separate volume, enables the reader to appreciate the breadth of Araki's continuous photographic activity. The title is taken from a *tanka* verse by Minori Miyata:

Lying on my sickbed
In May when even
Morphine has no effect
I intertwine my finger
With yours

MEMORIES OF SEOUL AGAIN
(Futatabi Souru no 'kioku')

Arton, Tokyo

A collection of photographs taken in the back streets of Seoul in the summer of 2004 in the company of Nori Nakagami, Kenji Nakagami's daughter and herself a writer. Places left behind in the midst of rapid urbanization are highlighted in photographs and writing.

THE SCENIC BEAUTY OF CHEJU ISLAND: ADRIFT
(Fuko no Saishuto 'Hyoryu')

Arton, Tokyo

A documentary record of South Korea's Cheju Island produced together with the non-fiction writer Seiji Fujii. Divided into nine chapters entitled 'Sea, light', 'Gaze, gathering', 'Island, around', 'Women divers, living', 'Prayer, dance', 'Autumn, harvest', 'City, tranquillity', 'Night, lively'. A collection of carefully taken black-and-white photographs.

JAPANESE FACES: FACES OF ISHIKAWA
(Nihonjin no kao: Ishikawa no kao)

Nobuyoshi Araki 'Japanese Faces' Project, Tokyo

The fourth instalment in the 'Japanese Faces' project executed from May to July to mark the opening of the Kanazawa Twenty-First-Century Museum of Art. Simple but effective book design by Kazushi Suzuki and Misaki Fujita. There are more family portraits than in the earlier instalments and the relationships between the models are brought to the fore.

EROTICISM OF MARRIED WOMEN, VOLS. 1–9
(Hitozuma Erosu 1–9)

Futabasha, Tokyo

Features twenty-five nudes in each of the first six volumes selected from the popular column serialized in the magazine *Shukan Taishu*. The number of women featured increased to thirty-three in Vol. 7 (2002) and fifty in Vol. 9, suggesting the unflagging popularity of the series. The bold stripping of the wives is astonishing in itself, but this series might perhaps be considered as Araki's way of ensuring that his camerawork did not get rusty, by establishing close relationships with the models as he photographed them.

CHRONOLOGY

Compiled by Tomoko Sato

This chronology sets Araki's life in the context of key events of the times from 1940 up to 2005.
The biographical information concentrates on Araki's activities in relation to the development of his career,
rather than individual works or exhibitions, which are mentioned only where appropriate.
The historical information focuses on Japan, especially Tokyo, where Araki has lived and worked throughout
his life. The events featured in this chronology illustrate the currents of contemporary thought in politics
and culture, and especially photography.

Born 25 May in Minowa, downtown (*Shitamachi*) Tokyo, near red-light district Yoshiwara, as the fifth of seven children of *geta* (traditional clogs) craftsman Chotaro Araki and his wife Kin. His parents run the Nimbenya *Geta* shop.	1940	Major shortages of foods and other goods; prices rise rapidly; puppet Japanese government established in Nanking under Wang Ching-wei; Japan's expansion policy in Asia established under Prime Minister Fumimaro Konoe; Japan signs Tripartite Pact, a military alliance with Axis powers Germany and Italy; Japan occupies northern French Indochina.
	1941	Group of photographers including Chuji Yasui make portraits of Jewish refugees in Kobe; Japan moves troops into southern French Indochina; in retaliation, US, Great Britain and Dutch East Indies freeze Japanese assets in their countries and impose total embargo on exports to Japan; with General Hideki Tojo as Prime Minister, plans for war with the US develop; Emperor Hirohito approves government war plans in December; Japanese navy attacks Pearl Harbor, Hawaii, and other US bases on 7 December; Pacific War begins.
	1942	First of many air raids carried out by US on Tokyo, Yokohama, Nagoya and Kobe.
'When the war ended, I was five years old; I remember being given chocolate and condoms by the American soldiers. They said they were balloons! I belong to such a generation.'	1945	Massive air raids over Tokyo on 9 March kill over 100,000 people and burn down most of city; US drops first atomic bombs in history on Hiroshima (6 August) and Nagasaki (9 August); Japan ends the war on 15 August, with emperor's surrender speech broadcast by radio; US occupation begins in September; destructions of war documented by photographers Koyo Ishikawa (Tokyo), Yoshito Matsue (Hiroshima) and Yosuke Yamahata (Nagasaki).
	1946	Emperor Hirohito renounces his divinity, which has been ideological basis of military Japan; International Military Tribunal for the Far East war crimes trials begin in Tokyo; Emperor Hirohito exempted from prosecution as war criminal; new constitution of Japan announced, coming into force May 1947; trade union movement grows rapidly.
	1948	Tokyo War Crimes Tribunal delivers verdict; Hideki Tojo executed as Class A war criminal; Japan Photographers' Group formed by Ihei Kimura, Ken Domon and Yoshio Watanabe.
	1950	Outbreak of Korean War as Communist North Korea attacks the South: increases Japan's strategic importance to the US in the Cold War; D.H. Lawrence's *Lady Chatterley's Lover* (translated by Sei Ito) banned for obscenity; Japan Photographers' Society formed, with Ihei Kimura as president.
	1951	Japan signs San Francisco Peace Treaty with 49 nations and US-Japan Security Treaty; Akira Kurosawa's film *Rashomon* (1950) wins Golden Lion at Venice Film Festival; *Photo Art* magazine banned for featuring nudes.
Given his first camera – Baby Pearl 3 x 4 spring camera – by his father, a skilled amateur photographer; takes his first photographs during a school trip; his father buys him subscriptions to *Sun Photographic Newspaper* and the magazine *International Photographic Information*.	1952	US occupation of Japan officially ends 28 April; heated debates on realism in photography generated by photographic magazines; *Asahi Graph* magazine, publishing photographs of Hiroshima and Nagasaki for the first time, sells out in one day (520,000 copies).
'When I was a high-school kid, I had no particular ambition to become a professional photographer. In the Shitamachi *environment, I was more conscious about skills or craftsmanship, the value shared with my father, rather than art.'*	1953	Yasujiro Ozu makes *Tokyo Story*, one of the greatest films produced after the war (the film receives an award at the London Film Festival in 1958).
	1954	Japan Self-Defence Force formed; Robert Capa visits Japan.
	1956	Japan joins United Nations; 'Jinmu' boom: Japanese economy returns to 1936 level and end of post-war recovery period declared; dramatic increase in market for popular weekly magazines.
Enters Chiba University, majoring in photography and film.	1959	'Iwato' boom: Japan's rapid economic growth begins; Crown Prince Akihito marries Michiko Shoda; Tokyo underground trains start running between Ikebukuro and Shinjuku; National Museum of Western Art opens in Ueno, Tokyo.

	1960	1951 US-Japan Security Treaty renewed as US-Japan Treaty of Mutual Security and Cooperation; massive, violent student demonstrations against the treaty; many photographers among demonstrators; Inajiro Asanuma, leader of the Socialist party, assassinated by 17-year-old right-wing student; Eikoh Hosoe exhibits *Man and Woman*, a collaboration with Tatsumi Hijikata, founder of Butoh dance.
While studying at Chiba University Araki is absorbed in Italian neorealism films; wins many competitions organized by photographic magazines with snapshots of neighbourhood and portraits.	1961	Preparations begin for Tokyo Olympic Games in three years' time; William Klein visits Tokyo; W. Eugene Smith stays in Japan for a year; Shomei Tomatsu and Ken Domon jointly publish *Hiroshima Nagasaki Document 1961*.
	1962	Tokyo becomes world's largest city with population of over 10 million; avant-garde artists including Jiro Takamatsu and Natsunori Nakanishi perform happening in Yamanote trains in Tokyo; Japan's camera industry overtakes West Germany's; Shomei Tomatsu holds exhibition *<11:02> Nagasaki*. Eikoh Hosoe holds exhibition *Ordeal by Roses*, which features writer Yukio Mishima as subject.
Graduates from Chiba University; takes up a position as commercial photographer at Dentsu, a Tokyo advertising agency; pursues personal interest in photography after office hours, using Dentsu's photographic equipment and studio facilities.	1963	Anti-art group, High Red Centre, formed by Jiro Takamatsu, Natsunori Nakanishi and Genpei Akasegawa; art magazine *Taiyo* founded: will become influential.
Meets Kineo Kuwabara, photographer and editor of *Camera Art* magazine; wins first *Taiyo* magazine prize for photography with *Satchin*, a series of black-and-white still photographs from 1963 graduation film project, *Children Living in Apartment Blocks*, which features primary school children in downtown Tokyo.	1964	First bullet trains run between Tokyo and Osaka at 256 kph (160 mph); Tokyo Olympic Games held in October: official photographers include Shomei Tomatsu, Eikoh Hosoe and Shigeichi Nagano.
Holds first solo exhibition, *Satchin and His Brother Mabo*, at Shinjuku Station Building, Tokyo.	1965	Outbreak of the Vietnam war; first anti-war demonstrations in Tokyo; Saburo Ienaga, history professor at Tokyo university, sues government over Ministry of Education's control of school history textbooks: trials generate massive debates about teaching of modern Japanese history, especially Japan's war record; Henri Cartier-Bresson visits Japan.
Araki's father Chotaro dies 18 March; photographs the corpse and inherits his favourite camera – an Ikonta Super 6 (a collection of photographs taken with this camera, *A Tale of Ikonta*, is published in 1981); meets Yoko Aoki, a typist at Dentsu, who is seven years younger than him; begins taking photographs of her.	1967	'Futen-zoku' (the Vagabond tribe) – youngsters leading a free lifestyle – flock round Shinjuku station; poet and playwright, Shuji Terayama, forms his avant-garde theatre group Tenjosajiki.
	1968	US atomic submarine, *Enterprise*, stops in port of Sasebo, fuelling anti-American feeling; anti-treaty, anti-Vietnam war movements develop into radical student movements; photographic magazine *Provoke: Provocative Material for Ideology*, founded by Daido Moriyama, Takuma Nakahira, Koji Tagi, Takahiko Okada and Yutaka Takanashi; Daido Moriyama publishes *Japan: A Photo Theatre* with text by Terayama.
	1969	Tokyo university becomes centre of political radicalism; radical students occupy Yasuda university hall: 8,500 riot police arrive; anti-war rally at Shinjuku station escalates into violent clash with riot police; first performance of *Hair*, anti-war rock musical; Tomei Shomatsu visits Okinawa for the first time and rediscovers roots of Japanese culture.
Privately publishes *Xerox Photo Album*; sends copies to friends, art critics and people selected randomly from Tokyo telephone directory; holds exhibition entitled *Sur-sentimentalist Manifesto No.2: The Truth about Carmen Marie*, at Kunugi Gallery, Tokyo, featuring enlargements of female genitalia; begins exhibiting series 'Ero-realism' at Kitchen Ramen, a noodle restaurant in Ginza, Tokyo, which continues until 1976.	1970	First World Exposition in Japan held in Osaka; armed student activist group, Red Army, hijacks a Japan Airlines plane; Tokyo has highest cost of living in world; Yukio Mishima commits suicide at Japan Self-Defence Force's Ichigaya base, after passionate speech calling for *coup d'état*; first assembly of women's liberation groups held in Tokyo.
Marries Yoko Aoki 7 July; displays a slide show of nude photographs of Yoko at their wedding reception; privately publishes *Sentimental Journey*, documenting honeymoon with Yoko; forms the group *Fukusha-shudan Geribara 5* with his colleagues from Dentsu: Kojiro Yaehata, Fukuo Ikeda, Yoshio Takase and Naohisa Tamogami; the group advocates in exhibitions and periodicals idea that 'photographs are copies'; visits Okinawa, then under US control, working on Dentsu poster campaign.	1971	First Japanese branch of McDonald's opens in Ginza, Tokyo; government commissions Dentsu to produce poster campaign for return of Okinawa island to Japan.

LIFE OF NOBUYOSHI ARAKI		KEY EVENTS IN JAPAN
Leaves Dentsu; becomes freelance photographer; buys new camera – Asahi Pentax 6 x 7 – with his retiring allowance; begins 'Tokyo Atget', a project where he walks around Tokyo and photographs the city, inspired by Eugène Atget and Walker Evans.	1972	Far-left student movement declines after Asama Incident, which ends with gun battles between students and riot police; extremists move focus of activity outside Japan (e.g. Japan Red Army's attack on Tel Aviv airport); US returns control of Okinawa to Japan.
	1973	Shomei Tomatsu moves from Tokyo to Okinawa and serializes 'The Pencil of the Sun' in *Camera Mainichi* magazine; Diane Arbus exhibition in Tokyo; W. Eugene Smith exhibits *Minamata: Life – Sacred and Profane*, documenting the struggles of Minamata pollution victims; Japan suffers first oil crisis as oil price increases fourfold over four months (October to January 1974); cost of living rises rapidly.
Forms the Photo Workshop School with Shomei Tomatsu, Daido Moriyama, Eikoh Hosoe, Masahisa Fukase and Noriaki Yokosuka, which runs until 1976; his mother Kin dies 11 July; photographs the corpse.	1974	Leonardo da Vinci's *Mona Lisa* exhibited at the National Museum, Tokyo; Eisaku Sato, former prime minister (1964–72), awarded Nobel Peace Prize.
Edits issue 7 of magazine *Workshop*, featuring photographs of women; opens Nobuyoshi Araki's Private Photo School, which runs until 1977; meets Akira Suei, editor of erotic magazine, *New Self*; starts working on series 'Romantic Photography' featured in the popular *manga* magazine *Garo*, which runs until 1985.	1976	Kakuei Tanaka, former prime minister (1972–4), arrested for accepting bribes from Lockheed Corporation; explosive growth in *manga* publication: over 80 million *manga* magazines sold in this year.
Participates in first exhibition outside Japan, *New Photographers from Japan* at Stadtmuseum Graz mit Museumsapotheke, featuring 22 contemporary Japanese photographers.	1977	Kishin Shinoyama and Takuma Nakahira jointly publish *A Duel: Theories on Photography*; Richard Avedon exhibition *The Portrait of the Age*; Daido Moriyama exhibition *Tokyo: The City of Webs*; Japanese average life expectancy highest in world (72.6 years for men, 77.95 for women); *karaoke* becomes popular form of entertainment.
Leaves Minowa and moves to Tokyo suburb of Komae; publishes first book of essays on photography, *Between a Man and a Woman is a Camera*.	1978	New Tokyo international airport opens at Narita; Japan suffers second oil crisis as oil price increases dramatically overnight. Masahisa Fukase exhibits series *Yoko*, about his wife.
Visits New York for *Japan: A Self-portrait*, exhibition at International Center of Photography, curated by Cornell Capa and Shoji Yamagishi; begins series of bondage shots for *S&M Sniper* magazine.	1979	G7 economic summit in Tokyo; Seiji Kurata exhibits series, *Streets: Photo Random Tokyo 1975–79*; Taeko Tomioka, novelist and critic, publishes *The Age of Photography*; Japanese translation of Susan Sontag's book *On Photography* published.
Works as still photographer for *Zigeunerweisen*, film by Seijun Suzuki; publishes *Araki Nobuyoshi's Pseudo-Diary*, incorporating photographs taken with compact camera that shows date; book becomes prototype of his photo diaries, with idea of manipulating dates, then rearranging images mechanically in 'fake' date order.	1980	Japan boycotts Moscow Olympic Games; Seijun Suzuki's surrealist film, *Zigeunerweisen*, shown in a mobile theatre, Cinema Praset; sex industry flourishes: *nopan kissa* – cafés with waitresses wearing no underwear – and *bini-bon* – adult pornographic magazines sealed in plastic covers – become part of sub-culture.
Founds Ararchy Limited Company; Akira Suei founds magazine *Photo Age*, which features three new series by Araki; travels to Paris, Madrid and Buenos Aires with Yoko to celebrate tenth wedding anniversary; first work as film director, *Pseudo-Diary of a High School Girl*, released by Nikkatsu.	1981	Exhibition *The World of Shomei Tomatsu* travels to over 30 cities in Japan, continuing until 1984; Daido Moriyama exhibits series *Light and Shadow*; weekly photo-reportage magazine *Focus* founded.
Opens new office, Photo Clinic; visits South Korea with novelist Kenji Nakagami; moves from Komae to Gotokuji in Setagaya, a few kilometres outside Tokyo.	1982	
Begins documenting scenes from sex industry in Kabuki-cho, Shinjuku, a Tokyo red-light district.	1983	Tokyo Disneyland opens; Ken Domon Memorial Museum opens in Yamagata; *Photo Japon* magazine founded.
Publishes *The Night of Nostalgia*, collection of photographs accompanied by Yoko's text to celebrate 13th wedding anniversary; it documents night they watched Andrei Tarkovsky's film, *Nostalghia*.	1984	Chon Du-hwan, president of South Korea, visits Japan; during this visit Emperor Hirohito expresses regret over 'an unfortunate past' between Japan and Korea. Weekly photo-reportage magazines *Friday* and *Flush* founded.
Walks around Shinjuku with Akira Suei to capture last glows of Kabuki-cho's sex industry; Yoko's first book of essays, *Love Life*, published to celebrate 14th wedding anniversary.	1985	New Entertainment and Amusement Trade Control Law enforced; first AIDS patient officially registered in Japan; G5 economic summit held at Plaza Hotel, New York: Plaza Agreement for new US/Japanese exchange rates triggers Japan's 'bubble economy'.
Publishes *I-Novel*, collection of photographs with text by novelist and actress Izumi Suzuki: book, with layout by Araki, commemorates Suzuki, who committed suicide this year; creates 'Arakinema', a slide show using two slide projectors accompanied by music: first shown at Cinema Rise, Shibuya, Tokyo, by Shiro Tamiya and Nobuhiko Ansai.	1986	Equal Opportunities Law enforced; Takako Doi (Socialist party) becomes first woman to lead a major political party in Japanese history; 'bubble economy' builds as property and share prices soar, continuing until 1989.
Performs *Arakinema 2*, a three-hour event accompanied by Akira Suei on saxophone; Arakinema becomes an important aspect of his artistic expression.	1987	Japanese insurance company Yasuda Kasai causes controversy in international art market by purchasing Van Gogh's *Sunflowers* at record price of ¥530 million; the biggest one-day stock market crash in history happens on Black Monday.

Chiro the cat arrives at Araki household, given by Yoko's family; police order Akira Suei's magazine *Photo Age* to withdraw all copies of April issue because of obscenity; magazine discontinued and Araki ordered to appear before the police; opens new office, AaT Room, with Shiro Tamiya and Nobuhiko Ansai.	1988	Recruit Scandal, exposing corrupt 'money politics' system, erodes public confidence in the Liberal Democratic party, which has now been in power for 38 years; Kawasaki City Museum opens with the first department of photography in Japan.
Publishes *Tokyo Story* 29 April, coinciding with Showa Emperor's birthday; meets Robert Frank; Yoko starts serializing essay 'Tokyo Fine Day' in *Science of Ideas* magazine, but stops after three issues because of hospitalization in August; in collaboration with Akira Suei, publishes *Tokyo Nude* which juxtaposes nudes on left-hand page and fragments of cityscape on right.	1989	Emperor Hirohito dies on 7 January, aged 87, marking end of Showa Era; Heisei Era begins with accession of Emperor Akihito; Japan enjoys rapid economic growth, with a strong yen; Bank of Japan keeps interest rates low, sparking an investment boom; a 3 per cent Consumption Tax comes into force; Nintendo starts selling a portable computer game called 'Game Boy'.
Yoko dies 27 January, aged 42; photographs the corpse in coffin as well as the ashes after cremation; shows *Skyscapes* 7 July, series of sky photographs taken since Yoko's death, coinciding with what would have been 19th wedding anniversary: the exhibition, at Gallery Verita, Tokyo, dedicated to Yoko; participates in *Op: Positions: Fotografie Biennale, Rotterdam II*, in Rotterdam and *Photos de Famille* at Grande Halle, La Villette, Paris.	1990	Iraq invades Kuwait in August, starting Gulf war in January 1991; Japan unsure how to participate in war under current constraints of Peace Constitution; Tokyo Metropolitan Museum of Photography opens; Quarterly photographic magazine *Déjà-vu* founded.
Exhibits *Winter Journey*, which documents daily events from time of Yoko's last birthday celebration to aftermath of her funeral in photo-diary style, at Egg Gallery, Tokyo; Sakiko Nomura becomes his assistant after seeing this show; publishes *Sentimental Journey/Winter Journey*, combining the two series: book generates heated debate with Kishin Shinoyama about issues surrounding Yoko's death photographs.	1991	Tokyo Metropolitan government offices move from Marunouchi to Shinjuku; sudden fall of Japanese stock market (60 per cent down from its peak in 1989) marks end of 'bubble era'; a branch of disco club Juliana opens in Tokyo, becoming symbol of Tokyo's bubble sub-culture; Kishin Shinoyama's book *Santa-Fe*, about actress Rie Miyazawa, becomes a bestseller.
Exhibits *Photo-Maniac's Diary*, including eight images of female genitalia at Egg Gallery; accused by police of 'displaying obscene objects' and fined ¥300,000; first solo exhibition outside Japan, *Akt-Tokyo: Nobuyoshi Araki 1971–1991*, opens at Forum Stadtpark, Graz; exhibition travels to 10 European cities, including Rotterdam, Essen, Munich, Zürich and Newcastle, continuing until 1995; exhibits *Tokyo through a Car Window*, Tokyo cityscapes photographed from car window at Egg Gallery: exhibition dedicated to Robert Frank.	1992	Cooperation for PKO (Peace Keeping Operations) Law instituted; Japan sends mine sweepers to Gulf as part of reconstruction effort; Emperor Akihito's first state visit to China.
Publishes *The Banquet*, close-up photographs of leftover food at the dinner table: the film changes from colour to monochrome after Yoko's hospitalization; publishes *Tokyo Fine Day* 27 January, Yoko's essays accompanied by his photographs, coinciding with anniversary of her death: the book is their 'last collaboration'; police consider obscene *Akt-Tokyo* exhibition catalogue, being sold at *Erotos* exhibition at Parco Gallery, Tokyo: a gallery staff member is arrested, Araki is questioned and his house searched.	1993	Emperor and Empress make first visit to Okinawa in Japanese history; Crown Prince Naruhito marries Masako Owada, who works for the Ministry of Foreign Affairs; Nan Goldin visits Japan, invited by *Déjà-vu* magazine; photographer Kyoichi Tsuzuki publishes *Tokyo Style*.
Rejects invitation to participate in *Venice Biennale*; first solo exhibition in US, *Tokyo Nude/Private Diary* at Luhring Augstine Gallery, New York; participates in joint exhibitions: *Body and Memory: Nobuyoshi Araki and Larry Clark* at Sala Parpallo Gallery, Valencia and *Tokyo Love* (with Nan Goldin) at The Ginza Art Space, Tokyo; publishes *Ararchism*, an anthology of writings from last 30 years, compiled by art historian Toshiharu Ito; publishes first collection of digital photographs, *Arakitronics*.	1994	Religious cult Aum Shinrikyo sprays deadly sarin gas in Matsumoto City, killing seven people and injuring over 600; *Switch* magazine features work of Robert Frank; *Déjà-vu* magazine features 'New Tokyo Photographers', showing works by Chikashi Kasai, Osamu Kanemura, Sakiko Nomura and Arie Nagashima.
First solo exhibition in France, *Journal intime*, at Fondation Cartier pour l'Art Contemporain, Paris; exhibits *Erotos* first at Gallery Index, Stockholm and then in other European cities, including Oslo and Graz; Araki's exhibitions abroad dramatically increase in number; privately publishes *Endscapes* 15 August (End-of-the-War Memorial Day), featuring 'My emotional landscape' beginning on 30 November 1971' and other series; publishes *Tokyo Sex*, a large collection of photographs documenting Tokyo's sex industry, 'commemorating' 10th anniversary of new Entertainment and Amusement Trades Control Law.	1995	Kobe earthquake, magnitude 7.2, kills over 6,000 people, causing US $100 billion damage; Aum Shinrikyo releases sarin gas in Tokyo underground, killing 12 and injuring over 5,000; Robert Frank's exhibition *Moving Out*, at the Yokohama City Art Museum; Takashi Homma publishes *Babyland*; Kiyosato Museum of Photographic Arts opens in Yamanashi prefecture, with Eikoh Hosoe as director.
Heibonsha begins to publish a comprehensive anthology of Araki's photographs in 20 volumes, *The Complete Photographic Works of Nobuyoshi Araki*.	1996	
Attends opening of largest solo exhibition, *Tokyo Comedy*, at Wiener Secession in Vienna; shows live version of Arakinema for first time outside Japan, also in Vienna; first retrospective exhibition, *Araki Retrographs*, held at Hara Museum of Contemporary Art, Tokyo; *Tokyo Fine Day* filmed by the actor/director Naoto Takenaka: Takenaka plays leading role, a photographer, and Araki makes guest appearance.	1997	Increase in Consumption Tax to 5 per cent causes public outrage; Japanese banks and firms suffer deepening recession: Hokkaido Takushoku Bank and Yamaichi Security declare bankruptcy; Kyoto Protocol to control emissions of greenhouse gases signed by 180 countries; Nintendo computer game *Pocket Monster* (Pokémon) becomes TV animation; Pokémon craze grips primary schools.

Heibonsha begins to publish *The Complete Literary Works of Nobuyoshi Araki* (8 volumes); visits Asia for shooting and attending exhibition openings: *Story Portraits* and *Arakinema: Erotic Women in Color* in Bangkok, *Arakinema: Taipei* and *1998 Taipei Biennial: Site of Desire* in Taiwan, and *Sur-everyday-life* in Shanghai.	1998	Government launches major financial reform, 'Japanese version of the Big Bang', to revitalize Japanese economy; North Korean test missile Taepodong flown over Japanese territories brings over issues of North Korean affairs and self-defence mechanism; Takashi Homma's *Tokyo Suburbia* published.
First solo exhibition at public museum in Japan, *ARAKI Nobuyoshi: Sentimental Journey, Sentimental Life*, at Museum of Contemporary Art, Tokyo; first major solo exhibition in Taiwan, *Nobuyoshi Araki: ALive* at Taipei Fine Arts Museum: the exhibition travels to Athens, Prague, Cologne and Vancouver.	1999	Japan's first nuclear accident occurs at uranium processing facility in Tokaimura, Ibaraki prefecture, killing two people; unemployment rate reaches 4.9 per cent; two major banking corporations, Sumitomo Bank and Sakura Bank, announce plans to merge.
Major retrospective exhibition *Araki: Viaggio sentimentale (Sentimental Journey)*, held at Centro per l'arte contemporanea Luigi Pecci, Prato; shoots in Prato, Naples and Florence specially for the exhibition's last section, 'Viaggio in Italy'; exhibition travels to Centre nationale de la photographie, Paris.	2000	Major department store Sogo goes bankrupt; three large corporations, Daiichi Kangyo Bank, Fuji Bank and the Industrial Bank of Japan agree to merge; increase in teenage crimes recorded; Takashi Murakami curates *Superflat* exhibition at Shibuya Parco Gallery, featuring HIROMIX, Masafumi Sanai and Yoshitomo Nara.
Features in Japan Festival UK 2001: first retrospective in Britain, *Tokyo Still Life*, at Ikon Gallery, Birmingham; participates in *Facts of Life*, survey of contemporary Japanese art at Hayward Gallery, London.	2001	American nuclear submarine USS *Greenville* collides with a Japanese fishing trawler and training ship for high school students near Hawaii, killing nine Japanese crew; Japanese stock market falls to a 17-year low and unemployment rate is record high: 4.7 per cent of women and 5.2 per cent of men; on September 11 terrorists hijack and crash commercial passenger jets into World Trade Center, New York, killing thousands, including 24 Japanese; US declares 'War on Terror'; Japan sends two destroyers and one supply ship to Indian Ocean to support US fighting in Afghanistan: this is first despatch of military ships outside Japan since Second World War.
Launches 'Japanese Faces' project, starting in Osaka, photographing the faces of 1,000 people; largest book to date, *Araki*, published by Taschen; visits Venice for opening of exhibition *Suicide in Tokyo* at Italian Pavilion (a Venice Biennale site), and to run workshop.	2002	Japan and Korea jointly host 2002 FIFA World Cup, with matches taking place throughout Japan; Prime Minister Junichiro Koizumi visits North Korea and meets Kim Jong-Il.
Continues 'Japanese Faces' project, moving to Kyushu, photographing faces of 500 people in Fukuoka and 500 in Kagoshima; Kodansha International publishes comprehensive anthology *Araki by Araki, The Photographer's Personal Selections*; publishes *Tale of a Tokyo Summer*, a collection of snapshots of street scenes taken from a car window, dedicated to film director Yasujiro Ozu, whose *Tokyo Story* (1953) inspired Araki's idea that 'Tokyo is a story'.	2003	Iraq war begins as first American bomb is dropped on Baghdad and US/UK coalition troops invade Iraq; Prime Minister Koizumi's cabinet approves plan to sends soldiers of Self-Defence Forces to help in Iraq's reconstruction; two diplomats killed in Iraq, first Japanese victims of Iraq war; Hayao Miyazaki's *Spirited Away* wins Oscar for Best Animated Feature; Takeshi Kitano wins a special director's award for *Zatoichi* at Venice Film Festival.
First documentary film on Araki and his impact on Japanese culture, *Arakimentari*, released, directed by Travis Klose, and featuring Björk, Takeshi Kitano and Daido Moriyama as commentators; continues to work on 'Japanese Faces' project, shooting in Ishikawa; works on joint project with Daido Moriyama to shoot Kabuki-cho, Shinjuku, on the same day, with Araki working in colour and Moriyama in black and white.	2004	Japan's recessions continue; two of Japan's oldest insurance companies, Yasuda and Meiji, merge to form Meiji Yasuda Life Insurance Company; 1,000 soldiers of the Self-Defence Forces are sent to Iraq, marking first despatch of land troops outside Japan since Second World War; Gender Recognition Act instituted; former actress Chikage Ohgi becomes the first woman President of the House of Councillors in Japanese Parliament; Korean-style boom, with increasing popularity of Korean films and culture.
Joint exhibition with Daido Moriyama, *Moriyama-Shinjuku-Araki*, at Tokyo Opera City Gallery (January–March); publishes *Colour-eros (Shiki-in)*, a collection of 'photo-paintings' and *Hiunkaku*, an unusual book of architectural photographs of a national treasure, Hiunkaku-Temple in Kyoto; first visit to London to attend the opening of *Nobuyoshi Araki: Self, Life, Death* exhibition at Barbican Art Gallery, London (October 2005–January 2006).	2005	Vehicle Recycling Act enforced; the 2005 World Exposition held in Aichi (March–September); massive anti-Japan demonstrations in Beijing and other cities in China increase political tension between Japan and China; violent teenage crimes continue to increase; Prime Minister Junichiro Koizumi attends G8 Summit at Gleneagles, Scotland.

SOURCES

Kotaro Iizawa, *Araki! The Legacy of a Prodigy* (Tokyo: Shogakukan Bunko, 1999)

Kotaro Iizawa (ed.), 'Japanese Modern Photography', *Bijutsu Techo*, December, 2004

Michiyo Mukaino, 'Chronology', *Tokyo: A City Perspective*, exh. cat. (Tokyo Metropolitan Museum of Art, 1990), pp. 156–161

Akihito Yasumi, 'Chronology', *Araki Nobuyoshi: Sentimental Photography, Sentimental Life*, exh. cat. (Museum of Contemporary Art, Tokyo, 1999), pp. 78–84 (English edition); pp. 134–140 (Japanese edition)

INDEX

The Publishers would like to dedicate this book to the memory
of Carol Brown (1954–2004), Head of Art Galleries at
The Barbican Centre.

EDITORS' ACKNOWLEDGEMENTS

We are very grateful for the assistance and the contribution of the
following in compiling this book: Ansai, Kate Bush, Alex Daniels Jr.,
Kotaro Iizawa, Ian Jeffrey, Yuji Kogure, Mario Kramer, Museum
für Moderne Kunst (Frankfurt am Main Geschenk der Künstlers),
Hisako Motoo, Sakiko Nomura, Hans Ulrich Obrist, Natsuko Odate,
Mariko Oikawa, Axel Schneider, Shiro Tamiya, Yuko Tanaka,
Robin Thompson, Louise Vaughan, Jonathan Watkins, Oliver
Winchester. Our special thanks also go to our colleagues at
Phaidon: Sonya Dyakova, Amanda Renshaw, David Salmo and
Richard Schlagman.

Phaidon Press Limited
Regent's Wharf
All Saints Street
London N1 9PA

Phaidon Press Inc.
180 Varick Street
New York, NY 10014

www.phaidon.com

This book is published as a companion to the exhibition
Nobuyoshi Araki: Self, Life, Death, 6 October 2005 to 22 January
2006, at the Barbican Art Gallery, London.

All texts by Araki are taken from *Genius Ararchy: Method of
Photography* (2001) except for 'Satchin' and 'Thoughts on receipt
of the 1st Taiyo Prize', from *Taiyo* (July 1964); 'Satchin is all
about self-timer photos' and 'Genius Ararchy', from *Photo Art*
(October 1969); 'Preface to Sentimental Journey', from *Sentimental
Journey* (1971); 'Questionnaire: My ten favourite photographers',
from *Playboy* (February 1983); 'My laboratory', from *Dentsujin*
(1 June 1965); 'Tokyo, in Autumn', from *Becoming a Genius* (1997);
'My mother's death, or an introduction to home photography', from
Workshop (September 1974); and 'Photographing the sky', from
Voice (September 1990).

Edobei, Servant of Otani Oniji III by Sharaku (p.549) is courtesy
of the British Library, London, UK / Bridgeman Art Library

All translations by Robin Thompson, except for 'In Conversation
with Araki' by Tomoko Sato

First published 2005

© 2005 Phaidon Press Limited

ISBN 0 7148 4555 8

A CIP catalogue record for this book is available from the
British Library.

Designed by Sonya Dyakova
Printed in Italy